donation 2019

LEO AND HIS CIRCLE

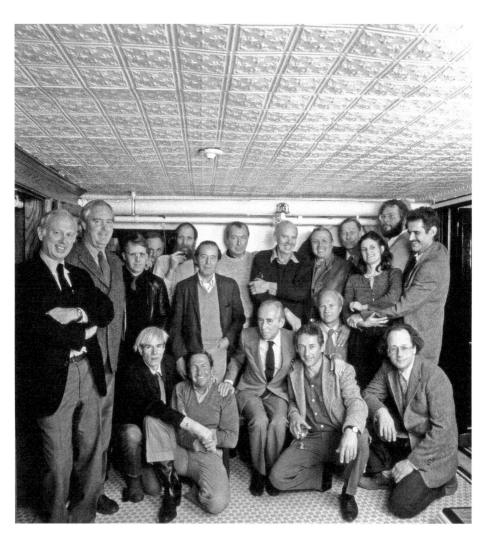

THE ODÉON CAFÉ, NEW YORK, FEBRUARY 1, 1982, TWENTY-FIFTH ANNIVERSARY CELEBRATION OF THE CASTELLI GALLERY

STANDING, FROM LEFT TO RIGHT: Ellsworth Kelly, Dan Flavin, Joseph Kosuth, Richard Serra, Lawrence Weiner, Nassos Daphnis, Jasper Johns, Claes Oldenburg, Salvatore Scarpitta, Richard Artschwager, Mia Westerlund Roosen, Cletus Johnson, Keith Sonnier. SEATED, FROM LEFT TO RIGHT: Andy Warhol, Robert Rauschenberg, Leo Castelli, Ed Ruscha, James Rosenquist, Robert Barry. Photograph by Hans Hamuth.

LEO AND HIS CIRCLE

The Life of Leo Castelli

ANNIE COHEN-SOLAL

TRANSLATED BY MARK POLIZZOTTI WITH THE AUTHOR

ALFRED A. KNOPF
NEW YORK
2010

THIS IS A BORZOI BOOK
PUBLISHED BY ALFRED A. KNOPF

Translation copyright © 2010 by Mark Polizzotti

Originally published in France as *Leo Castelli et les siens* by Éditions Gallimard, Paris, in 2009.
Copyright © 2009 by Annie Cohen-Solal. Copyright © 2009 by Éditions Gallimard.

Library of Congress Cataloging-in-Publication Data
Cohen-Solal, Annie, date.
Leo and his circle : the life of Leo Castelli / Annie Cohen-Solal.—1st ed.
p. cm.
Includes bibliographical references and index.
ISBN 978-1-4000-4427-6 (alk. paper)
1. Castelli, Leo. 2. Art dealers—United States—Biography.
3. Castelli, Leo—Friends and associates. I. Title. II. Title: Leo and his circle.
N8660.C38C64 2010
709.2—dc22
[B]
2009034454

Manufactured in the United States of America
Published May 15, 2010
Reprinted One Time
Third Printing, July 2010

To the young generation,
August and Prosper Castelli,
Tomás Ilean Laddaga, Cecelia Rose Reitter,
Zoe and Ari Weingarten,
and, of course, Archie!

CONTENTS

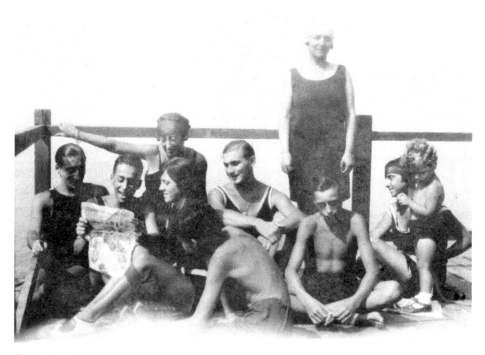

ON THE BEACH IN TRIESTE, 1927
Leo Krausz, SECOND FROM LEFT, age twenty, discussing the cartoons in the local daily, *Il Piccolo di Trieste*

ENVOI

"SO, YOU ARE THE NEW ONE. Well, you're going to take the city by storm with your orange skirt and your long gloves! Why don't you come to the gallery tomorrow around five? You'll see the show, you'll meet Roy.[1] He has an opening, and you'll stay for the party!" With such melodious guile did Leo Castelli greet me at a dinner two weeks after my arrival in New York to take my assignment as cultural counselor for the French embassy. That encounter in 1989, our first, immediately set the easy tone for our relationship, which lasted until his death in 1999. Castelli, despite being eighty-two and wearing a hearing aid (a very discreet one, almost invisible), was still very much the flirtatious man-about-town, sailing on the confidence of his legendary name. That evening, he was escorting a new girlfriend, Catherine Morrison, a stylish British architect in her forties, and he giggled with her constantly, like a young lover.

On that day I unwittingly became part of "the family," and so during my first year in the United States, I would find myself shuttling along with him from Minneapolis to Basel, from London to Houston, from New York to Washington, D.C., for the opening of Jasper's[2] latest show. "I am going to teach you everything you need to know about American art," he declared, lending me books and taking me to exhibitions on Sunday mornings. He introduced me to the writer Calvin Tomkins, to collectors such as the Daytons and Barbara Jakobson, to the curators Christian Gelhaar and Nan Rosenthal, to the gallerists Ileana and Michael Sonnabend, and many others. During ten years, his role as my private coach in American art was facilitated by our living within a block of each other. But his devotion to the mission was hardly dictated by convenience, as was clear whenever he expatiated on Clement Greenberg, Alfred Barr, Jackson Pollock, Pierre Matisse, Andy Warhol, and Sidney Janis, heedless of the time. He was likewise energized when he took me to art auctions at Sotheby's and Christie's to watch his artists sell for ever more dizzying prices; initiated me in the work of Eva Hesse at the Whitney; recounted his donation of Bob's *Bed* to the Modern; recalled seeing Frank's first *Monochromes* when the artist was a recent Princeton graduate, or recounted his most unforgettable

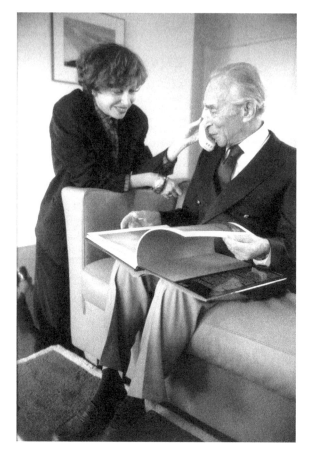

NEW YORK, OCTOBER 1990
With author as the cultural counselor to the French embassy in the
United States

moments with Jim and with Ellsworth.[3] But there was nothing to rival his
rapt intensity when he started to talk about Jasper, or when he was in
Jasper's presence.

In fact, few were truly immune to Leo's charm. Even when he stepped
into a restaurant unexpectedly around midnight with a group of friends,
whether in New York or Venice, the waiters and maître d' would always set a
table, treating him like a film star. A call of *"Bellini per tutti . . ."* and the
evening was under way! A few hours in his company could be a magical
experience. If he had decided to adopt you, as he had me, the span of his
wings spreading over you was most impressive, whichever of his haunts he
brought you to. It was, however, not merely the urbanity of his presence that
was so winning but also a certain eternal boyishness, as when he recited

La Fontaine's "Le Corbeau et le Renard" to me in perfect French with evident pride. Or, on one of our last museum excursions together, to see a Schiele show at MoMA, around Christmastime in 1998. The exhibition presented a beautiful and unknown series of erotic watercolors, and as Leo looked over the figures of naked women with an almost devotional regard, he drew near to one and said, *"Questo vorrei prenderlo a casa per guardarmelo bene"* ("This one, I would like to take it home with me and look at it more closely"), with a naughty smile.

Over the years, Leo told me about his life in bits and pieces. He mentioned consulting Edoardo Weiss—a student of Freud's and the most renowned psychoanalyst in Trieste—at the age of eighteen, when he was having trouble "approaching girls"; he mentioned discussing business with Mihai Schapira, his father-in-law, who called him *un bon à rien* (a good-for-nothing) for still living on his wife's money at the age of fifty. He spoke of his mistresses, his wives, his children; of Trieste, Vienna, Paris, Bucharest, and New York. Of course, all my impressions were formed in the context of New York in the 1990s in a world that was Leo's, under the spell and choreography of Leo, the peerless maker of myths.

It would be another decade, and only after he had passed away, before I started making my own inquiries, following up the few leads he had given me, and longer still before I had managed to patch some of the pieces together. I traveled by plane, by boat, by train, by car, visiting Trieste half a dozen times over the course of four years, as well as going to Udine, Venice, Monte San Savino, Milan, Vienna, Budapest, Siklós, Bucharest, Paris, São Paulo, San Francisco, and New York; I excavated archives in Italian, Hungarian, Hebrew, German, French, English; I met with archivists, historians, rabbis, synagogue and consistory officials, mayors, bankers, and insurance company employees; I interviewed first and second cousins, nephews and great-nephews, visiting too all the houses where he had lived as well as the ancestral graves in the Jewish cemeteries of Italy and of Hungary. At the end of the quest, I was able to discern, in the chain of the forced displacements and wanderings his family was made to endure, a story of origins much more complex, much more fascinating, and much more tragic than that of the effortlessly jovial figure his self-fashioning had suggested. And it made me wonder: what was Castelli so determined to achieve by his self-portraiture, by his relentless rehashing of the same few stories that however elegant were, with regard to understanding him, ultimately a dead end?

Excited by the mystery, I persisted, as if conducting a criminal investigation. The very best moments of my journey were those in Monte San Savino, when, for instance, Renato Giulietti pulled out, among a mass of huge parchment scrolls, one page dated 1787 which read *"Nazionne Ebrea, Famiglia Castelli . . . Castelli, Aarone, 50 . . . Castelli, Anna, 30 . . . Castelli, Giacobbe, Figlio, 9 . . . Letizia, Figlia, 20 . . . Sabatino, Figlio, 21 . . ."* Likewise memorable was the day in Trieste when Mariu Hassid delivered to my hotel room a big envelope with a white sheet of paper which read in Italian: *"Comunità Ebraica di Trieste, Copia Integrale Dell'Atto Di Nascita . . . Anno: 1907; Giorno e mese della nascita: 4 settembre; Data Ebraica: 25 Ellul; Nome del neonato: Leo"* followed by a Hebrew translation. Or the April morning in Göntér, a thriving commercial city on the border of Hungary and Croatia, crowned by a Turkish mosque, when I found the house of the Krausz family in the middle of a great vineyard as the new landowner was visiting on horseback. Or the moving hours I spent with "Giorgio" (Dr. George Crane, Leo's brother) in his San Francisco nursing home, or the lunch at the Yale Club in New York with Robert Reitter, Leo's nephew, who gave me the documents pertaining to the family's wartime history in Budapest; the breakfast at the Phillips Hotel with Mariève Rugo, Ileana's niece, who produced a raft of materials documenting the lavish life that Leo and Ileana, his first wife, had lived with her family, the Schapiras, in Bucharest. And so, as many fabulously colored pieces fell into place, I found myself facing an unimagined mosaic, so much richer and more complex than the stick figure that emerged from Leo's endlessly recited handful of anecdotes.

Fittingly, thrillingly, the story of Leo Castelli's family, I came to realize, had followed the very history of art, starting in Renaissance Tuscany, progressing through Baroque Italy, Expressionist Vienna, modernist Bucharest, Surrealist Paris, landing on the shores of Abstract Expressionist New York, finally to see the emergence of post-Dadaist, Pop, and Minimalist artists in the late twentieth century. And it was a story that encompassed all ruptures and displacements that had enabled European Jews to sow innovation throughout the world of modern art. In the patrimony of generations of brilliant traders and brokers from Monte San Savino and Trieste I found a ready paradigm to explain Castelli's gifts as a consummate networker and promoter. But it was when I found a volume of lectures on commercial agents in early modern Europe, in the stacks of NYU, that it became clear to me how perfectly he conformed to the ideal of those enterprising predeces-

sors, all "highly mobile, well-traveled, [with an] immigrant background . . . and a crucial knowledge of languages, local trade customs, networks and routes."[4] I became forcefully convinced that it was only in the context of this long tradition that Castelli's unrivaled knack could be fully grasped, and that I *had* to anchor his story in Renaissance Tuscany.

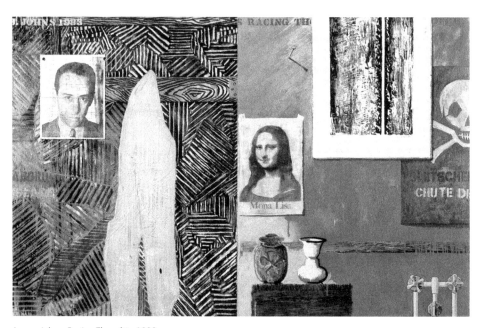

Jasper Johns, *Racing Thoughts*, 1983

PROLOGUE: BORN ON A POWDER KEG

I am dying of boredom and of cold . . . barbarism is closing in on me . . . The bora blows twice a week, the high wind five. What I call high wind is when you spend all your time holding on to your hat. What I call bora is when you're afraid your arm might snap.

STENDHAL TO MADAME ANCELOT[1]

Co' un colpo de bora
Un sior se scapela
Le côtoie in aria
Ghe va ala putela

La va dapertuto,
Ma questa xe bela:
Che ti te la trovi
Perfin in scarsela!

Comare, che bora
Comare, che inferno
Che vada in malora
La bora e l'inverno![2]

TRIESTINE RHYME

"LEO CASTELLI, you've sometimes been described as the Vollard of Pop Art: does that type of definition bother you?"

"No, it doesn't. On the contrary, I'm rather proud of it, but I don't think that is an entirely perfect analogy."

"May I suggest an alternative, which is just as imperfect as the first? What if I said that Leo Castelli is the Metternich of art, that he always thinks four or five moves ahead of the other art dealers, just as in a game of chess, would that be more apt?"

"Now then, listen to me. Having studied modern history, I'm fairly familiar with this Metternich—he was certainly an extraordinary politician. We could sorely use such a competent man in these difficult times! Be that as it may, in order to make plans, look after the interests of artists, of art itself, organize exhibitions, etc., naturally requires a particular strategy; such things cannot simply be improvised . . . So while I don't think that the analogy is perfectly fitting, why not?"

"Thank you so much, Mr. Castelli. I hope to have you on our airwaves again soon, and perhaps to meet you in person someday soon."

"I can tell you that it has been a great pleasure for me to be able to speak with my native city, a city that I deeply love and one I always think of with enormous affection."

Amid such platitudes concluded the telephone interview of February 12, 1984, a conversation between Nadia Bassanese in the RAI studio in Trieste and Leo Castelli in his apartment in New York. The exchange would air the next day on RAI–Venezia Giulia as part of a series on contemporary art produced by Bassanese, a dealer in Trieste. After the formal interview, the telephone conversation had continued for a few more minutes; before hanging up, Castelli asked a question, an unmistakable sign of complicity between natives of Trieste, which showed his talent for reconnecting after the fifty-two years he had spent far from his home city: "C'ē la bora oggi?"[3]

New York, February 12, 1984, 9 a.m. In his apartment on Fifth Avenue at Seventy-seventh Street, Leo Castelli hung up the phone. He quickly resumed his daily ritual. Coffee, *The New York Times,* a phone call to Ileana, his first wife, a discussion with Toiny, his present wife, about their son Jean-Christophe, now at Harvard. In a few minutes, today as on every day, he would get his BMW from the garage and drive down to his gallery in SoHo. As always, his agenda was packed: lunch with the collector Count Panza di Biumo, who was visiting New York; interview with a German journalist; back to his gallery at 142 Greene Street, where the exhibition Jasper Johns: Paintings was running from January 28 to February 25—the artist's first solo show since 1976. Then it was on to a meeting with Jasper before his departure for St. Martin, and a benefit dinner for the New Museum.

The Johns exhibition included *Racing Thoughts* (1983), inspired by Castelli's life. With this work, Johns, Castelli's most enigmatic artist and the closest to him, portrayed in his cryptic way all the pieces of the puzzle that was

Castelli's personality. A torn photograph of Leo, Mona Lisa's enigmatic smile, and the duck/rabbit of Wittgenstein's *Philosophical Investigations* all offered a totemic imitation of the complexity of Castelli's personal history. The mention of *chute de glace* in both French and German as well as the title, *Racing Thoughts,* may have alluded to Castelli's prowess at mountain climbing in the Dolomites, the most difficult range in Europe, or offered a sort of metaphor for Trieste, the most unsettling mutable city at the time of his birth. Castelli would sell *Racing Thoughts* (1983) to Jane and Bob Meyerhoff for $850,000, the largest sum that the Castelli Gallery had ever gotten for a painting! As soon as the check arrived the gallerist, delirious with joy, messengered a photocopy of it to his wife uptown.[4]

"I am not an art dealer. I am a gallerist," Castelli would emphatically tell me, but even if he preferred to claim a less glitzy-sounded métier, he was by far the most media-savvy seller of art in the whole world. He adored receiving journalists, peppering them with anecdotes, weaving and reweaving his personal myth, the myth of the sophisticated European with the effortless Midas touch. And yet Castelli's rise begins in the context of a political and historical tragedy, the tragedy of Europe's Jews during the Nazi era, his roots anchored in a family legacy far more complex than he ever admitted to in superficial banter with the press. His is a family story that overlaps the history of European art and carries us back to Renaissance Tuscany, where his ancestors probably crossed paths with Piero della Francesca and Vasari. This background suggests the hypothesis that Castelli's exceptional skill at negotiating between money and art is a long-cultivated, almost genetically based, gift forged by centuries of political and social persecution . . . But let's not get ahead of ourselves.

Castelli would wait until he was fifty before launching himself, opening his first gallery and eventually becoming the great Leo Castelli who in the last four decades of the twentieth century revolutionized the status of the artist in America and changed all the rules of the art market. In the former half of his life, however, he was a man of several different identities, different countries, different cities, with many strong personalities surrounding him, both influential and protective. In Trieste, his father, Ernesto Krausz; in Bucharest, his first wife, Ileana, and her father, Mihai Schapira; in Paris, his first partner, René Drouin; and finally in New York, the collector and dealer Sidney Janis. "Sometimes," writes Stefan Zweig, "when I unconsciously speak of 'my life,' in spite of myself, I wonder: '*Which* life?' "[5] This question

asked by another cultural cosmopolitan summarizes the Central European experience in the early 1900s.

Castelli seldom evoked his native city. "The fact that I was born in Trieste, and that I lived the early years of my life there has a certain relevance even though it is so far in the past,"[6] he declared abruptly when asked. Left behind when he was twenty-four, Trieste was nothing to him then but a distant, time-worn town and, ultimately in Leo's mind, a closed case. But investigation of Leo's life in New York reveals the case was not so entirely shut after all. Reopening the archives, interviewing the principal players, becoming the forensic detective, I discovered Leo to be, just like Stefan Zweig, a man of many lives, a nodal point, a convergence of stories. And as this reality revealed itself, the mystery only grew: who exactly was Leo Castelli? And who might know?

Behind his legendary affability, Castelli did harbor secret places, Trieste foremost among them. He never dwelt on the fact of his having spent nearly a quarter of his life there under another name: Leo Krausz. It was an interval by turns blithe and troubled, informed by all the contemporary political upheavals. His father would change the name from "Krausz" to "Krausz-Castelli" then to "Castelli" (his wife's maiden name), under the compulsion of Mussolini's government, which required the Italianization of family names. The change, made official by royal decree in Rome on December 3, 1934, was recorded in the city register on January 9, 1935: "The Krausz family is authorized to add the name 'Castelli' to 'Krausz' and to use the name of 'Krausz-Castelli.' "[7] During the first decades of the twentieth century Trieste seemed an "excellent historical sounding board" for the rest of Europe, but for the Krausz family especially, it turned out to be a place of "unusual seismographic sensitivity."[8] Historical, political, geographical, economic, and racial displacements, ruptures, and adaptations: they would be spared nothing.

Through the abundant literature that Trieste inspired, we can trace the singular destiny of this former capital of the Austro-Hungarian Empire, a natural victim of its geographical location, prey to the schemes of the Continent's politicians. We know its historical diminuendo: a flourishing port under the Hapsburg monarchy which, after the Great War and the annexation to the Kingdom of Italy, entered a long decline to become the sleepy provincial town it remains today, known for staid commerce and life insurance. It is a city of multiple incongruities: its location, perched unexpect-

edly on the shores of the Adriatic between mountain and sea, between Austria and Croatia, allowing it to enfold its disparate Austrian, Jewish, Slavic, and Greek communities; an imposing architecture, now almost too imposing; a café culture producing little of note—the San Marco, the Tommaseo, the Stella Pollare, the I Specchi are places for writing, speaking, and conviviality, which now lend it only a staid charm where once they ignited imagination. Once Trieste was known for breeding great writers, serving them as both subject and Muse,[9] the same spell it cast over literary luminaries just passing through.[10] Its power continued outside time like its *bora,* the wind unique to the place, born in the cold mountains of the northeast, whirling at nearly one hundred miles an hour towards the Adriatic Sea and, on certain days, so strong that the locals were obliged to cling to the "anti-bora ropes,"[11] strategically scattered throughout the street grid, to keep from being blown away.

The *bora,* inspiration of innumerable cartoons, photographs, popular sayings, and scientific commentaries, is the product of a geological anomaly. While along their entire length the Alps—rising towards the Balkans and running alongside the western coast of the Adriatic—shelter Italy from the glacial winds of Central Europe, there is "between Mount Nanos and Mount Nevoso, a strange fissure, a break, a gap, like a door that Mother Nature must have forgotten to close." According to the meteorologist Giuseppe Ongaro, "it is through this door that . . . the heavy, cold air from the east-northeast gathers and builds up and . . . from there, the *bora* swirls violently over Trieste towards the Adriatic Sea."[12] It is called the *bora scura* when, mixed with rain, it whisks away the flimsy umbrella from one's hand; *bora neverina* when it lifts the snow and sets it down in surreal dune formations; *il borino* when it blows gently; *bora nera* when it topples cranes, boats, trains, with cyclone force.[13]

How can we resist comparing these two species of vulnerability: the geographic reality of a devastated city, worn down by the elements, and the political Trieste, torn by diplomatic failures, the veritable Achilles' heel of Europe? The first almost insists on being simply an allegory for the second. There have been more or less haphazard interpretations of the consequences of this meteorological phenomenon on its inhabitants, as on the psychology of the "people of the *bora.*"[14] One theory developed by Giacomo Debenedetti and reported by Umberto Saba: " 'Citizens of Trieste, you are truly the children of the wind. That is why you so love both morality and

excuses, true stories and tall tales: because you were born in the city of the *bora.*' "[15] Indeed we cannot faithfully convey the mood of Trieste without recourse to the writings of its prodigal sons, who nevertheless do not agree. If Umberto Saba and Italo Svevo see it as "the epicenter of spiritual earthquakes,"[16] Scipio Slataper hails it as "peaceful and tolerant, the city of *si,* of *ja,* of *da,* [capable of becoming once again] a hub of cultural synthesis,"[17] while Angelo Ara and Claudio Magris define it by its "border identity"[18] throughout its history.

In the face of a mercurial Trieste, local writers have been given to propose symbolic constructions, while foreigners record a certain "malaise," an uneasiness, in their journals. "This city, evenly built, is situated beneath a rather beautiful sky, at the foot of a barren chain of mountains; it has not one monument. The final breath of wind from Italy dies out on its riverbanks, where barbarism begins,"[19] Chateaubriand remarks. "It isn't Italy, it is only Italy's antechamber,"[20] writes Stendhal, while Gérard de Nerval judges it to be "bleak"[21] and Rilke downright "detestable."[22] Dostoyevsky proposes "an abstract and premeditated city,"[23] rather like St. Petersburg: "For, like Saint Petersburg, Trieste was born of a government edict rather than a natural process of organic development." Perhaps most telling in its nihilism is the observation of Hermann Bahr, who writes in his travel journal, in the very year when Leo Krausz was born: "Trieste is not a city. One has the impression of being nowhere. I had the feeling of being suspended in unreality."[24]

And so it is in this place of "unreality" where Leo Krausz grows up, just as the city is changing national identity, economic destiny, political status, even its language and its currency. Trieste, the focus of great political, financial, and geostrategic jockeying between the Austro-Hungarian Empire and the Kingdom of Italy; Trieste the inspiration of James Joyce's reinvention of the modern novel and of Filippo Marinetti's anarchic cry: "Trieste! You are our unique *powder keg*! All our hope rests in you!"[25] A city, a powder keg, that in the same explosive decade gave birth to *Ulysses,* the Futurist manifesto—and Leo Castelli.

On September 4, 1907, Leo Castelli arrived, the second child of Ernesto Krausz and Bianca Castelli, whose marriage was probably arranged by the local rabbi, between a newly landed executive of the Austro-Hungarian bank and the daughter of a local middle-class family. It was a merger of two communities, both Jewish but otherwise different in every respect: the first, Hun-

garian Jews, Ashkenazi, progressive, nomadic, drawn to Trieste by hope of profit from financial dynamism; the second, Italian, Sephardic, still scarred by years spent in the ghetto, taking refuge here from religious persecution.

A sanctuary since the fifteenth century for all the Sephardic Jews driven out of Spain, Greece, Turkey, and various Italian provinces, Trieste was one of the rare cities in the Mediterranean to allow Jews certain trading privileges, which "even a Christian couldn't obtain."[26] Thus, in 1799, twenty-year-old Giacobbe Castelli, Leo's great-great-grandfather, came to Trieste from Monte San Savino in Tuscany. Giacobbe was the son of Aarone Castelli (noted as *Ebreo,* or "Jew," in the archives) and his wife, Anna, and brother of Sabato, Vitale, and Sara. The family had been chased out of the city of their birth by the nominally Christian group Viva Maria. On June 3, 1803, Giacobbe Castelli married Susanna di David Jacchia in the synagogue in Trieste. According to Jewish tradition, when their first son was born, he gave him the name of his own father, Aarone. The second Aarone Castelli was the flamboyant maternal great-grandfather of Leo Castelli. In 1867, he hit the jackpot (thirty thousand gold guilders) in the Signoria, Trieste's lottery; he bought a horse-drawn carriage and lived the high life, with white-gloved footmen and private tutors for his children, frittering away the easy fortune in just a few years.

Even if the New York gallerist sometimes humorously recalled his picturesque ancestor, and even if he had heard that the cradle of his maternal ancestors was Monte San Savino in Tuscany, he never sought out further details. "You should wander around Monte San Savino, the city of my ancestors, and look for graves with the name Castelli in the cemetery . . . ," Leo urged me one day, with his typical mixture of provocation and lighthearted charm. But his own ramblings were only in search of art. Coming to see me in Cortona during the summer holidays, first in the company of Catherine Morrison in 1991, then with Barbara Bertozzi in 1994 and 1995, he insisted on visiting the Church of Santa Maria del Calcinaio, built in 1475 by Francesco di Giorgio Martini (1439–1502), to see again and again Fra Angelico's *Annunciation* (c. 1445) in which astonishingly the words of the angel are written backwards. He took pleasure in visiting the house of Pietro da Cortona (1596–1669), always wanted to go to Città di Castello to see Rosso Fiorentino's (1495–1540) *Deposition from the Cross* (1528), and, of course, to return to the Chiesa San Francesco in Arezzo, to admire once more the frescoes (1452–59) of Piero della Francesca (1410/20–92).

But despite these journeys on the borders of Tuscany and Umbria, to the villages of the Val di Chiana, a few dozen miles apart, all along roads that led to Monte San Savino, Leo never expressed the slightest desire to visit the city of his forebears, from which every trace of the Jewish community had disappeared, save for the *"antico borgho della sinagoga"* (the old quarter of the synagogue), the hinges of the gates sealed in the stone that used to demarcate the ghetto, and the former Jewish cemetery, now overgrown with brambles, "down there, at the edge of town, near Campaccio, on the other side of the torrent we call the Ghisio," as a local directed me in the summer of 1990.

Necessarily the story of the Castellis and of the Krauszes must be told first, and it constitutes a book within a book. We pick up the thread during the Renaissance in Monte San Savino, where Castelli's maternal ancestors revitalized the small Italian city with prosperous trading. We follow it through their forced displacement to Trieste, where they enjoyed new freedoms and built anew a thriving business. We then discover the Krauszes, Leo Castelli's paternal ancestors, who were landowners under the Austro-Hungarian Empire, and cherished the imperial family. Ernesto, Leo's father, left his village on the border of Croatia to ride on horseback to Trieste, where he would quickly become one of its most important bankers. Trieste, where Leo was born, was a liminal space in Europe, a place both within and without; a seismograph of the Old World, it gave him the sense of constant flux that was his birthright. And it gave him one thing more. Castelli, despite his self-obfuscating myths, became, by virtue of place, an exemplar of modern Jewishness. "I never understood very well his Jewish side," his son Jean-Christophe told me. "Growing up in New York, I used to go to bar mitzvahs and to Passover dinners, and three quarters of my friends were Jewish. My mother would ask my father, 'Why don't you tell him a little bit?' He never really offered much of his past. He would be more than happy to answer any question I might have and sometimes at great length! But, in looking back, there was often something nonspecific about his anecdotes or reminiscences. It was hard for him to feel the *personal,* and maybe his Jewishness was one of the most personal things of all for my father, therefore, one of the most difficult to access. He built his myth, he sold his myth, and rare are those who didn't buy his myth."[27]

Leo Castelli never told me the whole history, but he gave me just enough clues to begin my quest. And so to begin with what I found in Monte San

Savino of the history of the Castellis, Jews from Tuscany, forefathers of the preeminent American art dealer, the greatest gallerist of the latter twentieth century: an epic tale of wanderings and persecutions that begins during the Renaissance and ends with astounding success in the New World at the dawn of the twenty-first century.

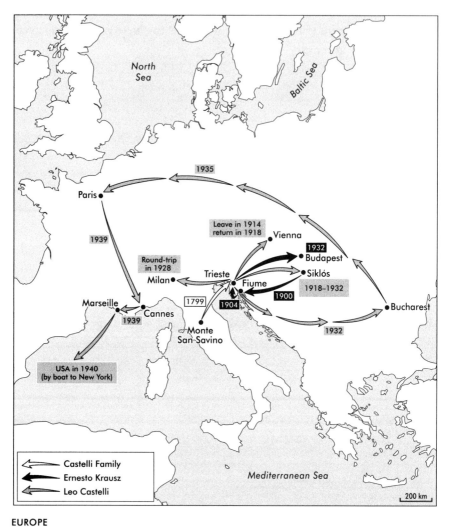

North
Sea

Baltic Sea

1935

Paris ●

1939

Leave in 1914
return in 1918 Vienna ●

Round-trip
in 1928 ┌ 1932 ┐
Milan ● ● Budapest
Trieste ●
● Siklós
Fiume
1918–1932

1900

1799 1904 Bucharest ●

Marseille ●
● Cannes
1939

Monte
San Savino 1932

USA in 1940
(by boat to New York)

Mediterranean Sea

200 km

Castelli Family
Ernesto Krausz
Leo Castelli

EUROPE
Forced displacements of the Krauszes and the Castellis for racial or political reasons

EUROPE: PERSECUTIONS, WARS, RUPTURES, DISPLACEMENTS

1907–1946

and a Prehistory

Monte San Savino, La Loggia dei Mercanti, built by Andrea Contucci (called Sansovino) at the beginning of the sixteenth century

1. AROUND THE HALL OF MERCHANTS

My father never talked about the fact that he was Jewish.[1]

JEAN-CHRISTOPHE CASTELLI

Ebreus perfidus est, ut cantat Ecclesia est inimicus fidei, et ideo presumitur odium abere Christi fidelibus, ergo abetur pro suspecto.[2]

ARCHIVES OF MONTE SAN SAVINO

MONTE SAN SAVINO, 1656. "Those people bristle with ideas, they brim with inventions!" The enthusiastic delegate seemed unable to find words to extol the ingenuity of the local Jewish merchants. Taking advantage of the city's geographical location, they imported their goods from the Marques and the Vatican regions, avoiding the prying eyes of the Cortona customs officers, before "racing all over the country to sell them, not just in the Valdichiana, but even further afield, right to the borders of the Papal State!"[3] Monte San Savino was a small city of some two thousand tucked away in the Tuscan hills between Sienna, Arezzo, and Cortona. Since 1550 it had enjoyed feudal privileges granted by the Medicis, rulers of the Grand Duchy of Tuscany, to one of the great local families, the Cosci di Monte, in homage to one of their sons who became Pope Julius III.[4] Monte San Savino was thus exempt from the customs duties imposed by the Florentine corporations, operating as a free zone and independent enclave within the Grand Duchy of Tuscany.[5] What would have become of this little rural center, floundering with its local artisans, its few leading families, and its numerous religious orders, but for its Jewish citizens, who skillfully took advantage of the exceptional circumstances to become moneylenders and establish a monopoly in commodities, the only professional prerogatives of Tuscan Jews at the time?

Even today, Monte San Savino seems to revolve around its hall of merchants, the Loggia dei Mercanti. Austere and grey, with slender arcades, fluted columns, and Corinthian capitals carved in *pietra serena,* the hall is solidly lodged between two private houses on the main street, and its elegant, imposing presence surprises the visitor to the city center. Constructed at the beginning of the sixteenth century, the Loggia was rented out a hundred years later to Jewish merchants, who set up stalls there. Directly across the Ruga Maestra stands the majesty of Palazzo di Monte, the masterpiece of the great Renaissance architect Sangallo, which was the home to a local boy who would one day become Pope Julius III. Today, he is remembered for his patronage of Palestrina and Michelangelo, for his religious life "perverted by pleasures and indulgences or else for his political life as an inveterate nepotist"—and for the papal bull of August 12, 1553, whereby he decreed the destruction of all the copies of the Talmud. While the covered market looks out over the main street of the city, the Palazzo di Monte, extending upwards with its interior courtyard, hanging gardens, and amphitheaters, opens out towards the hills of Sienna. The Jews of Monte San Savino thrived commercially, but were constantly hemmed in, forbidden the splendors of its rich medieval culture. The physical constraints of the Jewish merchants in the Loggia embody the limitations that confronted and challenged Leo Castelli's ancestors.

Apart from the Palazzo Pretorio, built in the thirteenth century, the city's other aristocratic residences—the Palazzo della Canceleria, the Palazzo Tavamesi, the Palazzo Galleti, the Palazzo Filippi—exemplify, through their imposing façades, the stages of the Renaissance. Around the covered market, in a circumference of a few dozen yards, the palaces, cloisters, and churches whose names ring like their bells—Chiesa della Pace, Chiesa di Santa Croce, Chiesa di San Antonio, Chiesa di San Giuseppe, Monastero di San Benedetto, Monastero di Santa Chiara, Santa Maria delle Neve, Chiesa di Santa Agata, Chiesa della Fraternita—seem to chime in a kind of utopian harmony that might negate social distinctions. At first glance, behind its heavy medieval walls, Monte San Savino looks like a miniature Tuscan city, but a city without social distinctions, where the lay folk, the clergy, and the aristocracy might live side by side in perfect amity. But when you look closer, you can see that, within its odd oblong shape, rising up on the western side with palaces, churches, and cloisters, Monte San Savino has a narrow street less than six feet wide to the northeast, hidden by the immense Benedictine monastery.

From the early eighteenth century on, this street was the Jewish ghetto, the home of about a hundred people whose houses were clustered around the synagogue.

The most evident signs of social demarcation in Monte San Savino, an egg-shaped labyrinth veined by narrow streets, are the four carved doors set in the great medieval walls like the points of a compass. The Porta di Sopra, also called the Porta Fiorentina, decorated with the five red orbs of the Medicis' coat of arms and so the most noble of the doors, leads to the north, towards the road to Arezzo and Florence beyond; the Porta Romana, or Porta di Sotto, the most ancient, its *arco ribassato* bearing the Orsinis' coat of arms, opens to the south, towards Rome; the turreted Porta della Pace, or Porta Senese, faces to the west and gives onto the road to Sienna; and finally, to the east, the Porta San Giovanni, the one closest to the Jewish ghetto, with its *arco a tutto sesto,* on a steep hill, lead the traveler past Cortona, to Perugia and Umbria. It was here, within those points, that the Castellis, Tuscan Jews, lived during the Renaissance.

When did the Castellis settle in Monte San Savino? How did it come to pass that one of their ancestors, apparently chased out of Spain by Isabella the Catholic, managed to wander into the *nazione ebrea del Monte,* the Hebrew nation of the Mount, taking refuge in this beautiful hilly region of southern Tuscany? It was doubtless following the creation of the ghetto in Rome in 1555, and those in Florence and Sienna in 1570, that one of the first Castellis heard of this small city that had not yet forced its Jewish citizens into confinement. Thanks to the Medicis, Monte San Savino enjoyed political autonomy as well as certain privileges, for example, the ability to grant asylum to debtors.[6] Bordering the Papal State, it became the ideal refuge for small groups of wandering Jews as they fled the harshness of the Counter-Reformation and the persecutions of the Papal State and the Christian population between 1555 and 1750. As a "border community," smaller than the great urban centers and under less scrutiny than Florence or Sienna, Monte San Savino was more reassuring. When the ghettos in those cities were established, there were only eight Jewish families in Monte San Savino. But in 1620, immediately after the prominent Passigli family opened their bank in the city,[7] Monte San Savino saw the rise of a lively, colorful, and even illustrious community of Jews, which numbered only a hundred (5 percent of the population), but which would prosper in the environs of its synagogue, its school, and its cemetery for nearly 172 years.

The first members of the Castelli family arrived in Monte San Savino in the same era when, a dozen miles away, Piero della Francesca was working in Arezzo on the frescoes of *The Legend of the True Cross,* while in Cortona, Francesco di Giorgio Martini was building Santa Maria del Calcinaio and Fra Angelico, having been forced to leave Sienna because of the plague, was finishing his *Annunciation.* Perhaps it will one day be discovered that ancestors of Leo Castelli, the Castelli brothers, who would in the next two centuries establish a monopoly in the production of paper, had already been suppliers to the artists of the region, such as Vasari, Perugino, Pontormo, or even Andrea del Sarto! In any case, just like the other inhabitants of the ghetto in Monte San Savino, the Castellis lived precariously, subject to humiliation or favor at the whim of the religious and administrative authorities.

The lives of local Jews changed drastically under Cosimo III, grand duke of Tuscany from 1670 to 1723. The most oppressive sovereign since the Counter-Reformation, he enacted a series of harsh and degrading measures, such as the decree of January 1678: every citizen of the "Jewish nation" had to "wear a distinctive symbol, yellow or red, sewn onto his clothing," brick up his windows so as not to "demean Christian processions by leaning out of the window," "refrain from selling precious stones, new clothing or fabric, but only used rags."[8] Cosimo enforced strict segregation in the domestic sphere as well, forbidding Jews to "hire a Christian midwife or nanny." On August 10, 1707, the grand duke took his repression to its logical conclusion when, through the *Testo del Bando,* he decreed the creation of a ghetto in Monte San Savino. All the Christians who lived on the easternmost end of the narrow Borgo Corno were to leave their houses, and rent them out to Jews, all of whom were thereafter confined to that area; any infraction was punishable by a fine of one hundred crowns; the narrow street was then renamed the Borgo della Sinagoga or the Borgo degli Ebrei.[9]

But even during the oppressive seventeenth century, some Jews found economic opportunities and even social mobility. The Passigli banking family flourished, growing wealthy by trading in money, like other Tuscan Jews during the Renaissance. Originally from Florence, the patriarch Ferrante Passigli was a multilingual and cultured man, interested in art.[10] With the help of his employees—his *ministri*—he developed a network of clients throughout the region, extending as far as several hundred miles from the city. By reason of his abilities he will earn a privileged status from the Marquis Alessandro Orsini: the right for himself, his family, and his employees to

venture outside the ghetto and to "move freely within Monte San Savino without displaying the usual symbol."[11] And so he lived in a comfortable house, adjacent to the Porta Fiorentina, at the entrance to the city. When Pope Innocent XI abolished money lending, the Passiglis lost their preroga-tives in Monte San Savino, though they still lived grandly. In 1717, for instance, the wedding of Samuele Passigli was a weeklong affair, with Chris-tian musicians in attendance.[12]

For most members of *nazione ebrea del Monte* in the seventeenth century, however, the years spent in the overcrowded, disease-ridden ghetto, in houses with boarded-up windows, were grim times indeed. The community, made up mostly of petty merchants, assumed an oligarchic structure. At the top were four or five powerful families, the Usiglis, the Montebaroccis, the Passiglis, and the Toaffs, all intermarried. In perpetual conflict with these were the Borghis and their relatives, the Castellis and the Fiorentinos; more recently established in business, they were retailers who bought their goods at a discount and resold them for profit in the surrounding countryside. In time, the Castelli brothers, who had traveled throughout the country dealing in cotton and linen fabric,[13] also managed, with the help of thirty employ-ees,[14] to achieve a monopoly not only in paper, but also tobacco and alcohol, in the Monte San Savino region. From 1712 onwards, they extended their reach to include Montevarchi, Lucignano, and Foiano.[15] At the beginning of the eighteenth century, with the relaxation of some Counter-Reformation anti-Jewish strictures, the Castellis joined the Borghis, the Passiglis, and the Montebaroccis as the only Jewish families with permission to live outside the ghetto, even if only for the duration of their monopoly.[16] At the time, Monte San Savino was a buzzing, welcoming little city, with artisans, a few aristo-cratic families, various religious communities (one out of every four inhabi-tants wore a cassock), and a Jewish population that still consisted of about a hundred living in the ghetto, within little more than four hundred square yards.

In the eighteenth century, the Jews of Monte San Savino, known as the *kehilla,* set up their own democratic government. Eleven elected governors, the *massari,* ruled the political life of the "Jewish nation" and determined the laws, recorded in the "Book of Deliberations of the Hebrew Nation of Monte San Savino."[17] Four of the *massari* were in charge of teaching Hebrew in the yeshiva, the city's Jewish school, located inside the synagogue. The latter was a large three-story building with many functions—*Talmud torah* school,

place of worship, communal meeting place, and home of the rabbi. The synagogue contained all the amenities necessary for worship: the ritual bath or *mikvah,* for conversions and for purification, the *aaron ha kodesha,* which held the Torah. It was here that the rabbi officiated, performing circumcisions, celebrating bar mitzvahs and weddings, gathering a minyan (or quorum for prayer), and saying Kaddish for the dead, who were buried far away, in the terrible Campaccio, a ravine the Jews were allowed to visit only at night. In funeral procession, they would circle it seven times, carrying the coffin on their heads before the interment prayers. Monte San Savino even had a *sciochet,* so animals could be slaughtered according to ritual kosher law.[18]

However the governance evolved, pressures of life in the ghetto inevitably engendered commercial rivalries, legal disputes, brawls and skirmishes, sometimes ending in violence, especially between those Jews confined to the ghetto and those entitled to live outside it. In December 1698, for example, knife fights erupted between the Montebaroccis and the Usiglis on one side; the Borghis and the Pelagrillis on the other, after exchanges of insults in the marketplace and even in the synagogue. "The place of worship became the fight club," as the historian Toaff wrote, "and the time for prayer was the ideal occasion for each person to air his own complaints against the injustices, whether real or imagined, that he had suffered at the hands of other members of the community, or even a time when everyone could give free rein to their frustrations."[19]

Indeed, Saturday mornings in the synagogue were volatile as the petty merchants and grand bankers, the marked Jews who dwelt in unwindowed houses and the unmarked Jews with the liberty to travel, prayed side by side. The contention seemed to center on the ritual calling to read the Torah, an honor conferred during the Shabbat service, for which one had to make an offering. Sometimes, the privilege was offered as a "gift" to one of the poorer families by one of the more prosperous, as on Saturday, June 11, 1700, when Gabriello Vitali was given this honor by the Usiglis. But, as there was no rabbi present that day, the Usiglis felt free to behave like veritable despots, insulting other worshippers they considered their inferiors. When Dr. Leone Usigli, a pillar of the community, called Ventura dell Aquila a "dirty bastard," forbidding him to help Vitali read the Torah, dell Aquila fought back: "Leone Usigli is a troublemaker and lawbreaker . . . The Usiglis are unfair, arrogant and outrageous; they want to tell everyone what to do for no good reason. Christians as well as Jews have plenty to say about their behavior, their arro-

gance and their pride . . . They want to be monarchs . . . As for Abramo
Borghi, he was judged and even condemned for less than that!" At the trial
that followed, Manuela Montova came to dell Aquila's aid: "The Usiglis have
been here for a long time, but they want to remain foreigners!" As for
Gabriello Vitali, he backed up his protector: "Dr. Leone Usigli wants to
appear superior and as far as I'm concerned, he is superior, because he was
the first of us Jews here."[20]

Those years were equally marked by interminable frictions with the
municipal authorities. Naturally there were the petitions for admission to
live outside the ghetto, but even more numerous were transgressions of the
line separating Jews and Christians. Raffaello di Salomone da Lippiano, age
fifteen, was sentenced to two days at hard labor and fined fifty lire for spend-
ing the night of November 29, 1654, in the town's inn with a Christian prosti-
tute;[21] Flaminio Castelli di Vitale was fined one hundred crowns for having
gone outside the ghetto without authorization;[22] Stella Castelli di Vitale and
Gioia Castelli di Angelo were fined forty crowns for having fought with
Christian women.[23] Other members of the Castelli family turn up in the
municipal records: Emmanuele Castelli was found guilty of having chal-
lenged Isaaco Cardoso to a game of hockey, which was considered an overly
dangerous sport,[24] and Giuseppe and Vitale Castelli had been found guilty
(though without malicious intent) of striking the head of Caterina, a young
country woman, in the course of playing the same game.[25] Despite the laws
and punishments, Gentiles and Jews continued to mix. Even today, while
walking through the streets of Monte San Savino, I marveled at the many
locals who still pass on Jewish stories: "We all have Jewish blood here," an
official at the city hall told me with enthusiasm and warmth.

It is in the eighteenth century, with the family of Aarone Castelli, his wife,
Anna, and their children Sabato, Letizia, Sara, Vitale, and Giacobbe that we
uncover with certainty the traceable ancestors of Leo Castelli. It is known
that Aarone Castelli lived from 1720 to 1780, that his wife, Anna, was born in
1740 and that, among their surviving children, Sabato was born in 1766,
Letizia in '68, Sara in '70, Vitale in '72, and Giacobbe in '77. The tax records
also indicate that Aarone Castelli belonged to the middle class of the Jewish
community. It is thanks, in particular, to the misadventures of Sabato and
Giacobbe Castelli, who would each see the best and the worst of conditions
for Jews in Monte San Savino, that we are able to tell their history.

In 1737, when the Medici dynasty died out, the Grand Duchy of Tuscany

Monte San Savino tax rolls, 1776, listing Leo's ancestors

and the Holy Roman Empire saw the ascent to power of the Habsburg-Lorraine family. Emperor Joseph II, whose seat of power was in Rome, and his brother Pietro Leopoldo, grand duke of Tuscany from 1765 to 1790, introduced an enlightened modern government, abolishing the death penalty and torture, establishing freedom of the press, and limiting the reach of the Catholic Church by banning religious discrimination. Under this regime, the situation of the Jews improved considerably, and they were granted something close to full citizenship, notably in Monte San Savino, where the ghetto was abolished. Beginning in 1778, Jews were allowed to hold public office, and in 1779, they were admitted to scientific and literary academies. During the same period, certain members of the Monte San Savino community became landowners or bought shops. The best educated (like the Passiglis, the Padovanos, the Usiglis, and the Fiorentinos) went to live in the great nearby cities, Arezzo, Cortona, and even Sienna; some of them became wealthy in the cloth trade.

And so the condition of the Jews of Monte San Savino began to catch up

with that of those in northern Italy, which had long been more progressive. From 1650 onwards, Livorno became a model city for Jews, owing to Ferdinand I's liberalizations of the civil code, the Livornina. (In his petitions after 1655, Rafaello Montebarocci of Monte San Savino requested permission to purchase the house in which he had been living for ten years, "in the name of the privileges enjoyed by the Jews of Pisa and Livorno.")[26] But by the end of the Enlightenment, the Jews of Tuscany were reading in the local newspaper, the *Gazzetta universale,* about the Austrian Edict of Tolerance issued on October 30, 1781. Another paper, the *Novelle Letterarie,* carried a speech by Rabbi Elia Morpurgo, who had traveled to Gradisca (outside Trieste) to celebrate the imperial decree.[27] This decree, he explained, served both the Jews and the State by encouraging the Jews to advance culturally and integrate themselves into society. In the Tuscan press, some writers were already attacking demonstrations of religious intolerance.[28] The contagion was spreading across the Continent. In Florence, *Lo spirito dell'Europa,* which openly supported Voltaire's radical ruminations, published an article extolling religious tolerance, while the *Corriere dell'Europa* praised the city of Frankfurt for its gift of liberty and spirit of freedom. The Revolution of 1789, which brought full emancipation to the Jews of France, was of course warmly celebrated by the entire Jewish community of Italy.

The most famous Jew in Monte San Savino during this prosperous period was surely the writer Salomone Fiorentino, born in 1743 into a family related to the Castellis. Fiorentino's father, Leone, was a cloth merchant and one of the governors of the community; he indulged his son's passion for learning by sending Salomone to study at the Tolomei School in Sienna, where, at the age of twelve, he began writing poetry. As an adult, while running a cloth business in Cortona, Salomone Fiorentino pursued his literary interests to become a committed public intellectual before the invention of the term. He praised the new political reforms, especially the penal code and the new civil code of Leopold I, in sonnets and elegies.[29] Through friendship with Francophile Tuscan writers such as the philosopher and playwright Vittorio Alfieri or the doctor and fabulist Lorenzo Pignotti, and sometimes even with the Jacobins of the Enlightenment, Salomone Fiorentino became part of the salon of Corilla Olimpica in Florence and was elected, in 1785, a member of the Accademia degli Infecondi in Prato. But it would take the intervention of Grand Duke Pietro Leopoldo for him to be admitted, in 1791, to the Accademia Fiorentina, then in 1808 to the Accademia Italiana di Scienze, Lettere ed

Arti of Livorno. If we have paused on this symbolic career of one of the prodigal sons of the *nazione ebrea del Monte,* it is because he was the perfect example of how far-reaching were the civic and political liberties accorded to the Tuscan Jews thanks to the Enlightenment and the new rulers.[30]

While the years of Leopold's reign represent a taste of freedom and the beginning of emancipation for the Jewish population, the closing of 90 percent of the churches and the limiting of religious orders felt intolerably unjust to the lower clergy and the farmers. The ensuing discontent, stoked by the priests and monks, manifested itself in anti-French feelings. In 1796 and 1797, for example, during the Italian campaign of the young General Bonaparte, the French soldiers had their throats slit by fanatical farmers in Verona in an episode that came to be known as the Veronese Easter. The dynamic about to develop is thus very obvious: the Jewish population, protected by the Austrians and full of Francophile feeling, would soon serve as the scapegoat for rural Italian Christians and suffer the brunt of the backlash from the French invasion. The saga of the Castelli family is entangled in this web of prejudices and violence; the events of these years portend the end of their relatively peaceful lives as merchants in Monte San Savino.

On December 16, 1798, Salomone Fiorentino, sensing danger in the air, exhorted the leaders of the Jewish community in Florence to seek the grand duke's intervention on their behalf: "The Sovereign's Edict, which hopes to persuade all his subjects to consider how to protect themselves," he wrote, "instilled hatred within them, and the barbaric idea of considering our innocent nation as an enemy state . . . A false rumor, spread throughout all of the Valdichiana, would have us believe that weapons were found in a Jewish home in Livorno. Outright slander, to discredit us, has been spread by evil peasant farmers who, without even considering . . . if it is true or false, threaten us in the cities and the countryside . . . Consequently, our situation is most precarious."[31] In fact, as the historian Carlo Capra points out, "an aggressive campaign, launched by the Church, especially by confessors and parish priests and spread by the worst of the local newspapers, and almanacs, describe the French as savage, bloodthirsty beasts, enemies of the faith and the family. The efficiency of this propaganda owed much to its references to the Apocalypse."[32] Anti-Jewish feelings based on religion, long common in the rural churches, increased, and hateful sayings were given the air of authority by being rendered in Latin, such as *"Ebreus perfidus est, ut cantat Ecclesia est inimicus fidei, et ideo presumitur odium abere Christi fidelibus, ergo*

Notificazione

Ebrei Malingni e Maledetti Voi che siete Traditori a Nr Avmi Imperiali e Arete Preso L arme Dei E.cesi guai a Voi Se No prestate Soccorso Agli Aretini Quando Verano a Eirenze Ci a corderemo ttutti e Sachegaturi ——, e poi manda rui fori di Eirenze Spersi; Viva Viva (inperddore Viva gli dretini

Anti-Jewish inscription on the walls of Monte San Savino, at the time of Viva Maria

abetur pro suspecto." ("The Jew is treacherous, just as the Christian Church says he is an enemy of the faith, he has hatred for the faithful of Christ, this is why one must be suspicious of him.") In the cities, such feelings were less visceral, but they were still fostered by financial realities, an irony summed up by the philosopher Carlo Cattaneo: "Our ancestors condemned Jews to earn their living through money lending and smuggling, then they curse them because they are moneylenders and smugglers."[33]

With the advance of Napoleon's troops towards Florence, the emperor went into exile on May 27, 1799, giving free rein to the violent masses. On April 12, in the Tuscan capital, mobs blamed Jews for the arrival of the French, plastering the walls with slogans: "Evil cursed Jews, you are the ones who have betrayed the Imperial armies and taken up arms on the side of the French, shame on you if you do not give aid to the Aretins when they come to Florence. We will increase our numbers to pillage you, to force you out of Florence, and to exterminate you. Long live the Emperor! Long live the Aretins!"[34] On May 6, in Arezzo, as the group known as Viva Maria railed against the Jews, the new city leaders started hunting down the French, arresting nearly a hundred supposed Jacobins and jailing about a dozen Jewish citizens suspected as sympathizers: among them were a Giuseppe, a Godolia, and a Sabatino Castelli, relatives of the family, eventually thrown out of Arezzo with Salomone Modigliani for having corresponded with the French.[35]

On the night of June 12, villagers attacked the synagogue in Monte San

Savino. A few days later, authorities of the Borgo della Sinagoga imposed a curfew. On June 25, the local authorities issued a new decree: "The Deputation of the Provisional Government of Monte San Savino declares to all members of the Jewish race currently residing in this region that if they leave the city, they do so at their own risk. Until a new order is established, they are required to report to the municipal guards at ten o'clock in the morning, and every evening at eleven-thirty; they must go back into their houses and are not allowed to leave them again until one hour after sunrise. Any infraction of this law will be punishable by imprisonment."[36] In the meantime, in Sienna, events took an even more dramatic turn: on June 28, the ghetto was attacked, the synagogue sacked, and thirteen Jews lynched or burned alive.

On July 18, 1799, the authorities in Monte San Savino published the following law, which would take effect a week later: "We give notice to all Jews living in this region, whatever their social status, that they must be responsible for their own lives, taking the greatest precautions possible until the return of our Sovereign."[37] At this point, the Castelli family was in unprecedented jeopardy. Throughout the following week, the Jews left the city in small parties. On July 31, the last remaining group hired four horse-drawn carriages and two carts. Vitale Castelli was officially in charge of the entire operation, but it was Vitale di Leone Finzi who paid the sum of sixty-two lire to the guards in Arezzo to escort the party led by Castelli.[38] Anna Castelli and her children fled to Florence, where they would remain. A few months later, those who had been forced out and dispossessed presented a petition for compensation,[39] but the municipal authorities denied it, giving as an excuse "the danger of new upheavals in the region." A similar effort in 1805, drawn up for the group by Salomone Fiorentino and signed by Sabato di Aarone Castelli, among others, met with some results.

As for the young Giacobbe Castelli, who was in his twenties at the time of the exodus, he would reappear four years later in Trieste, one of those mythical northern cities, like Livorno or Pisa, where the Jewish community had long enjoyed favorable treatment. On June 3, 1803, in the synagogue in Trieste, Giacobbe married Susanna di David Jacchia. In homage to the city of his birth and the events he had witnessed, he named his firstborn son after his own father, Aarone, who had died when Giacobbe was just a child, just as he would name his first daughter, born in 1811, after his mother, Anna. This Aarone Castelli, born in Trieste in 1808, is the great-grandfather of Leo Castelli.

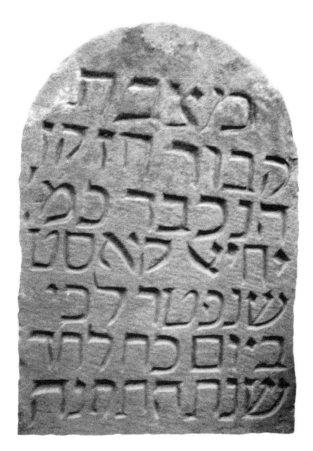

The gravestone of Leo Castelli's ancestor Yechiel Castelli in the Monte
San Savino cemetery

In July 1799, the Jews of Monte San Savino left behind several centuries of
a good life—spent on the whole in amity with the other inhabitants of the
city—as well as their memories, their synagogue, and their cemetery. They
were never to return. On January 30, 2005, Holocaust Memorial Day, the
mayor of Monte San Savino, Silvano Materazzi, ordered that the Jewish
cemetery be cleaned, the brambles removed, and invited the rabbi of
Florence to say Kaddish there, to symbolically reconsecrate it. The first
tomb uncovered, large and imposing, was engraved with beautiful Hebrew
lettering. It read: *Al zaken ha nehbad Yechiel Castelli che niftar il 28 giugno anno
5555:* "In memory of the elderly, well-respected Yechiel [Vitale] Castelli who
died on June 28, 5555, according to the Jewish calendar."[40]

2. AT THE SAN CARLO PIER

We, Maria Theresa, . . . wish to grant the Jewish community of Trieste in general, and the Jewish merchants of the Exchange in particular, a solemn demonstration of our Sovereign approval, in order to attract more families and individuals who would become worthy of the City and the State, through the establishment of new commercial enterprises, and the commitment to the prestigious business of import-export.[1]

MARIA THERESA OF AUSTRIA, PRIVILEGE OF 1771

SEPTEMBER 1799. SAN Donà di Piave, Santo Stino di Livenza, Portogruaro, Latisana, San Giorgio di Nogaro, Gradisca d'Isonzo . . . an endless journey that leads Giacobbe Castelli from Florence to Trieste via Friuli. Will he, he must wonder, ever reach the mythical city, whose reputation has spread far and wide among Jews on the peninsula as a kind of merchants' paradise? Then, beyond Monfalcone and the final bend in the road, the blinding brilliance of the Adriatic Sea erupts, the bay dotted with sails and ships, and up on the hill, the city of Trieste. In the following days the traveler, used to the labyrinthine little streets of his village and the cypresses on the Tuscan hills, topples into another world. From the pier, he discovers a buzzing port, colorful, chaotic: goods, loaded and unloaded, on men's backs and in bundles, trunks, jars, and all kinds of baskets, "bottles of wine from Dalmatia, barrels of salt from Slovenia, bales of Egyptian cotton, sacks of coffee from Java, indigo from Senegal, exotic oak from the Levantine, rare wood from Brazil and black diamonds from England; in sum, treasures from every corner of the world."[2]

His astonishment inevitably surges before this colorful cosmopolis, "a swarming amalgam of people and races, all very diverse . . . Italians native to the city, Slavs born inland, Germans, Jews, Greeks, Levantines, Turks wear-

The Grand Canal, Trieste

ing red fezzes on their heads."[3] With increasing fascination, he discovers the Canal Grande: the elegance of the great sailing ships whose masts rise several yards above the surrounding houses, the warehouses where ships off-load food, the hum of a swarming crowd of young sailors who scurry up the masts to lower the sails or who, at the behest of captains of the larger ships, paddle to land. It is an encounter with a city that "everywhere . . . gives off an aroma that belongs to it alone, as if it were nothing more than an immense warehouse for spices and drugs."[4] Finally, he marvels at the unbelievable majesty of its neoclassical palaces and its enormous squares so incongruously set before the Adriatic Sea, slowly taking in places and their names: Tergesteo, San Giusto, Piazza Grande, Borsa di Commercio, Molo San Carlo.

When Giacobbe Castelli decided to try his luck in Trieste, he could scarcely have realized that the Castelli family would become, through its commercial activities, "worthy of the City and the State," fulfilling the wish of Empress Maria Theresa. And, apart from one notable interruption, when Italy was under fascism, the name Castelli would stay linked to the city of

Trieste for six generations, where the family's descendants remain until the present day. But even in 1799, Giacobbe Castelli arrived in a city whose prosperity and welcome manifested the express will of the empress of Austria thirty years before. In order to cultivate international trade, Maria Theresa had created in Trieste the institutional framework that would establish in its free port a "class of merchants who were simultaneously multi-religious, multi-racial and cosmopolitan,"[5] This new framework would accord a place of privilege to Jewish merchants with the benefit of past financial experience and shrewd counsel. "Persecuted by almost every nation, wandering between the old and the new world, dispersed or settled, the Jewish people accumulated great wealth through commerce and brought it with them wherever they went . . . The dispersal, then the settling of the Jewish people all over the world made them one of the most experienced in the field of international trade," wrote Giuseppe Pasquale Ricci, Trieste's commercial advisor, to the Court of Vienna in 1761, having criticized the "poor standard and inexperience of the local traders."[6]

In the space of a few years, then, Maria Theresa had built, along the bay of the Adriatic, a port, a canal, a pier, factories, workshops, warehouses, hospitals, and a stock exchange building, as well as various squares and public buildings, sparing no expense.[7] She had also granted the Jewish community religious, legal, and economic rights that would allow them to own property, to live in safety, and to carry out free trade, exempt from custom duties.[8] Not surprisingly, vociferous expressions of allegiance to the Austrian monarchy were widely heard among the Jews. "Is there no end to the happiness she will afford her subjects?" asked Elia Morpurgo, silk manufacturer and head of the community in Gorizia, a suburb of Trieste. "Open ports, shorter, renovated routes with easy access, a safe and respected maritime trade, the reduction of transit taxes, more factories and protection for them," he continued, "in a word, a flourishing trade with benefits for her subjects, profits for the Treasury and the admiration of all her people."[9] Morpurgo proposed "Blessings on our Sovereign, the best, the most just, so tolerant and so wise."[10] Arriving in 1799, Giacobbe Castelli could not have helped but marvel at the dynamism of a Jewish community proud to be one of the most privileged in all of Europe.

On June 3, 1803, in the old synagogue of the ghetto, on Via delle Beccherie, near the *scuola ebraica,* Giacobbe Castelli launched his effort to fit in by marrying Susanna di David Jacchia, with whose family he would speak "a

strange language made up of schmaltzy local words, mingled with Hebrew terms, unintelligible to the non-initiated." From this point onward, he would belong to the merchant's class who "fight harshly for their clients . . . a fight for survival as passionate as the kind we see and admire in insects, in the grass of a prairie or the sand near the sea."[11] But, despite the removal of the gates of the ghetto in 1785, the community, though free, was still reluctant to emerge from its isolation, to lose its identity, and thus continued to confine itself, now by choice, to the streets of the poor district, the Riborgo. A succession of unstable political regimes, culminating in Napoleon's occupation of Trieste for four months in 1805 and 1806, would validate this prudence, and Giacobbe would relive a nightmare no less terrifying for being familiar— the prospect of the people of Trieste taking out their rage on the Jews, as had happened in Monte San Savino. On May 12, 1808, his first son, Aarone (Leo Castelli's great-grandfather), was born in an Austrian Trieste; three years later, his daughter, Anna, was born under French rule; while in 1815 and 1823, Bella and Vittoria, the two youngest, enter the world in a city again under the Austro-Hungarian monarchy and to remain so for several decades. Such vicissitudes of national identity will indeed brand the Castelli family right down to their most famous son, Leo.

Despite their abolition of the free port, French rule did see numerous measures favorable to Jewish interests, as if to outdo the Austrians in courting this constituency. The election of Aron Vivante to the city's provisional government, for instance, might mark the first Jewish presence in the municipal office of Trieste. On November 27, 1810, a ruling by the General Judicial Committee also granted, for the first time, to the "Jews of Gorice . . . and Jews from other Illyrian provinces . . . such as those in France and Italy, the right to freely practice their religion and the full protection of the law."[12] A few months later the committee went further and abolished all personal and special levies that the Austro-Hungarian monarchy was still collecting from the Jews, "as an example of tolerance and protection."[13] The elected officialdom of Trieste also reflected the whole cosmopolitan makeup of the city, soon comprising "twelve Catholics, three Jews, three Greek Orthodox, one Illyrian Greek, one Calvinist in its ranks." But despite Graziadio Minerbi, Filippo Hierschl, and Filippo Kohen, all merchant traders in the city government, despite equality before the law, the Jews remained divided in their feelings towards the French authorities. Certain merchants, such as the followers of the Freemason tradition, passionately embraced French and even

Jacobin ideas, while others, wary of losing the privileges granted so faithfully by the Habsburgs or decrying the closure of the free port, showed much more restraint.

This regime change undoubtedly gave rise to various reactions and ambivalences, and the Castellis, still traumatized by events in Monte San Savino, were no exception. Thus they confined themselves within the borders of the ghetto, a phenomenon the poet Umberto Saba thus described: "Jews who were born or who immigrated to the free city . . . whose status after [1810] was the same as other citizens, not required to pay salt tax or to be treated in a specifically humiliating way, had not all learned how to overcome their congenital mistrust or how to live their daily lives with the 'goys' whom they feared (and therefore detested) . . . This aversion . . . rooted within them by centuries of persecution and ostracism, even kept certain families, who were quite well-off, from living in new houses on new streets, relegating them to that part of the city where their ancestors had been, and still were, traders, drawing strength from their picturesque slums . . . They continued to live in their much-loved ghetto, which, to them, belonged to them alone and was full of memories."[14]

In October 1813, when the Austrians triumphantly returned to power, the Jewish community renewed its ties with its old patron, the Austro-Hungarian monarchy, and finally allowed itself a less hesitant social assimilation in its country. An extraordinary document sent in July 1845 by the leaders of the community to the local government epitomizes the transformation: "For a long time," they wrote,

> the Israelites have encouraged industry, sold agricultural goods, created new products useful to commerce, all this . . . not out of self-interest, but in the interest of the State or the province; they wish to be a part of it, but not as the Israelites of the past were tied to the banking sector, strangers in a society that held them at a distance. They wish to belong as Israelites openly and honestly involved in agriculture and industry; as Israelites who esteem other men as brothers, as sons of the same homeland, as subjects of the same Sovereign; as Israelites who, while preserving their religion, feel themselves obliged to be fully integrated into society and to work for the general good; as Israelites who progress through education and a sense of civic duty.[15]

Recalling these prosperous years, Umberto Saba describes "the era when the community grew in number every day, with new Jews attracted by the increasing prosperity born of trade, and transforming before their very eyes the small, old fishing town into a great buzzing enterprise. And many who came from the neighboring Levanti, debarking at the port of San Carlo, in red fezes and their jackets in shreds, with no worldly possessions save, perhaps, a letter of introduction for the Rabbi, or some elderly philanthropist, could be seen, after a few years, sometimes after only a few months, sharply dressed in the city uniform, in a top hat, at religious ceremonies, in the three synagogues, the Italian, the German and the Spanish, two of which were open to the Jews from the ghetto itself, and the third, not far away, on the Via del Monte."[16]

While, according to one descendant, Giacobbe remained his entire life "a poor devil living in the ghetto,"[17] his son Aarone "threw his weight" around the port and grew rich. The family tradition, which presents its climb up the social ladder as a fairy tale, insists that Aarone's son, little Carlo, come home for Passover, discovered an unexpected crowd around his house; when he drew near, the rabbi triumphantly lifted him up: his father had won the Italian lottery, the "Signoria"! Overnight, Aarone Castelli proudly began to exhibit all the trappings of the nouveau riche: horse-drawn carriage bearing the imperial crest, servants in white gloves, and, for his children, private tutors all previously employed by Emperor Maximilian. The photo kept by Piero Kern, one of his great-grandsons and Leo's first cousin, shows him, like a character out of Balzac, in black morning coat and starched collar, an imposing figure. Although strikingly dignified, the legendary Castelli ancestor looked good-natured: large almond-shaped eyes, high forehead, bushy eyebrows, a broad flat nose, heavy, sensual lips, a thick white moustache spilling over the lower lip, a large double chin, and, except for the bald patch, a tangled mess of white hair down to his neck. His relaxed jovial aspect speaks of the indolent nature of a genuine Levantine—a true *Triestino* already! The Castellis and the city of Trieste entered a profound symbiosis, and in this swarming, open society, the very atmosphere seemed an encouragement to dreaming up schemes of enterprise. As the writer Warsberg puts it, "Ever since I have been breathing in this air that smells of the sea, the ships and the stacks of merchandise, I feel energetic and alert once more . . . And who hasn't gone into a spice shop and, remembering the *Thousand and One Nights,* imagined themselves to be in Babylon?"[18]

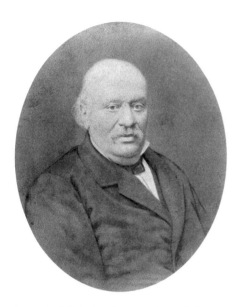

Aarone Castelli, Leo's maternal great-grandfather, a colorful man who hit the Trieste lottery in 1867

Though his father had been wed in the old synagogue of the ghetto nearly forty years earlier, on October 12, 1845, Aarone Castelli married Rosa Cittanuova in a new neoclassical structure, built to replace its predecessor after a fire. First, they had to comply with a vestigial statute of the monarchy that required them to obtain official permission to marry. Despite repeated petitions, this law would not be abolished until December 1867, and by the time Aarone and Rosa Castelli's four children—Emilia (born in 1847), Giacobbe (in '49), Alberto (in '52), and Carlo (in '54)—were ready to marry they could do so with only the family's consent. Throughout the nineteenth century and right up until today, the Castellis would record their family history in reference to the significant corresponding dates in the life of the imperial family. In which year did Aarone hit the jackpot? "The year of the assassination of Emperor Maximilian in Mexico," Piero Kern reports. In which year was Aarone's first son, Giacomo, born? "One year after the coronation of Emperor Franz Joseph," according to George Crane, Leo's brother. But even under the Austro-Hungarian Empire, the Castellis, like the majority of Jews in Trieste, considered themselves Italian: after naming his first son Rafael Giacobbe (he would be known as Giacomo) in honor of his father, Aarone Castelli chose to name the next two Alberto and Carlo, after the "good King Carlo Alberto"[19] of Italy, an enlightened, cultured sovereign who, through the Statuto Albertino of 1848, abolished absolute monarchy.

It is Aarone Castelli, that colorful ancestor, who first flees the curse of the ghetto, who blots out the sad memories of Monte San Savino, who establishes himself in the society of Trieste, making his own luck by whatever means he can, just like a character in one of Saba's short stories who asks, "Why don't you ever play the lottery? You risk very little but that little, and I'm speaking from experience, is always won back, at least in hope . . . Why shouldn't we have some luck, at least in the lottery? . . . A few liras won with-

out too much difficulty wouldn't do any harm."[20] Indeed, for Aarone, as we have seen, the lottery did quite a lot of good! Sustained by a particularly favorable economic climate and even more by sheer luck, the Castelli tribe catapults itself in one generation—perhaps even in one day—from the ghetto in a shabby part of the city to the choicest spot in the bourgeois quarter. Through the good offices of an aristocratic Italian family, a private chapel for the captains of the city (representatives of the emperor of the city) had been built in the fourteenth century, in an elegant part of town, not far from the Anglican Church: this grand property was known as the Villa, giardino e campagna Prandi. And so by these rather unusual means the Castelli family acquired its sudden quasi-noble social standing within Trieste.

"My father had good ideas regarding our education," wrote the novelist Italo Svevo. "He always told us: 'You must be good students and become well-educated young men so you can help me later in the business. Everyone will compliment you and I will be very proud of you. A good merchant trader must have a fair knowledge of at least four foreign languages. In Trieste, you must speak at least two fluently."[21] As for Aarone Castelli, he thought likewise, and his notions of education would form his great-grandson Leo as well. It was his very first investment once he'd struck it rich: Emilia, Giacomo, and Alberto received private lessons in music, English, and French, and, after 1863, when the Jews were granted free access to public schools, the young Carlo Castelli entered the Ginnasio Communale Italiano, recently established, where he would study for a business degree.

Despite the rising fortunes of the Castelli family and the picturesque comfort of their new life, they enjoyed nothing like the prestige of the Jewish families of Trieste, whose wealth has been growing for several decades—the underwriters, industrialists, and bankers, such as the Usiglis, the Stocks, the Daninos, the Brunners, or the Morpurgos. Nor were they party to such alliances as were formed in the first half of the century among banking families—the Luzzattos, the Parientes, the Morpurgos, and the Almanzis—in order to keep family fortunes concentrated through continual intermarriages, according to a tradition called *familismo,* which perpetuated a connection between Jewishness and financial management.[22] Nevertheless, for the Castellis as for these clans, family comes to supplant the community and the ghetto as the principle of social organization, regulating the life of each individual; it represents, according to the historian Anna Millo, "the essential element of life in the community. It stabilizes the rights and responsibilities of

its members, assures the observance and rule of law and once more assumes the function of transmitting property. Unity, harmony and solidarity between the members of the family form its moral code. The more loyal a family remained to these values, the greater its reputation in the world of business. Opportunities and resources increased tenfold through the organization of a network of relations with other families through marriage."[23]

Under such "unity, harmony and solidarity," in the Villa Prandi, the Castellis would live together and work together, prudently developing their family business and advantageously marrying off their daughters during the last quarter of the nineteenth century. By the time Aarone Castelli died in 1874, every country in Europe was being transformed by the Industrial Revolution. The port of Trieste was experiencing an exceptional prosperity in the last decade of the nineteenth century, and the Castellis knew exactly how to seize this opportunity to transform their social position, still rather tenuous, in order to become, within one generation, the respected merchants "whose wisdom and honesty, admired throughout Trieste, became proverbial in the world of wholesale trade."[24]

In 1869, Trieste, the only Mediterranean port connected to both Ljubljana and Vienna by rail, was on the verge of a colossal commercial boom thanks to the prospect of the Suez Canal opening.[25] At that very moment, Giuseppe and Elio Morpurgo, the two energetic brothers in business, acting on behalf of the Chamber of Commerce of Trieste and Lloyd Austriaco (the Empire's first shipping company), jumped in to represent the city at the opening ceremonies. Regular guests in the salon of Baron Pasquale Revoltella, they had met Ferdinand de Lesseps and the Archduke Ferdinand Maximilian, the emperor's brother and viceroy of Lombardy-Venetia. Carlo Marco Morpurgo had been knighted in Vienna, in recognition of the amazing technological innovations he had brought to the port. With the election of Salomone de Parente as president of the Chamber of Commerce in 1872, the Jewish network of Trieste was further strengthened.[26] It would still take several years for the Castellis to penetrate those networks; this finally happened with the marriage of Giacomo's daughter, Bianca, to Ernesto Krausz, to whom she gave three children, including Leo. In 1882, Ernesto Krausz would make his appearance in the port after the signing of the Triple Alliance, which ended hopes of unifying Trieste with Italy and revived the interest of Viennese financial concerns. But let's not get ahead of ourselves.

For now, Rosa Castelli, surrounded by her three sons, Giacomo, twenty-

five, Alberto, twenty-two, and Carlo, twenty, forcefully ruled over the clan in the Villa Prandi, set on the hills of the city where Leo Castelli would eventually grow up. "Women shopping, bustling about, brightly colored sweaters, carrying a basket full of food, in food stores that smell of spices; a man enters a tobacconist. And then, silence . . . How cool it was in summer! And how satisfying to see all this greenery, behind the surrounding walls! There was a fig tree and a cherry tree that would soon bear fruit, and perhaps soon an almond tree . . . A bit further up, the imposing property of the Prandis could be seen, with its gate, its wrought-iron balcony, the half columns adorning its façade and dividing it into harmonious sections at regular intervals. It is impossible to know why, but the elegance of its architecture endows it with an aspect of beauty and joy. By comparison to it, all other houses in the neighborhood . . . seem shabby."[27]

To all Triestines, the seat of the Prandi counts remained the *"nec plus ultra of the aristocracy, bearing all the marks of a bygone society,"* according to Vito Levi. "Coats of arms engraved in marble, an immense entrance hall, a grand drawing room leading out to several other rooms, vast sloping grounds full of trees hundreds of years old. The aristocratic family was now gone—had they died out or just dispersed?—and these three brothers now inhabiting it had decidedly no coat of arms: only two of them had wives and children, and the third was an artist and confirmed bachelor with no head for business, so that he was incapable of even looking after his own interests."[28] The youngest son was Alberto (1852–1912), *il maestro Castelli,* second violin in the Heller Quartet and music instructor to the city's children. Painfully shy, generous, absentminded, a dreamer, this great beanpole with a mop of brown hair lived for classical music and for years, every Sunday morning, he organized sight-reading training sessions for his students, choosing the most gifted to play in his Quartetto Triestino.

"He could have had a career as a top-notch soloist," Levi goes on, "if he hadn't suffered from terrible panic attacks. How many times had a pupil come upon the Maestro as he was embellishing the melody from a page of Bach, or Corelli, or Tartini with extreme virtuosity, but all it took was the entrance of a single person, even just a student, to extinguish his talent, and destroy his confident technical execution. Where teaching chamber music was concerned, it was completely different; responsibilities were shared, and Castelli felt protected by the calmness and eminence of Julius Heller."[29] With the Heller Quartet, Alberto Castelli was a regular visitor at the salon of the

young Signora Fanny Brunner, the daughter of an upper-middle-class family from Manchester, all of them cultured and musical, who married her cousin, Philip Brunner, by the sort of arrangement typical of the Jewish haute bourgeoisie of Trieste, who would go every year to the big synagogue in Trieste with their children to celebrate the birthday of Emperor Franz Joseph.[30] He heard talk of the salon of Clementina Hierschel de Minerbi who, in 1850, in her Palazzo sul Corso, had given a party for Giuseppe Verdi and his librettist Francesco Piave. And so it was thanks to classical music that Alberto, the most assimilable of the clan, was able to ascend. In fact, the artistry of the quartet was so impressive that after a concert in Vienna, the critic of the *Neue Freie Presse* exulted: *"So spielt man Beethoven!"* ("This is how Beethoven should be played!")[31]

Alongside Alberto, the family's two great personalities were Giacomo and Carlo, importers of coffee and rice, nicknamed *I due Tiracchi,* inseparable as a pair of suspenders, and sometimes known as "the one who cries (Giacomo) and the one who laughs (Carlo)." After selling various wares, they began a successful coffee import firm, Castelli e Castelli, with their offices on the "Molo San Carlo, Punto Franco." The story of coffee is its own fascinating journey: it began in the fifteenth century in Yemen, Ethiopia, Syria, and Turkey, its consumption spreading throughout Europe in the seventeenth century. Coffee was one of the exotic myths that fascinated the great explorers. Drinking coffee was part of a new way of seeing the world; it meant you could get a product from one of the most faraway countries in the world and make it your own. From that point on, the Castelli brothers traded with Brazil, Venezuela, Colombia, Java, Sumatra, Ceylon, Santo Domingo, Cuba, Puerto Rico; they established themselves in a supply chain that consisted of planting, picking, trimming, sorting, and packing the dark beans before roasting and grinding them. Soon their business would become the third-largest coffee importers in the city of Trieste.

By the end of the 1870s, the Castelli family table had to be set for six instead of four, when Carlo married Antonietta d'Italia (1878) and Giacomo Eugenia Gentili (1879). In less than fifteen years, there would be fourteen places at table with the birth of eight first cousins (Rosa, Arturo, Guido, Ortensia, Bianca, Laura, Lea, and Marcella), producing a sometimes contentious but joyful disorder. Of course, tensions grew between the two daughters-in-law, Eugenia, better educated, and Antonietta, rather timorous, the two attempting to outdo each other by their culinary skills: Antonietta,

small, round, friendly, excelled at chicken galantine, *il dindio,* while Eugenia had a way with quinces. On the first floor lived Rosa, Alberto, and Giacomo's family; on the second floor, Carlo's family. The two brothers diverged as well—Carlo, a great lover of opera, continued to go to synagogue and to fast on Yom Kippur, while Giacomo, less energetic, preferred to relax in the garden. But many affectionate, colorful, and moving episodes *en famille* survive (not unlike those of the Solals, beautifully documented in the novels of Albert Cohen, my great-uncle).[32]

With social and financial success, the Castellis distanced themselves from the generality of the Jewish community. "The slackening of ties, together with their ability to partake of social and cultural activities formerly forbidden to them, represent the break with the past and the beginning of a new life,"[33] writes the historian Tullia Catalan. The Castellis' practice of Judaism resembled that of their counterparts in Livorno, south of Genoa, the most progressive community at the time: "My mother . . . had a very strong belief in God, while simultaneously according little importance to religious observance. We went to synagogue at Passover, Yom Kippur and Rosh Hashanah, but never on Saturday, and we happily ate pork, while continuing to observe—how can I put it?—a moral code: the ten commandments."[34] One cannot fail to see it as a great step towards assimilation, a process Leo Castelli would, one day, carry to the point of severing his Jewish roots altogether. Though, of the three sons, only Carlo would honor religious tradition by attending synagogue on the holidays, every single marriage in the family would be celebrated in the temple. The Castellis, as "Jews from Trieste, middle-class, assimilated, lax about tradition, [would be] more Italian than the Italians and more native to Trieste than those actually born there, while remaining, in spite of everything, profoundly and completely Jewish, to the extent that they transformed the dialect of Trieste into a language that they alone could understand."[35]

"Come te sta?" "Va ben!" "Andremo a magnar!" "Le babe xe tute mate!" "El mato no capissi gnente!" "Giulio, xe un negron!": Giacomo and Carlo Castelli, the *due Tiracchi,* found a picturesque and intense professional life on the San Carlo pier. Meeting in the magical light of the late afternoon, in front of the unassuming warehouses, they felt the city was theirs. Standing on the prosaic embankments, with the vast sea at their backs, they marveled at the city's majestic architecture whose lights, mirrored in the water, flamed and sparkled with imperial magnificence. They would even be described in 1934,

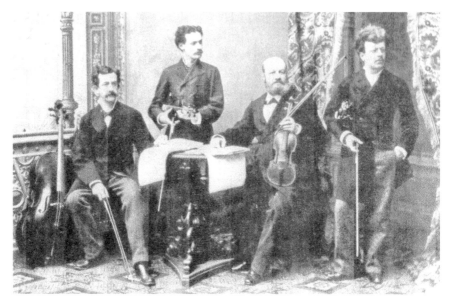

TRIESTE, CIRCA 1900
Maestro Alberto Castelli, Leo's great-uncle, STANDING LEFT, with the Heller Quartet

in the Fascist survey regarding coffee quotas, as "exceptional international merchants," because of owning the fourth-largest import company in Italy![36] Just as the Castelli brothers of Monte San Savino, with their monopolies in paper, tobacco, and aquavit, went back and forth across the Val di Chiana region, benefiting from the lack of customs duties and the strategic position of their border city, a century later Aarone's sons, their descendants, the new Castelli brothers, brought the ancestral gift for business to bear on coffee from around the world, distributing it throughout Europe—the knack one day transposed to the commodity of art but no less manifest in that context as practiced by their descendant Leo.

3. ERNESTO KRAUSZ MAKES HIS ENTRANCE

My father, whose name was Ernesto Krausz, was born in Hungary to a family that had settled there in the nineteenth century or even before perhaps . . . They were landowners as well, which was rare.[1]

<div align="center">LEO CASTELLI</div>

TRIESTE, SEPTEMBER 1900. With a grey suit, white shirt, white pocket handkerchief, a sharp geometric pattern on his tie, Ernesto Krausz was impeccably turned out as he entered the head office of the Credit Anstalt. A few years later, having married Bianca Castelli, he would be the father of three, the second child being Leo Castelli. But for Ernesto Krausz, who at barely twenty-five had just been transferred from the Fiume branch, this was only the beginning of an unusual banking career that would progress inexorably for the next thirty years. Three months after his arrival, he would be noticed by the director and become his assistant; fifteen years later, he would be appointed head of the Banca Commerciale Triestina, the largest bank in the city, quite a leap for a self-educated man. If, by all accounts, Ernesto Krausz always displayed in his social life the demeanor of the perfectly assimilated banker, in the privacy of his own home he always preserved the proof of his family's swift rise from the shtetl to secular respectability, but guarded it as a family secret, almost a taboo. "In the Trieste dining hall, our father had hung, side by side, two immense photos measuring three feet by one and a half feet," Dr. Crane (Leo Castelli's younger brother) recalls today. "On the first one, Jacob and Esther Weisz, his maternal great-grandparents, shtetl Jews, stood in traditional religious Jewish clothing: long religious dress and head covering for her; beard, sidelocks, and *kippa* (skullcap) for him. On the second one, his grandparents, David and Rachel Weisz, who, after being granted the Privileges of 1848, had been able to buy land and to step into modernity: David Weisz, bare-headed, wore a dark suit, while his wife,

Ernesto Krausz, Leo's father, age twenty-five, at the time of his arrival in Trieste

Rachel, in a light dress, revealed her great beauty and even her sensuality. David Weisz was a powerful man, who truly reigned over the economy of Siklós and worshipped the Emperor Franz Joseph, who had allowed him to become a landowner."[2]

Leo Castelli's family secret, revealed by his brother during the first stage of my inquiry, this disciplined obfuscation of the past carried on in daily life by their father—with a certain family history exhibited at home but hidden in public—seemed related to the somewhat evasive way that Leo Castelli had answered his son's questions about his Jewish identity. In time I would grow more and more convinced that, in prospecting for Leo, there was much more ore to mine in the remote territory where his father was born, at the borders of Hungary, Croatia, Slovenia, and Serbia. I contacted Dr. Laszlo Karzai, the leading expert on Hungarian contemporary history. With a colleague, he looked for the history of Leo Castelli's paternal ancestors, digging up archives, documenting, cross-referencing data. His cover letter accompanied a thick ream of some one hundred pages.

> Szeged, January 22, 2007, Dear Annie, This is a progress report about our (Dr Judith Molnar and myself) [sic] working week in Pecs, Baranya County, January 15–19, 2007. First of all, a few words about the history of the Jews in Siklos. According to the official census I. A zsido népesség szama településenként [sic] (1840–1941). Központi Statisztikai Hivatal, Budapest, 1993, the Jewish community was small but very old . . . The original documents are hardly legible . . . Dear Annie, that is all. Sorry, but it is extremely difficult to find the traces of a given person, or a family when the majority of the documents are missing . . . The Jews of Siklos were among the first deportees, i.e. among the Jews who were "cleared" from the Southern-border zone already in April 1943. From Siklos they were transported to one internment camp in Barcs . . . In case you have any question or suggestion, please do not hesitate to contact me! Sincerely yours, Lazslo Karzai.[3]

In April 2007, at the urging of the Triestine journalist Francesco Montenero, who had assisted me in taping Leo's family interviews, I embarked on a road trip to Göntér, the Krausz property near Siklós, in order to truly understand the geographical, cultural, and social circumstances attending

the birth and youth of Leo Castelli's father. After visiting the majestic Triestine villas, the elegant yellow Viennese mansion, and the classical Budapest house where Ernesto Krausz had lived as an adult, I was quite curious to discover his original birthplace, under an intuition that it might hold some key to understanding his own story at least. The effort was rewarded. Siklós is a picturesque, cosmopolitan, and lively market city, protected by a towering Roman fortress and the mosque of Bey Malkoch; houses of shockingly bright colors—yellow, green, pink, white, and red—lining the main street lend to the feeling of the Mediterranean Sea close by. Under a dark blue sky, on that beautiful spring morning, Siklós looked especially inviting, and I noticed many migratory storks building nests on the local rooftops. The vineyard road of Villány-Siklós has fostered a dynamic tourist trade, and everyone liked to recall that the cultivation of wine had been carried out in the region first by the Romans, then by the Turks, who occupied southern Hungary in the sixteenth and seventeenth centuries. I asked a local wine merchant about Göntér. "Over there, in the direction of Croatia," he said, pointing out towards the immense flatland.

Leo's nephew Robert Reitter had given me portraits of himself, aged six, in front of the house at Göntér: in many, a little boy perches on a white wooden balustrade of very distinctive shape, as if on horseback. After driving through long and strictly uniform lines of the vineyards, between Ujpetre and Harkány, it did not take us long to identify the birthplace of Leo Castelli's father. We found nothing grand, but discovered a rustic white house set peacefully overlooking the immense vineyard, its low pointed brown roof, green shutters, white columns, and wooden balustrade just as they appeared in the pictures. There was activity on the property on that bright day, which happened to be the morning of the first night of Passover. The vines had recently been dressed, new leaves appeared on the trees, and many kinds of birds were singing as someone on horseback was inspecting the property: business seemed to be going on as usual. But the house was bolted, apparently uninhabited, even abandoned, and we learned that, since 1943, the date of the deportation of Miklos Freund, the last family owner and Leo's first cousin, to Auschwitz-Birkenau, the land passed from state ownership to collective agriculture. But something struck me as I sat outside the house, marveling at the clean lines of the vineyard and at the austerity of the environment. It was Dr. Crane's recollection—"In Göntér, my grandmother had a bunch of servants that helped her keep her home kosher"[4]—

SIKLÓS, HUNGARY
Krausz family property, owned by Leo's paternal grandparents, in the Göntér vineyard

and also Leo's bland description—"It was a place I liked very much, the country house was surrounded by fields and woods, the freedom!"[5] I imagined Ernesto as a child playing in the wheat fields during his summer holidays: from rustic to urban gentleman, from landowner to banker, from Göntér to Trieste, then to Vienna and to Budapest, the trajectory of Ernesto Krausz (Leo Castelli's father) had carried him far indeed!

The last missing piece of the puzzle came from Robert Reitter, who provided me with the photos of Ernesto Krausz (his grandfather) and included some written recollections. Reitter had his own experience of the sorrows of Jewishness: raised as a Catholic, he had been forced nevertheless to wear the yellow star during the siege of Budapest, before deciding to reconvert to Judaism later in life, an experience he recounts beautifully. His own son, Paul Reitter, a brilliant academic in German studies, analyzes Jewish shame in postwar Vienna, devoting his life to deciphering the reasons for Ernesto Krausz's "family secret." If Leo Castelli circulated in New York society with the utmost ease of bearing, a seeming thoroughbred of the salon, it was now

Antonia Krausz, born Weisz, Leo's paternal grandmother, a strong widow who raised four children while skillfully managing her agricultural property

clear that all the members of his family bore the scars of the story he always chose to conceal.

The administrative register of Siklós is a startling document: hardly legible, its fragile and awkward calligraphies nevertheless record all the Krausz and Weisz family milestones—a looping sequence of marriages, births, deaths, marriages, births, deaths—in Hungarian, in German, and sometimes in Hebrew, since even in this small German-speaking enclave in the south of Hungary, Jews by tradition added a second Hebrew name to their given names in German. Here one finds the life of Antonia Weisz and of Leopold Krausz, Ernesto Krausz's parents, both children of powerful Siklós landowners. Thanks to the reforms of 1848, a David Weisz and a Samuel Krausz had managed before the age of thirty to step into modern life as landowners, thus escaping from the shtetl to which their respective parents had been confined. When Leopold Krausz married Antonia Weisz, he was twenty-three years old, she was nineteen; they spent the first four years of their marriage working in the vineyard of Antonia's father, on the great fertile Baranya plain, a few miles from Siklós. And then, without break, they produced five children in six years: Ernö *Ernesto Efraïm* (1877); Irma *Myriam* (1878); Sigismund *Ishaie Shmuel* (1879); Josefina *Yael* (1880); Ilona *Hadas* (1882). We lose trace of the youngest girl rapidly, probably because she died at a young age. Then, ten years after his wedding, at the age of thirty-three, Leopold died, leaving Antonia a twenty-nine-year-old widow, with responsibility for both management of the property and the education of their four children, aged six, five, four, and two! Also recorded in this Hungarian register: the birth in Trieste, on September 4, 1907, of Ernesto Krausz's older son, "Leo *ben Israel.*"[6]

It was in 1848 that the Krauszes became Hungarian citizens and landowners with full civil rights, and their past, unlike the Castellis', bears no mark of

Leo's birth certificate, archive of the Trieste Synagogue

ק"ק טריאֶסטי
Comunità Ebraica di Trieste

N. _____

Anno 1907

COPIA INTEGRALE DELL'ATTO DI NASCITA

Si certifica che nel registro dei nati della Comunità Ebraica di Trieste, Libro _VIII_ _____ risulta quanto segue:

N.	Giorno e mese della nascita	Data Ebraica	Nome del neonato	Sesso M. F.	Legittimo	Illegittimo	PATERNITÀ Padre	Madre	Abitazione	Levatrice	Operatore	Padrini	Osservazioni
81	4 Settembre	25 Elul	Leo	/		/	Ernesto KRAUSZ — Condizione _impiegato_ — Data e luogo di nascita 1/3/77. Sinkos — Pertinenza Sinkos (Ungheria) — Data del matrimonio Trieste 18 giugno 1914	Bianca CASTELLI — Condizione _____ — Data e luogo di nascita 24/7/1885 Trieste — Pertinenza	Via delle Croce n. 16	Caterina Traversa	V Dr. Romani n	Giacomo Castelli	x xx xxx

Trieste, _____

COMUNITÀ EBRAICA

xx Con Decreto Reale dato a Roma addì 3/XII/1931, trascritto li 4 gennaio 1935 nei registri di nascita del Comune di Trieste, il N. 3 Parte S.3. Krausz Leo e suo padre Ernesto sono stati autorizzati ad aggiungere al cognome "KRAUSZ" quello di "CASTELLI", ed a farne uso del doppio cognome "KRAUSZ-CASTELLI"

x Krausz Leo nel giorno 7/3/1933 ha celebrato matrimonio con Sharira Ileana a Bucarest. Nel Comune di Trieste l'atto fu trascritto nel relativo registro di matrimonio n. 31 1/c

xxx Leo Castelli è deceduto in New-York il 22.08.1999. (Atto N. 302 parte II serie S anno 1999)

exclusion, of expulsion, or of exile. Ironically, this happy circumstance would ultimately prove unlucky for them. For they would establish themselves in this promising land, conducting their swift social assimilation with such lively optimism that they succumbed to the temptation of opportunism and self-confidence. Their aggressive integration into secular life would tragically blind them to the sinister political developments of the twentieth century, which would in the end sweep away several generations of European Jews in one stroke. During the summer of 1943, Miklos Freund (Leo Castelli's first cousin), then in charge of the family property in Göntér, would be snatched away with his pregnant wife, Leni, to the camp of Auschwitz-Birkenau. Ernesto Krausz would elude the camps where so many of his relatives were to perish, but this is hardly to say he came through unscathed.

Who could have imagined such an end in the light of Ernesto Krausz's auspicious birth? Arriving on March 4, 1877, Ernesto Krausz, the firstborn son, was the pride of the family. After losing his father at the age of six, he dutifully helped his mother run the vineyard. A little later, he struggled as an itinerant wine and beer merchant, traveling between Hungary and Croatia before finding a position in a Fiume bank. One of the photos that Reitter gave me shows him as a young man: a high forehead due to premature balding; clear, engaging eyes; and a thin moustache that discreetly lent his full lips masculinity. The image is consistent with the character of an ambitious young banker who, behind his good manners, harbored a gentle warmheartedness. In another shot we see him at a social event, an extremely elegant haute bourgeois, seemingly worshipped by those surrounding him. Negotiating a balance between the Austro-Hungarian banking world and the life of the family property would remain somewhat difficult. Robert Reitter writes of the challenge, "My mother's father (Ernesto Krausz) is strongly associated in my mind with Göntér. He grew up there, and was known there. I was told a story about a visit he once made there from Trieste, where he had spent the major part of his career, during a period in which his work was not going so well. Sitting on a fence, he must have had a downcast air, because one of the peasants was said to have addressed him, 'Uncle, why such a sad face? You are still rich, you are still the owner here.' Grandfather was said to have answered, 'Not so rich these days, business has not been good.' And as the story has it the peasant answered, 'Then why be a Jew, Uncle, if you're not going to be rich?' I could see as a child that we only played at the role of owners. Real ownership would come with a belief in its own freedom from chal-

lenge, and I could see that our way of playing the role was tentative, provisional."[7] Indeed, status as a landowner would fail to protect him from the political and racial travails of the 1930s and '40s.

Things had first begun to change for the shtetl Jews under Emperor Joseph II: during the last few decades of the eighteenth century, drawing on observations made during his travels in other countries, the emperor decided that the Jewish problem was not a matter of religion but of the socioeconomics of a people. In his Edict of Toleration of 1781, therefore, he expressed his ambition to "free the Jews from constraints that only allow them to practice usury and fraud in order to meet their needs."[8] In his Regulation of 1783, he went even further along the path of "civilization": "It would be useful to get them involved in agriculture, by allowing them to become tenant farmers on condition that they cultivate the land themselves . . . it is necessary to put an end to every type of discrimination regarding the way they dress." He also asked the Jews to give up speaking Yiddish, to use Hebrew only for religious purposes, and to study the history and geography of Hungary.[9] It was, therefore, thanks to all these measures and to the January 1791 law, known as *De Judaeis,* that the Weisz and Krausz families would eventually be able to give their descendant Ernesto Efraïm Krausz the means by which to pursue a brilliant career in the Viennese Bank.

Siklós lay at the foot of the medieval fortress built during the thirteenth century on Mount Villány, on the Croatian border, in the Baranya province, one of the small islands of German speakers in Hungary. Once the Krausz and Weisz families were actually settled in their new home, they undoubtedly experienced exhilaration at the transition from Yiddish to Hungarian, from the synagogue to the Chamber of Deputies, from rabbi to senator. We know they cherished the sudden attainment of their civil rights under laws enacted several hundred miles away, in Budapest or Vienna or Hungary or Austria-Hungary, and that from this point on, they were pleased to regard themselves as citizens of Austria-Hungary. At the same time, however, they remained apart from the dominant culture of the empire. Would not the kind of sudden and complete emancipation advocated by the philosopher Wilhelm von Humboldt have facilitated the integration of the Jews of Austria-Hungary even more, instead of the gradual assimilation that took place? "Gradual assimilation," wrote Humboldt, "brings with it justification for the very discrimination it claims to suppress in every domain where segregation persists. The new freedoms granted, in fact, increase the attention

drawn to those restrictions that remain, and in this way, the abolition of such restrictions is counterproductive." He also noted that gradual emancipation "necessitates 'euthanasia' of religious identity, and demands the sacrifice of their [Jewish] identity in order to be accepted in German culture."[10]

In 1790, in a Memorandum petitioning the Diet, the Jewish representatives of fifty-four counties outlined their demands, in the context of an ardently expressed patriotism: "We have no other homeland anywhere in the world except Hungary. No other protectors than the official authorities and the Lords who own the land."[11] Likewise, in 1847, in a declaration submitted with the approval of all his colleagues, Rabbi Emmanuel Loew would ceremoniously avow:

> We, the Hungarian Rabbis, in keeping with our holy religion, solemnly proclaim ourselves prepared to carry out all our obligations towards our neighbors, as stipulated in the Holy Bible . . . for we consider all men our neighbors, whatever their religion, just as we consider Hungary our true and only homeland . . . We declare as anachronistic and invalid anything in our theological texts that is contrary to the aforementioned commitments . . . The government may be certain of benefiting from us, for we are intelligent and cultured citizens, a nation of enthusiastic, hard workers, as long as we can enjoy peace of mind, the grace of our God and this resolution to the Jewish issue, which will no longer resemble Penelope's mythological web: spun during the day but destroyed by night.[12]

In 1848, when a new law allowing Hungarian Jews to own land was enacted, David Weisz and Samuel Krausz, Ernesto Krausz's grandfathers, then in their thirties, promptly abandoned the ghetto and stepped towards a new life.

In 1867, Leopold Krausz—Ernesto's father—then aged seventeen, saw the passage of a comprehensive law emancipating Hungarian Jews; it was unanimously ratified by both chambers of Parliament. According to the new legislation, "1. Jewish residents of the country are declared able to enjoy all civil and political rights as equals with our Christian citizens. 2. Any existing decrees, laws or customs contrary to this principle are hereby abolished."[13] Also in Leopold's seventeenth year: the signing of the Ausgleich, the constitutional agreement with Austria inaugurating a new political arrangement, the Austro-Hungarian "dual monarchy." And so in the space of twelve

months, as though on the fast track to modernity, Leopold Krausz acquired
the status of full Hungarian citizen and watched his country throw off the
vestiges of feudalism to become a constitutional monarchy, a democratic
state. From this point on, though separate kingdoms, Austria and Hungary
had a common market, a common diplomatic and fiscal policy, and the same
army and currency. With no border or customs between them and Austria,
Hungarian landowners gained access to the European market and its hefty
profits.

Hailed by Rabbi Armin Kecskeméti as "our visionary monarch,"[14] and by
others as the *"Kayser Juden,"* his birthday to this day celebrated by no few
Jewish families, Emperor Franz Joseph had truly established a Jewish partici-
pation in the cultural, political, and economic life of the empire unique in
Europe. It has been argued that the emancipation was less than progressive
in spirit, "the result of a necessity imposed by the social and economic mod-
ernization of European societies, rather than the result of a political plan
inspired by the philosophers of the Enlightenment."[15] And certainly, deeply
entrenched prejudices had the effect of establishing at least an implied dis-
tinction between "wealthy, useful Jews" and "poor Jews from Galicia," along
with other ambivalences. "Jews are more intelligent and more hard-working
than Hungarians, their emancipation could certainly advance our economy,
but to the detriment of our national identity, the uniqueness of the Hungar-
ian race," stated Count Széchenyi, countering Baron Eötvös.[16] The Masonic
delegate Nagybathy offered less grudgingly that "the Jews bring not unsub-
stantial profits to the country, particularly to the aristocracy whom they
serve as stewards, buying and selling their wine, wheat and other prod-
ucts."[17] As for Count Aurel Dessewffy, he praised the numerous Jews living in
the rural areas who "already speak perfect Hungarian and who, as far as the
language is concerned, have become true Hungarians," yet he advocated
curbing the immigration of the "poor Jews" from Galicia, and a proposal
that was taken up in the Upper Chamber to allow the immigration of only
"wealthy Jews who, through their hard work and knowledge, would benefit
the country."[18] The Krauszes, for their part, as they belonged to the rare
group of Jewish rural landowners, did not really fit into either class.

By the very enumeration of his titles at his coronation in 1848, the
emperor had given expression to the hornet's nest of nationalities that
would explode in 1914. "We, Franz Joseph, by the Grace of God Emperor of
Austria; King of Hungary and Bohemia, King of Lombardy and Venetia,
Dalmatia, Croatia, Slovenia, Galicia, Lodmeria and Illyria; King of

Jerusalem, & Archduke of Austria; Grand-Duke of Tuscany; Duke of Lor-
raine, Salzburg, Styria, Carinthia, Carniola; Grand-Duke of Transylvania;
Margrave of Moravia, Duke of Upper and Lower Silesia, Modena, Parma,
Piacenza, and Guastalla, Oswiecim and Zator, Teschen, Friuli, Dubrovnik
and Zadar; Count with the rank of Prince of Habsburg, the Tyrol, Kyburg,
Goricia, and Gradiscia; Prince of Trente, Bressanone; Margrave of Upper
and Lower Lusatia and Istria; Count of Hohenembs, Feldkirch, Bregenz Son-
nenberg & Lord of Trieste, Kotor and Windish March . . ."[19] To declare the
extent of his domain was to acknowledge the volatile diversity of its popula-
tions: the emperor reigned over an area of 257,478 square miles, the largest
country in Europe after Russia, with over thirty-seven million people; but
unlike the others, his country had no single dominant national group, but
rather comprised Germans, Hungarians, southern Slavs (Serbs, Croats,
Slovenes), northern Slavs (Czechs, Slovaks, Poles, Ukrainians), and Italians.

If Ernesto Krausz seemed to gravitate towards Trieste as naturally as Gia-
cobbe Castelli had a century earlier, it was under totally different conditions:
where the Castellis had been expelled during the early Tuscan pogroms and
attracted by the haven Trieste offered to Jewish merchants, Ernesto Krausz
came entirely of his own volition, drawn by a bold and massive economic
dynamism, and settled in the city during the glorious years of the Körber
government, which was actualizing liberalization of the Austro-Hungarian
monarchy. Trieste, the "key to the Adriatic," was then attracting all the
region's entrepreneurs, Gentile and Jew alike.

On February 22, 1900, Austrian Prime Minister Ernst von Körber addressed
the Chamber of Deputies in Vienna: "Distinguished members! Today, mate-
rial and cultural issues are pounding violently at the door of the
Empire . . . This is why I implore you to resolve at once our racial dis-
putes . . . and I ask you to think about the free path that is left for us, and vote
to give the State full power in the service of culture and of econ-
omy . . . While throughout the entire world industrialization is symbolized
by an intensification of effort and joining of forces, we remained disadvan-
taged and even paralyzed by our racial disputes. To gather all together in the
service of the providential state and the social progress of the Nation as a
whole, is a plan that should stir the heart of every patriot. The goal that this
government has set itself is to place the full power of the State into the ser-
vice of our national culture and of our economy . . . In this respect, we must
modernize and expand the port of Trieste, the most important maritime
market for Austria, which is so difficult to access . . . Two railways will

simultaneously increase the city's economic potential and justify the demands of the Monarchy regarding its port. Industry will be the decisive vehicle of our plan of action . . . Our task is to create an era of peace for the State."[20]

In his radical vision, Ernst von Körber confounded the people's representatives by exhorting them to shake up the empire. Sweeping aside the outdated conflicts that had paralyzed politics during the previous three years, he skillfully steered his country towards the twentieth century with a particularly ambitious bill to finance a major economic expansion with a budget of half a billion crowns ($100 million in contemporary terms). Among his public investment priorities, those "that can no longer wait," von Körber counted the construction of a second railway between Vienna and Trieste, with a tunnel more than five miles long dug out of a rock-solid section of the Alps, the Tauern, at an altitude of 3,600 feet. He further proposed the construction of a shorter rail line to link Prague and Trieste, thereby attracting trade from all of Bohemia; he also envisaged genuinely navigable routes through every river, as well as a huge system of canals. Finally, there was to be a full-scale reconstruction of the port of Trieste. The vision was grandiose, the budget colossal, the perspective resolutely modern.

Von Körber's plan electrified the Viennese delegates, whose hostile reactions rang out. "A budget of half a billion crowns could only be passed by a government that deserved it!" declared a representative of the Radical Czech party. "Our opposition focuses on the very needs that our government must address. That is why we will block this law!" Bald and stylish, with a great black moustache, expressive bushy eyebrows, and a devastating dark gaze, von Körber seemed completely improbable as *Ministerpräsident*. Following a long series of aristocrats (such as Prince Felix Schwarzenberg, Count Karl Ferdinand von Buol-Schauenstein, Count Johann Bernhard von Rechberg, Count Friedrich Ferdinand von Beust, Prince Karl Auersperg, Baron Ludwig von Holzgethan, Prince Alfred Windisch-Grätz) who sometimes remained in power for only a few months, Ernst von Körber was the first commoner to hold the post of prime minister. But unlike his predecessors, often inexperienced or irresponsible dilettantes, von Körber was an able statesman. "A political genius" to some, "uncommonly intelligent" to others, "the most extraordinary personality in the Austrian State machinery" and a "great modernizer," who displayed such imagination, energy, and devotion that some said he was "married to the State." Ernst von Körber had a visionary plan for the economy and the arts, and his unconventional views were

reflected in his choice of advisors. He appointed a well-respected economist, Eugen Böhm-Bawerk, as minister of finance, but for his principal advisor he chose Rudolf Sieghart, a thirty-four-year-old professor of economics, educated at the Ecole de Vienne (by Carl and Anton Menge) and the son of a rabbi from Silesia. It was only one of the *Ministerpräsident's* shocking moves in a city whose mayor, Karl Lueger, scarcely hid his anti-Semitic feelings.[21]

An academic and distinguished classicist, Wilhelm Ritter von Hartel, was appointed minister of art. It was no merely ceremonial post. The policies that would propel Ernesto Krausz to Trieste would markedly affect cultural production. The minister's supranational scheme explicitly repudiated "the sacrosanct ideals of art and the definition of style," encouraging a deep cosmopolitanism among artists. And while in several European countries (France for one), government officials expressed mistrust of modern art, the old Austro-Hungarian monarchy paradoxically took up the cause, embracing the so-called Vienna Sezession. Otto Wagner, Gustav Klimt, Karl Moll, Koloman Moser: architects and painters participated in every aspect of the city's policies concerning the arts, from the revolutionary architecture of buildings to the design of coins and postage stamps. In music (Alfred Roller would become Gustav Mahler's stage designer) and the plastic arts as well (a Modern Gallery was founded and numerous Sezessionist artists were appointed to chairs at the Wiener Werkstätten Arts and Craft School), modernism blossomed in the daily life of Vienna during the twentieth century. Von Körber's grand program would not last long. It was under constant attack by the opposition, especially the nationalists, and von Hartel's modernist projects were equally reviled by right-wing delegates like Karl Lueger. But in Parliament, von Hartel insisted on the importance of the Vienna Sezession, not just in Austria but throughout the world, concluding: "Anyone opposed to such a movement clearly demonstrates a lack of understanding of the urgency and necessity of a modern policy where the arts are concerned."[22] And the new openness did not extend only to the fine arts. After Wagner and Klimt, another prominent figure from the University of Vienna was to feel the liberalizing warmth of the arts minister: in March 1902, Sigmund Freud was awarded the chair of the faculty of medicine, for which he had waited five years. Was Austria ready at that moment for the great economic leap that von Körber dreamed of? In the face of archaic bureaucracy and ethnic turmoil in the provinces, von Körber attempted to use economic progress to resolve their political issues, hoping to dissolve

nationalist division with the solvent of a great Industrial Revolution. In the end, he failed.

During those few years of true democracy, the Austrians enjoyed many great advances: freedom of the press, "working days and peaceful nights" for the people,[23] support for heavy industry, long-deferred bolstering of monetary reserves, stabilization of unemployment, and reform of the bureaucracy. Nevertheless, the right wing and the nationalists persisted, stirring a restive populace and scuttling von Körber's Canal Project, after which the opposition managed to arrest his policy of expansion and force him from office.[24] When von Körber resigned in 1904, it was the end of what Joseph Schumpeter had praised as "political dynamism and impartiality."[25] On March 14, 1910, Rudolf Sieghart was appointed by imperial decree director of the Boden Credit-Anstalt Bank. It was a tribute, of sorts, to von Körber's vision, which, though defeated, had lived long enough to draw Ernesto Krausz to Trieste. The year 1900 had marked the start of Krausz's rise as a star of Trieste's banking world.

Ernesto Krausz's ascent in Austro-Hungarian society followed the Hungarian Jews' "golden age of assimilation." Spurred on by the liberalization and the secularization of the empire, they participated in its political, economic, and cultural life as in no other European country, and often built unexampled and till then unimaginable careers for themselves.[26] There were many like Adolfo Frigyessy, born in Raczalmas, a small village north of Budapest,[27] who arrived in Trieste in 1876, where he became the director of the RAS insurance company (Riunione Adriatica di Sicurta). Others who succeeded were Baron Zsigmond Kornfeld, senator and director of the Hungarian Bank, and the seven Goldberger brothers (Arnold, Gusztav, Albert, Gyula, Ferenc, Samuel, and Ödön), who became prominent in society as owners of a textile dyeing factory. On the eve of the First World War, Hungary's Jewish citizens—numbering some nine hundred thousand, nearly half of whom lived in villages or small cities[28]—seemed to be living up to Franz Joseph's dreams. Ernesto Krausz's career at first seemed destined for the glorious path of a Frigyessy, a Kornfeld, or a Goldberger, but it suddenly faltered, stalled, and withered. Perhaps he arrived twenty-five years too late to enjoy all the fruits of change in a society that had held out the promise of acceptance only to regress. But his entrance into the modern world was if nothing else swift, excusing perhaps what in retrospect would seem a strange, even tragic, political myopia in a man so manifestly intelligent and perceptive.

MONTE SAN SAVINO

AARONE and ANNA CASTELLI
1720–1780 1740–?

SABATO	LETIZIA	VITALE	GIACOBBE	SARA
1776–?	1768–?	1772–?	1777–?	1770–?

TRIESTE ◄
1799

GIACOBBE CASTELLI and SUSANNA DI DAVID JACCHIA
(married 1803)

AARONE	ANNA	BELLA	VITTORIA
1808–1874	1811–?	1815–?	1823–?
and			
ROSA CITTANUOVA			
(married 1845)			

EMILIA	GIACOMO (known as Giacobbe Rafael)	ALBERTO	CARLO
1847	1849–1930	1852–1912	1854–1929
and	and		and
ELIO	EUGENIA GENTILI		ANTONIETTA
MUSSAFIA	1860–1929		D'ITALIA
?			?

ROSA	GUIDO	BIANCA	LAURA	MARCELLA	ARTURO	ORTENSIA	LEA
1879–?	1881–?	1886–1945	1889–1944	1894–1961	1880–1945	1885–1937	1890–1981
		and	and			and	
		ERNESTO	VITTORIO LEVI-			MAX	
	▲	KRAUSZ	CASTELLINI			KERN	
		1877–1945	?			?	
		(married 1904)					

GIULIO
1911

SILVIA	LEO			GIORGIO	PIERO
1905–1995	1907–1999			(GEORGE	1911–2008
				CRANE)	and
				1911	?

and	and	and	and	and	
MIKLOS	ILEANA	ANTOINETTE FRAISSEX	BARBARA	ETTA MAE	
REITTER	SCHAPIRA	DU BOST (TOINY)	BERTOZZI	PALMISANO	
1898–1994	1914–2007	1928–1988	1964	?	
(married 1936)	(married 1933)	(married 1963)	(married 1995)	(married 1952)	

ROBERT	NINA	JEAN-CHRISTOPHE		STEPHEN	LAURA
1937	1937	1963		1953	1960

▲SIKLÓS

ANTONIA WEISZ and LEOPOLD KRAUSZ
1854–1924 1850–1883
(married 1873)

ERNESTO	IRMA	SIGISMUND	JOSEFINA	ILONA
1877–1945	1878–1942	1879–1920	1880–1937	1882–?

LEO CASTELLI'S FAMILY TREE

4. MIRACULOUS YEARS IN TRIESTE

The world . . . was rich . . . Austria was rich . . . Trieste was one of the richest cities . . . in the richest state in this rich world.[1]

ROBERT BAZLEN

UPON DISEMBARKING IN Trieste, Ernesto Krausz, thanks to an introduction from the city's rabbi, became a regular visitor to the Villa Prandi, the Castellis' home. He spent his Sundays with them, listened to Alberto play in the Heller Quartet, and got on well with Carlo. He enjoyed the company of all the female relatives, for a time courting Ortensia, "the prettiest, the most cultured, but also the most independent,"[2] and on June 12, 1904, he married Bianca Castelli. On the subject of Ernesto Krausz and Bianca Castelli's union, let us hear their children comment: "There was nothing romantic about their marriage," says their son George Crane, brother of Leo Castelli. "They went to Salzburg on their honeymoon and my mother, who had absolutely no sense of humor, described how she hated the trip because at night the bells ringing from the churches kept her awake! Our father was very superior to our mother in every way. But she made it possible for him to be accepted into society in Trieste, and as far as his career was concerned, it was a good marriage, for she belonged to one of the city's old families."[3]

Ernesto and Bianca settled on the Via delle Coste before moving to the Via Roma, at the corner of Via Ghega, in 1907. Their union brought three children into the world: Silvia in 1905, Leo in 1907, Giorgio in 1911 (it was in the United States that Giorgio would later change his name to George Crane). If the name "Leo" is short for "Leopold," the name of Ernesto's father, whom Leo knew only through photographs, it was the only meager concession made to the Krausz lineage. To hell with ancestors' names, to hell with Hebrew names, to hell with holidays at the synagogue: that world was behind him! Ernesto Krausz had decisively chosen assimilation. But the

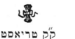

קֿק טריאסטי

COMUNITA' EBRAICA DI TRIESTE

FEDE DI MATRIMONIO

Si certifica che dai Registri dei Matrimoni della Comunità Ebraica di Trieste,

Vol. *1902/1912* *risulta quanto segue:*

N. *11* *Data del matrimonio* *12 giugno 1904*

	DELLO SPOSO	DELLA SPOSA
NOME e COGNOME	Ernesto KRAUSZ	Bianca CASTELLI
Giorno, mese ed anno di nascita	4 marzo 1877	29 luglio 1885
Stato	celibe	nubile
Luogo di nascita	SIKLOS	TRIESTE
Pertinenza	SIKLOS	COSTANTINOPOLI
Cittadinanza	UNGHERIA	TURCHIA
Condizione	impiegato	privata
Nome e cognome del padre	fu Leopoldo	Giacomo
Nome e cognome della madre	Antonietta WEISZ	Antonietta D'ITALIA
I, II o III matrimonio	I°	I°
Causa dello scioglimento		

OSSERVAZIONI:

..

..

Trieste, ..

Bianca Castelli and Ernesto Krausz's marriage certificate, archive of the Trieste Synagogue

destiny of the Krausz family, in spite of Ernesto's attempts to orchestrate it according to his social ambitions in Trieste, would play out very differently than he had envisioned, shaped by political upheavals far beyond his control.

With the first Moroccan crisis, the annexation of Bosnia by Austria-Hungary, the second Moroccan crisis, the conquest of Libya, and the outbreak of the Balkan wars, the period from 1906 to 1913 was one of unremitting

instability. Could Ernesto Krausz's three children feel it from their apartment right in the middle of town, on the Via Roma, in a bedroom whose ceiling sparkled with gilt stars? Or across the way, at the best ice-cream parlor in the city, Zampolli, where children like them could choose from a hundred flavors? They had a governess from the Friuli region, the sister of their cousin Piero's governess; in summer, they went to the beach, to the mountains, or to Hungary to stay with their paternal grandmother. In Trieste, they would go to play with their cousins, Giulio Levi and Piero Kern, and visit their maternal grandparents. Once a week, the three little Krauszes would joyously burst into the house of their grandmother, Nonna Antonietta, and their great-aunt Zia Eugenia, whom they called Zia Cotognata, "Auntie Quincie," for she would never fail to produce for them from the cupboard the little squares of quince cheese she had made in the autumn. Every year, the entire Krausz family took the boat to Venice, stayed at the Hôtel des Bains, visited the Lido, went to see the altarpieces of Titian in Frari and San Marco.

In 1905, just when Silvia appeared, the city vibrated with international convulsions, among them the first Russian Revolution. May 1 saw a demonstration of several thousand workers and their sympathizers: the Società Operaia Triestina, who supported the ideas of both Garibaldi and the Irredentists, the Confederazione Operaia (more internationalist), the Lega Sociale Democratica which, along with Il Lavoratore, joined the Partito Socialista degli Italiani in Austria, not to mention the Freemasons whose Triestine lodges remained powerful. On the cultural front, 1905 also brought a penniless young Irish alcoholic to Trieste, where he settled, intending to earn his living as an English teacher. "He came in with his female companion. Wearing . . . a jacket and an old sweater, a shirt, squeezed into his vest, [that] fell in folds around a belt that was too big and from which hung wrinkled breeches; his head was cylindrical . . . and his eyes very blue, very pale, very clear; one lovely morning in 1906 he rang the bell at the Villa Veneziani and introduced himself: 'I am Joyce.' "[4] Thus began for James Joyce an exhausting and productive journey, which he described with characteristic wryness. "I am teaching English here at the Berlitz School. I've been here for sixteen months with the tricky task of living and meeting the needs of two other people who trust in me, on a salary of 80 pounds a year. I'm teaching English to young people as quickly as possible without wasting time on the elegance of the language, and in exchange I receive ten pence an hour for the work. I shouldn't fail to mention that one of my pupils is a Baroness."[5]

Two years later, Trieste joined the country in taking another important political step. In January, a new law, ratified by the emperor, extended suffrage to all male subjects of the Austro-Hungarian Empire, a move one journalist forebodingly called "a leap into the dark." The election of May 14, the first under universal suffrage, brought triumph for the Socialists: the Triestines sent four Socialist delegates to the Reichsrat in Vienna, including Valentino Pittoni and Giovanni Oliva, as well as a Slovenian, the lawyer Ottokar Rybar. But the *Nazionalsozialisti* bridled, accusing the Socialists of electoral fraud and condemning their internationalist tendencies and their *austriacantismo,*[6] which, it was claimed, represented the greatest threat to the Italian character of Trieste. As for the Irredentists and Garibaldi's supporters, increasingly threatened by newcomers from Slovenia, they sought to convert the masses to nationalism as the last resort to save the "Italianity" of Venezia-Giulia. Throughout the summer, ethnic tensions pitted Italians against Slovenes: on August 25, shouting *"Viva Trieste Slovenia!"* a group led a raucous march down the Via Carducci that caused numerous casualties and led to forty arrests. On September 1, fresh incidents between Slovenian nationalists and Italians brought about some twenty more. Tensions were lowered a bit when, less than a month later, on September 5, the *Tsukuba* and the *Kitose,* two Japanese navy ships, docked in Trieste, allowing the locals to marvel at the vessels for nearly a week and happily rub shoulders with five hundred Japanese on shore leave.

On Wednesday, September 4, 1907, the sun rose at 5:31 a.m. and set at 6:37 p.m. At 7:00 in the morning, the temperature reached 70° F; in the afternoon, it rose to 77° F. *Il Piccolo,* the local daily, announced the meeting between King Edward VII and Tsar Nicholas II in Finnish waters; the visit of the Italian arts minister at the Correr Museum in Venice; the attack, in the Louvre, on a painting by Ingres, by a young girl who slashed a canvas depicting the Sistine Chapel with a pair of scissors, and the consequent decision of undersecretary of fine arts Dujardin-Beaumetz aimed at preventing such acts of vandalism. During that week in Trieste there were 42 marriages, 7 stillborn births or abortions (of which 3 were illegitimate), 132 live births (68 boys, 64 girls, of whom 23 were illegitimate), 79 deaths (41 male, 38 female, of whom 27 were less than one year old, and 21 under twenty years of age). And that day Leo, the second child of the Krausz family, was born.

"Assassinons le clair de lune! [Down with the moonlight!]"[7] April 1909: the voice of Filippo Tommaso Marinetti, a young Italian artist born in Alexan-

dria, rang out. Having just founded the Futurist National Party in Paris, with aspirations both political and aesthetic aimed at fighting academicism, he decided that Trieste should be the location of the first Futurist happening. On January 12, 1910, at the Politeama Rossetti,[8] Marinetti delivered one of his most famous speeches, transforming Leo Castelli's native city into the definitive node of modernity. How could one ignore such a rich cultural context? "Instead of all our ancient Romans, instead of all the medieval inhabitants of Florence, before all our outdated Venetians, give us the people of Trieste," Marinetti exclaimed, "whose beautiful patriotic eagerness will soon, I hope, be the spark that ignites the bomb! . . . Trieste! You are our one and only time bomb! All our hopes rest with you! . . . In our blood, we fuel our overriding hatred of the Italians of the 20th century: the hatred of Austria! . . . We stand at the very edge of two centuries! . . . It is from Italy that we hurl into the world our manifesto of inflammatory, excessive violence that we use today to found Futurism, because we wish to free this country from the putrid gangrene of its professors, archaeologists, Classicists and antiques dealers!"[9]

The winter of 1910 is remembered as one of the harshest in the city's history. On March 31, 1911, the *bora scura* blew and hail fell, violently precipitated by hurricane-force winds. Railway service between Trieste and Parnezzo was suspended, but once the *bora* had died down, the 957 local, which had one baggage car and six carriages with a capacity of 180 passengers, was back in service by the afternoon . . . Between Zaule and Muggia, however, as it left Stramare, the train derailed on the Rio Ospo Bridge, a catastrophe leaving three dead and fifteen injured.[10] With this tumult as background in 1911, Giorgio Krausz was born, the last child of the Krauszes; then, his first cousin Giulio Levi-Castellini, the son of Marcella Castelli and Vittorio Levi-Castellini; finally, a few months later, came another cousin Piero Kern, the son of Ortensia Castelli and Max Kern. The three cousins of the same age were destined for a deep and turbulent friendship.

Ernesto Krausz's career would take him very far into the heart of the most important bank in Vienna. Along with the Boden Credit-Anstalt and the Rothschild Bank, the Credit-Anstalt of Vienna was one of three institutions forming the Rothschild Group. Theodor von Taussig was at the head of the Boden Credit-Anstalt and oversaw the Rothschild Bank with Baron Albert de Rothschild; directing the Viennese Credit-Anstalt was Julius Blum, known as Blum-Pacha, brother of Oscar Blum-Gentilomo, "the benefactor" of Ernesto Krausz in Trieste. Along with his other progressive moves, Ernst

von Körber had lent the lavish sum of 267 million crowns[11] to the Rothschild Group, allowing it to enjoy several "extremely favorable" years, right up until 1910.[12] But how should we view the tenure of Ernesto Krausz at the Viennese Credit-Anstalt, considering that, unlike the other Viennese bankers, he had pushed his way in through the back door? Despite his incontrovertible talents, despite his impressive professional career, despite his perfect sympathy with the values of the banking world, Krausz would never adequately compensate for a deficit of political insight, nor would he gain the purchase on current events so necessary in this field.

Krausz succeeded to the holy of holies in the most important bank in Vienna, but he was by no means to the countinghouse born. Being from rural Hungary, he had no direct link either to the correct "social milieu" or to the "dynasties of Viennese banking," among whom the profession was handed down from father to son. Absent such lucky birth, one might gain entry by marrying the daughter of a banker, or by being educated at the Theresianum, the prestigious school in Vienna that was the breeding ground of high officialdom. But Krausz had not benefited from the famous *Bildung,* that cultural sophistication gained through schooling and deployed by so many German Jews as the means par excellence of social integration. *Bildung,* which offered the hope of continual self-refinement, was for German Jews more than a vehicle for privileged social integration; it assumed the status of a new "religion."[13] Furthermore, as Bernard Michel points out, "agricultural Austria found itself completely cut off from capitalist and banking Austria,"[14] which makes Ernesto Krausz's progress from provincial Hungary all the more remarkable. Did he compensate for lack of formal education by becoming an avid reader of the *Neue Freie Presse,* the daily of the Viennese Jewish bourgeoisie, which, according to Stefan Zweig, was read "like a morning prayer" and venerated "as an oracle"?[15] Perhaps, but despite all his handicaps—Hungarian, self-educated, provincial—Krausz had a surprising aptitude that cleared his way into the banking class: he was an excellent equestrian! The expertise, acquired during his childhood when he needed to get around his family property, would serve him well at the Triestine Riding Club, the scene of his social integration.

But this is not to say he simply rode his way to success. Ultimately, Krausz belonged to that tiny minority of executives in the Viennese banking world who progressed through sheer will, hard work, and a natural ability to network, as our parlance would have it. These were qualities he shared with

Theodor von Taussig, the son of an industrial worker who became Director of the Boden Credit-Anstalt; Franz Donebauer, son of a restaurant owner at the Pardubice train station, who would become one of the principal shareholders of the Credit-Anstalt in Prague; and Angelo Vivante, a junior employee in the Credit-Anstalt in Trieste before becoming its director. Thanks to his perfect identification with an entirely new system of values, and to the miraculous Austrian economic growth of those remarkable years (in which the money supply doubled), Krausz's determination to succeed was rewarded. Nestled within an enclave in the far west of the immense Austro-Hungarian Empire, between Austria and Italy, during the first decade of the twentieth century, the port of Trieste benefited from linking the great wealth of the hinterland to the rest of the world, and under the "Körber Plan," Trieste, the empire's third-largest city (after Vienna and Prague), became the ideal nexus for complex financial operations.[16] Soon, the Viennese capital would take over the city: it was the end of the local Triestine banks, and Ernesto Krausz was one of the foot soldiers in this coup.

At the Viennese Credit-Anstalt, Ernesto Krausz was able to exercise his social skills and to learn his trade under the beneficent patronage of its director Oscar Blum-Gentilomo. Did personal tragedy inspire this professional "adoption" of Ernesto Krausz? On January 31, 1905, San Gentilomo, Blum-Gentilomo's only son, died unexpectedly at the age of twenty-one. It is plausible to imagine a transfer of affection to Ernesto Krausz, young, talented, worthy, and himself an orphan. In any event, Oscar Blum-Gentilomo, thirty-four years Krausz's senior, scion of a Viennese banking dynasty,[17] became so infatuated with the Krausz family that one day he would make a gift to young Leo, his protégé's son, of his own personal watch, accompanied with an affectionate note that read *"al mio caro leoncino."*[18] It was a present that Castelli would treasure his whole life, his own Rosebud, à la Charles Foster Kane.[19]

Blum-Gentilomo remained one of the three mainstays of Viennese finance in Trieste,[20] together with Fortunato Vivante, Count de Villabella, for the Union Bank, and Oscar Pollack for the Wiener Bankverein. Their financial backing of Trieste's trade and industry would bring them into contact with its "two hundred local families," often "millionaires many times over, thanks to the profits from international trade." Among these were the rare native Italians (the Parisis and the Richettis, for instance); the powerful Greek community with the Barons Giovanni and Demetrio Economo, and

Scaramanga d'Altomonte; the Germans, like the Brunners (Jews from the Rhineland settled in Trieste for two generations) and Italo Svevo, born Ettore Schmitz; and a few Italianized Slovenes, like the Cosuliches. Their collective wealth was reinvested in insurance, in industry (food, textiles, oil), and—to Krausz's good fortune—in banking.

The imposition of "Adriatic tariffs," which Krausz personally managed, caused an explosion of wealth for Viennese businesses in Trieste.[21] With its tax-free area, its warehouses, its silos, and its elaborate factories, the city saw its economy double in size in the first decades of the twentieth century.[22] Von Körber's grand scheme had paid off at least for Trieste, whose local government began to take on the trappings of an imperial ministry.[23] Beginning in 1904, the construction of the Franz Joseph Port and the development of the San Andrea pier and the Servola embankments solidified Trieste's advantage as "the first port of the Empire." Shipping revenues were bolstered by the development of new industries (a rice refinery, a burlap mill, a linoleum factory), both to the south, in the village of Servola, and to the north, in Monfalcone.[24]

The industrialization of the port deeply transformed the social fabric of the city: in ten years' time, the population almost doubled. The demographic future seemed to hold only more promise, with some predicting that in 1920 the population would reach half a million people, though for the Irredentists the projection was daunting as it foresaw only two hundred thousand Italians.[25] Indeed, the emerging modern proletariat, fed by the immigration of Slovenian workers among other ethnic groups, moved Governor Hohenlohe to predict that "Trieste, as the State's national port, would not belong to one single nationality, but rather become a kind of city of many cultures!"[26] Though Europe was as yet pro-multicultural, such a fractured society was bound to become fractious if not downright explosive. Did Ernesto Krausz even notice the anti-Slovenian riots of 1911, during which the demonstrators vandalized a branch of the Zivnobanka in the Via Nuova? The fault lines between Slovenian newcomers, the people of Trieste, and other Austro-Hungarians went largely unnoticed amid the boom times, not to surface until a few years later in the larger tremors that would affect the Krauszes along with all other families.[27]

Despite the unprecedented economic expansion, not everyone received von Körber's policy enthusiastically, and the city's upper-middle-class traders were among the discontented. As one would put it: "If Trieste's port trade

has certainly increased, business *within* Trieste has fallen off." And, though the gross tonnage passing through Trieste was hugely increased, the profits earned by the Triestine brokers (the shipping companies and traditional trading firms) had considerably declined, passing to their Viennese counterparts. Mistrust was rife among the local traders, often setting Triestines and Austro-Hungarians at odds. As for Ernesto Krausz, married to Bianca Castelli, he would undoubtedly have felt himself torn. Among the very companies that would find themselves impoverished (some to the point of bankruptcy) by the Adriatic tariffs that Ernesto Krausz had himself contributed to establishing was the coffee and sugar import firm Castelli e Castelli! Krausz might have made his way in Trieste by marrying well, but he would prove an agent of financial misfortune for the very family that took him in and helped him assimilate. What did they think of him?

In this precariously fraught environment, Leo Krausz would remain until the age of seven. What intimations of strife filtered through the shutters of the villa on the Via Buonarotti, where they now lived? How could a seven-year-old locate himself in such a disjointed family, with Italian pro-Garibaldi grandparents (the Castellis), a monarchist Austro-Hungarian father and an Irredentist uncle (Vittorio Levi-Castellini)? How could he negotiate the thousand complexities of his native city, which so many artists both native (Cergoly, Slataper, and Kosovel) and foreign (Joyce and Marinetti) persisted in attempting to capture? For the Krausz children, the summer of 1914 began with a celebration: Wednesday, June 24, was declared a holiday in homage to Archduke Franz Ferdinand, passing through Trieste on his way to Sarajevo. Four days later, *Il Piccolo* would carry the grim headline: *"S.A. l'Arciduca Francesco Ferdinando e la consorte duchessa di Hohenberg uccisi in un attentato a Seraievo"* [His Highness, the Archduke Franz Ferdinand and His Consort, the Duchess of Hohenberg assassinated in an attack at Sarejevo]. Four days after that, the city of Trieste was again mobilized by the *Luogotenenza* (the city administration) to honor the archduke: all the shops were ordered to close while the remains of the heir to the Austrian throne and his wife passed through again, their coffins transported by train from Sarajevo to Metkovic, by boat from Metkovic to Trieste, and finally, by train from Trieste to Vienna. The funeral offered the imperial subjects of Trieste the opportunity either to wax maudlin or to express their anxiety, depending on their political leanings. "Today, in the day's early hours," wrote the correspondent for the *Osservatore Triestino*, the city's Austrian daily newspaper, "the sky was overcast, then the

TRIESTE, JUNE 28, 1914
Funeral procession for Archduke Franz Ferdinand and his wife, assassinated in Sarajevo, before their burial in Vienna

clouds gave way to a hint of blue, producing a solemn and funereal air. In the city streets, drowned in grief, a crowd gathered, overcome with emotion, anxious to find a spot, wherever they could, from which to see the remains being taken off the ship or watch the funeral cortege pass by."[28] By contrast, the next day's edition of the local Irredentist daily, *Il Piccolo,* bore this headline: "The remains of the Archduke Franz Ferdinand and the Duchess of Hohenberg in Vienna. Concerns over the extent of Anti-Serbian rage in Bosnia and Croatia."

Thus concluded, for the Krausz family, those strange, miraculous, final imperial years in Trieste, within a world doomed to decline. According to writer Roberto Bazlen, it was a city in which each ethnic group had a meeting place of its own, "the Italians their Società Ginnastica, the Germans their Turnverein Eintracht, the Slovenians their Sokol adjoining the Narodni Don." But this was not enough to promote a shared sense of society: "They all capered about defending their respective political ideals, the city continued to grow wealthier, the oppressors continued to oppress, and the oppressed continued to feel their condition. And suddenly, 1914: at school, we earn a holiday to grieve; I pray the Good Lord that two Archdukes be assassinated every month."[29]

5. IN THE HIETZING BUBBLE, VIENNA, WORLD WAR I

In the vineyards of Baden . . . an old winegrower once told us: "We haven't had a summer like this one in a very long time. And, if it lasts, we'll have wine like never before! People will remember this summer!"[1]

STEFAN ZWEIG

ON JUNE 28, 1914, Arthur Schnitzler's journal reads: "Afternoon, Julius phoned us to say that Franz Ferdinand and his wife had been assassinated in Sarajevo . . . Beautiful summer's day; in the garden, Heini, Lili play with their little cars . . . After the initial shock, the assassination of Franz Ferdinand doesn't affect people much anymore. It is unbelievable how disliked he was."[2] Upon learning of the death of the archduke of Austria, on this glorious summer day of 1914, few imperial subjects were worried about the future. Whatever their level of political consciousness or involvement, the writers of the Austro-Hungarian Empire, from Vienna to Budapest and from Trieste to Sarajevo, comment on the event according to their degree of familiarity with the emperor's family and their affection towards them. "When the suicide of Crown Prince Rudolf was announced," noted Stefan Zweig, "the entire city of Vienna was overcome with emotion . . . Franz Ferdinand, on the other hand, lacked . . . personal kindness, charm and sociability. I had often observed him at the theater . . . he remained seated in his box . . . his eyes cold and staring, no one ever saw him smile . . . he had no feeling for music, no sense of humor whatsoever, and his wife had the same sour expression . . . In addition, it was well known that the Emperor held the Prince in polite contempt, because he couldn't tactfully hide his impatience to accede to the throne . . . On that day, there were many people in Austria who gave a secret sigh of relief, grateful that the heir of the old Emperor had been eliminated, making way for the young Archduke Charles, who was infinitely more well-loved."[3]

A month after the assassination of Franz Ferdinand, when Austro-Hungary declared war on Serbia, many, like the young Karl Zalesky, succumbed to the prevalent wishful thinking: " 'With the Serbs, it will all be over in 3 weeks!' people said then."[4] But, very quickly, between July 30 and August 4, the general mobilizations in Russia, in Austria-Hungary, in Germany, and in France, the declaration of war by Germany on France and then by Great Britain on Germany, left no doubt whatsoever about the gravity of the situation. From that point onwards, the political commentaries were of a completely different order, and the peoples of Europe soon intuited the vortex into which they had been drawn. "Newspaper sellers in the streets hawked special editions," noted the painter Oskar Kokoschka. "The world war had started. Soon you saw young farmers, their hats decorated with shiny ribbons, marching in columns along the Ringstrasse, carrying small wooden cases; farm horses, which should have still been harnessed to plows, pulled gun carriages and ambulances. Horses and their riders were thirsty, starving, covered in white dust from the main roads. From every direction, people flocked towards Vienna, speaking all the languages of the Empire. Military fanfare did what it could to ward off the silent anxiety, but several spectators were crying. Everyone felt, in his own way, that it was the beginning of the end."[5]

Some, like Schnitzler, voiced consternation over the tactics of the Triple Alliance. "Pontresina. Banks closed. No money with my letter of credit. Complete madness. Switzerland in a state of war," he noted on August 1. Four days later, he continued: "In the hotel, news of the declaration of war between England and Germany!—World War. World destruction. Horrible and alarming news . . . As for current events, we are living through a terrifying moment in world history. In a few days, the entire world has been shattered. It feels like a dream! Everyone is baffled."[6] Others, however, like Stefan Zweig, allowed themselves to be carried away by patriotic feeling: "In Vienna . . . people streamed into the streets, flags were suddenly raised everywhere, banners were waved, music could be heard; the young recruits marched forward triumphantly, their faces glowing, and people let out cries of joy as they passed by; those ordinary, unremarkable men whom no one normally noticed nor applauded . . . If I am truthful, I have to admit that there was something grandiose, contagious and even seductive in this initial rising up of the masses . . . which gave, for a moment, a wild and almost irresistible momentum to the greatest crime of our age . . . the people trusted

the authorities unconditionally; no one in Austria dared think that Emperor Franz Joseph, the father of the universally revered homeland, would have called his people into battle in his eighty-fourth year, unless it were absolutely vital."[7]

In Trieste, Leo Krausz, not yet seven years old, received the assassination of the archduke of Austria as a heaven-sent two-day hiatus from school, a chance to swim in the sea, even before the long summer vacation. For the Castellis and the Krauszes, who marked the time of family life in sync with the events of the Austro-Hungarian monarchy, opinions followed those of the Viennese writers. That summer, Silvia, Leo, and Giorgio left their villa on the Via Buonarotti to spend their customary month's vacation with their grandmother in Hungary with no idea what lay ahead: they would not see Trieste again for four years. In fact, after the declaration of war, along with the rest of the imperial bank's employees, Ernesto Krausz was brought back to the capital. In the final days of August 1914, he would settle with his family, first in a private boardinghouse, then in a beautiful villa in the Hietzing district, part of Vienna's "noble outskirts," above the Schönbrunn palace. Silvia was eight, Leo was seven, and Giorgio was two; they were cared for by the governess, Maria Pinter (Maria Sanoli Friuli), a native of Carinthia, who helped Bianca. "It was almost like living in the country," says Leo's brother, George Crane. "There were many parks, and right near our house, as soon as winter came, there was a hill covered in snow where we went sledding."[8]

Living in the outlying areas of Vienna—Hietzing, Döbling, Penzing, and Hütteldorf—became a trend during the final third of the nineteenth century, with the construction of the grand Ringstrasse around the old city. There, the upper-middle-class industrialists flaunted their privilege with imposing, elegant palaces, while many artists and intellectuals from the *Bildungsbürgertum,* the cultural elite (including the architect Otto Wagner, the composer Gustav Mahler, the painter Koloman Moser, and the writer Hermann Bahr), chose Hietzing in which to build their beautiful Jugendstil villas, living an illusion of countryside, far from the bustle of the center, without being cut off from the city. Southwest of central Vienna, behind the emperor's palace, Hietzing, with its magnificent parks and beautiful architectural wonders, became a sort of large village sheltering, within the city limits, a cultural bubble; from now on, the three Krausz children would stroll through the Schönbrunn grounds, some of the 1,441 rooms of the imperial residence, visit the Gloriette Pavilion (erected in 1775 to commemorate the wars of

Maria Theresa's Austria against Frederick II of Prussia), go to the Tiergarten (the oldest and most splendid zoo in Europe with its African ostriches, elephants, and families of orangutans), the Palmenhaus (the largest greenhouse in Europe with its hundred-year-old trees from tropical, equatorial, and temperate climates), the Technisches Museum (Museum of Science and Technology), constructed in 1908, with its interactive displays that fascinated the children. Every day, leaving the Elsslergasse where they lived, they would stroll down the Larochegasse, past the Villa Schopp and the Villa Primavesi; on the Wattmanngasse, they would pass the "gingerbread" house, becoming acquainted with all the beautiful dwellings of the district designed by Adolf Loos, Josef Hoffmann, and Otto Schönthal, winding their way through placid streets with names like Gloriettegasse, Opitzgasse, and Heimgasse.

In September 1914, Leo Krausz was enrolled in middle school, the Bezirk II Mittelschule in Hietzing. One of his classmates, a charming boy who looked like "a gentleman . . . with a romantic face and curly hair, a dreamer, musical, following every song, every piano piece, every beautiful woman,"[9] was the young Raimund von Hofmannsthal, son of the poet, who despite artistic talents and social skills showed almost no interest in his studies, much to the alarm of his mother.[10] Much later, in London, Paris, Hollywood, and New York, Raimund von Hofmannsthal would live flamboyantly, still careless of the future. As one friend described him, "with the charm of an upper-class Englishman, he is one of the last remaining figures of yesterday's world, a dreamer, a gentleman, who finds himself at the edge of a world in ruins."[11] It is not a trivial matter that the young Leo Krausz began his education among the privileged offspring of the Viennese *Bildungsbürgertum* sophisticates. How does a child of seven face the challenge of confronting his putative betters, the need to adapt under these conditions? Leo's account of this period is surprisingly detached: "When I started to go to school, my father, who was working in a branch of a large Viennese bank, was soon transferred to Vienna. At the time, so to speak, when Trieste found itself in the ideal position for a conflict between Italy and Austria. Of course, it was an uprooting, but all the same, I spoke rather good German, so I didn't feel completely out of place. I quickly fit in at school . . . and of course, living in Vienna was a rather exceptional experience, even for a child of that age."[12]

In autumn 1914, post–fin de siècle Vienna sparkled thanks to its world-renowned intellectuals, its Sezessionist artists (architects, painters, designers), its writers, its musicians, and its scientists (psychoanalysts, of course,

but also sociologists, historians, economists). Under the benevolent Habsburg rule some fifteen or twenty years earlier, these intellectuals, with the help of journalists, bankers, and other members of the sophisticated Jewish bourgeoisie, created one of the greatest cultural revivals that Europe had ever known. "My father was a cultured man," Leo Castelli would later remember. "His library contained several classics that, as a very busy man, he probably never read anymore. On the other hand, he did regularly buy the *Neue Freie Presse* of Vienna, a very cultural newspaper. It reflected what was happening in Vienna at the time, in painting and sculpture, which was, as is well known, exceptionally rich. I obviously did not understand the impact of all that when I was young, but I am still realizing its importance even today, through recent exhibitions."[13] As the exact contemporary of Stefan Zweig, Arnold Schönberg, Karl Kraus, Robert Musil, Hugo von Hofmannsthal, and Otto Bauer, Ernesto Krausz belonged to a generation that was but twenty years old at the turn of the century.

Little wonder that, walking through Vienna with his father, young Leo Krausz marveled at the manifold beauties of his new city: the bend of a formal little street in the Prater district; the grand avenue of Graben; the imposing bourgeois houses of the Ringstrasse; the majestic Schönbrunn gardens; the monuments raised to the memory of Goethe, Brahms, Schubert, Bruckner; the banks of the Danube. It is easy to imagine that in the entrances to the Wiener Stadtbahn (the Viennese streetcar system constructed by Otto Wagner), or in the white and gold manifesto emblazoned on the Sezession Building *Der Zeit ihre Kunst, der Kunst ihre Freiheit* ("To each age its own art, to Art its own freedom"), he would have apprehended the resolute signs of an artistic age making its breach with historicism. To the young boy, the air thick with the names of Freud, Schnitzler, Schönberg, Kokoschka, Klimt, Moser, Hoffmann, among so many others, virtually buzzed with cultural energies.

Of course, life went on as usual at the Staatsoper, the Burgtheater, the Albertina, the Kunsthistorisches Museum, the Urania observatory, and even at the Krone circus itself, where, in consideration of the war, admission was discounted.

> *Krone Circus! Weltbrand! The world on fire! Monde en feu!*
> Grand equestrian patriotic spectacle in 5 acts
> In the Prater, with 500 performers and 100 horses
> Act 1: The Grand Prince

Act 2: At Namur
Act 3: In Galicia
Act 4: The Holy War
Act 5: The Great Victory
To allow the greatest number of people to enjoy our
country's greatest patriotic display, the management has decided
that tickets will be sold at a lower price, a wartime price![14]

On March 25, 1916, Schnitzler attended a children's matinee performance of *Snow White* at the Volksoper, with his daughter Lili, who was the same age as Leo Krausz. "Patriotic kitsch," he wrote scathingly, while remarking the child's precocious reaction. "This is the first time that Lili has been to the theater, but she is already very critical. At a certain point, when a new regiment came onstage and everyone applauded, she said, 'Oh, I'm not applauding for that!' "[15] If many years later the three Krausz children would remember their stay in the empire's capital for some deprivations (George Crane in San Francisco, November 2005: "I still recall the straw we found in the bread we ate!")[16] and perhaps a loss of connection with their roots, life in Vienna would nevertheless remain for all a profoundly stimulating formative experience. In 1995, at lunch with Paul Reitter, Silvia's grandson, who told him he intended to write a thesis on Viennese literature in the first two decades of the twentieth century, Leo (normally so reticent about his past) suffered an unexpected rush of particularly indelible fond memories that he confided to his great-nephew. Back to 1916: young Leo Krausz is learning, hearing all kinds of poems that he would remember for his whole life.

Ich hatt' einen Kameraden,
einen bessern find'st du nicht.
Die Trommel schlug zum Streite,
er ging an meiner Seite
im gleichen Schritt und Tritt.

Eine Kugel kam geflogen,
gilt's mir oder gilt es dir?
Ihn hat es weggerissen,
Er liegt mir vor den Füßen,
als wär's ein Stück von mir.

Will mir die Hand noch reichen,
Derweil ich eben lad:
Kann dir die Hand nicht geben,
Bleib du in ew'gen Leben
Mein guter Kamerad![17]

At school, in nursery rhymes, in songs and slogans—"Für Gott, Kaiser und Vaterland!"—young Viennese participated, unknowingly, in the war ministry's mobilization of the "children of Austria."[18] They received the *Kriegsbildung* (education about the war) officially conceived for the *Kriegskinder* (children of the war) by the Austrian government, which considered them "primed" to receive a certain "idea of the Austrian State." This view perfectly aligned with the emperor-patriarch's: in 1908, to commemorate sixty years on the throne, he began his speech with these words: "*Alles für das Kind!*" ("Everything is for the children") and created the "k.k. österreichischer Jugend-Reichsbund," the Imperial Association of Austrian Youth. So great was his mindfulness of the young, in fact, that in a poem distributed to the children of the empire on the eve of war, the emperor stated: "It is to you, children of Austria, the jewels of all my subjects, / To you on whom I confer, a thousand times over, the blessing of the future.[19]

The cult of the emperor was part of Austrian education, and the young Krausz children, of course, partook of the mystical aura when they were officially received at the Schönbrunn palace, in a customary ceremony vividly recounted by Stefan Zweig: "I had seen the elderly Emperor innumerable times in the legendary splendor of magnificent festivities; I had seen him on the grand staircase of Schönbrunn, surrounded by his family and the dazzling uniforms of the Generals, when he received the homage of eighty thousand Viennese schoolchildren who stood in rows on the vast green meadow singing, with their reedy voices, a touching chorus of Haydn's 'God protect our Emperor.' "[20] Austrian children were thus bred to become consummate citizens of what they were given to believe was a mighty state. And the war propaganda was not above co-opting certain of the state's children as symbols. After the assassination of Franz Ferdinand and his wife, the popular press portrayed their three children, Sofia, Max, and Ernst, as the face of the Austrian tragedy, and their effusions about the three orphans were both mawkish and inflammatory: "These three children, whose parents suffered the horrible destiny of dying on the altar of the fatherland, belong to all of Austria . . . The love of Austria will protect them."[21] In the same way, in Sep-

tember 1914, when Rosa Zenoch, a young Polish girl of twelve, was hit by a Russian shell while bringing water to the soldiers on the battlefield, necessitating the amputation of one of her legs, all the newspapers would declare her one of the first heroines of war, with many photos of the emperor at her hospital bedside in Vienna.

From the beginning of the winter of 1914, with the first reports of Franco-British defeats and heavy Austro-Hungarian casualties, an imperial order came down to all the schools: to pray for the souls of the fallen and for "total victory," since, according to Franz Joseph, "God listens to the innocent" and the prayers of the children would be the empire's ultimate shield. Over time, the publication of books, letters, and children's poems about the war became an industry, reflected in nursery rhymes such as:

> *Peter, du blöder, mit deinen zwei Buben*
> *Wir machen von euch saure Rüben!*
>
> *Heil Wien! Heil Berlin!*
> *In 14 Tage*
> *In Petersburg drinn!*[22]

Soon the Minister of the Interior produced the game *Wir spielen Weltkrieg!* (Let's Play World War!), a "topical present for our little ones." And so the Viennese boys dressed up as soldiers, the girls as nurses, and they were photographed in their costumes. Under the Kriegsspiel, the State marketed board games and puzzles "rich in historic and geographical context" that praised battles and helped children learn the empire's natural boundaries. How did the young Krauszes experience these efforts, as the children of a man who was an avid reader of the *Neue Freie Presse* and a staunch patriot? In their privileged neighborhood, would they have been aware of the propaganda scrawled on the city's walls? The world was calmer in their garden on the Elsslergasse, as Giorgio and his cousin Piero competed at tennis, as Leo tried to teach the others what he had learned of wrestling.[23] Even the outcry against Italians in May 1915, as Italy went to war against the Austrians on the side of the Allies, might have been muted there. "Once the Italians leave the Triple Alliance . . . they are considered no more than *Katzelmacher*,"[24] recalled the young Karl Zalesky. Stefan Zweig notes that the news "aroused . . . a surge of hatred. Everything Italian was reviled."[25]

Actually, whatever one's age, there was no eluding the propaganda in a

city where, despite the concerts, the plays, the literary conferences, updates and exhortations proliferated on posters and in the newspapers.

> War bags! One *Heller* for a bag! Women and other buyers,
> Going to the market, ask for your 'war bag,'
> Your money will go the the *Schwarz-gelben Kreuz*!

> Donate your old shoes
> They will be repaired and given to the poor of Vienna
> By our committee!

> Austrians, think of your fleet!
> It courageously protects the Adriatic Sea,
> If it had been stronger, the English and the French never
> Would have been able to transport
> Hundreds of thousands of colonial troops to Europe.
> If God grants us victory,
> The fleet will be of an importance even more decisive
> To the well-being of our country!
> Ask for our information pamphlet![26]

—Association of the Austrian Fleet

"There were photos everywhere of Emperor Franz Joseph and his allies, the Emperor of Germany, the King of Italy, and the Sultan of Turkey; everywhere along the largest squares, on trestle tables, plates picturing the Emperor warmly shaking someone's hand were on display,"[27] recounted the young Margarethe Riedl. And then, just as 1914 was drawing to a close, after Belgrade was taken by the Austro-Hungarians (on December 2) and then retaken by the Serbs (on December 15), the great government war bond drives began. Martial slogans and imagery would be ubiquitous on the walls of Vienna for the next four years. "Victory is ours!" the Bankhaus Schelhammer & Schattera proclaimed, for example. "Join the third series of war bonds, the financial triumph is the best guarantor of our weapons. Germany has recently amassed 12 billion crowns and we mustn't be outdone."

"Since the state needed money, they started issuing government bonds," recalled Karl Zalesky of his wartime childhood. "My parents gave their hard-

earned money to the state and what they got in exchange was a piece of worthless paper. The state was also after our gold, and our rings and necklaces were exchanged for rings made of iron on which the words *Gold gab ich für Eisen* were engraved . . ."[28] *Gold gab ich für Eisen!* "I exchanged my gold for iron!" With such aggressive and misleading appeals for the last pennies of ordinary folk in the name of cartoonish patriotism, the Austro-Hungarian government was able to finance cannons, bombs, and tanks with the wealth of the very families whose most precious treasure, its sons, would be lost in the horrific slaughter. Margarethe Riedl, then a girl of ten, would later reflect on the war propaganda: "So we gave our gold in exchange for iron. We exchanged our metal and pewter plates for porcelain and earthenware dishes on which we could read 'Through war! To victory!' and we were all convinced that the plates had it right."[29]

The most energetic, the most implacable critic of this frantic patriotism, of this façade of heroism, of this ridiculous frenzied drive towards the illusion called "victory," as well as the bad taste of simple "martial kitsch," was surely the writer Karl Kraus. In his magazine *Die Fackel,* he wrote of "a time when pens are dipped in blood and swords in ink,"[30] tirelessly denounced the intolerable games of all the culprits, starting with poets who, like Hugo von Hofmannsthal, Richard Dehmel, or Hermann Bahr, composed odes under the waving flags or wrote patriotic articles in the *Neue Freie Presse.* "How are our poets and great thinkers doing? . . . By involving themselves in journalism, the poets are enlisting in the war as volunteers. Look at this Hauptmann, look at these gentlemen, Dehmel and Hofmannsthal, who crave a decoration in the first lines, and the dilettantes who fly into a rage following their lead."[31] Later on, in his masterly play, *Die letzten Tage der Menschheit,* Kraus targets with scathing irony the astounding fruits of such propaganda. In one scene, he presents a war-zealot schoolteacher, Zehetbauer, before his class. "Zehetbauer: 'And so you must act by asking your good parents or guardians to give you, for your birthday, that very wonderful game designed for children: 'Let's play world war,' or even, since Christmas will soon be here, 'Death to the Russians' . . . I cannot stress it enough: hold strong, make your little contribution, beat the drum for war bonds, collect metal; gather up the gold that sits useless in your dressers!' "[32]

Not all artists, however, were glad to be conscripted, literally or metaphorically. The painter Egon Schiele, for one, balked at the notion that he owed any duty to imperial self-congratulation. "Everyone wishes the war to

end, whatever the outcome," he wrote at the time. "As for me, I couldn't care less where I live, that is, which nation I belong to. In any case, I am more tempted by the other side, by our enemies, as their countries are far more interesting than ours; they have true freedom and thinking men, far more than in our country. What can be said about the war today? Only that every extra hour is a waste."[33] Such dissent notwithstanding, by October 1915 the empire was proposing to tap even its children for money. Spurred on by the slogan: *"Konnt ich auch nicht Waffen tragen / Half ich doch die Feinde schlagen,"*[34] a loan was demanded of each, representing the first financial transaction in the lives of Austrian schoolchildren, who also gathered together their *Liebesgaben* (love tokens) to send to the front along with knitted socks and scarves for the soldiers.

In 1915 and 1916, while Austria-Hungary was launching its offensive in Trent, and despite the German occupation of Warsaw, the war's most notable event to date for all Austro-Hungarians was surely the death of Emperor Franz Joseph. As with all the milestones of imperial life, it was met with indifference, patriotism, or emotion, depending on the subject's age and political inclinations. Arthur Schnitzler wrote: "22/11/16. In the newspapers, we learn of the death of the Emperor at 9 o'clock last night . . . out of curiosity went with O. into the city, a few black flags, photos being sold on the Graben, black or dark-colored clothing in shop windows; atmosphere is hardly affected and certainly not one of shock, which would have been the case in peacetime, in spite of his old age. Today, no event has any true effect; not victory, not defeat, not the death of the Emperor."[35] By contrast, Stefan Zweig's Austrian colors did not run: "I had seen him at Court Balls, I had seen him in brocaded uniform at the Paré Theater, and again at Ischl, leaving for the hunt, wearing the green hat of the Styrians . . . and, one damp, misty day, right in the middle of war, I saw the catafalque as, in the middle of the war, the old man was lowered into the crypt of the Capucins for his final rest. 'The Emperor,' *this word* combined all power, all wealth; he had been the symbol of the permanence of Austria, and, from childhood onwards, we had learned to speak his name with veneration."[36] As for little Margarethe, the same age as Leo Krausz, she gives us the event through the eyes of a child, however precocious: "Our Emperor died on November 21 at the age of 86; that day is unforgettable for every Austrian; there were black flags everywhere in the streets, and we were convinced that not only the Emperor had died, but that the old Austria had died as well. Unfortunately, I only saw the

pictures at the cinema, but I was deeply affected by the funeral cortège pulled along by eight horses, and by the huge number of mourners that followed it; from the moment when the old Emperor was buried in his grave, our luck in the war began to fade."[37]

With the British naval blockade, Germany and Austria-Hungary found themselves caught in a stranglehold, and Vienna became the most afflicted of all the wartime capitals. The city was cut off from Hungary, the agricultural breadbasket of Austria, and to make matters worse, that winter was the harshest in a generation. Indelible memories formed of this stricken city, of interminable lines in front of shops, of the distribution of ration cards, of bread made without wheat, and even of the slaughter of the famous Lipizzaner stallions. "In the forest, we found mushrooms and berries, we ate anything we could bear to," recalled Karl Zalesky, nine years old at the time. "Of course, the general situation of food supplies improved a bit when people began killing the horses on the stud farms; I felt so sorry for those poor horses; some of them were magnificent; throughout the entire war, those horses had served the people and now they ended up at the butcher's!"[38] "Normally, I would go and line up in front of the butcher's the night before they opened," remembered Karl Sellner, then fourteen. "But by the time it was my turn, there was nothing left, and the amount of food we were allowed under rationing wasn't enough to satisfy our hunger anyway. In the autumn of 1918, we had no shoes, no underwear, no soap, everything was some substitute for shoes, clothing, underwear; it was the lowest point we had ever hit, so the soldiers began to desert, they'd had enough of this war with no respect for human life."[39]

Margaretha Witeschnik-Erlbacher couldn't stand the *"Kukuruzbrot* (corn bread) that crumbles because it is too dry, which only a mouthful of ersatz coffee, made from chicory root, could help wash down . . . Towards the end," she added, "the Viennese took saws and axes and went into the Wienerwald forest to cut down trees to bring back home. The Wienerwald that we so cherished in our songs became the victim of poor, miserable folk suffering from the cold. Soon the people of Vienna began singing songs about it, like *'Du Lieber, du heiliger Wienerwald, man sieht es dir an, den Wienern war kalt.' "*[40] What of the Krausz children in their beautiful Hietzing villa? Did they too lament the Wienerwald in song, like the rest of Vienna's children that cold winter? Did they utter the sad shibboleth *'Gold gab ich für Eisen!'* mindful of their father's purchase of war bonds? We know for sure

that they were not spared the ration cards and corn bread. "That last winter was freezing," recalls George Crane, "and since we had to go for a walk every day with our governess, we often came home with chilblains, and it was even worse since towards the end of the war we had no heating."[41] They were (almost) in the same boat as the other children of Vienna, except for Christmas Day 1917, when Ernesto Krausz, who had been sent to Trieste on business, came back with two kilos of oranges for everyone: a real treat![42]

The following year, the final news of the war reached them: in the autumn of 1918, the English defeated the Turks, the Italians invaded Trent, Udine, and Trieste before defeating the Austrians in the Battle of Vittorio Veneto; revolutionary movements broke out all over Europe, and on October 4, Germany sued for peace, followed in short order by Turkey and Austria-Hungary. In the stricken capital of Vienna, the Habsburg dynasty stepped down as various nations, starting with Hungary, declared their independence, and the Austro-Hungarian Empire witnessed the end of its years of splendor. It was, according to Stefan Zweig, a farewell to "that Austria which, on the map of Europe, was now nothing more than a twilight glow, a grey, vague, lifeless shadow of the former imperial monarchy. The Czechs, Poles, Italians, Slovenes had seized their territory; what remained was a mutilated trunk, bleeding from every vein . . . in the capital were two million beings, starving and shivering with cold . . . there was no more flour, no more bread, no more coal, no more fuel."[43]

In the face of massive destruction, with ten million soldiers dead and twenty-one million wounded, amid the unprecedented hardships of inflation and rationing, Europe would not soon forget the horrific cost of those four years of war. Politically, four empires—the German, the Austro-Hungarian, the Russian, and the Turkish—disappeared from the map. For the Krausz family, however, the most significant development was that Trieste would henceforth be part of Italy. They would leave the fallen empire to return to their native city, now in enemy hands. A few doors away, in 1918, Egon Schiele moved back to his studio in Hietzing and resumed his life as an artist; after a long period of ostracism, he began to win recognition: the Sezession, which was celebrating its twentieth anniversary, offered him the curatorship of its forty-ninth show, with his work to appear in a central room, the place of honor. Mourning his master, Gustav Klimt, who had just died, but forming a symbiosis with the members of the Blaue Reiter of Munich, Schiele dreamt of creating a *Kunsthalle* that would take over where

20 ELSSLERGASSE, VIENNA
In the outskirts of Hietzing, the first-floor apartment of the Krausz family during World War I

the politicians had failed to support art, "so that painters, sculptors, archi-
tects, musicians and poets are given the chance to relate to the public, in
order to combat the cultural disintegration that is brewing."[44] His discordant
vision had ultimately triumphed after years under attack. On October 28,
1918, however, the Spanish flu epidemic claimed his pregnant wife, Edith,
and three days later he succumbed to it as well, an end highly symbolic of
Vienna's denouement.

"The years spent in Vienna were *peaceful*," Leo would remember, "until
the so-called 'liberation of Trieste from the yoke of Austro-Hungary.'" It is a
strange detachment or indifference that he expresses, given the reality. Did
Leo really experience the city of Vienna at war, and then in revolution, or did
he pass it in protective enchantment, cloistered in Hietzing, Vienna, the *Welt-
stadt*, in which the Habsburg *Juden* had forged a proud cosmopolitan identity?
Let us listen once more to a conversation he had with Robert Pincus-Witten:
"In Vienna, where the value system of the city of Trieste, where I grew up,
was being put in place, the most bourgeois Jews always felt a sort of ambiva-
lence: they felt both assimilated and rejected at the same time . . . as for me,

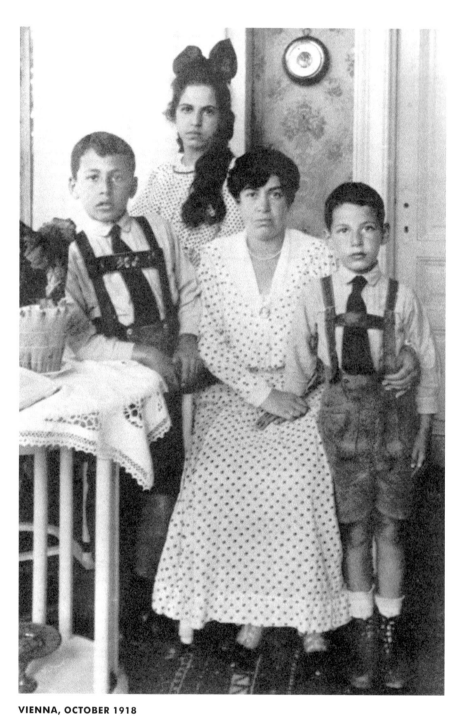

VIENNA, OCTOBER 1918
Final family portrait before the return to Trieste. FROM LEFT TO RIGHT: Leo, Silvia, Bianca, and Giorgio Krausz

I was a dyed-in-the-wool assimilationist, and if I was a traditional agnostic rationalist, then it was, I have to admit it, for social reasons."[45] But might the very paroxysms of the crumbling Austro-Hungarian empire (to which he had imagined himself immune) have helped to shape the future Leo Castelli? Was his ease as the archetypal *Luftmensch*—a dreamer, out of touch with reality—in fact concealing the complexity of his own situation?

In the turbulent context of prewar Vienna, some artists, like Kokoschka and Schönberg, had already prophetically expressed their discord; writers, like Schnitzler and Kraus, had anticipated the unease that was to surround them by developing the idea of the self as the ultimate refuge. At the end of his novel *Der Weg ins Freie,* Arthur Schnitzler gives us perhaps a key to understanding the effect that life in the imperial capital had on our hero: "The question is always one of knowing how deeply into ourselves we look," explains Heinrich to Georg von Wergenthin, a character incapable of action, paralyzed by the chaos that reigns all around him. "And when on every floor the lights are lit, we are simultaneously guilty and innocent, cowards and heroes, madmen and sages."[46] Could Georg von Wergenthin be, in fact, an imaginative doppelgänger of Leo Krausz?

Elsslergasse, October 20, 1918. A final family photo before the return to Trieste. Adorned with a gigantic ribbon, Silvia stands, her gaze floating absently past the camera. Bianca Krausz, with a dour face, all pearls and cameos, surrounded by her children, sits royally, clutching little Giorgio, one arm around his waist and the other trapping his hand. Was it a maternal suggestion that Silvia wear a black-and-white polka dot dress that day, identical to her mother's? And were the two little boys forced to wear the traditional Tyrolean costume—lederhosen, tie, and white shirt—in anticipation of the journey? But while Giorgio, stiff in his ankle boots, yielding to his mother, poses nicely, like a model child, Leo remains deliberately remote from the scene: lips slightly parted, elbows leaning on a lace place mat on the table; slightly off to the left, he is already setting himself apart. No smile, no game pose, not the slightest attempt to feign photogenic joy. As they left the large yellow villa, and with it the crumbled empire, one cannot help but wonder what memories, what images, what questions the Krausz children took away from their four years in Vienna—why the resigned sadness in Silvia's pose? Why the solitary light in Leo's eyes?

VIENNA

Michaelertrakt, Hofburg Palace, the Habsburgs' imperial residence, such as the Krausz children would experience during their Viennese days. Soon, with the dismantling of the empire, the palace would lose part of its splendor.

6. A FAKE MOUSTACHE FOR THE EMPEROR

The Austrian officials are leaving . . . A reddish glow suddenly lights up the sky warning us that the Austrians who are making a hasty retreat are blowing up their munitions. Then, for two days, Trieste belongs to no one.[1]

ANNA FANO

AUTUMN 1918. THE war is over. The Krausz family returns to their house on the Via Buonarotti in Trieste. It is the same house, it is the same city, but it is no longer the same country. Every day, vestiges of the Austro-Hungarian Empire are wiped away. Silvia, Leo, and Giorgio Krausz, along with the rest of Trieste, are witness to a strange flurry of symbols: the streets are renamed, the statues moved. Via Vienna becomes Via Filzi, Piazza Lipsia is now Piazza Vittorio Veneto; the Fountain of Neptune in the Piazza della Borsa is dismantled, the monument in the Piazza Libertà that claims the city for Austria is transported to San Giusto; the statues of Empress Sissi and Archduke Maximilian are moved into the grounds of the Castello di Miramare; and soon, the Austrian crown is replaced by the Italian lira.

"Last week of the war," Anna Fano wrote. "After Bulgaria, it was Turkey's turn to ask for an armistice . . . News is getting through, muddled, but getting through. You can sense something in the air has changed. On the evening of October 29, 1918, shouts and songs call me to the window. Students are singing at the top of their lungs: 'In Rossetti's homeland / only Italian is spoken!' Emotional for me and for everyone. We sense that it's all over. That Austria is on its knees. On October 30, the city is gradually decked out with Italian flags, right in front of the Austrian guards. But the order has already been given: leave the city. I find myself on the Piazza Grande at the very moment when they raise the Italian flag at the Town Hall. It is one of those rare moments in my life when I have the impression of participating in col-

20 VIA MICHELANGELO, TRIESTE
The Krausz family's first villa

lective enthusiasm, that I am a living part of a multitude. With a feeling of freedom and joy, I sing along with the others: '*Viva Trieste italiana!*' Impatient, the people of Trieste continually search the horizon, waiting for the ships to arrive . . .

"November 2. The drone of engines forces me to raise my eyes. Italian planes are dropping leaflets warning of the landing tomorrow. A pilot contravenes his orders and lands. The crowd lifts him up in triumph. On the Piazza Grande, people are celebrating the Italian landing . . . General Petitti de Roreto declares: 'In the name of the King of Italy, I take possession of the city of Trieste!' The feeling I am left with of those days is like a joyful fever. Moving from an abundance of the darkest despair, through illness to recovery. The shops are all lit up and full of things to buy, people are happy and cheerful, kissing one another in passing. Soldiers parade down the streets; the Italian officials watch them, along with us, full of emotion. After a while, you can hear the strains of a song: 'The young women of Trieste / all sing passionately / O Italy, o my dear Italy, you have come to free us!' For us, the

war is truly over. It cost ten million lives and more than twenty million wounded."[2]

For the first state holiday, on Sunday, June 1, 1919, all the Italian flags were again raised in the streets. The Duke d'Aosta, accompanied by General Petitti di Roreto, reviewed the Italian troops assembled in front of the bay. Then, on horseback, they led an impressive march through the city streets, while a squadron of planes performed aerobatics above the Piazza Grande. On Sunday, March 20, 1921, the city of Trieste, with daunting majesty, celebrated the official annexation of Venezia Giulia to the Kingdom of Italy. The Piazza Grande was full to bursting; the crowd huddled in every corner, clambered over the statues, hung on to the fountains, and scaled the roofs of the palaces, tricolors waving everywhere. In the bay, ships were hoisting multicolored ensigns. Among those assembled in the piazza, some were in dark uniform, some in white with epaulettes and full decoration, with ostrich-plumed shakos, some in top hats and morning coats. The generals, admirals, ministers, and other dignitaries, the mayors of Turin, Naples, Venice, Bologna, and Florence, and almost every government official on the peninsula came to celebrate the occasion and to parade through the streets— everyone except the king, who, unable to attend, sent his fervent good wishes. At the official ceremony in the cathedral and at the gala performance in the Verdi Theater the presence of Ministers Ranieri and Soleri, de Berenini, the vice president of the House, and General Petitti di Roreto filled the population with pride, and many felt that from this moment on, Trieste would be among the foremost of the great cities of the peninsula.[3] The city was turning back to Italy, and from now on, it would take nearly twenty hours, instead of ten, to get to Vienna by train—a strange notion of progress! While the Italians rejoiced, the Austrians lamented: "Never has the feeling of losing a war felt as sad as today. After this event, for us, the Great War has also lost all meaning,"[4] the *Neue Freie Presse* commented.

In 1918, at the age of forty-two, Ernesto Krausz became one of Trieste's leading citizens, serving in the powerful role of director of the Banca Commerciale Triestina; with working capital of eight million lire, the bank functioned as a clearinghouse and financial resource in the collaboration of the large industrialists and bankers. Ernesto Krausz became an imaginative entrepreneur, and deciphered social protocols to expand his influence. He sat on nineteen boards of directors—including the Prima Filatura Fiumana di Riso e Fabbrica d'Amido, the Riunione Adriatica di Sicurtà, the Soc. An.

Commerciale Industriale e Finanziaria, the Soc. An. Forestale Triestina[5]—pursuing professional advantage so zealously that today we might call him a workaholic. He was hyperactive at leisure, too. Every Sunday, he went horseback riding with Baron Economo, just as he used to in Hungary on the grounds of the family estate. He adored music and went frequently to concerts and the opera; although self-taught, he had a good ear and a strong musical understanding. He kept company with his neighbor, Alberto Frankfurter, the director general of Lloyd Austriaco, one of the largest shipping companies in the world. Lloyd Austriaco had a fleet numbering about a hundred, which had made Trieste famous throughout the Mediterranean and the Black Sea, and even in India, China, and Japan.

Nevertheless, manifold were the problems that Ernesto Krausz had to confront, and the social distinctions he struggled with were perceived, though obscurely, by his children. "Socially, there was a great difference between our family and our Castelli cousins," recalls George Crane. "They weren't poor, but, socially, they had nothing to do with us. Apart from our Aunt Lea, our side of the Castelli family never came to see us: not my Uncle Guido, my mother's brother, whose wife, Zia Amelia, was from a different social background and had ridiculous common manners, and not my mother's parents, who had difficulty in getting around because my grandfather was blind. The families who we invited around were the Lekners, the Contis (the sister of Mrs. Lekner), and my father's clients who were visiting Trieste, for example, a banker from Zagreb or Vienna. My father, who was really a nobody when he arrived in Trieste, succeeded in creating a fine career for himself at the bank and won a place amongst the city's elite, something that became more and more important to him. In professional matters, he was on good terms with all the luminaries of the world of business, industry, and shipping. But when it came to being accepted by them socially, well that was another story! I can't remember my parents ever being invited into aristocratic circles, or to the homes of the elite socialites, like the Brunners or the Economos: there was clear discrimination. It definitely happened because of my mother's personality, because she was poorly educated, conventional, and prone to depression; she played bridge several times a week but didn't like sports and didn't feel comfortable except within the family circle."[6] Given a particularly fluid social, cultural, and political situation, Ernesto Krausz decided that his children should be enrolled at the large public secondary school of the Kingdom of Italy rather than a private Austrian school, which the previous generation of Castellis had attended.

On January 2, 1919, Professor Baccio Ziliotto, director of the Ginnasio Superiore Communale Dante Alighieri, organized the reopening of the institution.[7] In the presence of General Petitti, Deputy Mayor Doria, and numerous former students wearing the uniform of the Royal Italian Army, he gave a solemn speech before unveiling a bust of Dante, with an the inscription on the base in "solemn Italian": "GENIO TUTELARE VOLLERO QUI GLI ALUNNI IL SOMMO VATE D'ITALIA."[8] In his address, General Petitti exhorted the students to love their majestic homeland and stand ready to fight for its peace and grandeur. In men like Marino de Szombathely, Gianni Stuparich, and Aldo Morpurgo, the students of the Liceo Dante had teachers of quality. Szombathely taught Italian, Latin, and Greek, as well as German and philosophy, and had published studies of Triestine dialect and Greek poetry. Gianni Stuparich, brother of the poet Carlo Stuparich, who was killed during the war, dedicated himself to the memory of his brother, teaching his poems in his literature courses. Others who were trained in Vienna or Graz, though overqualified, taught in the secondary school because there was no university to hire them in Trieste. Leo Krausz was twelve when he started his second year of high school. He was an intelligent boy, sensitive, amusing, and proper in short trousers and a shirt with a sailor collar.

"Last name: Krausz; First name: Leo; Date of birth: September 4, 1907; Place of birth: Trieste; Nationality: [left blank]; Religion: Israelite; Native language: Ital.; Father's name: Ernesto; Father's profession: Direct. of Bank."[9] Such are the laconic particulars surviving in his school records, together with his grades for each term, with no further comment except a note on his "conduct," which was "good." In fact, at Dante, as it was called, Leo Krausz was rather an average student, inconsistent from year to year, not unpredictably given the combined effects of adolescence, family tribulations, and political upheavals, including the Castellis' dislocation. Still thanks to his education in Vienna, his Austro-Hungarian heritage, and his father's relations, who spoke only German, he would always be at the top of the class in German, though his favorite subjects seemed to be history, geography, and physical education. As for Italian, Latin, and especially math, he seemed less engaged, his grades usually five or six out of ten.

Leo did not like secondary school. "It gave me a certain educational grounding," he recalled, "but I was unbelievably bored. So I read under the desk during class, and I only read books that interested me, I never studied what was on the syllabus. Needless to say, my results were mediocre." In 1923, in his fifth year (at age fifteen), Leo's grades fell dramatically—in math,

No. 12, 404

Cognome e nome _Kraush Leo_
Paternità _Ernesto_
Nome della madre
Data di nascita _4 settembre 1907_
Luogo di nascita _Trieste_
Cittadinanza _____ Nazionalità _it._
Confessione _israel._
Abitazione _V. Ginnastica 51_

ISTITUTO DI PROVENIENZA

Scuola
R ~~Ginnasio~~ Liceo _Dante Alighieri_
_____ Classe _V a_

INSCRITTO IN SEGUITO A

promozione - ~~ripetizione~~ ~~trasferimento~~ ~~esame di~~
ammissione - ~~idoneità sostenuto presso~~

SCRUTINIO | ESAMI

	I BIMESTRE	II BIMESTRE	III BIMESTRE	IV BIMESTRE	Risultato dello scrutinio	ESTATE	AUTUNNO
CONDOTTA	otto	otto	otto	otto		/	
Italiano	otto/otto	otto/otto	sette/otto	otto		sette	
Latino	sette/sei	sette/otto	sette/sei	sette		sette	
Greco	sette/sei	otto/sette	otto/sei	otto		otto	
Storia e Geografia .	sette	sette	7 otto	otto		sette	
Filos. ed Econ. pol. .	sette/otto	nove/otto	otto	otto		sette	
Matematica e Fisica .	sei/sei	cinque/sette	quattro/sei	sei		otto	
Sc. nat. Chim. e Geogr.	sette	sei	sette	sei		otto	
Storia dell' Arte . . .	sei	dieci	nove	otto		otto	
Francese o Tedesco . .							
Educazione Fisica . .				lodev.		lodevole	
MATERIE FACOLT.							
Ore giustificate / d'assenza non giustif.		14	5	13			

RISULTATO FINALE: _maturo_

OSSERVAZIONI:

Leo's report card for the school year 1922–1923, archives of Liceo Dante in Trieste

down to four out of ten (from six the year before)—and he was compelled to take a makeup exam in September. The teenage boy told no one, out of fear, secretly taking the exam, only to get another four. The result was like a bolt from the blue: *respinto* (failed). He had to repeat the year. When his grades reached his parents by mail, Leo tried to make excuses, but his failure and lies unleashed his father's fury. This episode, explains George Crane, "was a very critical period, very difficult for Leo, perhaps even the worst experience of his life. It was also a source of great embarrassment for the whole family, almost tragic. Leo then developed—oh, but not for very long!—a profound sense of inferiority, until my parents found him a math tutor and until, little by little, he became very good at sports. In any case, the event remained legendary within the family!"[10]

Giorgio Voghera, one of his school friends at the time, would remember that as a teenager Leo Krausz, "stood out for being by vocation a genuine charlatan. But his vocation was honest and unselfish, to the extent that he plied in it even when to his own harm." Voghera's portrait is of a student who irritates everyone around him: "He often raised his hand, interrupted the teacher without having been given permission to speak, to pretentiously spew forth all sorts of bizarre ideas that, most of the time, had nothing to do with what we were discussing in class, and which were in general vague and incorrect. Our teachers, who still retained some of the remnants of the old way of thinking from Vienna, did not altogether appreciate this type of display. They forced him to be quiet and sometimes treated him quite harshly; but that never bothered him. All this continued until they failed him in his exam, giving better marks to his friends, who were certainly neither more intelligent nor better prepared than he was. He had all the gifts of a very accomplished smooth talker and no scruples whatsoever in using them to his advantage. Besides, he was a very intelligent young man, likeable and generous to others, who never played on the fact that he came from an extremely comfortable family (his father was an important banker)."[11] His first cousin Piero Kern confirms this trait in the young Leo Krausz: "On only one occasion did I hear an anti-Semitic remark against Leo; it came from one of his teachers, a native of Trentino, but it was probably Leo's fault, given his 'Know it all' nature!"[12] "Only one" can go a long way in the development of an impressionable psyche!

But how could the Krausz children, with their bourgeois ways, their servants, and their Austrian-style villa not have come across as spoiled brats to

TRIESTE, 1920
Leo, age thirteen, in the garden of his home on Via Michelangelo

their classmates, the sons of Slovenian workers or politicized Italians like the
Vogheras and other socialist intellectuals? Let's listen to George Crane again:
"We were obviously amongst the wealthiest at school. In class, I could see a
boy, sitting in front of me, who oddly kept scratching his back and neck, and
who I finally discovered was crawling with cockroaches. Once, but only
once, in the courtyard, a student threw a rock at me, shouting insults
because I was rich, Jewish, and Austrian!" One cannot fail to notice, just
among the names of Leo's classmates—Manlio Malabovitch Malabotta,
Hajm Wolf (called Valerio), Katz Sacerdoti, Paolo Colbi Kolb, Paolo
Medanich Medani, Miroslavo Kuhelj Cuchelli—the ethnic variety underly-
ing the city's fragile equilibrium of cultures.

 Krausz engaged private tutors to supplement his children's public school
education, ensuring they received the education befitting the elite society in
Trieste. Private piano lessons, tennis instruction, horseback riding, and ski-
ing, among other privileges, but most important, private lessons in French
and English. For, as Roberto Bazlen put it so well: "at that time, anyone who

knew how to speak any foreign languages had the world at his feet."[13] Of no one was this more true than Ernesto Krausz, who spoke Hungarian, German, Italian, Croatian, French, and English. He even had a smattering of Yiddish, using words like *halomot* (twaddle)! The French lessons were left to a Swiss governess, Adèle Buache. She went to the Krausz home twice a week and worked with Silvia and Leo at first, then separately with young Giorgio. "She looked very prim and proper with her very high collar," remembered Leo, "and even though she was Swiss, she was very open-minded, and she had me read extraordinary things like Anatole France at the age of 14 or 15. I also read certain great books, like *War and Peace* in French translation. And so with the help of the *Nouvelles Littéraires* and Miss Buache, I was able to read French literature fluently."[14] Grammar, literature: Giorgio studied *Le Bourgeois gentilhomme* by Molière while Leo and Silvia learned the fables of La Fontaine and the poems of Ronsard. Miss Buache, despite looking like a "typical spinster," succeeded in reaching her goal, and the three little Krausz children became fluent in French.

Mrs. Rossi, who was part of the small British community in Trieste, taught the children English at her home twice a week for several years. They read Shakespeare and Dickens, all three becoming completely fluent. When Mrs. Rossi retired in 1925, a young Irishman, whose brother had taught at the Berlitz School a few years before, took over the children's English lessons. His name was Stanislaus Joyce. As for their piano lessons, the efforts of Mrs. Caligaris to teach Silvia and Leo would be short-lived and in vain. "They hated the piano!" their younger brother attested, not putting too fine a point on it.

Life was happy and carefree for the Krausz children. During the summer of 1919 in Vallombrosa, near Florence, they spent two weeks at the Baglioni Hotel with the Pontecorvo family, and for his twelfth birthday, on September 4, Leo was delighted to receive his own bust of Dante as a present! But he was less pleased to be forced to share one large bed with Giorgio. Because Leo was older, his brother recalled, "things varied: when Leo was sixteen or seventeen and I was twelve, he treated me with a great deal of contempt. Sometimes, he would help me do my homework, especially in Italian literature: once or twice, he did it for me. He also tried to stimulate my interest in literature; he forced me to read *Tarzan of the Apes* in English and in particular introduced me to foreign writers. However, he didn't really have a truly dominant personality; he was rather passive in general. But he was a good

Silvia Krausz (Leo's older sister), the family photographer,
age fourteen

athlete, a very intelligent boy, and without being exceptional, well educated,
with a good knowledge of literature and music. Above all, he was very socia-
ble, much more sociable than I was."[15]

"*Fóto* Silvia, *fóto* Leo, *fóto* Krausz": attentive and passionate, Silvia Krausz,
the photographer of the family, would capture almost every outing in these
early years, sometimes relying on her brother and (rarely) her father to get
the shots, all of which she organized and carefully annotated in numerous
albums. Her ubiquity in these albums seems to reveal the inevitable ado-
lescent narcissism underlying her hobby: Silvia in Courmayeur, in August
1920, on horseback, while climbing, seen from snow-capped summits and
drenched in torrential rain. Silvia, a lovely smile on her face, wearing a dark
dress with a sailor collar, posing with her friends Emma and Genia in her bed-
room in Trieste. Silvia in Carso, in the countryside, grinning and flanked by a
group of friends. Silvia, as femme fatale, with her long hair wet, in a black
swimsuit on the beach at Grignano. Silvia, prim and proper in a white skirt
and conservative blouse, in the garden of her villa. Silvia and her friends "*Sotto*

l'ombrello," as the legend goes, in Canazei. Silvia drinking from a gourd *"alla mina di San Servolo."* Silvia with short hair in a Charleston dress with a tie, on board the *Martha Washington*. Silvia visiting the Villa d'Este with father "Krausz." Silvia in a white lace ball gown, embroidered enigmatically with the letters "OLSO."

These trips with friends and cousins gave the Krausz children their privileged exploration of a diverse world. Knowing foreign languages, they could well apprehend the richness and complexity of their cultural background. As Piero Kern has recollected of the linguistic subtleties of Trieste, "With his mother, Leo spoke the dialect; we all spoke it, it was a local dialect, gentrified. There were people who 'spoke the language' (Italian), who 'put on airs,' like the Dorflès, because they had Roman governesses, but we made fun of them."[16] In addition to the dialect of Trieste spoken at home, they spoke German with Grandmother Krausz in Hungary. Between their Castelli grandparents and Grandmother Krausz, they had a stereophonic family life—two languages, two worlds. "During my childhood and youth, two cultures were combined," George Crane noted, "and I believe they truly had a great influence on my development; an influence that is still felt today, in the tendency I have to switch from one thing to another without any obvious transition."[17]

In the Via Udine lived Nonna and Nonno, Antonietta and Giacomo Castelli, kindly and affectionate, though their house was constantly in disorder. Nonna, who was short and fat, always made turkey galantine for Christmas and Easter. The couple had been rather at sea ever since Giacomo went blind in 1920, and especially since defaulting on the famous London "loans," causing the Castelli e Castelli Company to go bankrupt after the war. It was Guido Castelli, their son, and Ernesto Krausz, their son-in-law, who helped provide for them, in a large house that they shared with Carlo, the Kern family, and Arturo and Lea Castelli. The Krausz children went to visit their Castelli grandparents every Sunday, and Giorgio enjoyed it greatly: "I loved hearing my grandfather talk about politics and blame Bismarck for all his mistakes."[18] But Leo took absolutely no interest in that side of the family per se, inevitably making straight for his great-uncle Carlo, whose enormous collection of opera records he loved to listen to. It was also in the large house on the Via Udine that they met up with their other Castelli cousins. Once the three Krauszes found their cousin Piero proudly sporting an American navy cap; they started to taunt him: *"Cogo Americano!"* But the humiliation was

TRIESTE, 1929, AUSTRO-HUNGARIAN ELEGANCE
Piero Kern (Leo's first cousin) and Giorgio Krausz (Leo's brother), both age twenty

quickly forgotten when they set about playing one of their favorite games: *l'assalto alla Banca Bolaffio,* the assault on the Bolaffio Bank. Leo, the oldest, was Braico, the leader of the gang; his right-hand men were Piero and Giorgio, who helped him carry out his crimes and each time, without exception, cousin Giulio Levi Castellini was the poor Bolaffio whom they murdered.[19]

In Siklós, at the house of Großmutter Krausz, it was a completely different world. Antonia, "the widow of Lipot Krausz," as she was called in official documents, was a tall, elegant woman with almond-shaped eyes, hair worn in a bun, a black dress, and long necklaces. She was an energetic woman who, widowed at twenty-four with four young children—Ernesto Efraïm, called Ernö, age six; Irma Myriam, age five; Sigismund Ishai Samuel, called Giga, age four; Josefina Yael, age two—and a property to manage, scarcely had the time to realize she was beautiful. She sold off part of the estate and did an excellent job of child rearing as well as producing her own white wine, sold in Budapest and as far away as Vienna; she went on with this work

until she died at the age of seventy. Here is George's remembrance: "We were terrified of our grandmother. She was a very powerful woman whom everyone feared, but also an excellent cook, who made complicated recipes, with the help of many servants. When she was making her *Apfelstrudel,* she would push together four or five long tables and roll out the dough over the entire length of them all, until it was thinner than cigarette paper. For her gefilte fish, she would use carp from the Danube, the whole process lasting several days. As for the Göntér wine, a barrel of which she sent us every year in Trieste, it was rather good."[20] On the farm near the Croatian border, still immense after the land sale and very well cared for, Antonia Krausz reared pigs as well. It was a surprise for her grandchildren, since she also kept kosher!

For Leo, the summer months spent in Hungary with his grandmother every year until her death, "the big house, the countryside, the freedom," would remain among the happiest memories of his childhood.[21] "The estate at Göntér," Leo's brother adds, "was half an hour from the city of Siklós; we would drive there in a horse-drawn carriage to see, above the hill where my grandmother's vineyards were, the area's only real attraction: a large cross which was said to mark the tomb of a Serbian king killed in a battle with the Turks. It was the site of a pilgrimage for Serbs and Slovenes, who would go there to meditate and hold beautiful ceremonies. Our father told us that it wasn't a king who was buried there but a Serbian general who had lived in the sixteenth or seventeenth century."

If Ernesto Krausz enjoyed demystifying local Hungarian legends for his children, was he at all aware of his own situation? Was he aware of the precarious political environment? Was he aware of his own professional vulnerability, when, in the summer of 1921, he bought the magnificent villa on the Via Ginnastica from Baron Hütterhot, a villa that loudly announced his rise and success? For despite the Italian kingdom's annexation of Trieste, the Krausz family would be on the move once again before too long. "In fact, we moved quite a bit when I was young,"[22] Leo would later admit in an understatement. That summer Ernesto, Bianca, Silvia, Leo, and Giorgio left the Via Buonarotti along with their servants, less than three years after returning to Trieste from Vienna. The immense villa on the Via Ginnastica was only two hundred yards away from their previous home. On the ground floor, leading off a spectacular entrance hall, redecorated by the architect Gustavo Pulitzer, were the grand rooms for receiving: a dining room for special occa-

18 VIA GINNASTICA, TRIESTE
A new villa for the Krausz family, even grander than its predecessor

sions, a library, and two drawing rooms. On the second floor, the family took
their daily meals and had three large bedrooms (one for the parents, one for
Silvia, the third for Leo and Giorgio) and a boudoir. On the third floor, a
large guest room and "a few cubicles" according to George, as well as rooms
for the housekeeper, the cook, and the two chambermaids. On the grounds,
there was of course a house for the caretaker, a garage, and a tennis court.

The room Leo shared with his brother had "an impressive history,"
according to George Crane. "A cousin of the emperor had often stayed in that
room. Large, square, with nice proportions (it measured five meters square),
it had an especially impressive ceiling, displaying a fresco, the work of
Giuseppe Gatteri, a local painter who had decorated a number of cafés in Tri-
este. In the center was the Emperor Franz Joseph, in his thirties, on horseback
and wearing the red-and-white uniform of a general in the Austrian army,
accompanied by the Empress Sissi. Around them were the coats of arms of
the Habsburgs and the Wittelsbachs of Bavaria, with black-and-white dia-
monds. In the four corners of the ceiling were other members of the imperial
court on horseback. And yet, a few days before moving into the villa, my
father called in a painter to touch up the frescoes. He left the empress, but he

disguised the emperor. He painted a black hat over his kepi, a black suit over his beautiful uniform, and added a particularly ridiculous large black moustache onto his face!"[23]

The villa on the Via Ginnastica, a veritable enclave of Austrian sentiment on Italian territory, was conspicuous in more ways than one. Owned by someone close to the court, it had seen a number of the imperial cousins come and go, these guests generally lodged in the famous frescoed bedroom. Ernesto Krausz did what he could to efface the imperial connection, not only retouching the fresco but renaming the house "Villa Bianca," honoring his wife to helpfully Italianizing effect. It was almost certainly fear of being perceived an *austriacanto* that compelled Ernesto Krausz to order at least that Duchampian gesture—an omen, one is tempted to say, of his eldest son's future profession. Indeed, the retouched emperor "surprised Leo a lot." What effect might we expect on an adolescent who, every night, went to sleep staring at the emperor disguised in a fake moustache? Whatever the effect on Leo, the disguise was for naught. "Despite these laudable efforts," comments George Crane, "our Italian loyalty continued to waver during the initial years after the war!"

While the Krausz children, on their large estate, were being molded by language lessons and other methods of inculturation into paragons of a reformed Austria submissive to the elite of Trieste, many others in the city had lapsed into bitter disillusionment. "Gradually the men were coming home," Anna Fano writes. "Some had fought on one side, some on the other, many had grown wealthy. Young men, older men were wandering around, looking at each other with sympathy . . . The war was over. All the vagabonds were arriving from the rest of Italy. Bright shops full of customers. The girls, tired of dressing in rags, were buying everything in sight. Whether they had money or not, it didn't matter, they ran up debts. 'Did you see that? Sailor suits are all the rage!' . . . Lively meetings at the 'Young Socialists Club' . . . In the meantime, great confusion throughout the country. The euphoria of the happy conclusion of the war was very quickly followed by a sense of general discontent, mainly caused by unemployment. Everywhere, workers go on strike and clash with the members of the new Fascist Party. Every now and again, meetings are held in the streets. One day, while leaving the office, there is suddenly machine gun fire and everyone runs to hide behind the doors. In Trieste, there is general unrest. Is this really the Italy we dreamed of?"[24]

7. THE IRREPRESSIBLE RISE OF ERNESTO KRAUSZ

—A chi sara Fiume? —A noi!
—A chi sara Fiume? —A noi!
—A chi sara Fiume? —A noi!
—Eià-Eià-Alalà![1]

CHANT OF GABRIELE D'ANNUZIO'S FOLLOWERS

STREWN WITH ITALIAN flags bearing the motto *Italia o morte,* the city of Fiume, an hour away from Trieste along the Adriatic coast, had, since September 12, 1919, conducted one of the most delirious political experiments in history, one that would last nearly a year and a half. Armed with quotations from his heroes—the poets Guido Cavalcanti (1250–1300), Guido Guinizelli (1235–1276), and, of course, Dante—the poet Gabriele d'Annunzio made the wildly ambitious choice to launch himself into the world of politics and violence. With the backing of a group of *arditi* in black shirts (committed nationalists, dropouts in search of adventures, students entranced by the epic poems of their Comandante, as well as activists, anarchists, anarcho-syndicalists, and even Freemasons), d'Annunzio staged a rejection of the Treaty of Versailles, under which Fiume had been given to Yugoslavia and renamed Rijeka. Declaring that Italy's victory in the First World War was nothing more than "a mutilated victory," d'Annunzio forcibly annexed Fiume through a military insurrection, a gesture that was only the start of a grand scheme intended to culminate in a march on Rome and a world revolution.

In his Charter of Carnaro, the putschist-poet proclaimed the coming of a "kingdom of the human spirit," based on a kind of Orphic cult and proposing a radical constitution providing for gender equality (including the eligibility of women for all private and public offices), a minimum wage, disability and unemployment benefits, and pensions for the elderly. "My very dear mommy," writes a young American volunteer in the Red Cross on Sep-

tember 21, 1919, "there were two platforms, one for the civil authorities and the other for the military. I stood on the second one with d'Annunzio, as the only woman in our group and, moreover, the only nurse. He is fantastic. I clearly understand why he mesmerizes everyone who comes near him—for he exudes a kind of fascinating magnetism. Naturally, he made a speech, and the troops were wildly enthusiastic. The pilots then shouted out their famous war cry—*Eià-Eià-Alalà!*, and the *Arditi* punched the air and replied—*A noi!* My blood ran cold, that's how passionate, determined and devoted to the cause they are."[2]

Fiume, Hungary's free port since 1870, was a city that Ernesto Krausz knew well: there, he first became an urbanite; there, he began his banking career; there, he even learned to speak Croatian, just before arriving in Trieste. And so, Fiume's business became his business. Right after d'Annunzio's epic experiment, Fiume's public records and transactions were placed in Krausz's care. He corresponded with Oscar Cosulich, president and managing director of the powerful Cosulich SA, with his lieutenant, Dr. Moschoni, and even with Igino Brocchi, head of the cabinet of the Ministry, Finance Kingdom of Italy. When Cosulich urgently asked about share prices in Fiume, Krausz somewhat awkwardly replied that he hadn't "yet been able to calculate the value of either the Fiume crown, or the Yugoslavian crown, because of a fluctuation in the exchange rate between the two countries, which is currently being determined in Fiume." He hastened to add, "I will try to reach our branch in Fiume tomorrow morning, to get a clearer idea of the situation. Our government has not intervened, or so it seems. They have been informed of the financial plans of the government of Fiume, but the government's exact purpose cannot be determined at present. The expectation of a rate of twelve lire to one hundred Fiume crowns . . . should be possible, given the financial aid conceded by Italy."[3]

Working at the hub of a great network of mergers, acquisitions, and loans between Fiume, Trieste, Vienna, and Budapest, Krausz seemed a providential figure, since he knew these dealings better than anyone else. All the largest Triestine companies sought him out for the best loan rates, whether from the Austrian government or the Hungarian banks. "I hope that the visit of Zimmermann, the Austrian Inspector very favorably impressed by our port and our railway constructions, will positively influence the Austrian rates," Dr. Moschoni anxiously wrote Krausz before returning to another issue also under his correspondent's purview, the banking situation of Fiume. Cosulich

SA had customers in Fiume, and Moschoni wondered which system would be selected for the "regulation of Fiume's debits and credits with regard to Hungary?" "Would it be the one used for the Italian provinces," he asked, "or else another system (that might be the clearing system[4])?"

Despite the monetary fluctuations, the social tensions, and the rising specter of fascism, Ernesto Krausz, ever the expert and jovial banker, evidently enjoyed managing the destiny of the Banca Commerciale Triestina. Yet, dizzied by his ascent within Trieste's high society, he would grow oblivious to developments that had no immediate bearing on that progress. He would ride out those years under the spell of power—working, traveling, growing ever wealthier—and possessed of all the trappings of bourgeois success. Not that he didn't face real challenges. In 1904, the Triestina had been taken over by the Wiener Bankverein. But after the war, the local branch remained the city's linchpin, particularly with the merger of the Cosulich SA and the Figli di Jacob Brunner, the two most important companies in the city, which were linked by a great labyrinth of common interests.[5] Thus jointly controlled by Viennese bankers (the Union Bank and the Wiener Bankverein) on the one hand, and on the other by the most influential families in Trieste, the Banca Commerciale Triestina required an extremely diplomatic central management. For it was both the guarantor and the hostage of these two worlds, which would soon start pulling away from each other.

After the war, the city was bedeviled by extreme currency fluctuations: the Austrian crown became virtually worthless, the lira also collapsed, and nothing was done to limit speculation. For Trieste, after years of generous imperial patronage, the transition to Italian rule saw a sudden and unsettling impoverishment. "The people of Trieste are complaining that the cost of living is rising to dizzying heights from one day to the next . . . The city feels all the vibrations of the Italian economy, even anticipating them, with a seismographic sensitivity."[6] As the economy soon entered free fall, and as unemployment climbed, the myth of the beneficent free port quickly collapsed. Desperately, the Italian government invited the most important economists and financiers from the Giulia region to meet with Italian diplomats in Paris, in the hopes of forming a working party. They wrestled with the question of how to regain their former markets along the Danube, which were the lifeblood of Trieste, now that the hinterland, a ghostly spectral vestige of the Austro-Hungarian Empire, was carved up among Austria, Hungary, Yugoslavia, and Croatia—a process that had left the harbor economically stranded, a crippled city.

The Banca Commerciale Triestina was one of the last financial bastions of the Giulia region. But as Roman bureaucracy came onto the scene, taking over regional political and economic decisions, the elite of Trieste quickly realized that their future was no longer in their own hands. Even before the Treaty of Rapallo, which had ceded the free port of the Austro-Hungarian Empire to the Kingdom of Italy, the Italian government was bent on dissolving Trieste's ties to its past and eliminating with all haste whatever control the Austro-Hungarian banks held over the *"italianissime* city of Trieste."[7] On February 2, 1919, Bonaldo Stringher, the Italian minister of the treasury, wrote Guido Segre, the supreme commander of the city's armed forces, a very blunt letter: "We have absolutely no interest in allowing foreign banks [to continue to function here] . . . for they might present a certain danger . . . In every way possible, the Triestine Bank must become Italian."[8] Very quickly, Italian funding flowed from the Banca Commerciale Italiana to the key companies of Trieste, and new men, staunch Italian nationalists, were appointed directors of the Banca Commerciale Triestina, to speed up the process of Italianization.[9]

Did they not trouble Ernesto Krausz, these winds blowing from Rome, which was now sovereign over a new political and financial system for Trieste, a system created out of suspicion about the city's largely Austro-Hungarian sympathies? Did he not realize the precariousness of his position, as the ranking officer of an "army of Austro-Hungarian financiers" who had come to power during the first years of the twentieth century? Did he not discern that the economic policy of the Italian government would progressively reduce him to an ever more marginal and passive role? Naïveté, foolhardiness, a total lack of political insight—it is impossible not to consider these charges in light of Krausz's blunders during these years. How else to explain that, despite his being advantageously placed to negotiate for Vienna, Budapest, Fiume, and Trieste, he hopelessly failed whenever he demanded a special favor of the Roman officials? "I hope that the papers regarding the Stabilimento fiumane de credito have been handed to you rightfully in person," he anxiously wrote Ugino Brocchi, member of the Council of State and head of the cabinet of the finance minister, ex officio an important person in Trieste. "In any event, and just in case, contrary to what we had anticipated, the decision will remain definitively in the hands of the Ministry of Finance, so I have taken the liberty of sending you once again a request that has already been sent to the Ministry."[10] One must ask what this paragon of bankerly discretion thought in his heart of hearts of the Italian political situation, whose gravity was now obvious to all.

Gabriele d'Annunzio's moment of power in Fiume, both in its brevity and heated patriotism, anticipated the national tensions that would eventuate in the rise of fascism. On July 13, 1920, the Balkan Hotel, head office of the Narodni Dom, the social, political, and cultural nerve center of the Slovenian community of Trieste, was burned down by the Fascists, a crime greeted with apathy by the police. The Socialist Aldo Oberdorfer was first to see in this an omen of the inevitable. "With such an act, the possibility of a truce, let alone an agreement between different nationalities was set back several decades," he wrote, "if it hasn't been destroyed forever, that is. Trieste is condemned to become the center of a new Slavonic Irredentism which will be just as dangerous to peace in these territories as the old Italian Irredentism: this is what this incident has just taught us, and in an unforgiving way. Under the madness of Fascism lies the wreck of the national freedom program that we tried to establish from the earliest days of the annexation, a program that offered the only hope for the Italians and Slavs in the Giulia region to live together in peace . . ."[11] The Slovenian poet Srečko Kosovel portentously wrote:

> The first thing is the horror, the horror of: being
> in the middle of chaos, in the middle of the night,
> looking for a way out, and sensing
> that no, there isn't one, there is no salvation[12]

And so when Mayor Pettiti di Rorato promised, "Slovenians! Italy, a state of great freedom will give you the same rights as other citizens, it will give you schools in your own language, more numerous than you ever had under Austria," his assurances were perceived as pure electoral pandering. As for Fascists like Francesco Giunta, they believed themselves merely reacting to "Bolshevik and subversive" incitement.[13] As for the authorities, although acknowledging incidents like the Balkan Hotel fire as "serious acts of reprisal and vendettas," they saw justification on the grounds of "odious provocation." A few months later, it was the Caffè Commercio's turn to be torched by the Fascists, followed by the Socialist newspaper *Il Lavoratore,* which was under the direction of Ignazio Silone. All in all, Triestines had front-row seats for the spectacular downward spiral of Italian civil society from the end of the First World War to the beginning of the Second.

In Venezia Giulia, the Fascists took action in the autumn of 1920, using

the "struggle against Bolshevism" as pretext for new repressive measures against the Socialists and Slavonic minorities. On September 20, Benito Mussolini chose Trieste as the setting for his first speech, which commemorated the fiftieth anniversary of Garibaldi's march on Rome. "O people of Trieste, I do consider you Italians to whom we still cannot tell the truth or the whole truth, because I regard you as among the best Italians, and your ardor demonstrates this superiority once more today . . . Today, after half a century of Italian unity . . . Trieste is Italian and the tricolor waves on Brenner Pass. If you would linger a moment on the wonder of this event, you would understand that the fact of our flag waving on the Brenner is of major importance, not only in the history of Italy, but also in the history of Europe. It means that the Germans will no longer set their sights on our land with impunity. Glaciers have now been placed between us and them, and on these glaciers are the magnificent mountaineers who are launching an attack on Monte Nero, who have given their lives on Monte Ortigara and whose flags bear the words: 'None shall pass through here.' [thunderous applause] And, the most essential point is that Trieste has come to Italy after a colossal victory."[14]

In his outlandishly demagogic performance at the Politeama Rossetti, Mussolini also pointed a finger at the Communist and Slavic threat, appealing to the memory of the glory that was Rome. "People who talk about a reactionary government really make me laugh, especially when they are immigrants or renegades from Trieste; if there is a single country in the world where freedom borders on licentiousness and where liberty symbolizes the inviolable homeland of all its citizens, that country is Italy . . . Trieste not yet annexed must first be purged; after ethnic and social cleansing, the international Socialist and Slavic elements must be expelled."[15] On February 6, 1921, *Il Duce* returned to the Politeama Rossetti, this time to detail his foreign policy, maintaining that Italians must "be proud of our race and our history . . . against the pessimists who believe that everything is great in other people's houses, while everything is too small in their own."

Four years and many speeches later, the two houses of the Italian legislature would vote, by large majorities, to grant extraordinary powers to Mussolini, making him the country's lawful dictator. With the assassination of the Socialist Giacomo Matteotti, the delegate for Rovigo and one of the few parliamentarians who would venture a full-throated condemnation of the regime, Italy entered a phase of burgeoning tyranny under which all opposition was sys-

tematically criminalized. In October 1925, the government forced all represen-
tatives of the Italian Confederation of Labor Unions, the Cofindustria, to sign
a document guaranteeing Fascist unions exclusive representation of salaried
employees; in short order, they would also be compelled to assent to a govern-
ment decree regarding the "rules of employment." The terrifying crescendo
came with the *"fascistissime* laws" by which Mussolini, as "Head of the govern-
ment and *Il Duce* of Fascism," would "legalize the illegal." With the closing of
all the Masonic lodges, the dissolution of opposition parties, and the banning
of the opposition press, the repeal of laws guaranteeing free association and a
free press, together with the organization of an official monopoly for Fascist
trade unions, the iron-clad infrastructure of dictatorship was well and truly
in place.[16]

On November 26, the directors of the Banca Commerciale Triestina met
with the senior Fascist officials Captain Lupetina, of the Party, Captain Live-
rani, and Captain Chiarelli, for the public and private Fascist labor organiza-
tion. Giulio Camber and Gastone Slataper, directors of the recently
disbanded Banking Federation, circulated the following statement to BCT
personnel: "All bank employees: the General Banking Confederation of Italy,
Trieste branch, was closed on November 21, 1925, at seven o'clock in the
evening, pursuant to article 3 of the city and regional law, by order of the
Chief of Police of Trieste . . . But it is our firm intention to preserve your
right to unionize."[17] On November 30, 1925, the staff of the BCT gathered in
Dante Hall to meet the Fascist trade union.

"The controversy among the employees of the Banca Commerciale Tri-
estina has been satisfactorily resolved," wrote a journalist from *Il Piccolo* fol-
lowing the meeting. "On the Agenda was the cancellation of their work
contracts; the employees gathered to hear the new resolutions of the Fascist
organizations in their workplace . . . After the Management of the BCT can-
celled the contracts, a certain tension was visible between the management
of the bank and the employees. Slataper, former head of the workers' union,
took the floor . . . Battaglierini proposed a vote for unconditional member-
ship in the Fascist organization. Liverani greeted all the employees of the
BCT in the name of the Federation of Fascist Trade Unions. He listened to
Slataper's speech; he was unfamiliar with his background, and he refrained
from judging him, but he declared that the Fascist Trade Union did not aim to
draw in the defeated, but rather aimed to 'gather together everyone who fer-
vently believed in the new principles of Fascism. If the employees of the BCT

had understood what was happening sooner, their situation today would be different. Fascism considers the financial sector to be an instrument of national power and this instrument must be continually strengthened and not divided. Whether one is a Director or a worker, one cannot grasp such a concept if one's background is in the old, elitist Democratic school, in which personal and class interests are put before the interests of the Nation. [Applause] With these principles, we will defend the interests of the BCT's employees, without questioning them about their past.' "[18]

It was a dreadful time in Ernesto Krausz's career. He was confronting the postwar chaos of monetary fluctuations, personally overseeing the changeover from the Austrian crown to the Italian lira. He was confronting the arrival of the Fascist trade union at the heart of the institution he directed. He was confronting the great global economic crisis of 1929. But most immediately and forcefully, he was confronting the recession and the attendant agony of Trieste: from this point on, the city that had been the third-greatest of the Austro-Hungarian Empire would be reduced to a provincial town in decline, cut off from the hinterland, slowly stagnating, never again to emerge from the morass into which it had fallen. Having fifteen years earlier, at the age of twenty-six, risen to professional prominence by unlocking the financial potential of this free port and its Adriatic tariffs, its markets, and its industries, with their indispensable links to the hinterland, Krausz would now stand by powerless, witness the collapse of the port of Trieste, of the Viennese financial prestige, and of his own professional position. But let's not get ahead of ourselves. Ernesto Krausz faced these numerous misfortunes with exceptional grace and discretion—to such an extent that his own children barely realized what was happening.

Stuck with a neurasthenic mother and a workaholic father, in a family where neither politics, nor art, nor literature was ever discussed, a family that displayed not the slightest concern for its children's individual interests, seeking only to conform them to the city's elite, in a villa that echoed all the national hypocrisies and tensions, in a city doomed to provincialism and decline, in a country hurtling headlong towards fascism, on a continent drifting towards a second world war, the young Leo Krausz began to evolve an independent sense of himself. Amid the exaggerations, the lies, the failures, the malaise, the delusions of grandeur, he laid the groundwork for his future identity. He inclined towards a Nietzschean plan of subjective development, testing his physical strength through various sporting activities—swimming,

skiing, tennis, riding, and mountain climbing—and eagerly devouring most
of the masterpieces of European literature. Towards the end of the winter
of 1925, he came down with scarlet fever. During the requisite quarantine of
two months, Leo was relegated to the third floor of the house, with a nurse
hired specially to bring his meals and look after him. His little brother, Gior-
gio, was in charge of the patient's reading. Every day, at the same time, the
nurse took Leo's book order and Giorgio ran to the Benporad bookstore to
fulfill it. "At that time, Leo was reading at least one book a day! I had to buy
him more than fifteen novels by Anatole France, as well as Tolstoy, Dos-
toyevsky, and Thomas Mann. He was enormously interested in literature, he
read a lot, and in four languages: Italian, German, French, and English. That
was when he decided he would study either literature or history."[19]

This passion for literature from all over the world would never fade; even
when the fever had passed, it would continue to be secretly cultivated
beneath school desks and on his regular visits to Umberto Saba on the Via S.
Niccoló. Leo later recalled, "In the middle of Trieste, there was a bookshop
run by a very intelligent man, where I bought my books, choosing them
rather haphazardly. I wanted to be a Renaissance man, and physically
strong . . . one of my role models was Leon-Battista Alberti, the great archi-
tect. It was claimed that he could throw a stone higher than the Campanile de
Giotto in Florence, and that impressed me a lot. So I wanted to be very
strong, and, as a consequence, I took part in a lot of sports, mainly mountain
climbing and skiing. I also wanted to be extremely cultured; I wanted to know
everything. To do that, I had to devise my own means, for the only thing that
truly bored me was school. I dreamed of being a Renaissance man, without
actually having the means to accomplish it."[20]

Young Leo Krausz—nascent political dissident, a would-be Renaissance
man in a henceforth Fascist Trieste—was then nothing but a bookworm. Still
it is difficult not to recognize, in the deliberateness of his undertaking, all the
elements that a few years earlier had led the writers of Trieste to fashion "a
reaction and a breech of social norms," making their city one of the capitals
of modernism. This was an astonishing development in a city deprived of
cultural traditions and "built entirely to attain mercenary goals," in which "a
writer [was] an illegal immigrant" and literature "nurtured like a secret
vice," not in the context of a "literary circle," but in hiding in "the office, the
bank, the back room of a bookshop, the cafés, the inns." By what alchemy
did Trieste, despite "the wretchedness of its cultural traditions," find itself

Advertisement for Banca Commerciale Triestina, at the time Ernesto Krausz became its director

the "capital of poetry," so that "this mercenary city devoid of poetry should become a font of words"? The merchant Ettore Schmitz made his living in the world of Austrian finance, only to be reborn as Italo Svevo, a light in the Italian cultural firmament. By such genesis, during those very same years, there also came into being the essential works lining the shelves of the Saba Bookshop, as well as those of the Irish teacher from the Berlitz School.[21]

In the Villa Bianca, the seventeen-year-old Leo Krausz, word by word, page by page, book by book, secretly molded his eventual sensibility. The clandestine reader spent his days on the third floor, grappling with Lucien de Rubempré in *Lost Illusions,* with Ulrich in *The Man Without Qualities,* with Julien Sorel in *The Red and the Black,* with Frédéric Moreau in *Sentimental Education,* as unremarked as Saba, Svevo, and Joyce in the mercenary city. To them, as to the young Leo Krausz, avid reader of European literature, Trieste could but have seemed a spectacle, threatening, provocative, and deceptive all at once, inciting in all such spirits a desperate search for identity. "Deadly boring," writes Joyce of those days. "Not a single soul I can talk to about Bloom. Showed one or two chapters to a few people but they understood them about as much as the eloquent part of my ass . . . Winter here is rather mild and will soon be over. There are a lot of good operas but I never go (because someone has either sold or pawned my suit and a new one costs 600 lire)."[22] A few years later, he would again lament: "Apart from Baron Ralli, not one of my admirers in Trieste has subscribed to *Ulysses.*"[23]

8. TURNING TWENTY UNDER FASCISM

Siamo l'eterna gioventù
Che conquista l'avvenire
Di ferro armato di pensier.
Per le vie del Nuovo Impero
Che si dilunga nel mar;
Marceremo come Duce vuole;
Come Roma già chiamo.[1]

YOUNG FASCIST CHANT

THE SONGS OF the black-shirted Piccole Italiane made it quite clear: in the recruitment and indoctrination of future Fascist generations, there was little room for subtlety. Not when the aim was to celebrate the leader and to create a new breed of man that would swell the ranks of the Fascist Party (which was structured like a religious or military order). The law of December 24, 1925, bestowed a heap of titles on Mussolini: head of government, prime minister, secretary of state, and by this concentration of power the regime turned increasingly totalitarian, its legitimacy rooted in the cult of charisma surrounding *Il Duce* who, according to ubiquitous posters, "never slept," was "always right," and, most famously, "made the trains run on time."[2]

"I remember feeling this terrible boredom at the crudity and stupidity of the regime," recalled Vittorio Foa, a Turinese student, explaining his involvement with the antifascist group Giustizia e Libertà. "The only way you could survive within a world so stupid and boring was to become stupid yourself. I made the choice to be politically active when I realized I would become an idiot too, unless I did something to maintain my integrity."[3] When a bomb demolished the Fascist paper *Il Popolo di Trieste* in February 1930, there were brutal reprisals. On September 5, a military tribunal under General Cristini

handed down fourteen lengthy prison terms and four death sentences; the very next day, a firing squad of fifty-six Black Shirts executed Francesco Vlencic, Francesco Marussic, Ferdinando Bidovec, and Zvonomir Milos at Basovizza, a natural sinkhole suited to the disposal of corpses. But Giustizia e Libertà was undeterred, its leaders—Gabriele Foschiatti, Bruno Pincherle, and Amos Chiabov—escalating their activities through a growing nationwide network.

What about the Krauszes? Did they become politicized like the Vogheras and other Socialist militants? Hardly. As Jews, were they at least alert for signs of incipient anti-Semitism? In 1922, for instance, had they read Filippo Tempera's appeal to Mussolini to save Italy from Jewish bankers like Stringher and Toeplitz—puppet masters of "the red and black international . . . the diplomatic corps, the press, the courts, and the schools"?[4] Probably not. Were they, in fact, just assimilated opportunists and bourgeois conformists? Leo's brother, George, suggested as much: "My father became a member of the Fascist Party very, very late. He was a conservative man who didn't like leftist politics and did not encourage Leo's and my tendency against fascism. When I told my father that I wanted to live in France, he said that the political regime was worse there than in Italy. And when, once, at the station I ran into Dubis Farnese, assistant to the head of the Fascist Party (whom I knew from high school), my father was flattered to shake his hand. Generally speaking, we had little interest in politics, not much respect for Italy, and we mainly missed the Austrian regime. A number of cartoons showed Austrians taking advantage of the situation and licking the Italians' plates. People knew that my uncle Vittorio Levi-Castellini had fought on the side of Austria during the First World War, but I don't recall any particular hostility directed towards us."[5] Silvia's photographs provide a chronicle of the Krausz children under Italian fascism, from Trieste to Vienna, Opicina to Brioni, Courmayeur to Cortina d'Ampezzo, San Martino di Castrozza to Valgardena, Pörtschach to Muggia. They led the active life typical of privileged youth, enjoying winter sports, motoring, mountain climbing, swimming, horseback riding, and tennis, in the company of Herrmann Von Artens, Emmanuel Du Plaix, Franzi Matejka, Silvia Lekner, Nando Calda, Manolo Belleni, Rinaldo Delord, and Stefano Macchi di Cellere, their tanned, good-looking friends. The young ladies wore cloche hats, fur-collared coats, geometric haircuts, low-waisted pleated skirts; the men sported long coats, well-tailored three-piece suits, silk ties, and casually tilted fedoras: the Fitzi-Continis of the Adriatic. Did the

Silvia Krausz's photo album from the family vacation in Cortina d'Ampezzo, during the summer of 1928. In the top photo, Leo stands to the left and Silvia is perched on top of the group.

regime's grandiose projects and public spectacles get a rise out of these well-bred oblivious youngsters? After life in Vienna and a cosmopolitan upbringing, how did the young men with a passion for literature adjust to this climate? "I found the fascist regime rather intolerable," Leo later remarked. "Sort of in bad taste and gross. I was not so much politically conditioned or interested; but, you see, there were restrictions. England and France were sort of the enemy, and yet they were the countries I was most interested in. Fascism was a vulgar, illiterate movement. The whole atmosphere was oppressive and certainly no one who had any kind of intellectual life would want to stay there!"[6]

"Mussolini, elevated to the status of a demigod, appeared no longer in civilian clothes, but always in uniform," writes the historian Alexander Stille. "The man Benito Mussolini was replaced by *Il Duce,* the name printed in newspapers in capital letters, 'DUCE.' Articles portrayed him as the master of all pursuits: a world-class economist; an unrivaled scholar of Roman history, statesman, aviator and horseman; a virile Don Giovanni; and a devoted

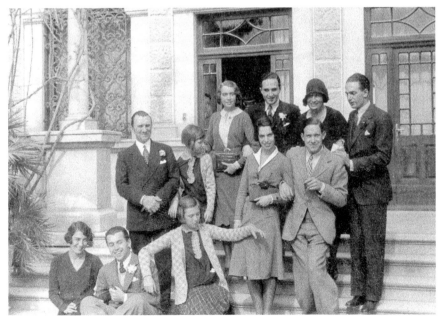

SILVIA KRAUSZ'S SOCIAL EVENTS DURING THE YEAR 1930
TOP LEFT: Relaxing on deck on her way to a Rotary party in Brioni, off the coast of Croatia. TOP RIGHT: Automobile excursion in Pörtschach, Austria. BOTTOM: Visit to the Cosulich family mansion in Monfalcone.

TRIESTE, AUGUST 18, 1938
Welcome festivities for *Il Duce*, who spent his vacation in Venetia

family man. As Mussolini pursued his pretentious dream of re-creating the glory of ancient Rome, the regime's chest-thumping oratory became more insistent. Public life under fascism became a string of interminable military parades, with everyone from kindergarteners to doddering old veterans marching and singing Fascist hymns."[7] In 1925, Pietro Fedele, the minister of public education, had declared: "The government requires every school, at every level, in all its teachings, to educate Italian youth to understand fascism and to live in the historical climate created by the fascist revolution."

Such was the atmosphere in which Leo Krausz celebrated his twentieth birthday in Trieste on September 4, 1927. With fascism at its apogee, most Triestines made a good show of celebrating pride at the prestige their city enjoyed, while swallowing whole their leader's grandiloquent fantasies. On August 24, they celebrated as *Il Duce* launched the *Saturnia*, "the largest and fastest steamship in the world," fresh out of the Cosulich shipyard and powered by "the world's largest diesel engine," 20,000 horsepower, manufactured at the Fabbrica Macchine di Sant'Andrea. At the Bersaglieri pier, a

crowd of more than one hundred thousand crushed in to cheer Mussolini and watch him effusively embrace each and every member of the Cosulich dynasty: Antonio, Callisto, Guido, and Mario. In his honor, businesses lowered their shutters at 5 p.m., and even the Slovenian daily *Edinost* saluted "a great Italian, who energetically guides the rudder of the new postwar Italy."[8] Articles about the *Saturnia* ran in the world's chicest magazines, with *Vogue* in Paris devoting an entire page to the maiden voyage (Trieste to Rio de Janeiro in eleven days). As for Brazilian postcards, they celebrated *"O Navio Motor 'Saturnia,' o mais grande e veloz do mundo."*

Behind the triumphal scenes, meanwhile, Roman authorities pounced on Trieste's Slovenian population—a quarter of the city's inhabitants—shutting down more than four hundred associations and businesses, confiscating property, and relocating teachers to other cities. The campaign had begun with the law of December 1925 and the purge of ethnic Slovenes from administrative posts for "disloyalty to the regime"; it would culminate in 1929, with the banning of both *Edinost* and the teaching of Slovenian in school.[9] Moreover, the vigorously enforced decree of April 7, 1927, which mandated the Italianization of patronymics, heightened pressure on the Triestine population, most of which bore "foreign-sounding" names. "One part of the city's inhabitants cannot properly read the names of many of their fellow citizens," Aldo Pizzagalli fulminated in *Per l'italianità dei cognomi nella provinzia di Trieste*. "The simplest and most practical solution is to go the other way and provide names of foreign origin with a Latin translation."[10]

Giovanno Gentile, minister of education, visited Trieste on April 3, 1926, to inaugurate courses on Fascist culture sponsored by the Università Popolare. Several days later, after an attempt on Mussolini's life, he harangued some thirty thousand listeners from the prefecture balcony on Piazza dell'Unità d'Italia: "I am so thrilled to see this crowd gathered around the prefecture, united by a sentiment of joy, of devotion—if you will permit my saying so, a religious sentiment," he proclaimed. "After today's ordeal, you Triestines, like all Italians, you feel relieved because, O Triestines, the constant failure of these attempts against the Duce Benito Mussolini demonstrates— as if proof were still required—that the person of Mussolini is providential, that Providence shields him for the good of Italy against these hateful and ludicrous attacks! O Triestines! May God protect and keep our *Duce!*"[11]

On Via Ginnastica, Leo Krausz was finishing his studies—or rather privately poring over literature, at home, at school, on the tram; he inhaled Kafka,

CORTINA D'AMPEZZO, 1928
Leo the talented skier

Thomas Mann, Freud, Proust, Joyce, Dickens, Thackeray, T. S. Eliot, and Huxley with a solitary single-mindedness. "I needed a tutor to help me out with school," he later explained, "because I was pretty bad, not being interested in knowing the usual subjects. This teacher was a good literary man, a poet in his own right, and he was absolutely amazed at my knowledge of foreign literature. He just couldn't understand how somebody that knew so much about literature could be made to repeat a class. But I was very interested in one particular field and neglected everything else. I was reading even when I was in school. I wasn't even listening. I had a book, reading."[12] In June 1926, with his tutor's help, Leo earned his diploma, the *maturità classica*. Statistics for that year show a success rate of 100 percent for the Dante Alighieri School and 87 percent for the Petrarch School.

Leo Krausz was an engaging, sociable, athletic, elegant young man. But he lamented his size—he was short—and confessed to his father that he "wouldn't mind having a girlfriend." Immediately an appointment was set up with the famous psychoanalyst Edoardo Weiss, Freud's former student in Vienna. "I'm no good at attracting girls . . . ," young Leo began. "You might not know why that is, but they do!" Weiss shot back. One session was apparently all it took to unblock the future Don Juan. In Bagno Savoia, Courmayeur, and Cortina d'Ampezzo, Leo could be seen escorting Linetta Mann, Silvia Lekner, Leonor Fini, and other young daughters of his father's friends.

Resigned to his stature, then, he proved himself physically in sport. Above all, he became a formidable alpinist, climbing with the Gruppo Rocciatori e Sciatori dell'Alpina delle Giulie. On July 22, 1929, with Virgilio Neri, Piero Slocovich, and their guide, Micheluzzi, Leo realized the world's first ascent via the Preuss Wall of the Campanile Basso, a daunting mountain in the Dolomite range, at an elevation of 9,459 feet! Before them, only Karl Berger and Otto Ampferer (on August 18, 1899) and Paul Preuss (on July 28, 1911) had finished the climb, taking different paths. The Gruppo Rocciatori's exploit,

which experienced mountaineers graded at V− or IV+, was trumpeted in all the press. "From the Garbari ledge (spike)," wrote Micheluzzi in the Italian Alpine Club bulletin, "we climbed directly via the striated blocks of yellow rock along the Povoli route (spikes) until we came level with the small *pulpito* near the peak, from which we climbed with double ropes. We traversed by the overhanging rocks using small but excellent handholds, with no foot support (absolute exposure), up to the notch on the Ampferer Face; then, by the easy rocks of the wall, we reached the pinnacle. Extremely difficult."[13]

TRIESTE, 1928
A group of friends in the garden of the Krausz villa. IN THE BACK, with arm raised, stands Leo; FRONT, SECOND FROM THE LEFT, Leonor Fini; NEXT TO HER, the professor and critic Gillo Dorfles; BACK RIGHT, Gerda Bretani, who became a famous Brazilian artist after the war.

At his father's urging, Leo agreed to study law in Milan: a pleasant prospect of four years away from Trieste in the company of his friends "Peppi" Basso and Nunzio Senigaglia, both likewise crazy about literature and music. The three comrades frequented La Scala, especially to hear Toscanini conduct the complete *Nibelungen* cycle and the *Meistersinger*. Leo took a room with a family for thirty lire a month, laundry included. "I was not terribly interested in law, but I was happy to get out of Trieste to go to a big city. I had various friends in Milan, so we had a rather happy life. For the first couple of years, I was pretty conscientious. Then I started neglecting my studies more and more, and by the end I just squeezed through. I did a lot of sports at that time . . . and then went back for exams. It was a very pleasant life. But I can't say my law studies were brilliant."[14] Three years of freedom to explore the world during long vacations: interning at Griffith, Tate and Co., marine insurers in London, and in Milan at the Banca Rosenberg-Colorni (both through his father's connections); after that followed a few months of military service as second lieutenant in the field artillery.

Nunzio was the son of Virgilio Senigaglia, a Socialist deputy and outspoken antifascist. There were other Triestine antifascists in Milan. Both Aldo

Oberdorfer, editor of *Il Lavoratore,* and Ermanno Bartellini slipped into the Lombard capital for clandestine meetings of Giustizia e Libertà. The group published its resistance pamphlets in Paris, under the aegis of Carlo Rosselli. "Fascism is digging its roots into the Italian substratum," asserted Rosselli. "It expresses the ingrained vices, latent weaknesses, and miseries of our people. In certain respects it stands as the autobiography of a nation that has given up on political struggle, that makes a cult of conformity, takes refuge in heresy, and dreams of the triumph of facility . . . To fight against fascism, therefore, means to fight . . . against a certain mentality, sensibility, and tradition that are endemically Italian . . . This fight is difficult . . . It is above all a matter of moral and political education, independent of class distinctions."[15]

Meanwhile, as his older son was becoming a doctor of law and the talk of the mountaineering world, Ernesto Krausz had reached his own professional pinnacle. "We were very impressed by our father's office," George Crane recalled. "It was an enormous room, on the first floor of the bank, in which his diploma as Commendatore, signed by the king of Italy, had pride of place. Adjoining the office, two very spacious waiting rooms were bursting with people waiting to see him. The ballet of secretaries constantly entering and leaving, and him giving them orders, completed the image of power."[16] Certainly, since the end of the war, Commendatore Krausz, head of the Banca Commerciale Triestina and honorary consul to Sweden, radiated success. As head of his institution, he controlled the daunting concatenation of interests at the heart of economic life in Venezia Giulia, and he conferred daily with the city's power brokers, including Arnoldo Frigessi di Rattalma, director of the Riunione Adriatica di Sicurtà, Edoardo Morpurgo, president of Assicurazioni Generali, and Alberto Frankfurter, the director of Lloyd Triestino. Apart from Cosulich, they were all, like Ernesto Krausz, Jews of Austro-Hungarian origin.

In Rome, some shrewd Triestines had jockeyed to prominence in the Fascist apparatus. Claudio Suvich, for instance, was undersecretary for finance; Igino Brocchi, the main private secretary at the ministry of finance; Vittorio Fresco, a member of the Fascist Party's national committee; Francesco Giunta, head of the Fascist squadrons, then undersecretary to the president of the council of ministers; Bruno Coceani, secretary of the Unione Industriale Fascista della Venezia Giulia; and Carlo Perusino, federal secretary of the local Fascist Party.[17] These men, with their direct access to Mussolini,

were crucial relays for Trieste's industrialists, whose absolute and unstinting favor they enjoyed: Giunta was named president of the Cantieri Riuniti dell'Adriatica; Fresco, a member of the board of directors of SICMAT (Brunner Group) and of the Riunione Adriatica di Sicurtà; Perusino sat on the board of directors of Lloyd Triestino.[18] On April 30, 1927, the "Labor Charter" (officially entitled *An Original Contribution to the Evolution of Humanity*) divulged the regime's basic philosophy "for maintaining social order": it placed "the supreme interests of the nation over those of individuals or groups" and made "guarantees to private enterprise, on condition that it agrees to serve the views of fascism and the directives of its leader, as determined by the collective interest."[19] The government, in other words, offered employers a secure market and protection against labor demands but in return, required total allegiance to its dictates. As a consequence of these new interventionist policies, Ernesto Krausz was directly targeted.[20]

If Commendatore Krausz at all recognized how utterly Trieste's new political and economic alliance had sidelined him, he didn't show it. He was, perhaps obliviously, flanked by pilot fish sent by the Italian government to amass power in the BCT. Among these were Sergio Segre, Carlo Hermet, and especially his right-hand man and deputy director, Nazario Peterlini, an unrepentant Irredentist who never passed up a chance to proclaim his orthodoxy. "In honor of the new period we are entering," Peterlini wrote to Scaramanga d'Altomonte, president of the board of directors, "the first act of the Banca Commerciale Triestina to ensure its future and its prosperity must be to terminate its contract with the Wiener Bankverein . . . a contract that now proves superfluous and wholly out of step with the current situation."[21] It was no mean feat for Ernesto Krausz to maintain his authority in the face of these changes. He knew perfectly well, as his son later said, that "Peterlini, like other pro-Italian Triestines who had fought in the Italian army," envied his position. "No one questioned my father's intelligence or abilities," Crane added, "but after all, even though he had never been in uniform, he had spent the war in Vienna and, more than anything, he wasn't a native Triestine!"[22]

The government's Italianization of Trieste included opening local branches of Italian banks and tightening its grip on the nation's industries. The free-port economy, choked off since relations with the hinterland were severed, continued to decline, provoking a chain reaction. The world financial crisis of 1929 would strike hard at the businesses of this already devas-

tated region, causing more dark clouds to gather over Ernesto Krausz's suc-
cess. But not until 1938 did Italy's anti-Semitic laws definitely remove any
remaining Jews from official posts. And indeed, Commendatore Krausz,
with his ballet troupe of secretaries and bustling waiting rooms, would find
himself in the eye of a storm about to break over the whole city. While the
postwar years had fostered the impression of prosperity and the illusion of
serenity, the first cracks in the façade began to show in 1928. The Cosulich
Group, weakened by slowdowns at its Monfalcone shipyards, applied for a
loan of 62 million lire. One year later, Arminio Brunner requested 20 million
lire to bail out his cotton mills. Several months after that, the Banca Com-
merciale Triestina was forced to ask the Credito Italiano for a loan. Finally, on
December 21, 1928, the Brunner Group declared bankruptcy, 43 million lire in
debt—a collapse so brutal that some described it as an "utter and absolute
disaster, almost divine retribution." This bankruptcy produced a domino
effect among the other Triestine businesses, spreading to the Brunner Hold-
ing Company, the Banca Commerciale Triestina, Cosulich SA, and the Stabil-
imento Tecnico Triestino (STT), which comprised the Cantieri di Trieste and
the Fabbrica Macconeria San Andrea.[23] The crisis grew so dire that on Febru-
ary 22, 1929, the prefect of Trieste held an emergency meeting to address
the situation, attended by Edoardo Morpurgo, president of the Assicu-
razione Generali, and Arnoldo Frigessi, director of the Riunione Adriatica
di Sicurtà—both members of the Banca Commerciale Triestina's board of
directors—as well as Camillo Ara, the bank's president, and Ernesto Krausz,
its director. To help stem the catastrophe, in 1930 the Banca Commerciale
Triestina was forced to disburse the astronomical sum of 800 million lire—
the equivalent of 1.2 billion in today's euros, or roughly 1.7 billion dollars!

Was self-delusion and shortsightedness to blame, as so often in economic
meltdowns? The region's relative financial and industrial stability from 1926
to 1930 might explain the general bullishness—for even after the Crash of
1929, there were still orders on the Triestine books.[24] On February 12, 1932,
Ernesto Krausz issued a communiqué, signed by every member of the board
of directors and addressed to his entire staff:

> At yesterday's meeting, the board of directors resolved to pro-
> pose to the assembly that our institution merge with the Banca
> Commerciale Italiana and become incorporated into it. This res-
> olution addresses the necessity, imposed by the general economic

situation, to combine similar organizations. We must submit to this necessity, though regrettably it means relinquishing our institution's independence and adopting cost-cutting measures mandated by our new partners. It is our greatest wish, and we shall make every effort to ensure it, that the majority of our employees find positions on the staff of the BCI. For the others, we shall work in good faith with your trade union representatives.[25]

The Banca Commerciale Italiana, on the other hand, announced in the minutes of its board of directors' meeting of February 10, 1932, that "the staff of the Banca Commerciale Triestina comprises roughly 280 employees, all of whom will be laid off . . . As for Director Krausz, whose contract does not expire until 1936–37, our plan is to use him in our Hungarian branch, which is currently undergoing a major restructuring that implicates much of the upper management . . . The former General Director, Dr. Halmi, a highly valuable asset, shall be named General Director. To date, the officials we have appointed to the Ungara-Italiana bank have been individuals of second rank. Mr. Krausz, who is by contrast a valuable asset and speaks fluent Hungarian, could step in as temporary replacement for the General Director when needed."[26] The press reported the developments laconically: "On Thursday, April 11, 1932, the board of directors of the BCT met to approve the budget for 1931, which closed with a net profit of 1,413,530.50 lire. A merger was proposed with the Banca Commerciale Italiana, which already holds all the Triestine shares: this arrangement does nothing more than implement a de facto situation."[27]

Too Hungarian for the Austrians, too Austrian for the Italians, too Triestine for the Romans, too much a parvenu for Trieste's Two Hundred Families, too arrogant for his in-laws, Ernesto Krausz navigated among many half-welcoming groups, gaining full admittance to none in a series of national, political, and social dead ends. He arrived too late in the course of Trieste's enrichment to build a fortune like that of the Daninoses, the Frigessi di Rattalmas, the Brunners, the Toplitzes, or the Stocks. If his career ran full tilt when Trieste was a prosperous nexus of the Austro-Hungarian Empire, if it raced unimpeded when he became director of the Banca Commerciale Triestina, it stalled and broke down with the collapse of the Viennese economy. In this city of irreconcilable interests, which preserved all the unresolved conflicts of old Europe, Ernesto Krausz, despite the outward trappings of social

status, remained one of the situation's most naïve protagonists, a vulnerable pawn disguised as a knight in a chess game of continental proportions.

Amid so much professional turbulence, he did manage to keep up appearances, but in his heart of hearts he knew he was floundering. Resolving to create a safety net for his elder son, Ernesto secured him a job at an insurance firm. In the Triestine business world, insurance companies held a solid and privileged position: first conceived in the eighteenth century, they acted as crucial guarantors for maritime shipments. Local branches were set up abroad, but always with Trieste as headquarters, prefiguring the first "multinationals in the full sense of the word."[28] In 1923, Assicurazioni Generali and Riunione Adriatica di Sicurtà had forced the repeal of the 1912 *lege giolittiana* (which made life insurance a state monopoly in Italy), allowing the companies to keep operating within the former Austro-Hungarian Empire.[29] By 1930, they had become too powerful to tolerate national restrictions on their activities and had created for themselves a protected industry, a kind of industrial oligarchy beyond the control of the Fascist state. Realizing that his son must have a career safe from political hazards and economic instability, Krausz *père* quite shrewdly settled on insurance.

Ernesto's reasoning, however, utterly escaped Leo, who at twenty-three remained a pampered and frivolous scion, understanding neither his father's own perils nor the political and economic atmosphere more generally. As his later remarks made clear, his grasp of the situation never deepened. "My father—being by that time very much involved with the whole economic life of the city and trying to direct my career—felt that I should follow more or less in his footsteps. He was a director on the boards of many important enterprises there: oil refineries, insurance companies, shipping companies, and so on. Well, there were two particularly gigantic insurance companies with world identification in Trieste, one of which my father had some control in, being on the board. He felt that that would be the most interesting career that I could embrace . . . So I got into that insurance company."[30]

And so it was only reluctantly that Leo Krausz, on July 9, 1930, dropped off an application and CV at the Assicurazioni Generali's headquarters. A week later, he was called to complete a questionnaire. His answers speak volumes about the depths of nepotism in Trieste. Question number 18: "Do you have any relatives or acquaintances in upper management or on the board of directors, or who are executives or employees of this company?" Leo, never mentioning his own father, replied: "I know people in upper management

ASSICURAZIONI GENERALI - TRIESTE

SOCIETÀ ANONIMA ISTITUITA NELL'ANNO 1831

Capitale Sociale interamente versato L. 60,000.000

AMMINISTRAZIONE

DOMANDA D'IMPIEGO

Registrata sotto il N.

All' On. Direzione delle „Assicurazioni Generali"

TRIESTE

Il sottoscritto, desiderando di ottenere un impiego presso codesta Compagnia, fornisce qui appresso le richieste indicazioni convalidandole con i documenti allegati alla presente.

Il sottoscritto stesso dichiara di assoggettarsi, per il caso di sua assunzione, incondizionatamente alle norme vigenti per il personale addetto agli Uffici di...

Domande della Direzione:	Risposte dell' aspirante:
1. Qual'è il vostro nome e quali sono i vostri titoli?	1. *Leo Krausz laureando in legge*
2. Dove ed in qual giorno, mese ed anno siete nato?	2. *Trieste, 4 settembre 1907*
3. Qual'è l'attuale vostro stato di salute? Quali malattie avete avuto?	3. *Ottimo Scarlattina, appendicite.*
4. a) Quale è il nome, il domicilio, la professione di vostro padre? (Secondo i casi queste indicazioni sono da fornirsi rispetto alla madre avente la patria potestà, oppure rispetto al tutore).	4. a) *Ernesto, direttore Banca Commerciale Triestina, Trieste*
b) Che età hanno i vostri genitori?	b) padre *53* madre *45*
c) Se i medesimi non sono più in vita, a quale età e di quale malattia sono morti?	c)

Leo's application for a position at Assicurazioni Generali

and on the board of directors, Doctor Salvatore Besso and Doctor Weiss." On January 7, 1931, Leo Krausz started work at the Assicurazioni Generali in Trieste, a job about which he would never have one good word to say. "I found it just terribly boring. Since everybody there was very friendly, the older friends of my father, they really did not exact much from me (which was wrong of them). I was just around; and if I didn't do anything, they wouldn't feel that they should tell me to be serious. So that job didn't go very well. I was still very interested in reading, in literature. I was there for about one year."[31]

Ernesto Krausz, embarrassed by his son's lackadaisical attitude and deeply concerned about his own uncertain future in Trieste, took steps to send Leo abroad. "I do not see the point for someone so inexperienced in the insurance

ERNESTO KRAUSZ
DIRETTORE CENTRALE
DELLA
BANCA COMMERCIALE TRIESTINA

Trieste,10 gennaio 1931-IX.

Illustrissimo Signor Presidente,

 non essendomi stato possibile - causa la
Sua assenza - di farLe visita personalmente, come avrei
voluto, colgo questo mezzo per ringraziarLa sentitamente
della sua gentile accondiscendenza che ha permesso a mio
figlio di essere assunto dalla Sua spettabile Compagnia
per Bucarest.

 Sono certo che mio figlio farà onore alla
distinzione che così gli viene accordata di appartenere
in qualità di impiegato ad una delle maggiori Compagnie
di assicurazioni esistenti, e con rinnovate grazie mi
raffermo

Illustrissimo Signore
Grand'Uff.Edgardo M o r p u r g o
Cavaliere del Lavoro
Presidente delle Assicurazioni
Generali
T r i e s t e.

Letter from Ernesto Krausz thanking Edoardo Morpurgo, director of Assicurazioni
Generali, for looking after his son's career

field to start in the Trieste office," Max Sanielevici, the Generali's director in
Bucharest, wrote to his Triestine colleague, a certain Sulfina. "I believe that
after having worked with us for at least a year, his *tirocinio* (training period) in
Trieste would be much more useful to him. In any case, I await your further
instructions."[32] But the suggestion that Leo might return to Trieste after only
a year did not sit well with Ernesto Krausz. "I am certain that my son will do
honor to the distinction granted him by becoming an employee of one of the
most prestigious insurance companies in the world," he obsequiously wrote
the *"Illustrissimo Signore Grand'Uff. Edoardo Morpurgo Cavaliere del Lavoro Presi-
dente delle Assicurazioni Generali Trieste"* on January 10, 1931.

 Meanwhile, Sulfina requested, "on behalf of Mr. Krausz, Sr., what would

APRIL 1932
Telegram requesting Leo's departure for Bucharest

be the approximate salary allocated for his son. I realize this is only an esti-
mate, but just to be clear, permit me to ask if the terms would be the same as
those you offered earlier to Mr. Debenedetti (1,000 lire a month plus lodg-
ings). As I mentioned in my previous letter, Mr. Krausz leaves the matter
entirely up to you. Personally, I would underscore that it would be desirable
for the young man, first, not to have to worry about his room and board, and
as to the salary, if you would kindly accept the figure of 1,000 lire per month,
Mr. Krausz would be very appreciative."[33] After endless negotiations about
residency papers, salary, and lodgings, and countless delays in Leo's depar-
ture for Bucharest (initially scheduled for January 1931 but put off month
after month), the Romanians began losing both patience and interest.

From Trieste, Sulfina stepped in to save the day, explaining that "Doctor
Krausz had already taken the necessary steps to ensure proper support for
his Romanian residency papers and [that] he was ready to leave." However,
he added, "owing to repeated absences from the office where, over the past
six months, he has acquired some experience, we deemed it best to keep him

here so that he could assist the office during said absences. I am certain you will not object if, for that reason, we delay the start of young Doctor Krausz's functions at the Generali in Bucharest for two or three months; during this period, the party in question can take advantage of his additional time with us to complete his training. At all events, Doctor Krausz will certainly be at the Generali's disposal by next autumn at latest."[34]

Imagine the web of tensions pressing in: widespread crisis in Trieste, the shuttering of the BCT, Ernesto Krausz's enforced departure for Budapest, and Leo with his nose ever buried in books! "When my father saw that things were going very badly there, one day we discussed the subject. I said to him that this really was not what I wanted to do, could I just switch and go back to studies and to study literature seriously. I was pretty good at foreign languages, and I could probably do something with that. There weren't many people who could speak so many languages. Since I could, probably I could get a professorship in English literature or something like that. I always wanted to do something more creative than that, but I thought that would be a good beginning. So my father said, 'All right, I'll let you do it. But please do me the favor of giving it another year. I'm going to send you abroad; and then perhaps being abroad, you'll find it more interesting and you might change your mind.' My father . . . was sort of precise and severe, but he understood problems . . . So I said, 'All right. Fine.'"[35]

Finally, on April 2, 1932, a relieved Sulfina could write to Sanielevici: "Doctor Leo Krausz, having spent time in the various departments of these offices, the workings of which were particularly useful for his future activities at the Generali, has now completed his training period in Trieste (which, truth be told, lasted well past our initial expectations) [and] can present himself at your offices at your convenience." The reply from Bucharest didn't take long: "EXPECTING KRAUSZ FIFTEENTH THIS MONTH: SANIELEVICI." On April 30, nearly two years later than planned and only several days before his parents' departure for Budapest, Leo Krausz finally left Trieste for Bucharest. Appearances notwithstanding, young Mr. Krausz had not wasted his time at the Generali offices, but what he learned there—to conduct his business affairs in a global economic context, like a "multinational in the full sense of the word"—would not prove its full value until some thirty-five years later.

9. BUCHAREST: FIRST BRUSH WITH THE AVANT-GARDE

More than a capital, Bucharest is a meeting place, a public square where
people come to do business, lodge protests, or beg for alms; to rap at the
door—formerly the prince's door, now the state's. You empty your purse
and fill up with the thoughts and customs of the East.[1]

PAUL MORAND

IN 1932, WITH Dada officially over for nearly a decade, Bucharest was still
burgeoning with the seeds its native son Samuel Rosenstock, a.k.a. Tristan
Tzara, had sown there. Tzara had carried his influence throughout Europe—
Zurich, Berlin, Munich, Cologne, Paris, Barcelona—since leaving the Roma-
nian capital in September 1915, but Bucharest had not forgotten him. In *Patul*
lui Procust[2] (1933), the writer Camil Petrescu described an iconoclastic open-
ing that had caused a sensation on November 30, 1929: "Throughout the
salon (whose walls were dressed in cardboard-colored burlap and illumi-
nated by some sort of small zinc pipes that resembled theater footlights) low
easy chairs in the American style stood, carved out of one piece of thick
wood in alternating slices of black and yellow. They all sported an easy air
of improvisation, of theatrical decor." The paintings, with their "geometry
of long rays and concentric circles,"[3] heralded the Apocalypse.

Meanwhile, the critic Tudor Vianu captured the musical atmosphere of
that legendary evening, sponsored by the avant-garde magazine *Contimpo-*
ranul with funding from the modern art collector, eccentric landowner, and
anarchist sympathizer Alexandru Bogdan-Pitesti: "The obscurity of the
salon [with its] multitude of guests in fluttering agitation . . . was suddenly
dispelled by a drum roll. The lights which then erupted revealed on the
stage, behind the master of ceremonies, a jazz band full of Negro musicians.
The sounds of strings, sirens and drums . . . Did the directors of the exhibi-
tion plan this first impression, the bewildering amalgam of tones like a

ARAD (RUMANIA), 1930
King Carol, CENTER, visits the Schapira train factory with Manole Schapira, RIGHT.

gigantic swarm of multi-colored butterflies? Actually, the jazz band assured that this was not a mere theatrical effect but a true instance of modernist ritual, that Dadaist manifestation."⁴ Indeed, the men responsible for the fur-niture's functional aesthetic were none other than the artists Max Herman Maxy and Marcel Janco, who had worked, respectively, in Berlin with the Constructivists and in Zurich with the Dadaists.

The Bucharest where Leo Krausz (finally) settled bore no relation to the Trieste of Mussolini. If, like Trieste, Bucharest was a provincial, gaudy, mul-tiethnic, and thus heteroclite capital, dotted with grimy tenements, it also remained, with its Cubist houses, a city in full artistic ferment. Since the end of the war, with the annexation of Transylvania, Bessarabia, and Bukovina and the formation of Greater Romania, it had seen hundreds of thousands of Hungarians, Germans, and Ukrainian or Russian Jews flood in, tripling its population. Given the country's natural wealth of raw materials (petroleum, silver, lead, gold), the capital prospered in the 1930s. Stunning examples of diverse international architecture sprang up, a sign that "Romanian artists, writers, and subsequently architects . . . demonstrated, through their atti-

tudes and their work, their desire to participate in Romania's global integration."[5] Every day, along the banks of the Dambovitza, booksellers came to flog their old volumes and weavers to hawk rugs. In nearby Calea Victoriei, the city's most elegant and bustling street, with its public buildings, luxurious residences, and gorgeous display windows, the "dense crowd . . . moved leisurely, like lava," wrote Sasha Pana. "I could hardly make my way through it . . . In the window displays sat plates of boiled sturgeon (that made your mouth water) and tins of black caviar . . . and who knows what other delicacies. But the newspapers spoke about misery and suicides, about hungry people."[6]

While the elite lunched at the Capsa or the Terasa Otelesteanu, on Baratia Street near the Piata Mare (the central market), the blue-collar Café Enache Diu became a magnet for modernists. "There," said Pana, "around [the poet Stephan] Roll, for the last four years gathered all the iconoclasts of a time which none will forget as long as they live. There was the most original literary circle that Romania ever knew, and perhaps not from our country alone."[7] It was the birthplace of *Unu,* the magazine that chronicled the Romanian vanguard's passage to Surrealism. After *Simbolul,* founded by Tristan Tzara and Marcel Janco in 1912, Bucharest saw a flowering of other avant-garde periodicals in the 1920s, with titles like *Contimporanul, Integral, 75 HP, Punct, Unu,* and *Urmuz*—all forums in which Romanians, Russians, Dutchmen, Frenchmen, and Germans proclaimed their radical manifestos, where Dada crossed paths with De Stijl, Constructivism, German Expressionism, and Russian Futurism, and in whose pages activists demanded that "the streets be used as a school for aesthetic and moral education."[8]

By 1933, not only would Romanian artists and intellectuals be in sync with developments in Vienna, Berlin, Paris, and Amsterdam; some, like Constantin Brancusi, Tristan Tzara, Marcel Janco, and Victor Brauner, had even spawned some of the most explosive cultural movements that Europe had seen in the past two decades. A talented diaspora, infusing Romania with foreign effervescence, granted Bucharest pride of place in the European avant-garde. Tristan Tzara continued to travel and delight audiences, as an early comment by Louis Aragon attests: "As we entered the salon on Rue Emile Augier . . . the door to the next room opened to reveal a short, dark man who took three quick steps, then halted . . . It was Tristan I had just seen . . . So here he was, the agitator we had summoned to Paris; the one who, wearing kid gloves in his photo, looked so much like Jacques Vaché; the

one whose poetry was often likened to Rimbaud's—and that was saying something. A slender figure with his elbows glued to his sides and slender, half-open hands at the end of outstretched forearms, he looked like a night bird startled by daylight, a shock of black hair continually falling over his eyes . . . He spoke . . . rather slowly and incorrectly, with a thick Romanian accent: I remember he said *Dada* in two short, sharp syllables, and it was Théodore Fraenkel who taught him how we say it here."[9] Tzara was unmatched in his powers of transgression and radical challenges, provoking such reactions throughout Europe: from Max Ernst and Otto Freundlich in Cologne; Francis Picabia in Barcelona; the Constructivists and the Bauhaus in Weimar (Cornelis Van Eesteren, Kurt Schwitters, El Lissitsky, Lazslo Moholy-Nagy, Hans Arp, Van Doesburg); Hugo Ball, Arthur Cravan, Marcel Duchamp, Man Ray, and Surrealists such as Crevel, Aragon, and Breton in Paris.

Such was the atmosphere in Bucharest, as Leo Krausz prepared to embark on his four-year sojourn. After the daily barrage of propaganda from the Mussolini dictatorship, the young insurance agent couldn't have wished for a more congenial atmosphere—so consonant with his own literary curiosity— than the monarchy of Carol II. Posted at the Generali, Krausz, working under Sanielevici, sold life insurance all over Europe—the daytime hours a slow death by boredom. But in the evenings, he socialized. Backed by his father's contacts, he was invited for instance to Alberto d'Agostino's, director of the Banca Commerciale Italiana and Ernesto Krausz's former colleague in Trieste. The young Krausz would soon find himself in the finest circles of Bucharest society, in particular a regular at the home of the Schapiras, one of the most well-to-do families of the Jewish haute bourgeoisie. "There was a certain literary culture, French culture, because French was a great influence in Romania," he recalled, without going into much detail. "They had a good library in which you would find all the French classics."[10] The Schapiras' granddaughter, Mariève Rugo, is more explicit about the family's social station: "Between the World Wars, there were three classes in Romania: the aristocracy, the peasants, and a small middle class composed of academicians, doctors, some successful merchants, and a few very wealthy Jews. Because Jews controlled much of the industry and most of the banking, the richest Jews were accepted everywhere even as, in this deeply anti-Semitic country, they were resented. When my grandfather's railroad empire had expanded sufficiently, it became convenient for the aristocrats to treat him as

one of their own. He and my grandmother were invited to every important dinner party, every ball, every reception at the palace. In time, he became financial advisor to King Carol . . . Entertainment was lavish in Bucharest, even by the standards of the rest of Europe. One New Year's Eve, my grandparents gave a dinner party for sixty; there was a footman behind each chair and a favor from Cartier beside each plate: for the ladies, gold compacts; for the gentlemen, gold cigarette cases."[11]

Mihai Schapira, an astute businessman, was a powerful figure in his country. In 1919, he had made "enough profit to begin construction of his own factory in Arad, a small town near the Austrian border. It was the first plant in the country designed to manufacture railroad cars and with it, [Mihai] began to realize his lifelong dream of becoming a railroad baron. He never doubted that his position as one of Romania's leading industrialists gave him such power over his family as he wielded over his subordinates at Astra Vaguana, his largest company. He had gone almost completely bald in his thirties but somehow it suited him. His long face, his intense black eyes with large pouches under them, his hooked nose above a small moustache, made him resemble an Oriental pasha."

He lived at 8 Strada Victor Emmanuel, next to the German embassy, with his wife, Marianne, an elegant, educated, refined woman of Viennese intellectual stock, and their two daughters, Eve and Ileana, as well as numerous servants. His big Frenchified house was "surrounded by an eight-foot iron fence; its gate was attended twenty-four hours a day by a man in a little guardhouse. The semicircular driveway led to a French door covered by an elaborate wrought-iron grille. The interiors were filled with tapestries, Aubusson carpets, antiques, and paintings from France and Italy. The entrance hall was large enough for people to dance on its peach-and-buff marble floor to the strains of an orchestra tucked under the stairs. The dining room sat twenty, and at the head of the long table adorned with flowers, its white cloth laced or embroidered, [Mihai] Schapira presided across from Marianne. Light from the chandeliers glinted off her reddish-gold chignon; her dark eyes watching Mircea, the butler, as he leaned over to serve the bowls of pale grey caviar. She was ever obliged to quiet her bickering daughters. Eve might have just told her sister (Ileana) that were she living in Paris, she wouldn't think of coming to lunch in such a dreary dress. In return, Ileana could have reminded Eve she had never passed her baccalaureate. 'Chéries,' my grandmother murmured, 'for once, can't we have peace?' "[12]

In this sumptuous environment, Leo Krausz would thrive. He first courted Eve, the older sister—and the more outgoing if also the more superficial of the two—who was considered to be the most beautiful woman in Bucharest, a city of great beauties with slightly exotic, near-Eastern looks, around which "hung the taste of the harem."[13] According to her daughter, Eve Schapira was "small, shapely and sultry. Her face was oval, with pronounced cheekbones, absolutely black eyes, a large nose, a wide mouth. She bought her clothes in Paris, at Patou or Schiaparelli or Lanvin; she had her hair done every day; her father had given her beautiful jewelry. She worked and planned tirelessly to create for herself a setting in which she gleamed like a pearl on black velvet."[14] After not quite succeeding with this gem, Leo Krausz turned his attention to her younger sister, Ileana. She was impish, refined, and determined to make a life away from Romania. When the family vacationed in Paris, Vienna, or Venice, while her older sister immediately hit the shops, Ileana begged to spend her time in the museums.

"In the city of Bucharest, I was truly happy," she recalled many years later. "As a child, I would watch the gypsies from my window and see a mass of swirling colors. I loved calling them over and buying their flowers. The men would offer us their excellent yogurt, which they carried on their backs in huge sacks. At around three in the afternoon, peasants with huge baskets on their heads brought us hot corn on the cob. And there were carriages drawn by horses wearing striped ribbons, flowers, and other ornaments. The coachmen belonged to a Russian religious sect; some were ascetics, and others (whom we called 'muzhiks') were eunuchs who wore long garments of dark velvet, with wide belts of white, pink, and blue silk and two scarves floating at their sides. In my family, we lived in luxury. We were spoiled, but our education remained very strict . . . For instance, if you wanted to make someone's acquaintance, the person had to visit your house no later than a week after your first meeting to drop off his calling card. It was totally ridiculous. And if you wanted to pursue a romantic relationship, you had to announce it by visiting her people. So Leo came to my house and my parents invited him to dinner. Since I found my life rather stifling, I had only one wish: to get married. As a child, I'd always known a stranger would come and take me away. I met Leo. He wasn't like everyone else. He was going somewhere. He was going to leave Romania, and as I wanted to get out of Romania at any cost, I married him."[15]

Even though her family nicknamed her "Mausi" because she was short

BUCHAREST, 1930
Mihai Schapira, Leo's future father-in-law, a formidable businessman with the air of an Oriental pasha

(perfect for Leo!), even though she felt rivalrous with her dazzling sister, Ileana was herself beautiful, sophisticated, elegant, and rich. She was also, as Leo would discover, provocative, willful, whimsical, and curious; all the more, she cut a splendid figure in Schiaparelli, with an oval face like her sister's and magnificent brows arching above her dark, alluring eyes. But unlike her sister, she detested the social standing imposed on her by her family and the conventions of her milieu. For her, Leo would be a marvelous getaway accomplice, the key to her escape from the Schapira family, from Bucharest, and from Romania. Never would she harbor the slightest nostalgia for her native land, or even her native tongue. Moreover, she was already a seasoned European traveler, who at seventeen felt at home in Paris, Venice ("where we stayed at the Excelsior Hotel"), Rome, and Vienna (her mother's native city), pursuing everywhere her education "based on reading, the theater, and trips to museums." Like all well-educated Romanians, she spoke perfect French, which undoubtedly endeared her to "young Mr. Krausz."

On October 7, 1933, Leo Krausz married Ileana Schapira at the town hall of Bucharest. Two months later, during the Christmas holidays, the two families officially met at the Krauszes' apartment at 20 Nyul Utca in Budapest. "My parents had very mixed feelings about Leo's marriage," George Crane recalls. "Ileana's family was so much more worldly than ours, so superior socially! We were terrified of making a faux pas, not living up to their standards. Everyone was in a tizzy before their arrival, because we were intimidated by the difference in standing. Where should we greet them, and how? What made it worse was that Mr. Schapira always acted like he was a big shot and made you feel like there was no one in his class. And he had to be entertained all the time! One day, Ileana caught a chill, so I dumped my coat on her shoulders. I felt so clumsy! But she thanked me with such grace."[16] In this alliance, which would take both families far, a certain power struggle would appear over time; we'll return to it later. Clearly, with his contract job at an insurance company, his monthly salary of a thousand lire, and his free room (thanks to a hard bargain by his father before he left Trieste), Leo Krausz had indeed "married up." The young couple's apartment in Bucharest fascinated his brother, Giorgio: "very fancy, very elegant, where one was very well received, thanks to several servants!"[17] Meanwhile, Ernesto Krausz, now a mere associate director at the Banca Ungara Italiana in Budapest, no longer enjoyed such social pull as he had in Trieste.

While his father was suffering his tribulations in Hungary, Leo, the newest

BUCHAREST, 1933
Ileana Schapira, age seventeen, at the time of her engagement to Leo

VIENNA, 1933
At Eve Schapira's wedding, Mihai Schapira, SECOND FROM LEFT, TOP ROW, is surrounded by his seven brothers and sisters.

member of the Schapira clan, was enjoying the high life. "We didn't have much in our heads," he later admitted, and Ileana amplified: "We lived like a couple of senseless kids. We wanted to move into a nice building with modern furniture, like the kind we'd seen in French magazines. We also wanted to buy drawings by major artists, since we didn't have the money to buy paintings—one drawing by Matisse and one by Picasso, the main artists of the time. It wasn't about interior decorating, but about culture."[18] So hereafter we find Mr. and Mrs. Leo Krausz at the wheel of a fabulous automobile or in St. Moritz, Venice, Vienna; or crisscrossing Romania, ferreting out small artistic finds. We find them in hamlets with names like Olari and Horezu. We find them skirting the Carpathians in Walachia, on the Timisoara road, looking for colored ceramics issuing from a thousand-year-old tradition handed down through generations of potters. Leo and Ileana fell in love with those old plates and pitchers, decorated with spiral-shaped

BUCHAREST
The Schapira mansion, 8 Strada Victor Emmanuel

sun symbols in ochre and iridescent green. "You would spot them as you would go through the peasants' homes; and you would offer them a modest sum, which seemed enormous to them!"[19] They also searched for painted chairs from the eighteenth century that barely looked like chairs. With their passion for the folk art of the Széklely, the carved wooden doorframes of Sighetu Marmatiei, the frescoes of the Oltenia monasteries, and their first purchase of a Matisse drawing, they had indeed taken their first steps as collectors. Iconoclasm, refusal of convention, love of subversion, insatiable curiosity, juvenile humor: from that young couple unmistakably emanated a Dadaist streak. Meanwhile, on January 30, 1933, Hitler seized power in Germany, and on April 11 the Bauhaus ended its experience. Thanks to Alberto d'Agostino,[20] Leo was offered a job at the Banca d'Italia in Bucharest with the promise of a rapid transfer to Paris. Finally, in the middle of the year 1935, Leo and Ileana Krausz took off for the French capital.

10. FROM NEUILLY TO PLACE VENDÔME

A place unique on Earth. You can visit London, Amsterdam, Madrid, or Vienna, and you'll still see nothing like [Paris]. You can find everything there. Especially for a young man in his twenties with fifty thousand pounds in the bank, it is a magical place that he will never want or be able to leave . . . This enchanted abode is a luxurious town, surrounded by a large city.[1]

LOUIS-SÉBASTIEN MERCIER

IN JUNE 1932, Paul Valéry delivered the traditional scholastic awards address at the Lycée Janson de Sailly in Paris. "You happen to be living in a very interesting historical period," he told the students, adding the warning: "An interesting period is always a worrisome period, not conducive to rest, prosperity, continuity, or security . . . Never has humankind joined so much power with so much confusion, so much anxiety with so many toys, so much knowledge with so much uncertainty."[2] Despite its enchantment, Paris in the early 1930s was a city in crisis; between 1928 and 1938, successive devaluations had cut the value of the franc in half, and the political establishment was uninformed and ill equipped to handle the situation. Recalling the hardships his gallery faced, the art dealer Daniel Henry Kahnweiler confirmed that the Crash of 1929 introduced "seven years of lean cattle," and testified to "that horrible sense that everything had lost its value . . . We sold nothing . . . We would sit in that gallery for whole days without seeing a soul. All this would have been relatively bearable if I had not had the responsibility of the painters. I did not want to desert them . . . It was then that we invented an organization that we called the 'artistic mutual-aid syndicate,' which consisted of a group of friends. Each one gave so much per month. The gallery distributed this money to the painters . . . [and] deducted a small percentage from this sum in order to keep going . . . This is how we kept the painters alive until about 1936."[3]

The impact of the economic crisis felt in Paris echoed a more serious crisis that affected the entire country, a profound structural flaw that afflicted all of Europe and that, according to one economist, expressed the "explosive divorce of two worlds: the productivist world of the twentieth century, announced by the economic boom in the 1920s, and the world of the nineteenth century, in which pressure on salaries and consumption was the rule."[4] In addition to these economic discontents, the French right-wing parties, bucked up by Hitler's rise to power, ridiculed the "ministerial waltz" of the Third Republic (eight prime ministers between 1934 and 1938) and took action on February 6, 1934, when they tried to storm the National Assembly; the riots left fifteen dead and fifteen hundred injured. Six days later, a massive general strike and demonstrations by Socialist and Communist militants confirmed the awakening of the left, resulting two years later in the rise of the Popular Front.

With Jean Zay, the French government acquired a minister of public education and culture with classical tastes: he hung original Bonnards in his office on Rue de Grenelle[5] and would, through numerous associations (such as the popular Association of the Friends of Museums) democratize public access to museums and theaters. With the advent of mass culture, cult films by Marcel Carné and Jean Renoir—*La Bête humaine, La Marseillaise, Grand Illusion, Le jour se lève, La vie est à nous*—and actors such as Michèle Morgan and Jean Gabin, who embodied the working classes of Paris's blue-collar suburbs, fired the imagination of mainstream audiences. Meanwhile, in Munich, Hitler inaugurated the Entartete Kunst exhibition, which denounced avant-garde painters as "harboring values that would erode the Aryan race," just as Bauhaus members such as Moholy-Nagy and Josef Albers left for the United States, the former heading to Chicago for the New Bauhaus, the latter to Black Mountain College.

While economic fluctuations sent shock waves throughout the art world, the 1930s proved a golden age for literature; France abounded in editors and writers who published, traveled, critiqued, and wove the history of their times. In less than five years, Céline, Malraux, and Sartre published four of the century's key works: *Journey to the End of Night, Man's Hope, Nausea,* and *The Wall.* The year 1935 saw the literary tribes gather, the jubilation of the united left, the assemblies of European artists at the Amsterdam-Pleyel antifascist rallies. On June 23, at the Palais de la Mutualité, André Gide, André Malraux, Louis Aragon, and Paul Nizan, side by side with Aldous Huxley, E. M. Forster, and Isaac Babel, their fists raised in salute, welcomed

the first bars of the "Internationale" before a rapturous crowd. For five days, French and foreign writers from every part of the political spectrum debated and discussed; only Montherlant, judged too reactionary, had been excluded. The venerable Henri Barbusse intoned the message that Gorky had sent from Moscow; Aragon, as a good ex-Surrealist, said a few words in memory of René Crevel, who had committed suicide only days before; and Breton's text tried in vain to rally the crowd in favor of Victor Serge, then held in a Soviet prison.[6]

Several months later, a massive mobilization of writers, artists, and intellectuals alerted the French to the fate of the Spanish Republicans. In the pages of *Ce Soir,* Paul Nizan reported the fall of the Hotel Colón, the militia's headquarters, while André Malraux formed an air squadron and recorded the battles of Sierra de Teruel for his film *Hope.* Picasso accepted his government's commission to decorate the Spanish pavilion at the 1937 International Exposition: only several days after the tragedy, he depicted in a black-and-white mural the massacre of Guernica by pro-Franco forces.

Intertwining literature, philosophy, and visual arts, the avant-garde periodicals related the aesthetic and social evolutions of the remaining avant-garde movements, henceforth censored by European Fascist states. In the pages of *Plastique,* César Domela and Hans Arp introduced their social project—half Dada, half Constructivist—and continued to champion non-figurative art; in *Les Réverbères,* Michel Tapié and Noël Arnaud tried to revive Dada through gatherings, books, and records, while *XXe siècle* provided a forum for Kandinsky's essays on concrete art and Christian Zervos gave *Cahiers d'art* a pluralistic bent. "We're not trying to resuscitate Dada," explained Jean Van Heeckeren. "Dada never died . . . It just got buried under the Surrealist catafalque. Dada, when understood properly, is total liberation."[7] Such statements and sensibilities would have a profound impact on Leo and Ileana, who, sailing between museums and galleries, developed their taste in the zone between the abstraction of Klee and Kandinsky, the Surrealism of Miró, and the Dadaist loyalties of Tapié.

Having arrived from Bucharest in a sleeper car on the Orient Express, Mr. and Mrs. Leo Krausz seemed to share neither the economic woes nor the political upsets of French society. They moved into a large apartment in affluent Neuilly-sur-Seine, courtesy of Mihai Schapira. In addition to the traditional house staff (two chambermaids, a cook, a laundress), they had a chauffeur and an Italian majordomo, hired in Milan by Leo's brother, Gior-

Place Vendôme, Paris circa 1930, during the installation of the René Drouin Gallery

gio. In this privileged suburb just west of Paris, their neighbors included Wassily Kandinsky, another Bauhaus refugee, who enjoyed watching the barges drift gently up the Seine; they passed by the "studio" on Rue St.-Jacques where, fifteen years earlier, Jacques Doucet had composed his famous collection, with the *Demoiselles d'Avignon* as its first gem. The furnishing (Art Deco style) of the Krauszes' apartment was entrusted to René Drouin, who had recently emerged as one of the most admired interior decorators in Paris. He edited the "Decoration" and "Exhibitions" columns of the magazine *Architecture d'aujourd'hui,* and would soon display his own aluminum furniture at the Salon des Artistes Décorateurs. The first act of the Krauszes' Paris sojourn proved true to expectations: Leo bided his time at the bank, but together the couple canvassed museums, galleries, antiques shops, bookstores, theaters, and the opera.

They saw Giraudoux's *Ondine,* with sets by Pavel Tchelitchew, and visited the exhibitions that opened in those years: Kokoschka at the Galerie Saint-Etienne, Masson at Kahnweiler's, Miró at the Maison de la Culture, Domela at Galerie Pierre, Cézanne at Bernheim-Jeune. At the 1937 Expo, they passed

by Picasso's *Guernica,* which faced the Calder fountain; appreciated Mallet-Stevens's Palace of Light; and loved Gallery 14 of the Jeu de Paume, devoted to foreign schools (Kandinsky and Klee). Finally, at the Galerie des Beaux-Arts on Faubourg St.-Honoré, they particularly delighted in the International Exhibition of Surrealism, enjoying works by Max Ernst, André Masson, Man Ray, and Kurt Seligmann, and especially Dalí's extravagant *Rainy Taxi*—an actual black taxi parked in the gallery courtyard near the entrance, artificial rain pouring inside it, while through the windows one could glimpse the strangely troubling scene of a reclining mannequin teeming with live snails.

One of Ileana's favorite events was the May 1937 opening of the gallery Gradiva on Rue de Seine, managed by André Breton and designed by Marcel Duchamp. René Magritte, who attended the opening with Marie-Laure de Noailles, recalled seeing "a chair covered in ivy and a wheelbarrow cushioned with red velvet in which one could sit very comfortably."[8] For *Harper's Bazaar,* Man Ray photographed both the Oscar Dominguez wheelbarrow, in which a model lounges wearing a lamé gown by Vionnet, and Wolfgang Paalen's astounding ivy chair. The Surrealist assault on the boundaries between art and design, or art and literature, captivated Leo and Ileana: Salvador Dalí's aphrodisiac telephone with a lobster receiver and his sofa shaped like Mae West's lips; Elsa Schiaparelli's jacket for her fall 1937 collection, based on a drawing by Cocteau, showing a woman's profile with gold embroidered hair by Lesage spilling down the right sleeve; Meret Oppenheim's "skinned" gloves veined in blood. "I loved going to places where the atmosphere was gay," Ileana recalled, invoking the happier moments of their Paris years. "We often dined in a restaurant near the Elysée palace where gorgeous models wore the latest gowns, straight out of *Vogue* or *Harper's Bazaar.* It was so different from life in Bucharest!"[9]

While the Krausz couple approached the art world via literature, fashion, and interior design, and while they shared the Surrealists' taste for provocation and oddity, what gained them entry into the Paris creative milieu was their network of childhood friends. From Bucharest, Ileana reconnected with Olga Tomasian, now married to René Drouin; from Trieste, Leo renewed acquaintance with Leonor Fini. Finally, Ileana's personal fortune allowed her to become a client of Elsa Schiaparelli, just like Marie-Laure de Noailles, the Duchess of Windsor, Gala Dalí, and Daisy Fellowes. "To be dressed by Schiaparelli," wrote the historian Dilys Blum, "was automati-

cally to acquire confidence and chic, whether one was beautiful or not. Schiaparelli's fashion philosophy was anchored in classical mythology, particularly Ovid and the Pygmalion myth, and in its stories of magical transformation and metamorphosis, themes also explored by the Surrealists."[10] By wearing Schiaparelli's "butterfly dress," "skeleton dress," "monkey boots," or "shoe hat," and by spraying herself with the designer's "sleeping perfume," was Ileana—a twenty-three-year-old Romanian heiress still incapable of expressing her identity and independence—starting to envision her own metamorphosis?

The news they heard from their respective families at the time was not reassuring. The Italianization of family names had been mandated by royal decree on December 3, 1934. An entry in the Trieste town register the following January 9 reads: "The Krausz family is hereby authorized to append to the name 'Krausz' that of 'Castelli' and to use the hyphenated name 'Krausz-Castelli.' "[11] In the summer of 1938, the sudden announcement of Mussolini's anti-Semitic measures caught unawares a Jewish population that had thought itself immune. Fascist pressure weighed more and more heavily: in Milan, Giorgio, now a medical student, received a letter from the Gruppo Universitario Fascista ordering him to attend Mussolini's upcoming rally, in uniform. (His cousin Piero Kern in Trieste received the same letter.) "I dressed up in a blue scarf, dark shirt, and purple socks," he recalls. "I looked like a clown!"[12]

In his Italian bank in Budapest, Ernesto Krausz was notified by the head office of the Banca Commerciale Italiana that, "in accordance with the general directive that bank employees may not sit on the board of a private company, [he would not] be confirmed in his position as trustee of the Soc. An. Forestale Triestina." He was also asked to "resign as vice president and trustee of the Soc. An. Triestina de Comm., Afenduli, and of the Soc. Industriale dell'Olio Ignazio Weiss."[13] In the space of a few months, Ernesto was removed from the boards of Prima Filatura Fiumana di Riso e Fabbrica d'Amido (on which he'd served from 1928 to 1935), the Riunione Adriatica di Sicurtà (1932), the Soc An. Commerciale Industriale e Finanziaria (Sagas) (1930–33), the Soc. An. Forestale Triestina (1928–35), the Soc. An. Triestina di Commercio Afenduli (Giorgio) (1930–35), the Soc. An. Triestina per l'Industria Meccanica (Satima) (1922–34), the Soc. Finanziaria Cosulich (1930–34), and the Soc. Industriale dell'Olio Weiss (I.) (1930–35).[14]

Finally, along with the "Commendatore Roberto Adler" and the "Cav. Uff.

Guido Schwarz," the "Commendatore Ernesto Krausz Castelli" was informed that he must resign from the board of directors of the Banca Ungaro-Italiana. "We regret being obliged to dispense with the collaboration of such meritorious colleagues, who have always demonstrated their devotion to our firm through their valuable efforts and unflagging support," the official letter mendaciously apologizes.[15] In July 1936, in Budapest, Silvia had married Miklos Reitter, a Hungarian Catholic. In Bucharest, the regime hardened, and Mihai Schapira, nobody's fool, quietly began transferring funds and buying factories in the United States.

Meanwhile, at the head office of the Banque d'Italie in Paris, Leo, now named Krausz-Castelli, grudgingly pursued his professional activities. In 1937, for example, he was assigned to spearhead market research into the advisability of offering traveler's checks in Italian lire on French soil. His first duty was to acquire a license and open an Italian travel agency in Paris; then find a suitable location, such as the ground floor of the Riunione building at 51 Rue de Châteaudun; and after that, establish a provisional operations budget, covering rent, patents, salaries for one manager and two assistants, and publicity costs. Finally, Leo met with his Italian superior, Professor Sacerdoti, to determine the best course for the project. The report preserved in the Banque d'Italie archives was unambiguous: "Doctor Krausz [sic] believes the Paris market for tourist lire is saturated, as they are sold by practically every bank and travel agency, as well as other Italian shops and agencies. The commission on these sales is 3.5, half of which is passed on to the corresponding agencies. The situation is different in the provinces . . . and Professor Sacerdoti has noted that the underwriters would not be interested in this work outside of Paris . . . As for the work of UTRAS in Paris," the memo concluded, "putting it into practice mainly depends on the relations that the Riunione[16] intends to maintain with ISTCAMBI regarding the sale of lire to tourists, as local interest in such an activity seems limited and costs are recouped only when the sale of tourist lire passes the sum of 4 to 5 million, which seems inordinately high outside of Paris."[17]

As for Ileana, despite her beautiful house, despite her readings (Flaubert, Balzac, Maupassant), despite her visits to galleries, museums, and designers, she slowly sunk into depression. She was an elegant young woman barely in her twenties, but isolated and going through what we could call a nervous breakdown. "I wasn't happy in Paris," she explained years later. "I always felt marginalized, out of place, a foreigner without a home of my own; I was

drifting. We didn't really have the opportunity to meet French people; they all lived in closed circles. As for the artists, they were interested in art, but not in people like us, landing from another planet. That world frightened me, or maybe I was just intimidated."[18] How can we explain the couple's evolution in these years? Ostracized in the upper echelons of society, forced to conform to the wife's traditional role in the family, passive and unable to find alternative outlets for herself, Ileana lost her bearings. Leo, meanwhile, didn't ask, didn't understand, didn't offer support. "Sometimes, to cheer myself up," Ileana continued, "I went out to buy hats at Schiaparelli . . . When I was by myself, depressed and idle, I had our driver, Ernesto Fratta, take me to the Bois de Boulogne so I could forget my depression. In the car, on the way there, I would sob, but since the windows were tinted I could let myself go without anyone seeing me. Ernesto kept my secret. And besides, my parents were so hoping for a grandchild, and I told myself I should have one because it was the rule."[19]

Nina, born in Vienna in 1937, was mostly raised by a governess. On the couple's return to Paris, their bonds slackened, though the estrangement happened gently, without bruising their great complicity. "We lived under the same roof but were free to do as we pleased. I wouldn't say we didn't get along, but we were both young and we formed other attachments," Ileana explained matter-of-factly. In Neuilly, she had an affair with Nina's pediatrician, while Leo took an apartment at St.-Germain-des-Prés on the Left Bank, on the ground floor of 80 Rue de l'Université. "Each went his own way," he commented. He went out, enjoyed himself, led a carefree life. "Leo was an extraordinary dancer," says his cousin Piero Kern. "I can still see him dancing the tango and the waltz with a beautiful Austrian aristocrat who clearly fancied him."[20] As for Ileana, despite her new relationship, she could not find her equilibrium. "I felt like my universe was about to end," she recalled, "and I had a very definite feeling that everything was going to change."

During the first months of 1939, in the midst of this improbable political, economic, social, and personal turmoil, Leo Castelli would find his path! How does a middling bank employee in his thirties, with an eighteen-month-old daughter and a failed marriage, become virtually an overnight success in the art trade—in a foreign country on the brink of war and economic collapse to boot? How did Leo Krausz, well read and articulate, charming and urbane, but also frivolous and a social butterfly, transform himself into Leo Castelli, art dealer? How, when for eight years his professional path impris-

oned him in administrative boredom, when his family life was in pieces and Europe was itself about to shatter, did he manage to branch off towards what would become, eighteen years later, his true vocation? It required daring, luck, sheer obliviousness, and a solid instinct for opportunity! Settling on a choice location, in Place Vendôme between the Ritz and Schiaparelli, he entered into a partnership with René Drouin. Their gallery took an original approach, mixing decorative arts and fine arts in the spirit of Breton's now-defunct Gradiva. Actually, Mihai Schapira, devastated by his daughter's separation from her husband, was trying to shore up the faltering couple. He lent Leo five hundred thousand francs; with this sum, on March 2, 1939, Leo formed a limited liability company, the Société René Drouin, in which he owned 490 shares and Drouin 10. Given the disproportion, we might wonder why the company was named after Drouin and not Castelli. Was it because of Leo's *Luftmensch* behavior, fostered by his years in Vienna, or his Italian passport, which required a French front man? More on this later.

Let's listen to Leo Castelli as he recalls the characteristic moments of his metamorphosis. Though he had been dancing on a volcano, he always presented this brief professional parenthesis as a magical episode, miraculously effacing the tragic context: "I knew Leonor Fini from Trieste; we had been childhood friends more or less. She found out about my project. She was extremely active in the Surrealist group at that time, and as soon as Dalí, Max Ernst, Tchelitchew, and so on, found out that we had this place, they rushed upon us like locusts and immediately had all kinds of plans for our first show. They would do panels, furniture, objects, all kinds of things. Drouin would make furniture. Since I was the specialist in antiques, I would pick bizarre antique furniture—special things that you would find with Surrealist designs—bizarre chairs, bizarre tables, and so on. That was my province. By April the gallery was not quite ready and the lights were not installed, but we showed one large painting that Tchelitchew had just completed, called *Phenomena*. We showed that by candlelight. So that was our first show, and then this other show came about. Oh, there were all kinds of things. Leonor Fini and Berman did two special painted cupboards. Leonor Fini's had doors that were like swans, lady swans. Berman's was a rather sinister setting that looked like a wild landscape, like something out of Canaletto—or rather Guardi, you know, those romantic landscapes. It was quite nice. Then Meret Oppenheim designed a table with legs that were the legs of some animal or bird—and a hand mirror that was all like hair, like locks. Leonor Fini

designed tall panels with all kinds of heraldic figures. There was all that antique furniture and then the modern furniture of Drouin's. We had a grand opening. That was our first and last show in that particular place. Then the war broke out. We all went away for the summer; and then, in September when we came back, the war had broken out and Drouin got into the army."[21] In her turn and in her way, Ileana also described the strange gap between political events and their personal concerns: "The opening of the exhibition was polemical. We were so carefree—what did the war matter to us? It was unimportant. What *was* important was what we were doing, which was so much more fun!"[22] Among the souvenirs left of that magnificent opening is the elegant white invitation card, on which Leonor Fini had drawn, in a continuous red line, volutes borne by five cupids:

> R. Drouin L. Castelli
> request the honor of your presence
> at the inauguration of their
> Galerie d'Art Décoratif
> which will take place from 4 to 9 p.m.
> on Wednesday, July 5, 1939
>
> RENÉ DROUIN
> 17, place Vendôme
> Paris

This is followed by the sober mention of "cocktails." The exhibition had an undisputable success in the foreign press. "The *Tout Paris* was invited to a private opening," Marcel Zahar wrote in *The Studio*. "This appeared to ennoble works by an interesting group of artists from the Surrealist milieu. We were pleased to see these artists' talents applied to decorative objects, such as wall panels and painted dressers. The results were original and elegant, and hint at possible future collaborations between painters and decorators."[23] *Harper's Bazaar,* in its September 1, 1939, issue, ran images by the fashion photographer Hoyningen-Huene captioned: "Amazing silhouettes against more amazing backgrounds at the new Galleries of Drouin and Castelli, on the place Vendôme, where Leonor Fini, Eugene Berman, Max Ernst, Meret Oppenheim, and other artists are creating modern decorations. Left, against a cabinet by Eugene Berman, Alix's dinner dress of black silk jersey with a

vous prient
de leur faire l'honneur
d'assister à l'inauguration de leur
Galerie d'Art Décoratif
qui aura lieu de 16 à 21 heures
le mercredi 5 juillet 1939.

RENÉ DROUIN

17, PLACE VENDÔME

cocktail

PARIS
Invitation to the opening exhibition at the René Drouin Gallery

shirred taffeta corselet and a bow that holds all the fullness in back. Below, against Leonor Fini's angel armoire, Schiaparelli's dinner dress of black brocaded crepe, the bolero ending in a pouf like a muff trimmed with a pink moiré bow."[24] On the following page, "Mainbocher's roman-striped faille and satin dress and gloves" was presented in front of Max Ernst's painting *L'Ange du Foyer.* In this haunting final image, how could one ignore the distant, impassive gaze of the hieratic model in evening gown, placidly extending her bare, gloved right arm towards the Surrealist monster as it shakes, screams, flings its ominous tentacles in all directions and hammers its left foot in a macabre dance of death?

PARIS, JULY 1939
A model in a Mainbocher dress, posed for the *Harper's Bazaar* September issue, in front of *L'Ange du Foyer*—a Max Ernst painting that was part of Leo's legendary exhibition at the Drouin Gallery

11. DRAMATIC AND PERILOUS, AN EXODUS TO THE UNITED STATES

I did not begin to understand the situation until the day we went on board between two rows of helmeted gardes mobiles with Sten guns in their hands . . . Far from being a solitary adventure, it was more like the deportation of convicts . . . The riff-raff, as the gendarmes called them, included, among others, André Breton and Victor Serge.[1]

CLAUDE LÉVI-STRAUSS

"THREATS AGAINST THE Jewish population will only get worse, and I advise you to leave as quickly as possible" the German ambassador to Romania bluntly warned "his friend Mihai Schapira," in the early months of 1938. Schapira understood the message and, despite heavy financial losses, decided to leave the country without delay. He sold off his homes and factories, transferred his funds, joined his family in Western Europe—Marianne and Eve in London, Ileana in Paris—bought a villa in Cannes, and moved to the Côte d'Azur.

In fact, the situation in Europe—the significance of which largely escaped Leo Castelli in the years before World War II—had been worsening steadily since 1918, with each new day carrying a fresh load of anxiety for those with eyes to see and ears to hear. Though the Alliance powers had expected the Treaty of Versailles to neutralize Germany and usher in peace and stability, the 1930s had been marked by global crises and a succession of political and social convulsions that affected every European citizen. On the one hand, the Soviet regime roused the idealism of millions of Communist revolutionaries and sympathizers, who dreamed of an international workers' brotherhood without borders and celebrated itself as the home of the "new man," where poverty, solitude, and misery were unknown.[2] On the other, the rise of fascism in Germany and Italy allowed Hitler and Mussolini to indulge in a frenzy of expansionism, fostered by increasingly sinister displays of national-

ism. In February 1938, Schuschnigg was determined to reassert national independence through a plebiscite to be held on March 13, but his plans were negated by the Anschluss, March 11–13, and gave way to Austria's annexation to Germany. After Austria, the German dictator turned to Czechoslovakia, but in September the governments of France and England tried to secure peace with the Munich Pact, forfeiting the Sudetenland to Germany while safeguarding the other Czech territories.

Hitler's irresistible advance would continue: barely five months later, Nazi troops entered Prague, and with this new provocation, the German dictator informed the "political midgets" of France and England that their hopes for peace were in vain. The most astute commentator, Paul Nizan, described Munich as a "shadowy drama, played out in the back corridors of Europe behind the theatrical façade of daylight,"[3] and other close observers wondered why Daladier and Chamberlain had accepted Hitler's conditions. In April 1939, Mussolini—who had represented himself in Munich as the champion of peace—decided to invade Albania; less than two months later, he and Hitler signed the fallaciously defensive Pact of Steel. Soon afterwards, on August 23, Stalin, the self-appointed arbiter of the rift, brushed aside ideological scruples and signed the Nazi-Soviet nonaggression pact—a gesture as wholly cynical as the ones leading up to it. Finally, on September 1, after Austria and Czechoslovakia, Poland suffered Nazi invasion. This daunting escalation led the French and British to issue ineffectual ultimatums to Germany, a pro forma prelude to an immediate declaration of war.

"That day in the Grand Hotel, at La Baule, on the Atlantic coast, the air is charged with tension, and we don't know why," Ileana said. "In the midst of the confusion, someone tells me to go read the announcement posted in the village: it is the declaration of war. Puzzled, I call my father, who tells me not to move because I am in a safe place—no factories or army bases around there. We thought a resort town was the safest place to be. Little did we know it was a designated target zone!"[4] In the Grand Hotel of La Baule-les-Pins, on her first family vacation since the triumphant Surrealist exhibition, Ileana Castelli again submitted to the direction of her father, for never had the patriarch and compass of the family been more urgently needed. Over the next two years, Schapira would again shepherd his semi-wayward son-in-law, rescuing him from the Nazi vise and bringing him to safety across the Atlantic. How did the other Schapiras, Krauszes, and Castellis react, during those unimaginable days, to the maneuvers of those sordid chess players in

whose hands their people were less than pawns? Did Leo Castelli, as an Italian citizen, feel himself imperiled by the anti-Jewish laws of the summer of 1938, which had stripped his father of his last honorifics? What exactly did he think of the newspaper photos showing the throngs Hitler had assembled for Mussolini's visit, or the grotesque parades staged in Rome to impress Hitler? How did he judge the anti-Semitic persecutions in Germany and Austria since Kristallnacht that November? Apolitical, insulated, naïve, callow, and pampered, he simply put himself in his father-in-law's hands.

"During the 'phony war,' we waited for something to happen," Leo recounted. And indeed, from September 1939 to May 1940, with the fall of Kraków, the fall of Warsaw, and the Soviet invasion of Finland keeping the Germans occupied on the northern front, little happened on the French borders. Everyone had his way of expressing the malaise caused by the impending conflict, the odd sense of anticipation, the chaotic, incoherent news reports, the new chain of events, so unlike the last war! "Sunday, November 26, 1939. I'm ashamed to admit it, but I'm already waiting for this war to end," wrote private second class Jean-Paul Sartre. "I'm restless at war, as in '38–'39 I was restless at peace . . . All the guys who left with me were raring to go at first . . . At the time they said the war would last six years . . . then suddenly we started hearing rumors that it would be a short one."[5] Leo and Ileana Castelli, whom Mihai Schapira finally convinced to get out, stopped in Paris to put their Neuilly and Left Bank furniture into storage, before retreating to Villa Isabelle in Cannes. "Paris was weird in that winter of '39," recounts the wife of the writer Paul Nizan. "Fixated on magic and meaningless gestures, pointlessly reenacting practices from the First World War. I saw windows in which people had painted latticework resembling the strips of paper glued on in 1917 to secure the glass that shattered during bombardments . . . The 'block captains' did their parts conscientiously, and small children learned to play with useless gas masks. And people knitted! 'All of France is knitting,' the newspapers said. Soldiers wrote to their families to please stop, don't send any more! They didn't know what to do with all those scarves! . . . The soldiers were dozing off in torpor and boredom."[6]

Leo Castelli passed one last time through a fast-emptying Paris, the capital soon to see the arrival of its new occupiers: Francophile Nazi officers like Otto Abetz, Karl Epting, Karl-Heinz Bremer, Gerhard Heller, and Ernst Jünger, who would shamelessly indulge themselves in a city and culture they had always dreamed about. They would happily settle into the Ritz and the

CANNES, 1940
Villa Isabelle, Mihai Schapira's property, where the family and their friends took refuge after the invasion of France before they were forced to leave for the United States

Crillon, between Place de la Concorde and Place Vendôme, and dine at the Tour d'Argent and the Hotel George V, as the city turned into some bizarre stage set for an alternative drama. "Sunday: Today I went twice to the Madeleine, its steps stained green by boxwood leaves," Jünger noted in his diary with "a German aesthete's smug good conscience."[7] "At Prunier's for lunch and dinner. The city is like a long-familiar garden gone to seed, in which one can still make out the paths and alleys."[8]

In May 1940, after the invasions of Denmark and Norway and the Battle of Narvik, the Germans finally attacked France, Belgium, and Holland. On May 15, Sedan fell; the French government, terrified at the speed of the German advance, fled Paris on June 10. Only then did Italy declare war on France and Britain. Leo, an Italian Jew in enemy territory, suddenly found himself in jeopardy; and to make matters worse, he had recently been branded a deserter. In Cannes, Mihai Schapira's property, the providential Villa Isabelle,

became a refuge for family and friends. In the couple's early years in France, the seaside house had been a carefree retreat. Ileana's niece Mariève Rugo remembers driving on the "corkscrew" roads around Cannes, Schapira's driver constantly shifting gears and Leo sitting next to him, "elegant as a mannequin, his cigarette glowing in a tortoise-shell holder." She recalls, "Leo was usually reading or chatting with guests but I never entered a room without hearing his cheerful 'Bonjour, Mariève.' Although he was the best-dressed man I have ever known, he didn't mind getting rumpled and would give Nina and me piggyback rides around the garden."[9]

In that same villa, on June 14, the family heard about the fall of Paris. Schapira came to an immediate decision: they must leave France at once. The "phony war" had abruptly turned quite genuine. As Rugo explains, "because he was a Jew, as well as one of Romania's richest businessmen, [Mihai] was on Hitler's most wanted list, so it was imperative that he leave France for more neutral territory."[10] The next morning, despite his fury at having to plan a second exodus so soon after the first, Schapira decided that their only hope lay across the Atlantic, if possible in the United States. Into two cars he piled the nine members of his family, plus Piccina the dog, and headed for Biarritz and the Spanish border: two days and two nights in transit under hellish conditions, with chaotic scenes of mass flight, panic lining the roads. No inn or hotel, no shelter at all, not even a restaurant. On June 16, just as the Schapiras reached Biarritz, German troops crossed the Loire. "Our anguish was at its peak; we expected the Germans from one minute to the next and didn't know which way to turn,"[11] Leo recalled. Schapira crossed into Spain, alone and on foot, to smooth the way for the others. "Once we reached the border, we all hugged and cried as we said our goodbyes, thinking we might never see each other again," said Ileana. Several hours later, Mihai Schapira returned: the situation was more complicated than they'd expected; they had been misinformed and were all in danger of arrest by the recently established government under General Franco, whose sympathies lay with the other Fascist regimes throughout the region. The best thing was to head back to Cannes and plan their next departure attempt more carefully. And so the family returned to Villa Isabelle to learn of Marshal Pétain's appointment as head of state, General de Gaulle's calls for resistance on June 18, France's signing of the armistice with Germany on the twenty-second, and finally the installation of the Vichy government on July 1.

"It is summer when we arrive. In the morning I hear the crunch of steps

on the gravel. There are orange trees in the garden and we have to climb
down a cliff to get to the boat, but we feel no joy in it because the war has
come." Jean-Claude Drouin, the son of René Drouin, retains a vivid mem-
ory of that summer of 1940 at Villa Isabelle, where he too was taking refuge
with his parents. "For my seventh birthday, I walk up to see Ileana in bed, as
she rarely comes down to the dining room. Ileana gives me presents, but she
seems unapproachable: with her strange charm, both strong and lucid, this
slim, beautiful, self-possessed society woman appears like a queen in my
mind. Leo waits on her attentively, though in the end their marriage is a fail-
ure. And then there is Nina, very, very beautiful with long blond hair, who,
when asked her age, simply answers 'I have four years,' and Frances, her gov-
erness, with whom she speaks English."[12] The extended Schapira family, in a
villa full to bursting, faced the "elusive moods of the summer of 1940," after
having absorbed the "stunning shock of defeat."[13] "Collaboration," wrote
the historian Robert O. Paxton, "was not a German demand to which some
Frenchmen acceded, through sympathy or guile. Collaboration was a French
proposal . . . It was from the Pétain regime that a stream of overtures came
for a genuine working together."[14] "Hitch France to the German wagon,"
Hitler ordered. Sure enough, in July 1940 the residents of Villa Isabelle were
informed of the first French measures against the Jews. Several weeks later
came the first air raids on London and the German invasion of Romania.
"There were a lot of us in that house," Ileana recalled. "I don't know how we
managed to live there so crowded, but in a way the atmosphere was light-
hearted because we were together and we loved one another. It was our
nest."[15] In those days, Leo spent a lot of time caring for little Nina; often he
sat her in his scooter and took her to the nearby studio of Leonor Fini, from
whom he commissioned the girl's portrait.

Schapira, ever on the alert, spent those weeks busily planning. Deter-
mined not to let a second departure attempt fail, he contacted his network of
friends and spared no expense, chasing visas for as many countries in the
Americas as he could: Brazil, Mexico, Canada, Argentina, the United States,
and Cuba. As before, he first went off alone, carrying a border pass. His fam-
ily's departure for the United States was ultimately organized by one of his
friends, the providential Baron Henry Malval, according to Ileana "a fairly
mysterious fellow who, after we left, turned the villa into a safe house for the
Resistance, with the help of his nephew. But he was denounced, arrested,
and tortured." Finally, in December 1940, as the first groups of patriots began

organizing spontaneously and the word "resistance" entered common par-
lance, Leo Castelli, together with the whole Schapira clan and thanks to the
concerted efforts of Schapira and Malval, left Villa Isabelle and Cannes for
the port of Marseille armed with a fat wad of visas.

The speed of the French defeat dumbfounded America. In June 1940, Dr.
Reinhold Niebuhr, president of the American Friends of German Freedom,
gathered two hundred notables at the Commodore Hotel in New York to
explain the threat and raise money. First Lady Eleanor Roosevelt got her hus-
band to provide entry visas for endangered refugees. And Varian Fry, a thirty-
two-year-old American journalist on the editorial board of *The New Republic,*
volunteered to represent the Emergency Rescue Committee in France and
secretly organized the departure of a long list of anti-Nazi intellectuals and
politicians. He had witnessed the persecution of Jews in Berlin in 1935 and did
not want to "miss the chance to save at least some of the future victims of
the horror that was spreading throughout France." Arriving in Marseille on
August 13, 1940, he began arranging—against the advice of the American
diplomatic corps and with the help of a young French leftist named Daniel
Bénédite—the clandestine escape of those menaced by Article 19 of the
armistice that Pétain had signed on June 22: "The French government must
surrender on demand any German or foreign nationals living on French soil
and hand them over to the Reich."[16]

Who were those first "administrative internees," deemed "suspect of dis-
turbing the public order" in the eyes of occupied France? André Breton, his
wife Jacqueline Lamba, and Victor Serge. With other Surrealist refugees in
Marseille, such as Max Ernst, Victor Brauner, André Masson, Wifredo Lam,
and Oscar Dominguez, they began meeting at Au Brûleur de Loups, a café
opposite the old port at the corner of Rue du Bailli de Suffren. Not far from
the offices of the *Cahiers du Sud,* the café became a gathering place for artists.
Some of them lived at the Villa Air-Bel—which Serge rebaptized "Château
Espère-Visa" ("Covet-Visa Castle")—where everyone met on Sundays. While
biding their time, they created an extraordinarily fanciful deck of thirty-two
playing cards, in which the hearts suit was replaced with a flame ("Love"),
diamonds with a black star ("Dream"), clubs with a bloody wheel ("Revolu-
tion"), and spades with a keyhole ("Knowledge")![17] Sustained by the Ameri-
can heiresses Mary Jayne Gold, Peggy Guggenheim, and the countess Lily
Pastré, who lent her property in Montredon as a way station, these refugees
would finally reach the United States after many long months. "To leave

France," wrote Bernard Nöel, "you first needed a valid passport, a visa for the country of destination, transit visas for the interim countries, and an exit visa for France. Once in possession of all those papers, each of which depended on the others, you could buy a boat ticket; but some boats were so infrequent that at least one visa would expire by the time you got a reservation. You then had to start all over, standing in line at the consulates, waiting, pleading, while money ran out—for it took a lot of money to pay for all these steps."[18] With compassion and disquiet, the protagonist of Anna Seghers's novel *Transit* describes the draining obstacle course of uncertainty and Byzantine bureaucracy that awaited the horde of those at the port of Marseille who, forced into exile, had no resources but their own courage,

VILLA AIR-BEL, MARSEILLE, 1939
André Breton and his daughter, Aube, with Peggy Guggenheim and Victor Brauner, awaiting the arrival of their visas for immigration to the United States

imagination, and tenacity. "After an imaginary noonday meal, I sat out in front of the cheapest café I could find. The ersatz coffee was terribly bitter, the saccharin terribly sweet. All the same, I was quite contented at the time . . . With their tattered flags and beliefs people from every country came pouring before my eyes, the vanguard of the refugees. They had crossed all Europe in their flight, but now, when they saw the narrow strip of water sparkling innocently between the houses, their wisdom reached its end. The names of the ships on the slates didn't mean real ships, but just a faint hope. And no sooner had these names been chalked up than they were rubbed off, because some strait had been mined or another harbor bombed. Death marched closer and closer, still flaunting his lashing swastika flag . . . All about me I heard strange languages as if that [café] counter at which I stood were flanked by two pillars of the Tower of Babel. And yet, certain words occurred over and over again. There was a certain rhythm to them, and I finally understood them: Cuba visa and Martinique, Oran and Portugal, Thailand and Casablanca, transit and three-mile zone . . . Sud-

denly everyone started talking all at once. I was hardly conscious of what
language they were speaking, for it was a kind of chant: They won't let any
more foreigners into Oran . . . As for us, Spain won't let us in . . . Portugal
won't admit anybody any more . . . A boat is going to sail by way of Mar-
tinique . . . From there you can get to Cuba . . . But you'd still be under
French sovereignty . . . Anyway, we'd be gone from here."[19]

By now, foreigners in Vichy France, routinely arrested and sent to the
camp at Milles (near Aix-en-Provence), were living in a permanent state of
panic, under constant threat of interrogation and police break-ins. On
December 4, 1940, for instance, Marshal Pétain's visit was announced with
great fanfare: "The entire city was packed onto sidewalks, balconies, and
roofs in a surge of enthusiasm that witnesses remember as a collective delir-
ium. On the Canebière, the façade of the Legion building bore a twenty-five-
foot-tall Pétain, but his portrait was everywhere else as well: in shop
windows, on lapels, in classrooms, and every schoolchild had to sing in cho-
rus 'Marshal, here we are!' "[20] The narrator of *Transit* relates such peculiar
moments, shot through with menace, worry, danger, and despair. "I sat
down at a table in the Brûleurs de Loups. The people around me were all
excited just because a swastikaed car had dashed down the Canebière at
noon. It was probably carrying one of the commissions that were discussing
various things with agents from Spain, Italy, and Vichy at one of the big
hotels. But people acted as if the devil himself were riding in it, ready to
imprison his lost flock in a barbed-wire fold. They were all, I felt, on the point
of flinging themselves right into the sea. Because no ships were scheduled to
sail for the next few days."[21]

Six months earlier, on June 14, 1940, having learned of the Nazis' entry
into Paris, the writer and doctor Ernst Weiss, a friend of Kafka's, had com-
mitted suicide in his hotel room on Boulevard St.-Germain, not far from the
Odéon métro station. Soon afterwards, the German Jewish writer Walter
Hasenclever died in the Milles camp, like so many other "refugees, anti-
fascists persecuted by the Nazi regime, who before then had been barely tol-
erated by their adoptive country, living without work permits and at the
limit of extreme destitution . . . [and who] were interned in camps in May
1940, when the German troops invaded Western Europe, under the
grotesque pretext that they were 'enemy aliens' . . . : 'We the exiles, we the
stateless, we the damned, do we still have a right to exist? . . . What we have
thought and written—we who belonged to a people that never understood

MARSEILLE, AUGUST 31, 1941
Soldiers parading through the Canebière before an immense photo of Marshal Pétain

its poets—what we felt we needed to say crumbles to dust at the approach of a hellish phantom train.' "[22]

In Vichy France, Leo Castelli was suspect on several counts: as a foreigner, a Jew, and a deserter on enemy soil. He was also privileged, however, and under Schapira's umbrella of visas, passports, and tickets, he was more than covered. During this pampered scion's hazardous exodus, a few moments of panic were unavoidable, but a brash mountain climber of his caliber, even one so cosseted, was no stranger to risk. As Ileana recalled, "The city of Marseille was packed, so we all got on board the day before we were to leave. But the boat didn't raise anchor, because the passport verification office first had to give its authorization, and they called us all in. All of us were very suspect: the governess was English, Leo Italian, I was Romanian, and Nina was born

in Vienna!" A policeman came for Frances the governess, declaring that she had no chance of leaving. Everyone was in despair, but an hour later the same officer returned with her authorization. After Frances, it was Leo's turn to be summoned for an identity check, inducing further despair—when suddenly, in walked an official in Fascist uniform. A "very close friend," according to Ileana, he was none other than Alberto d'Agostino, Leo's former boss in Bucharest and his sponsor at the Banca d'Italia in Paris. Having since become a general, he headed the passport verification office. "That was an incredible stroke of luck—it's thanks to him we were able to leave,"[23] Ileana later said with a smile.

And so the exodus proceeded: Marseille, Oran, Oujda, Casablanca. Sea travel was often miserable at that time of year, but the Schapira tribe made the best of it. "There was very little food. I was fine because everybody was serving me first," recalls Nina Sundell. "My mother taught me to read, she wrote beautiful books for me that she illustrated, so she did both pictures and the narratives, and there were stories of dwarves."[24] And, as always, literature served as a constant companion. At Oujda, where they waited for Moroccan visas, Ileana began reading Emile Charcot. The stopover in Casablanca lasted nearly two months. One day in a café, a man came up to Leo and Ileana, flashed his badge, and ordered them to follow him to the commissariat. There, without explanation, an officer demanded their passports and calmly looked them over. "At the café you were talking about dollars," he said abruptly. "Why is that?" "Because we're hoping to go to America," Leo answered. "Lots of luck!" the policeman smirked. After a long and thorough interrogation, he made them promise never again to talk about dollars in public and handed them back their passports. "He realized we were just young and naïve," said Ileana, "so he let us go."[25]

Castelli confirmed this judgment: "It was December, and despite the almost insurmountable problems we were faced with, we had the insouciance to spend Christmas in Marrakech. After our return, we managed to find a passage on an old Spanish boat named the *Marques de Comillas,* which was due to leave from Vigo in the north of Spain. That meant crossing the Strait of Gibraltar in stormy weather and traveling through the whole of Spain to get to Vigo, where we arrived just in time to board our ship!"[26] In the course of these several twists and turns they had a fortuitous encounter with a Triestine, Ricardo Bonomo, a former colleague of Leo's at the Assicurazioni Generali and now an Italian spy, who happened to be in love with

Nina's governess, Frances. He brought her chocolates, helped them obtain visas, and told them which security checkpoints to avoid. Then, more travel: via Tangiers, and the Strait of Gibraltar, the old boat reached Cuba two weeks later. Finally, on March 12, 1941, in these parlous circumstances, but aided by their protectors Mihai Schapira, the Baron Malval, Alberto d'Agostino, and Ricardo Bonomo, the Schapira-Castelli family entered the port of New York. The day would be memorialized religiously with an annual telephone call from Frances to Leo. As the ship approached Ellis Island, and Castelli, leaning on the railing, watched the close-packed skyscrapers of the island city loom closer, all kinds of images ran through his head—including Winnetou, the hero of a series of German tales of the American West that were his childhood favorites, an "American Indian" unknown to Americans. "I used to dream of New York when I was a child," he later explained. "I was sure there were Indians there, whose adventures I read in Karl May's books. He *invented* the American Indian."[27]

"The arrival in New York was magnificent," writes Pierre Radvanyi, who reached port at around the same time. "There was fog and the foghorns were blowing. Suddenly the skyline appeared, with the sun behind it. It was magical, a vision. And the foghorns were still blowing as we rounded up towards Manhattan. It was about eight o'clock in the morning. Since the authorities knew the ship was carrying emigrants, officials came on board with a doctor, who stayed in back and watched. Then we were quarantined on Ellis Island. We had to pass before a court presided over by a colonel to whom we explained that the only thing wrong with us was travel fatigue."[28] Nina Sundell clearly remembers those first moments on (almost) American soil. "In Ellis Island, there was hot water, and everything was white, white milk, white soap, white towels, white mashed potatoes, white bread, white cauliflower."[29] Ileana, for her part, was "terrified at the idea that the United States was a country without any culture. That's why we insisted on bringing along a trunk full of books. But it wasn't as catastrophic as all that!" she added. "On the contrary, at first the country was very charming. Everyone was wonderful with Nina, who was four at the time. Only the agents at Ellis Island were obnoxious; they kept shouting, 'Hurry, hurry, hurry!' Through the bars in the windows, we had a lovely view of the Hudson River. And though they turned the lights off at night without warning, everything was very civilized. A few days after we arrived, an inspector offered to take us into New York, and the four of us went for our first look around the city. At

Macy's, the inspector bought Nina a doll! Back on Ellis Island, we had to go through more questioning, but our English governess, who was acting as our interpreter, couldn't understand their American accent. So they brought in an American interpreter who spoke Yiddish, and him we understood. They let us go, and we moved into the two rooms my father had reserved for us at the hotel."[30]

On the evening of their arrival, as the Schapira-Castelli family was preparing to spend its first night on Ellis Island, the Surrealist writer Nicolas Calas, recently emigrated from Europe, was about to give a lecture on "the fate of Jocasta and the future of painting: Surrealism, painting, and iconoclasm" in the Preview Room, on the fourth floor of the Museum of Modern Art.[31] A few days later, barely settled in, alone for the first time, Leo Castelli stepped into MoMA. For him, as for most Europeans, the building on Fifty-third Street between Fifth and Sixth Avenues was hallowed ground. It was to MoMA that they went to discover European masterworks such as *Les Demoiselles d'Avignon,* which had for all intents and purposes never been shown in France,[32] and which, on May 10, 1939, had been presented to a New York audience for the first time. In his catalogue essay, the museum's director, Alfred Barr, had called it "an imposing laboratory experiment which, more than any other single picture, marks a change in the direction of early 20th century painting . . . in no other painting has the most influential artist of our time expressed more powerfully his formidable and defiant genius."[33] And it was to MoMA that the new arrivals also headed, to see Meret Oppenheim's *Fur-Covered Cup, Saucer, and Spoon* and the pliant watches of Dalí's *The Persistence of Memory.* "The Europeans were in raptures over this accessible building, with its very modern architecture, nestled in a sculpture garden in the heart of the city," said Dolorès Vanetti, a French journalist who was friendly with the Surrealists. "By recognizing the art of its time, MoMA broke radically from all the museums we were used to."[34]

Of the city's four largest museums—the Metropolitan, the Whitney, the Museum of Non-Objective Painting (later rebaptized the Guggenheim), and MoMA—three were largely devoted to European art, as were many galleries, such as those of Julien Levy, Pierre Matisse, Karl Nierendorf, and Carl Valentin. But compared with Paris, the gallery scene was "a desert" (said Ileana), and a "very provincial" one at that (said Leo). Local artists were all but invisible. As Barnett Newman, one of Abstract Expressionism's most articulate progeny, bluntly put it, "In 1940, some of us woke up to find our-

selves without hope—to find that painting did not really exist."[35] And Adolph Gottlieb recalls that "during the 1940s, a few painters were painting with a feeling of absolute desperation. The situation was so bad that I know I felt free to try anything no matter how absurd it seemed."[36] When Castelli arrived in New York, crowned with the fleeting laurels of his Paris exhibition, he very naturally found his way to Julien Levy, who showed the same artists that he had—Tchelitchew, Dalí, Fini, Ernst, Berman—and socialized with them as well.[37] "When I got here back in 1941, everybody knew me from that very brief experience I'd had in Paris. Julien Levy knew me. Dalí knew me. Max Ernst knew me," Castelli recalled. "To them, I was sort of an interesting person though I couldn't offer anything at the moment. But they felt that I was one of them."[38] Peggy Guggenheim, having lived most of her life in Europe and opened a gallery in London, arrived in New York in July 1941 with her new husband, Max Ernst. "I can remember going to Peggy's," said Castelli, "and seeing a huge Pollock there, *She-Wolf*. She was already talking about Pollock at the time . . . And I was, well, impressed. My knowledge of art in general and American art, developing American art in particular, was very scanty at that time. I had just started really. I remember being impressed and connecting it with the Surrealist movement."[39] The following months saw the great Surrealist influx to New York, the newcomers joining fellow immigrants like Duchamp, Lipchitz, Masson, Matta, Dalí, and Mondrian.

Along with exploring the city, Leo and Ileana tried resuming their studies at Columbia University. She would study psychology and he, economic history, with a concentration on Renaissance mercantilism and the work of Jean Bodin. "I thought I could go back to my teaching project. By this time, my interest had shifted to other things. Curiously enough, I didn't think of doing studies in literature or art but rather in history. Since I had the law degree, they gave me full credit for college; and I could start on a master's degree and Ph.D. Perhaps I was so terribly interested in history because I wanted to know why this war had broken out—change of king or president, or maybe economic factors. Naturally, I quickly leaned towards the second hypothesis, so that, instead of studying history at Columbia, I ended up studying economics. I divided my time between the museum, my artistic friends, and the economics department."[40] At the end of 1941, the family settled at 4 East Seventy-seventh Street, in a brownstone that Mihai Schapira, who now called himself Michael Strate, had recently purchased. And Ileana, having initially relapsed into depression, brightened when she met a fellow Colum-

VILLEFRANCHE-SUR-MER, 1939
Marianne and Mihai Schapira, CENTER, and their daughters, Eve and Ileana, RIGHT, enjoy the view on the French Côte d'Azur.

bia student named Michael Sonnabend, a cultured American Francophile—
an émigré like her, he said, but an "émigré from Buffalo." In 1958, he would
become her second husband.

Nina Sundell still remembers the rituals in that family of exiles, who at
first clung tenaciously to the remnants of their past. Politics: "We had a dog,
very well trained. Frances would put a piece of sugar on his nose, and if she
said, 'Hitler made it,' he wouldn't eat it. But if 'The Americans made it'—
then he would take it." Food: "At the Hotel Weylin, we had pancakes and
bacon and maple syrup that I was the only one to like! We went to Hungar-
ian restaurants, everybody was very nostalgic about Hungarian food, espe-
cially goulash and *palatschinken*." Literature: "Michael and Leo would recite
Dante; Marianne knew La Fontaine and the letters of Madame de Sévigné."[41]

In March 1942, Castelli decided to volunteer for the army. What purpose
could this novice gallerist, seasoned mountaineer, and erudite polyglot have
served in the American army? For the next several years the future Sergeant

Castelli underwent one form of indoctrination after another. Basic training at Fort Bragg, like everyone else: physical, intensive, and miserable. Special intelligence training at Camp Richard, where he put his knowledge of Europe and languages to better use in fascinating simulations and hypothetical invented scenarios. Training with the Military Intelligence Service for a mission in France, which was aborted because of bad timing. In Washington for a Romanian operation with the Allied Control Commission, as part of a fifty-man unit—three quarters of them officers and the rest enlisted men, like Leo, who in December 1944 found himself back in Bucharest.

12. BUCHAREST REDUX:
FIRST FROST OF THE COLD WAR

Capital of a tragic land, where things often finish comically, Bucharest has let itself drift with events without the rigidity, and thus without the fragility, conferred by anger. Because of this, Bucharest has remained lighthearted through the sinuous course of its picaresque destiny.[1]

PAUL MORAND

MAY 1945. WHAT was running through Sergeant Castelli's head as he left Bucharest with his driver to travel the four hundred miles to Budapest? What was he thinking as they took the road to Moldavia, past the Paclele Mari towards the grey-green lunar landscapes of Berca, with its strange, muddy volcanoes? What occurred to him as they crossed the hidden mountains of Buzău and saw Manastirea Dealului, the monastery of the Carpathians, which Nifon, the ancient patriarch of Constantinople, had cursed in the Middle Ages, eternally damning Walachia and its prince, Radu cel Mare—the Great? And what occupied his mind as the archipelago of Vâlcea's monasteries paraded by: Govora, Dintr-un Lemn, Bistrita, Arnota, Horezu? Was he remembering the legendary princes, enlightened humanists, such as Matei Basarab and Constantin Brâncoveanu, who in the eighteenth century commissioned these formidable structures—part Byzantine, part Italian Renaissance, part Baroque—to thank God for their escape from the Turks?

What was Sergeant Castelli thinking before the blue, thatch-roofed houses of the Saxon lands, the medieval citadels of southern Transylvania, the Baroque edifices of the Banat, along the endless road from Bucharest to Târgoviște, Râmnicu Vâlcea, Timișoara, Szeged, Kecskemét, Nagykőrös, and finally Budapest? What was he thinking as they crossed into what had once been a flamboyant capital of the Austro-Hungarian Empire; a city that, from Christmas 1944 until its liberation by the Soviets in February 1945, had endured one of the most horrifying sieges of the war? How much did he

BUDAPEST, JANUARY–FEBRUARY 1945
Leo Krausz found the city devastated by war when visiting his sister, Silvia Reitter.

know about what his parents, sister, nephew, and brother-in-law had suffered in the preceding months? Did he expect to find them dead or alive? What had he heard at OSS headquarters in Bucharest about the fate of Jewish citizens under the collaborationist Horthy dictatorship? And how did he—who had been living safely across the Atlantic, in a country whose values he supported by his mission and whose uniform he wore—visualize his reunion with these figures from his past? Did he look forward to it with optimism, impatience, or trepidation?

"Leo showed up in Budapest one beautiful May morning," recalls Silvia's son, Robert Reitter. "He looked great, in his American uniform and his jeep with its military driver. He draped his jacket over my shoulders and, proud as Artaban, I went around the entire block to show it off! I was eight years old and we had just gone through a horrific time. He arrived during that transition; the light was just beginning to show after months of winter, cold, and war, during which we'd lived in humiliation, hunted as Jews and marked by the yellow star. And even though there still wasn't much food, even though

everything was still in chaos, even though my father was in the prison camp, that remained a special day for me! Leo gave me a four-color pen, like nothing I'd ever seen before. Because there was no electricity, to get into our building you had to ring the bell by hand, and the super would open the gate by pulling on a rope. That day, since the super hadn't heard the bell, I kept shouting, '*Kaput! Kaput!*'—'gate' in Hungarian—so that he'd open up. Leo, who didn't speak Hungarian, thought I was shouting in German: 'Broken! Broken!' And he asked in the kindest voice, 'Is it broken already?'—thinking I meant the pen he'd just given me!

Leo Bacsi [Uncle Leo] and my mother had a lot to talk about. He was happy, and so was she; it was a very gay and lighthearted moment, and such a joy to discover I had such a nice uncle! He asked me what I'd like from America, and without thinking twice I said, 'Chewing gum and chocolate!' A few months later, we received a plain, round cardboard box containing twenty packs of Juicy Fruit and fifteen bars of Milky Way. My mother shut the box in the entrance closet and every day she broke off a square of Milky Way, which I savored as if it were the sacred host. Less than three years later, on February 22, 1948, with help from my uncle Giorgio, Father, Mother, and I landed in New York airport."[2]

On the west bank of the Danube, in Buda, stands the Rozsadomb ("Hill of Roses"), a rather heterogeneous residential neighborhood, with large 1930s villas hidden behind handsome gardens, the sulfur baths of Felhéviz, and especially the Turbe, the octagonal mausoleum with its delicate blue-grey dome, built in the sixteenth century by the Turkish dervish Gül Baba. From the hill, one can see across the Danube to Pest, where, behind the basilica, like a gigantic red-and-black spider looming over the city, stretches Országház, the sumptuous neo-Gothic Hungarian parliament. And it was on the Hill of Roses, in the Reitter apartment at 24a Garas Utca, that the two eldest Krausz children, Leo and Silvia, were reunited after so many years. What did they have to say to each other that day, fifteen years after having enjoyed the gilded existence their father once provided? Silvia and her brother wasted no time on banal sentimentalities or nostalgic prattle. The dark, impulsive, sensual, provocative young woman, who in the 1920s had been one of the prettiest girls in Trieste (famed for the prettiest girls in Italy!), was, at nearly forty, still attractive, warm, and outgoing. But it was Silvia Reitter, Hungarian citizen, who sat facing Leo Castelli, an agent in the American intelligence service. Nearby stood an eight-year-old boy who

spoke only Hungarian, and around them were the ghosts of her imprisoned husband and their parents, who had recently died under horrible circumstances. A few streets away was Nyul Utca. It was there, at number 20, on Christmas Day 1933, during a strangely formal ceremony, that the Krausz family had laid out its best china to welcome the entire Schapira clan, come especially from Bucharest to celebrate the recent marriage of Leo and Ileana. Two and a half years later, in July 1936, the Krausz family had again hosted such festivities for Silvia's wedding to Miklos Reitter.

Krausz-Castelli Ernő és neje szül. Castelli Bianca örömmel tudatják, hogy Silvia leányuk folyó év július 5-én Reitter Miklós urral házasságot köt.

Ifjabb Eördögh Virgilné szül. Fischhoff Gizella örömmel tudatja, hogy fia Reitter Miklós folyó év július 5-én Krausz-Castelli Silvia kisasszonnyal házasságot köt.

Budapest, 1936. junius havában.

Gratulació 12 órakor II. Nyul-utca 20.

v. Aulich utca 5.

So read the wedding announcement in beautiful gothic script.[3] After her carefree years as a well-to-do young girl and amateur photographer, Silvia had studied art history at the University of Vienna, before marrying Miklos, whom she'd met in Trieste through a mutual friend.

Now in May 1945, in the Reitter apartment on Garas Utca, Leo and Silvia exchanged news, alternating between standard Italian and the Triestine dialect. Silvia told of the move from Buda to Pest in August 1944, with Ernesto and Bianca and Miklos's mother, Gizella. They had hidden out in Miklos's office building on Balvannyie Utca, one of the few structures available to shelter Jews. By then it was obligatory to wear the yellow star, and only Miklos left the house, to do the shopping and get the latest news. SZIDOK (Jews), the handbills blared in huge capitals, conveying the orders of the Arrow Cross, the Hungarian Fascist party responsible for deporting thousands of Jews to Auschwitz. Several months later, their hideaway no longer safe, they'd had to find a new refuge. Silvia, Miklos, and their son, Robert, lived temporarily with the family of Josef Visontaï, who grudgingly agreed to take them in. "You'll see, my son won't be a problem, he can keep himself entertained all day long just by swinging on the door!" Silvia assured

a dubious Mrs. Visontaï. To little avail: this was the harshest period, when
the Arrow Cross was systematically purging the city of its Jews. Several
months later, with measures stiffening against Christians who harbored Jews
(the offense now punishable by death), Josef Visontaï reached his limit and
put the Reitters out. More searching, more days of anxiety followed, until
they found shelter in an empty building in Buda, near the Gellert Hotel on
Bela Bartok Utca.

During the harshest days of the siege, between Christmas 1944 and Febru-
ary 12, 1945, hidden in the building's filthy cellar with forty other families, the
Reitters survived on one bowl of potatoes or white beans per person per day.
A neighbor taught them how to make a lamp from a glass of oil and a box of
matches; another, a practicing dentist, served as nurse, bringing medicine
and bandages for the children. Sometimes, during the endless evenings, Sil-
via would bring out a leather-bound volume, her mother's recipe book, and
she and her son would read their favorites—"*Oreillettes:* three eggs, three tea-
spoons of sugar, three glasses of milk, three spoonfuls of flour, a pinch of
salt, a packet of yeast . . . *Palatschinken* . . . *Aprikosen Knödel* . . ."—before
going to sleep. Little by little, they became experts at interpreting the music,
the sounds and noises of the outside. A long, discontinuous breath, like sleep
apnea, meant German Stukas. Sustained rumbling, Russian fighter planes. A
shrill whistle was the air siren signaling the end of the danger.[4]

Silvia told of Miki and little Robert's first walk in a finally liberated Buda,
when the trees in the garden were just beginning to bud. They returned to
find Soviet soldiers questioning the able-bodied men in the courtyard of
their building; Reitter, understanding that he was about to be taken away (as
part of the Soviet policy designed to weaken the civilian population), called
out to his son: "Tell Mama to take the money hidden under the kitchen
stool!" After the liberation, in the icy cold of March, Silvia, bringing little
Robert along to help discourage rape by the Russian soldiers, had crossed the
city on foot four or five times, hoping to reclaim her apartment. The city was
a field of ruins. Only a single wooden bridge still joined Buda to Pest, all the
others having been destroyed. Margit Utca was a terrifying sight, with its car-
bonized trees, gutted buildings, and fragments of balconies swinging from
crumbling, tottering walls.[5] Silvia told over and over how she had tracked
down their parents. Ernesto and Bianca had hidden in a china closet in an
apartment. There, concealed like escaped convicts, they survived on a
spoonful of tomato sauce per day for two weeks before crossing the Danube;

but Bianca, too weak to swim, would drown. Silvia had found Ernesto in an infirmary a few weeks after the cease-fire, only days before he, too, would succumb.

Since speaking of their Jewishness was taboo in the Krausz family, Leo and Silvia did not linger on it that day. They skirted around the subject of having worn the yellow star, as they skirted around the number and names of family members who had disappeared into camps (such as Miklos Freund and his wife, Leni, sent to Auschwitz in the summer of 1943). It was only much later that the story came to light, when Robert Reitter, now sixty and living in New York, decided to break the family silence. He converted to Judaism and wrote a beautiful text about his family, *Yellow Star,* the intensity of which speaks for itself. "'They say Jews now must wear a yellow star every time they go outside, Madame,' she said. My mother glanced at me and feigned a laugh, so tensely fake and shrill that I found myself cringing. What the maid had heard was true, and all that fall and winter, none of us left the apartment without a coat that had a star sewn on its lapel. They were hand-made, these yellow stars, cut out freehand from yellow fabric by a seamstress in the neighborhood, each a little different from the others. They all meant the same thing, though. They meant shame. We were Catholics, my parents and I, but we were keenly aware of being Jewish by descent. Growing up with this awareness gave rise to a kind of split identity, the adopted one proud and assertive, the other, hidden, silent, mysterious. So, yellow star notwithstanding, we had a Christmas tree that year, a big one. It was set up at the entrance of the room my father called the library, a room with matching sets of gray, drab, forbidding books. Grandfather [Krausz] came over one day to fuss with the tree. He seemed nervous, though I couldn't tell why . . . It is only now looking back that I can account for his nervousness that day, fussing with the Christmas tree, trying to set it right. But how could it be made to seem right to him, in December '43?"[6] Through the eyes of a child, in the context of their new life in Hungary, a different Ernesto Krausz appears, one deeply marked by the reversals he had suffered in Trieste.

In recollections preserved for more than half a century, a final portrait of Ernesto Krausz emerges: "He was a dignified man, my mother's father, short, but with a strong, erect posture. He dressed carefully in custom-made clothes of expensive fabric. He wore a bristly moustache that scratched my face when he would kiss my cheek upon arriving and leaving. He had a delib-

erate way with him, and I knew even then that we were rather alike, and that I wanted to grow up to be like him, respectable and self-respecting . . . For a long time he had succeeded at being an upstanding and honored figure in the Christian world, and yet his life ended in want and disgrace . . . We heard about [his ordeal when we went to see him in the hospital] the day before he died, too weak to fight off an infection in his foot, caused by a shrapnel wound."[7] From the Siklós archives, we learn that on July 10, 1941, Ernesto Krausz had applied for authorization to build a family mausoleum in the municipal cemetery. His letter, along with the architect's rendering, received official approval on the twenty-sixth. Did that mausoleum, the last project of a man who had planned out his entire life without counting on history, ever see the light of day? Just as Bianca perished in the Danube, Ernesto's body would be buried in a common grave.[8]

Leo then told his own story. He told of the exodus from France and its many twists. He told of little Nina, eager to meet her Hungarian cousin. He told of New York. He told especially of his most recent experiences: the city of Bucharest and the Capsa café, citing the French writer Paul Morand: "The Capsa is the topographical and moral heart of the city. The Capsa is four things at once: a hotel, a sweet shop, a restaurant, and a café. Imagine four of Europe's venerable glories—the Foyot restaurant, Rumpelmayer's confectioners, the Caffè Florian of Venice, and the Sacher Hotel of Vienna—gathered in a seemingly modest and rundown building!"[9] Later, he made Silvia laugh by quoting Guillaume Apollinaire on the reputation of the Romanian character: "Bucharest is a beautiful city in which East seems to meet West. Speaking strictly geographically, we are still in Europe; but when we look at certain customs, at the colorful specimens of Turks, Serbs, and other Macedonian races roaming the streets, we are already in Asia. And yet, it's considered a Latin country."[10] Leo told of Romania's natural wealth, which made it such prized territory. He told of the Romanian collaboration with the Nazis in October 1940, and then their 180-degree turnaround in August 1944, when they jumped on the Soviet bandwagon. He told of the political burlesque: once back on the throne after the armistice, the young King Michael dismissed Marshal Ion Antonescu, suspected Nazi sympathizer, and replaced him first with General Constantin Sănătescu (who lasted barely a month), then with General Nicolae Rădescu. Leo described the American peacekeeping mission in Bucharest under the leadership of its brilliant young commander, Frank Wisner. He spoke of the State Department's representative in Bucharest, Burton Berry, a warmhearted, intelligent, cultured man who

served as liaison between the king and the Romanian government. He told of the sea change in the war's momentum as the Allies began to take back territories the Nazis had seized.

Leo especially told Silvia about his immediate superior, General Cortlandt Van R. Schuyler, the American delegate to the Allied Control Commission, whose personal interpreter he had been during the first part of his tour of duty, the thrilling period from December 1944 to January 1945. From his ringside seat, Leo translated the urgent discussions between Schuyler and Rica Georgescu, head of the Romanian-American Oil Company in Ploesti, where the oil deposits were. The Soviets, Leo explained, were shamelessly confiscating American equipment and sending it to Russia! Georgescu begged the Americans to intervene, but Schuyler's protests to General Vinogradov, the Soviet president of the Allied Control Commission, were in vain. "Spoils of war!" Vinogradov replied tersely. "Spoils of war!" echoed Molotov in Moscow several days later, answering complaints from the American ambassador, Averell Harriman. The Soviets' impenetrable secretiveness and refusal to cooperate, said Leo, forced the Americans on the Control Commission to get their intelligence from the Romanians. With such irony, humor, and detachment, he related his strange Romanian adventure.[11]

Leo was also present for Schuyler's negotiations with Prime Minister Rădescu, a decisive and politically independent officer who until recently had been in a concentration camp for denouncing Antonescu's Nazi sympathies. Rădescu's coalition government included Communists, Social Democrats, and members of the Peasants' Party; their protests to the contrary notwithstanding, Schuyler was convinced that the Soviets were secretly swaying Romanian internal affairs via the local Communist Party. Even more frustrating, no one in Washington seemed to recognize the gravity of the situation, despite urgent telegrams from every American in the field trying to alert the departments of war and of state to the Soviet machinations.[12] We Americans have absolutely no power, no voice in Romania, Leo insisted. When Averell Harriman visited Bucharest at the beginning of 1945, Schuyler, Berry, and the other Americans on site urged him to dampen President Roosevelt's optimism about the Soviets: the Russians were not their friends, and they had designs on Romania. Harriman couldn't persuade Roosevelt, however, and his failure had serious consequences for the Yalta Conference of 1945, for had Roosevelt listened, things might have taken a very different turn and the Americans might have secured free elections in Romania.[13] As it was,

the Americans were obliged to accept the Communist takeover of Romania as a fait accompli.

Soon afterwards, Leo was transferred: General Schuyler felt his low rank in the military made it inappropriate for him to be privy to such politically sensitive conversations. "Stay in touch and keep your eyes and ears open!" the general nevertheless advised. Bivouacked first in a palace, then in a luxurious villa formerly owned by a Romanian industrialist, Leo watched helplessly as the Soviets seized control, all too aware of the absurdity of his job. Well housed and well fed, able to move about with reasonable freedom and safety, he hoped in vain that the Yalta accords, which called for open elections in the formerly Nazi-occupied countries, would be respected. But only a few weeks later, he saw the Soviets make a mockery of Yalta as they steamrolled over the signed agreements. Leo told of the Communists' objections to Rădescu as too conciliatory towards ex-Nazis—though, as he also conceded, "very little was actually done [about them] and the purges didn't really happen." And Leo told of the audacity of Vyshinsky, the Soviet assistant minister of foreign affairs, who several times threatened the king and demanded the "immediate resignation" of the coalition government, saying he would give King Michael two hours to announce the dissolution of the Rădescu government and the appointment of a new prime minister. Otherwise, he ranted, "We can no longer guarantee the existence of a free Romania!" Leo recounted how Vyshinsky banged his fist on the king's desk and slammed the door so violently on his way out that a crack had appeared in a wall of the royal office. He told of the king's forced acquiescence to the appointment of Petru Groza, head of the National Democratic Front, as prime minister.

And Leo described the atmosphere in Bucharest in February and March, as the city became an arena of entrenched camps. There were mass demonstrations led by the two Romanian Communist leaders, Ana Pauker and Gheorghe Gheorghiu-Dej; Rădescu denounced the demonstrators on the radio as men "with no country, no god, led by foreigners," but Soviet authorities blocked the broadcast of this speech, and the NKVD—the Soviet secret police—instituted harsh crackdowns. And then came the counterdemonstrations: "Long live Maniu!" "Down with the Communists!" "Down with Pătrăşcanu!" "We don't need the Red Army!" Bucharest was covered in handbills: "We've just freed ourselves from one tyranny; let's not fall under another!" In short, what Leo described was a country on the verge of civil war, with the brief moment of détente fast yielding to the era of distrust. The king,

Iuliu Maniu, and Lucretiu Brătianu, expressed "deep disappointment that neither the British nor the Americans had intervened in Romania's recent events." The Americans' powerlessness or indifference had become intolerable.

For Sergeant Castelli, the Bucharest duty would continue nearly another year, until March 1946—a year during which he became less and less popular with the NKVD, even to the point of being at risk of physical harm. "An Allied Control Commission will be established which will undertake, until the conclusion of peace, the regulation of and control over the execution of the present terms under the general direction and orders of the Allied (Soviet) High Command, acting on behalf of the Allied Powers," read Article 18 of the armistice treaty between Romania and the Allies, signed on September 12, 1944. Cold War historians have recently unearthed a secret pact between Stalin and Churchill, revealing that the Cold War did not begin (as formerly thought) at Yalta in February 1945, nor in Potsdam that July, but several months beforehand, in Moscow, where on the night of October 5, 1944, Stalin and Churchill carved up the territory covering Romania and Greece.

Churchill, believing "the moment . . . apt for business," appealed to the Soviet dictator, saying, "Let us settle about our affairs in the Balkans . . . We have interests, missions, and agents there. Don't let us get at cross-purposes in small ways. So far as Britain and Russia are concerned, how would it do for you to have ninety percent dominance in Romania, for us to have ninety percent of the say in Greece, and go fifty-fifty about Yugoslavia?" The British leader recalled in his memoirs that in the time it took for these remarks to be translated:

I wrote on a half-sheet of paper—

Romania	
Russia	90%
The others	10%
Greece	
Great Britain (in accord with USA)	90%
Russia	10%
Yugoslavia	50–50%
Hungary	50–50%
Bulgaria	
Russia	75%
The others	25%

Having finally understood, Stalin paused slightly and "took his blue pencil and made a large tick upon it, and passed it back to us." Thus, concluded Churchill, "It was all settled in no more time than it takes to set down."[14]

Today, with the opening of the secret archives, we have the key to these transactions, and we can judge the astonishment and frustration of Harriman, Schuyler, Berry, and the other Americans fooled by this covert Anglo-Soviet pact, which reduced these men to mere figureheads in the Allied Commission. "It must be admitted that our efforts towards the establishment of a freely elected government for Romania were doomed from the start," General Schuyler later wrote darkly. "There was simply no way we could successfully challenge Soviet domination. Yet, given the mood of our nations, the statements of our leaders, and the earnestness of our commitment to a peaceful, freedom-loving, postwar world, we had no choice but to make the effort . . . We learned, I think, a number of lessons: We learned, as others have said, that fruitful negotiations with the Soviets can be conducted only from positions of strength."[15] Was President Roosevelt's naïveté and optimism vis-à-vis the Soviets behind what some have called the American government's "non-policies" in Eastern Europe? Whatever the case, at the beginning of the war, FDR had deemed the Russians "perfectly friendly; they aren't trying to gobble up all the rest of Europe or the world . . . They haven't got any crazy ideas of conquest."[16]

As for Harry Truman, the improbable, self-educated president thrust into office on Roosevelt's death in April 1945, he did understand that "the Russians were running the Allied Control Commission without consulting the British and American members. The government was a minority government dominated by the Communist party, which, [General Schuyler] estimated, represented less than ten per cent of the Rumanian population. The vast majority of the Rumanian people, Schuyler said, did not want either the government they had or any other form of communism. The Communist party, however, was using every means possible to gain full control of the governmental machinery, and the opposition groups under young King Michael and the leaders of the majority parties were becoming ineffectual."[17]

During his last six months in the Romanian capital under Soviet control, Castelli rediscovered the Capsa café and the Calea Victoriei, where "people spoke of everything—food, politics, love"; he saw "oxcarts next to Fords in the middle of the main street; taxis jumping curbs and passing each other in all directions; *braya* sellers with their little copper kiosks on their backs; Met-

ropolitans, nasally intoning their prayers like the priests on Byzantine frescoes, except that here the liturgical word falls into the small white porcelain hexagon of the radio." For a few months more, he succumbed to the charm of that "patchwork city," as Queen Elizabeth of Greece described it; to the allure of a few beautiful Romanian ladies; and to the country's "stitched-up history, mended capital, and unstrung humor." All his life, Castelli would remember the atmosphere of those strange years in Bucharest, humorously comparing them to Hergé's cartoon melodrama *The Adventures of Tintin: The Sceptre of Ottokar.*

After Bucharest, Castelli spent time in Vienna, Budapest, and Paris; the depressed postwar capitals presented him with the realities of Europe in 1945, and with an awareness of what was needed to get the economy going again. He had long conversations with René Drouin about the state of the French market, and witnessed the everyday hardships of rationing. Shortages of food, raw materials, and capital would soon afflict the heart of Europe, and by 1947 American exports to the Continent outstripped imports sevenfold. In every country of Europe, recantations, purges, and the settling of scores kept people looking backward and preoccupied everyone, while intellectual debate revolved around one obsessive question: "How the hell did we get here?" The trials of Pétain and Laval in France, the Nuremberg judgments in Germany led to life sentences and death sentences. At the same time, throughout Europe, the urgency of creating a new social order and rebuilding national stability demanded a new generation of leaders. "For the past century, every writer who comes from the bourgeoisie has known the temptation of irresponsibility; it is traditional in the literary trade," wrote Sartre, the intellectual polymath who emerged in the fall of 1945 with his magazine *Les Temps Modernes* and his project for a literature of commitment. "Some situations leave room for only one alternative, the outcome of which is death . . . The Occupation taught us our responsibility . . . We must concern ourselves with the future of our age . . . An age, like a man, represents first and foremost the future."[18]

In the airplane carrying him back to New York, Castelli pondered the stinging irony of Janet Flanner's comments in her "Letter from Paris" for *The New Yorker:* "Now that not only Paris but all Europe is liberated, it seems reasonable to view Paris as what is left, after another plague of German war, of the city that was once the civilized, intellectual capital of so-called French Europe. Paris is not gay; it is restless, anxious, cantankerous, and probably

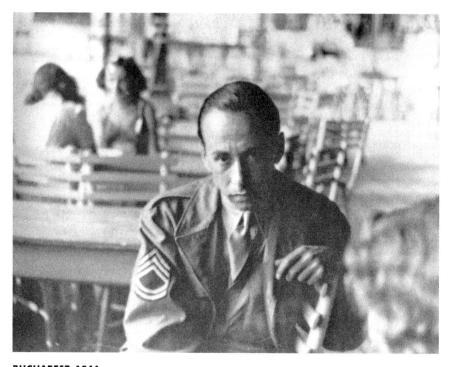

BUCHAREST, 1944
In OSS uniform, while serving as personal interpreter for General Cortlandt Van R. Schuyler, permanent representative to the Allied Control Commission in Romania

convalescent . . . The first new American movie to reach film-famished Paris was 'Mrs. Miniver,' whose sweetness and light were given a peculiar twist by the fact that the opening night was a gala charity affair to raise money for the sick, sad women returning from the concentration camp of Ravensbrück. The only other big American movie that has been seen since the liberation is Charlie Chaplin's 'The Dictator,' which Paris, after four years of one, did not find funny."[19]

THE YEARS
OF THE
METAMORPHOSIS
1946–1956

13. PLAYING HOOKY AT MoMA

My father was devoted to the U.S.; his army experience Americanized him. He became a Democrat and he wanted to be a citizen. His religion was humanism: my father was a man of the Enlightenment.[1]

NINA SUNDELL

AT THE BEGINNING of 1946, returning from Europe, Sergeant Castelli, now an American citizen thanks to his army service, moved back into the fourth floor of his father-in-law's marble townhouse at 4 East Seventy-seventh Street, and took a job in . . . his father-in-law's factory! Mihai Schapira had by now Americanized his name to Michael Strate, and continued to play the beneficent patriarch, settling his wife and each of his two daughters in different floors of the townhouse. Castelli rejoined a family that had substantially changed in his absence, beginning with his own daughter, Nina, now nine years old. "I was taken to the museum, or I went there myself, as soon as I could go alone. I hated school," she later recalled. "The others made fun of me because I was different—I had underpants that matched my dresses—so I changed schools every year. I had trouble at school because the United States was pretty anti-intellectual and precocity was not valued."[2] Castelli became manager of a knitwear factory in Jamestown, New York, and embarked on the strangest ten years of his life. While nominally going to work at his desk, soon he would fall into the habit of ducking out before lunch, first to the coffee shop, then to Manhattan, frequenting the Fifty-seventh Street galleries or heading to Fifty-third Street, where, without a thought to his knitted cares, he would play hooky at MoMA! As for his private life, while he still lived with Ileana in the Schapira townhouse, their relationship was now foundering. At nearly forty, Castelli was an arrested adolescent, with darkened brow, stormy eyes, and sensual lips, seductive as ever in his English tweed suits, impeccable shirts, and

New York, 1946, upon his return from Romania

refined ties. For Mihai Schapira, whose views about marriage qualified as bourgeois and practically Balzacian, this odd duck of a son-in-law, with his books and his museums, remained impossible to classify . . . in short, a good-for-nothing— a hopeless case!

About the organization of the townhouse during those years, Mariève Rugo, Eve Schapira's daughter and the Castellis' niece, writes, "The Castellis were to live on the fourth floor. Nurse, Mummy and I were to live on the third floor. The other floors were rented. My grandfather's social engineering was not a success. On a typical visit to the fourth floor, Leo drew my attention to a new painting. 'What do you think of it?' he said. I struggled to impress him, to explain why I liked Mondrian's *White on White,* but had difficulty understanding Jackson Pollock. Even with the Castellis, I felt I had to say the right thing in order to be welcomed back. Eventually, I wandered off to Nina's room. Nina would be reading or busy with homework, or playing with Miss Grundy a game that could be played by only two. Standing alone, I petted her dog, Noodle, for a while, then left. The adults waved as I crossed the living room on my way out. 'Lovely to see you, dear. Be sure to come back tomorrow.' Back in our apartment on the third floor, Nurse was out at the market. In her room at the end of the corridor, my mother hadn't even noticed I'd been gone. Years later, Ileana said to me, 'We could often hear Eve shouting at you downstairs. We were sorry for you. We wanted to make you feel how much we loved you but you were always so guarded and self-conscious and tense, we never knew how to reach you.' In the Castellis' household, with its rarified intellectual atmosphere, making money was regarded as a vulgar preoccupation. Nina grew up thinking Bopa dull and uneducated. She did her best to avoid him except for the command-performance lunches she and I ate with him every Sunday at a restaurant on Madison Avenue called Longchamps."[3]

For ten years, then, Castelli would navigate between this ordered bour-
geois household and the separate identity he was constructing, as he
explored the city and orchestrated his own transfiguration. Behind the
charming, cultivated figure who circulated, questioned, listened, and
probed, lay a forty-year-old man still dependent on his father-in-law. His
metamorphosis took place between 1946 and 1956, precisely the same years
as the transformation of the New York art scene. Castelli would evolve with
it, from an observer to a protagonist and a product—just as surely as his cur-
riculum vitae (Trieste, Vienna, Bucharest, Paris) had tracked the rise and the
disintegration of European art movements in the teens, the twenties, and
the thirties: from Italian Futurists to Austrian Expressionists, Romanian
Dadaists, and international Surrealists. Castelli had flowed with the transat-
lantic migration of the art world, just as he had been carried along to
Bucharest as an OSS official in American uniform, an agent in the building of
the new European order that would lead to the onset of the Cold War.

In parallel with his open family life, Castelli indulged a less advertised pas-
sion: his own artistic education, nurtured by his ardent veneration for
MoMA and its director, Alfred H. Barr, Jr. He "was an exceptional scholar
and perhaps had a better global comprehension of the origins and develop-
ments of modern art than anybody else," Castelli later commented. "I was
an assiduous visitor of the museum, so meeting Alfred Barr was one of the
great moments of my life."[4] In March 1941, he spoke in the strongest terms
of how transformative his first exposure to MoMA had been: "I was amazed
at the fact that I didn't know anything about art at all until I got there."[5] His
discovery of the permanent collection was "an utter revelation," and he
added, "I was dazzled. Alfred Barr was presenting an encyclopedia of Euro-
pean art, such as no European museum could have offered at the time. Side
by side, you could find French Surrealists, German Expressionists, and Russ-
ian Futurists. Along with the huge collection of French Impressionists,
unlike in France, you also found artists from other countries, completely
unknown in France, whose works (as with the German Expressionists) had
originated many later developments. The museum was organized so care-
fully that you could trace the history of all those aesthetic movements,
through an analysis that was not at all the European style."[6]

Castelli the dilettante, with his piecemeal knowledge, paced the galleries
of "his" museum, avidly basking in Barr's great project, systematically mold-
ing his sensibilities. Just as, with René Drouin, he had integrated decorative

arts and fine arts in a single exhibition while Europe clung to the precipice, so in New York he naturally took to MoMA's interdisciplinary vision, in which traditional painting and sculpture departments were set alongside others devoted to design, architecture, cinema, and photography. A scholar, Castelli had been a voracious and discerning reader in Europe; here, he could not help but thrill to the museum's educational mission, which fairly burst from the catalogues it produced with quasi-scientific rigor: *Cubism and Abstract Art, Fantastic Art, Dada, Surrealism,* and *Picasso: Fifty Years of His Art.* With Ileana, he had sought out emergent aesthetic impulses; here, he marveled at the institution's dual role as a *Kunstmuseum* (embodied in its permanent collection) and a *Kunsthalle* (revolving exhibition space for the new). The newness was not confined to the art: installations were intriguing, asymmetrical, below eye level, underscoring historical connections between works and stimulating the viewer's complicity with the artist, a revolutionary conception of the display of art.

In short, Castelli fully assimilated Barr's brand of modernism. The "encyclopedia of European art," which barely registered with the isolationist New York art world of the 1930s, became a bible to him. In this visual and spatial narrative understanding, art history was freed of its Austro-German theoretical apparatus. Why should this empirical approach to European culture via the paintings, sculptures, furniture, decorative objects, photos, films, and architecture of its finest decades have so strongly affected this *Homo Europi*, however mutant? What Barr narrated, through the works of Cézanne, Picasso, Matisse, Brancusi, Dalí, Magritte, Duchamp, Moholy-Nagy, Kandinsky, Lissitzky, Albers, and so many others, at this critical juncture in Castelli's metamorphosis, was in fact the fully integrated story of his own life: it was a globalized reconstruction of the varieties of the European avant-garde, as inflected by American pragmatism. "What particularly struck Europeans about Barr," said Castelli, "was the fact that such a young man could be so knowledgeable and have already done so many things."[7] Compared with Castelli, a thirty-nine-year-old amateur with but one exhibition under his belt, Alfred Barr, a mere five years his senior, had created a museum world.

At the age of twenty-five, Barr, then an assistant professor at Vassar College, had embarked on a year-long tour of Europe. Surveying the art scene only five or six years before the Nazis obliterated it, Barr encountered the European modernist vanguard scattered in the capitals of England, Holland, Russia, Poland, Czechoslovakia, Austria, Germany, Switzerland, and France.

"Nowhere more than in Holland are the old and new so abruptly, so piquantly contrasted," he wrote after the first leg of his trip. Bolstered by his admiration for the Dutch museums, Barr crusaded to import modernism to America. He was disappointed by the lukewarm reception of those who "take it for granted that public museums should be indifferent to modern art—except to give occasional memorial exhibitions to painters who have just died," and realized that "nothing similar to Holland is possible at present in American museums." A denunciation immediately followed by a cri de coeur: "Will any of it come into American museums? . . . To Americans, the success with which this policy of showing contemporary advanced work has been carried out is a sad reminder," wrote Barr, "and perhaps a challenge."[8]

Between Barr's discovery of the European avant-garde and his attempts to ship it overseas, barely a year elapsed: in November 1929, he presented his first exhibition as director of the new Museum of Modern Art in New York. "Nowhere has [the rising tide of interest in modern art movements] been more manifest than in New York," he noted. "But New York alone, among the great capitals of the world, lacks a public gallery where the founders and the masters of the modern schools can today be seen. That the American metropolis has no such gallery is an extraordinary anomaly."[9] Barr would quickly mine his European discoveries to develop a visionary plan for MoMA. Over the course of a decade, assiduously battling hidebound detractors, the young director negotiated with journalists and various museum factions to realize his project, which was nothing less than to present an encyclopedic vision of European art, educate the public, and transform the cultural ecology of New York City by becoming a "guide for its people." But the question of how to integrate American artists into a modern art museum remained. What place should they be assigned in a history that virtually excluded them? "The modern French school, after years of bitter controversy, has conquered this country as it has every other," an especially hostile New York critic wrote at the time. "We have carried our admiration for it to an absurd length, accepting almost without question anything which bears the cachet of Paris, exalting certain distinctly second-rate artists far beyond their deserts and in the process neglecting the art of every other country and to a certain extent our own."[10] Such qualms would soon plague Castelli too. For him, as for every émigré, MoMA represented, above all, New York's preeminent cultural space, and the exclusion of the indigenous struck them as indefensible.

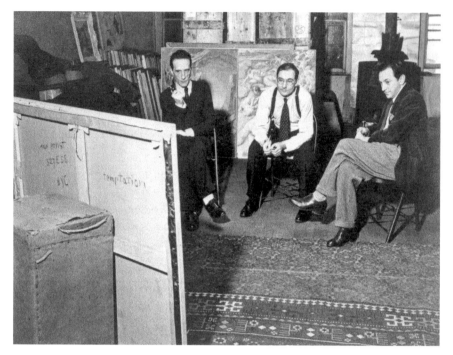

1946, MoMA, NEW YORK
FROM LEFT TO RIGHT: Marcel Duchamp, Alfred H. Barr, Jr., and Sidney Janis, jurors for the Loew-Lewis
competition

During his first stay in America, in 1941, Castelli had already recognized that MoMA's engagement with European artists far surpassed that of an ordinary museum. Barr, in constant touch with Varian Fry in Marseille, had found the means to underwrite the foreign artists' travel expenses to New York, inviting some to deliver lectures, others to show their works, transforming his institution into a haven for exiled Europeans (much as the New School for Social Research had become for academics). "As I've had the opportunity to witness," a grateful Nicolas Calas wrote to Alfred Barr, "MoMA is doing everything it can to help artists emigrate from Europe . . . The hardest thing for an artist or intellectual trying to earn a living in America is to make contact with an educated public. If our work isn't known here, or if a writer doesn't have a publisher, it's nearly impossible to go on."[11] In 1941, Castelli could have heard Salvador Dalí speaking on "Surrealism Today," Piet Mondrian expounding his ideas on "A New Realism," and others. Castelli was no less enthusiastic about the exhibitions he found at MoMA, including Under-

standing Modern Art, Paul Klee, Joan Miró, and Salvador Dalí. The follow-
ing year, at a show of Pavel Tchelitchew, he rediscovered *Phenomena,* the very
painting that he had shown by candlelight on Place Vendôme before the
gallery had even opened!

Upon his return from Europe in 1946, in a highly symbolic gesture, Castelli
donated a piece from his personal collection to MoMA, a Gorky drawing.
Monroe Wheeler, the new head of exhibitions, acknowledged the gift: by
that time, campaigns waged by certain trustees had all but defeated the
doughty founding director. Considered too pro-European, too intellectual,
too radical, Barr nevertheless managed to save his neck by becoming head of
collections, ceding the directorship to René d'Harnoncourt. Dorothy Miller,
an elegant, refined young woman on excellent terms with local artists, now
worked as his assistant, and maintained increasingly frequent contact with
Castelli. Over a period of ten years, Castelli would become both Alfred Barr's
most fervent disciple and MoMA's main booster. Making deals in Paris and
New York, he would find his way in circles close to Barr's, but never dared
speak to him directly. The man Castelli considered "unapproachable" was
indeed committed, defending a mission that had never been easy in the best
of times. For the moment Alfred H. Barr, Jr., an ascetic pastor's son, an Ivy
League scholar in the best sense, groundbreaker in devotion to European art
and in the mission of public education; and Castelli, son of a social-climbing
Austro-Hungarian banker, self-taught, self-consciously limited, a late
bloomer who worshipped culture, remained on parallel paths. But the day
they would meet would be a significant moment indeed.

Castelli had returned from Europe at a pivotal time, right after the Surre-
alist wave and just at the advent of the New York School. Tirelessly he ana-
lyzed the local scene as a privileged observer, watching the incessant
reshuffling, as artists and dealers came and went, and painters moved about
the chessboard of galleries. During his absence, the map of New York had
been redrawn: new territories, new forces, new periodicals, new cafés, new
customs, new gallery spaces. There were new personalities as well, such as
Betty Parsons, Charles Egan, and Sam Kootz, the first to gloat over "the
death of Paris and the moment for New York to create something original."[12]
To the great relief of some, the displaced foreigners had gradually gone
home; but they had left behind their mark on the New York art world. At the
Cedar Tavern on Eighth Street, artists continued to enjoy café life as they had
when the Surrealists were among them. With their galleries, their habits,

their language, their cliques, their snobberies, their magazines, and their widely celebrated presence, that school (and André Breton in particular) had often seemed intrusive in the New York scene. As intrusive, one might say, as the first European modernists—Duchamp, Brancusi, and others—at the 1913 Armory Show had seemed for Ashcan painters like Robert Henri and George Bellows, whose work suddenly looked provincial and dated.

Some, like the painter William Baziotes, recognized the benefits of the émigrés' presence: "It was fantastic to see them behave as artists outside of the studio, to observe their reaction, their attitude, their way of life, and above all to see them express their confidence in their own talent."[13] Stimulated by Matta, who visited them in their studios, and who on Saturdays conducted Surrealist games in his own space on Ninth Street, Motherwell, Gorky, Baziotes, Rothko, Busa, and others were introduced to the hitherto unknown practice of group collaborations.[14] Between émigrés and (at least some) Americans, a solidarity began to form. Even if others occasionally sensed "a tremendous incompatibility of ideas"; even if Breton, with smug arrogance, dismissed Motherwell as *le petit philosophe*; and even if, finally, the poorly grasped notion of psychic automatism spurred misapprehensions, ambivalence, and conflict, Matta would not have traded the relief brought by the Surrealists to the American situation, till then so restrictive that they were virtually "ready to explode."[15] For even as the New York School emerged,[16] the position of the American artist, for decades a second-class citizen in American society, remained tenuous. The long battle for recognition was still being fought against the bastions of philistinism.

In the spirit of the European tradition and guided by his lifelong reverence for creators of every stripe, it would be precisely that battle Castelli would join. In various ways over the next ten years, he would aid and abet this burgeoning art world, doing favors, brokering alliances, and supporting a series of variously successful initiatives as go-between, advisor, independent curator, collector, agent, jack-of-all-trades—most often behind the scenes, performing thankless tasks with alacrity. At first, he would serve as the go-to man of the New York art scene, the eager fixer you could call when things had gone awry, the petty clerk, the runner between the Old World and the New. Like Sidney Janis, he would evolve in time from small-time collector to dealer, passing through various intermediary stages. But for now he studied.

In his insecurity and indecision, this omnivore of art and literature took on a second mentor in addition to Alfred Barr, a second Virgil through this ten-year journey. For while he could depend on Barr for European art, for

American, he needed Clement Greenberg. "I started educating myself about American art, but I didn't get very far," Castelli admitted. "Clement Greenberg, who knew of my interest, said to me, 'I'll take care of showing you what's going on here, what the young American artists are up to.' "[17] It was Greenberg who, in 1947, introduced him to Arshile Gorky, at a party in Connecticut hosted by the painter's sister-in-law V. V. Rankine. Marianne Schapira's divorce from Mihai and her relationship to the painter John Graham was likewise propitious: Graham would introduce Castelli to Robert Motherwell. And so building on the chain of acquaintanceships, with a keen sense of forging links—the social aptitude so evident in the dreamy boy— Castelli constructed his network. Through Peggy Guggenheim, he discovered Pollock's work; through Greenberg, he met Gorky; through Gorky, finally, he encountered Pollock. In 1969, recalling with the art historian Barbara Rose the various players of that period, Castelli described Matta and Motherwell as intermediaries or "bridgers." "Motherwell was really my contact, my first American contact, let's say literate and articulate American contact with the art scene . . . Most definitely, he acted as a bridger. And I owe him really a great debt for making me, not purposely but just through being what he was and his activities."[18]

The origins of this network, which over the next five decades would become the gallerist's secret weapon, bear close attention. "After Matta left, I lost interest in the Surrealist movement and began to gravitate towards what was going on in New York," Castelli said, remembering Gorky's friend whose departure for Europe roughly coincided with the artist's suicide. "That really was the beginning of my involvement with New York art. All those people, if they found somebody who was really interested, they would sort of get hold of you as the Surrealists had gotten hold of me in Paris. They thought that here was an ally—and why not? I didn't know exactly what I was going to do. Greenberg knew about Drouin and my involvement with that gallery. So he felt, well, here's somebody maybe we can do something with."[19] Feigned passivity or benevolent deference? Greenberg introduced Castelli to the new artists that he had discovered, the emerging greats—first de Kooning, then Paul Resika. Still, Castelli allowed, "there was no close relationship with Greenberg ever . . . I considered him in a way my senior. I admired his visual perception very much. It was only much later that I began to disagree with him here and there, because it seemed to me that he was focused too much on just one possibility in art and not on others."[20]

"Peggy and Matta went away around the fall of 1947," he continued.

"Peggy was doing a very interesting job, and it's a shame that she left. She was showing Baziotes at Art of This Century, and Pollock, and Motherwell especially. She had all the elements there to become a very, very important central focus for this movement. But then she left, and all those painters were taken over by two galleries at that time, Betty Parsons and Sam Kootz. Then Dudensing also left. Pierre Matisse, of course, was there."[21] In the still uncertain world of postwar New York art dealers, the only constant was change, and the New York artists lacked a solid foundation to support them. One day, Sam Kootz called Castelli with an unusual proposition: "He said, 'You are the first person I'm talking to about this. I'm leaving the space and I would suggest that you take it.' So that means that back in 1948 everybody took it for granted that I should open a gallery. And just imagine, it took me another nine years before I did. But anyway, I didn't. Then the next person that he talked to was Sidney Janis, and Sidney took that space. At first Kootz was extremely erratic. And Janis the first couple of years was very tentative; he really didn't know what he was going to do here. He was really interested in the classics, and certain artists he favored over others, like Léger. I used to see Sidney very, very often. We had lunch at least twice or three times a week and talked about things and worked out plans, projects, and things like that, although not many came about."[22]

Though he deferred becoming a dealer, Castelli was already a collector—one both rabid and penniless, as he admitted with a gleam in his eye. "I preferred to spend what little I had on art," he said. "I bought the two Klees and the Mondrian. The Mondrian that I had bought for two thousand dollars, borrowing money from my brother, had to go later. I sold it for eight thousand to a doctor in Baltimore who, after some years, resold it for four hundred fifty and complained about the low price he had obtained."[23] To those initial purchases, we can add a drawing by Gorky, *Summation,* bought from Julien Levy under amusing circumstances: "I remember this drawing wasn't framed yet, just lying on the floor, and I fell in love with it. I bought it for nine hundred dollars, in installments of a hundred a month."[24] In 1949, when Drouin's gallery was liquidated, Castelli again added to his collection, acquiring several handsome Dubuffets, including the famous *Taxi,* a Kandinsky, a Pevsner, and a Léger—works he would gradually sell off to finance his other projects.[25] And after that, still juggling his finances, he bought four Pollocks from Sidney Janis, then two more, both horizontals, with Ileana (including *Scent,* the artist's final canvas). Years later, Castelli still relished recounting coups, pre-

ceding the gilded age of gilded price tags: "Just imagine, I had bought *Scent* for three thousand dollars, which back then was a lot of money for me! So one day, I went up to Joe Pulitzer's place out in the country, and I look around and see this old friend of mine. 'Oh, Joe, you got this one here. How lucky!' 'Well,' he said, 'I had to pay a stiff price for it.' So I said, 'Well, how much? Three hundred?' 'More, more!' 'Three fifty?' He said, 'More like it,' so he must have paid at least three hundred fifty thousand. Now that painting, if I had it around today, would probably be worth three million dollars!"[26]

However sedulously Castelli wandered through the galleries of Fifty-seventh Street, watching, asking, buying, searching, exulting, it was ultimately his amazing gift for personal relations that gained him entry into art circles. Castelli was a social creature, with a bon vivant's special know-how for making friends. He was engaging, funny, generous, the life of the party, and possessed of one invaluable asset: his father-in-law's beautiful town-house on Seventy-seventh Street. "I had great parties at my house up there on the fourth floor with everybody around in the art world. I can remember one party that we had, it must have been around Christmas. Julien Levy got terribly drunk, and he fell into the Christmas tree that had real candles on it. That was a real catastrophe!"[27] Castelli was also a man of taste: "We had very simple kind of furniture—Eames furniture, some simple sofas. The dining room table was a round Victorian. When I changed my furniture and bought something else, Bill de Kooning, who was a great friend at the time, said, 'Could I have the table? I like the table.' And I gave it to him."[28] With a marvelous Kandinsky in deep Prussian blue on the wall, alongside the Klees, Mondrians, Pollocks, and the Gorky drawing, Castelli showed off an apartment as elegant as any in Paris. The Schapira house, facing Central Park and just a few blocks from the Metropolitan, also became a layover for visiting Europeans. "I remember that Hans Arp came," Nina Sundell reminded her father. "I don't think you had anything of his, but I remember that he visited." To which Leo added: "That reminds me of a friend of those times, Frederick Kiesler, who was an architect and painter, a man of all trades, and who said [something] about Arp: 'This is Arp, not art.' He was very small, very lively, Kiesler, and wanted to be involved in everything that was going on at the time; also with the younger generation." Nina continued: "And I remember that you and my mother usually had rather sharp things to say about the Surrealists, but many of them were around, and I remember meeting Max Ernst and Matta and Huelsenbeck, who wasn't very clever." "Right,

Huelsenbeck, the German Dada artist," Leo segued. "A bit of a pedantic kind of guy."[29]

As the first provisions of the Marshall Plan started to emerge, Castelli, a fervent admirer of Truman, grew infatuated with his adoptive country. "The moment I arrived, I realized that America was an ideal place, and it seemed to me that Europe was stagnating. After the cultural transfer following the war, America gave Europe new confidence . . . Without it, I'm not sure Europe could have gotten back on its feet."[30] Against this backdrop, Castelli underwent his ten-year metamorphosis in several stages: as avid collector, as apprentice art aficionado, as transatlantic *passeur,* as independent curator, and ultimately, the providential patriarch of American painters!

14. *PASSEUR* TO THE NEW WORLD

*Drouin had been showing Kandinsky since 1945 . . . He had really under-
stood something. But in Paris, it was going very, very badly for him. He
started by sending me a rolled bundle and in this bundle was a Kandinsky
and some other canvases of the same type.*[1]

LEO CASTELLI

IN PARIS ON December 13, 1944, Wassily Kandinsky died at the age of
seventy-eight, leaving an impressive number of oil paintings, watercolors,
and drawings piled in his studio. He had enunciated a grand vision for him-
self as both a painter and a theoretician: "If fate grants me enough time, I
shall discover a new international language that will exist for eternity and
never stop enriching itself," he had written magniloquently in *Concerning the
Spiritual in Art* (1912). "Its name is painting . . . Must we then abandon utterly
all material objects and paint solely in abstractions?" But he would never
enjoy the recognition he craved, and as Kandinsky waited in vain for an
enterprising French dealer to relieve his financial woes, the work that did
leave his studio would be dispersed among small galleries (Jeanne Bucher,
L'Esquisse) that failed to garner much attention for it. Things were, however,
markedly better in the United States, where several collectors, including the
Guggenheims and Albert E. Gallatin, took an early interest in his work. Still,
the 1936 MoMA exhibition Cubism and Abstract Art had been a source of bit-
terness, and what he saw as Alfred Barr's "scornful treatment" in the cata-
logue inspired Kandinsky to send a long letter of protest to the director.[2]

Barely three months after her husband's death, Nina Kandinsky took mat-
ters in hand and wrote to René Drouin, whose gallery was among the few to
remain open under the Occupation. In June 1945, she sent the dealer "twelve
canvases and three oil paintings on cardboard for a retrospective"; she would
try the same tack again three times in as many years. "Kandinsky's show,

PARIS
Nina Kandinsky and René Drouin

Parisian Period, opened this afternoon at Drouin's: a revelation here," Henri-Pierre Roché wrote to the Baroness Hilla Rebay, New York director of the Guggenheim Foundation, which was about to inaugurate the Museum of Non-Objective Painting. The baroness had purchased a number of Kandinsky canvases, one of which still hung in Drouin's Paris gallery. Two years later, Roché would follow up: "Your Kandinsky at Drouin's (*Parisian Period*) is in the center of the best panel of the best room: so much admired, a perfect choice . . . Everything happens, sooner or later, here or there, as it must happen—and takes its rightful, just, place. Time corrects everything . . . Your much hoped for, expected, needed museum, a great feature in New York and in the world, will soon begin to be built. What splendid news! Travel will yet increase and people will come to see it. You need do nothing in Europe."[3] Naturally the superb exhibitions at Drouin pleased Roché and Karl Nierendorf, the German dealer who had long championed Kandinsky in the United States; but in the devastated city of postwar Paris, clients remained decidedly scarce, inspiring Drouin to finally entrust those famous rolls to a pilot friend who flew the Paris–New York route. He knew that Castelli could be depended on to collect them at the airport, frame them, and "show them to the Baroness, who bought them systematically."[4]

For his part, Karl Nierendorf, living in America since 1936, had already tried before the war to find a market in America for Kandinsky, accumulating quite a few works in the storage space of his New York gallery. But then, during a trip to Europe in the spring of 1947, Nierendorf met with the artist's widow. "I am fighting a very hard and unpleasant battle with Nina Kandinsky, trying to obtain some late works," he reported to Hilla Rebay. "The prices are high and she is absolutely convinced that they will continue to rise and will reach at least Picasso's level. Zervos told me that she said to him that Kandinsky deserved MORE attention than Picasso—which amounted almost to blasphemy to him . . . The recent success of Kandinsky has quite overwhelmed her. She sees in this the victory over the French press at last after long years of resistance, and the situation here actually has changed entirely."[5] It was not the start of a fruitful relationship! In the rather bleak and hesitant market of the postwar years, art dealers, following the example of French intellectuals, would painfully ponder how to relaunch what we might call their brands. One point of light in the dismal atmosphere was Drouin's beautiful exhibitions. "Being permanently hungry is naturally paralyzing," Nierendorf observed. "Here in Paris, too, you feel the uncertainty of the situation. In politics there are constant crises, the currency is shaky

23 Novembre 1947

Chere Madame,

 Je suis, enfin, en mesure de repondre, au moins en partie, aux questions que vous me posez dans vos lettres. Permettez-moi de vous dire, dès le debut, que c'est avec tres grand plaisir que je m'occupe des tableaux de votre mari et que je ferai tout ce qui est dans mon pouvoir pour mener a bien la tache que vous m'avez confiee.

 Ce pauvre Nierendorf est mort tres soudainement et sans laisser de testament. Ceci, comme vous pouvez bien l'imaginer, rend tout tres complique et difficile, car c'est un Administrateur Public qui s'occupe de la liquidation de ses biens. Heureusement, Madame Prytek est une bonne amie, toujours prete a m'aider autant que possible, mais elle-meme n'etait pas au courant de toutes les affaires de Nierendorf. C'est pourquoi, comme vous le verrez, qu'il y a pas mal de questions que, pour le moment, nous n'avons pas encore reussi a resoudre.

 Dette de 3469 dollars. Il faudra que vous reclamiez cette somme a Francis J. Mulligan, Public Administrator, Hall of Records, Room 309, 31, Chambers Street, New York 7, N.Y. Pour eviter que cette somme vous soit remise par voie officielle, je vous conseille de specifier qu'elle doit etre envoyee ainsi que toute correspondance relative a cette question c/o Mr. Rupf a Berne. En tout cas je crains qu'il faudra que vous attendiez plusieurs mois avant de recevoir cet argent.

 Dette de 1776.89 dollars (Dr. Wiechner) J'ecris aujourd'hui-meme au Dr. Wichner de me remettre ce montant pour votre compte. Je vous prie, cependant, de lui ecrire une lettre en lui donnant instructions de me verser la somme en question.

 "Heiteres". Madame Prytek n'a jamais vu ce tableau qui, apparemment a ete vendu avant qu'elle devienne la directrice de la Galerie. Elle a deja fait des recherches mais n'est pas encore parvenue a trouver quand et a qui ce tableau a ete vendu.

 "Monde Bleu". Ce tableau se trouve toujours chez Guggenheim et n'a pas encore ete payé. Je vous conseille d'ecrire a la Baronne pour lui demander quelles sont ses intentions concernant ce tableau. Si necessaire, vous pouvez lui dire de prendre contact avec moi.

 Tableaux Galka Scheyer. Madame Prytek m'a montré la liste des tableaux qu'elle a reçu apres le deces de Madame Scheyer. Les numeros suivants de votre liste n'y figuraient pas: 392, 393, 416, 439, 468, 470, 563, 570, 577, 595. Quant aux aquarelles, les numeros suivants manquent: 114, 249, 415, 456, 459, 463, 465, 466, 474, 475, 494, 495, 510, 544. Pour ce qui est des lithos, il y en a 11 au lieu de 18. Tout le reste, c'est a dire 39 huiles, 20 aquarelles, et 11 lithos se trouvent chez moi. Madame Prytek n'a aucune idee au sujet des tableaux qui manquent. Elle suppose qu'ils ont ete vendus, mais ne sais pas a qui et comment.

 Versements mensuels de 1000 dollars. Ces versements continueront a etre faits regulierement jusqu'a l'epuisement de la somme qui vous est due.

NEW YORK, NOVEMBER 23, 1947
Letter from Leo Castelli to Nina Kandinsky

<u>Tableaux chez Nierendorf</u>. Ici la situation est plus compliquée. J'ai reçu les huiles suivantes figurant sur votre liste: 652, 590, 412. Je n'ai pas reçu les autres. Par contre Madame Prytek m'a donné les huiles suivantes qui ne paraissent <u>pas</u> sur votre liste: 356, 384, 390, 652, 558. Par consequent j'ai reçu au total 8 huiles au lieu de 15. Certains des tableaux indiqués sur votre liste sont encore la, mais figurent comme etant la propriete de Nierendorf. De certains autres, Mrs. Prytek n'a aucune connaissance. Elle m'a promis qu'elle tacherait de sortir ceux qui sont la, mais elle craint qu'elle aura des difficultes car elle a deja dit a l'Adminis- trateur que ces tableaux appartenaient a Nierendorf. De toute façon on pourrait echanger les tableaux que j'ai reçus et qui ne figurent pas sur votre liste contre ceux qui vous appartiennent. J'attends vos instructions a ce sujet avant de proceder, et je pense qu'il faudrait garder en tous cas les tableaux plus importants, puisque l'erreur a ete faite.

Quant aux aquarelles, j'en ai reçu 5 au lieu de 14, et aucune de ces 5 ne figure sur votre liste. La aussi Madame Prytek fera encore des recherches.

C'est tout pour le moment, chere Madame. Je vous ecrirai de nouveau aussi tot que j'aurai des nouvelles au sujet des questions qui ne sont pas encore eclaircies. En attendant, je vous prie de croire a l'expression de mes sentiments les meilleurs.

Leo Castelli

√² = Soulignés sont retrouvés

and . . . there are frequent strikes. No one knows what the outcome of all this will be. In Rome, and all over Italy, I had the same impressions: Europe is heading for a crisis that may take on unexpected proportions . . . In terms of art the situation is just the same. In all of Italy, once the cultural center of Europe, there is not a single artist of rank or personality to be found. Paris is not more inspiring anymore. One is bored when walking through the Louvre galleries . . . There is a distinct feeling here of being near the end . . . Sinister and demonstrable signs of decline hang over Paris. The bold layout of the city under the Spring sun, the blooming parks; all that remains beautiful. But the human spirit that had once created all that has now lost its creativity . . . Looking at the architecture of churches, palaces, etc., it seems strange and lifeless . . . Exhibitions . . . are old-fashioned, lackluster and, in a word, boring . . . Buying art is not advisable anyway, 1) because there is nothing good, 2) because everything is very expensive."[6]

On October 25, 1947, just as Castelli was starting to receive his first rolls of Kandinskys from Drouin, Karl Nierendorf dropped dead of a heart attack. Nina Kandinsky tried to retrieve the works that the German had in storage and, on Drouin's advice, she turned to Castelli, who became a providential figure for her. "Permit me to say at the outset that it would give me great pleasure to look after your husband's paintings, and I will do everything in my power to accomplish the task that you have entrusted to me"[7]: so runs the elegant preamble of Castelli's cheerfully fearless reply to Mme Kandinsky's first query, on November 23. Between the canvases that Drouin sent from Paris and the ones that were reclaimed from Nierendorf's gallery, Castelli would soon find himself in possession of roughly one hundred Kandinskys, which he deposited in his father-in-law's downstairs storage. His mission was to find a proper welcome for the abstract master's work in the New World.

Let us pause a moment to notice Kandinsky's geographical trajectory, which had been marked by the political upheavals plaguing Europe between 1900 and 1944: "The USSR had banned him. Germany had rejected him. Spain, where a few critics had begun taking an interest in his work in 1936, had fallen under Franco's dictatorship. Italy, which he greatly admired, was also in political disgrace. Europe had been reduced to France, Switzerland, and Great Britain. Beyond that territory, there was only an imaginary geography: China, but he was too old to go there; and America, where he enjoyed his greatest financial success."[8] Kandinsky's oeuvre, developed between Moscow, Munich, Berlin, and Paris, bore the scars of all the public disasters

and personal misadventures that had decimated the European avant-garde. In becoming the *passeur* of Kandinsky's oeuvre into the New World, did Castelli realize the symbolic gravity of the project he had so gamely taken on?

"Poor Nierendorf died very suddenly without leaving a will," he wrote to Nina Kandinsky. "As you can imagine, this makes everything rather complicated and difficult, as the liquidation of his assets is now in the hands of a trustee. Fortunately, Mrs. Prytek is a good friend, always willing to help as much as she can, but even she didn't realize the full extent of Nierendorf's dealings. This is why, as you will see, there are quite a few questions that we haven't yet been able to resolve . . . That's all for the moment, dear Madam. I will write again once I have news about the outstanding issues."[9] Between the "incredible disorder" of Nierendorf's papers, pressure from the American administrator who was trying to recoup the estate taxes, and the frailty of Mrs. Prytek, the gallery's manager, who suffered a sudden if not unexpected nervous breakdown, Castelli had indeed chosen quite a peak to climb. Now he was obliged to deal with creditors, appease the impatient widow, and disentangle the mysterious knots of Kandinsky's contract with Nierendorf, not to mention organize exhibitions and hunt for clients.

"I can confirm that the following canvases and watercolors by Kandinsky are in my possession: fifty-five canvases (from 1923 to 1938), twenty-nine watercolors and gouaches (from 1922 to 1936), and three lithos (in eleven prints)," Castelli reassured Mme Kandinsky on May 10, 1948. In a telegram of November 10, he reported: "Received yesterday forty four oils, twenty two watercolors, and eleven lithos. Will send list René STOP Will handle other paintings mentioned your letter best Leo Castelli." Castelli worked to create order from chaos by putting the works in proper sequence, verifying their dates, estimating their value, and drawing up long inventories in his handsome, elongated Austro-Hungarian script. But like Drouin and Nierendorf before him, he received only an impatient rebuke. "I demand, and *this is very serious*," she fired at Castelli, "that you send me the trustee's letter. Dr. X, who has just returned, told me you promised to write me in detail. I repeat that I want to know what paintings were bought by Baroness Rebay and when she will pay; the prices were given in Swiss francs fortunately, as the French franc took a terrific dive."[10] Castelli obliged by return mail: "The Baroness has promised to pay . . . in January. Therefore, please do not be alarmed. In January you will receive the amount of 34,375 Swiss francs. You can absolutely count on me,"[11] he wrote, soothing to a fault.

Around mid-February of the following year, Castelli confirmed that "the

Baroness indeed settled her account several days ago. Consequently, I am able to send you the 22,750 Swiss francs that I owe you, at the address provided. Could you let me know whether this money should be sent in francs or dollars and if your name should be mentioned? Next, for reasons too long to explain, I would prefer to make payment in four installments: 7,500, 5,000, 5,000, and 5,000, spread out over a period of roughly one month, with the last payment made before the end of March '49."[12] Over the next six weeks, Castelli would take four mysterious trips "on behalf of" Nina Kandinsky, probably to Switzerland, to deposit the money in a bank account. "Dear Madam, I have just now returned from my first trip. Everything went smoothly. I will most likely leave again soon and in any case I will keep you apprised. Needless to say, I will leave with Janis any paintings he might need," he wrote on March 4, 1949. Letters of March 22 and April 22 mention further trips, until he could report that "the matter is finally resolved."[13]

Once Nina Kandinsky had received her arrears, the next objective was to go ahead and find spaces where the works could be presented to potential new collectors. It was Sidney Janis that Castelli first chose to approach. Janis would recall: "When we opened the gallery, Leo came to every exhibition. He was excited by the artists that we were showing. He was rather close to Nina Kandinsky, who had let him have a lot of her husband's paintings, because there was nothing happening in Europe on him. On the basis of that, we did a Kandinsky show. We borrowed a lot of paintings from Nina through Leo. He was helpful in our getting them . . . It was not really known that Leo was a dealer. He tried to sell the paintings for Mrs. Kandinsky in the same way that Galka Schleyer tried them, as well as Kandinskys and Klees and Jawlenskys, ten to fifteen years before that."[14] Despite initial reservations, the widow finally gave in and the opening took place. "The exhibition at Sidney Janis is very beautiful. You did well to let him handle it,"[15] Castelli exulted, stroking his skittish mistress. One painting was sold, to a Baltimore collector for twelve hundred dollars, and Janis bought two for himself. Later, having found another new client, Castelli wrote to ask if she "would be willing to sell *Leichte, Bildung,* no. 584, 1933 . . . lent for an exhibition, for which there is a buyer. If you agree to sell the painting, kindly write back to let me know your minimum price."[16]

After several months of such smooth and fruitful handling, tensions began to surface between the artist's widow and her agent, over several paintings that Nierendorf had declared "destroyed" or "burned" during the war, but that gradually started reappearing in the catalogues of other New

York galleries. Several drawings had undergone the same sort of resurrection as well, and Nina Kandinsky grew testy with Castelli; as the pleasantries gave way to suspicions, a new tone emerged. *"I am absolutely serious* that [those works] must be found, I suppose you gave them to a dealer on commission or maybe you forget they had been sold? They are *major drawings* and not little sketches that might have been misplaced. This is why I hope you will find them as quickly as possible. What is this Bauhaus exhibition? Who is organizing it? There has been no catalogue and no information,"[17] she snarled. From that moment, and until the end of their relations, the problem of the lost works would poison their correspondence, with Castelli focused on tracking down the paintings that had resurfaced, and Nina Kandinsky concentrating only on the ones still missing. "All the paintings are now with Leps, except for the following: *Im Blau, Verenchleichtes Volupten,* and *Berührte, Schwarz,* which are with clients of Sidney Janis; *Spitzenblau,* in the Bauhaus exhibit that is touring the US; *Zwei Bewegungen, Leichter Block, Verträumt, Aus der Tiefe,* and *Vier Teile,* which I have not yet managed to find. I'm still looking and will keep you posted."[18]

Despite Castelli's goodwill and conciliatory tone, relations would not improve and, though still wearing his courtier's hat, he in turn started to lose patience:

> Your letter of December 16 came as a bit of a shock. The shippers came to get *Im Schaden* on October 16, and I thought you had received the paintings a long time ago. When I called them, they told me they were waiting for the other paintings before making the shipment. I gave them immediate instructions. *Spitzenbass* [*sic*] is still traveling with the Bauhaus exhibit. Sidney Janis was the one who lent it, and he will return it to you as soon as he gets it back. As for the five watercolors, I now know what has become of *Verträumt.* Reading over your old letters, I see: "February 6, 1948, among the six paintings sold to the Baroness, *Verträumt* belongs to M. Drouin." Consequently, the painting is now at the Guggenheim, in the Baroness's private collection. You must have forgotten about that sale, and I would be grateful if you would look through your own papers to verify this. There are still four watercolors that I have not managed to find, and I don't understand how they could have vanished. You very kindly offered to give me a painting by Kandinsky in thanks for the services I have

rendered over these past years. I must therefore, very regretfully, forgo this painting, and naturally any reimbursement for expenses incurred during the six years those paintings were with me. Permit me to remind you, however, that it was only because of my prompt action that the paintings at Nierendorf's were not seized by the trustee, who would still have them today. I took a considerable risk at the time, and it is still possible that I will face serious consequences when the estate is adjudicated. Just ask your attorney, Mr. Slaff: he will confirm this. I did you a favor on which it is difficult to place a monetary value. And, finally, I would like to remind you that it was because of me that a considerable number of very important paintings have been sold here in America, and that these sales cost me a huge amount of work without earning me a dime. It is not my habit to blow my own horn, and I am saying this only so you understand that the loss of those 4 watercolors, worth 5,315 Swiss francs minus 30%, or 3,721 Swiss francs in total, is relatively minor.[19]

It was unprecedented professional and personal assertiveness on Castelli's part, indicating a growth of confidence in his powers. But the widow Kandinsky would not budge: "We are still missing three paintings . . . ask the shipper . . . In any case, you kept 30%, which is utterly reasonable and per our agreement. When you paid me for those ten paintings, you still kept 30% to store those paintings and watercolors. That is why I offered to let you choose something from among my husband's works as a souvenir of Kandinsky. Three watercolors would be quite a souvenir."[20] Castelli's retort came without delay:

Dear Madam, I believe that . . . you must have received *Im Blau*. The paintings left port on January 12 on board the *American Reporter*, and T Transport's agent in Paris should be able to provide the specifics if by any chance you haven't yet received it. I asked Janis to find out about *Spitzenblau* and he authorized me to write to the organizers of the Bauhaus exhibit to ask them to send him the painting as soon as possible. I do not believe I am confusing the painting *Reverie*, no. 520, 1930, with the watercolor

Vertraümt, 480, 1932. It was never in my possession and, if there is any confusion, it must have originated when you first wrote to me in 1948. In any event, *Vertraümt* is now with the Baroness and it will not be possible for me to get it back. There are thus five missing watercolors. You were kind enough to offer me 3 in recompense for services rendered, for which I am sincerely grateful. To compensate you in turn for the two missing watercolors (even though for one of them I do *not* consider myself responsible), I am offering to send you a canvas by Kandinsky that I own, *Stabil,* no. 544, 1931. I believe it is more than worth the two watercolors. As such, I hope that this entire episode, which, believe me, I have found quite distressing, will be definitively settled. Very cordially yours, Leo Castelli.[21]

It was only two and a half years later, after a long silence, that Nina Kandinsky agreed to take back *Stabil:* "It has been an eternity since I last saw you. I tried telephoning during your trip to Paris. My lawyer, Monsieur Slaff, is holding onto my two paintings *Nacheinander* and *Futterhaff.* I am now finally able to take them back. This is why I would ask you to send me the two with you, *Stabil* and *Spitzenbau,* no. 399, 1927, along with the ones at M. Slaff's + 50% insurance. Write me as soon as they have been shipped."[22] But by now it was too late. "Unfortunately," Castelli informed the widow, "having had no reply to the two letters I wrote you about *Stabil* nearly two years ago, I concluded that you were not interested in that painting and I sold it on April 11 of this year to a local gallery, the New Gallery, for the sum of $850. Kindly let me know where I should send this amount. As for *Spitzbau* [*sic*], I have just telephoned Monsieur Slaff to ask him to add the two paintings he is holding to the shipment. I hope to have the opportunity to come to Paris soon and would be very pleased to see you after all these years."

And so ended, in dysfunction and bitterness, exacerbated by the slowness of the pre-electronic age, a relationship that had been born eight years earlier under Drouin's good auspices. Between 1948 and 1953 Castelli, undergoing rather a baptism of fire, had managed to restore to the rolled paintings he received their status as works of art, overcoming the political obstacles that had successively displaced Kandinsky from Moscow to Munich, from Munich to Moscow, from Moscow to Berlin, and from Berlin to Paris. Castelli gained for the artist's work the visibility that it had lacked and helped

the American public discover its importance, alongside Miró and Klee, while repatriating to Europe the financial proceeds of his efforts. Thanks to him, collections of Kandinsky's work would develop at the Baltimore Museum of Art, at MoMA, at the Phillips Collection, at the Sidney Janis Gallery, at the New Gallery, and at the Davlyn Gallery; he also found the artist a home in private collections, selling *The Escape Ladder* (1940) to Helen Acheson, *Dominant Violet* (1934) to Mark Goodson, *Penetrating Green* (1938) to Saidie May, and *Relations* (1934) to David Lloyd Kreeger. Above all, Castelli placed a gigantic group of works with Drouin's earliest American convert to Kandinsky: the Baroness Hilla Rebay, who was collecting for the Museum of Non-Objective Painting. The Kandinskys he sold her formed a hoard of works so large that the Guggenheim Foundation's board of trustees would later vote a deaccession of rare magnitude for any museum: fifty oils would be auctioned at Sotheby's, London, in 1964, with thirteen more oils and thirty-three watercolors meeting the same fate at Parke-Bernet in 1971![23]

In becoming Kandinsky's agent, though perhaps ultimately doomed to disappoint the implacable widow, Castelli gained his footing in the world of New York museums and galleries, and he established the modus operandi of selling through personal networks that would be one of the unlikely keys to the future gallerist's success. Perhaps there was little choice. "He had no interest in our gallery in an economic sense and he had no income from it. The things that he did, he did out of love and out of his belief,"[24] explained Janis. Castelli, looking back at those years, would note, "I had had the experience of working as a private dealer, but opening a gallery seemed unfeasible because of the lack of money—or courage—who knows?"[25] Whatever the limitations and indignities of this thankless and secondary role, it nonetheless for the first time heralded Leo Castelli's role as an artists' *passeur* to the New World.

15. "A TOUCH I AM GLAD NOT TO HAVE"

An American culture is forming, founded on the best Europe has to offer.
This spiritual alliance that must and will continue is a shining beacon, a
guiding light on which the eyes of Frenchmen are fixed.

Given the intensity with which the young painters are working, it is
inevitable that this nation, which has attracted the best teachers and can
afford the most magnificent art collections, will someday devise an origi-
nal expression of its own.[1]

FERNAND LÉGER

"UP THE STEEP and often rickety stairs that lead to Greenwich Village's cold-water flats on Sunday a few weeks ago went two perceptive critics of avant-garde American painting, Clement Greenberg (one of the first to champion the now increasingly recognized group of 'extremist' U.S. abstractionists) and Meyer Schapiro (professor of art history at Columbia University and a distinguished authority on such diverse subjects as Byzantine iconology and modern expressionism). The results of this Sabbath trek—a selection of twenty-three pictures by as many artists—have just been hung in the Kootz Gallery (till May 15), and it all adds up to one of the most successful and provocative exhibitions of younger artists I have ever seen." Among the curators, collectors, dealers, and critics now flocking around American artists, the great model of the artist's life remained the nineteenth-century French one of heroic penury. "About two-thirds of the artists represented happen to be under thirty," continued Thomas B. Hess, "and it is perhaps just because they are still young that they can survive the life our society so drastically imposes upon them. Rickety stairs and cold-water flats are not figures of speech; they exist, in the deepest Sartre sense, as do all the gray discomfort, bleakness, and economic insecurity that go with them. Only nineteenth-century Paris has been as tough on its artists as has our equally

smug civilization. And—perhaps not surprisingly—this very toughness and pressure of neglect has pushed together a group that seems as blithe and as debonair as were the bohemians of the Impressionists' Café Guerbois. These young New Yorkers have been compared by Clement Greenberg to Verlaine's *Poètes maudits,* but though their conditions may be comparable, their products are not."[2]

By the late 1940s, the New York press, traditionally so hostile, gradually began to soften its habitual deprecation of homegrown art. While Clement Greenberg could write in 1943 that "for the tenth time the Whitney Annual gives us a chance to see how competently and yet how badly most of our accepted artists paint, draw, and carve,"[3] and in 1944 still rail against "this year's Whitney Annual . . . more disheartening than ever," believing that "American art, like American literature, seems to be in retreat,"[4] a mere four years later his tune would change. "If artists as great as Picasso, Braque, and Léger have declined so grievously, it can only be because the general social premises that used to guarantee their functioning have disappeared in Europe," he wrote in March 1948. "And when one sees, on the other hand, how much the level of American Art has risen in the last five years, with the emergence of new talents so full of energy and content as Arshile Gorky, Jackson Pollock, [and] David Smith . . . then the conclusion forces itself, much to our own surprise, that the main premises of Western art have at last migrated to the United States, along with the center of gravity of industrial production and political power."[5] Following Greenberg, other critics, too, would have to admit that with the fifties came a renaissance in the New York scene.

In this aesthetic construction zone, artists, critics, and dealers radiated quasi-magical powers. And Leo Castelli—enlightened amateur, small-time collector, agent, curator—was a handyman par excellence, shuttling between uptown and downtown, New York and East Hampton, the United States and Europe, moving among galleries, museums, studios, and cafés, connecting, mixing, and joining in. As a curator, he devised exhibitions and organized shows, but always in others' galleries and at their financial risk. Formerly second fiddle to Drouin, he knew well the benefits and drawbacks of the part, and was now playing it to Janis, Kootz, Thaw, Ployard, and Copley.

By a strange coincidence, in the month of June 1948, while Sidney Janis opened his New York gallery to show European painters, Peggy Guggenheim introduced Jackson Pollock's works to Europe at the Venice Biennale.

Between 1944, the year Pollock painted *Gothic,* and 1948, when he produced *Summertime,* he slipped his moorings and sailed full ahead towards a new artistic horizon. In those few years, he progressed from static, traditional easel painting to a more gestural and dynamic way of working, his canvas laid flat on the ground. In April 1948, de Kooning's first solo show at the Charles Egan Gallery attracted wide notice. But Pollock's fragile and dazzling kinesis struck a different chord; it proved that an emotion as potent as any inspired by Gothic cathedrals could span the Atlantic and grip the world with its purity, violence, and energy. That June, after a six-year hiatus imposed by the war, the Venice Biennale resumed with a bang, when Peggy Guggenheim created a sensation. It was a "memorable Biennale," wrote the critic Enzo di Martino. "We discovered the great canvases by Pollock, the most violently new of all the painters . . . The young Italian painters were strongly impressed and their work began to change."[6]

Nevertheless, the New York dealers did not have an easy time finding buyers for artists like Pollock. Business stayed slow through 1950, and so it would remain until collectors and the art market could tune in to a new generation of artists and critics. Dealers turned to critics in particular to conceptualize the new movement in a way that hadn't been needed before. In September 1949, Sam Kootz, with Harold Rosenberg's backing, showed the artists what the philosopher Ortega y Gasset labeled the "Intrasubjectives"; several months later, Kootz hired Clement Greenberg and Meyer Schapiro to scope out new talent in the rickety, insalubrious studios of the East Village. Then the Metropolitan began showing contemporary pieces as well—an odd move for an institution that had long ignored the art of its own country. But the exhibition, American Painting Today, was poorly received by local artists, eighteen of whom boycotted the event. They wrote to the director, Roland Redmond, denouncing the conservative selection committee as "notoriously hostile to the avant-garde." The *Herald Tribune* devoted an editorial to the "Irascible Eighteen," and little by little the press picked up on the story. An article in *Life* showed fifteen of the eighteen rebels glowering for the camera, in postures of defiance: a pyramid of seated men (Rothko, Newman, Stamos, Ernst, Brooks) surrounded by standing men (Tomlin, Motherwell, Still, Pollock, Baziotes, Pousette-Dart, Reinhardt, Gottlieb, de Kooning) and with a lone woman (Hedda Sterne) at the apex.

Hoping to rescue American art from this impasse, Castelli brought Janis an old idea of Pierre Matisse's, recast in a more systematic, explicit, and

ambitious form: by staging a competition between Paris and New York—or rather, New York and Paris—they might elevate the Americans' status. "We decided that Leo would select the Americans and I would select the French," said Janis. "Leo was helpful. He was a great champion of the work of Jackson Pollock and Rothko and people like that."[7] "The comparisons were rather curious and amusing, but well founded nonetheless," Castelli added. "However, I was roundly criticized for this approach. Charles Egan, a very chauvinistic fellow, was especially incensed. The night of the opening, he told me it was an absurd idea and that there was no possible comparison between the Americans and the French. As for Barr, who didn't really buy American painters and was content to watch from the sidelines, he wasn't very enthusiastic either!"[8] Nevertheless, "I felt that in my first show I wanted to stress this idea that American painting was just as good as the European, the great Europeans. So I . . . compared Pollock with Lanskoy, Kline with Soulages, de Kooning with Dubuffet, Gorky with Matta, Rothko with de Staël, David Smith with Léger, Coulon with Cavallon. That was something that I wanted to demonstrate for a long time, and nobody had done it. Janis, for example, never mixed his European masters with his Americans. Well, that was one first."[9] That "one first" gave rise to others, and others still: five years later, Feigl, Doris Meltzer, Obelisk, and the Galerie Moderne had flattered Castelli's scheme by imitation, holding contests of their own between Europe and the States.[10]

ARTnews commented dryly that " 'Young U.S. and French Painters' brings together a remarkable combination of works by younger contemporaries, pairing representatives of the two countries to indicate similarities in direction . . . suggest[ing] that art can be created anywhere. While educational, the show includes many superior works that exist forcibly on their own, with some of the best men of both countries being shown."[11] Such an event, at that particular juncture, was a critical boon to the confidence of the New Yorkers. In those postwar years, French and American artists incessantly watched each other with a critical eye, eventually swapping roles in a new cultural configuration. Speaking at Yale University, Sartre confounded his audience by celebrating the rejuvenating effect of young American novelists on French literature. "The Occupation heightened the French intellectuals' fascination with the violence, proliferation, and mobility of American life. The American novel's influence stems from the revolution it wrought on narrative techniques . . . It's not that we were morbidly interested in stories

SIDNEY JANIS GALLERY, NEW YORK, 1951
View of the exhibition Young U.S. and French Painters curated by Leo Castelli

of murder and rape per se; rather, we were seeking tips on how to revive the art of writing. Without realizing it, we had been crushed under the weight of tradition and culture. The American novelists, with no tradition to back them up, forged with savage brutality invaluable instruments . . . What raw talent and unselfconscious spontaneity had wrought, we used consciously . . . Soon the first French novels written under the Occupation will start appearing in the United States. We will give you back the techniques you lent us. We'll give them back to you digested, intellectualized, less effective and less brutal, intentionally adapted to French tastes. Because of this constant exchange, in which nations rediscover in other nations what they themselves have invented and discarded, these foreign books might well reacquaint you with the eternal youth of that 'old' Faulkner."[12] Just as Sartre trumpeted the impact of Faulkner and Dos Passos on Camus's (as well as Sartre's) writing, so Castelli, by setting Dubuffet against de Kooning and Rothko against de Staël, sought alliances and complicities beyond national labels.

Several months later, extending his role as transatlantic go-between, Castelli would make another conceptual leap: rather than favoring Euro-

peans and Americans who stood up to the French, he would devote himself exclusively to an American avant-garde headed in a direction that defied comparisons. Witness the exhibit he organized in New York (at Janis), and in Paris one month later (at Galerie de France). "In the winter of 1950, American abstract art reached what we might call its zenith," the Belgian critic Michel Seuphor noted on his return from New York. "I made a complete tour of the New York art scene, rummaged in every corner, and I can say that there is indeed a young generation of American painters who are gaining notice, with accents that can be very pure and very violent . . . This form of painting emerged only five or six years ago and began making itself felt. Before that, everything was imported . . . Today, most Americans . . . think their young painters are every bit as good as ours. Some even claim that they're better than the ones in anemic Europe, an old world at the end of its run."[13] On both sides of the Atlantic, the views of critics and artists were converging, and Seuphor's observations corroborated those of every European who came back from New York. First Léger became enthralled, then Jacques Lipchitz: "I've never worked as much as I did in New York. I didn't move from there," the latter said. "I don't know what was in the air over there, what atmospheric charge, but you either worked feverishly or you got calcinated—there's no other word for it."[14] Indeed, with the end of the war, the departure of the Surrealists and of their long shadow, the New York artists felt energized as never before.

"Why did Fifty-seventh Street always seem sunlit to me, even when it was snowing?" wrote Seuphor. "Was it Sidney Janis's smile, Wittenborn's singsong voice, Egan's veiled humor, or, just around the corner on Madison Avenue, Kootz's cordial welcome? This street of art dealers has very wide sidewalks: room for everyone." In his fine exploration of the New York art world, Seuphor was among the first to spot Castelli's efforts at Janis, and devoted several laudatory lines to his contest between American and French painters, as well as including some striking photos. One shows a wall on which the portrait of a woman by Dubuffet, hung high, seems to fade away beside a larger *Woman* by de Kooning, hung lower and to the right of it. Near the doorway, the Rothko likewise outshines the Nicolas de Staël, again hung to the right; Kline's raging brushstrokes run riot over the calm of Soulages; and Pollock's drips, circles, and many other curves besides swirl around Lanskoy's forms. Seuphor's exhaustive report, entitled "Paris–New York 1951," captures Castelli's intended provocation, the clash of two artistic capitals,

one in decline and the other ascendant. But Seuphor never names Castelli, which is in itself quite telling—for the time being, Leo Castelli kept to the shadows, behind Janis. Seven years later, however, his name would be on everyone's lips.

Meanwhile, Castelli, entranced by the aura of the native-born artists, remained alert and inquisitive, rushing about to the many lectures, conferences, and roundtables held in those years. While still merely a fellow traveler in the midst of the artistic ferment, he would soon find himself at the confluence of all those paths. "I see a culture in a state of change—changing its very deep premises," declared the anthropologist Gregory Bateson at a San Francisco symposium composed of George Boas, Marcel Duchamp, Darius Milhaud, Frank Lloyd Wright, and Mark Tobey. "If you take the work of Villon, he has stated a protest against the rigidities of nineteenth-century science which come into the culture . . . The Villon, the Matta, the Surrealist Ernst, the Duchamp 'Nude,' this Mondrian which flickers—all are making statements about process movement and dynamics." "We don't emphasize enough that the work of art is independent of the artist," Duchamp interjected. "The work of art lives by itself, and the artist who happened to make it is like an irresponsible medium. No artist can say at any time: 'I am a genius. I am going to paint a masterpiece.' "[15] Fascinated by this concept of art's own magical being, Castelli silently armed himself for a coming ideological battle.

A year later, in New York, he was thrilled to hear similar questions debated by Newman, de Kooning, Hofmann, Hare, Gottlieb, and Motherwell, the group moderated by his mentor Alfred Barr. "Do we artists really have a community?" asked Newman. "If so, what makes it a community?" "I see no need for a community," interrupted Hare. "An artist is always lonely. The artist is a man who functions beyond or ahead of his society. In any case seldom within it." "Why should we create a community? Everyone should be as different as possible," Hans Hofmann leapt in. "There is nothing that is common to all of us except our creative urge . . . It seems to me all the time there is the question of heritage. It would seem that the difference between the young French painters and the young American painters is this: French painters have a cultural heritage. The American painter of today approaches things without basis. The French approach things on the basis of cultural heritage—that one feels in all their work." To this de Kooning would add: "I agree that tradition is part of the whole world now. The point that was

brought up was that the French artists have some 'touch' in making an object. They have a particular something that makes them look like a 'finished' painting. They have a touch which I am glad not to have."[16] Even Barr, who had awakened notoriously late to American art, now began to evolve under the influence of the young curator Peter Blake, conceding that "the spirit of painting after World War II seems by contrast much bolder . . . Everywhere in the United States as well as in Western Europe many strong young artists and a number of talented old men are engaged in renewed exploration and adventure."[17]

Ever since *Life* magazine had devoted an article to Pollock in the summer of 1949, alluringly headlined "Is He the Greatest Living Painter in the United States?" and featuring a full-page photo, the New York artists were becoming increasingly visible flesh-and-blood presences in the public imagination. "To enter Pollock's studio," wrote Robert Goodnough, addressing Hans Namuth's depiction of Pollock dancing around his canvas, "is to enter another world, a place where the intensity of the artist's mind and feelings are given full play."[18] Michel Seuphor couldn't resist offering his Paris readers thumbnail sketches of his new heroes. "Pollock is grumpy. What burdens could the poor man be shouldering? What regrets are gnawing at him? The only time I ever saw him lighten up was after a film that showed him painting, his canvas flat on the ground, under the blue sky, as a peasant might hoe, plant, and weed. Motherwell seems very kind. But is he as kind as all that? Civilized—maybe too civilized. A hint of decadence wouldn't do his refined paintings any harm. De Kooning, quicksilver, blunt, enthusiastic, subject each day to fresh anxieties, from which only painting delivers him. Has a messy studio on the second floor of a Fourth Avenue building that almost blends with the life of the street."[19]

As pins on the map moved and critics confirmed the migration of energies in the postwar cultural landscape, Leo Castelli too remained in perpetual motion, gliding from Manhattan to East Hampton to Paris; from collector and broker to art lover and curator; from interest in the European scene to a new and permanent fascination with the American painters; from Surrealism to abstraction to Abstract Expressionism. Gliding too from his partnership with Drouin and the failing Vendôme gallery to his arrangement with the ascendant Sidney Janis. Gliding among multiple workspaces, multiple residences, multiple identities, multiple reference points, and widely scattered resources. Gliding among many activities, but steadily headed from the

VENICE, SUMMER 1960
Biennale XXX, with Sidney Janis

periphery to the center of the action while embodying multiple identities: dilettante, European with no occupation, collector with no money, husband with many girlfriends. As time went by, he seemed to be ubiquitous, seen in Paris, New York, East Hampton, standing alongside artists, critics, intellectuals, collectors, curators, and dealers, ever the good soldier though awaiting a rise beyond adjutancy.

It was with Janis that Castelli traveled this stretch of the road, as he had traveled an earlier part with Drouin. And it was with Janis that Castelli would effect his own metamorphosis, while contributing to the transformation of New York. "I could never convince Drouin or Tapié to work with the States, even though they were the only ones who saw clearly enough to try to find a way out of the crisis. But their arrogance made them believe that only a European could produce a new aesthetic leap forward. In reality, poverty was too widespread and the economic situation too desperate. Drouin was so poor that he'd had to give up his apartment and was living in the basement of his gallery."[20] Like Castelli, Seuphor also subscribed to that insistent and inevitable comparison, noting that "New York is sharp metal. At its best, it's a diamond giving off a thousand reflections, among which we

sometimes recognize the moon . . . Everything in this city is open, accessible, approachable . . . The various artistic groups are not at each other's throats, as they are in Paris; they don't propound exclusions or wave doctrinaire banners. There are no clear-cut boundaries: all the artists know and see one another. This doesn't mean there isn't competition, only that it's not vicious. Take your place: there's room for everyone on this round earth and we are all at the top."[21] Between beleaguered Europe, whose ups and downs he shared through contact with Drouin, and New York City, where he still occupied a diminutive place at the Schapira table, Castelli gradually staked out his own territory by monitoring the slightest tremors in the New York cultural scene and reacting with strategic discretion. Only a few months more and he'd emerge from the shadows.

16. THE RIGHT MAN FOR THE JOB, OR JUST A TANGO DANCER?

To me, there was fantastic prestige attached to the great painters—a sort of hero worship, of which there is more in Europe than there is here. In America, nobody seemed to be very interested in artists and writers, which surprised me . . . For me, the point was to be with these people, to live their lives.[1]

LEO CASTELLI

MIKE LOEW: That's exactly the weakness of the Expressionists. No composition.

MILTON RESNICK: Look me in the eye and say that balancing the composition isn't straight from the (expletive) Bauhaus.

LUDWIG SANDER: You all need the Mondrian discipline.

MICHAEL GOLDBERG: Talk to me like a grown-up, not one of your college students. Why (expletive) say all elements must harmonize.

ROBERT RAUSCHENBERG: Why should the artist be left out of the work of art? He's as important as geometry and should have an equal presence.

ESTEBAN VICENTE: Agreed! But is it a weakness? Isn't it the act of the expressionists to knock down geometry?

MERCEDES MATTER: Do we have to go on and on? Cézanne never made his composition geometric, always a moving frame or format, backward and forward. The space was elastic.

GEORGE CAVALLON: Right. He left the composition open, the space to fix the format.

MATTER: You mean to say, after all these profound quotes from profound sources, that we end up to one big difference. The composition or the format?

HARRY HOLTZMAN: You Expressionists talk like Mondrian wasn't even born. Can you see yourselves? You are still living in the nineteenth century with a romantic illusion of personality to make a work of art.

VICENTE: First, you are a human being, then an artist.

RESNICK: Please stop. Don't bring in Existentialism![2]

The Club, 39 East Eighth Street, July 20, 1950. Abstract and Expressionist artists were attempting to define themselves in endless discussions, using models handed down from old Europe.[3] In the fall of 1949, to remedy their isolation and stake their claim in an inhospitable culture, they had created the Club. Leo and Ileana Castelli, together with the dealer Charles Egan, were the only non-artists to join as founding members. Among the artists, some were on the verge of fame, such as Franz Kline, Willem de Kooning, Ad Reinhardt, Jack Tworkov, and Robert Rauschenberg; others less so, such as Lewin Alcopley, Giorgio (George) Cavallon, Ibram Lassaw, Landes Lewitin, Conrad Marca-Relli, Philip Pavia, Milton Resnick, and Ludwig Sander, who had a way yet to travel, some never quite to arrive. "In 1947," *Horizon* reported, "Clement Greenberg wrote that the fate of American art was being decided below Thirty-fourth Street by 'young people, few over forty, who live in cold-water flats and exist from hand to mouth.' He said their reputations did not extend beyond a small circle of fanatics . . . misfits obsessed by art and isolated in the United States as if they were living in Paleolithic Europe."[4]

With this view now ratified by their friends—critics, journalists, philosophers, and musicians—the downtown artists were about to engage in a joint undertaking unprecedented in the States, its impact nothing short of revolutionary. Soon a more general awareness would arise of what only a small elite had known. Not that it would be easy, however. "Everyone was desperate at the time, the artists really felt isolated," Ileana explained. "They had no audience, nothing. It was hard for them to survive. And yet they kept at it, feeling like they were working only for themselves." Or, as Ludwig Sander put it, "We were really just like Bowery bums, in a way. Of course, in those days, a lot of us visited each other's studios in the afternoon." They began by meeting in a member's loft, "a rather small and modest place, with a piano," as Ileana described it. "The first to arrive was supposed to sweep up, empty the ashtrays—do the housekeeping. And since I usually got there first, I had to clean up before the others came." "Everyone did their part," added the

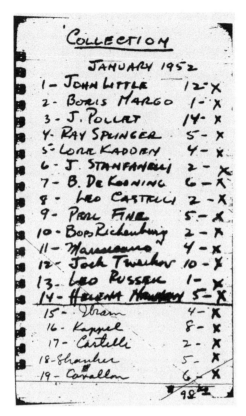

NEW YORK, JANUARY 1952
The Club membership dues. Leo and Ileana Castelli are
numbers 8 and 17, respectively.

painter Esteban Vicente. "De Kooning washed, say, a hundred or two hundred glasses at one time!"[5]

In such isolation, group discipline was essential to survival. Rules were rigid and roles were assigned as the identity of the whole took form: "We did sort of make common laws that there were to be no pictures on the walls, no manifestos; it was not an aesthetic grouping but merely a social grouping," Sander explained.[6] Ernestine Lassaw related that "Philip [Pavia] was the bookkeeper, he kept the books and planned the programs. I used to address the cards for him, for the Friday panels. There were a couple of members who did not want women to join, but Elaine de Kooning and Mercedes Matter demanded to be members and we got them in."[7] As Ileana confirmed, "*Outsiders* were viewed very unfavorably . . . A founding member had to sponsor them and fight to get them accepted. They would ask Marca-Relli,

who'd say, 'That guy is of no interest to us!' The Club rejected a lot of appli-
cants, because the outside world had to remain on the outside." The small,
typed invitation cards conveyed minimal information, in the obsessively
exclusionary spirit of a secret society, taking no chances with interlopers:

Wednesday Round Table Discussion
May 9 On subjects selected by the Members
9.30 p.m. For Members Only — RSVP, no guests!
Friday CONFERENCE
May 11 Clement Greenberg
9.30 p.m. RSVP, one guest only per member!

39 East 8th Street
New York City, NY

This is not to say the woes of more inclusive societies were not ever-present:

Fellow Club-members:
We are asking you to pay your 1950 dues before the season ends.
The Club needs the money to cover current and future expenses.
We would not ask by mail if this were not pressing. You can
leave your payment with one of the three members of the
Treasury Committee:

Landes Lewitin	Philip Pavia	Ludwig Sander
117 Waverly Place	473 6th Ave.	84 E 10 Str.
NYC	NYC	NYC

Thank you.[8]

Though Wednesday meetings were restricted to members only, the Friday
sessions were open to guests and outside speakers, and word of the Club's
activities spread fast through rarefied New York intellectual circles. The
steady rise in membership certainly reflected that community's growing
infatuation with the group: in a mere five years, the original roster of fifteen
had increased tenfold. It was an organic expansion, if not entirely cordial. "A
speaker would come talk about his own work or someone else's, or share his

views on a current exhibit," remembered Ileana. "Other times we showed a film, or a composer like John Cage or Morton Feldman played the piano. And afterwards we talked about the film or lecture and the debates became very heated, even violent. We passed the hat and someone went to get some whiskey from the Cedar Tavern downstairs. Everybody got drunk and then went home . . . Almost all the foreigners passing through New York came to see us at the Club: we had Moholy-Nagy, Pevsner, and Gabo, who even ended up staying with us. Of the lecturers, I remember Mark Rothko and especially Joseph Cornell, who brought the silent film *Broken Lilies* [*sic*] by D. W. Griffith; but people laughed and he got very upset—he felt humiliated!"[9] Among other notable speakers at the Club were the philosophers Hannah Arendt and Heinrich Blücher, her husband; professor William Barrett of NYU and Father Flynn of Fordham University, who debated Existentialism and the nature of political commitment; the critics Clement Greenberg and Thomas B. Hess (offering a formal approach to art), or Harold Rosenberg and Meyer Schapiro (with a more social perspective); a roundtable on "the problem of the committed artist" with John Ferren, Lionel Abel, John Cage, and Edwin Denby; and finally the critic Harry Holtzman on Mondrian.

If the success of the Club over the six years of its existence seems dazzling, it must be set against a long history of failure and rejection experienced by American artists who had wrestled with their countrymen's hostility to art. It was not until the 1950s that the American artist, consciously or not, took responsibility for a challenge that had been facing him since the nineteenth century: the struggle for identity, in a society with strong puritanical impulses and dominated by the philistine values of money and power, in relation to which painters or sculptors had long been considered useless and superfluous. Artists such as Thomas Eakins, Robert Henri, John Sloan, and Thomas Hart Benton had fought long and hard, mostly without luck, to vent their distress at such marginalization, in a land where *Time* magazine would describe Pollock's work as "apt to resemble a child's contour map of the Battle of Gettysburg"!

But the war had two fronts. In the fifties, the American artist was also fighting for emancipation from the great, stifling European model on which he had always depended and to which he had always been compared. "In New York, we were living in the Picasso era," explained the painter Nick Carone. "Everyone was crazy about Picasso, Matisse, and Braque; therefore we would read Melville and other local writers to appear truly American."[10]

And so it was in relation to two contexts—that of American society, and that of Western civilization—that the American artist of the fifties had to define himself. Someone like Castelli would have seemed in principle a dubious ally: too European for the Americans, too East Hampton for the Manhattanites, too uptown for the "downtown bums." No wonder, then, that he would be stigmatized by many, provoke unfriendly reactions, and from time to time be referred to as "coq au vin"! To be fair, he was an anomaly in the rather homogeneous milieu of these embattled artists. What did they share with him except a common belief in the magic power of art? To gain their trust, it fell to him to prove his good faith: offering lavish Christmas presents, financing the Ninth Street Show, inviting the de Koonings to spend two successive summers at his home in East Hampton, a vacation residence Ileana bought during the fifties.

　　"Leo Castelli was a charter member," insists Ludwig Sander in retrospect. "But Philip Pavia started denying it right after the first Stevenson campaign," he added, referring to Adlai Stevenson's first presidential bid. "As I recall, his complaint was that Castelli was getting the Club organized as Artists for Stevenson, whatever that amounted to—not even a drop in the bucket. But he felt that Leo had taken the thing out of their hands and given it to Motherwell and his crowd." Actually, several of the Club's artists designed posters for the Democratic candidate in 1952 and decorated the ballroom of the Commodore Hotel. But Castelli's strong support for Stevenson is worth considering. Although Castelli had but eight years earlier squirmed in his front-row seat as the Soviets took over Romania, the Republicans' anti-intellectual and paranoid reaction to the communist threat as epitomized by Joseph McCarthy's crusade was not congenial to a soul as reflective as Castelli's. "How do we counter this external threat of communism?" Stevenson asked on September 12, 1952, in his speech to the National Guard Armory in Albuquerque, New Mexico. "There is only one sound answer to this, and that is by increasing the strength and the unity of the free world . . . by hard, patient building of strength in the free world . . . With these policies, we have already checked Soviet aggression and perhaps saved the world from a third world war. The Truman Doctrine, the Marshall Plan and the North Atlantic Pact have restrained Soviet power in Europe . . . I say to you in all sobriety, that in this direction is the long-run hope of restoring the independence of nations now under Soviet dominion. We must face the bitter unhappy fact that this is no easy task."[11] Stevenson's argument seemed

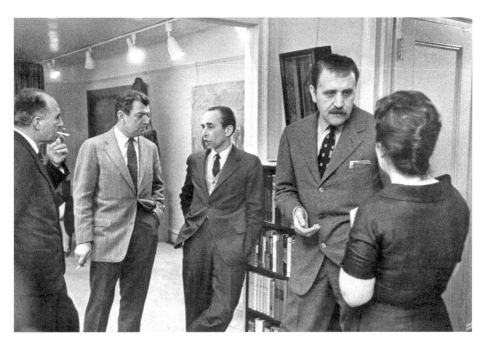

NEW YORK, JANUARY 1, 1953
Reception at the home of Leo and Ileana Castelli

perfectly sensible to the young European immigrant, even if it did not sway the American electorate.

Such clashes aside, "Castelli liked the Club," Ernestine Lassaw, the de Koonings' close friend, confirmed. "He was interested in artists, he would come to all the parties. He especially liked to dance: that's how he got involved with artists." But, she continued more critically, "he was a tie sales-man, he had a factory! It was his wife, more than he, who went to the lec-tures. Leo Castelli had no art background. Every Christmas when we would go to Leo's house, he would have a present for everyone: ties for all the men!"[12] Castelli was well aware of the suspicions he aroused: "They thought it strange that I, a European with no particular interests, should take an interest in them, and they figured there must be some financial angle to it. In reality, money played no part in what I was doing. While they didn't know what to make of me, I had tremendous admiration for them." Ileana Castelli more wryly noted the disparity of wealth: "We were . . . people interested in art, with greater financial means than they had, and I remem-

ber that one year, as a Christmas card, we gave them all a Wols watercolor!" Did this disparity color the judgment of the painter Esteban Vicente, who described Castelli as merely "the group's patron"? Of course wealth is always relative. "At that point nobody had a penny—Castelli himself didn't have much anyhow—but he was playing the role of the man that will help with his means."[13]

The story of the Club seems to resemble that of the British art syndicates responsible for the Royal Academy of Arts in the late eighteenth century. It's the story of a more or less spontaneous coalescence of individuals as a grass-roots initiative, with all the pitfalls and potentialities that such a thing brings with it. "Before that I never saw any relationship between writers and painters in this country," Vicente stated. "The first months of the Club were almost too good to be true," recalled the sculptor Ibram Lassaw, Ernestine's husband. "All the members worked very hard cleaning and painting the place, and building shows. Nobody shirked their duty. They didn't even have to be told what to do. Everybody just jumped in to the niche as they saw it. It was a most amazing experience. We were almost organically united."[14] "The Club was very good," added Sander. "It did an awful lot for a lot of us. We began to evaluate ourselves." Jack Tworkov was even more effusive in those days: "The Club is a phenomenon. I was first timid in admitting that I like it. Talking has been suspect. There was the prospect that the Club would be regarded either as bohemian or as a self-aggrandizing clique. But now I'm consciously happy when I'm there . . . There is a strong sense of identification . . . Here I understand everybody, however inarticulate they are. Here I forgive everyone their vices, and I'm learning to admire their virtues. How dull people are elsewhere by comparison."[15] Ileana Castelli considered it "a stroke of genius to demand that people focus more on the artists and their heroism than on their works." We should not fail to note Ileana's growing importance at Leo's side in this enterprise. Whatever had put them asunder in their private lives, the Club was for them, too, a place of union. And so she took to it even more naturally than Leo: increasingly active there, she enjoyed the status of an intellectual, possessed of true empathy towards the artists and their aims, and exceptionally gifted at articulating the meaning of their struggle.

More than anything, the story of the Club is the story of a very specific geographical context: that of the square block bounded by Eighth Street to the south and Ninth Street to the north, Broadway to the east and University

Place to the west, in what was in the early fifties a rather gloomy part of the East Village. Club members paid out of pocket (five hundred dollars in "key money") to rent the loft at 39 East Eighth Street, in which, three evenings a week for six years running, as if in an extended psychoanalysis, they together with sympathetic others (critics, gallerists, museum curators, musicians, philosophers) found the words to describe a collective identity, though not a homogeneous fellowship. "We were supporting each other," recalls Marca-Relli. "There were the older artists, some of them such as Pollock who had already succeeded and others such as de Kooning, who was about to succeed and who exhibited in the uptown galleries, and there were the younger ones who had never shown anything."

But it was not a purely harmonious band of brothers, by any means. That would have defeated the purpose. The Club also acted as an arena for all the art world's latent conflicts, a place where they could be continually enacted and reenacted, where factional tensions could rage productively, although such strife was not to everyone's taste. Jackson Pollock, who spent most of his time in Springs (a hamlet of East Hampton), made only rare appearances, as did his champion Clement Greenberg; besides being out of town so often, Pollock never really felt welcome and had a distaste for intellectual debates. Once, during one of his rare visits, he became an "immediate target" and quickly bolted from the room, mumbling, "I don't need a club."[16] He was not paranoid; even in this artistic Elysium, factions formed and clashed. Pollock's partisans considered the Club the territory of the enemy camp, "de Kooning's camp," of which Thomas B. Hess, the new editor of *ARTnews,* was the official champion. "Hess was playing a power game," recalled Marca-Relli, "pushing de Kooning and trying to get rid of Jackson in the number one spot."[17] Soon thereafter Motherwell and his buddies Rothko, Gottlieb, and Newman formed another cohort, known as the "Bowery bums." To Conrad Marca-Relli and others, they represented "another kind of artist . . . people who had already made a name, already had a gallery uptown before they joined. With their arrival came panel discussions and guest speakers, and everything became more public, more formal."[18] Motherwell, above all, was criticized for his veneer of intellectualism (buffed by the Surrealists), his frustrated ambitions, and like the members of de Kooning's camp, his envious disdain for Pollock!

In May of 1951, the Club decided to mount a collective show. "One day I was going to the studio and I met Marca-Relli on Ninth Street, where he used

to have his studio," said Sander. "At that time, there was a building that was already condemned, in which a big store had been vacated. Marca-Relli was looking at the place and telling me, you know it would be fine if we'd rent that and have a show . . . It had tremendously high ceilings and was deep and open, and we thought we ought to have a show. We had a meeting, a charter members' meeting, and Leo volunteered to run it. Everybody was supposed to give him five bucks for expenses. We had to have electricity put in. I know I was one of the few who gave him five dollars."[19] In May, at Sander's instigation, they rented the abandoned antiques shop on the ground floor of 60 East Ninth Street, repainted it, built vertical gallery partitions, and thereby appropriated a visibility that American society had denied them for so long. No matter that some of them had already exhibited uptown, already been recognized by the press! The group, comprising artists, critics, a few dealers, and some fellow travelers, would now manifest its existence as a collective. The event came together in disorder and chaos, with ninety works on display and a poster by Franz Kline. When Sam Kootz forbade his artists to join the show, some, such as Gottlieb and Baziotes, obeyed, leaving others, such as Motherwell, to choose defiance.

Legend has it that Castelli played an active, if not central, role in this exhibition, though accounts differ and continue to be disputed. Did he finance the rental of the space, coordinate the works, organize the installation, and mediate the artists' disagreements, as some would have it? As a freelance, uptown curator, Castelli certainly had the know-how, but how would one hang ninety works by so many artists without offending *someone*? Vicente is categorical: "The role Castelli played was purely financial. There was not much money involved anyhow because, you see, nobody had a penny to pay the rent for this month, for that month. I believe it was something like forty dollars; that was all. So that was the whole thing. And then in the process Castelli wanted to intervene, but naturally we didn't allow him to do it."[20] Others remember a more conciliatory intervention. "On the day of the hanging, I got frantic," Marca-Relli recalled. "We were all standing there in front of the paintings and Leo started to organize them. I said that we the artists should be responsible for the hanging and I left in a huff. When I came back an hour later, Castelli had hung Pollock, de Kooning, and Kline on the big wall on one side, and I was on the other one. I said okay."[21] The party in question would admit that it was a delicate exercise: "Hanging the show! I must have hung it about twenty times! Every time I thought it was done, one

ALCOPLEY • BOUCHE • BROOKS • BUSA • BRENSON •
CAVALLON • ~~CARONE~~ • GREENBERG • DE KOONING • DE
NIRO • DZUBAS • ~~DONATI~~ • J. ERNST • E. DE KOONING • FERREN
• FERBER • FINE • FRANKENTHALER • GOODNOUGH • GRIPPE
• GUSTON • HARTIGAN • HOFMANN • JACKSON • KAPPELL •
KERKAM • KLINE • KOTIN • KRASSNER • LESLIE • LIPPOLD •
LIPTON • MARGO • MCNEIL • MARCA-RELLI • J. MITCHELL
• MOTHERWELL • NIVOLA • PORTER • POLLOCK • POUSSETTE
DART • PRICE • RESNICK • RICHENBERG • REINHARDT • ROSATI
• RYAN • SANDERS • SCHNABEL • SEKULA • SHANKER •
SMITH • STAMOS • STEFANELLI • STEPHAN • STEUBING •
STUART • TOMLIN • TWORKOV • VICENTE • KNOOP •
KAROLY· DIENES· ALBERT·NICHOLS· FL.GRIPPE· ANITA · CORNELL
COURTESY THE FOLLOWING GALLERIES: BORGENICHT, EAGAN,
TIBOR DE NAGY, THE NEW, PARSONS, PERIDOT, WILLARD, ~~HUGO~~
RAUSCHENBERG· SISKIND· FINKELSTEIN, FARBER- L.SANDER·
A. KENT

MAY 21ST TO JUNE 10TH, 1951

PREVIEW MONDAY, MAY 21ST, NINE P. M.

60 EAST 9TH ST., NEW YORK 3, N.Y.

EXHIBITION OF PAINTINGS AND SCULPTURE

Poster for the Ninth Street Show, with Leo's handwritten corrections

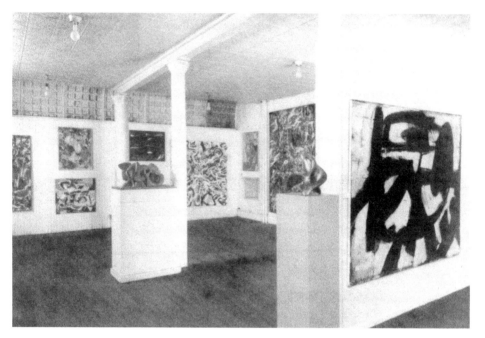

NEW YORK, MAY 1951
Installation of the Ninth Street Show

of the artists came in and complained about where I'd put his work!" Still, it's clear that Castelli favored Pollock and put *Number 1, 1949* on the large wall, in the best spot, even though, lacking enough space, he had to turn the work on its side and show it horizontally.[22]

May 21, 1951. The day of the opening, a banner was stretched across the street and a light hung from the second-story window. Already by six o'clock, the crowd of visitors left no doubt as to the show's success. "All the stars!" recalled Sander. "And the jam of taxis pulling up, five or six at a time. People getting out in evening clothes, whoever they were in those days, I didn't know too many. I remember I was a little surprised that Leo Castelli didn't know Bertha Schaefer—I thought Leo knew everybody! Really it was amazing the number of people that came to that. It gave us enthusiasm about ourselves, I think. It did us more good in our own eyes than it did in any other way. I think there was only one thing sold." Indeed, from their flea-ridden downtown block, as if from a Trojan horse, the East Village artists had captured the city, and in particular the multitude of the rich and famous who never ventured into the Village; in this way, they erased the line between uptown and down-

town, between bourgeois and bohemian. That evening, Dorothy Miller came to the exhibition, accompanied by Alfred Barr. "With great enthusiasm," Castelli recalled, "he took me aside and said, 'Let's go to some quiet place so you can explain to me how you accomplished this remarkable feat' . . . I took Barr to the Cedar Bar and showed him photographs [of the works]. He proceeded to put the name of each artist on the back of each work and confessed that he had never heard of most of them. He knew Pollock, of course, Kline, de Kooning, and some of the others but, as far as I know, at that time none of them, except Pollock, had been purchased yet by the museum."[23] That day, by his participation in the Ninth Street Show, Castelli turned the tables: now it was he, with his freshly acquired knowledge of the contemporary American scene, who would teach Alfred Barr a thing or two and introduce him to a whole network of local artists utterly unknown to the director of MoMA. If Barr the American had created a narrative for European art and guided Castelli in a belated apprenticeship, Castelli the European was now taking giant steps towards initiating Alfred Barr, even more belatedly, in the new spirit of American painters.

The New York Times remarked on the "uncommon exhibit," and in *ART-news* Thomas Hess spoke of "New York's avant-garde" coming together "spectacularly," and summed up the scene. "An air of haphazard gaiety, confusion, punctuated by moments of achievement, reflects the organization of this mammoth show which, according to one of the organizers, 'just grew.' Some pictures were chosen by the artist himself; others picked by [a] small delegation of colleagues. A few entries were accepted because 'so-and-so' is 'such a nice fellow'; a few because 'such-and-such' was a 'great help'; several for no conceivable reason whatsoever . . . But such hit-or-miss informality and enthusiasm has resulted in a fine and lively demonstration of modern abstract painting in and around New York—or more properly, Greenwich Village. Authoritative statements come from de Kooning, Pollock, Franz Kline, Tworkov, Hofmann, Kerkam, Vicente, Brooks, Motherwell, McNeil, Cavallon, Reinhardt, and sculptors David Smith and Peter Grippe. Among the lesser-known painters—whose extensive representation will make this exhibition doubly interesting to specialists—we especially noted Resnick, E. de Kooning, De Niro, Farber and Sander."[24]

The Club experiment would last until 1955, when jealousies and infighting would start to set artist against artist. "Barnett Newman was doing complex, innovative work, which he then exhibited," Ileana commented. "All the Club

COCKTAIL PARTY, NEW YORK, 1950
With Barnett Newman, LEFT, and Robert Rauschenberg, CENTER

artists came to see it; they felt threatened by the purity of his work and treated him very shabbily. In my view, it was a magnificent exhibit and it impressed me deeply. Artists can sometimes be quite cruel and envious. De Kooning was put off by Newman's rigorousness, and that's why he turned everyone against him. That was the beginning of the end for the Club. It became so popular that the general public, people who weren't part of the art world, wanted to see what was going on and hear what we were saying. As a result, you ended up with fifty artists and five hundred snobs—graphic artists, architects, publishers, designers, and so on—and all of them wanted to join."[25]

Ironically or perhaps fittingly, just as Castelli was making a name for himself in New York with the Ninth Street Show, a bankrupt René Drouin was closing the Place Vendôme gallery. But what support did the Castellis offer in this episode? Certainly, the financial and symbolic endorsement of those who had already piled into the Trojan horse. With the respect for art and culture that he was born into, Castelli, European bourgeois, uptown socialite,

had dared to view the American artist not with the damning glare of the average American, but with the admiring gaze of the educated European. And despite the skein of identities entangling him—patron, man of leisure, curator, businessman, merchant, tango dancer—that day, Castelli had truly become for emergent New York painters the man of the hour.

17. FROM POLLOCK TO DE KOONING: TOWARDS THE GALLERY OPENING

I decided it was finally time to open a gallery because of the very banal fact that I had to make a living, that I saw that there was no other way for me to make a living, and that I had to become serious about it if I wanted to go on paying my rent and my grocery bills.[1]

LEO CASTELLI

"IT WAS THE summer of 1952, the summer I turned sixteen. I went for dinner several times at Leo and Ileana's on Jericho Lane in East Hampton. There was de Kooning and his wife; Ileana's mother, Marianne, who had remarried to John Graham; Michael Sonnabend, who would marry Ileana a few years later, and some others," Robert Reitter, Castelli's nephew, remembers. "Everyone had fun mimicking the TV announcers, with their pat phrases and their inane clichés. Everyone tried to outdo the others, upping the ante, ridiculing America's naïveté in those years, until one of the guests emphatically exclaimed *'From Coast to Coast!'* and everyone burst out laughing."[2] In this bohemian bower not far from New York, the rise of mass culture as transmitted by television provided ample cause for snide contempt, as did the medium's reassuring but artificial image of the idealized American family. For the last two years, political life in the United States had been dominated by the rantings of Joseph McCarthy, who fulminated against a perceived Communist takeover of the State Department. McCarthy created a rather poisonous national climate of mistrust and inquisition in the aftermath of the Rosenbergs' execution. "This is a legally sanctioned lynching," Sartre protested in June 1953, "that covers an entire nation in blood and exposes, glaringly and for all time, the failure of the Atlantic Pact and your inability to assume leadership of the Western world . . . Something is obviously rotten in America . . . Don't be surprised if from one end of Europe to the other we shout, 'Beware, America is rabid!' . . . We must cut our ties with her before we, too, are bitten and infected."[3]

JERICHO LANE, EAST HAMPTON, SUMMER 1953
Elaine and Willem de Kooning's improvised studio on the Castellis' porch. Photograph by Hans Namuth.

In their charming shingle cottage on Jericho Lane, Mr. and Mrs. Leo Castelli, together with their guests, when not scoffing at televised banality, basked in the charms of Amagansett beach and of Georgica Pond. They watched the wild birds that flocked off Accabonac Creek or Barcelona Point, and swam at Louse Point, in crystal-clear waters that, since the previous century, had drawn artists such as Thomas Moran, Childe Hassam, and Augustus Saint-Gaudens. It was Motherwell, whose house had been remodeled by the French architect Pierre Charreau, who had enticed them to this still-unspoiled paradise, three hours from the city; Jackson Pollock and Lee Krasner had already moved there in 1945, followed by Conrad Marca-Relli, Franz Kline, and Harold Rosenberg. Thanks to friendships forged at the Club, the Castellis came to enjoy the company of de Kooning and his wife, Elaine, and for two summers in a row they invited the pair to be their guests at East Hampton. It was a difficult time for Pollock's rival, a notoriously slow worker: for the past year and a half, he had been grappling with *Woman,* and only a studio visit from Meyer Schapiro finally persuaded him to consider it

finished. By way of fashioning a separate space to serve as a studio, the Castellis installed a partition on their porch, but still de Kooning produced little that summer. Moreover, the proximity of the nouveau riche East Hamptonites occasioned its own humiliations for the penurious artist and his wife—as when one of the neighbors, spying de Kooning on his bicycle in work clothes, mistook the Abstract Expressionist for a common laborer and called upon him to tell his "boss" to silence that wretched barking dog!

Unhappy with his dealer, Charles Egan, de Kooning confided in Castelli. "They all wanted to go to Janis," the latter explained, "because it was the gallery where the great Cubist painters, Marcel Duchamp, Léger, and Klee and Mondrian were shown, so that was *the* gallery. So I said, yes, I would talk to Sidney, and I told him, 'Look, you were complaining about not getting enough material. What about taking on de Kooning? He's dissatisfied with Egan.' He knew his work and knew what it was about. Then, very rapidly, this business was concluded."[4] As an intermediary between artists and dealers, Castelli soon became an essential cog—if still only one—in the New York art machinery, all the more as his relations with Pollock had grown closer over time. Since their arrival in New York, Castelli and his wife had followed the evolution of Pollock's work religiously, attending all his shows and even buying his works. Little by little, along with John Graham and Marianne Schapira, they became friends with Pollock and Krasner in New York as well as in East Hampton. "Pollock was a marvelous human being," said Castelli. "I remember wonderful evenings in Springs when Lee prepared these marvelous dinners. Sometimes he was in an excellent and splendid mood, and we spent some very nice evenings at his house, a sophisticated kind of atmosphere. He was very sure of himself, incredibly sure about the fact that he was a great painter. There was no doubt in his mind about that, and he would affirm it constantly—not in a blustery way but with true conviction. But sometimes he used to come over, and very often we were terrorized because he was in terrible shape, from the drinking. Then he would run around all over the house. Ileana tried to hide somewhere not to be in his path. One time he almost crashed his Model A Ford into a Larry Rivers sculpture we had in our driveway. He didn't actually, but he wanted to. He hated the thing!"[5]

The summer of 1952 (when he and Lee Krasner lived on Fireplace Road) was not a particularly happy time for Jackson Pollock. Krasner was indeed having trouble keeping him away from the bottle, and his drunken sprees

SPRINGS, EAST HAMPTON, 1950
Jackson Pollock, in one of his legendary cars. Photograph by Hans Namuth.

were becoming more and more public. Three years earlier, *Life* magazine's provocative question "Is he the greatest living painter in the United States?" had brought him a degree of exposure unprecedented for an American artist, inspiring both overweening public approbation and bitter jealousy among his colleagues. Pollock had enjoyed times of plenty, but by the summer of 1950, the sawtooth path of his career, as he zigzagged between sobriety and alcoholic dysfunction, made his existence fragile and chaotic. When Peggy Guggenheim left New York in 1947, he lost not only a reliable buyer but also the famous monthly stipend that had ensured his financial stability. With his new dealer, Betty Parsons, he signed a renewable yearly contract, but the relationship soon fizzled: Parsons was too passive, Pollock too tem-

peramental, and his December 1950 exhibition was a commercial flop. Who should he sign with? Egan? Kootz? Tibor de Nagy? Grace Borgenicht? Like de Kooning, Pollock turned to Castelli for advice. "As soon as Bill got into the Janis Gallery, Jackson came along and told me, 'You got Bill into the gallery, I'd like to be there too.' So then I spoke to Janis again, and Janis said, 'Well, you know how much I admire Pollock's work. He's a great painter and all that. But God knows he's a difficult character. He's always drunk, and I think he'd be impossible to deal with.' So I said, 'Well, you know he is such a good painter you just have to put up with it, that's all.' He hesitated a little while, but then he said okay, and he did take him on."[6]

And so Pollock would exhibit with Sidney Janis, joining Kline, Gorky, Baziotes, and de Kooning. Was it really on Castelli's advice, as the latter claimed? Or was it rather Lee Krasner's choice? What really mattered during those lean years was the artist-dealer relationship. Throughout the summer of 1952, Pollock would work feverishly to prepare his first show at Janis, scheduled for November. That summer, the Castelli home became the stage for repeated performances of the weird and unveiled antagonism between the two greatest artists of the period, a conflict that seemed to unleash years of resentments, created by all the rivalrous episodes in the Club's six-year history. "There was his relationship with de Kooning, which was a rather strange one of friendship and envy," Castelli said. "A competition between the two. He would appear at the Cedar Bar occasionally, and they would have fights there."[7] Pollock would regularly show up unannounced at the Castelli house, sometimes stumbling drunk, to visit de Kooning, even though his boorish behavior was wearing out his welcome. Motherwell long remembered a party at the Castellis' when Pollock was in his cups. "Around midnight, my wife and I decided to leave. We sensed that something was about to explode, and we did not want to stay because Pollock looked really threatening."[8] But it was Ileana who provided the most subtle analysis of the two rivals' temperaments: "Pollock was more genuine and original, while de Kooning, feeling threatened, tried to compete and attacked Pollock, claiming that *he* was the true representational painter. Personally, I thought he was being unfair, and anyway I preferred Pollock. I told de Kooning that, in my view, Pollock's paintings were more interesting and freer than his, more masterful. This came up several times, and de Kooning got offended."[9]

The Castellis were receptive, open, and reassuring. Over time, their residences in Manhattan and East Hampton would become a privileged harbor

for artists' mood swings. "I had *Scent* then," Leo recalled. "Jackson came to see me one day. He was in very bad shape. He really felt that he couldn't paint anymore. Then he sat in front of that painting for a very long time and looked at it and looked at it and sort of—I saw him feeling terrible—he evidently felt very disturbed looking at that painting."[10] During the month of August 1956, in a moment of impotent devastation in Rome, the Castellis would hear about Pollock's fatal car crash. "We had seen him only two weeks before," said Ileana. "We couldn't understand it. He often talked of suicide, but this wasn't a suicide—or maybe it was, since he always had a deep-seated self-destructive streak in him."[11]

By now, the Castelli home had become a meeting place for a wider range of artists, critics, dealers, collectors, and curators; it was a porous border between their public life and private life, between personal and professional friendships. Their place in artistic circles had become so obvious, so instrumental that opening a gallery of his own would soon appear an obvious move for Leo. But obvious or not, the birth was attended by controversy, including a "very violent altercation with de Kooning" that Ileana described. "He told Leo everything he should and shouldn't do. He said that once Leo opened his gallery, he must give him a show. I told him, 'I'm not so sure about that. What makes you think Leo will do a show for you? I think he has other plans.' I added that in my opinion, Leo was more interested in what was coming up than in what had already bloomed."[12] A most prophetic insight!

How does someone suddenly emerge at age fifty, after staying in the background for so long? What can transform a *Luftmensch* into a man of action? There are many determining factors, though none is clearly decisive: his years in the Club as a regular member; his role as Janis's assistant; his journeyman work as Kandinsky's agent; his instructive veneration of Alfred Barr's taste and acquisitions, and his apprenticeship under Clement Greenberg; his frequent trips to France, where he tried to persuade Drouin to work with the United States; his lean years; his innovative efforts to juxtapose European and American artists. Then, too, there was his lifelong fascination with artists and with their creation of a symbolic world. "Leo could be very difficult," his ex-wife explained. "He didn't want to work with just anybody, but only with people he respected; economics didn't enter into it. Leo was never very sure of himself. He constantly needed reassurance, and I found that one of his more endearing qualities."[13] Castelli would be attacked on

two fronts at the outset, beginning with the browbeating from de Kooning, and soon followed by a natural irritation on the part of Janis. "Sidney began to get tired of it [the existing arrangement]," Castelli admits. "After all, he was running a gallery, an expensive place, and there was no reason for him to just share profits when he had all the work to do—to pay the overhead, publicity, and whatnot. So it seemed that the beautiful days of naïveté were over. And besides, Janis had two sons to take care of and also felt that perhaps whatever he was doing should stay in the family."[14]

Castelli would persist for a while in his intermediary efforts, organizing another Dada show for Janis and introducing Duchamp to the visiting René Drouin, who had just opened a small new space on Rue Visconti. But soon after that, he flew off to Paris to ponder his options. Having now thrown in his lot with the American artists, there was no question that it was *their* heroism he intended to serve. "Janis and I had some kind of project going for a while for me to open a branch in Europe to promote American painting," he continued, "which really would have changed my life. But I had no capital and he did not seem interested enough to provide it. I went to Europe in 1955 and explored possibilities of opening a gallery there."

Without Janis's support, Castelli turned to Alfred Barr. The young critic Leo Steinberg helped him (for Castelli was a poor writer) to compose the following letter. "Dear Alfred," he wrote:

Here is the draft of my project. You will probably find many flaws. Please feel entirely free to criticize and make suggestions. I shall take the liberty of phoning you at the beginning of next week to have your reaction. I am most grateful for your invaluable help and ask forgiveness for the added burden.

OUTLINE OF PROJECT FOR A PARIS GALLERY
 1. *In recent years American art has come of age. Many of us, here, believe that it is gaining a position of leadership. Even among Europeans there is a growing awareness of the significance of our painting and sculpture; but this awareness remains unfocussed and unformulated.*
 2. *Owing to long-standing habits of thought, Paris still reigns supreme in the world of art, both as center and fountainhead. Consequently, its waning importance as a source of new inspiration in creative art—perhaps a temporary phenomenon—and the emergence of new forces in America to fill the void, have passed almost unnoticed. The American public itself, is often reluctant to give its*

full appreciation and support to U.S. artists who have not received a European stamp of approval; and, while many new arrivals from Europe—not infrequently watered down versions of trends which have originated in this country—shown here by our Museums and Galleries meet with immediate success, parallel efforts to promote American art in Europe have had, at best, a succès d'estime. At any rate, very few European galleries have been willing or able, so far, to back American artists.

3. *This anomalous situation leads to two undesirable results:*
 a) *Artists of the first rank are denied deserved international recognition*
 b) *The European art world is deprived of the vivifying influence of much that is creative in contemporary art.*

4. *It is proposed, therefore to establish an art gallery in Paris which, we feel, could make three major contributions to the art world:*
 a) *emphasize the fact that there is a vital and adventurous artistic movement in America*
 b) *take advantage of American critical judgment—which, from the time of Impressionism to this day has been often ahead of France in the early perception of emerging greatness—by exploring neglected areas of European art*
 c) *introduce American display techniques, which, we believe, are also in advance of European methods, by devoting exhibitions to developmental themes, such as the history of collage, open work metal sculpture, etc.*

5. *European artists will, thus, figure prominently alongside of our own in the shows planned by the gallery. There are other compelling reasons for their inclusion:*
 a) *It is the very purpose of the project to prove by close comparison that our artists can compete on equal terms with their European contemporaries*
 b) *The presentation of both Americans and Europeans ought to dispel any suspicion of cultural diplomacy*
 c) *It is confidently expected that the handling of European artists will enable the gallery to become self-supporting after a period of about two years.*

6. *Many of the contemplated exhibitions will be circulated to Museums and Galleries of other European cities which, up till now, could rarely satisfy their desire to show the work of our artists because of the considerable cost involved. With Paris as a central point of distribution, this obstacle will be removed with a consequent further extension of the potential market for American art.* [In the left margin, Castelli (or perhaps Barr) put a question mark.]

7. *The cost of setting up the gallery and operating it for one year has been carefully estimated, with expert advice, at fifty thousand Dollars. It is hard to forecast the*

financial support needed for next season. But, even if progress were to be slower than expected, half of the sum mentioned above, perhaps much less, should enable the gallery to reach the goal of self-sufficiency at the end of the second year. [In the left margin, in Leo's hand: "This probably needs (illegible) amplification and discussion."]

8. *Personal qualifications: Activity in the field of modern art, both France and the U.S., for the past twenty years, Partner of the Galerie René Drouin, 17 Place Vendôme, Paris, from its founding in 1938 to 1949.*

Representative of that Gallery in New York after war service in the U.S. army Cofounder, in 1949, of the Artists Club. This little advertised organization has created a feeling of solidarity among vanguard artists, unprecedented in this country, and has given them much needed support.

Organization and installation of the Ninth Street Show in 1951. This show included about sixty artists, and was perhaps the starting point for a greatly increased interest in our artists. It also led to the discovery of many promising new talents. [In the left margin, in Castelli's hand: "This confined to my art activities. Perhaps experience in other fields should be mentioned."]

Codirection and installation of numerous exhibitions; French-American show at the Sidney Janis Gallery, Group Show of American artists, first presented at the same Gallery, then shown in Paris, and, on its return, circulated in the U.S., etc. [In the left margin, in Castelli's hand: "exhibition catalogs to be attached."]

9. *References:*
10. *Program of projected exhibitions:*
 1. *Selection of European Masters: Fauves, Cubists, Matisse, Mondrian, Klee, etc.*
 2. *Jackson Pollock*
 3. *Mondrian: first exhibition in Paris*
 4. *American Group: de Kooning, Still, Rothko, Kline, Tomlin, Guston*
 5. *Brancusi*
 6. *American Pioneers: Marin, Stella, Carles, Feininger, Davis, Macdonald-Wright, Hofmann, Tobey, Gorky*
 7. *Gonzales*
 8. *Willem de Kooning*

9. *Collage: Evolution of Collage from Picasso and Braque to such Americans as Motherwell, Vicente, Marcarelli, etc.*

10. *American Metal Sculpture: David Smith, David Hare, Ferber, Lippold, Rozzack, Lipton and, of course, Calder*

11. *Further Shows: One man shows for the artists introduced in the American Group Show; Younger American and European artists singly or in groups, and in a variety of contexts; Other possibilities; Gave, Pevsner, Kiesler, Dubuffet etc.*[15]

A month and a half later, Barr finally sent his underwhelming reply. "Dear Leo," he wrote, "You are very considerate to forgive my long delay in answering your letter of October 26th, enclosing an outline of the project for a Paris Gallery. I was desperately busy, but would have phoned you had I found anything to criticize seriously in the outline. I thought it excellent and I will be glad to support it if asked to do so by the foundation. I have tried to reach you by phone this morning but have had no luck, so since I am on duty as a juror this afternoon I am writing this note. Good luck! Sincerely, Alfred H. Barr, Jr."[16] And with polite indifference, he added in a postscript: "May I keep the outline?" With this thinly veiled demurral, Castelli was stuck.

"In every moment in history," Castelli once told me, "there have been periods of economic or cultural prosperity, as in France or Holland. It's in those periods that art inevitably develops, and an elite forms around certain centers. Similar phenomena have happened in all of the world's great capitals. In the United States, there was a period of accelerated growth, and we were able to take advantage of a very healthy economy."[17] Auspicious circumstances notwithstanding, the Castelli experience taught that one creates one's own luck. And so just as the Castelli brothers of Monte San Savino had relentlessly crisscrossed the region, seeding and then cultivating the prosperity of their city, making the most of its tax-exempt status; just as in Trieste Castelli e Castelli had once developed the international coffee trade, thanks to Maria Theresa's patronage and to her fleet traversing the entire globe; so too, in New York, towards the end of the 1950s, would Leo Castelli, as if by some atavistic impulse, turn his daughter's room into a makeshift gallery and champion, for the entire world, his heroes, the American painters, whose greatness—about which he had not the slightest doubt—was about to become explosively and forever manifest.

ABSOLUTE LEADER OF AMERICAN ART
1957–1998

18. NEW YORK AS A MAGNET

It wasn't so much America that attracted me as New York like a magnet.
I used to dream of New York when I was a child.[1]

LEO CASTELLI

Poetry was declining
Painting advancing
We were complaining
It was '50.[2]

FRANK O'HARA

ON THREE MEMORABLE evenings at the Club, in March, April, and May of 1952, the Castellis attended readings by an extraordinary twenty-five-year-old poet, recently graduated from Harvard University and the University of Michigan at Ann Arbor, whose star—since his appearance in New York only six months earlier—had risen with blinding speed.[3] A pianist, poet, obsessive enthusiast of Russian and French poetry, given to wandering New York's streets as Breton, Cendrars, and Apollinaire had once wandered those of Paris; a bottomless human well of curiosity about not only art, but also film, dance, and contemporary music; a carouser, boozer, schmoozer, and sensualist, Frank O'Hara epitomized the New York cultural activist and was drawn to the crossroads of so many artistic paths. With his unlikely boxer profile and movie-star grin, he bridged the world of fine art and the world of literature, as well as that of the first and second generations of postwar American painters. A critic for *ARTnews* and a staff member at MoMA, heedless of generational, intellectual, or cultural boundaries, he stoked the energies of the Club and became the ultimate *salonnier* of 1950s New York, effusively declaiming his passion for the city:

On the molten streets of New York
the master puts up signs of my death.
I love this hairy city.
It's wrinkled like a detective story
and noisy and getting fat and smudged
lids hood the sharp hard black eyes [. . .]
I walk watching, tripping, alleys
open and fall around me like footsteps [. . .]
The subway shoots onto a ramp
overlooking the East River, the towers!
the minarets! The bridge. I'm lost.
There is no way back to the houses
filled with dirt.[4]

No one equaled O'Hara in the poetics of the city. No one surpassed him in expressing the new solidarity between artists of every discipline who converged on the nation's preeminent metropolis. No one rivaled the voice he gave to the creative synergy transfiguring New York, whereby poets, composers, dancers, and critics enthroned painters and sculptors—as once they had done in Paris, in the grand tradition of messianic bohemianism, when Baudelaire heralded Delacroix and Zola, Cézanne. All the elements of the American identity (the pioneer ethos, the faith of the Puritans, the business of business) had until then conspired to reject the artist as a second-class citizen.[5] American painters had long bemoaned their outcast state—*nemo propheta in patria!*—while puzzling over the relative fame that writers enjoyed; but apart from Walt Whitman's defense of Thomas Eakins after his ejection from the Pennsylvania Academy of the Fine Arts in 1886, few were the writers who defended, or indeed even supported, painters.[6] Now, in the New York of the late fifties, with the Cold War raging, the poet Frank O'Hara was effacing himself before painters and sculptors, whom he revered; while seeking out creative partnerships with Larry Rivers, Grace Hartigan, Norman Bluhm, Jane Freilicher, David Smith, Al Leslie, he gave voice to a solidarity, expressing his appreciation in odes, elegies, sonnets, and ballads. He was their unworthy champion, as he plainly declared to Larry Rivers:

You are worried that you don't write?
Don't be. It's the tribute of the air that
your paintings don't just let go

NEW YORK, 1958
Larry Rivers, LEFT, and Frank O'Hara, during the production of
Stones. Photography by Hans Namuth.

> of you. And what poet ever sat down
> in front of a Titian, pulled out
> his versifying tablet and began
> to drone? Don't complain, my dear,
> You do what I can only name.[7]

The ascent of Frank O'Hara in the new culture of New York typifies the great ferment then under way, which the Castellis, out of boundless regard for their artist "heroes," had watched and encouraged as collectors, as patrons, and as friends. Over the next four decades, Leo and Ileana Castelli, in their respective ways, would minister to the art of their adopted homeland; ultimately they were to become high-flying tastemakers in the great cultural epic that was only just beginning.

On January 16, 1957, when Arturo Toscanini died, American obituaries warmly recalled the Italian conductor's defiant refusal to lead a performance of the Fascist anthem, choosing exile instead: "Of all the newspaper

writers who applaud today the Maestro's bravery, who is brave enough to note that we ourselves do not encourage our artists to be Toscaninis?" wrote the iconoclastic crusader journalist I. F. Stone. "Our artists have been taught that it is safer not to mix in politics. In this sense, not to mix in politics is not to mix in life, to be but half a man; to look the other way when other men are treated unjustly; if there are crematoria, not to hear the screams; to abdicate . . . There is a numbness in the national air . . . Our country is supposed to be the citadel of private conscience against State power . . . What if a new McCarthy appears?"[8]

For his part, the no less committed, radical O'Hara developed another type of discourse with his friends, an alternative culture on the fringes of the dominant capitalist culture. In statements not always explicitly political, he relentlessly challenged the social and economic conservative orthodoxy, even as the city around him came to be home to the nation's 135 largest companies, as well as the heart of a consumer market that had absolutely no equal in the world. Thanks to the earlier generations of businessmen, who though pursuing profit tooth and nail were not content to be thought philistines, New York now boasted a wealth of museums, concert halls, theaters, and even a few contemporary art galleries, making the metropolis what it still remains, the ultimate magnet for those who would be cultured as well as rich.

On February 3, 1957, two weeks after Toscanini's death, Leo Castelli opened his New York space. He didn't need more than a few hours to reorganize his apartment, emptying the L-shaped living room and taking over the bedroom of his daughter, Nina, away at Radcliffe, making it his showroom. With martial precision, Castelli drew up his agenda: lug the furniture down to the basement, paint the walls white, install overhead track lighting, send out invitations, affix a copper plaque to the building façade (unassumingly engraved "Leo Castelli 4 East 77"), and, last but not least, hang the paintings! After sixteen years of procrastination, sheer necessity finally forced his hand. Once determined, he became a gallerist as precipitously as he had in Paris eighteen years earlier, in the first months of 1939 under the most inauspicious conditions; one morning in New York, having stored the sitting-room furniture in another apartment of the Schapira townhouse, Castelli the dilettante metamorphosed into the art dealer. He may have treated the decision as something matter-of-fact, but this reflected his gift for the profession as well as a dormant taste for risk, the alpinist's daring in the face of the abyss.

On February 1, 1957, a snowstorm had slammed so violently into New York that, just minutes after takeoff from LaGuardia, a Northeast Airlines DC-6 crashed into Rikers Island, killing twenty-two passengers and drawing a notably emotional response from Robert F. Wagner, the mayor. Two days after this shock, as piles of filthy snow still clogged the streets, the visitors to the first Castelli opening endured the lesser ordeal of the tiny and rickety elevator creaking its way to the top floor in the classic white four-story townhouse on the corner of Fifth Avenue at Seventy-seventh. The gallerist's project became evident as of the entrance door: a dialogue between Pollock and Delaunay—a confrontation between one of the most magnificent drip paintings of the 1950s and a truncated Eiffel Tower. The transatlantic dialogue that Castelli had initiated in 1950 at the Sidney Janis Gallery with Young U.S. and French Painters was thus continued here, with two variant approaches to abstraction: the two masterpieces covering the full height of the walls dominated the room, while smaller paintings echoing one another filled in the narrative of the show—works by Marsden Hartley, de Kooning, and David Smith representing the Americans; and canvasses of Mondrian, Picabia, Léger, Giacometti, and van Doesburg, the Europeans.

"Leo's first exhibition had great style! He had chosen pieces from his private collection and borrowed others, some from Sidney Janis. There was some magic, something about it. Jane Austen famously said that 'everything happens at parties.' That day, with his instinct for gatherings and his spare, simple elegance, Leo also launched himself."[9] Barbara Jakobson, who along with her husband, John, would become one of the Castelli Gallery's first clients and, later, Leo's closest friend, vividly remembered his first opening. The elegant young Smith graduate was well heeled and avidly curious, following in the footsteps of her cousin Harriet Peters, her "mentor," who guided her through the world of galleries in search of excellence in all mediums.[10] And so it was only natural that Donald and Harriet Peters should arrange to meet their cousins the Jakobsons at the Castelli opening.

No one has ever commented so amply on his first steps in the profession as Castelli himself. But aside from a few details, from the mists of those innumerable pronouncements one finds very few significant pieces of information; his account shows his ability to speak charmingly without revealing much, a trait that would prove one of Castelli's hallmarks. Here, for instance, is Castelli talking with the producer Claude Berri:

CASTELLI: I started with a very beautiful show, again based on the idea of comparing Americans and Europeans . . .

BERRI: It was an announcement of intentions: "I, Leo Castelli, am opening a gallery and am showing paintings."

CASTELLI: No, not just paintings, but the best paintings by those whom I thought were the best artists. I might add that the show, which opened on February 1st, 1957, was a big success.[11]

One will concede the fastidiousness and insistence upon excellence evinced by this collector, energetic playboy, sometime broker, and sometime courtier, long held back by circumstantial complexities, when he finally took flight at the age of fifty. But did anything about this trim, dapper man foretell his becoming the greatest gallerist of the late twentieth century? Only if personal charm counts for anything. Castelli had a high forehead, slicked-back hair, neat, economical movements, and was flawlessly dressed. Though short of stature (five feet five), he had managed to assume, over the course of his dilettante years, the bearing of a paragon of civility and gregariousness, with cocktail in hand. All that Old World urbanity burst forth to pyrotechnic effect during this first opening. He had laid out an exquisite spread quite beyond the norm, and he moved about smiling, irresistible to men and women, artists and collectors, critics and curators alike. Generous, loquacious, and attentive, he made sure everyone's flute was always filled, everyone's *amour propre* flattered, working the room, deploying his personal and material charms as a peacock spreads its tail. It did not hurt his cause that he was displaying the finest canvases from Europe and America, inviting the *beau monde* to elevate themselves with him to the pinnacle of artistic excellence, for which he received in return their extreme gratitude. All things considered, on this February 3, 1957, it is fair to say that Castelli outdid himself! But there was much more to come.

Now the long-bottled "Castelli magic" had burst out for all the world to behold. Behind the scenes, though, tensions abounded. Though only a few days after the opening a triumphant Castelli would announce to Ileana that their first painting, a Mondrian, had been sold, his compulsive womanizing and financial dependence were taxing his wife's nerves; after twenty-five years, their marriage, although long an open one, was fast losing altitude. A dutiful young woman at ease in her own shyness and reserve, Ileana was

finding it more and more difficult to abide some of her husband's numerous forms of narcissism and could only express her pain through symptoms of depression. "Abstract Expressionism was the dominant movement then, and I really had no very clear ideas about what I was going to do; I had some European paintings that I had accumulated over the years, more as a collector than as a dealer,"[12] Castelli told Emile de Antonio, strangely erasing the wife beside him in this recalled self-image. It was *their* collection, even if informed by a mutuality of good taste. Ivan Karp, who a few years later became second in command at the gallery, remembered, "They had a number of powerful Dubuffets of the very best, 1946, 1947 period. They had some Giacomettis. They had three Pollocks. Fabulous paintings. They had a number of de Koonings. It was a very impressive collection to me. I know it was very deep, very complex, and very complete . . . of the highest quality."[13] But as Karp would confirm, the collection would never have existed absent Ileana's personal fortune.

"In the back of the gallery, in a little black dress, charming, very coquette, with Piccina the dog at her side, Ileana was always there. She was shy, bright, and eccentric,"[14] Barbara Jakobson recalled. "She was one of the formulators of the gallery," Ivan Karp added, "a very strong personality, a very sensitive woman." Everyone confirmed that the gallery was the couple's joint initiative—even, when asked point blank, Castelli himself. "Oh, yes, Ileana was around; however, we really went through some difficult years right after the war up to the moment when I set up the gallery."[15]

In the gallery's first months, Castelli's project of drawing parallels between the finest Europeans and Americans hit a wall. While he presented a series of solo exhibitions by second-generation Abstract Expressionists such as Jon Schueler, Norman Bluhm, Paul Brach, and Marisol, he could manage to show only two middling Europeans, Claude Viseux and Horan Damian. A few months later, his historical survey, *Pioneers 1910–1950,* which set Pollock alone against Delaunay, Dubuffet, Giacometti, Kandinsky, Léger, Miró, Picabia, and Schwitters, was his last such attempt. After that, caught up in the ever-widening gyre of American art, Castelli began reluctantly cutting his ties to Paris.[16] Amid this retooling there would be few notable achievements during the first year of the Castelli Gallery, apart from the exhibition New Work that opened on May 6, showing Bluhm, Budd, Dzubas, Johns, Leslie, Louis, Marisol, Ortman, Rauschenberg, and Savelli. But before that, one of those epiphanies that would famously define Castelli's career took place.

In *Off the Wall,* Calvin Tomkins gives the definitive account of an unlikely but providential crossing of trajectories in New York on a Sunday in April of 1957; Leo and Ileana Castelli, two European émigrés in search of the new, met two young American painters recently arrived in New York from the South, and themselves searching no less ardently for an alternative to Abstract Expressionism—it was the couple's first acquaintance with Robert Rauschenberg and Jasper Johns. "Leo will open a gallery, but you're not who he'll show," Ileana had bluntly told Bill de Kooning in the summer of 1952, "because he is looking for something new!" It may be that the pair of gallerists and the pair of artists, already having a common cause, were bound to meet. But who could have predicted the ensuing tremors the art world would feel?

Like Frank O'Hara, Robert Rauschenberg had heard the siren call of New York well before coming in 1949. After training at Black Mountain College with the Bauhaus master Josef Albers, briefly attending the Académie Julian in Paris, and traveling around North Africa, the young Texan leapt into the world's amazing art capital with nerve, humor, talent, generosity, and heart. Few would capture, as he did in his Combines, the poetry of the heterogeneous cityscape in the late fifties: torn-off building cornices, stuffed animals, dented bins, broken mirrors, lightbulbs, and various other transfigured detritus. A voracious, brilliant, enlightened, genial, and exultant wanderer, Rauschenberg paced the streets, documenting his "observations" with an anthropologist's implacable dedication to fieldwork, blithely plunging into and scavenging the urban chaos, besotted with the "constant, irrational juxtaposition of things that I think one only finds in the city."[17]

"I felt very rich in being able to pick up Con Edison[18] lumber from the streets and whatever the day would lay out for me to use in my work," he later said. "In fact, so much so, that sometimes it embarrasses me that I live in New York City, as though I'm a guest here . . . I was in awe of the painters; I mean I was new in New York, and I thought the painting that was going on here was just unbelievable. I still think that Bill de Kooning is one of the greatest painters in the world. But I found a lot of artists at the Cedar Bar were difficult for me to talk to . . . There was something about the self-assertion of Abstract Expressionism that personally always put me off, because, at that time, my focus was as much in the opposite direction as it could be. I was busy trying to find ways where the imagery and the material and the meanings of the painting would be not an illustration of my will but

NEW YORK, 1957
Robert Rauschenberg in his studio, surrounded by his Combines. "Nobody cared about my work," he said of
this period.

more like an unbiased documentation of my observations, literally of my
excitement about the city."[19] These statements strikingly echo those of the
French anthropologist Claude Lévi-Strauss, whose preconceptions of New
York had similarly been shuffled, displaced, and knocked over by actual expe-
rience. Expecting "a city," an "ultra-modern metropolis," he found "an
agglomeration of villages . . . an immense horizontal and vertical disor-
der."[20] Drifting with the movements and contrasts, the ebb and flow, Lévi-
Strauss observed the cultural juxtapositions: the "trade-union and political
atmosphere" of Greenwich Village, where he lived, and the "New York aris-
tocracy" on the Upper East Side; he enjoyed the "unbelievably complex
image . . . of modern and almost archaic life styles," such as the "Indian in a
feather headdress and a beaded buckskin jacket who was taking notes with a
Parker pen [in] the American room of the New York Public Library."[21]

Like Frank O'Hara's, Rauschenberg's work offered a sidelong critique of
society rather than head-on protest. "Although personally I do take a stance
in questions like race issues and atrocities of all sorts,"[22] he said, he professed
an incrementalism in art. "I've never thought that problems were so simple

politically that they could, by me anyway, be tackled directly," he explained. "But every day, by consistently doing what you do with the attitude that you do it, if you have strong feelings, those things are expressed over a longer period, a few words at a time, as opposed to, say, one *Guernica* . . ." And like O'Hara, Rauschenberg would become a veritable cynosure of cultural energies: the first to support him were not the postwar painters but two composers, John Cage and Morton Feldman, as well as a choreographer, Merce Cunningham. As for Rauschenberg's encounter with the AbEx "clique," it was so intense that one day in 1953, with a regal smile and fierce tenacity, he rang the bell at Willem de Kooning's door, asked for a drawing, and then, in a symbolic, peremptory, essential gesture, he completely erased it—birth by symbolic quasi-parricide, or at least literal effacement of the begetter's mark.

In 1954, Jasper Johns, also recently landed in the city, worked nights at the Marlboro bookstore to support his painting habit. It was Rauschenberg who would convince him to become a full-time artist and encouraged his explorations. Together they made a living designing department-store display windows, starting a venerable tradition to be continued by Warhol; then, in their two lofts on Pearl Street in lower Manhattan (in the same building, one above the other), they would follow parallel patterns, as Braque and Picasso had done before them in Paris. Emile de Antonio, an English teacher, amateur musical producer, and friend of John Cage's, relates the affectionate atmosphere of their daily life, but also the two artists' isolation at the time. "We talked constantly of painters and painting and food and drink. We played cards and drank. Once Jap [Johns] made a dinner of mallards and wild rice. I brought Jack Daniel's and invited some uptown people—Condé Nast editors, a few collectors—hoping to find Bob a gallery. Bob moved the big Combine paintings so that Martha Jackson, who had an uptown gallery, could see them. She didn't. She fell asleep, drink in hand, nodding and snoring quietly as a Combine went by. I woke her up. Most of the dealers I knew were sluggish in ideas, greedy, blind, and looking for complex and dramatic versions of the master-slave relationship with painters . . . At the time, many second-generation Abstract Expressionists were puzzled and outraged because I preferred Bob's and Jap's work to theirs . . . They accused me of being an anarchist, a Dadaist, a wrecker. Maybe I *was* an anarchist; that in no way lessened the fact that Rauschenberg and Johns were making a new art and a beautiful one. New work never threatens the past, only the present that is yesterday."[23]

Rauschenberg recently recalled those unique years himself—with distinctive irony: "Nobody cared about [Jasper's] work and nobody cared about my work. So we had a very exclusive club. We had great times . . . What brought us together was that we were not doing Abstract Expressionism. That's what made our group of two people a threat to the Abstract Expressionists!"[24] "Jasper's loft was always immaculate, white, and nothing out of place," added their mutual friend Rachel Rosenblum. "Bob's was full of objects, multicolored, chaotic and jumbled." This complementarity between two spaces and two personalities struck everyone, and Rauschenberg was the first to admit his attraction to his friend's world: "I was so envious of [Jasper's] working materials: there was warm bee's wax, it smelled so good. My place smelled like the streets."[25]

A month after Castelli's first opening, Ilse Goetz, a young painter assisting him at the gallery, dragged him to an unusual show that had just opened at the Jewish Museum. The first in a series of "three exhibitions marking the tenth anniversary of the opening of The Jewish Museum in its present building," wrote the director, "the present show intends to look forward instead of concerning itself with the past . . . This new exhibit extends beyond [the museum's past] boundaries, inasmuch as it shows an entire group of painters, Christian as well as Jewish."[26] Though it broke with established tradition, the exhibition nonetheless appeared under rather respectably conservative auspices, since the twenty-three post-Expressionist artists had been selected by Columbia professor Meyer Schapiro, a specialist in Byzantine art, and the catalogue introduction written by the art historian Leo Steinberg, a Renaissance expert. "No sense pretending that the work of these 23 younger New York painters is easily understood. It is not," Steinberg declared flat out. "With few exceptions, it is deliberately recondite, uncompromising and exclusive; we are meant to break our teeth on it . . . He who desires the luxurious pleasure of a fine object well made is not to be gratified . . . The rupture between content and appropriate form is wider than ever; we are invited to stare into the gap and to experience the tension of irreconcilable poles . . . To exhibit these painters at The Jewish Museum is perhaps a departure from established practice . . . And yet, this perhaps passing conjunction of the modern in art and the Jewish has, I suggest, certain aptness. Both Jewry and modern art are masters of renunciation, having at one time renounced all the props on which existence as a nation, or art, once seemed to depend. Jewry survived as an abstract nation, proving, as did modern art,

how much was dispensable."[27] This characterization of Jewishness must have intrigued some part (however veiled) of Leo Castelli, as any mirror would.[28]

According to Jasper Johns, the inclusion of his works and of Rauschenberg's in the show had started in an aptly chaotic way. "Alan Kaprow suggested us," Johns explained, "and brought a Mr. Richter to Pearl Street, where Bob Rauschenberg and I had studios. Bob and I were expecting the Dadaist Hans Richter but I think Mr. Richter had peach orchards in North Carolina or Georgia. He said that he was selecting works for an exhibition at the Jewish Museum. He wanted three or four of my paintings, saying that all but one would be exhibited unless, as he hoped, there was room for all of them. He selected a painting by Bob that had a goat standing on a projecting shelf. The goat had to be dismantled before the painting could be moved uptown and, one Sunday morning, Bob asked me to go with him to help reassemble his work in the museum. We walked into a large gallery with many paintings propped around the walls and a group of people who were obviously selecting and rejecting works. I saw that works of mine were among the rejected. After helping Bob attach the goat, I approached Mr. Richter and told him that I had not been aware that my works were being submitted to a jury and that I would like my paintings returned to my studio. He told me that he thought I should speak with Meyer Schapiro about my work, and I replied that I had nothing that I wanted to express about it. But he called across the room, 'Dr. Schapiro, Jasper Johns would like to talk with you about his work.' A friendly and thoughtful-looking man turned to me and I said, 'Dr. Schapiro, I think that means that I am supposed to talk to you about my work, but I have nothing to say.' Richter then told Schapiro that he wanted to show him another work of mine, that there had not been room for it in the enormous gallery in which we were standing, and we were taken into a sort of hall where my *Target with Plaster Casts* was pulled out from a cleaning closet. Angry, I returned to the gallery and told Bob Rauschenberg, who was working with the electric lights that were part of his painting, that I was leaving. Mr. Richter appeared from the hall and said, 'Dr. Schapiro thinks that your *Target* should be included in the exhibition, but my coworkers say that, if it is shown, I will lose my job. If some of the compartments were closed, don't you think that would add to the mystery of the work?' I said that I was not interested in adding mystery and I left. A day or two later Dr. someone, whose name I have forgotten, called to say that he would

like to come to the studio to select a work for the exhibition. He was a very gentle man with an interest in Buddhist philosophy. He selected my *Green Target*."[29] It is a fascinating counterfactual experiment to imagine the course of the art world had Johns's *Green Target* not been part of that seminal show!

"When Leo came back from the Jewish Museum exhibition," said Ileana, "I asked him if he'd seen anything of interest. 'I'm not sure about the show,' he replied, 'but I did see a green canvas. I can't say I understood it, but I liked it immensely. It intrigued me so much that I can't think of anything else.' "[30] The rest, as the cliché has it, is history, and one often retold. Here are the essentials: a few days after that museum visit, the painter Paul Brach and the composer Morton Feldman offered the Castellis, as they often did, the opportunity to visit a young artist's studio, this being Robert Rauschenberg's. Rauschenberg was not unknown to the two collectors: in May 1951, Leo had hung one of his paintings in the Ninth Street Show, and they had both been thrilled by his Red Show at the Charles Egan Gallery on Christmas 1955—two moments still without consequence. After the usual pleasantries, Rauschenberg offered his visitors a drink, with or without ice. "With!" Castelli answered. "Then I'll be back in just a moment because my neighbor Jasper Johns owns the common fridge!" "Did you say Jasper Johns?" Castelli perked up. "The one whose green painting is at the Jewish Museum? May I come with you?" Castelli described this encounter to Claude Berri in the following way:

CASTELLI: We went down to his studio and there I was confronted with an astonishing sight: paintings of flags, red, white and blue, plain, and a big all-white one; targets with plaster casts above them; alphabets; numbers; and all in a material I hardly knew—encaustic.

BERRI: Was it love at first sight?

CASTELLI: Yes. Total and absolute, the like of which I had never experienced before and rarely since. I asked him, "Do you want to join my gallery?" His answer was simply "Yes." He was twenty-seven at the time. He and Rauschenberg, who had been his mentor, had already been friends for a few years . . . It wasn't easy to have a gallery then. There were very few around. One of them, a very good one, was Betty Parsons's, which showed Pollock, Barnett Newman, and Rothko.[31]

. . .

Ileana has her own take on events: "Jasper's was a world apart. There were very strange canvases, subjects we'd never seen before, paintings made of numbers and letters, absolutely perfect in terms of both form and materials. They were distant, detached, and monumental, even when they measured only four inches square. There was the 1954 flag, his first, which I bought. Jasper and Bob were like the sun and moon: two complementary stars. Johns's work was strange, Rauschenberg's mysterious." It was Leo who would literalize her insight by adding, "Jasper was Ingres and Bob was Delacroix."[32]

"Jasper was very happy, that went without saying," Ileana continued. "Not that Bob was unhappy. But we were very struck by Jasper's work and we kind of forgot about Bob. Leo recognized it right away. Jasper had a series of white paintings, very, very beautiful, white numbers in encaustic . . . Meanwhile, Rauschenberg had gone back upstairs, where he was awaiting our answer about the show we were supposed to give him. When we went back up, Leo said: 'Your friend is very interesting, you know; we'll do a show of Jasper Johns and one for you, too.' 'Yes, you too,' I confirmed. 'We'll do your show as planned.' But it was already May, the season was nearly over, and Leo wanted to do Jasper's show first!"[33]

One is tempted, in contemplating the encounter, to recall a Paris where Gertrude Stein and Picasso—both drawn to the Universal Exposition of 1900 (one from San Francisco, the other from Málaga)—blazed a path between the decidedly bourgeois Rue de Fleurus, near the Jardin du Luxembourg, and the jarringly bohemian Rue de Picpus in Montmartre. Fifty-seven years later, along a path linking the East Side world of Fifth Avenue townhouses to the East Village world of cold-water lofts, New York becomes just such a city, the emergent nexus of so many complex and improbable migrations, its syncretic potential as yet only glimpsed. European gallerists, American artists, European critics, American collectors and museum directors: they were all there, ready to act and be acted upon, more or less knowingly, in the presence of that unique Castelli magic, the singular catalyst that would precipitate an unexampled chemical reaction such as these constitutive elements could not have imagined.

19. TRIAL SHOT AND MASTERSTROKE: THE JASPER EPIPHANY

I was young, and it was of extreme importance to me, because it was right at the time that is classically important for a young man . . . I think that the combination of my lack of . . . well, of people not knowing who I was (very few people knew that I existed, they didn't know my work) and people's interest in seeing what Leo was going to do (since Leo was known, in a certain way, as a collector, because of his involvement with artists as well as with Janis). It made for a lively few minutes.[1]

JASPER JOHNS

Leo Castelli
4 East 77th Street *for immediate release*
New York 21, N.Y.
From January 20, 1958, to February 8, 1958
BU 8-8343
JASPER JOHNS—PAINTINGS

JASPER JOHNS *was born twenty-seven years ago in South Carolina. This is his first one-man show. The subjects of his work are simple visual symbols: targets, numbers from 1 to 9, or letters from A to Z, the American flag. These themes recur, faithfully reproduced in sizes from large to small; and in various materials: encaustic, pastel, or collage . . . To quote a recent review "there is his elegant craftsmanship . . . which lends these pictures the added poignancy of a beloved hand-made transcription of unloved, machine-made images."*[2]

WITH THIS clinically descriptive press release, Castelli announced the arrival of his new talent. After the gestural irruption of the Abstract Expressionists, who finally signed the death certificate of European dominance after so many decades; after Pollock's radical and revelatory break from easel paint-

LEO CASTELLI GALLERY, NEW YORK, JANUARY–FEBRUARY 1958
With his first Jasper Johns exhibition, Leo achieved a masterstroke.

ing, Newman's abstract purity, Rothko's abstract colorism, and de Kooning's formal distortions, what did this return to representation—this polished, refined, but puzzlingly ironic work, which brought back impeccable technique—mean? The very gallery that had shown one of Pollock's last drip paintings less than a year before was now exclusively displaying American flags, targets, numbers, and alphabets. Some of these works were topped with odd sculpted addenda (such as severed face masks or body parts); others combined collage with encaustic, coating the canvas in a sensual, translucent pigmented goo that still exuded the fluid, barely coalescent state in which the artist had so meticulously traced the forty-eight stars and thirteen stripes of the American flag, inducing a great urge to touch it. After Pollock, was Johns simply a regression, or a radical rupture?

"The elements of Johns's picture lie side by side like flint pebbles. Rubbed together they would spark a flame, and that is their meaning perhaps. But Johns does not claim to have ever heard of the invention of fire. He just finds

and places the pebbles," Leo Steinberg wrote in an essay based on lengthy discussions with the artist. "He had his one-man show four years ago, exhibiting the now famous variations on the American flag, on targets, numbers and letters . . . The pictures aroused both enthusiasm and consternation, above all by their subjects. These were of such unprecedented 'banality,' it seemed nothing so humdrum had been seen since before. Why had he chosen to paint subjects of such aggressive uninterest? To be different? . . . The subject matter he displayed in January 1958 was different enough to precipitate a crisis in criticism. Despite a half century of formalist indoctrination, it proved almost impossible to see the paintings for subject matter."[3] On the other hand, "to explain the fascination of these works, one might refer to their disarming rearrangements of customary esthetic and practical responses," Robert Rosenblum proposed in *Arts*. "Johns's work, like all genuinely new art, assaults and enlivens the mind and the eye with the exhilaration of discovery."[4] And Fairfield Porter in *ARTnews* described the effect as supremely elemental, noting that "Johns's paintings compel your attentiveness: they bring you back to what art is in itself, before its meaning, before its usefulness."[5]

A new generation of critics for a new generation of artists. It was they, the young academics, the Rosenblums, Steinbergs, and Porters, who would back Castelli's artists and consummate the break with the postwar critics and painters (Greenberg, Rosenberg, and Co.). But what depths of anger, what depths of resentment were plumbed in the ranks of Abstract Expressionists! "If *this* is painting, I might as well give up!"[6] cried Esteban Vicente as he stormed out of the gallery. For years thereafter, Castelli would be accused of digging the graves of the Abstract Expressionists. In any case, by wagering on the new with the Jasper Johns exhibition, Castelli achieved a masterstroke true to his stated ambitions to foster the best of the emergent. Let's listen to the artist himself: "I think it helped to direct Leo. I think it threw him into something he hadn't expected, so if you look back at the things he was showing, he revised . . . he didn't revise, but where he might have gone is not where he went. He went somewhere else because of certain things that happened, and I was part of that."[7]

Undoubtedly, Castelli's coup grew out of the instantaneous seduction of the New York art world's two heavyweights, two long-cultivated figures now part of his network: Thomas Hess, editor of *ARTnews*, and MoMA director Alfred Barr. Even before Johns's exhibition was fully hung, Hess visited

Castelli and, noticing the canvases lying on the floor, asked for permission to borrow *Target with Four Faces*. Several days later, in an unprecedented gesture towards an unknown artist, he reproduced the work on the cover of his magazine's January issue. Score one. The Saturday following the opening, Alfred Barr left his apartment at the corner of Ninety-sixth and Madison for his usual forty-three-block stroll down Fifth Avenue to his museum. Midway he stopped at Castelli's and climbed the four flights of stairs in the Seventy-seventh Street townhouse. He took in the show, stepping forward, stepping back, stepping forward again, and then asked permission to use the telephone. He called his assistant Dorothy Miller, telling her to come immediately, and, in another unprecedented development, decided then and there to buy four works for MoMA. (Philip Johnson's help was enlisted for one canvas that threatened to ruffle a few trustee feathers.) Score two. The rest is anecdotal, but the salient element is the dealer's role: in the space of a few days, Hess, Barr, Johnson, Rosenblum, Steinberg, and Miller, one after the other, succumbed as both agents of culture and of commerce to the Jasper epiphany, and overnight Castelli was anointed a master tastemaker. For if Castelli indeed launched Johns, Johns no less surely launched Castelli!

Few discoveries in the history of art have risen to the status of revelation as did Castelli's first sighting of Johns's work. What, exactly, is so compelling about Castelli's lightning metamorphosis from dilettante dandy and financial dependent to master gallerist? One might be tempted to reduce it to a fortuitous combination of opportunity, a keen eye, and drive. But this is to ignore factors that predate that first exhibition and that also stretch beyond it. Sixteen years of taxiing on the runway around New York—noting trends, contributing sporadically, watching and waiting—had allowed Castelli to assemble a range of acquaintances throughout the art world that no one plunging in precipitously could have anticipated. Then, after spotting his ideal opportunity, he pounced, seducing the lot of them before even deploying the full panoply of his talents, including his innovative business practices. He would go on to institute financial support for his artists, regular monthly stipends over three, four, even five years that freed them from non-creative concerns—"as French publishers used to do for their authors," he gamely pointed out. Jasper Johns gingerly suggests a somewhat different genesis of the financial stipend system: "Leo did not advance me money. At one time, he owed me a large amount and I didn't think I had any real use for it. I asked him to keep it and to give it to me in monthly installments of one thousand

dollars. We continued that arrangement, and once I was two thousand dollars behind. It made me feel terrible to owe Leo money and I never got into that position again."[8]

But Castelli's method went well beyond that contested legend. The work of Jasper Johns proposed a kind of theme and variation on the status of the American artist. For even as Johns shuffled the deck with his oblique discourse, he took as subject matter the signifiers of Puritans and philistines alike (the flag, the target, the map, the letters and numbers)—the most ubiquitous symbols of the very society that had stigmatized its own artists as pariahs, thereby addressing the whole of America with his provocation. His work was a festival of virtuosity, a symphony of sensuality, weirdly marrying the artifacts of the American heartland with a Parisian touch, as if the sophistication of European references (Cézanne, Monet, Duchamp) could detonate the desperate provincialism and isolationism of his native culture. Was it this message, partly overt and partly subliminal, that Castelli perceived? Was it the neo-Dadaist provocation that moved him? The European touch? The Ingres-like refinement? The new era inaugurated by debates at the Club, the solidarity among collectors, writers, composers, and visual artists, Castelli's regard for his artistic heroes: all of these changes now wafting through the canyons of the city were dissolving the decades of ostracism suffered by the American artist.

Castelli put at Johns's service a cultural and commercial network, the means of national and international exposure and, within a few months, the work had circulated throughout the world—Zabriskie Gallery, Bern, Milan, Paris, London, South Carolina, Nebraska, Ohio, Smith College, Rollins College in Florida, Los Angeles. He also found the artist his earliest collectors in New York, in the persons of Ben Heller, Robert Scull, Mrs. Donald Peters, Robert Rosenblum, Leo Steinberg, Mrs. H. W. Glaswall, and Michael Sonnabend. "A friend . . . asked me whether there was any special significance in my having reproduced your three pictures in one shot instead of individually," a solicitous Alfred Barr wrote to Johns. "I . . . intended to emphasize the fact that we had acquired three . . . As you know, the Museum and I myself have been under some criticism for having bought three works by one artist and he rather little known. I think the Bulletin emphasizes rather than soft pedals this controversial action."[9]

Risk taking, monopoly, commitment: one can't help recalling Paul Durand-Ruel's visits to the studios of Manet, Monet, and Seurat, his imme-

NEW YORK, 1960
With Jasper Johns

diate decision to become their exclusive agent, even though it meant going into debt, and even though these artists had found little favor with French audiences at the time. Courage, audacity, dedication: such were the traits in Castelli at this key moment that would catapult him into an entirely different league from his colleagues, as he metamorphosed into a dynamic entrepreneur and his nascent gallery sprang into preeminence. But how? The necessary elements were contributed not only by nature but by nurture as well, particularly the "awe for things never before seen, combined with an historian's interpretation of the new that transmutes novelty into necessity,"[10] as the sociologist Raymonde Moulin wrote. Castelli himself confirmed this in an interview with Milton Esterow: "The secret was, in part, knowledge about art of the past. I studied art history and figured out that one movement followed another and that there were changes that occurred periodically . . . I knew all [the Abstract Expressionists], knew what they were doing. They dominated the scene for a while, so I felt that something else had to happen. I tried deliberately to detect that other thing and stumbled upon Rauschenberg [and] Johns."[11]

When he was in the presence of Jasper or when he was talking about

Jasper, Castelli would become someone else. In the company of Jasper, the gallerist, as if sedated, would restrain his usual loquaciousness for fear of offending the artist's unusual sensitivity. (Here perhaps was an expression of the negative capability that allows a great ego to minister to another.) Between them, one sensed a rare and unconditional bond of mutual affection, respect, and admiration. Why did Castelli's relationship with Johns appear to be so different from all others? I often wonder. Was it Jasper's art? His immense and immediate success? Or more simply his strange personality? After the first exhibition, several months after their meeting—a trial balloon that achieved unimaginable altitude—Castelli would go on to share his *coup de foudre* with the whole world.

Among the artist's early partisans was Leo Steinberg, the young European intellectual born in Moscow, the son of Lenin's first legal counsel, who had lived in Berlin and London before immigrating to New York. He had written the catalogue for the exhibition at the Jewish Museum, where Castelli had been thunderstruck, then haunted, by *Green Target*. After Steinberg came Robert Rosenblum, who would become one of Johns's most perceptive exegetes. And Frank O'Hara, who dedicated a poem to him:

> The root an acceptable connection
> ochre except meaning-dream partly
> where the will falters a screw polished
> a whole pair of shutters you saw it
> I went in the door the umbrella
> apart from the hole you see a slide up
> two blue yes the wind mutters
> it slides and gulps it is the snow
> where your breast pocket exception
> to the rule whenever the beast moves
> a lion is the same at lunch as at dinner
> tow-head your heaviness is rather exciting
> ai-ai driving the taxi into the ai
> where to whereto yet an appendix
> stops the trip on the East River Drive
> zooming downtown to Jap's eating
> later a bevy of invitations a Chinese bar
> what done undone a long wait for rain

you were under the settee eating cough drops
I mean nougatines where are you now
whose hand behind the pale Housatonic I
waited wait will wait
and what fun it is Great Northern Hotel
and the sole of a foot substantial in the snow
warm through a hole in the stocking the sky[12]

Finally, the larger public, too, would discover the work of this young artist from the South, not a natural darling of the press, not really outgoing, but who, over the years, would become the object of a veritable cult. He is tall, blue-eyed, handsome, gentle, attentive, disarming. He listens, watches, refrains from comment for long minutes on end, establishing an uncomfortable silence between the interlocutor and himself. Then he breaks it with an immense Rabelaisian burst of laughter that seems to go on forever. He equally disdains crowds, honors, those consumed with self-importance, and rather prefers the company of children, students, and others who strike him as authentic. He is a great reader, a true intellectual, a man who questions, who searches, who challenges.

On March 4, 1958, Castelli gave Rauschenberg his first show. The decision was far less spontaneous than it had been in Johns's case and required Ileana's prodding, even after the day the same promise had been made to both men. "One day I happened to be in the gallery office," she recalled. "No one was there, not even the manager, Ilse Goetz. I was all alone, and suddenly Rauschenberg walked in, tense and nervous. 'I've come to see if you're going to do my show or not, because I still don't get it and I'd like to know why you're doing Jasper's show and not mine. When's mine going to be?' 'Next season, for sure,' I said. Meanwhile, I was racking my brains for something else to tell this man, and I blurted out: 'You know, you're older, we have to prepare for your show more carefully. Jasper's comes at the end of the season.' He calmed down at that and I added: 'If you're not sure, Leo will call you to confirm what I've just said, but you can count on it.' That's why we're such good friends, because I was very encouraging with him. It was sad, because I had no doubt that his work was extremely important, extremely interesting, and I knew Leo shared my opinion. But Leo had a more classical temperament, while I'm more of a romantic or expressionist."[13]

"The Southern Renaissance" was the term John Cage coined to describe

the immediate impact of these two artists and the work they had done in their underground years. Indeed both came from the South, but what a great contrast there was in Jasper Johns's controlled encaustic, obsessive subject matter, reflective constructions, unending philosophical labyrinth, and disconcerting interrogations versus the unbridled verve, dynamic accretions, teeming gestures, inventive luxuriance, and raw urban poetry of Rauschenberg's Combines. "Ingres and Delacroix," indeed! "Rauschenberg's latest show at Leo Castelli's seems to me to include two or three pictures of remarkable beauty,"[14] Leo Steinberg would write. Unlike Johns's work, Rauschenberg's had already been shown several times—at the Ninth Street Show, Egan's, Betty Parsons, the Stable Gallery—but with his stained *Bed,* or the Combines incorporating stuffed animals and other scavenged objects, his work seemed so truculent that only a compellingly appreciative text such as Steinberg had the power to write could hope to mollify the critics. And even he would fail to convince Alfred Barr, who this time acquired nothing.

With patience, tenacity, and cunning, Castelli tried his best to sway Barr and bring him around to the young Texan's work. An internal memo from MoMA gives a sense of the dealer's multipronged lobbying: "Mr. Castelli called about your wish to see Rauschenberg's work," wrote Barr's secretary, "specifically the pheasant picture, to offer the alternative: 1. If Marga and you would like, you are invited to dinner Friday evening late (8–8:30) with Senator [Jacob] Javits and the [collectors Harriet and Donald] Peters at Rauschenberg's to feast on Texas turkey sent on dry ice from his family in Texas! Marga had told Castelli you had other cocktails, so he will rather expect you to refuse this solution. 2. Rauschenberg will receive you in his studio at your convenience at a time to be set up. 3. Castelli will have that picture brought to the gallery so you can step in to see it. (I'm betting the turkey will end up on canvas and you'll be served the pigment.) Marie."[15] These inducements notwithstanding, it would still be a long wait before a Rauschenberg would enter MoMA's collection. In fact, by far the most notable result of that show was Castelli's encounter with a new actor on the New York scene, Alan Solomon. A professor of art history at Cornell University, Solomon would become one of Leo's closest friends after Steinberg and Rosenblum, a pillar of the gallery, and in 1964 the force behind one of Castelli's signal achievements.

Nineteen fifty-eight: to all appearances a banner year! However, backstage, things did not look that great. Since their wedding in 1933, the Castellis had tried out every type of relationship: traditional marriage in Bucharest

and Neuilly; an estrangement—she remained in Neuilly, he took a place in town—during which their "official love" coexisted with "contingent loves" (to borrow the terminology of Sartre and Beauvoir, who symbolized this type of arrangement in those years); a wartime reunion enforced by their exodus of 1939–41; a marriage of convenience in New York, when they shared the second-floor apartment in the Schapira townhouse and kept up appearances; a transatlantic separation during his military service (she "lived her life" in New York while he was in uniform); and finally another marriage of convenience in New York, from 1946 to 1956. Bound by shared cultural experiences, while also contending with, on one side, Leo's weakness for women and his many blatant affairs, and on the other Ileana's depressions and search for a public identity to shield her from her husband's will-o'-the-wisp faithlessness, the Castellis remained together for reasons that included joint financial interests, social propriety, but also, and not least, genuine friendship.

In the eyes of such a Balzacian character as Michael Strate, emotional frictions could always be soothed by money and influence. He had already tried to repair his daughter's broken marriage in Paris by underwriting the Place Vendôme gallery. Once, running into Ileana in the street, he expressed concern at seeing her alone: "And how's your husband? Oh, having problems? He hasn't taken up gambling, has he?" To their daughter, Nina, on the other hand, things were perfectly plain: "When Leo went in the army, we stayed with my grandmother, and Ileana was not in the background anymore. She started studying. She met Michael Sonnabend, who used to do the things he thought a father should do: he bought me toys, took me to museums, and she became different."[16]

Despite the vows, things left unsaid, the wear and tear of absences, hypocritical arrangements for expediency and appearances; despite shared displacements from one country to another country (Romania, France, the United States); despite political ups and downs and the war; despite financial dependencies that weighed heavily and the mounting compromises, Castelli's first marriage had limped along for a quarter century. In 1959, however, at the end of lunch one day, fed up with her husband's passive-aggressive behavior and his silences, Mrs. Castelli forgot her good manners. Deciding she had had enough, she yanked the cloth off the table, and all that went with it. Robert Pincus-Witten, a friend of Nina's, remembers Ileana's description of the very odd way in which it happened. "Ileana divorced Leo, yes. But how? It would seem that as a function of the old Jim Crow laws of the South, you could divorce your husband in Georgia, if you were free,

white, and 21, as well as a landowner. Ileana flew to Atlanta—the land deal and the divorce papers had already been worked out. She bought land, divorced Leo, resold the land on the way back to the airport, returning to New York on the same day. That evening she served Leo dinner in the 4 East 77th Street house. Leo began to complain. 'Forget it, Leo. I'm no longer your wife. I divorced you today.' "[17] Soon afterwards, in May, she married Michael Sonnabend, a double ceremony in which her daughter also married Michael Sundell.

"Ileana left me in early 1959. She got into some kind of depression at that time," Castelli later rationalized. "We hadn't been really getting along very well for years on a personal basis, although we always had been friends really. But as far as [a] man-woman relationship is concerned, it didn't work at all. But she was in the gallery and very concerned with that. She'd been sort of very helpful all along in our difficulties . . . She had been very patient with me, as I had been pretty bad in many respects. Then probably she got into some depression owing to physical conditions and so on. And she just left. Well, I had all kinds of problems that were intolerable, but she really didn't mind that so much. I would say, after all, that we had just a friendly relationship, but still it's a little bit much. So, she had to leave and she did." "By divorcing Leo," a close observer remarked, "Ileana lost a faithless husband but gained a friend, an accomplice, and a professional partner for life."

And so, exit Leo Castelli from the Seventy-seventh Street apartment. He went to live downtown and commuted uptown for his work. He now handled his own finances, and his artists' as well. But Ileana and Michael Sonnabend kept their hands in the gallery, solicitously watching over Leo's future. Deciding he could not function without the help of an assistant, they set up lunch with a dynamic young art critic for the *Village Voice* named Ivan Karp. "Michael Sonnabend heard me lecture at Martha Jackson Gallery on Tàpies," the latter recalled, "a spontaneous presentation in front of a group of women. He said, 'Do you know Leo Castelli?' 'Of course, he comes to the gallery, and he was the only one who came to the Hansa gallery. I've seen all his shows.' A few days later, I had lunch at the Stanhope Hotel with Leo and Ileana."[18] Karp was hired on the spot as Castelli's lieutenant, to "help poor Leo, who had so little business sense."[19] Strate sold the house, but Castelli took a lease on the second-floor apartment, which in October 1959 became his new space.

In the fall of 1959, Castelli, at last a successful gallerist, backed by a real

professional team, had decisions to make. According to Betsy Baker, later to
become the famous editor of *Art in America,* this was the turning point in
Castelli's career. "After the slow start of stage one, when Castelli picked up
pieces in the fifties and got a real mixed bag, comes stage two, with Jasper
and Bob, in the sixties, and that is when the gallerist gained real momen-
tum."[20] He had made such improbably spectacular breakthroughs in New
York that some began questioning his success. Was it his network? His
charm? His chutzpah? Perhaps it is even possible to point to a Jewish atavism,
the family history scarred by a series of exiles and the concomitantly
acquired expertise in crossing borders between societies, between the worlds
of culture and of business. Should we recall the mercantile Castelli brothers
crisscrossing the Val di Chiana to foster their monopoly in paper, tobacco,
and alcohol, enriching Monte San Savino in the process? Or the Castelli
cousins, launching their merchant fleet worldwide to expand their coffee
trade and share in Trieste's golden age? Most of all, should we recall Leo
Krausz, the young Assicurazioni Generali agent, who, as early as 1930,
started selling life insurance throughout the world? Bridge, broker, interme-
diary: how to characterize the knack of one who, displaced from country to
country in rather unpropitious historical circumstances, should tirelessly cul-
tivate a pragmatism and patient creativity, making an extraordinary virtue of
necessity? What is, then, the source of the masterstroke that flabbergasted
so many? Leo Steinberg, for one, seems to offer a perfectly plausible answer:
"It was the international aspect—no, the international *nexus.* The other gal-
leries, Egan, Parsons, Ward, Bellamy, were all Americans, and from Leo
Castelli's point of view they probably were somewhat provincial. They had
no concept of the world. They were not what Goethe called a '*Weltbürger.*' "[21]
But though he obscured this Jewish ancestry of traders and agents, his cos-
mopolitanism was a manifest component of his success.

20. A WHIRLWIND OF INVENTION: "DISCOVER A GENIUS A WEEK!"

Castelli was entirely involved in maintaining his position as the avant-garde gallery who spotted all the new talent. And Ivan Karp, who had a wonderful sense of humor, would say, "We should discover a genius! It's been two weeks since we last discovered a genius!"[1]

LEO STEINBERG

FROM 1958 TO 1981, in order of appearance: Jasper Johns, Robert Rauschenberg, Frank Stella, Cy Twombly, Lee Bontecou, Roy Lichtenstein, John Chamberlain, Andy Warhol, James Rosenquist, Donald Judd, Christo, Edward Higgins, Robert Morris, Joseph Kosuth, Dan Flavin, Bruce Nauman, Keith Sonnier, Richard Serra, Richard Artschwager, Ed Ruscha, Claes Oldenburg, Lawrence Weiner, Ellsworth Kelly, Hanne Darboven, Kenneth Noland, James Turrell, Julian Schnabel, and David Salle, among others—discovered, shown, promoted, and sold at a dizzying rate, at home and abroad, by the Leo Castelli Gallery, New York, N.Y. And this summation of efforts does not include the group shows and exhibitions of lesser-known artists; nor the architecture, photography, drawings, and prints; nor the concerts and books produced by Leo Castelli; the music, films, and video productions. It does not take into account the opening of new galleries, collaborations with colleagues, benefits sponsored (to aid Merce Cunningham's dance company, for instance, or the New York Studio School, or the Save Venice society), the countless interviews in English, French, Italian, German, Spanish, or Romanian. Nor the constant trips to Los Angeles, Chicago, Minneapolis, Kansas City, St. Louis, Houston, Miami, Paris, Venice, Milan, Amsterdam, London, or Cologne, to see fellow dealers, curators of major traveling shows, and museum officials. Omitted as well is the time devoted to family, friends, and love interests. In the course of two decades, Leo Castelli launched the major figures who broke with Abstract Expressionism, then

moved on to Pop Art, Minimalism, and Conceptual Art. In two decades, he aligned himself with the finest contemporary American artists, pursuing his activities according to the art-world model of the impresario-cum-dervish, a "constant whirlwind of invention,"[2] and leaving the breathless observer continually to wonder what he would do next.

What precisely made Castelli tick? Was he throwing himself into a strategic plan or just losing himself in work in an indeed endless cycle of self-immolation and re-creation? Was his a will to power? A taste for the spotlight? A pure aesthetic fascination? What was he after? What hidden dynamo torqued his professional engine with such relentless efficiency? What figurations, what formulas, could describe the inexhaustible kinesis of those years? "What his enemies say may be true," Emile de Antonio reflected. "He loves the power; he loves the money. But he loves the work most, and well. And he has a very deep sense of the history he has lived. As work becomes bigger and bigger, he opens newer and bigger galleries."[3] To Bil Ehrlich, then a student of architecture at Harvard and one of the gallery's youngest clients, the answer seemed evident: "I don't know how much of that came with luck or how much of it was some kind of vision that he had, but . . . you cannot continue to ask [that question], given the fact that he acquired a succession of remarkable artists and you can't say every one of them was luck."[4] The collector and financier Donald Marron offers a businessman's perspective on the intangible: "Leo identified a time that was coming, he identified a number of the great players, and then he created an atmosphere in which they would flourish. I have no idea how he did financially, but he created this atmosphere of discovery and success."[5] In today's parlance, one might say a brand. To wit: 1959, opening of the new gallery at 4 East Seventy-seventh Street, second floor; 1970, Castelli Graphics, 4 East Seventy-seventh Street, first floor; 1968, the West 108th Street warehouse, for oversized works; 1971, 420 West Broadway, to replace 4 East Seventy-seventh; 1980, 142 Greene Street . . . a veritable chain for a business in one-of-a-kinds!

At the eye of this entrepreneurial storm stood a short, svelte, meticulous man of habit, his elegant but sober clothes expertly stitched by his Milanese tailor (the classically tailored grey suit and monochromatic Hermès tie were his signature look); who lunched and dined with equally refined simplicity (*straciatella alla romana, piccata al limone,* and a salad), always in the same Italian restaurants of New York; who spent Thanksgiving at Snedens Landing with Judy Tomkins, his Christmas holidays at the hotel La Samanna on the

island of St. Martin, near Jasper's house, and his summer vacations in Castellaras in the south of France, reading and rereading the same European classics before bedtime: Dante, Goethe, La Fontaine, Tolstoy, Thomas Mann, Flaubert, Proust, Balzac. Ever true to himself, with unfailing grace ("*con garbo,*" the Italians say), Leo Castelli, like some sorcerer of ancient lineage, performed the arcane alchemy that unleashed the fabulous destinies of American art.

Beginning in October 1959 and for the next ten years, his Sancho Panza (chosen by Ileana and Michael Sonnabend to be Leo's protégé-cum-guardian) was a young Brooklyn-born art dealer, friendly, enthusiastic, inquisitive, stimulating, and yet good-humored: Ivan Karp. Castelli's assistant was a tall, gregarious carrot-topped man of contagious optimism. "I didn't have an actual title, I was just there," Karp would explain. "I received the people. I was the cushion. I was able to deal with obnoxious characters. Sometimes Leo would hide in the corner of his office. People would come and see me first, and I would entertain them. There were collectors with questions, there were artists who would show me slides—and if the work was exceptional, I would show it to Leo. I did the preliminary job, I would filter the personalities, the characters. Leo would also come with me to see three or four studios on Saturday morning."[6] An interesting third-party recollection of the operation is offered by the collector Wynn Kramarsky, who notes, "My contact in the gallery was more with Ivan, because in my view Ivan was always more of a businessman than Leo, and while I enjoyed talking with Leo, Ivan was always more available. In the fifties, I had no money, so I was somebody who went there, but except for '58 when I bought a Johns drawing, I never did any business with him—but I used to see him all the time, we liked each other and we spent a fair amount of time talking."[7]

The discovery of Lee Bontecou is a signal instance in the gallery's annals. Let us listen to Karp's version: "The gallerist Dick Bellamy told me he had visited a studio in the lower, really dark depths of the Lower East Side, Avenue B or C, which still retains that medieval cast about it. Dick said he had gone there to visit a girl in a loft on the top, and on the way down there was a door open to a studio. The building wasn't heated and everybody kept their doors open to get the heat from a laundry on the first floor. So Dick looked through and he saw these incredible tent-like apparatuses. And he said that if I should ever go to that building I should try to see these things. The first day I went it was in midwinter, very cold, and the building was vio-

RECEPTION AT 4 EAST SEVENTY-SEVENTH STREET, NEW YORK, 1960
With Ivan Karp, ON THE RIGHT, and Jasper Johns in the background

lently vibrating from the laundry machinery. I knocked on the door of this studio and a very delicate little girl-like creature came to the door. I said to her, 'I'm looking for the artist who works in this studio, a certain Miss Bontecou, I believe it is. Is she at home? Is she your mother?' And she said, 'No, no, I'm Miss Bontecou.' She looked to me like a fourteen-year-old girl, a very fragile creature, with a very delicate face and straight blond hair. I remember going in there and seeing these tent-like structures with their fierce apertures, and in contrast to them this little girl. It was rather overwhelming. I was unsettled for a week by the confrontation of these objects and delicate, pale, little Miss Bontecou there.

At that time, I used to come back from my tours and report to Castelli and to the now Mrs. Sonnabend that I saw So-and-So downtown, that this looked good, and so on. And one day a group of us—Leo, me, Michael Sonnabend, and Ileana—went to Miss Bontecou's studio. She was very soft-spoken, if spoken at all, she hardly issued a word about her art; she never referred to it as her art; just as things that she'd made or something like that. And we were all rather shocked because they were scary in their way, especially in that environment. It was Michael Sonnabend who felt very strongly about them.

He said they had a kind of logical power that was really more than he had seen in years. Leo was very brave in inviting those works to come into the gallery. They really seemed terribly alien to anything we had ever seen.

The day we had them shipped in, we were sitting in the back room talking to two museum officials. One of them was Alan Solomon, who was then working at Cornell. And there was the curator of a museum in upstate New York. And two men from the shipping room said, 'We got dose tings. Where do you want them?' I realized that it was Bontecou's work being brought in. I thought that really neither Castelli nor I could see how those could possibly fit into the gallery, in this fragile gallery space. Anyhow the men brought the two pieces into the room and they really were transformed in that setting. They were capable of being seen. They had their clarity and they had their object power. And within seven minutes of their being brought into the room both works had been purchased by the two museum officials sitting there. We concluded the deal there, without even a show or any promotion!"[8]

Perhaps it would not have happened without Castelli's magic touch, but if he was the author of his own luck, he also assuredly had his guardian angels. For a case more nearly illustrative of Castelli's own sense of his effortless heroic narrative, we need look to a more familiar artist. In September 1959, Castelli met the one he would ever after introduce as his second epiphany: Frank Stella. "I believe it was Robert Rosenblum who first spoke to me about this young artist, whose work he had seen a few days before, who seemed exceptional and that I must go and see him. So I set off for Stella's studio the next day . . . Frank had turned twenty-three and had just finished his studies at Princeton. It is difficult for me to describe the extraordinary shock I experienced when I saw the large black paintings that he was doing at the time [black stripes with thick dividing lines between each stripe] . . . Stella's hard and brutal abstractions had an extraordinary effect on me. I realized later—and Stella confirmed this—that the stripes in his paintings were inspired by the stripes in the flags of Jasper Johns. Without hesitating for a moment, I asked him to join my gallery."[9]

Castelli continues: "I sort of imprudently or wisely, I don't know, told Dorothy Miller that there was this young painter (I just had seen him a few days before) that I had really been terribly taken with, and would she like to come and see him. So we went and she looked and she said, 'I must have that young man in my show'—she was preparing one of those Fourteen Americans or Sixteen Americans shows, and she was still looking for some artists."

Miller, then fifty-five years old, was MoMA's first curator and is perhaps the least appreciated female champion of American art in the period. "I said that was just absurd," Leo continued. "Nobody has ever seen him. He's twenty-three years old. After all, the people you have in that show are people that have had shows and are known, and you shouldn't do that to a young fellow. 'And by the way, I have planned to show these black paintings of his in my first show,' I told her. 'So what do I do?' She said, 'Never mind, you will find something else to do, and I must have him.' I did find something else to do, and she had him." Castelli's find would catch the eye of Miller's boss Alfred Barr, whose buttoned-up overlords were, to his credit, as always a step behind him. "The trustees or whoever decides there said it was absurd to buy that painting of Stella's, that it was much too big, never mind the money (I think it was something like $900), it was just too big, they didn't have enough space to store a stupid painting like that. Barr, from what I heard later, threatened to resign if the trustees did not accept his opinion. So they bought that Stella, and from then on they didn't buy Stella anymore for years and years and years."[10]

And so were sown the seeds of a fascinating conflict between MoMA and the Castelli gallery, at least according to the leonine gospel. The incident is narrated very differently by Dorothy Miller. Here is her story as told to Lynn Zelevansky: "William C. Seitz, who had been Stella's professor at Princeton, first told Miller about him . . . Then, over lunch in early September 1958, [Castelli] told Miller that he planned to visit Stella, and they decided to go together. Later, Miller recalled a very thin young man who was missing his front teeth, in a small studio with a large stack of paintings leaning face to the wall. In order to show his work, Stella had to grab a painting by the stretcher, carry it out into the hall, turn it so that it was facing forward, and reenter the studio: 'It was like a ballet.' A couple of days later, Miller took Barr to Stella's studio and he was very enthusiastic."[11] As for Frank Stella, he offers yet another version. Miller had seen his canvas in a group show at the Tibor de Nagy Gallery, and when, at Castelli's urging, she and Leo had visited Stella's studio together, Castelli offered Stella his first solo show, and Miller promised him a place in Sixteen Americans.[12] Whatever the exact sequence of events, this narrative competition alone gives an inkling of the fever consuming the New York art world, the feeding frenzy for emerging artists. "Leo was distressed because he wanted to be the first to show Stella, and Dorothy Miller beat him to it," said Leo Steinberg, a disinterested party.

"So he got Bob and Jasper (who at that point had the status of Old Masters) to go down to Princeton to try and persuade Stella not to agree to show at MoMA!"[13] Fat chance of that happening!

A month after meeting Stella, Castelli showed Cy Twombly, another Southerner like Rauschenberg and Johns. He was a painter of sensual, allusive work, making unique use of traces, scars, and scratches, and with a deep sense of history, though his paintings might seem abstract to some. An artist with some independence who was already established in Italy, he was not unformed enough to become the gallerist's creature, and he would always maintain a certain distance from Castelli. "Ileana should be given her due," Twombly comments today, slightly dismissive of the maestro. "She had the eye. Leo had a silly side and a very honorable side."[14] Indeed, as Twombly suggests, Ileana Sonnabend was quite present during those first years of her ex-husband's gallery. As earlier with Pollock and de Kooning, and more recently with Bontecou, she excelled at personal contacts with the artists, seconding Ivan Karp in his studio visits. Then there was Roy Lichtenstein, who one day plunked down five of his canvases in the entry foyer of 4 East Seventy-seventh Street. In recollection the scene itself is as suggestive of a comic strip as the art in question. "I said," Karp remembers, "'What are these?' He said, 'Well, Mr. Kaprow called about me. I'm Lichtenstein and I wish you'd look at these paintings.' I said to him, 'You really can't do this, you know.' It was just too shocking for words that somebody should celebrate the cartoon and the commercial image like that. And they were cold and blank and bold and overwhelming. So I said, 'Well, look, I'd like Castelli to see these. They're pretty unsettling.' We kept four of them. And then Leo saw them and had his own set of reactions. We both were jolted. We thought, well let's put them in the racks and we'll take them out again and see how they feel as the days go by. And after a time we agreed it was really an intelligent and original innovation."[15] After the Sonnabends had visited Lichtenstein's studio, Castelli, despite resistance from the "Old Masters" Jasper and Bob, decided to show him.

As for Andy Warhol, he appeared at the Castelli Gallery as a collector at first. He bought a Johns drawing for $350, then spotted a Lichtenstein propped against the wall. "He issued one of his curious little sounds like an astonished 'Oh!' that he says every so often," relates Karp, "which he still says in a state of astonishment. 'I'm doing something like this myself!' He said, 'What are these paintings doing here! Whose work is this!' He was really

Frank Stella (Castelli's second epiphany) working on one of his famous stripe paintings

shocked, and at the same time appalled. And he asked me if I wouldn't come to his studio and look at what he was doing. I said, 'Do you mean to say that you're really concerned with the same kind of images?' He said, 'Yes. I actually am doing cartoon things and commercial subjects. But they're different, of course; they're very different. Would you come and look?' " So it was Karp who first visited Warhol's studio: "I went to Warhol's powder blue building on Lexington Avenue, a four-story building which he owned. I was shocked to see that his was the only name on the bell. I went in there. It was a very dark place. There was one very bright light on in this living room area, which was beautifully decorated with fine, elegant furniture and beautiful paintings with a generally surrealistic character about them. But we were just beginning to launch Lichtenstein, and thought it would be very destructive to have these two new artists doing the same sort of thing."[16] Fortunately, Ileana paid a visit too: "I called Andy and went to see him in the house he had bought for his mother, Julia. He was doing advertising drawings, very beautiful, and the house was chock full of magnificent things, huge papier-mâché dogs and the like. He was very shy. Then we talked, he showed me his stamps, the paintings he did with airmail stamps, and also a Coke bottle and

NEW YORK, 1966
With the gallerist Holly Solomon and the artist Roy Lichtenstein at a reception

many drawings of shoes that I liked enormously and found very interesting. He said he didn't have any friends, so I called him again and we would go out walking. We went to Forty-second Street, which at the time was very different, very run-down; the buildings weren't exactly decrepit but not very well maintained either. There were newsstands selling hard-core porn and a lot of sex shops with lingerie for women and men . . . I advised Leo to take both Roy and Andy!"[17] And so in her subtle style, Ileana showed the way towards harmonizing the two talents, who by virtue of common interests had more to gain than to fear from each other. Among the other Pop artists that Ileana, along with Ivan Karp and the others, helped to bring to Castelli was James Rosenquist. "Rosenquist painted these huge billboards," she said. "He had a very interesting space in the city, at the intersection of several streets. There were no buildings around his, so he had an unobstructed view, with car headlights, neon signs on the roofs, and helicopters flying around. The first time I went there, he told me it was very difficult to work so high up with such a large brush. He never saw the whole thing, the subject in its entirety. That's why, I think, the images in his work are always fragmented. He considered himself an advertising artist, he didn't think he could show his work. Every-

thing was very hectic, and this hectic quality infiltrated his painting. That's what I loved about it: the very close relation between his life and his art."[18] But in this case, Ileana's enthusiasm for Rosenquist was overruled by Castelli, who found him "too close to Surrealism, to Magritte, and he really did not quite belong in the stream"[19] of his artists. For now, Dick Bellamy would show Rosenquist at the Green Gallery.

If Castelli's primary goal, prosecuted with ample help from his devoted scouts, was the discovery of new talents, a close second was getting his artists into the museum world. Since MoMA's opening in 1929, seeded with the modern European art collections of three women—Abby Rockefeller, Lizzie Bliss, and Mary Quinn Sullivan—the perennial question had been how to represent American art there. Whatever form the presence took, it would from the beginning live in a shadow. The excellence of MoMA's permanent collection and temporary exhibitions, as well as the expansion of educational programs initiated by Alfred Barr, had made the museum the preeminent showplace of twentieth-century European art in New York. Still Alfred Barr—though he had been perfectly clear that his project was to show the excellence of modernist European art—had been roundly criticized for "ignoring American art." The "American shows" instituted in 1942 had begun to remedy the situation, but only gradually—especially since the balance of power between European and American art was at first woefully lopsided in Europe's favor. On MoMA's walls, works by Darrel Austin, Hyman Bloom, Raymond Breinin, Rico Lebrun, and Knud Merrild wilted alongside masterpieces by van Gogh, Picasso, Matisse, Duchamp, de Chirico, Dalí, Magritte, and the others. How could one usefully identify the two groups, other than as oil and water? What Americans could stand up to Europeans of that stature? How could they be made to seem legitimate, let alone fit into the collection? Wait a few years: Castelli will provide the key.

Dorothy Miller's 1959 exhibition Sixteen Americans presented Johns, Rauschenberg, Stella, Ellsworth Kelly, and Louise Nevelson, plus eleven others. The consensus had it that although—or perhaps because—each artist was accorded his own space, the show was rather incoherent, and somehow less than the sum of its parts. "There is not a single painting, and very little sculpture, that I could imagine living with," John Canaday sniffed in *The New York Times*. Canaday also wrote that they were "the sixteen artists most slated for oblivion." "Chaotic but stylish," Robert Coates judged more kindly in *The New Yorker*. Emily Genauer of the *New York Herald Tribune*,

never a fan of Dorothy Miller's, opined that Stella was "unspeakably boring." And, ever faithful to the Abstract Expressionists, Clement Greenberg groused in *The Nation* about the show's organizer, saying, "whoever he was [*sic*], he seems altogether devoid of personal taste." Nevertheless, and against all odds, MoMA did buy Stella's *The Marriage of Reason and Squalor*, and Castelli could boast of having placed two of his protégés in the sanctum sanctorum of modern art. He wasted no time launching the third phase of his master plan: explaining to a skeptical public how *his* artists fit naturally into MoMA's collection. "The key figure in my gallery," he would later explain, "is somebody that I never showed, and that was Marcel Duchamp. He was the great influence on all the younger painters [in my stable]. Painters who are not influenced by Duchamp just don't belong here."[20] By boldly imputing such a continuity, and tracing a genealogy whereby Jasper Johns was Duchamp's heir and Frank Stella was Johns's heir, Castelli effectively ushered art history through the door of 4 East Seventy-seventh Street.

Castelli had been an early and unconditional admirer of MoMA's European collection; then, via the Club, he had drawn close to Alfred Barr. Finally, in 1951, with the Ninth Street Show, he had become for Barr a sort of accidental Virgil or at least a reliably shrewd consultant, who by remarkable powers of divination could predict the emergence of new American artists and deliver them up to Barr, preempting any competitor. In 1958, after he became a gallerist, these fruitful relations entered a new luminous phase: the Jasper Johns and Frank Stella period, in which Castelli's choices seemed in perfect harmony with Barr's and Miller's taste. Then came a period of some friction, as Rauschenberg's more effervescent and disturbing work had a hard time winning over museum officials. Obsessively and unabashedly, Castelli solicited, goaded, and hounded Alfred Barr (and Dorothy Miller even more) to ensure Rauschenberg's fitting presence in MoMA's permanent collection—in his view, the ultimate aesthetic consecration and an American artist's only way of being recognized outside professional circles as one who had crossed the borders of provincial obscurity and whose work deserved to be regarded as Art with a capital A.

In January 1959 the gallerist had vainly attempted (as described earlier) to invite the Barrs to dinner at Rauschenberg's in order to see the works *in situ*. A few months later, the gallerist would strike again. "Dear Alfred, Leo Castelli says he may have a donor for the Rauschenberg four-part painting with collage called *The Wager*," Dorothy Miller wrote, "although it is possible

that the buyer may want to keep it. He asked if it would be acceptable to the Museum and I told him that it would have to be discussed by our Committee but that I thought *The Magician* would probably be more desirable for us. I then asked him if he could find a donor for *The Magician* and he said he was sure he could. It is 2,250 dollars."[21] Two weeks later, with no donor in sight, Castelli blithely sent *The Magician* to MoMA, invoice attached:

> Leo Castelli, Inc., January 6, 1960
> Financial Department
> MoMA
> Rauschenberg: *The Magician*, 1957, Combine: $2,500
> Less 10% museum discount: 250 = $2,250[22]

Were his assurances of a donor even plausible? We can hardly fail to see, in Castelli's willful placement of the cart before the horse, the operation of his faith that a museum acquisition produced infinitely more reputation capital than a collector's purchase—an end that justified such over-the-top means. Refusing to quit, having already pulled a fast one, Castelli continued to press Miller for more. "Dear Dorothy," he wrote less than a month later, "Enclosed is a photograph of the painting of Bob's [*Allegory*] that I told you about on the phone. It is quite large, about ten feet long and six high. This is just to whet your appetite and to make you anxious to see it at the studio."[23] Weakening under the onslaught, even to the point of entertaining further dubious promises, Miller still required her boss's permission to pursue the work: "Leo Castelli has an immediate donor of Rauschenberg's latest work, *Allegory*, which said donor and Castelli believe to be his masterpiece to date. It contains part of an umbrella and a large panel of crumpled metal. Unfortunately, it is 10 ft. wide." She goes on, in virtual complicity, "Leo feels he can eventually find a donor for *The Magician* but the one he has presently in hand prefers to give *Allegory*, as he thinks it is a more important work. If you think the photograph looks promising, I will go down and see it some evening at his studio. D "[24]

Despite the bold maneuvers, outlandish and hard to resist, the efforts would be in vain: several months on, *The Magician* was sent back to Castelli—not because Leo's seductions failed but because, as Miller stated, although "the Committee voted to purchase [it,] we have failed to raise funds for it during the past year and its owner Mrs. Castelli wishes to with-

draw it from sale."[25] Two years later, having apparently found Barr and Miller immunized by experience, Castelli spied promise in Bill Seitz, a comparatively recent addition to the paintings and sculpture department, as the new target of the Rauschenberg assault: "Leo Castelli is holding for us a first refusal on Rauschenberg's *Trophy* (dedicated to Merce Cunningham), 1959," Seitz wrote in a memo to Barr and Miller. "The price, which is what he paid Cordier-Warren for it, is $6,000. In my opinion this is a very fine example of his work of that period. If we are not interested in it, Leo wants to know soon, as Ben Heller has a second refusal"![26] But it would prove another setback for Castelli; in the margin Miller jotted an irrevocable verdict: "AHB does not particularly like this one."

These refusals notwithstanding, Castelli was undertaking an important innovation in the art world—a functional link between market and museum, that is, between commercial agents (gallerists) and cultural arbiters (curators and directors). As such, he perfectly epitomized the dealer as entrepreneur. "His taste for sudden discoveries (epiphanies) and constant brinkmanship was entirely in keeping with the aesthetic of urgency and constant change," wrote the sociologist Raymonde Moulin. Preferential information was the second crucial element in Castelli's dazzling strategy. Thanks to the contacts he had been forging since 1941, he had an unmatched intelligence network, "inside information and tips that others did not yet possess."[27] Information circulated very unevenly in this fledgling art world, with artists, critics, and dealers on channels that collectors had no access to. Castelli's great epiphanies are mainly cases of being in touch with all the right people: he had found Jasper Johns thanks to Ilse Goetz; Lee Bontecou thanks to Dick Bellamy, Ileana Sonnabend, and Ivan Karp; and Frank Stella thanks to Robert Rosenblum, Johnny Myers, and Bill Seitz.

But in those same heady first years, one real handicap did confront Leo: in 1961, Mr. and Mrs. Sonnabend decided to move to Europe. "The gallery hadn't been around very long," Castelli remembered. Predictable as their leaving may have been, it still stung. "Then there was some acrimony for a couple of years," he continued. "Of course, we had so many common friends. She was, still is, a great friend of Bob's (especially Bob's) and Jasper's and Roy's. We had all these friendships in common that we had developed right from the beginning. So, that made things rather difficult. It was sort of like a tug-of-war of who was remaining friends with whom." Eventually amity would return: "We got it ironed out after a while and we are now, as

ITALY, 1960s
With Cy Twombly

you know, really very good friends and we cooperate on all kinds of ven-
tures. She's done an absolutely incredible job in Europe."²⁸ Despite the bit-
terness of the moment, it is clear in retrospect that by the time the
Sonnabends left for Europe, Castelli had become a unavoidable player in the
art world, and his four-year-old gallery a true New York cultural institution.
In time his first wife would establish one of its international outposts,
thereby contributing to the global reach of Castelli, from now on the con-
summate *Weltbürger,* to use Goethe's word. They had always been friends,
and—whatever the vicissitudes of their married life—the insoluble bonds of
mutual regard born of a shared experience few others knew of or could
understand, ensured they would always be partners of a kind.

21. THE SOLOMON YEARS

*The late fifties and the sixties were very special: you could be a nobody
and then, just by sheer enthusiasm, become somebody: the only qualifica-
tion you needed was chutzpah![1]*

FRANK STELLA

IN JANUARY 1944, the widow of the banker Felix Warburg donated their home—a six-story, fifty-room neo-Gothic mansion at the corner of Fifth Avenue and Ninety-second Street—to serve as the Museum of Jewish Cere- monial Objects, under the auspices of the Jewish Theological Seminary. In time, seeking a more assimilated profile, the Seminary would resolve to transform the museum's mission, reimagining it as "one museum among others" and softening its emphasis on liturgical material culture. With the guidance of art world figures such as Meyer Schapiro, the board voted to rename it the Jewish Museum and announced plans to mount exhibitions of contemporary art, and even show the work of Gentiles! After that, with backing from contemporary art collectors like Ben Heller and especially Albert and Vera List, the museum proposed to "fill a gap in the New York art world by emphasizing the work of younger or otherwise unacknowledged artists." In July 1962, Alan Solomon was appointed its new director. Given the Jewish tradition of involvement with intellectual progress of all kinds, the board reasoned, it was only fitting that the community take a leading role in cultivating the avant-garde of New York's art scene.[2]

With the Sonnabends now in Europe, Castelli, meanwhile, was entering a new phase of life, marked by his friendship with the same Alan Solomon, whom he had met in 1958. It was a friendship of art devotees and intellectual equals, but also "of fellow divorcés, with lots of talk about women"[3]—some- thing that Castelli also indulged in at the office, according to Ivan Karp, who describes "a romantic atmosphere, a kind of permanent flirtation around the gallery."[4] Brooklyn-born and Harvard-educated, Alan Solomon had until

recently taught at Cornell as well as running the university's museum. Frank Stella thought Alan a "pretty good person, weird, kind of the average academic, in love with the big time and with Leo. He didn't have any qualification of any kind, but he handled it quite well and was on his way."[5] Robert Pincus-Witten, remarking on "his round Charlie Brown face and black Vandyke," called Solomon "a rather good-looking fellow who quickly became Leo's closest friend. He was much younger than Castelli, from another generation, but they could go on for hours about literature, art, girls, and Leo found him fascinating. For several years, they made a real team—more than that, a tandem."[6]

"Alan appeared one day," Castelli recalled. "He may have come on the occasion of the Rauschenberg show. At that time he looked like a very modest young man, he had a hearing aid, his hearing wasn't good, and very short hair, and a rather scant Dacron suit, a ready-made suit. But he was very lively and terribly enthusiastic about [what] was happening in the gallery. Then he separated from his wife, divorced her and left Cornell. He got the offer to become the director of the Jewish Museum and he proceeded immediately to do the Rauschenberg show. He really transformed himself when he came to New York."[7] We may recall Jasper Johns's *Green Target* and the indelible impression the painting had left on Castelli when he first visited the Jewish Museum in 1957. But when Solomon was appointed head of the museum and mounted, in short order, a Rauschenberg retrospective (in 1963) and a Johns retrospective (in 1964), the Jewish Museum furnished Castelli an unimaginable bonanza—all the more gratifying given the gallerist's painful attempts to get Rauschenberg into MoMA. It is a noteworthy irony that someone as ill at ease with his own Jewish identity as Castelli should have enjoyed such good fortune on account of the Jewish Museum, which would prove second only to MoMA in having inscribed the Castelli Gallery in the annals of the New York art world!

"Dynamite!" Christophe de Menil, then a young collector-producer who had just left Houston for New York, raves about Solomon's exhibitions at the Jewish Museum. "They were daring, original, fabulous, much better than MoMA!" she continues. "And all thanks to the self-confidence, the passion, and the enthusiasm of its new director."[8] "The Rauschenberg retrospective was exceedingly important," comments Pincus-Witten. "It drew a lot of criticism from conventional museumgoers: people were shocked, they thought Alan had transformed the Jewish Museum into a hotbed of activism."[9] Adds

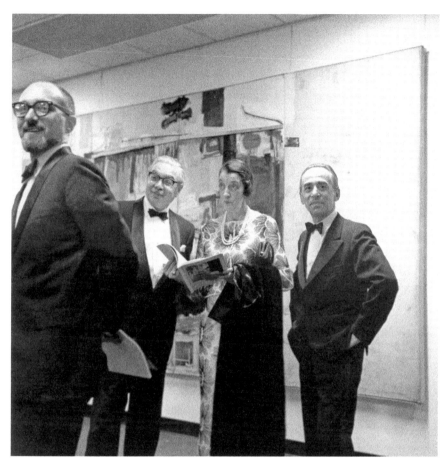

JEWISH MUSEUM, NEW YORK, 1963
With Alan Solomon, FAR LEFT, and collectors Albert and Vera List at the opening of the Rauschenberg show.
Photograph by Hans Namuth.

Barbara Jakobson: "Alan was an adept scene-maker. He took a drab museum known for shows of synagogue silver and made it *matter.*"[10] It was no exaggeration. "That first Rauschenberg show was in the nature of a real explosion," crowed Castelli. "You can't imagine the fantastic impact that it had, favorable and unfavorable. There was still a great deal of skepticism, since Rauschenberg had never really quite made it here. Ironically, he was the first artist in my gallery to have a big museum show and he preceded many other important artists that didn't have a chance to find somebody like Alan Solomon to do a thing like that. What really was so impressive about Alan was the extraordinary range of facilities with which he did these things.

There is nobody around of that caliber! There was that entirely new space that he had at the Jewish Museum, enormous space and I saw him install that show with the fantastic assurance that he had in putting all those diverse paintings all around the place and the way he directed the staff. After all, he was entirely new there, and it was as if he had been there for years."[11]

Solomon's catalogue is a masterpiece in itself. On the cover, a close-up shot of *Monogram,* the angora goat with a tire around its middle, stands against a white background; inside, the foreword is a model of precision and intellectual probity, as if Solomon had set out systematically to defuse dismissive critiques by situating Rauschenberg in a long-view art historical continuum of both American and international examples. Solomon's interpretation of Rauschenberg's and Johns's aesthetic tradition, however, differs from Castelli's, who saw them as the "Neo-Dadaist" heirs (however unwitting) of Duchamp, rather than of Picasso, whom he considered a "pompous academician."[12] But "their connection with Dada is far less important than the differences between the new artists and the Dadaists," wrote Solomon. "The apparently negative attitude of the Dada group towards art and society actually grew out of a deep sense of esthetic and political frustration. [Rauschenberg and Johns] operate, by contrast, in complete esthetic freedom, and politically they have disengaged themselves totally . . . The basis of Rauschenberg's position lies extraordinarily close to the aesthetic of Picasso, especially in the sense that both are involved in the tension between the illusionism of paint and the impinging presence of fragments of reality . . . Rauschenberg in all of his work is a kind of esthetic tightrope walker, easing his way along with a solid sense of balance above the pitfalls of ugliness, vulgarity or slickness. The sureness of his performance depends on taking chances."[13]

Brian O'Doherty, reviewing for *The New York Times,* dubbed the show a major retrospective, and the unclassifiable Rauschenberg "one of the most fascinating artists around": "Poised between painting and the object, between art and life, his work is part of a new question thrown at the confused nature of reality, and thus of art."[14] For *ARTnews,* the "virtuoso" exhibition demonstrated "that Rauschenberg is a pivotal figure in the latest freedom to use any environmental object in a paint construction."[15] As proof of the show's impact, the magazine published a profile of the artist, "Rauschenberg Paints a Picture," similar to the one it had devoted to Pollock nearly a decade earlier.[16] Less than a year later, Solomon would pay a similar

tribute to Jasper Johns, gathering over ten years of work. A clever text portrayed Johns as an Old Master, situated between Abstract Expressionism and the European tradition, but quite distinct from Dada with its "anti-aesthetic" prerogatives. "Jasper Johns, along with Robert Rauschenberg, played a major part in opening the way for a new generation of American artists," Solomon wrote. "As a transition from the first great generation of American painters, the Abstract Expressionists, they retain certain ties with the free-painterly technique of their predecessors. At the same time, they represent a radical departure towards a new involvement in the relationship between the traditions of European painting and a more complex mode of behavior for real objects."[17]

Such visibility and such success often lead to a backlash, and perhaps Castelli was overdue. In any event, the arrival on the scene of a new actor like Alan Solomon, one who could assemble major shows in record time, predictably roused significant animosity among critics and curators. In a shrill piece titled "The Phony Crisis in American Art," Thomas Hess vented his dislike of Solomon's exhibition policy: "Initiative is what the Jewish Museum has in superabundance. It is one thing to balance taste with fair play according to the mysterious rules of the Museum of Modern Art; it is quite another to nail things down into compartments . . . The function of a museum is not to tidy up the landscape, but to contemplate it. If contemplation can bring some insight, it may be appropriate to show this to the public. But it might be remembered that in art, insight and showmanship are at completely opposite poles."[18] Castelli was well aware of being an indirect target of the brickbats. "At that time," he said, "people thought of me as being a sort of monstrous schemer, that I had Alan Solomon in my pocket, that I was practically corrupting the whole art world, the critics. There was that Steinberg episode where I financed an important study by Leo Steinberg on Jasper Johns!"[19] In fact, Castelli had arranged to have a magazine commission the piece.

The gallerist was indeed conscious of the disconnect between his professional self-image—as one engaged in a passionate and worthy artistic enterprise—and the baneful, lowbrow image certain periodicals foisted on him, but he was not inclined to take such disdain to heart. Confidence seems to have immunized him against the effects of bad press: "I had immense faith in what I was doing. I was just very impatient. I could not understand how people were not bowled over by all this, all these things that were happen-

ing . . . There was a mission to be accomplished to find the best artists, to go on helping in supporting these great trends. It may be even playing an important role in that, well, like patrons used to do in the time of the Renaissance or the Baroque period, and then later during the age of Louis XIV where art was so seriously considered, and then in the nineteenth century. There was that sense of history that I always felt in connection with what I was doing and although things have changed so much I still feel that there is some kind of mission that I have."[20] Certainly, in considering Castelli's relative similarity to great patrons of the past (as opposed to dealers), one can point to the gallery's program of stipends for its artists, a practice harking back to the Medicis, but completely innovative in the context of New York. In arguing for the seriousness of his mission, one might also look to the exemplary quality of the archive that his assistants maintained and the generosity with which ancillary materials (documents, photographs, slides) were made available to the public. Indeed, he thought the effort incumbent upon him. "Since I have a historical background, I know that material is needed to advance this part of the art, of art history, that you needed documents, that you needed proper archives. So, I had that sense that I was not just there to see paintings—as a matter of fact that seemed to be the last thing that I was really involved with—but rather to educate the public."[21]

In the course of those years, the Green Gallery was born and symbolically shared emerging artists with Castelli. The gallery was superbly managed by Dick Bellamy and supported by Robert Scull, one of Castelli's first clients, the kind of self-made millionaire that New York started producing in the fifties (in Scull's case, the fortune coming from his cab fleet, Scull's Angels). That a bootstrap success like Scull should want to own a gallery speaks volumes about the remarkable gravitational pull of the art scene in this period. According to British gallerist James Mayor, "Leo's greatest years were the sixties, and the two unsung heroes of the art world were Bellamy and Karp. Scull wanted Karp to run the Green gallery, and Karp suggested Bellamy but he warned Scull that, though Bellamy was brilliant, he had no sense of business at all."[22] Frank Stella today recalls the scene this way: "There was Leo on his own, and then Leo and the Green Gallery, and that together made a very powerful force until '65. Scull was the most important player in the game. You could not like Scull. He was horrible. He defined vulgarity; nobody could be as vulgar no matter how hard you try. That's what made Scull so strong—he was the support mechanism. Scull was collector, gallerist, busi-

nessman; he controlled Leo from the bottom up."[23] Undoubtedly Frank Stella is alluding to Scull's huge cash reserves, which sometimes allowed him to outplay Castelli.

Owing to the friendship between Karp and Bellamy—they had worked together in a cooperative gallery called the Hansa—the membrane between the two spaces was quite permeable. "I discovered Rosenquist in 1962," Ivan Karp explains. "Dick Bellamy went to see Rosenquist's studio. He saw his work and immediately, the same night, he decided to show him at the Green Gallery. By sheer coincidence, during the same months in 1962, as we were showing Lichtenstein at Castelli's, Dick Bellamy was showing Rosenquist. I remember those two contemporary exhibitions as a rather unsettling time on the New York art scene."[24] The artist's own account reveals Castelli's delicate approach to the situation: "I was in the Green Gallery with Dick Bellamy, who was always on the verge of closing. One day I was sitting next to Leo on a plane going to California, and he said to me, very elegantly, 'Jim, if you ever think of leaving Dick, please consider me first.' I ended up staying with Leo in his gallery until he passed away, for my whole career. Sometimes he didn't even visit my studio because he always expected the best from me."[25]

Lichtenstein, Rosenquist, Warhol, and Oldenburg—this constellation was united by quite evident common themes, including the interest in advertisement, cartoons, big formats, repetition, and the enlargement of mundane objects. Nevertheless, the Pop artists would make their way onto the public scene in a chaotic way: Lichtenstein at Castelli, Rosenquist at the Green Gallery, Warhol at the Stable Gallery, and Oldenberg at Sidney Janis. Castelli had at first rejected the whole movement, but as soon as he perceived the unity among those artists, he decided to co-opt them, one after the other. With the glee of a juvenile jokester, he describes F111 (F One Eleven), Rosenquist's first show: "A huge painting which covered the whole space of the gallery from floor to ceiling and through all its width . . . and which represented a war plane. It was in 1964, at the time of the Vietnam War, and this painting had social, political, and anti-militarist implications. The image of a full-scale plane going around the gallery wall, that was extraordinary!"[26] A similar anarchic delight would attend the provocation of showing Warhol's *Cow Wallpaper* (painted wallpaper repeating the image of a cow) in a room next to the artist's *Silver Clouds* (rectangular silver balloons floating in space).[27]

WHITE HOUSE, WASHINGTON, D.C., FLAG DAY, JUNE 14, 1963
Presenting President John F. Kennedy with a Jasper Johns *Flag* sculpture from
his own collection

When the Green Gallery closed in 1964, Bellamy very naturally offered Castelli the chance to take on whichever artists he was interested in, and he chose Dan Flavin, Donald Judd, and Robert Morris. Bellamy would suggest other names as well. "When he discovered an artist who seemed major, he would show him to me," Castelli explained. "Through him, I met Serra and also Bruce Nauman and also Keith Sonnier. Bellamy would show me small pieces or pictures of their works in the little closet that he was working from at that time on Madison Avenue."[28] The pattern is by now familiar and undeniable; Ileana Sonnabend, Ivan Karp, Dick Bellamy, and others would perform, over those years, the scouting function, allowing the gallerist to preside knowingly over the big picture. But should one demand a logic that led to the selection of the Castelli stable, he was only too happy to provide it: "My policy was to have the principal artists of all the movements which appeared on the scene. Stella, for example, represented at first a phenomenon which seemed isolated, but in fact he influenced fundamentally another important movement, minimal art."[29] Best of a kind—a simple-sounding formula, and one that made Castelli's legendary taste and foresight seem like child's play.

The ability to conceptualize the contemporary movements generated by

his own artists was perhaps Castelli's greatest strength. Who could parry his thrust that "Warhol wished above all to be in Johns's and Rauschenberg's gallery,"[30] or deny his pronouncement that it was Frank Stella who justified the arrival of Minimalists? For indeed, artists seemed to gather in the Castelli Gallery according to the absolute principle of attraction and under his imposing authority to impute genealogy, or at least rights of succession, as he traced their development historically. After "Jasper and Bob"—the two great post-Dada masters—would come the Pop artists, the Minimalists, the Conceptualists, on whose disparate ranks (Kosuth, Weiner, Barry, Huebler, Darboven, Grisi) Leo conferred fraternity. But he knew the limits of his taxonomy as well. When asked to categorize Ellsworth Kelly, the all-knowing Castelli explained simply that "he was in fact an artist apart, neither minimal nor monumental . . . about whom one could say that he is not the product of any predominant influence, but an artist *sui generis.*"[31]

Castelli's visibility, the complexity of his relations with Scull, and the social dimension of the two men's interactions are well documented, but no one has captured the essence of the pair as colorfully as Tom Wolfe: "Jasper Johns's latest show opened at the Leo Castelli gallery, 4 East 77th Street. There were four huge paintings in the show and Bob wasn't going to get any of them. For a variety of reasons. For one thing, three of them had been spoken for, by museums. Nevertheless, Bob was in a good mood . . . Castelli's, especially at an opening like this, was where it was at. You could tell that at a glance. Not by the paintings, but by the Culture buds. They were all there, all these gorgeous little Culture buds, 20, 21, 22, 23, 24 years old . . .

"Out in the middle of the bud coveys Bob is talking to Leo Castelli. Castelli, New York's number-one dealer in avant-garde art, is a small, trim man in his late fifties. Bob is Leo's number-one customer. Leo is the eternal Continental diplomat, with a Louis-salon accent that is no longer Italian; rather, Continental. Every word he utters slips through a small velvet Mediterranean smile. His voice is soft, suave, and slightly humid, like a cross between Peter Lorre and the first secretary of a French embassy.

" 'Leo,' says Bob, 'you remember what you told me at Jap's last show?'

" 'Noooooooo—'

" 'You told me—I was *vulgar!*'—only Bob says it with his eyes turned up bright, as if Leo should agree and they can have a marvelous laugh over it.

" 'Nooooo, Bob—'

" 'Listen, Leo! I got news—'

" 'Nooooooo, Bob, I didn't—'

" 'I got news for you, Leo—'

" 'Noooooooooooo, Bob, I merely said—' Nobody says No like Leo Castelli. He utters it as if no word in the entire language could be more pleasing to the listener. His lips purse into a small lubricated O, and the Nooooooo comes out like a strand of tiny, perfect satiny-white pearls . . . 'Nooooooooo, Bob, I merely said that at that stage of Johns's career, it would be wrong—'

" '*Vulgar* you said, Leo—'

" '—would be wrong for one collector to buy up the whole show—'

" 'You said it was *vulgar,* Leo, and you know what?'

" 'What, Bob?'

" 'I got news for you—*you were right*! It *was* vulgar!' Bob's eyes now shine like two megawatt beacons of truth; triumphant, for the truth now shines in the land. For one of the few times in his life, Castelli stares back blank; in velvet stupefaction."[32] Such happy role-playing—Mandarin and barbarian—made for a most efficient symbiosis.

By positioning itself as a major partner in Dorothy Miller's American exhibitions at MoMA and Alan Solomon's at the Jewish Museum, the Castelli Gallery continued to ramify its program as a cultural institution of the city. "MoMA was were you went, in order to learn," the dealer Angela Westwater asserts. "It had a highly articulated aesthetic, and it was where Leo's artists were first acknowledged in such a huge way." On the other hand, "the Whitney was [a] small fiefdom, and the Guggenheim was focused on nonobjective art."[33]

Soon, other actors moved into the city—new individuals, new institutions—throwing themselves into the ever more selective game, with its new rules and its undeniable epicenter. Among them was Rosalind Krauss, a graduate student at Harvard, who had just started writing reviews for *Artforum.* "Leo was a legend, and I was in awe of him," she recalls today. "I would learn something every time I went there. The Castelli Gallery was a guarantee that there would be a show I would like to write about. It was very much a part of your education, and it made *my* art education because I trusted Leo's judgment. A teacher is someone you trust. Leo's talent came from having a kind of infallible quality of taste towards new work."[34] Also among those newcomers was a man even younger than Solomon, though just as well educated and just as ambitious. He was twenty-seven, brilliant, provocative, a bon vivant, descended from a line of Antwerp diamond merchants, a moonfaced fellow who, with a fat cigar and plenty of artist friends, would

defy all conventions when he became an associate curator at the Metropolitan Museum in 1962. He was soon on his way to eclipsing all others there: he was Henry Geldzahler. "Alan, Henry, and Scull—those three people around Leo made a nucleus," Frank Stella explains. "Henry was just as ambitious as Alan, but in an organic way; they were so enthusiastic that they blew by everybody. The only thing against them was [Clement] Greenberg; he always put them down, took a higher line, was competitive. He could be acute but he was nothing in the face of their emergence. The antithetical relationship between Leo and the Greenberg school was what made it interesting." Long a champion of the avant-garde when it took the form of artists like Pollock, Greenberg was now identified with his rejection of Pop as the effluent of the kitsch culture he loathed. "As for Alfred [Barr]," Stella continues, "he didn't want to take sides. But he had the authority of having looked at paintings and made up his own mind. That's the secret of those years."[35]

. . .

During those years of great chess moves, Castelli's emotional life took another turn. In the summer of 1962 in East Hampton, he had met a young Frenchwoman twenty-one years his junior, Antoinette Fraissex du Bost, known familiarly as Toiny. With close-cropped hair in the style of Joan of Arc, strands of fine pearls about her neck, and very elegant dresses, she was a breath of fresh air, and possessed of beauty and breeding that appealed to Castelli. Her grandfather was Charles Haviland, of the family that owned the Limoges porcelain works; famed for their fine workmanship, Limoges had proudly furnished the White House and had been commissioning artists to design motifs since the nineteenth century. Her great-uncle Paul Haviland, a friend of Alfred Stieglitz's, had been a lawyer, photographer, and arts patron; another ancestor, Ludovic Trarieux, a Protestant Dreyfusard and cofounder of the Ligue des Droits de l'Homme, had been France's minister of justice: in four years, Castelli had broken free of the Schapira orbit to enter that of the Havilands. In the spring of 1963, Leo Castelli married Antoinette Fraissex du Bost at Manhattan's City Hall; in September, with the birth of their child imminent, he oversaw their move to a new apartment and the purchase of furniture for the nursery. In some sense, his flight from his Jewish beginnings was now complete.

Double page from Leo's Hermès personal agenda during 1964, a "memorable year"

On September 4, 1963, the date of his fifty-sixth birthday, Castelli printed one of his many lists in neat and regular block capitals in his compact Hermès appointment book, embellishing some items with an exclamation point or two. Each would be meticulously checked off on completion:

— GIACOMETTI LAMP
— CHAIRS THORP BROS
— PHONE BOB S.
— POST OFFICE—MAIL TO 4 E 77
— THANK YOU CARD KIESLER
— ROY'S PTINGS
— RR SHOW AFTER ROY
— INVOICES TO FRED W.

Along with managing family matters—finding a pediatrician, buying a changing table and a mattress for the crib, arranging for the nanny's insur-

ance, mailing out Jean-Christophe's birth announcements, dealing with Christmas cards and presents, paying his income taxes and the rent on 23 West Sixteenth, and so on—Castelli used his appointment book to plan his exhibitions for the coming year: "Roy Ptings, RR Ptings, Annct Scarpitta, Accts Roy! Chamberlain show (Ivan) Frank, Twombly, Higgins, Scarpitta, JJ, Segal, Lee, Jim Dine, RR Ptings at Guggenheim show, Casting of JJ's pieces." He also mapped out strategies in his relations with collectors ("Bob S! Victor!! Scull!! Write Panza!, Maremont, David Rockefeller, Philip Johnson"); with the press ("*New Yorker*, Roy cover for *Art in America*, Reviews ICA show, Article *Temps Modernes, Temps Modernes* translate?, *Art Forum* feb issue"); with his colleagues ("Bob Elkon, Irving Blum, Dick Feigen, Janis Wed lunch 12.30, Glimscher [sic], Parsons, Bellamy: Rosenquist and Smith"); with museums ("Alan: Whitney Show!, Saturday lunch Alan-Vera [Solomon and List], Geldzahler, Dorothy"); with critics ("Leo's lecture Tuesday 28th, John Russell"); with art handlers ("Schmela, Schumacher, Kraushar"); with his own gallery ("*Ivan,* Delivery, Crate, Invoice, *Bryan* clippings catalogs [100?], Sunday Times to whom ?, *ML*"); and with European visitors ("Restany-Jeannine, Castellani Tremaines, Jakobson, etc!"). And he planned trips to London and Paris, communicated with other galleries, oversaw his artists' European shows ("see Alan *Wed* RR London, Roy new ptings to Stockholm? Turin catalogue, David Sylvester *Sunday Times,* Tate Show reconsider JJ map, sculpt-metal numbers? New Roy girl, Chamberlain, Poro Lee piece, Torpedolos; Paintings to Paris"). He made lists of young artists and critics who needed to receive catalogues, and outlined resolutions and undertakings:

—Andy!
—Travelers checks
Abrams (booklet)

Jan 15:
—Drowning girl
—Ace
—RR (3) ptings from Stuko
(2) to Santini
(1) gallery photos to London, Paris
—??? To Keating
—Dante frames[36]

NEW YORK, JUNE 1959
Antoinette Fraissex du Bost (Toiny), at the time she met Leo Castelli

The cascade of plans and projects bespeaks highly evolved organizational skills, and a remarkable drive to continually energize the other actors of his network. He was constantly striving to keep the bond between collectors and artists from fraying (negotiating aesthetic, household, financial problems), to cultivate the interest of the press, and to seek out younger artists. His work required a will to remain active on all levels, looking both forward and backward, continually charming museum people and other gallerists in the United States as well as in Europe, and working tirelessly to connect the unconnected elements (translating articles so they could travel from Paris to

New York or tweaking a catalogue for passage from New York to London). It demonstrated his uncanny knack for subcontracting, anticipating, orchestrating his artists' appearances in every public venue, every undiscovered country, and his determination to increase his artists' public exposure in every possible setting and land. What term could encompass such manifold inexhaustible talent? Fixer? Impresario? Power broker? "I did feel in the year '64 at the Biennale very triumphant about the crowning of all my efforts when Bob got the prize,"[37] Castelli later conceded.

Let us close the window on those amazing kinetic years with a suitably triumphant picture: that of Castelli in Washington, D.C., offering President Kennedy a Jasper Johns *Flag* for the White House, on the occasion of Flag Day, June 14, 1963. The image is exceptional among the photos of the gallerist: here a short Castelli, carrying the flag, looks, beside tall and relaxed Kennedy, strangely like a huckster, a little too pushy. Recently, when I ventured to ask about this event, Johns commented, "Leo suggested that I give a bronze *Flag* to President Kennedy. I refused the thought and said he should give his own bronze, and he did, on Flag Day. I heard later that Leo told the President that I wanted him to have it. I think that Leo hoped that Jackie Kennedy would become interested in his gallery. Perhaps he imagined she would start showing up at his openings. I told John Cage that I felt terrible when I saw the photograph of Leo, Kennedy and the *Flag*. Cage said, 'Just think of it as a pun on your work.' "[38] Inspiring admiration from some, rancor from others, Castelli relentlessly discovered, presented, represented, and promoted his artists. For this consummate social networker, the stakes were nothing less than international hegemony over art. "At the time," Frank Stella recalls, "Leo was trying to make connections to Duchamp, when Duchamp was nowhere in comparison with the power of Rothko and Pollock and Newman and Still that USIA promoted all over the world, starting with Basel and the Stedelijk. His great strength lay in replacing MoMA and the USIA with his own international network; Leo superseded them. That was a big turning point, and it made a tremendous commercial impact for his artists."[39] And it was again in tandem with Alan Solomon that Castelli would enter this new phase in his "triumphant year," taking the next steps in his unstoppable march forward.

22. THE "BEATLES BIENNALE"

The whole thing seemed quite rough and natural and, actually just the opposite from what it was reported to be, and it was already reported to be a sort of put-up job, pressures and all kinds of things . . . And actually I think the whole American presentation was done with such innocence that nothing could have been farther from the truth.[1]

ROBERT RAUSCHENBERG

Anything is political. As you see in politics somebody does get elected and it's not a simple thing. The currents, undercurrents, maneuvers and so on and the prizes at the Biennale obey the same laws that prevail when you have a political election.[2]

LEO CASTELLI

I hate the game of politics that goes on here, but I think if we are going to play it at all, we should play to win.[3]

ILEANA SONNABEND

In the midst of all this we were going through the awful business about the work in the Consulate being qualified and the whole business about changing the exhibitions . . . I can't tell you what hell I went through with the artists, and one thing and another. At this point I hate all artists and dealers.[4]

ALAN SOLOMON

The Rome–New York axis, situated between the dual poles of neo-geometrism and modern folklore, constituted the true scope of the Biennale.[5]

PIERRE RESTANY

THE XXXII Venice Biennale, a crucial staging point for American art's decisive penetration into Europe, has been much chronicled and analyzed. But neither the conditions under which Robert Rauschenberg won the Grand Prize nor the full story of the affair has ever been fully elucidated.[6] This is mainly because at all levels the event was complicated by the conflicting goals and competing agendas of its numerous participants, and discerning their motives and strategies now is no easy task. To understand what happened and its significance one must first start by stripping away the thick accumulation of commentaries, layer after layer, like so much old varnish, in order to excise the essential narrative of the event. By entitling one of its accounts "The Beatles Biennale," the newspaper *Il Gazzettino di Venezia* had underscored how in the month of June 1964 the torch seemed to pass to a new generation.[7] "It is difficult for a Venetian from another century to like this Biennale," confessed the journalist Diego Valeri, and added that it was clear the power now belonged to "artists from five continents, all dressed in white, sporting ultra-chic gladrags and Beatles haircuts."[8]

In fact, it was basically a showdown among three cultures, three histories, three countries: Italy, France, and the United States, locked in a kind of three-way agon of unprecedented ferocity. The Americans were irrepressibly clamorous in declaring the "American century," an outgrowth of the youthful and democratic dynamism of the Kennedy era. The French, mired in the Gaullist ideology, ever persuaded of their secularist superiority, defending their inviolable continuity, the smug rigidity of a disintegrated colonial empire resting on the laurels of a retired general, were caught between contempt for the Italians and distrust of the Americans.[9] As for the Italians, finally finding a way to avenge France's perennial condescension, they were only too happy to side with the Americans, to whom they felt relatively close thanks to their ongoing transatlantic diaspora. But it was not all chest-thumping. One cannot deny the breadth of the Americans' presence that year, with their ninety-nine works of art delivered by military transport. They had the goods to justify their confidence, friendliness, and optimism, a conviction for which the Italian shilly-shallying and *arrangiarsi* were no match. Even in their rancor, the French sensed the irreversible "Rome–New York axis," in the face of which they would be helpless.[10]

There were lesser cultural idiosyncrasies conspiring towards these results, too. In the Italian case, for instance, the Church forbade its clergy from visiting the pavilions, and venues of secular art in general: "The Venice Biennale

has reached the breaking point," wrote the Vatican paper, *L'Osservatore Romano.* "This is the complete and utter downfall of culture! The objects they are showing bear no relation whatever to art." The American case was bolstered by the federal government's unprecedented support for the arts that year (another Kennedy legacy) and the general resentment of Pop Art among U.S. officials. Finally, the French had their thick hide of *amour propre,* which the Paris dealer Daniel Cordier, who had been showing Rauschenberg in Paris since 1961, later broke ranks with his countrymen to excoriate: "Europeans, out of ignorance or arrogance, have thought they could deny the existence of the new aesthetic world . . . After Venice, the pointlessness of this anti-historic struggle became obvious."[11] In the midst of this tri-cultural skirmish, Castelli found himself in a singular position: Italian by birth, American by adoption, his links with France also considerable, he was a Francophone, a Francophile, married to a French woman, and his ex-wife had become a gallerist in Paris. Moreover, Castelli had long pictured himself as the champion of French artists in the United States, before committing totally to riding the American wave. He was uniquely a master of the three languages, the three cultures, the three traditions about to challenge one another during that summer in Venice. And, in this respect, no one else could have done what he would do.

<p align="center">✳　　✳　　✳</p>

THE ACTION of the drama takes place on the Venice lagoon, from May 20 to June 20, 1964, in locations ranging from Cipriani's bar, Caffè Florian on the Piazza San Marco, the Gritti Palace, the Giardini, and the former American consulate on the Grand Canal. As with any play, let us start with the dramatis personae.

GIULIO CARLO ARGAN, fifty-five years old, Italian art critic, curator of the exhibition The Art of Today in Museums; the anti-Castelli

LOIS A. BINGHAM, American bureaucrat, in charge of visual arts at the United States Information Agency (USIA) in Washington

LEO CASTELLI, fifty-six years old, New York gallerist born in Trieste, Rauschenberg's dealer

GIAN ALBERTO DELL'ACQUA, fifty-nine years old, professor of art history and secretary of the XXXII Biennale

ALICE DENNEY, Alan Solomon's assistant in Venice

GIORDANO FALZONI, American embassy staffer in Rome and Solomon's contact in Venice

A. M. HAMMACHER, sixty-seven years old, director of the Kröller-Müller Museum in Otterlo, Netherlands, president of the jury

SAM HUNTER, fifty years old, professor of art history at Brandeis University and the only American on the jury

MARIO MARCAZAN, sixty-two years old, Italian art critic and president of the XXXII Biennale

GIUSEPPE MARCHIORI, sixty-three years old, Italian art critic and jury member, pro-Castelli

ROBERT RAUSCHENBERG, thirty-eight years old, Texas-born American artist

PIERRE RESTANY, thirty-three years old, French critic based in Paris and Milan, supporter of the French "New Realists"

ALAN SOLOMON, forty-four years old, director of the Jewish Museum in New York, curator of the American exhibit, friend of Castelli

ILEANA SONNABEND, forty-nine years old, Castelli's ex-wife, dealer and Paris representative of the Leo Castelli Gallery

★ ★ ★

Act I: Thursday, May 20, 1964 **ARRIVAL OF THE ARTWORKS**

U.S. Information Service	American Exhibition
Venice	XXXII Venice Biennale
Press Office	organized by the Jewish Museum
Via Galatti 1	of New York under the auspices
Trieste	of USIA

| Memo no. 99/64 | May 28, 1964 |

Works by American Artists for the Venice Biennale
Fall from the Sky

THURSDAY, MAY 20, at exactly 10 a.m., a huge military cargo plane, a Globemaster C-124, lands at the U.S. Air Force base in Aviano from McGuire Air Force Base in New Jersey.

The Globemaster is delivering to Italy most of the works by artists representing the United States at the Thirty-second Biennial International Art Expo in Venice. The military transport is necessitated by the size of the works, too large to be crated for civilian transatlantic shipment. Present at the unloading were the commissioner of the American exhibition, Mr. Alan R. Solomon, and Mr. Geoffrey Groff-Smith, director of the USIA in Venice.

These logistics, handled with lightning speed, were made possible by the remarkable staff support and technical prowess of the 727th Support Combat Group, USAF, stationed in Aviano.

The United States is sponsoring two exhibits at the Biennale. The first, Four Seminal Painters, includes works by Morris Louis, Kenneth Noland, Robert Rauschenberg, and Jasper Johns. The second, Four Younger Artists, contains works by John Chamberlain, Claes Oldenburg, Jim Dine, and Frank Stella. Louis and Noland will be shown at the American pavilion in the Giardini, while the works of Rauschenberg and Johns will be shown with the second exhibition, situated in the former American consulate on the Grand Canal (the awkward segmentation to be explained presently).

Together the two shows were conceived to showcase the most advanced trends in contemporary American art. The first highlights important sources of two current tendencies: a new type of abstraction and a new passion for the use of found objects; the second demonstrates how several younger artists are already appropriating these still-emergent ideas towards original ends. The photo [page 291] shows one phase of the unloading from the huge Globemaster.[12]

Despite that impressive drop from the heavens, Solomon is all too aware of the difficulties and high stakes of the situation, his Venetian adventure having begun on November 7, 1963. "Through the Italian Foreign Office," Donald Wilson, the USIA's director, wrote to him at the time,

> the U.S. Information Agency has accepted the responsibility for
> providing an exhibition of American art as the United States sec-

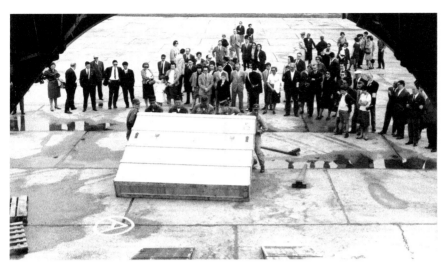

VENICE, MAY 1964
Works of art for the American pavilion being delivered by military plane

tion. Because of the importance of this international cultural event, we believe the U.S. exhibition should be planned and developed to highlight the present stature of American artistic accomplishment and to clarify through graphic examples the motivations and techniques of our contemporary artists. Since American art for the first time in history enjoys the role of acknowledged leadership in international art circles, the U.S. exhibition should feature those vital aspects which have focused the attention of the cultural world upon us. During the past year the excellent exhibitions of contemporary art presented by the Jewish Museum have attracted our particular interest and persuaded us that you and your Museum could produce an exhibition of the type and caliber desired for the Venice Biennial. It is my pleasure, therefore, to extend on behalf of the U.S. Information Agency an invitation to the Jewish Museum to organize an exhibition for the International Art Biennial of Venice in 1964 which will represent the best and most important aspects of fine arts in the United States today . . . Please accept my congratulations on your outstanding contributions to the stature of American artists and the Jewish Museum in the short time you have served as Director. I hope that the United States, through

the Venice Biennale, may similarly enjoy the benefits of your talents.[13]

A tall order if ever there was one.

Handed such a blank check from the highest powers, could Solomon have refused? Despite the news of President Kennedy's assassination, which he heard just as he landed in Venice, his early negotiations with Professor Italo Siciliano, the Biennale's initial president, started off on a favorable note. "From the first, we were greeted with a spirit of great enthusiasm and cooperation by the officials of the Biennale," he wrote in his official report, "both because of the new fact of U.S. government participation, and because of the prospect of an exciting and pathfinding American exhibition. (It should be pointed out that the recent decline of European art had been reflected in the Venice Biennale, which . . . also accounted to a certain degree for the official enthusiasm towards us.) We asked the Biennale for additional space for our exhibition, but there was none available on the grounds . . . We finally arranged to use the empty American Consulate. At this time there was a clear verbal agreement among all of us . . . When I left, I asked Mr. Barjansky, as our local representative in Italy to get these arrangements in writing, which was not done."[14] From the very start then, despite the Italians' enthusiasm, Solomon quickly sensed the daunting magnitude of the challenge he had undertaken: how was he to shoehorn his project's megalomaniacal artistic and political agenda into the tight fit of the exhibition space? "Your phone call helped to relieve some of the depression I felt when we got back. I do hope, one might say rather intensely, that the Consulate will be available to us," he pleaded to Lois Bingham, head of visual arts at USIA, on December 9. "The idea is to put the 'Four Old Masters' in the Consulate and to put a younger group show in the Pavilion. Again, I will just have to keep my fingers crossed about this."[15] In fact, he waited until after his return from Venice and drew up his complete list of objectives before officially accepting the mission. Finally, on December 20, he replied to Wilson that he "would be delighted to accept the honor" that USIA had offered him, acknowledging "the official participation of the American government in this important international art activity as an occasion of great historical importance."[16] But this good cheer would be short-lived.

For months on end, Solomon would devote ferocious efforts to negotiating with the Italians for budgets, space, and conditions, despite the desper-

ately slow and incompatible bureaucracies involved. "The whole business of finances has been grotesque," the fed-up commissioner eventually wrote to Bingham.

> I have been paying for everything out of my own pocket, with assurances of rapid reimbursement (so far not a nickel back) . . . The housekeeper is going to leave because she hasn't been paid since she came here. And so on and on. I won't bore you with my frustrations and anxieties about all this . . . The whole involvement with the USIA people (except Geoff and Ed) has been degrading and disgusting. People came here on per diems and chiseled about food, so that it has cost Alice and me a great deal of money out of our own pockets . . . Mike's wife came too; I don't know if you've ever met her; she didn't help much, sunbathing nude on the terrace and playing her guitar. She lost some jewelry, or, Mike says it was stolen; I don't know maybe he suspects me. He kept getting very angry about the gate being left open at night.[17]

Now that the Biennale is at last about to begin, myriad Italian dysfunctions will litter the American path like so many stones, beginning with the appointment of Mario Marcazan to replace Italo Siciliano as Biennale president only a few days after Solomon's arrival. Unlike his predecessor, Marcazan does things by the book, but this punctiliousness comes as no relief to Solomon. According to Marcazan's unyielding rules, only works exhibited inside the walls of the Giardini are eligible for the prize. "I went to see Marcazan," Solomon reports, "and I brought up the question of whether works in the annex were eligible for the prize. As a result of the abrupt confrontation we were placed in a difficult and disagreeable position. Subsequently, the Biennale officials were most devious in their attempts to compromise their own political (and financial) problems with their evident desire for significant American participation. We were forced to accept their rather arbitrary behavior without making a major issue of the matter."[18] Fortunately, while Marcazan, seconded by the prestigious Roman critic Giulio Carlo Argan, holds to his party line, Gian Alberto Dell'Acqua, the Biennale's flamboyant general secretary, openly campaigns for Solomon. The catalogue's keynote essay strikes a contentious note, with Dell'Acqua seeking to neu-

LEO CASTELLI

20 May, 1964

Mrs. Alice Denney
Consulato degli Stati Uniti
620 Dorsoduro
San Gregorio
Venice
Italy

Dear Alice,

Just a brief note to thank you so much for the lovely card from Rome and to give you a list of Americans who will be in Venice around Biennale time and want passes and things. Some of them are the red carpet type:

Gordon Dinshaft (4 passes), Seymour Knox,* Morton Newman (2)

others are gallery people:

Arnold Glimscher (3), Marilyn Fishbach

All these people have been told to contact Alan at the Consulate, so you don't have to run after them.

That seems to be all for the moment. Hope both you and Alan are having fun. See you very soon.

Love, S Love

Leo Castelli

* He'll come early, around the 10th insistent rumors here & in Paris that RR is a likely candidate for an important prize: what do you hear on location?

4 EAST 77 ST • NEW YORK 21

MAY 29, 1964
Letter to Alice Denney

tralize the critics in advance: "It is our pleasure to highlight the exceptional breadth of the American presence this year. Having previously been represented by MoMA, the United States has made its participation official by appointing a federal commissioner, Prof. Alan Solomon. Given the large number and overall size of the objects, not all the artworks sent from across the Atlantic could fit into the narrow confines of the American pavilion, and it has therefore been necessary to hold a supplementary exhibition in the former offices of the American Consulate on the Grand Canal, in the city center, at a location easily accessible to the Biennale's visitors."[19] But this does not resolve the ontological problem at the heart of the debate: are the American works shown outside the Giardini eligible to win the prize?

✷ ✷ ✷

Act II: Monday, June 14

The moment he arrives in Venice from New York, Leo Castelli, following Italian custom with a native's intuition, starts paying visits to the local notables of the city in order to "sniff the wind"[20]—and see what's brewing in Venetian circles. He calls first on the abstract painter Giuseppe Santomaso, a professor in the city's art school, and Giuseppe Marchiori, a critic, both long-standing allies. But the Roman critic Giulio Carlo Argan, whom he takes out to lunch, shies away from taking sides. Castelli is thrilled to meet with Solomon again, and marvels at the shows his protégé has put together, both at the consulate and the Giardini; he marvels, too, at Solomon's personal metamorphosis into a wheeler-dealer after Leo's own heart! "Alan, this shy, rather withdrawn man, had become by that time very sure of himself," Castelli later comments. "He'd undergone an operation which then made it unnecessary for him to have a hearing aid, his hair had grown long, his clothes were custom tailored, he had become a very elegant man with a great deal of authority and a good diplomat. He spent all the summer there in Venice just to attend to things, to be there, also because he liked it, and he spoke Italian a little bit, he had learned it during his studies . . . Solomon had the energy, the dynamism to do a smashing thing, a fantastic exhibition."[21] The first Castelli-Solomon confabs revolve around the essential question: how are they to ensure Rauschenberg's victory with no Americans on the jury? Martin Friedman, Bill Seitz, and James Johnson Sweeney—all three were contacted but refused to take part in the jury. No matter! Castelli learns that Sam Hunter, a professor at Brandeis, is traveling to Italy and manages to reach him by phone; Hunter arrives in Venice that Sunday evening. Later, Solomon will recall "several nightmares about this, including the unwillingness of people to serve on the jury, for personal reasons, which were apparently quite petty. One of them (and this I know to be true of Martin Friedman) was that they didn't want to help *me* win a prize. I think that Seitz had feelings like this, but more with respect to the museum, which after all had never won it. When Hunter arrived he was impossible about proving his purity, to the point where the Italian Jurors wondered if he wanted the prize to go elsewhere."[22]

During those days preceding the coronation, Ileana Sonnabend had been

a formidable presence beside her ex-husband, having started her mighty effort to lobby the Venetian critics for Bob Rauschenberg's victory a year before.[23] It was of course she who insisted that Castelli (himself more taken with Jasper) show Rauschenberg in 1958, barely a month after Johns's exhibition. And since the opening of her Paris gallery in 1961, she and Michael had carried on the crusade to introduce American art to Europe, fending off vicious attacks from all sides.

<p style="text-align:center">★ ★ ★</p>

Act III: Tuesday, June 15

The jury meets: Marco Valsecchi and Giuseppe Marchiori (two Italian critics), Franz Meyer (director of the Basel museum), Murillo Mendes and Julius Starzinski (respectively Brazilian and Polish art critics), and Sam Hunter (the lone American jurist), with A. M. Hammacher (director of the Kröller-Müller Museum in Otterlo, Netherlands) presiding. In the first round, Rauschenberg wins four votes out of seven, with the president abstaining, but the eligibility of works outside the Giardini remains a vexing conundrum. The large number of American objects (ninety-nine paintings and sculptures from eight artists) has forced a new precedent, unopposed by the Biennale's board of directors, that the works have to be shown in two separate locations. Hammacher tries to obtain more information about the "remarkable prehistory" of this decision and requests access to correspondence between the Biennale directors and the American embassy.[24] Hunter, for his part, persuades his colleagues to go see the impressive exhibit Four Seminal Artists at the American consulate, in which the Castelli Gallery's two stars, Johns and Rauschenberg, are represented by no fewer than twenty-two works each![25]

<p style="text-align:center">★ ★ ★</p>

Act IV: Wednesday, June 16

Denied access to the correspondence, Hammacher then approaches Marcazan, president of the Biennale, for his guidance on handling the situation, but the Italian refuses to take sides. Endless discussions between Marcazan and Dell'Acqua on how to proceed. A few hours before the American con-

sulate opening, Solomon learns that the jury, lacking clear direction from above, has ruled that works shown outside the Giardini are ineligible for the Grand Prize, which will go to Kenneth Noland instead of Rauschenberg. The official opening kicks off at 6:30 p.m. in the consulate, under the auspices of Mr. Frederick Reinhardt, the American ambassador to Italy— attended, says journalist Milton Gendel, "by several hundred invited guests and what seemed like several thousand uninvited. The mass of celebrants stuck together like a still from a movie mob-scene in a Pop decalcomania for hours after the drinks ran out, which was almost at once."[26]

<p style="text-align:center">⋆　⋆　⋆</p>

Act V: Thursday, June 17

The jury meets yet again. Marchiori shuttles indefatigably between Hammacher and Castelli, keeping the latter abreast of each new development. A distraught Alan Solomon threatens to withdraw all the Americans if Rauschenberg is not crowned. "New York is replacing Paris as an art world center," he comments to the press. "As an art historian, I am a specialist in modern French art, in the grand tradition from David to the School of Paris, and I believe that my observations about contemporary American art are not colored by national prejudice." Later, accused of blatant partisanship, he will reply that his "off-hand statement" has "generated a great [deal] of controversy in Paris, but not in Venice or elsewhere in Europe to the best of my knowledge . . . If the French regard the statement as a call to arms they should understand that I have spoken as an individual and that their quarrel is with me personally."[27] The Sonnabends feel that Alan might well dispense with such antagonistic declarations.[28] But Castelli rubs his hands in delight and backs Solomon unconditionally.

<p style="text-align:center">⋆　⋆　⋆</p>

Act VI: Friday, June 18

The jury meets again. Rauschenberg arrives in Venice to take part in Merce Cunningham's performance at La Fenice; he is in high spirits, drinks like a fish, and kisses everyone. That evening, he is spotted careening through Piazza San Marco on roller skates.

* * *

Act VII: Saturday, June 19

Muggy day on the lagoon. A day of final horse-trading, as the jury meets one
last time. Hammacher accepts the solution of shifting works around to give
Rauschenberg the prize. Solomon moves three large Rauschenberg Com-
bines by gondola to the Giardini pavilion.

* * *

Act VIII: Sunday, June 20

The journalist Paolo Rizzi's report of the official ceremony conveys the
amusement with which most Italians greet Rauschenberg's election, their
titillation by the whiff of scandal. "In a climate of intense debate, but with-
out incident," *Il Gazzettino* describes the process: "Seated on the grass,
Rauschenberg waited for the minister to come shake his hand, but the min-
ister was in Argentina and there were still fourteen countries to go before the
American pavilion. Robert chewed on a blade of grass while staring into
space with his light-colored eyes like a child. Thirty-eight years old but look-
ing like thirty, apart from a few wrinkles around the eyes . . . Several feet
away, under the tent of the American pavilion, his canvases were offered up
to public veneration, authentic incunabula of a new era in painting.
 " 'Mr. Rauschenberg, can you explain what Pop Art is?'
 " 'In the past, art was a transfiguration of reality. Today, it's a distortion.
This is why we don't need to play at illusion anymore . . . Transfiguration
into painting is a romantic fallacy. An artist has other means of expression
than pictorial illusionism. A real clock is more striking to look at than a
painted clock, don't you think? . . . Habit is the great enemy of art. That's
why I start fresh every day . . . Pop Art is a label coined by critics, but if Pop
Art is the art of today, I don't believe for a minute it's in decline . . . Yes,
Venice is a hot, humid city; it reminds me of my home state, Texas, like a
seashell below sea level . . . A painting of Venice? I think I'll support it on
something that's pitching and tossing!' That's Rauschenberg, the subtle bit-

VENICE, JUNE 19, 1964
In order to be considered for the prize, Rauschenberg's *Combines* being
transferred to the Giardini by gondola

ing humor suggesting everything he says might be tongue-in-cheek, a way of
teasing everyone he talks to. Could this be true?"[29]

Absent the president of the Republic and the minister of culture, it is Luigi
Gui, minister of public education, who hands Rauschenberg the statuette.
Second-tier officials are dispatched to congratulate the man of the hour:
Mario Ferrari Aggradi, the minister of agriculture, Senator Caron, an under-
secretary of state, Dr. De Bernart, prefect, and Dr. Favaretto Fisco, mayor of
Venice and president of the appellate court, come to shake his hand for the
photo op. Rauschenberg, decked out in white suit, white shirt, and dark
skinny tie, shines by his simple elegance and his youth beside a pompous,
bald, conventional Italian minister clad in grey with pocket handkerchief.

At noon, Castelli hosts a grand banquet in Rauschenberg's honor on the
island of Murano. But the affair of the XXXII Biennale is far from over! In the
press—French first and foremost, but American as well—the attacks against

VENICE, JUNE 20, 1964
Robert Rauschenberg and Alan Solomon, commissioner of the
American pavilion, at the awards ceremony

him come fast and furious. "Leo's European rivals immediately fingered him as the guilty party," attests the Venetian dealer Attilio Codognato, "while Marchiori was accused of acting as third man and helping in the 'American landing' and Peroccho, the cultural assessor for the City of Venice, was nearly forced to resign."[30] Castelli, therefore, emerges as the scapegoat in this whole drama. Certainly, he played a part—a very active one. Restany had several years earlier evoked the image of Castelli, all smiles, landing in Venice with a suitcase full of slides of his artists' works. But what has really brought things to this result? His tireless devotion to his artists, his friendship with Alan, and his political lobbying are all subject to scrutiny. The press, explicitly or not, insinuates that his actions have crossed the proper bounds

VENICE, JUNE 20, 1964
Ileana Sonnabend, CENTER, evidently enjoying the awards ceremony. The Golden Lion received by her artist owed a lot to Sonnabend's publicity drive in Europe.

of dealership and consequently that the Venice Biennale has lost its soul. Even the Venetian painter Guidi, receiving an award from the Cini Foundation, gloats that he especially values the honor because it's not "manipulated and sold" like the Biennale prize.[31]

* * *

"The one who attracted criticism from all quarters was Leo Castelli," wrote the German art critic Willi Bongard, "of whom it is always said that he initiated the whole affair. The fact that half of the American representatives at the Biennale were from his gallery (Rauschenberg, Johns, Chamberlain, and Stella) was in particular cited against him and was put forward as evidence that he interfered unduly in the matter. If one is to believe some American critics, Leo Castelli had not only installed Alan R. Solomon as the Biennale official, but had also taken the decision regarding the constitution of the

American Biennale entry and as far as possible had made Sam Hunter his henchman."[32] In *ARTnews*, meanwhile, Milton Gendel denounced the "prize candidacies discussed *ad nauseam,* and lobbies hastily organized to pressure the juries one way or another."[33] Other Castelli antagonists would fan the flames in the United States, imputing foul play, perhaps ultimately unknowable, and so lingering in its effects. We can understand how Bongard would feel moved to write: "Whether and in what measure the six judges, of whom three voted for Rauschenberg, were prompted or even pressured is never likely to come to light. I believe it to be a fairy-tale, however, that their votes were bought, as various people have tried to make me believe, but for all that it is obvious to what an extent the Biennale is considered corrupt. The fact that the most monstrous suggestions arose from the French and that the Biennale decision was branded as a great conspiracy cannot be wondered at. But in America, too, there was anything but pure joy at the outcome."[34]

Indeed, even a number of American officials, far from rejoicing, distanced themselves from the event. "Peter Selz . . . was full of sour grapes and nasty as usual," Solomon confided to Castelli. "He explained to me that everyone who had come to Kassel from Venice had said that the latter was the best international art exhibition ever held. He told me that the gossip in New York was that Seitz did not accept because the telegram of invitation was signed by you . . . Barr told me the same thing and added that the talk in New York was that the poor souls at USIA and I, alone and innocent in Venice, had been taken in by you and Ileana, and that was why Bob got the prize . . . I suppose a lot of this is attributable to the frustration and annoyance of the MoMA people."[35] Given all this backbiting among the MoMA and Greenberg camps, and the endless wait for reimbursement of out-of-pocket expenses, it's no surprise that Solomon spent the end of what should have been a triumphal summer "demoralized and depressed."[36]

Needless to say, the French critics would take the palm for the most savage comments, fiercely attacking the "Venal Biennale."[37] Solomon felt the magazine *Arts* had reached "the high point of hysteria [with] the allegation that the Americans and the communists had conspired together against the French." "Quite without our intending," he exulted, "the American exhibition had the effect of making dramatically apparent the end (temporarily at least) of a hundred and fifty years of French dominance of art."[38] The philosopher Jean-François Revel would pen some of the harshest barbs against the Americans, who, he wrote with heavy sarcasm, would have to marshal all "their cultural chauvinism and artistic xenophobia to consider

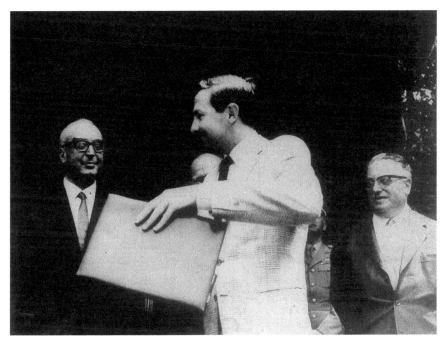

VENICE, JUNE 20, 1964
Robert Rauschenberg receives the Golden Lion at the XXXII Biennale.

'pop art' any kind of revolution. Indeed, New York's whimsy pushes igno-
rance to the point of presenting even second-rate geometrical abstractionists
like Kenneth Noland and Frank Stella as revolutionary. They proudly display
the schoolboy commonplaces of a Claes Oldenburg . . . while Jasper Johns
bores everyone stiff with his flags, numbers, and maps of the United
States . . . The Americans invaded Venice with missionary zeal. Not content
to exhibit in their pavilion inside the Biennale gardens, they held a huge ret-
rospective of their stars . . . Once people start opening annexes throughout
the city, the competition—because the Biennale is a competition—becomes
a fix."[39]

But what could all the French critics in the world do to deflate the jubila-
tion of the man, flush with success and ecstatic to be back home? He didn't
care a fig! By the afternoon of Saturday, June 20, 1964, the dust of the XXXII
Biennale had already settled for Leo Castelli. The dealer returned to his hob-
bies and his to-do lists, all adumbrated in his Hermès datebook. Once again,
he drew up his endless plans for the summer, scheduling his "reunions" with
the great European writers who had helped him form his sensibility as an

WASHINGTON, D.C., JANUARY 20, 1977
With Robert Rauschenberg en route to the White House for the inauguration of Jimmy Carter

adolescent—back when he had admired, for instance, the great Renaissance architect Leon Battista Alberti, who could throw a stone higher than Giotto's Campanile in Florence. "Books," he wrote, "Shakespeare, Dante, Ariosto, Petrarca, Racine, Montaigne, Flaubert, Dostoevsky, Proust, Joyce, Eliot, Bible, Proust by Maurois, Dictionaries Larousse, Columbia etc." The last page of the datebook for that long and fruitful year lists a work he was then reading, Francis Haskell's *Patrons and Painters: A Study in the Relations Between Italian Art and Society in Baroque Italy*.[40] On page 276, Castelli would have read the following: "State, nobles and Church had been the traditional sources of patronage and we have seen how they operated during the first part of the eighteenth century . . . But there was another Venice—the famous, cosmopolitan city of pleasure with its throngs of tourists and dilettantes who came from societies totally different in spirit; and to cater for their tastes a wholly new kind of art came into being—one far more in touch with contemporary fashion elsewhere in Europe, whether it veered to the rococo or the neoclassical, than were the exalted visions of Tiepolo, Piazzetta and other history painters."[41] The international press might fulminate against him, his name might become a household word, but such was the true space in which Castelli abided: History with a capital H, which endures.

23. THE FREE-SPIRITED TEENAGER
AND THE DEVILISH IMP

From her office at the back of the gallery, Ileana has unassumingly launched a true cultural revolution . . . using her intelligence, charm, and formidable political instincts.[1]

GRÉGOIRE MÜLLER

A LARGE BLACK-AND-WHITE photo: Venice in mist. Before the domes of San Giorgio Maggiore, a gondolier on the lagoon. "Rauschenberg," a lacerating diagonal white strip screams, while at the bottom a horizontal line reads: "Ileana Sonnabend Paris." As early as May 1964, the "Rauschenberg Ileana Sonnabend Paris" message began to spread in major art periodicals throughout Europe and the States via an "American-style" advertising campaign, conceived by the Sonnabends and designed by the artist Daniel Smerck, in which the painter's name blazes across large, sumptuous pages. This campaign would play an essential role in Rauschenberg's triumph at that year's Biennale. Yet things had not gone so smoothly for Ileana and Michael Sonnabend when they first left New York in 1960. The couple had lived through a veritable odyssey—Rome-Venice-Paris, the first station including a painful attempt at a gallery—before they settled in the fall of 1962.

Castelli always managed to outshine himself during his customary trips to the Venice Biennales. The collector Bil Ehrlich recalls the gallerist's total mastery of the environment: "I just was amazed by the way that he could—the only way I could describe it is—*'float'* from person to person and go from one language to another, and even though he wasn't great in German, he could still get by and then he'd be talking to somebody else in French and then he would be talking to somebody else in Italian and of course English. And his view of art and the way he would integrate his artists into the bigger picture always amazed me, because he made the Americans absolutely rele-

Ileana Sonnabend's 1964 promotional campaign for Rauschenberg's art was carried in most European art magazines.

vant and vital to the understanding of art to the Europeans, and then what was so amazing, was that he would really work with a number of major collectors in Europe and end up developing, in many cases, stronger collections of American art there than here."[2] It was at the XXXI Biennale, in June 1962, that Castelli's partnership with the Sonnabends truly began to make the three gallerists a force in the European market. "A table at the Colomb," recalled Harald Szeemann. "Ileana, Michael, Pontus Hulten, Françoise Szeemann, and myself. We talked about exhibitions and programs. After Stockholm, the 'Johns, Rauschenberg, Leslie, and Stankiewicz' show had gone to Amsterdam, and I was to mount it in Bern in early July. Moderna Muséet, Stedelijk Museum, Kunsthalle: what a marvelous avant-garde axis! Leo Castelli showed up at the opening, carrying a 007 attaché case containing ektachromes of his new artists."[3] Not surprisingly, this was also when Castelli's relations with his ex-wife were established on a new and stronger basis, allowing him, Ileana, and Michael to work as a trio. Michael and Leo laughed uproariously, talking of Dante and Michelangelo and much else, while off to the side Ileana came into her own, developing her taste for provocation and verbal jousting. "We showed everyone our documentation on the American Pop artists," she said. "Attilio Codognato and Giovanni Camuffo, who ran the Leone gallery, were interested, and so were the painter Giuseppe Santomaso, the critic Giuseppe Marchiori, and Carlo Cardazzo, who wanted to show Jasper Johns in his gallery Il Cavallino and partner with us. But then we decided to move to Paris."[4]

In November 1962, the Sonnabends took over a beautiful space at 37 Quai des Grands Augustins. "Through the tall French windows, your eye followed the flow of cars along the Seine . . . then flew over the river to alight on the spires of the Palais de Justice," recalled Robert Pincus-Witten, one of the new gallery's first assistants. "The view was magnificent . . . the room was huge and the ceiling high. The black and white marble tiles were not original Louis XIII, but were still wonderfully classical."[5] Burned by their failed attempt in Rome, the Sonnabends opted for prudence, taking a six-month lease this time; their first encounters with the landlady, Mme Dupuis, were not exactly promising. "One day, soon after we opened, we took delivery of some Warhol paintings that we had to hang for the show," Ileana recounted. "As we were unwrapping these large Marilyns, Mme Dupuis dropped by to see what we were up to. The minute she saw the Marilyns, she started shouting in a panic: 'I cannot allow you to show those, it's not art, it's necrophilia,

With ex-wife Ileana and her second husband, Michael Sonnabend

it's disgusting!' And she left, slamming the door behind her. Michael couldn't stop laughing, but I was sick with worry. I didn't know what to do. I kept saying, 'Come back, Mme Dupuis, wait!' Just then, in came Pontus Hulten, the young director of the Moderna Muséet in Stockholm. After looking at the painting that had so unnerved Mme Dupuis, he said, 'I'd like to buy it, but I have to confer with the museum first.' Mme Dupuis, who was standing there, said, 'Do as you wish, I don't understand any of it.' She left us alone after that, renting us the space until the end of the year. We could finally display our name on the door!"[6] For the visual arts, more than for any other cultural medium in that fall of 1962, Gaullist France was not only an "aging muse" but fast finding itself becoming a "hysterical and unstable" country.[7]

When the Sonnabends opened their gallery in Paris, France was suffering the ravages of the just-ended Algerian War, nostalgically watching the remnants of its great empire slip away; governed by a reactionary soldier, slow to embrace the modern technological era, it viewed America's cultural innovations with deep suspicion. Could there have been a less propitious moment to show contemporary art from across the Atlantic? Still, the two journeymen gallerists persisted. Let us listen to Michael Sonnabend: " 'Whatever you do, my friend, no flags!' René Drouin had cautiously warned us—probably think-

ing of the 'Yankee, go home!' that was sure to greet us in Paris. I said, 'That's not how it's going to be. I'm going to show six flags—not one or two, but six!' It was exactly the right thing to do, because the visitors to the exhibit, perhaps thinking of Monet's poplars, viewed the flags as paintings . . . with the same aesthetic detachment. And in fact, it was a huge success, even if opinion was divided."[8] Indeed, at the opening of the Sonnabend Gallery on November 5, 1962, crowds buzzed around the flags and numbers. Still, voices such as that of John Ashbery, who remarked on Johns's "exceptional finesse" in the *International Herald Tribune,* or those of Michel Ragon, Alain Jacquet, Jean-Jacques Lebel, Otto Hahn, Alain Jouffroy, Paul Facchetti, Daniel Cordier, Jean Larcade, and Michel Tapié, who showed up to support the Sonnabends' first venture, were very much in the minority. "We at the Stadler gallery are fiercely opposed to pop art [which] is more a social than an aesthetic phenomenon,"[9] sniffed Rodolphe Stadler, echoing a common sentiment. Overall, critics and colleagues either greeted Johns's exhibit—and, several months later, Rauschenberg's—with resounding silence, or else took a combative stance against a perceived cultural onslaught.

It did not help promote amity that Ileana Sonnabend was bombarding the French public in odd and unfamiliar ways. "We spent a lot of money, much more than the other galleries," said her husband. "We invited artists to group dinners at restaurants, published catalogues with contradictory viewpoints, often written by prominent authors like André Breton and illustrated with top-quality photos, gave artists copies of catalogues to hand out to their friends (Ileana's idea), bought advertising in magazines and on kiosks, and stayed available to the public: we saw people and people saw us. That's what counted."[10] Such a naked play to gain maximum exposure for the artists could not fail to shock the decorous French art world: after all, the country's first modern art museum was a mere sixteen years old, and still fixated on the School of Paris. After a six-month trial period, with no commercial success to speak of, the Sonnabends turned to Mihai Schapira for funds to continue the experiment another three years. Ileana's being a woman, and an American to boot, remained a formidable handicap. "People see me as rather quiet," she explained. "They assume I'm standoffish, which isn't really true. Quiet, yes. And sometimes I can be a bit blunt. I didn't realize when I came to Paris how difficult it still was to be a woman in the 'business world.' Many artists thought a woman was easier to push around, so I had to be a little more blunt than I would have been otherwise. I had given in so many times to so many people that I had to develop a defense mechanism. Being Ameri-

can is part of it, too. Everyone thinks of Americans as naïve children who can be controlled—I was the target of all that. So I'm not sorry to have the reputation I have."[11]

Under such circumstances, their first successes would be all the sweeter: "Dear Leo, Roy's opening was almost as crowded as Bob's," Ileana Sonnabend wrote on June 6, 1963.

> Some people lingered for hours, heatedly debating the paintings. The crowd stayed from 6 to 10 p.m. A lot of them congratulated us on what we were doing. There really is a cumulative effect that by now is turning the art world on its ear. Some unbelievably conservative critics came by to threaten us with their canes! We're well on our way to a marvelous massacre! But Spoerri carried Michael on his shoulders to the bottom of the stairs, like a soccer player! Ferro kissed his hand! Pierrot-the-Rest-any[12] hung around a long time with an amiable and rather forced smile on his lips. He's attacking us and Lichtenstein. Iris Clert was the only gallerist who came; our only problem (money aside) is the intense hatred of the gallery world, even in America. Alechinsky stayed for hours. The people from the Salon de Mai came by to tell us they'd like to organize an American show next year and asked for our cooperation—or rather, as they said so elegantly, "We can no longer remain unaware of you." Sandra [a gallery employee] attended an opening where they introduced her as our secretary. The indignant gallerist shouted, "She's a whore, she's seducing our French youth away!" Then she opened our catalogue and another gallerist shrieked in horror, "How dare they put a Picasso next to that filth!" . . . By the way, Monsieur de Montagu bought *Hot Dog*! It's great having such an exhibit to back us up. Hosiasson said it was better than yours! We could even have used two more paintings. I'll write again soon, with more news and updates. I'm looking forward to getting news of the house and also, since I spent more money than anticipated, a check for about $10,000. Love.[13]

While most French newspapers treated the new American artists with scorn or indifference, Jean-Paul Sartre's monthly magazine *Les Temps Mo-*

dernes mobilized opinion on their behalf. Since founding his periodical in September 1945, France's most charismatic intellectual had made a point of presenting culture in the process of becoming, living culture, wherever it came from. In 1946, a special issue on the United States had featured such emergent sensibilities as Richard Wright, Harold Rosenberg, James Agee, and Walker Evans. Indeed, despite what some superficial commentators have claimed, and notwithstanding his strident opposition to McCarthyism and its fallout (particularly the Rosenberg affair), Sartre always showed great favor towards the best and brightest of American democracy.[14]

In the January 1964 *Temps Modernes,* a young critic named Otto Hahn published "Pop Art and Happenings," a serious examination of the movement. He demonstrated how Rauschenberg and Johns had managed to "tear open the muted language" of the New York School just as it was "becoming academic" and fashion a movement "inspired by Picasso's collages, Duchamp's readymades, Picabia's Surrealist montages, and Schwitters's Dada assemblages." Unlike his sniggering colleagues, who caricatured the pair mercilessly, Hahn argued that they deserved a prominent place in art history and celebrated Rauschenberg's "highly refined intelligence," his "subtle plastic sense," and Johns's "poetic exuberance . . . dominated by a very intellectual set of concerns." In Hahn's words, the two artists had "established the grammar that regulates the new realism." As for Lichtenstein, his work was "at once condemnation and submission . . . a catalogue of the American dream" that imbued his "monstrously tasteless imagery" with "tragic, anonymous grandeur." Hahn described Rosenquist's paintings as "huge erotic reveries" and in passing also reviewed the work of Warhol, Indiana, Dine, Oldenburg, and Segal. Pop, he said, was an art that "preserves the banality of daily life as its details vanish around us" and that "holds a mirror up to consumer society." He defined the Happenings as representing an "unconscious form of protest and a refusal of the stereotyped existence offered by our culture of plenty." And therefore, it was in "today's New York," he concluded fervently, "that one must seek today's painting," for it "is developing a language for our urban, industrialized civilization."[15]

The "very good piece on the importance and meaning of Pop Art in the January issue of Sartre's magazine [marks] a sea change for European intellectuals and we'll feel the repercussions here in six months," Ileana Sonnabend wrote the moment the article appeared. And, like a sentinel in a border outpost abutting enemy territory, she immediately alerted Solomon

and Castelli. She could not but remark upon the incredible cohesion of this transatlantic network, so tightly knit among four individuals—Leo Castelli, herself, Michael Sonnabend, Alan Solomon. An astonishing paradox! And, at the center of this weird team, a divorced couple, accomplices through many years and many trials, and now assuming an unusual post-marital solidarity, which would only strengthen with time. In her second Parisian life, with the emotional support of her second husband, Ileana Sonnabend became the woman she would remain, an assertive, inspired gallerist, utterly alien to the depressed dutiful daughter she was in the thirties, forties, and fifties. Was it mere coincidence that her final decision to take the plunge, professionally speaking, came after meeting another woman, the critic Annette Michelson? ("Does Pop Art deserve to be exhibited?" asked Ileana. "If you believe in it, you should show it!" Michelson replied.)[16] Barely had Sonnabend told Castelli of Hahn's article than Castelli had it translated into English to extend its reach. It is in the enduring ardor of this couple, now legally divorced and separated by thousands of miles but never more committed to the same endeavor, that we discover the secret of the Castelli Gallery's European success over the next decades. Its frightening efficiency in Venice was but a foretaste.

"Dear Alan, Here we are back in Paris buried in work for the gallery, and practically drowning in the flood of bile distilled by the press," Ileana wrote on July 1, 1964. "Although I'm still worried about the effect our presence here might eventually have, I'm beginning to agree with you. The abscess had to be emptied. The violent reactions make me appreciate your integrity all the more. The situation is anything but boring. My only hope is that we can survive financially. Michael and I want to thank you for the way you held onto the reins of this whole affair, despite all the chaos."[17] After Rauschenberg won first prize at the Biennale that year, the French press unleashed its full wrath against the Sonnabends, Castelli, and Solomon. "Perhaps the most important thing of all was the outrage of the French and their violent attacks and sour grapes," Solomon wrote to Lois Bingham. "(The French papers were full of attacks on me, which I have to show you.) They claimed that the prize was settled six months ago, that it was bought, that the jury was loaded . . . To me the most hysterical statement of all, pure paranoia, [was about] the Americans and the communists combining to defeat the French, that I had arranged the dance concert to influence the jury. A fantastic experience in all."[18] France had dominated Western art for decades. Since the

First World War, however, America—thanks to proactive philanthropy, a dynamic civil society, enlightened fiscal measures, and some adventurous collectors—had set in place a system of museums and private ownership that usurped art's center of growth from across the Atlantic, paving the way for Abstract Expressionism.[19] But the French, draped in their faded glories, could not have cared less about American art, much less the whys and wherefores of its triumph. Indeed, after Rauschenberg's election, curators and critics all the more defiantly ignored what was taking place "over there"—to their detriment! "These are dark days in the history of human consciousness," droned Alain Bosquet. "These are shameful times in the history of sensibility. The consecration (so to speak) of the American painter Rauschenberg . . . is an act of degradation from which Western art might never recover . . . This was a carefully orchestrated conspiracy to discredit what is most pure and sacred in Europe . . . an attack on the dignity of artistic creation, an admission that the art of painting could vanish forever, unmourned . . . The future Rauschenbergs who are sure to proliferate and encroach upon us will claim much more: they will deny any painterly language, having smothered it under their infantile gizmos. I appeal to Malraux, Cassou, Georges Salles, and every man of culture to disavow the treason at Venice and create a counter-Biennale. Beyond that, I appeal to the painters, that they may refuse to follow these killers with their art. Picasso, Max Ernst, Kokoschka, Miró, Chagall, Tamayo, Pignon, Matta, Lam, Vasarely, wherever you are, deliver us from the barbarians!"[20]

Beyond these paranoid rants, some, like José Pierre, went so far as to invoke the dark days of Nazism to describe the irreparable damage they saw: "The denunciation of America's undeniable and indefensible cultural chauvinism ratchets up a notch when the adjective 'degenerate,' so dear to old Doctor Goebbels, rears its head. As such, we have nothing to regret—except maybe the dollars!—about the sudden allergy shown by the painters, critics, collectors, and dealers of New York and other accursed places to anything not manufactured on home turf."[21] Michel Ragon, meanwhile, launched a deeper debate, revealing the backwardness of a certain French conception of culture, which insists on segregating economics from the field of aesthetics. Ragon, who admitted that the School of Paris had "certainly made mistakes," deemed that "a tocsin had sounded" in Venice. "It seems clear that art dealers are increasingly assuming the role once played by the critics . . . No sooner has [a critic] discovered a painter than the dealers abscond with and

commercialize him. If we are not careful, the dealers will soon leave the crit-
ics voiceless."²² Were the Castellis, Sonnabends, and Solomons moneylend-
ers in the temple, making unclean that which was whole in steps ineluctably
and irredeemably leading to France's decline?

What is certain is that, after Venice, the relations among members of the
quartet grew closer, with Solomon now acting as relay between Castelli and
the Sonnabends: Leo, a father once more (Jean-Christophe was born on
October 1, 1963, marking the start of what was indeed a very triumphant
year!), had married a girl from a well-to-do French family, obliging him to
suffer the ritual of summers in the country, not always gladly. "I'd so much
like to spend a few days in Venice with you and talk things over," he wrote to
Solomon (still in Venice) on July 20.

> You must have done a lot of thinking and reappraising. I hardly
> had a chance to meditate here. The environment just doesn't
> seem to be favorable, in spite of Romanesque churches, vine-
> yards & nice relaxed people. Beginning of next week I'll go down
> South with Toiny . . . It will be a hot journey but I look forward
> to a little action . . . A. Did you make any arrangements with
> Francis Mason to show Jap's paintings at the Embassy? . . . The
> problems (among others): 1. Difficulty of assembling such a good
> group of paintings again in the foreseeable future, especially to
> go overseas. 2. Jap did have a raw deal in Venice which the Lon-
> don Show would correct to some degree. B. Did the Jewish
> Museum catalogues ever get to Venice? And if so, are they and
> Leo Steinberg's book being sold? C. How's Alice? Do you hear
> from her? For that matter, are you hearing from anybody? I've
> completely lost touch, except for some occasional (mostly admin-
> istrative) letters from Nina. Jap's back from Japan & seems to be
> relaxed. I haven't heard from Bob at all since Venice. He'll be in
> London end of the month. You could, perhaps, go and see him &,
> at the same time, set up the exhibition at the Embassy . . . That's
> about all. My best regards to all our friends, especially Marchiori,
> San Tomaso. Love, Leo.²³

As if picking up a vibration from her ex-husband, Ileana wrote to Solomon
that same day: "I hope things have calmed down in Venice and that you're

getting some rest. Bob came through Paris. He came to see us on Saturday. He's doing well, amused but hardly affected by the flood of press."[24] At the worst moments of the Parisian attack, some in Paris sensed imminent cultural defeat. The brilliant critic Pierre Restany, who supported the New Realists, found himself taking fire from both sides—so much so that Ileana suspected him as a double agent. While in July he seemed to defend the French angle, deeming the Biennale "irregular . . . less an academy for canonizing talent than a vast international news forum," by November he'd changed his tune.[25] Paris, he charged, was "lacking in spirit and becoming mired in provincialism. Its aesthetic debates degenerate into parochial squabbles and it has isolated itself from the radically evolving international context." Restany deplored "the defeatism of our scholars, the sclerosis of our bureaucrats, the conformism of our intellectuals, the pretensions of our elite, and the profound indifference of the public, in a country where there are few art connoisseurs or collectors, and even fewer patrons."[26] On December 27, in a letter to Castelli, he tried to distance himself from the madding Parisian crowd:

> Confusion reigns among the cuckolds of history! My dear Leo, you must have followed the chain of events from Venice all the way to Paris. Those jackals (as at the Galerie de France) yowling for the defense of the West against American barbarism (of which you are the lion) are not contributing to the glory of the French capital. A few voices, sadly too few, have tried to remain objective and encourage Europe to examine its conscience. You've probably read my article on the Biennale in the August *Domus* and my editorial in *Planète* 19. I wish I weren't so alone. Still, there is one consolation: "The emergence in the Paris critical firmament" of the young Otto Hahn, who is bringing a fresh and—I think—needed perspective to the whole sorry debate. Michel Ragon's position has also been quite dignified overall. Sadly, the kudos more or less end there![27]

How could the Sonnabend Gallery possibly hope to flourish in such an inhospitable environment? Much credit is due to the arrangement they enjoyed courtesy of Castelli. "I think that, in the long run, the disciplined sacrifice that I imposed upon myself not to deal with any Europeans—deal-

ers or collectors or even Americans that went to Paris and would buy Rauschenbergs or Johns there instead of buying here—was immensely useful in the end," he later judged. "Because that sort of monopoly that [Ileana] had for several years did create a market. Otherwise, it would have been all very imprecise. She gave that whole structure through post–Abstract Expressionism."[28] Earlier, in 1961, Castelli had lent the entire Rauschenberg show to Daniel Cordier's Paris gallery; he had done the same favor for the Virginia Dwan Gallery in Los Angeles in March 1962. For these exhibitions, he had assumed the shipping and insurance costs and forgone his commission. For the Sonnabend Gallery, Leo not only did the same, but also (to Ivan Karp's intense annoyance) restricted his own dealings so that Ileana had exclusive rights to the European market for his artists. Ileana, in other words, enjoyed Castelli's full support in her efforts to create a clientele outside New York; the loyalty of those collectors served Castelli's long-term goal of cultivating demand rather than scoring sales helter-skelter.[29]

Over the next two decades, at 37 Quai des Grands Augustins, 12 Rue Mazarine, or 14 Rue Etienne Dumont in Geneva, the Sonnabends (joined in 1968 by Antonio Homem) would decisively transform the state of European art. At first they showed only "Leo's artists"; then some European ones, like Pistoletto, Klapheck, Boltanski, the Poiriers, and photographers such as the Bechers; and finally their own stable exclusively, beginning with Gilbert & George. It was an unorthodox path—exuberant, euphoric, and stimulating to them—that eventually led back to New York, at first tentatively in 1970, then definitively in 1980. Along the way, the Sonnabends would also improve traffic flow on the Paris–New York axis in both directions, giving artists such as Jeanne-Claude and Christo, then just emerging, a strong foothold in the United States.

Having admired the *Wall of Oil Barrels, Iron Curtain* that Christo installed on Rue Visconti on June 27, 1962, Castelli encouraged the artist. "Leo is one of the few individuals in the art world who saw *Iron Curtain*," Christo and Jeanne-Claude recalled. "We were twenty-seven at the time, and he told us, 'If you come to New York, we'll do something together.' And then he suggested we go see Sonnabend, which was about to open. We spent every Saturday of 1963 at Ileana's gallery, talking and looking at the shows. Then Ileana arranged our first trip to New York, recommending we stay at the Chelsea Hotel and charging the reservation to Leo. She told us to look up Alan Solomon, adding an impressive string of details: 'He likes this, he

doesn't like that, he is friends with this one and that one, whatever you do don't invite him with so-and-so because they can't stand each other!' It was an extraordinary list of addresses and phone numbers. So we went to New York, already knowing who these people were thanks to her—fortunately, because when we arrived at the Chelsea we didn't speak a word of English! And in May 1964, in the group show '4 at Castelli,' with Artschwager, Hay, and Watts," Christo added, "I showed *Green Storefront,* a metaphor for my escape from Bulgaria in 1958."[30]

And so, from November 1962 to 1980, French and European artists, critics, intellectuals, and collectors were drawn to this "institution Paris sorely lacked," as their only logical destination, a place where "the 'new' held sway" (Harald Szeemann),[31] where "Pop was experienced live, in full effervescence" (Sarkis).[32] Visitors found "Ileana, easy and direct, a mischievous sparkle always at the corner of her eye . . . and Michael, who looked like a devilish imp, and who set off firecrackers named Oldenburg and Lichtenstein" (Michel Ragon).[33] Michel Guy, the future minister of culture, later paid homage to Ileana for "her exemplary taste, enthusiasm, and energy,"[34] and the gallerist Yvon Lambert noted that he "greatly respected the side of her . . . that always took an interest in nascent things."[35] Not to be outdone, collectors like Peter Ludwig ("She is always eager to learn")[36] and Giuseppe Panza di Biumo ("She had the ability to relay information about important cultural events throughout Europe")[37] testified to their admiration for her, as did Robert Pincus-Witten, who in affectionate recollections celebrated the Sonnabends' all-energizing spirit in pursuing the game for its own sake rather than any strictly mercantile motive: "Ileana, a free-spirited teenager, part sphinx and part flirt; and Michael, ebullient, bringing a fine critical sense to historical debates. For Ileana, notions like commercial value or financial stability were just petty, something to despise. Making money by accumulating assets, adding zeroes, or showing dead works made no sense to her. The adventure was all."[38] The Genovese curator Germano Celant beautifully echoes that sentiment: "I have no doubt that casting her gaze into the deep sea of artistic objects to bring up only one, the choicest and rarest, the most unusual and delightful, was for Ileana the essence of life."[39] It required, to some degree, the very sort of self-negating devotion to art that had always made her a soul mate, if not life mate, of Leo's.

As the Italian critic Achille Bonito-Oliva reflected, "Her mind works . . . by recognizing what is new in art—that is, the anthropological expression of

creativity in both high and low registers . . . Any portrait of Ileana must encompass all of her artists," but also, Bonito-Oliva continues, "Michael Sonnabend, acerbic and hedonistic as a figure in a late Empire medallion, and Antonio Homem, sharp and composed like an effigy from the Portuguese Counter-Reformation."[40]

Like Jean-Paul Sartre and Simone de Beauvoir—the existentialist duo par excellence—the Sonnabends were subversive heirs to a legacy, partisans of an alternative and emergent vision full of empathy with "nascent things" (Yvon Lambert). As they went seeking out "the life forces of their time" (Edi de Wilde), they operated as true cultural *passeurs,* linking in their inimitably idiosyncratic, full-hearted way disparate artistic forces, living like "cultural nomads" heedless of boundaries, whether national or generational. They helped to build a countercultural artistic Elysium even as they managed their professional relations in a conventionally familial way. "I worked at Sonnabend on rue Mazarine, doing a bit of everything," wrote the publisher Raphaël Sorin, "overseeing the catalogues, smoking a cigar with Michael, accompanying Ileana, greeting clients, 'infiltrating' the intellectuals."[41] The Sonnabends unexpectedly blended their quest for cutting-edge aesthetics with a sort of cozy alternative family.

24. THE CONQUEST OF EUROPE

*Curators like us—young, dynamic, eager, and penniless—couldn't afford
a trip to New York, so we fell back on Paris, which at the time was desper-
ately trying to assert its stature vis-à-vis New York's energy. We needed
the Sonnabends, their friendship and verve . . . Michael represented scin-
tillating curiosity . . . always trying to understand . . . while Ileana's
talent lay in scrutinizing, combining, controlling, synthesizing.*[1]

HARALD SZEEMANN

"VENICE RIGHT NOW is a terrible bore. After two agonizing weeks the
scirocco has finally ended and the weather is cool and bright. The tourists are
intolerable and the interesting Venetians have all left for the month of
August. My minor irritations of dealing with the government continue and I
find the whole experience rather depressing. I hope you have a pleasant sum-
mer."[2] In his letter to Ileana Sonnabend on August 4, 1964, Alan Solomon
could not help voicing his unease and his dismay at the backstage machina-
tions in Venice that he believed had become much too public. For the
Sonnabend Gallery now was serving as a locus and a source of support for
the numerous agents disseminating Pop Art across Europe; it confederated
the disparate initiatives by dealers, critics, curators, and (even!) American
bureaucrats. In Paris in 1961, Johns had been shown at Daniel Cordier's, then
participated with Rauschenberg, Tinguely, and Niki de Saint Phalle in a Hap-
pening at the American Embassy, before taking part in a group show at the
gallery La Rive Droite. Rauschenberg's work had appeared that same year at
the Moderna Muséet in Stockholm and the Galleria dell'Ariete in Milan; in
1962 at the Stedelijk Museum in Amsterdam; in the Four Americans show
of 1964 as it traveled to Stockholm, Amsterdam, and Bern; and at the
Whitechapel Gallery in London and the Salon de Mai in Paris.

The civil servant in charge of cultural affairs at the American embassy in London, Francis Mason, represented an anomaly. Too often, the United States demonstrated a rampant anti-intellectualism, the side effect of a can-do tradition of pioneers, business tycoons, and, to an extent, Puritans. Among its presidents, only Roosevelt in the 1930s and Kennedy in the 1960s had evidenced a relatively benign view of the arts.[3] And while civil servants so often act as poster children for philistinism, Francis Mason was a happy exception. "Dear Dr. Solomon," he wrote on July 15, 1964,

> After recent talks here in London with Leo Castelli I had hoped that it might be possible for us to entertain the idea of bringing the Jasper Johns section of your exhibition here to London for separate display after the close of the Biennale. This idea hinged heavily on the fact that the paintings by Johns might be packed separately from other works. After checking with USIA in Washington, I discovered that this is probably far from the case. Would you be good enough to let me know? Our funds here are so limited that they would be stretched to the breaking point by the shipping costs of the Johns which, as you know, we would have to undertake separately if these paintings were to return to the States separately . . . If the Johns are packed separately and if you could give me an estimate of what it would cost to ship them to New York via London, I would be most grateful. Now is the ideal time to show the Johns exhibition in London, and as Leo agreed, it would be a pity to miss any opportunity. May I in conclusion congratulate you on what has been a clear triumph at Venice?[4]

Though France still shunned the Pop artists, they were welcomed not just in London but elsewhere in northern Europe, where audiences greeted their work with wild enthusiasm. Under the leadership of its dynamic director, Pontus Hulten, the Moderna Muséet rapidly assumed a central role in the Americanization of the global art scene. Still, as Hulten stressed in a letter to Castelli, his institution remained "a small three-year old State museum with no money at all for exhibitions. The State does not give a single crown for such shows, the entrance fees have to pay for everything."[5] As if by contagion, after Four Americans visited Stockholm and Copenhagen, other Euro-

NEW YORK CHAPEL, 1968
With Pontus Hulten, director of the Moderna Muséet in Stockholm, in front of Rauschenberg's *Solstice*

peans caught the bug. "I have just returned from Denmark, where I have seen the pop-art exhibition in the Louisiana Museum," Edi de Wilde, the visionary director of the Stedelijk Museum in Amsterdam, wrote Alan Solomon. "I was so fascinated by it, that I wish to try to show the collection in Amsterdam too."[6] Then it was the turn of Dr. Udo Kulterman, of the Städtisches Museum Leverkusen, Schloss Morsbroich, in Germany, who, alerted by Sonnabend, staked his own claim. "Some weeks ago I wrote to you," he told Solomon,

> and informed you on our project MORSBROICHER KUNSTTAGE 1964. In connection with this 3 day festival we are preparing an exhibition of ROBERT RAUSCHENBERG. We will cooperate with Mrs. Ileana Sonnabend in Paris, and I hope we also can have the Dante drawings from New York here. I am most interested to make this first exhibition in Germany as comprehensive as possible. I heared [*sic*] that you are the commissioner for the American pavilion at the Biennale in Venice, and that RAUSCHENBERG will be included in

this year's show. May I ask you whether these works of RAUSCHEN-
BERG can be transported afterwards to Leverkusen? You under-
stand: this would be for us very important. May I ask again
whether you can come to our KUNSTTAGE with a lecture?[7]

In these early exchanges, the influence of the Sonnabend Gallery
(through its exhibitions, its catalogues, its promotional campaigns), magni-
fied by the considerable impact of the Venice Biennale and leverage by the
golden axis of Leo-Alan-Ileana, expanded throughout the Continent. Their
offerings were the rage, with numerous requests for works, photos, and cat-
alogues of Pop and pre-Pop artists pouring in from Paris, London, Stock-
holm, Copenhagen, Amsterdam, Bern, Venice, Kassel, Cologne, Turin,
Milan, as art professionals began to mobilize for the first time around the
Sonnabends, among them Daniel Cordier, Pontus Hulten, Edi de Wilde,
Will Sandberg, Wim Beeren, Jan Leering, Gian Enzo Sperone, Rudolf
Zwirner, Enno Develing, Harald Szeemann, Bryan Robertson, and Pierre
Restany. Then followed the first collectors: Marcel and Giselle Boulois, René
de Montaigu, Attilio Codognato, Hubert and Maryse Peeters, Roger Mathys,
Philippe Dotremont, Mia and Martin Visser, Jan Dibbets, Frits and Agnes
Becht, Peter Ludwig, and Giuseppe Panza di Biumo. For Panza, however, the
Pop adventure had got off to a decidedly rocky start.

"One day in 1959, in New York," Ileana Sonnabend recalled, "the gallery
mail brought a letter from Italy, written in a rather childish hand. A certain
Panza di Biumo was asking for photos of works by Rauschenberg. Figuring
he might be an artist out to copy Bob, we didn't reply. A few months later, we
got a second letter from Panza, still handwritten, but this one seemed more
focused, naming the works he wanted: all excellent choices." Thus began the
strange epistolary exchange between the Castelli Gallery and the man who
would become one of its mainstays, not to say one of the greatest collectors
of American art in Europe, Count Giuseppe Panza di Biumo. "Thank you
very much for your letter of April 7, 1959, and for your interest in Rauschen-
berg," Castelli answered dismissively. "Unfortunately, his work is very much
in demand here and we have nothing available at this time . . . Buying a
painting of Rauschenberg's, especially for a collector who does not live in
New York, is somewhat problematic—all the more so in that Rauschenberg
works very slowly . . . But, since you are interested in his work, I will soon
send you two or three photographs."

Some time later, apparently put off by his correspondent's importuning,

the gallerist delivered himself of some rather bluntly condescending remarks:

> There are certain things you do not understand. Rauschenberg does not produce manufactured canvases; rather, each of his pieces is an invention. There are approximately fifteen per year, and his work is well thought-out. Along with Johns, he is now considered the best painter of the younger generation, and probably the equal of his elders. This is the opinion not only of Americans but also of Europeans. It is currently impossible for me to sell you a work of Rauschenberg's—I don't have any. Do not feel bound by your commitment to buy *Winter Pool*. When it comes to Rauschenberg, I'm always glad to take back one of his works.

But Panza persisted undeterred in his interest and responded to Castelli's stiffness with a warm invitation, accompanied by photos of his "country home"—with the result that the dealer agreed to visit him in the summer of 1960.[8]

Panza's earliest letters date from April 1959, barely one year after Rauschenberg's first show at Castelli. At the time, upset that the Combines had not garnered the same enthusiasm as Johns's flags and targets, especially from MoMA's director, the gallerist nursed his disgruntlement. So while letters from this weird character from Varese were piling up in New York, Panza's insistent requests smugly rebuffed, Castelli continued bombarding Alfred Barr and Dorothy Miller with messages, phone calls, and suggestions, in a vain effort to ignite their interest in Rauschenberg. In a succession of exchanges straight out of Schnitzler's *La Ronde,* with its regress of disdain—Panza addresses Castelli who brushes him off, Castelli addresses Barr who brushes him off, and so on—one can observe the fascinating implementation, however frustrated, of Castelli's elaborate and singular selling strategy: the manufactured scarcity, quoted in inverse proportion to the potential collector's symbolic capital as calculated by Leo. The most obvious manifestation of this principle was in 1959, when Castelli plainly favored those American institutions, especially MoMA, that at his urging had opened the doors to American art. Only in the summer of 1960, on visiting Panza at his estate in Varese, would Castelli reconsider the potential of this new character and deem him *worthy* of election.

Let us listen to Castelli narrate the evaluation process: "I went to see Panza's place. It's near Milan, Varese on the lake, an old seventeenth-century palace right in the middle of the park. It reminds you of *Last Year at Marienbad*. There was a living room full of Rothkos, just Rothkos, and the dining room was just Klines. Really quite amazing. Eighteen major Klines and as many Rothkos. I mean, there is this castle with fantastic antique furniture in every room. You go up a solemn, very imposing staircase with all the ancestral portraits, and then there are all these immense numbers of rooms and corridors and such."[9] "During that visit," Panza explained, "we became very good friends. It was a test, and I passed: Leo decided I had the stuff to become a great collector. And that he would help me do just that."[10]

By imputing scarcity, by screening potential collectors, and by carefully positioning his artists' works with disciplined regard to the context, Castelli was actually taking a page from one of his most illustrious predecessors, Joseph Duveen, who for four decades, with Bernard Berenson's assistance, dominated the acquisition of old masters by American industrialists. For Duveen did not *sell paintings*, he *assembled collections*, each one validated by a specially prepared catalogue. Duveen had reversed an age-old way of doing things: while the status of artists of the classical era had been elevated by the interest the nobility took in their art, in turn-of-the-century America, it was the nouveau riche collector who acquired art as a shortcut to status. In the case of collectors like Andrew Mellon, such status was conferred especially by the Old Masters. But the same principle of what we might call the conspicuous consumption of fine art also applied to more recently canonized European artists. Following J. P. Morgan's lead, for instance, those seeking to rise in society would have bought Impressionists, not out of admiration per se but because they cost a mint. The aim was to own the most, and most expensive, paintings one could. Then as now, art was the way to keep score among the few who had everything else money could buy. Showing off these treasures conferred prestige, respectability, a place among (or above!) one's peers. For Panza, by contrast, quite to the manor born, collecting was a quasi-mystical office, a contemporary quest for the aesthetic grail.

Thanks to his network of satellite galleries, Castelli represented the first time that a gallerist had achieved a worldwide monopoly with respect to particular living artists. First among the disciples who made this network possible was a man with whom Castelli shared a remarkable cultural kinship in matters of taste, values, and fervor, Gian Enzo Sperone, a Turinese intellec-

TURIN, 1969
Castelli, impeccably dressed, between the gallerist Gian Enzo Sperone, LEFT, and the artist Joseph Kosuth,
RIGHT

tual in his early twenties, elegant, flamboyant, passionate, and enthusiastic. He would thus describe his personal odyssey: " 'Let's go to Paris! Why are we wasting our time here in Italy? Paris is where anything worthwhile is going on!' That's what Michelangelo Pistoletto said, and as an avant-garde artist he had his finger on the pulse of what was happening well before anyone else. So we hopped in the car and drove to Paris. I don't remember if it was winter, but I do remember that I'd dressed for the North Pole! The Sonnabend Gallery had just opened and we'd read about it in a short but interesting article by Ettore Sottsass, Jr., in *Domus*. We discovered Pop Art and saw how Ileana and Michael went about it. It was very impressive."[11] Immediately, Ileana Sonnabend took these new Italian acolytes into her care: in 1963, she showed Pistoletto's work in Paris, and she helped Sperone open his Turin gallery, Il Punto, with its debut exhibition of Lichtenstein—no mean feat for such a tyro. "The show included some very important canvases that hadn't sold in New York or Paris, like *Ok Hot Shot*," Sperone recalled. "And the strange thing is that they sold in Turin."[12]

The Italians' bonds with the Sonnabends came naturally to Ileana, who had always been crazy about design—Castelli's 1939 Paris show, after all, had

mixed in furniture by Dalí, Fini, and Berman. With *Domus,* the prestigious Italian magazine of architecture and graphic arts, a cross-fertilization began emerging between Pop and design, Italy and the United States. It was in this spirit that Ettore Sottsass poked gentle fun at Pistoletto, deliciously portraying the "boy from Turin" as "a true poet, though perhaps not as precise and caustic as the boys from New York: the Lichtensteins, Rosenquists, Rauschenbergs, Oldenburgs, and Chamberlains, when they relate our particular drama, our history. Perhaps, as a Parisian critic said, this boy from Turin employs colors that imbue his painting with 'crepuscular reflections,' and perhaps these reflections are there for a reason, and perhaps there exists a crepuscular air independent of these colors: the air of Turin and the ecstatic ennui of his days. Despite being less precise than the American boys, Pistoletto relates the stories he has to tell with talent and depth."[13] Unlike its French counterparts, the Milanese periodical showed no signs of animosity towards the United States, but rather proposed a two-way gaze establishing kinships and complementarities.

In fact, thanks to Sonnabend's self-interested magnanimity and to Gian Enzo Sperone's personal dynamism, the opening of the Pop's Italian outpost came at the perfect time for someone like Panza, who would find in the Turin gallery an inexhaustible trove of Americana. "During my first Lichtenstein exhibition in December '63," Sperone said, "Panza came alone, driving the two hours from Milan to Turin. He introduced himself as unassumingly as could be, for he is a very simple man, kind, inspired, without a trace of arrogance or belligerence, and I was Mister Nobody, a zero. He said, 'I came specifically to see this exhibit, which is very important.' But he also admitted he was not convinced that Lichtenstein was as important as Rauschenberg. The way he related to art, as a collector, was completely new: before him, no one thought it was important to love the works; they didn't necessarily buy them to put them in the house and live with them. With the conceptual exhibitions of '68 and '69, Panza came to all the openings and bought out the entire show."[14] Shuttling regularly between New York and Turin, and meeting frequently with Castelli and with Sperone, Panza quickly amassed a formidable collection, whose genesis is here recalled by Castelli: "He bought Rauschenberg massively in the early sixties. He had at least twelve or fifteen Rauschenbergs, very early ones, including some masterpieces" (the first Combine wouldn't enter MoMA's collection until 1972). "Then he got involved after that with Lichtenstein, then Oldenburg and Morris, and then

Judd and Flavin."[15] Signóra Panza remembers the lunches in New York: Castelli played "guide" while her husband, bearing "a large, ordinary manila envelope containing information on the artists, wrote down everything Leo said on the outside. The two of them shot observations back and forth as if playing ping-pong. My husband jotted down the new names and went to see the works, preciously preserving those historic envelopes."[16] And Panza, for his part, enjoys recalling a specific anecdote: "One day, because I had gone to New York to buy some Rauschenbergs, at my insistence Leo took me to his warehouse. It was a rather large space, filled with the most beautiful master-pieces from the 1950s, really fantastic, so I bought everything I could afford. I was young and didn't have much ready cash. Coming up with the funds was always a problem, and even there Leo was very generous because he didn't make me pay up front."[17]

Between gallerist and collector, a strong relationship soon developed. "Leo was a true gentleman," Panza continued. "The help he gave artists and collectors ensured that the works fell into good hands. If I've been able to assemble a great art collection, it's thanks to him. Before we met, I had bought Rothkos, Klines, very idealistic artists, pure energy. Leo's artists pro-duced work that looked like pop culture but actually wasn't, even though it used everyday objects. In Italy, people were repulsed by Rauschenberg's art at first and made fun of us when they saw pieces like the *Untitled Combine* with the hen. But we didn't care because we knew it was great art. Besides, we weren't in it for the money, and neither was Leo."[18]

Panza's modus operandi expressed a larger, redemptive vision of Europe after World War II. "After so much moral and material devastation, art helped rebuild a world borne by new values, and America showed the strength of true civic virtues," he comments. For Panza, then, collecting American art represented idealism, a quest for a better world, a contempo-rary search for the Holy Grail of a *novo ordo seculorum*. It was no less arduous a quest than the sacred one, littered with pitfalls and obstacles—not least Castelli's initial refusals, the jeers of Italian high society, and Panza's half-formed vision and half-depleted purse. But Panza's aesthetic crusade would have been less glorious had it not been for the aegis of Castelli, who served as his Virgil, a philanthropist in a merchant's guise, a *deliverer* of the aspiring collector. "There is a visionary dimension to Panza's Catholicism," confirms Sperone, "and I doubt anyone else has ever lived so intensely the idea of art as mystical, as suffering, while leading so austere a life. Panza paid little and

always on credit; he asked for the most preposterous discounts. That's one reason Leo made so little money."[19] It was indeed art for art's sake.

In the second phase of the Castelli-Panza story, their roles started reversing, and now it was the gallerist who, laboring to support the collector's buying frenzy, lost his head somewhat, to the point where one can almost imagine his having heard the same mystical hymn that inspired Panza. "Back then, no one but Leo would have agreed to Panza's terms," Sperone remarked. "Panza, who didn't have much money, always wanted discounts and credit, and Leo, to encourage him, agreed to insane conditions. I knew how precarious the gallery's finances were. Leo was always telling me, 'You have to sell, you have to help me, we have to keep doing things together.' And then he would shamelessly call up and ask, 'Gian Enzo, when can you send me some money?' "[20] In 1962, the apprehensive gallerist wrote to the collector, "Dear Panza, Thank you very much for your check, which I received a few days ago. Rauschenberg hopes that another will come soon. He's been doing wonderful things since your visit . . . I am enclosing some photos of the most important works . . . Ileana told you about a piece by Jasper Johns called *Good Time Charlie,* which is now being shown in SoHo and is going for $3,000—I've enclosed a photo. I'm looking forward to seeing you in Milan or Venice in June. With my best wishes, *molto cordialmente,* Leo."[21] In fact, by all accounts, Castelli's finances were so precarious that very often he did not know how he would make ends meet. It was only through acrobatic maneuvers that he managed to keep the enterprise solvent.

Soon after Panza, another major European collector, Peter Ludwig, also initially rebuffed by Castelli, came onto the scene. His more ample and less volatile finances would help stabilize the gallerist's precarious balance sheet. Having started by collecting medieval and pre-Columbian art, he would now move on to Pop. According to the dealer Rudolf Zwirner, he "bought two or three canvases several times a month. He was Ileana's main client in Paris, but he also bought from me in Cologne and from Leo in New York. In addition to his career as a chocolate magnate, Ludwig was an art historian—he had written his dissertation on Picasso—so all the museum directors knew he was the genuine article. Once he started buying Pop Art, people began thinking that maybe Pop wasn't just junk after all. Thanks to Ludwig, art historians finally took it seriously, especially when he started giving everything to museums and the museum in Cologne was renamed the Ludwig Museum."[22] Indeed, just as Panza's collection was linked to Turin via Gian

Enzo Sperone, Ludwig's would be tied to Düsseldorf (and later Cologne) thanks to an equally enterprising young man who had served as general secretary for Documenta II in Kassel in 1959: Rudolf Zwirner. "Our first connection with Pop came through Ileana," Zwirner explained. "I met her in Paris, back when she opened her gallery. I saw her first exhibitions and soon became one of her clients . . . Before I knew Leo, I was already doing business with Ileana."²³

"'Very well, I'm going to buy this Lichtenstein. Here's my address in Cologne where you can have it sent!'"—that, as Ileana herself told it, was how Peter Ludwig started relations with Sonnabend. "'Fine,' I said. 'As soon as I get your check, I'll send you the painting.' Instead of taking offense at being treated like some run-of-the-mill customer, Ludwig burst out laughing. He liked my answer because he realized I didn't know who he was, that I wasn't trying to rook him or jack up the price. He sent the check the next day and we became close friends. One summer, after I hadn't heard from him in a long while, he arranged to meet me in Munich to talk about Jasper Johns. That time he started haggling on the price of a flag. 'I don't understand, we agreed on a price and now you're reneging?' I told him. And he said, 'You have no idea how hard it is for chocolate in the summer! It melts in the heat, we lose a lot of inventory, business is bad, and I can't afford such an expensive painting right now. Are you sure you can't give me a discount?' So I lowered the price, he bought the painting, and that was that."²⁴

By and large, however, Ludwig paid the asking prices up front. Sometimes, he even sent them soaring. As Rudolf Zwirner recalled, "One day in New York, Peter Ludwig and I went to see Roy Lichtenstein in his studio on the Bowery. Peter saw an old painting of Roy's from 1962, the famous girl, and he wanted to buy it. But Roy said, 'I can't sell that now, it belongs to my wife.' And Leo piped in, 'No, you can't buy that.' So Peter asked, 'How much would it be worth if it *were* for sale?' 'Oh, I suppose forty thousand dollars,' answered Leo. So then, loudly enough for Roy to hear, Peter stage-whispered, 'I'll pay eighty!' And turning to Roy, he said, 'Listen, if this painting belongs to your wife, it's as a security. I can give you eighty thousand and we'll deposit it in Switzerland as a sort of insurance policy.' So they concluded the sale, with Ludwig doubling the market value in one fell swoop. Later, I asked Ludwig, 'How could you do that? You're ruining the market, you can't just make prices rise that fast!' 'Never fear,' he said, 'as of now, all Roy's paintings are worth eighty. But mark my words, in ten years this paint-

Poster of a new kind, Sonnabend Gallery, Paris

ing will go for a lot more. He's an American painter in an American culture, the Americans are going to discover their own art, and ten years from now they'll pay for it.' And as it turned out, Roy's prices not only shot up overnight, but Roy called Bob Rauschenberg to tell him about the sale to Ludwig, so Bob raised his prices, and then Jasper raised his. In the space of one day, thanks to Ludwig, everyone's price doubled!"[25]

Following the lead of Panza in Varese, Ludwig in Cologne, and a few others— de Wilde, Leering, and Hammacher in Amsterdam; Hulten in Stockholm; Szeemann in Bern; Bowness and Robertson[26] in London—the sixties and seventies would see large European museums assemble top-flight collections of American art. Meanwhile in Paris, the Sonnabends went on innovating by purchasing ad space on poles to give their artists maximum visibility (a relatively cheap promotional strategy similar to that used by the Paris museums). Still they ran up against French hostility. "One February day," Raphaël Sorin recalls, "I was alone in the gallery with the Rauschenberg exhibition, including the *Monogram* goat that Pontus Hulten later bought for the Moderna Muséet. I hadn't seen a soul all day, when suddenly a man came in, took one look at the goat, spat contemptuously on the floor, and stalked out again!"[27]

The European network activated by the Sonnabend Gallery would start unraveling towards the end of the sixties, and with it gradually the precious monopoly. "I sold to Ileana and then Ileana would sell to Sperone, and she would choose what to sell and what not to sell," Castelli explained. "But with the crisis situation in the United States [in my own finances], little by little I felt obliged to sell to Sperone directly, just to survive. He accounts probably for at least one third if not one half of my sales. So I started dealing directly with two or three European dealers, which I had not done before."[28] These adversities notwithstanding, the historical irony is breathtaking—catering to Ludwig the insatiable and Panza the mystic, Castelli (an Austro-Hungarian

Toiny with the Castellis' beloved Dalmatian, Paddie

Jew born on Europe's seismic fault line, set on a path of uncommon wandering, successively driven by the rise of fascism from Italy to Romania to France) had managed, less than thirty years after landing in America, to establish a new cultural ecosystem for Europe, by creating the two largest collections of American art in fascism's former homelands.

25. THE "SVENGALI OF POP"

Pop is as legitimate to our situation as the statues of saints on the exteriors of Gothic cathedrals were to that of our ancestors.[1]

JOHN CANADAY

AS THE GERMANS and the Italians—and soon the Swedish, the Dutch, the Danish, the British, the Swiss, the Belgians—swooned over the tears of Roy Lichtenstein's helpless damsels, as they acquired a taste for Claes Oldenburg's hamburgers and his giant lipsticks, as they struggled to decipher Bob Rauschenberg's prosaic poetics, and as they cheered Jasper Johns's flags, in Paris, a pugnacious Frenchman spat on *Monogram*'s goat. Meanwhile in New York, Leo Castelli, riding high on the publicity from the 1964 Biennale, was in the process of becoming a savvy operator in the emergent media age. Since the assassination of President Kennedy in 1963, the country had entered a period of sweeping reforms. In the eyes of a commentator overseas it was as if "the programs the late president had intended to implement [were] now a sacred national heritage, as if the Americans bore a collective responsibility for the tragedy in Dallas . . . A powerful resurgence of the Roosevelt spirit carried public opinion, Congress, and the presidency . . . America was prosperous. It could afford to pass reforms that thirty years earlier would have seemed like pipe dreams or sheer profligacy. It plunged headlong into a kind of rich man's New Deal." In his speech at the University of Michigan on May 22, 1964, Lyndon Johnson unveiled his plan for the Great Society, which he said "rests on abundance and liberty for all. It demands an end to poverty and racial injustice."[2]

It was in the ambience of this Great Society, where "nothing seemed impossible," that Leo Castelli, impulsive and high-spirited as ever, went on upending the expectations of the art world. Having instituted monthly

stipends for his artists, having built mutually beneficial partnerships with institutions, such as MoMA and the Jewish Museum, having stolen fire in Venice and ignited the interest of European museums in Pop, he now set about changing—the ultimate heresy!—the ritual of New York gallery openings. "Until 1964," explained Ivan Karp, "openings were on Tuesday evenings. But certain artists had no coterie in the city, so there was Leo, me, the artist, and his girlfriend. By moving it to Saturday, we always had forty or fifty people!"[3] In *The New York Times,* Grace Glueck anointed Castelli's innovation by describing the "high season for art openings, clamorous rituals at which some 50,000 new works are unveiled each year in New York galleries and museums." With archly anthropological dispassion she isolated "a rarefied strip of Manhattan bisected by upper Madison Avenue, in which most of the city's 300-odd galleries cluster [and where] an average of 30 to 40 such viewings a week will take place from now to the end of May . . . The species [of attractions] includes the big museum blasts that lure the art world's top layer; chic uptown revels at which celebrities and members of the solvent garde (avant-gardists from above East 52nd St.) sip Scotch or champagne, and the starker off-circuit gatherings where swingers of the art 'underworld' (intelligentsia from below 14th St.) imbibe inadequate red from paper cups." Beneath the accompanying photograph of a society lady viewed from behind, her poodle on a leash as she mulls over a canvas by Roy Lichtenstein, the caption reads: "SHOPPERS' SPECIAL—The all-day Saturday opening, innovated by Leo Castelli, draws buyers, browsers and dog walkers."[4]

"What is Pop Art?" "Anti-sensibility painting." "Pop Art sells on and on— why?" In the fall of 1964, a plethora of articles asked simple questions on behalf of an untutored public: "Whether or not Pop is a new art, and whether or not it can last, it has supplied a new bandwagon," quipped one cynic. A more earnest and perhaps prescient observer remarked, "Whatever Pop Art is . . . it has arrived and gives every sign of staying around at least for a little while . . . [Its] list of converts is impressive, at least in numbers."[5] Collectively the critics showed considerable hostility towards Pop. Leo Steinberg, for instance, recalled the vote being "two against four" among panelists at a MoMA-sponsored symposium in December 1962. The surest sign of Pop's grip on the art world's imagination, however, would remain the heightened media exposure enjoyed by its leading champion, the gallerist Castelli. Undoubtedly, the cult of personal charisma played its part. We might recall Ivan Karp's comment that "there was some kind of flirtation

PARTY AT RAUSCHENBERG'S STUDIO, NEW YORK, 1965
Castelli with, FROM LEFT TO RIGHT, Gerard Malanga, Roy Lichtenstein, and Andy Warhol. In the background, between Warhol and Castelli, Ivan Karp.

around the gallery. A romantic atmosphere. And also, a receptiveness to people in general. Leo was a very social creature."[6] "Leo was invariably courteous," according to collector Donald Marron. "He had an ability to welcome you and let you know about the pictures without being didactic. Then, in addition to that, it was also a place you wanted to spend some time because of *who* came. Unlike other galleries, where people came and looked and left, in Leo's gallery, people came and looked and stayed and talked: collectors, dealers, museum curators."[7] Little by little, in successive episodes, the experience of going to see art meant participating in the spectacle that Castelli staged by the power of his persona. It is no coincidence that the birth of celebrity and the advent of the iconic image in Warhol's sense coincided with this moment. It was not the art anymore, nor was it the artists: it was the gallerist who became the object of the journalists' curiosity. As a measure of how large he loomed in the public imagination, *The New York Times* would devote an extensive profile to Castelli—the "Svengali of Pop"[8]—and Karp as the indispensable, ubiquitous duo of the decade.

The *Times* described a scene out of an old Warner Bros. movie; one

almost expects Bogart to appear. "Two men are walking briskly on East 77th Street in midafternoon carrying a lumpy, dirty gray cloth bag, the kind that might be used for gold dust or a meshed catburglar's loot. One of the men is small, trim, nattily dressed; has the face of a rodent, an intelligent, sensitive rodent, wary of scientific experiment. The other man is younger, taller, fatter, flamboyant in a red vest; his face is like a cherub's. The dirty gray bag swings jauntily from his hand.

"The small man pecks his head towards the bag. 'Careful,' he warns.

"The cherub laughs. 'Don't worry. I'm guarding it with my life.'

"The two men turn on to the east side of Lexington Avenue, walking a half-block north, then duck into an entry, climb a flight of stairs, and push open a door marked: Rudolf Granec—Picture Restorer . . . Granec had been expecting them . . .

"The two men study the painting the way a man might inspect his own face in the mirror before deciding to shave. Finally, the taller one steps forward and hangs the dirty sack—carefully chosen by the artist himself—from the pulley. The clothesline becomes taut; the bag, containing sand, drops but does not touch the floor. The idea of stress was evident.

" 'Perfect,' said Ivan Karp, the cherub, director of the Leo Castelli Gallery.

" 'Voilà,' said Leo Castelli, the smaller man." The sack completed the multidimentional Combine; "a *Studio Painting* by Robert Rauschenberg, which had been sold for $18,000, was now ready for delivery."[9]

Of course, along with attention and admiration, so much visibility attracts envy as well. Inside and outside the gallery family, tensions would soon arise. Two years earlier, with the arrival first of Lichtenstein and then of Warhol, the Castelli Gallery had embarked upon its Pop adventure and begun its meteoric ascent as media phenomenon, but this aesthetic turn was hardly predictable in a dealer whose "Old Masters" were Jasper and Bob. "Why did you put *that* in the show?" Rauschenberg had complained, indicating a Lichtenstein at a group exhibition in 1961. "Just to try it out," the cautious gallerist replied. "Leo had this custom when a new painter appeared," recalled Leo Steinberg. "He would hang it in the office where only friends would come and he would listen to what people said. I remember the first Roy Lichtenstein hanging in the back room. I wrote about it, too!"[10] The dry runs were not always so encouraging. "When Roy's work was first shown here, there were just a handful of people besides Leo and myself, mainly Robert Rosenblum and Sal Scarpitta, who were very surprised and fasci-

nated by it," Ivan Karp remembers. "We finally put a painting up in the front room. But his canvases were alien and strange, no question about it, with their references to advertising and comic books. And there was fierce antagonism to the idea of even having that kind of work in the gallery. It was much despised by artists, critics, collectors, almost universally." "Is He the Worst Artist in the U.S.?" a *Life* magazine headline asked on January 31, 1964, intentionally echoing in the negative the accolade it had heaped on Pollock fifteen years earlier: "For some of America's best known critics and a host of laymen, the answer to the above question is a resounding YES. Others insist that he is no artist at all, that his paintings of blown-up comic strips, cheap ads and reproductions are tedious copies of the banal. But an equally emphatic group of critics, museum officials and collectors find Lichtenstein's pop art 'fascinating,' 'forceful,' 'starkly beautiful.' Provocative though they are, Lichtenstein's paintings have done more than stir up controversy. They have done something significant to art. The critical stew enveloping his work is gratifying to Lichtenstein. A quiet, affable man of 40, he fully expected to be condemned for the subject matter as well as the style of his paintings. But he little dreamed that within two years of his first Pop exhibition, his canvases would be selling out at prices up to $4,000 and he himself would be a *cause célèbre* of the art world."[11]

An exploratory visit by Ileana Sonnabend to Lichtenstein's studio in New Jersey, plus enthusiastic interest in his work by collectors such as the bespectacled lion of modernist architecture, Philip Johnson, and cult artists such as Duchamp and Dalí, had trumped Castelli's initial misgivings—unlike his former wife, and his native impulse notwithstanding, he always "preferred consensus to risk."[12] Very quickly, the simplicity of *Girl with Ball* or the pride of Donald Duck the jubilant fisherman in *Look Mickey, I've Hooked a Big One!!* became synonymous with the gallery. It certainly bolstered Leo's conviction that the Castelli-Lichtenstein alliance proved highly remunerative for all concerned. "When I saw the Lichtenstein show in 1962 at Castelli," the professor-critic Robert Rosenblum confessed, "I did not connect it with the show that I saw in 1954 at Keller, that is, with the same artist . . . Post-Castelli it was very different, it was as if he were reborn . . . The Gallery became a salon, a kaffeeklatsch, where the artists got to know each other pretty well. I remember constantly going up there to sit around and chat."[13] This financial windfall resulted in large part from Lichtenstein's incredible productivity. The artist typically sold eighteen to twenty-five paintings a year, and at high

prices. By 1990, his *Reflections On "The Artist's Studio"* went for $1,600,000; his total sales for that year topped $8 million, on which Castelli received his share of $800,000.

Roy Lichtenstein, for his part, would never mince words when expressing his gratitude for "Leo's support, which permitted me, for one thing, to afford the canvas. And it provided a good intellectual environment as well. I don't feel that there's any pressure to produce the same things, or that I should stay in one place just to please the market."[14] With his gentle charisma and grinning eagle profile, his vast knowledge of art and prolific imagination, Lichtenstein would gradually bewitch the gallerist; before long, he and his wife, Dorothy—an indispensable partner with an alert mind, throaty voice, and uncommon elegance—became close friends of the Castellis. Lichtenstein's work, the expression of an equally harmonious alliance, would grow in imaginative depth as the years progressed. "The cliché is a cliché if you don't know anything else," he explained, describing the impact of his canvases, "but if you can alter this cliché slightly, to make it do something else in the painting, it still seems to retain its cliché quality to people looking at it."[15] Through the 1970s, his sales would skyrocket and, thanks to his prolificacy, his work became a gallery mainstay. And in return the gallery offered the artist, as it always had, a home like no other. "Leo was such an amazing combination of different things," Robert Storr said. "He never had a contract with any of his artists, but he never let them down, he would pay them no matter what. I know Roy and probably Jasper felt the most loyalty. One of the things that made him so successful was that he had this big worldview and the European connection. That was a very big thing."[16]

During those years when Castelli, with the help of his team, became the "Vollard of the late twentieth century," inventing his own role as "collaborator with his artists," is any credence due that representation of him by the "paper of record" as a "Svengali of Pop"? A few years after the arrival of Lichtenstein, Andy Warhol's inclusion in his stable would prove, if anything, more problematic. From the outset, Castelli never felt entirely comfortable with Warhol, and as with Rauschenberg and Lichtenstein, the intuition and initiative of Ileana Sonnabend, more attuned to young artists, more sensitive to emerging talents, had largely enabled the process. In 1959, Warhol was a young and gifted commercial illustrator who had come from Pittsburgh ten years earlier and was now brooding in solitude, stuck at a dead end. He frequented the Castelli Gallery and admired Johns and Rauschenberg, some of

4 EAST SEVENTY-SEVENTH STREET, NEW YORK
In the sixties, all kinds of personalities celebrate the "Svengali of Pop": here, Salvador Dalí visits the gallery, offering comment on Jasper Johns's works with the help of his legendary cane.

whose work he bought while obstinately (and fruitlessly) offering his own to Ivan Karp. Sonnabend perceived Warhol's potential right away when the artist came to the gallery as a collector. Even more, she empathized with his nature. She recalled her admiration for the "very beautiful drawings of shoes, Coke bottles, and airmail stamps," as well as her feeling for his isolation in the city. "He told me he had no friends. I used to call on him regularly and we'd go to a penny arcade on Forty-second Street filled with odd characters, like the gentleman who wore a very elegant tuxedo and made fleas dance on a large green baize, like in a gambling club. The fleas all had names and the man, holding a pair of gold tweezers, opened his box and called them by name: 'Come on, come out of there, Rosy. Rosy!' "[17]

Was it due to Castelli's resistance or to Warhol's fragility that the gallerist would miss the first blush of the artist's success? "I told Andy that he seemed to be pretty close to Lichtenstein, whom I had met before, Castelli recalled. Therefore, I couldn't have two artists competing in the same direction in the gallery. He was very distressed about that. I asked him if anybody else had been interested in his work, and he said Eleanor Ward had been. So I said,

'Then do go to Eleanor Ward because in my gallery there would be this conflict. There you would be happy. She wants you very badly.' So he went reluctantly, but finally got back to me after it became quite obvious that I had completely misunderstood what he was about."[18] If Castelli could admit a misjudgment, Warhol would not hold it against him—such was the latter's eagerness for his work to be seen in the former's aura. An interesting paradox of art history deserves our pausing to note it. In 1960, Warhol felt trapped in the role of illustrator, just as his American progenitors had languished as "sign-painters." In both the nineteenth and twentieth centuries, such designations relegating painters to artisan status at best had poisoned the spirits of American artists trapped in their essentially philistine society. So when Warhol desperately sought out Castelli, it was a call to be rescued from his marginal position, a call that could only be answered by one of the rare ambassadors of the European tradition, whose regard for true artists was the gold standard of respectability. It came, coincidentally, at the very moment that the gallerist was in the process of elevating the artist generally in the United States. So, we might ask, how could Castelli fail to hear the plea of an artist whose work was as reflective of Castelli's mission as any artist's could be? Are Castelli's justifications persuasive, or do they mask the appearance of a blind spot in this consummate professional: an unease with an artist too flamboyantly gay? (Leo was after all a devout and exultant heterosexual.) Or was it perhaps a discomfort with one not so polished in his art as Johns or Stella, the sort who had sparked Leo's famous epiphanies? This may be, although conceptually Warhol can now be located midway between a John Sloan and a David Hockney.

Castelli didn't really struggle much to understand the artist's hunger for recognition nor to discern—behind Warhol's fascination with the media, with celebrity, with consumerism—the intellect of a genius about to explode. Nor did he understand that in the Factory—the atelier at 231 East Forty-seventh Street that the artist papered entirely in silver (the reflective surface celebrating or enabling narcissism?)—Warhol was pioneering, with his silk screens, a new form of continuous and collective production, ordaining as artists his own band of outsiders (through whose eyes the artist viewed the world and whom he vampirized). "That place was the vortex of the Warhol legend," wrote Raphaël Sorin. "Mirror ball. Staved-in sofa. Stocky little guy [Gerard Malanga]. 'Hello.' Andy comes in. Andy goes back out. Andy, 'the lovechild of Lumière and Duchamp.' "[19] Thomas Crow

PARTY AT ANDY WARHOL'S FACTORY, NEW YORK, 1964
With Toiny Castelli, SECOND ROW, LEFT, Henry Geldzahler, in sunglasses, FRONT RIGHT, and Alan Solomon
and Kay Bearman, FAR RIGHT

insightfully evokes the ethos: "Warhol came to produce his most powerful
paintings by dramatizing the hollowness of the consumer icon: that is,
events in which the mass-produced image [served as] the bearer of desires
were exposed in their inadequacy by the reality of suffering and death. Into
this category, for example, falls his most famous portrait series, that of Mari-
lyn Monroe, which is as much about the pathos of celebrity identification as
about celebration of the star."[20]

It was the curator Walter Hopps who, together with Irving Blum—the
actor turned gallerist with a voice imposingly rich, a Shakespearean brow
formidably darkened—offered Warhol his first solo exhibition, in June 1962,
at the Ferus Gallery in Los Angeles, which they jointly managed. In 1958, the
gallery had been established by Hopps, the painter Edward Keinholz, and
the poet Bob Alexander. A handsome, brilliant, and well-read giant of a man,
Hopps is warmly remembered by Christophe de Menil as "an excellent
speaker, very bold and very opinionated, a true genius with an incredible
eye, and, above all, extremely respected by the artists."[21] Warhol's work had
immediately appealed to both directors. "When I saw the *Campbell's Soup*

Can series in his New York studio," Walter Hopps recalled, "I said to Warhol, 'I absolutely must take your work and show it in Los Angeles!' And Andy, who had never been to California, got all excited: 'California—that's Hollywood!' he said, sitting amid a stack of magazines scattered across the floor so chaotically that you couldn't move about the room."[22] As for Blum, who had met Warhol through Ivan Karp, he was ready to plunge into the deep end in order to show the entire series of *Campbell's Soup Cans:* thirty-two rigorously identical canvases, each sixteen by twenty inches, presented in the form of a "cool, clean, distant image,"[23] with the only variable being the variety of soup indicated on the label (Black Bean, Vegetarian Vegetable, Chicken Broth, Beef and Carrots, Tomato)—collectively an anthem to the absurd and grandiose poetry of everyday American life.

The flourishing of Castelli's artists in California had been seeded several years earlier, thanks to Hopps and Blum's audacious steps, as well as to Castelli's astute recognition of his colleagues' capacity to build a true West Coast network. "I couldn't afford to come to New York even once a year," Blum recalled. "So I went to see Leo and I said, 'I represent a number of artists that you've never heard of, they're from California, Ed Moses, Ed Ruscha, and on and on. They're incredibly interested in Jasper and they've only seen magazine reproductions of his work. So, can we do something?' He said to me, 'The artist does *very* few paintings. *Everything* he does I can sell. I have a waiting list. And he virtually supports my gallery. And so you can see how difficult it is. However, go see him, and maybe something will happen.' So, I called Jasper. In his studio was a long table, and on this table, sculptures: ale cans, Savarin coffee cans, light bulbs. I said, 'What's this?' He said, 'I've been thinking about sculpture and I'm making this.' And meanwhile, I'm thinking, thinking, thinking, and finally I told him how important it would be for him to show in California. And I said I'd got an idea. I said, 'Schwitters collages and your sculptures.' And he said, 'Where will you get Schwitters?' I said, 'I know a German lady who lives in Pasadena, and she owns some Schwitters. I can get them from her.' And he said, 'Get the Schwitters, I'll send the sculpture.' In 1960 I had the show: Schwitters, Jasper Johns. Leo was thrilled."[24] Reciprocity and symbiosis—Castelli was naturally an almost effortless minister to both.

At the same time, Castelli had met Ed Ruscha, one of Blum's California artists, and would eventually show his work in New York. "In 1961, I went to Leo's gallery and showed him the stack of paintings on paper that I had done

while traveling to Europe," Ruscha recalls. "He seemed to be impressed and said, 'I'd love to do something with you at some time in the future . . . Let me show you something.' He took me to the back and showed me this tennis shoe by Roy [Lichtenstein]. I was stunned, really shocked! Here was an artist who was bringing the grotesque into the world of art, there was no good taste in it. I did not like it at first, it was hard to swallow, but in the end it was profound. That work influenced me deeply. Most of the art Leo supported was like Roy's; it would not sell at first and the artists that he accepted wouldn't sell themselves easily. It took *Leo* to bridge the gap. Ten years later, when Leo started showing my work, I became part of his stable of artists and, later on, I received a monthly allowance, but without ever having signed a contract. The funny thing is that this man, with his severe look and his European elegance, always had the mind of a youngster. That's what was so intriguing about Leo; he had a very youthful take on things. I did this drawing *Three . . . Two Valiums*. Leo said, 'Oh, Ed, I wouldn't like to take that.' He was always willing to look at the ironic side of things, and that was part of his charm."[25]

Just as the west coast was developing connections to New York, so were some Old World cities. Already, the New York art scene had started to attract a lot of interest overseas: in London, Tony Shafrazi, an energetic twenty-two-year-old Armenian artist, born in Iran, had just received a visa to the United States and plunged into the city for two weeks during the spring of 1965. By sheer luck, within his first two days, he bumped into Andy Warhol and Roy Lichtenstein. Amazed by the atmosphere of their studios, Shafrazi was instantaneously pulled into their world, studying their work, offering his help, suggesting approaches, following them around. With Lichtenstein, he found himself helping to ferry sculptures by cab uptown, into a place that he understood to be a gallery. Shafrazi's first encounter with Castelli, who turned him, on the spot, into a collector, is a pivotal moment, vintage Castelli. "A gentleman walks towards us," Shafrazi explains today. "A smallish, very lean, very thin, clean-cut man with a razor-sharp thin suit, obviously an Italian suit, tailor made. With open arms, he goes: 'Ohhh,' welcoming Roy.—'This young man is Tony Shafrazi, he's a young artist from England visiting me,' says Roy.—'Any friend of Roy's is a friend of mine! Welcome!' Leo says. I see a print of Roy Lichtenstein, a science fiction city and also a close-up of a lady's foot, black and white, with a lady's hand going there with cotton between the toes.—'Wow! These are great!,' I say. They

are both excited by the fact that I am excited.—'You like it so much!' says Leo, 'it would give me pleasure if you had them in your collection.'—'But Mr. Castelli, I'm just a student, I'm only traveling here,' I answer.—'Well, since you're an artist, and you're a friend of Roy's, I'm sure that we can do something,' he adds. I didn't know, I had no idea, I had never bought any art in my life, not even thought about it. I don't know how Leo did this, because I *did* buy these prints, I don't even know how I paid for them. Leo said things in a really easy and light way, as if it was nothing at all, showing that, of course, it was doable."[26]

While the Castelli Gallery worked such alchemy for young New York, Californian, and European artists, with new collectors amassing blue-chip investments for tomorrow by betting on Pop, Castelli himself would sometimes feel outflanked by other gallerists or curators, younger, bolder, and with more cutting-edge sensibilities. But mostly these actors only fired his impulse to look ahead, always and ever a key to his success. Among these forces: his ex-wife, Ileana Sonnabend; his assistant director, Ivan Karp; the director of the Green Gallery, Dick Bellamy; and especially the meteoric new personality who landed in New York in 1960 with the title of assistant curator for contemporary art at the Metropolitan Museum, Henry Geldzahler (about him, more shortly). In the same way the lesson of his initial deflection of Andy Warhol was not lost on Leo Castelli. The missed opportunity from 1961–64 coincided with the artist's most vertiginously creative years, which yielded a plethora of very powerful images commemorating the "time when the supermarket promise of safe and abundant packaged food was disastrously broken." By inscribing his variations on the theme of pain, sometimes in the guise of Marilyn Monroe, Jackie Kennedy, and Elizabeth Taylor, sometimes in the form of *Tunafish Disaster* and *Electric Chairs,* by "dramatizing the breakdown of commodity exchange," and by probing the "open sores in American political life," Warhol unveiled a "stark, disabused, pessimistic vision" of his country, in a phase of *'peinture noire'* that he would never again revisit.[27] Christophe de Menil, then a young political radical and observer of the New York scene, recalls, "He could hold forth on the politics of his day in a voice that barely rose above a whisper, but with such daring and incisiveness. On that subject, he was *always* right, and he could talk about it brilliantly!"[28] Leo, with a true intellectual's vision but an immigrant's caution, would see this only belatedly.

In January of 1964, Sonnabend would give Warhol his first Paris show

around a theme she coined: "Death in America." It was a masterstroke, revealing the knockout power of Pop Art while accommodating the French audience's traditional revulsion to it. By including some of the gloomiest elements of American society, the show was calculated to engage the Parisian intelligentsia who, in Warhol's view, had never properly appreciated the pathos behind the images of over-the-top consumerism. "Warhol has situated death at a level that Westerns have been struggling to reach in film,"[29] wrote Jean-Jacques Lebel. "Why does Warhol affect us?" asked Alain Jouffroy. "We find ourselves submerged in pure tragedy . . . Ripped from the context of the mainstream press, from the indiscriminate flood of information broadcast in every direction and at all times, his images become sacred icons in a godless world."[30] Commented Gérard Gassiot-Talbot, "Before, Warhol showed us popular merchandise symbolizing America's mythical abundance. Now he inventories that society's horrors and malaise, but couched in the same way."[31] As for the American expatriate poet John Ashbery, he offered the artist high praise indeed, hailing him in French terms: "This is a decisive step in the history of Pop Art . . . With Warhol, his most recent art has become unmistakably polemical, or as the French say, *engagé*."[32] Warhol himself would later sum up the demystification of American society he had effected. "You see houses everywhere, the green lawns with the sprinklers, the jungle gyms in the backyards, the kids riding their bikes to school, the mailman coming by with a smile, a woman unloading bags of groceries from her station wagon, and you can't help but think, 'This is the real America.' But then you start learning the details. You find out the nice man who always had an extra piece of gum to give you has gone completely off his rocker and killed his wife, that the ex-minister of the church you grew up in is now a big drunk who's totaled three cars . . . that your best friend's parents who were always so great are getting a divorce . . . that the girl you had a crush on in elementary school is now a religious fanatic . . . Nobody in America has a normal life."[33] The French, for their part, could find satisfaction in the conviction that American banality was merely a utopian affectation.

But one would have to wait until November 21, 1964, to attend Warhol's first exhibition at Castelli with the presentation of *Flower Paintings*. His dark phase over, his point having been made after Paris, the artist was now embarking on his *Celebrities* series, which demonstrated his talent for discovering the new and showed him working in a rather softened mode.

In 1966, when a nineteen-year-old Peter Brant, future media baron and

newsprint tycoon, stepped into the Castelli Gallery, a strong bond began to form between the two men almost immediately. Over the years, Castelli would become Brant's mentor, while Brant would play a key role in the rise of Warhol. Interestingly, Brant provides a contrary view of Warhol's attachment to the gallery; in his version, the magnetic force was Leo. "Andy had a lot of respect for Ileana, her eye, her love for furniture, but he respected her in a motherly sense. Andy really loved Leo, even if, later, he was hurt when Leo decided not to show those dollar sign paintings, and, instead, to put them in the basement of his Greene Street Gallery." This is not to say that Brant believed Castelli continued to harbor his initial doubts. Once Castelli committed to an artist, Brant noted, he was all in. "Leo knew that Andy was a very important artist, and when I started collecting in 1966, he really pushed me to Andy. In the following years, I bought the big *Flowers* from him, as well as the *Electric Chairs*."[34] Brant does shed some light on the Castelli-Warhol uneasiness. "It was Fred Hughes who did not handle things the right way. He would make deals and even sell to other people, to Bischofberger, for example." And Leo Castelli, despite his loyalty to his artists, did not happily suffer interference with his patented formula for success by meticulous control! "The way Leo liked to do business was to deal directly with the artists and then represent them to other dealers," Brant explains. "He would make an arrangement with Blum in California, Helman or Greenberg in Saint Louis, and then they would have a show."[35] The critic Glenn O'Brien comments, "If Andy was not at ease with Leo, it was because of the initial effort to get into the gallery, something he never forgot!"[36]

Throughout it all, Warhol's most consistent American champion would be not a dealer but a curator, Henry Geldzahler. Geldzahler had come to New York from Harvard grad school in the summer of 1960 and taken a curatorial job at the Met. His arrival helped spark a new dynamic among galleries, museums, artists, curators, and dealers; Castelli's dominance, until then unquestioned, suddenly felt rather precarious. Once outed as a Svengali, one can keep up that image only so long. Castelli's progress towards a more sustainable, less sinister-sounding preeminence would, like all his achievements, depend upon his quasi-familial support system. Besides, in 1964, getting Maurice Kanbar as a new landlord (he bought the townhouse at 4 East Seventy-seventh Street from Michael Strate), Castelli gained a new supporter. "I inherited Leo Castelli as a tenant. He was the finest gentleman,

an incredible art connoisseur. I would see him daily because I lived on the fifth floor: his gallery gave status to the building!"[37]

In the gallery, along with Ivan Karp, Leo was assisted by Connie Trimble, the wife of a composer, who would remain an institutional stalwart. According to Karp, "she worked very hard. She worked all day long. She never went out for lunch that I can remember. She was bookkeeper and accountant and everything." "Connie came to me through *The New York Times,*" said Castelli. "She advertised herself as a girl Friday, and she really was. She was here for a long time, and she was very good. I was heartbroken when she left because her husband got a job in Washington. The next one was Nina Sutherland, then Kay Bearman came to me, who had been Henry's secretary. She was very efficient and very good."[38] With her large black eyes, husky voice, and temperate nature, Kay would spend four years at the gallery. Born in Memphis, Tennessee, she graduated from Smith College, and was introduced to Geldzahler by her brother Leo, his classmate at Yale. "I was close to Ivan Karp," she recalled. "We would start working around nine to ten a.m. every day except Sunday and Monday. I was answering the phone, writing letters, dealing with artists, and keeping the archives, but didn't sell anything. Leo was suave, Ivan was rough—two opposite types that complemented each other. Leo would only see artists that other artists recommended, and he would have long conversations on the phone with Ileana, who was living in Paris."[39] After Kay Berman, Castelli's next assistant would be Barbara Wool, a smart and beautiful young woman from a prominent New York family. After three years, she left because "the triangle between Leo, Toiny and [her] became unsupportable."[40]

Also infusing new blood into the gallery, hired in the fall of 1963 as a curator to complement Ivan Karp's role, was David Whitney, a recent graduate in interior architecture from the Rhode Island School of Design and, since 1960, the companion of Philip Johnson. Endowed with a quick and cutting wit, good instincts, and a true passion for art, Whitney toured artists' studios tirelessly and in the process became a close friend of Jasper Johns. The young curator brought the gallery an undeniable cachet and attracted to it the growing openly gay segment of the art community. He would also recruit David White, a friend from RISD, as the gallery's assistant. At a time when anyone over thirty was suspect, the young learned to work around their elders. "David Whitney announced, 'I'll tell you what to do. Leo won't be a problem,'" White recalls today. "At first, I did the art handling, picked up

THE RICE MUSEUM, HOUSTON, OCTOBER 5, 1972
With his trusted same team at the opening of "Dan Flavin: Cornered Fluorescent Light." FROM LEFT TO RIGHT:
artist Dan Flavin, gallery director David Whitney, collector Barbara Jakobson, and assistant David White

pieces from artists' studios and loaded them in the truck, made deliveries, helped set up shows, typed labels for photographs and envelopes, emptied ashtrays and garbage. Later, after Whitney left, I replaced him in installing the shows. Leo was very busy seeing important people. He was European, elegant, sophisticated, polyglot, connected. He was the boss, and, as such, he was perfectly fair—we never had to work late, were always paid on time, and were given posters after the shows. Leo was very deferential to his artists; whenever one of them wanted something, he would say, 'Fine!' Leo thought the world of Jasper! With the museum people who came to the gallery, Leo was charming. With the collectors, he was gallant, effusive. Only once did I see him abrupt in front of someone: the day Bob Scull wanted to buy a whole show of Jasper."[41]

With the generation gap now yawning wide across the nation, Castelli found himself for the first time on the staid side of a social divide. In 1965 (the year of the Who's hit "My Generation"), Castelli's younger artists and associates—Frank Stella (twenty-nine), Henry Geldzahler (thirty), the two Davids (both twenty-seven), and Kay (twenty-six)—would get together in the evening for dinner in Chinatown, while Castelli (aged fifty-eight) remained habitually uptown. During the sixties, the gallery became an

unavoidable cultural institution, a beacon welcoming art lovers the world over. "You could borrow magazines. You could go through the photograph files. You could go through everything we had," explained Karp. "And everything was always very well maintained. You could always find the records. And it was open to everybody. We gave photographs to every art historian, every art critic, every museum for the asking. We received letters from Russia and Turkey and Hungary regularly . . . And Leo was always happy to receive the international museum directors and curators with the greatest courtesy."[42] Karp spoke in his rapid patter of thick Brooklynese, and tended towards snap decisions, in contrast to Castelli's deliberate *mitteleuropäische* restraint. One day an argument revealed the gap dividing them, culturally, generationally: "Life goes on," said Karp, shrugging with his final word. "No, life does not go on!"[43] Castelli fired back, hammering every syllable.

26. HENRY'S SHOW

After 1965, there were ups and downs and perhaps things weren't that simple anymore: all kinds of complex countercurrents had developed. There was a strong reaction against what I (and Solomon) had been doing, on the part of the forces of Greenberg helped effectively by Geldzahler, who was on the side of Greenberg, after having been very involved with Andy.[1]

LEO CASTELLI

In the end, Henry was by far the most powerful.[2]

FRANK STELLA

"I SELDOM HAD a cross word with Leo," André Emmerich, Castelli's fellow eponymous gallerist and East Side neighbor, attests. "In the sixties, we both participated in Documenta IV in Kassel. Among the American artists were Larry Poons and Al Held. The paintings curator for the show was Jan Leering, a Dutchman. Since I knew Dutch, which Leo didn't, I spoke Dutch to Leering, who gave my painter the best room and dropped Leo's painter Larry Poons! Later we laughed about it."[3] Seventeen years Castelli's junior and also of European Jewish origin, Emmerich had opened his gallery four years before Leo, at 18 East Seventy-seventh Street, and specialized in Color Field painters. The late sixties would see a series of skirmishes among dealers from which Castelli would emerge sometimes the victor, sometimes the vanquished, amid a remarkably uneasy balance of power. The New York scene was already undergoing a generational shift with the arrival of the shy, charmingly dishevelled new dealer Richard Bellamy, "a candid and insightful man," according to Christophe de Menil, "very focused and very open," who "was interested not only in Pop Art but also in poetry and literature, [who] managed to capture the ear of Philip Johnson and the Sculls, even though he lived like a nomad!"[4]

But it was Henry Geldzahler, another member of the rising generation,

who would most overtly throw down the gauntlet to challenge Castelli's primacy. Let us return for a moment to the 1966 Venice Biennale, two years after Solomon's coup, when Geldzahler became the official commissioner, thus mounting for this august event the first show to bear his signature. "There was a good Biennale that Henry Geldzahler organized that had Lichtenstein, Kelly, Helen Frankenthaler, and Olitski, a good well-balanced affair," Castelli recalled. "But then Henry went out all the way to say that the prize system was just ridiculous, he wrote a manifesto on why a jury was sitting there to confer the prize, which then in a ridiculous way went to a dark horse, because there was so much politics that the people who really deserved it didn't get it, nobody would dare give it to Lichtenstein although he was the favorite! The chief reason was that it was not possible to give the prize to an American twice in a row."[5]

Geldzahler had been approached to take over the American pavilion after the Guggenheim's Lawrence Alloway resigned, and the pinch hitter would later lament the whole affair as "the worst experience I've ever had in my life. Just the trickery and the deceit and the whole second-rate nature of the way people behaved. I came out of it with an ulcer!"[6] Once appointed, he made his choices very quickly, selecting Frankenthaler, Kelly, Lichtenstein, and Olitski because "all of them were involved in color in various ways. I knew that there were four rooms at the Biennale pavilion, and it just struck me that it would be a colorful, adventurous and yet classical way of putting it together."[7] A notable absence was his friend Warhol, who never got over the "exclusion," which Geldzahler justified not only in terms of aesthetic criteria ("I didn't think of Andy as a colorist so that the sort of greyed Warhols wouldn't have worked for the color thing that I had in mind")[8] but also professional considerations—namely, the fear that certain Metropolitan trustees, already skittish about his media antics, would pull the plug on his job. As Geldzahler explained, "A *Life* magazine article had just come out on me showing me in the swimming pool. The trustees were very edgy about me. Andy then had the Velvet Underground and was starting the film thing. I knew that if I took him to Venice there'd be a fantastic amount of publicity . . . and I'd become a super Pop figure. It just was a career decision I made."[9]

Did the rejection of a major Pop artist (albeit one not yet officially from his gallery) irk Castelli? In retrospect, it seems that cultural elites' snobbishness towards Pop, going against the keen interest shown by collectors of less conventional backgrounds,[10] further chilled the Geldzahler-Castelli relation-

ship to the point of cold war. It is something of a paradox: by temperament, Geldzahler gravitated towards Pop, though his job required a certain level of decorousness because he represented a proper, conventional institution. Castelli, on the other hand, though the product of an earlier generation, removed from the culture of Happenings, had tapped directly into the market and its growing animal spirits, with no queasiness about the new, so long as he thought it was good, and in this he was sustained by "the accelerated rhythm of acquisitions and media attention." In fact, the Geldzahler-Castelli divide mirrored the larger discord between museum and marketplace, the intergenerational role reversal notwithstanding. "Leo had been in a rage that I had dared to choose my four people without consulting with him," said Geldzahler, "and only one was from his gallery, and there wasn't enough Pop Art. Where was Warhol? Where was Rosenquist? And he was going to set up a counter-Biennale somewhere else in Venice. And wasn't I terrible and independent? And I didn't understand the Italians as well as he did. And he was murmuring and muttering this stuff all over New York and Europe. I met him at the Biennale the day before the opening and I went up to him and shook his hand and a photographer got that moment. I thought it was amusing."[11]

The tensions between Castelli and Geldzahler did not escape the press's notice. Hilton Kramer was among the first to note that "only Mr. Lichtenstein, the pop artist, seems to excite much interest here. He has, of course, the advantage of an immense amount of advance publicity carefully prepared by his American dealer, Leo Castelli . . . The bookshops here are prominently displaying [books and magazines] featuring Mr. Lichtenstein on their covers [but have] nothing about the other Americans showing here. At yesterday's press reception," Kramer went on, "the only man acting like a host in the American Pavilion was Leo Castelli, the man generally credited with 'arranging' the prize for Robert Rauschenberg two years ago . . . Despite the machinations on Mr. Lichtenstein's behalf, however, the feeling here is that no American will be allowed to capture a top award this year. Resentment over the award to Mr. Rauschenberg two years ago still runs high and it seems unlikely that the jury, on which the United States is not represented this year, will want to risk another scandal."[12] Indeed, despite his dealer's best efforts, the prize eluded Lichtenstein, and Castelli went home empty-handed.

On February 4, 1967, at 4 East Seventy-seventh Street, an exhibition entitled Leo Castelli's Ten Years opened, showing the sixteen artists from the gallery's "current impressive stable," according to the accompanying cata-

logue. Edited by David Whitney, it contained some twenty essays by critics, curators, dealers, professors, journalists, and friends, focusing on Castelli's accomplishments over the previous decade. Someone—the French critic Otto Hahn as it happened—naturally had to address the dealer's less-than-upright image abroad, noting that "there are those, in Europe, who delight in portraying Leo Castelli as the brain of a new sort of crime ring. Surrounded by Yes-men and backed by millionaires, his vast organization is, they assume, out to buy up Biennale juries, the press, the critics and museums. The motive is Art's destruction and the list of charges reads as follows: declaration of war on Paris, the desire to bring about the downfall of Europe, the unleashing of a horde of barbaric painters upon the civilization of the Occident." In his essay, however, Alan Solomon rushed to his friend's defense: "Leo is very misunderstood. In Venice, in 1964, he was supposed to be buying me, the jury, the administration of the Biennale, exercising his enormous power to win the prize for Rauschenberg. Actually, he was busy sorting out tickets for the Cunningham concert, helping us paste up labels (on other dealers' artists), and getting hoarse in the Piazza talking in those six languages while most of the other Americans shifted uncomfortably from foot to foot."

More generally, contributors tried to define the "Castelli phenomenon," constructing piecemeal a portrait of a new kind of dealer: entrepreneur, explorer, risk taker, jack-of-all-trades, equally at ease deploying aggressive marketing techniques and channeling the missionary zeal of the cultural evangelist. But there was more. "Leo has not only encouraged artists directly, he has helped to make the whole country art-conscious through his cooperation with curators, critics, and writers," wrote the critic Barbara Rose, then married to Frank Stella. "Whether the creation of a mass public is a good thing or not . . . it has, at any rate, resulted in a government program of aid to the arts that was previously unthinkable in this country. Leo's activities have in large measure stimulated this new interest in art . . . Castelli's was from the beginning an artists' gallery. Leo has never, to my knowledge, attempted to influence an artist's work. Typically, when a number of the gallery artists started to work on a new scale, Leo made his door larger . . . Leo's personal relationship with his artists makes him nearly unique among art dealers (Kahnweiler and Stieglitz are the only two others who come to mind). Leo was one of the very few New York dealers to treat his artists as social equals. This may not sound like much now, but ten years ago the

American artist wasn't the hero of the jet set he is today." As *apologia pro vita Leonis,* it could have served handily at the Last Judgment.

Beyond praising the Castelli Gallery as a cultural institution, Otto Hahn managed best to capture the gallerist's greatest legacy as a pioneer on the new international art scene: his creation of a global market for American art where none existed before. "In establishing his style, Leo Castelli has unsettled things. He is unsettling because he was the first American to understand that art might become a kind of international intellectual community, and that this in turn required a break with the isolationist tendencies of the Abstract Expressionists, who were, so to speak, somewhat stay-at-home, exhibiting only rarely in Europe. Leo Castelli was the first to understand that only on the basis of this international audience could one create a group of American collectors prepared to support a product generally considered 'provincial.' And he understood, as well, that television, advertising and the press now constitute art's fourth dimension, a fundamental aspect of its temporal realization, and that one had to come to terms with the mass media. By assuming, in addition to the role of dealer, that of manager, public relations man, cultural adviser and disseminator of ideas, Leo Castelli set off a process of change and renewal which continues, even now, to transform the roles of the artist and his art, to redefine the relationship of that art to its public . . . What does matter, however, for the writer in Rome, the museum visitor in Amsterdam, the Parisian student, the New York critic, the painter from Tokyo and the Sao Paulo architect and what will continue to matter in fifty years or in a century's time, is the cultural aspect of this phenomenon. For culture is common property and international in character, whatever the nationality and ownership of a given work of art may be. It is in this sense that Leo Castelli, Condottiere of Culture, deserves well of us."

If Hahn brilliantly foresaw as early as 1967 the future of the art market, as it would build on strategies invented by Castelli—a skillful global operator since his days as a twenty-three-year-old insurance salesman in Trieste—his analysis is certainly seconded in Leo Steinberg's observation that "you hear about repercussions in Venice and Tokyo. The Gallery has no settled circumference. But its refluent center is New York City where the scouting is done." Mainly, however, Steinberg delineated Castelli's work as cultural go-between: "Castelli himself is of European culture. He enjoys what is nakedly American in American art and rejects the puritanism in American critics. While our avant-garde formalists explain that works of art ought to be flat

and pure and free of anything that smells of non-art, Castelli's wall and floor spaces accommodate adventurous formalism and unforeseen contaminations." This identity as intermediary was also described, if more archly, by Annette Michelson, who tells of Castelli "emerging from a recent party into early morning air, remark[ing] that he had spent much of the evening reminiscing in a quiet corner about another, long past occasion and the New York of that time—the 40s. Sighing, he then murmured. *'J'ai plus de souvenirs que si j'avais mille ans.'* The nostalgia and ambiguity of the allusion evoked the very situation of the man, European in sensibility and style, his role and career as witness and agent, straddling two cultures and at least two historical periods." And so the mythopoeia under way for decades had now reached the concentration levels of testimonial!

It was as well the world Castelli built around himself that Max Kozloff, editor of *Artforum,* also recognized, i.e., the gallerist's "didactic force to win over the massively hostile environment." He declared that he had found "the archival and bibliographical resources at Castelli . . . models of their kind. More than that, I am sure I am not alone when I say that the place early came to, and still does, function as an informal meeting house of ideas, artistic events, and people, in constantly varying, but valuable combinations." But always to the man each writer would return, as inexhaustible phenomenon, sometimes the opposite of every preconception. Calvin Tomkins recalled a dinner when Castelli had been wounded by negative comments about him in the press: "In Leo's absence, the answer came from Jasper Johns. 'The thing that nobody gets about Leo at first is that he's very naive,' Jasper said. 'Leo is always getting carried away. He likes people and he feels emotionally about them, which means he's always going to be vulnerable.' "

A poem by John Cage was also included in the exhibition catalogue, saying almost everything:

> part and parceL
> > Eighth street artists club an
> > Old friend he
> > CAme to
> > front STreet
> > with Eyes that were open
> when other eyes were cLosed
> > now peopLe see eye to eye
> > hIs eyes [13]

In that same year, Alan Solomon, who had been forced to step down as director of the Jewish Museum in 1964, was named curator of the American pavilion at the Montreal World's Fair ("Expo '67"). There, the United States would shine more brightly than ever thanks to the genius of the legendary architect Buckminster Fuller, who built a resplendent geodesic dome more than 250 feet in diameter: transparent by day, gleaming like a diamond by night. Presenting the theme Creative America, the dome housed several hundred artworks on six levels, chosen to illustrate American popular culture, industry, and the space race. For the section American Painting Today, Solomon gathered twenty-three works by the most prominent American artists of the 1960s—more than half from Castelli's stable: James Rosenquist, Claes Oldenburg, Andy Warhol, Jasper Johns, Jim Dine, Ellsworth Kelly, Barnett Newman, Robert Rauschenberg, and Roy Lichtenstein. Hanging on long, white movable partitions, the works, several of them gigantic, seemed to float in space. For the occasion, Andy Warhol executed a similarly outsized self-portrait. Jasper Johns created a vast map of the world in twelve panels based on Buckminster Fuller's Dymaxion Air Ocean World published in 1943. For America, he included Canada, the United States and Mexico. A political statement?

After Solomon, it was Geldzahler's turn to take up the baton again for American contemporary art. On Saturday, October 18, 1969, the Metropolitan Museum inaugurated New York Painting and Sculpture, 1940–1970, a blockbuster exhibition of more than four hundred works, which would draw more than 254,000 visitors as well as a chorus of breathless description. From the dealer and critic Robert Pincus-Witten: "Utterly remarkable, extremely important and controversial";[14] Calvin Trillin: "A revelation from a traditional museum which, so far, would only recognize artists once dead";[15] Calvin Tomkins: "Immediately controversial, organized as a major event by a curator who did everything himself with no team, in such a powerful institution";[16] and Robert Storr: "Exciting and innovative, with incredible variety and lots of dynamic forms and colors, and a true historical perspective: there were things you hadn't seen before in those huge rooms at the Met."[17] "It was encyclopedic and convincing," enthused Frank Stella. "It pulled American painting over the top. Nothing like that had happened before in American art." Taking sides for once with his dealer's adversary, Stella added, "Picking on Henry was easy. It was easy to point out the gaps in his show. But Henry did something that Leo and the Modern could not do: he extended American art, made it better, historical."[18]

Were such impressions of novelty and of grandeur justified? Certainly a statement was made by the unprecedented use of the Met's entire second floor, which, for the occasion, was cleared of its permanent collection—Giottos, Rembrandts, and Impressionists—to make room for Larry Poons, Donald Judd, Roy Lichtenstein, Jackson Pollock, and Joseph Cornell. There was also the fact that "Henry's Show," as his friends would begin calling it, coincided with the centenary of the museum—"the most extraordinary visual encyclopedia in the Western Hemisphere," in the words of its director, Thomas Hoving, another impresario of world-class ambitions; with this masterstroke that encyclopedia would acquire a new volume. Almost as grandiose as the show itself was the accompanying essay by the Met's young curator, already settling into his role as ringmaster of contemporary art events for the city of New York, a part once played by Leo exclusively. "Not even at the height of the High Renaissance, Impressionism, or Cubism," Geldzahler gushed, "has anything like this number of artists finally seemed crucial to the art of their time."[19] He then enumerated, one by one, all New York's partners in art (museums, galleries, periodicals), in a precise inventory that seemed to hark back to the one that Barr, upon becoming MoMA's director in 1929, had offered the board of trustees. It was a precedent of which Geldzahler was keenly aware: "Secretly what I was trying to do was something in line with Alfred Barr's two shows of 1936 and 1937."[20] But if Geldzahler had managed in less than ten years to create a contemporary art department at the stately Met and in less than a year thereafter to mount such a mammoth show, no one would deny the chasm of stature between Barr the ascetic scholar, and Geldzahler the socialite and media-savvy curator! The gulf between them was observable in the divergence of method: on the one hand, Barr's painstakingly conceived structure, exhibits with acute scholarly apparatus, and the patiently systematic re-creation of a cultural context; on the other, the somewhat capricious choices, outsized presentation, and seemingly recycled hyperbole as accompaniment. Indeed, in his memoirs, Tom Hoving would lament his curator's indifference to deadlines and offer a rather lukewarm assessment of Geldzahler's "pallid essay" and "graduate-school jargon."[21]

Since, according to Geldzahler, "the Whitney emphasized perhaps too much the provincial and regional aspects of American art"; since MoMA, with its heroic educational program, sought "to illustrate art history [with] the world's finest collection of painting and sculpture of the period from

1870 to 1940"; since "the Jewish Museum, with several roles to play in the community and with space that is not really adequate to the task, cannot fulfill the need for timely exhibitions all by itself"; and since, finally, "the Guggenheim Museum, with its excellent collection of nonobjective art, [was] among the daily meeting places and discussion centers for the serious artist and student who had to come to grips with Cubism," a central role now proposed itself for the Metropolitan. "Four art magazines have served as forums in the presentation and interpretation of the new art," he continued, citing *ARTnews, Arts Magazine, Art International,* and *Artforum.* "The postwar New York market for European Modernist art and the growing challenge of New York's own artists led to the opening of two galleries [Sidney Janis and Castelli] . . . Like Janis, Castelli runs a gallery that reflects the growth and change of the American scene . . . One of the most fascinating galleries of the sixties was Richard Bellamy's Green Gallery. Its greatest strength was in Bellamy's constant search for new talent, a search not enough dealers are willing to undertake."[22]

Analyzing the show, Castelli expressed his disdain for "the way that Henry went about picking it. I'm against picking a show on the careful basis of just considering the artist and what he is like at a given moment. That kind of show I think is, of course, important and necessary; but they really, generally speaking, are quite dull . . . Of course, there are many omissions that are arbitrary and many inclusions that are arbitrary. I disagree with certain choices of his, but within a very narrow range . . . The way he has displayed sculpture is very debatable. I think that's really the worst thing of the show. He should have given proper independent space to the sculpture . . . And he has shown his lesser interest—say in Pop Art, which was one of his interests several years ago—by just putting two people in the same room where it was not necessary . . . So there is this mixing." The rebuke of the higgledy-piggledy juxtapositions was softened by the disclaimer "all in all it was a gigantic enterprise which, any way you cut it, it was almost impossible to carry it out to even approach satisfying everyone."[23] But there was no mistaking the hostility that underlay Castelli's criticisms.

Was his harshness singular? Some New York critics penned equally sour reviews, defying the more mainstream hoopla. In *Artforum,* Philip Leider began by admitting: "When the *New York Times'* Grace Glueck, in the first of the pre-opening puffs, called what was to become 'New York Painting and Sculpture, 1940–1970,' simply 'Henry's Show,' one's heart sank. So that was to

be the way of it: America is given a culture by a handful of geniuses and the celebration of it, come at last, was to be just Henry Geldzahler's show. Later, *Time* featured Henry leaning on a David Smith and *New York Magazine* had four pages of showing him along with some pictures from the exhibition, but smaller. In the end, Grace Glueck turned out to be right—it *was* Henry's show, not because he *painted* all of those pictures . . . but because there was no understanding the exhibition without referring to Geldzahler and his peculiar relations to the art of his time." Then Leider eviscerated the show's idiosyncracies with oxymoronic verve: "The exhibition is exquisite and rude, high-minded and petty, ravishingly beautiful and monumentally vulgar, and at no point can one be certain that one is dealing with a toughly thought out presentation rather than a series of irresponsible caprices. Had Henry Geldzahler, for example, truly pondered and deliberated, and having thus pondered and deliberated decided that Tony Smith was a greater artist than David Hare, Herbert Ferber, Louise Nevelson or Richard Stankiewicz? Had he considered deeply and concluded that Roy Lichtenstein and James Rosenquist were deserving of space in an exhibition with Pollock and Smith but that Jack Tworkov, Ray Parker, John Ferren and Conrad Marca-Relli were not? Had he really meant to divide a room between Guston and de Kooning while Stella and Noland are given a room each and Ellsworth Kelly is practically given a suite? Does he mean what he implies by showing late Motherwell but not late de Kooning? Does he really think that the only value of sculpture is to enhance paintings? Yes and no. For Geldzahler has been true—consistently and ruthlessly true—to his own experience, and he is plain in recounting to us in the catalog essay what that experience has been. It has not been an experiencing of art . . . so much as an experiencing of the art world, of dealers and galleries and museums and collectors and magazines and critics. It is a milieu the worst part of which consists of hypocritical art profiteers and mental go-go girls."[24] Beyond the aesthetic arguments, one cannot help but see in this lambasting of Geldzahler's frivolous, modish, and superficial relation to his subject a bullet that Castelli had managed to dodge. True, there was nothing shallow about Castelli's appreciation of his artists or their place in the ongoing narrative of American art, but the backlash against showmanship which he had suffered only in Europe was now making itself felt in America, and it was heading straight for Henry Geldzahler.

To return, however, to the question of Castelli's antagonism. We might ask whether it rests on a purely philosophical disagreement, such as would

inevitably have been provoked by a line like this from Geldzahler's catalogue: "It seems today that Pop Art was an episode . . . There are no safe reputations in Modern Art." Was Castelli annoyed because the exhibition, while giving pride of place to many of his artists, fit them into a chronological perspective different from his own comprehensive vision? He might well have been irritated by the time span Geldzahler had adopted (1940–1970), since, as we know, Castelli had refused to show the Abstract Expressionists, preferring to wait until "something new" came along. And yet, there could have been a natural kinship between the sixty-two-year-old gallerist, never known for being ungenerous, and the thirty-four-year-old curator. The two men shared similar backgrounds—Henry had been born in Antwerp to a family of Jewish diamond dealers and immigrated to the United States in 1940—to say nothing of their intertwined personal networks.

Calvin Trillin recalls that as a fledgling journalist for *Time,* in 1961, he had sought out Geldzahler, and the young assistant curator spontaneously ushered him across Fifth Avenue to 4 East Seventy-seventh Street for an impromptu official "introduction to Leo."[25] Geldzahler would have been the first to credit the Castelli Gallery with setting him on his professional path. "When I first came to the Met I walked into the Castelli Gallery and introduced myself," Henry told an interviewer. "[Ivan Karp] took me to see Warhol, and we became friends *immediately.* Another day, I joined Leo and Alan Solomon to visit Frank Stella's studio on West Broadway, and there I saw a painting. I bought it immediately, and we became friends."[26] But Geldzahler also ascribed only "manners" to the gallerist, discounting his vaunted and legendary talent for discovery, let alone his "epiphany." "Leo is a sweet, charming, continental man," he said. "The first people who belonged to his gallery, like Bob Rauschenberg and Jasper, were brought by Ileana, who was his wife at the time. After that I guess Dorothy Miller—I don't know how he found out about Frank Stella but in each case something intervened. The magic of the Castelli Gallery is that he put this package together, but one doesn't have the feeling that he went out and found them. They were brought to him and he was cultivated enough to understand what he was looking at."[27]

This would have rankled, but so might a fact beyond Geldzahler's control: because of Castelli's late start, he found himself awkwardly on a professional par with this younger man who put his youth to his advantage. "In the early sixties," Geldzahler recalled, "Frank Stella and I used to be smoking cigars in the back room at the gallery and Leo would walk in and he'd clap his hands

and say, 'Okay, boys; okay, boys, this is not a smoking club. Out! Out!' And we'd look at each other in amazement and leave. He thought we were just these kids who were hanging around the gallery."[28] For his part, Frank Stella fondly recalled a friendship of generational peers: "We were the same age, Henry lived with us; the other curators and dealers didn't live with us. He would go from gallery to studio and from studio to gallery. After the openings, we would go to a Chinese restaurant. Henry thought of himself as legendary."[29] Jim Rosenquist could also see the charisma of "this twenty-seven-year-old curator, with his cigar and an adolescent look, who was dancing around in parties, who was involved in Happenings, who then supported the avant-garde, stimulated the public consciousness on contemporary art."[30] Jasper Johns, who remembers Geldzahler's bonhomie similarly— "very friendly with all the artists, and also with me, of course"—and even allows that the behemoth Metropolitan exhibition was "very impressive," nevertheless detects something uncharming in the curator's personality. It was something "very egoistic; he was used to being the center of attention"—the origin, perhaps, of "a conflict of power with Leo."[31]

Are we confronted here with a true battle of titanic egos, as Johns and Stella seem to suggest—the latter going so far as to quip that "Leo probably would have taken credit for [the Met] show if he could have"?[32] A clash of personal styles? "Henry was a bit flighty; he was pals with people like David Hockney and Andy Warhol, part of a social scene that didn't really appeal to Leo,"[33] as Pincus-Witten put it. A rivalry of alpha personalities? "With Henry, it was as if he'd already seen the film they were going to make about him. He was always one step ahead, with an opinion about everything,"[34] Trillin, his fellow Yalie, affectionately recalls. In fact, with "Henry's show," Castelli found himself somewhat marginalized for the first time since opening his gallery, and worse still, upstaged by a figure who invaded *his* proprietary niche (contemporary American art), presuming to stake out for those artists a new institutional space (the Metropolitan), in an alternative vision that included such prewar masters as Hopper, Davis, Avery, and Cornell, plus the Abstract Expressionist and Color Field painters, all the while cultivating the favor of a parallel set of critical authorities (like Greenberg, Rosenberg, and Field). From 1957 to 1966, Castelli had operated unchallenged, building his alliances with Tom Hess (*ARTnews*), Alfred Barr (MoMA), Alan Solomon (Jewish Museum and Venice Biennale), Ileana Sonnabend (hub of the European network), Irving Blum (of the California network), and from his earli-

NEW YORK, 1965
Jasper Johns, in front of his *Flag*, visiting Leo and Toiny's house

est epiphanies to the paving of his royal road to Venice, he had achieved an inexorable and magnificent dominion. But beginning in 1967, Geldzahler had started to encroach, rapidly forming his own alliance with MoMA via its new director, René d'Harnoncourt, whom he remembered "planning the installation of the Picasso sculpture show, which had a great influence on the way I planned the installation of the New York show. But most important, I was able to see how he dealt with avant-garde artists on the one hand and with trustees on the other; always with a courtliness, a gentleness, and an understanding of the whole picture which was unique. I felt close to that point of view. It was an education."[35] It would not be long before Leo found the playing field uncomfortably level.

Apart from Geldzahler, another young newcomer to New York during those years was Arnold, "Arnie," Glimcher, already a dealer in Boston; he seemed, from the start, to enter a love-hate relationship with Castelli. "Leo had enormous style, Leo had the best style, he was very good at entertaining, he was the gallerist who gave the best dinners and, until today, he is the first celebrity art dealer," he now recalls. "I have admiration for Leo. Leo cre-

ated a unique *locus* for things to happen, the new version of a salon, an extraordinary place. I really enjoyed the gallery, I saw all the shows, it was indispensable." But like Geldzahler, Glimcher was loath to give the lion his legendary due. "When I decided to open my gallery in New York, I would fly in from Boston every Monday, Ivan Karp would pick me up at LaGuardia, and would take me to see studios. He was my angel, he was my only contact. There was magic in Leo, but alone he could not have made it, absolutely not. Do you realize how Ivan Karp changed things for Leo? If Leo became so important, it is because Ivan went to work with him." Perhaps the failure to pay court came at a cost: "It was very hard for me getting things from Leo. With me, he was not generous, although he was helpful and generous with so many others! One day, at the opening show of Frank Stella's *Lavender* Show, I wanted to buy two things, and Leo said: 'No, there are too many people who want to buy, but come back at the end of the show, maybe.' In fact nothing sold, and I was able to buy three paintings for $1500 each. So when I had clients who wanted works from his gallery, Leo never made anything available to me. I really cannot explain why, but in all humility, he might have felt threatened by me!" Castelli's perceived dismissiveness inspired Glimcher to cut to the quick of the older man's self-worth: "Leo was a wonderful host, but he was not a good dealer. He placed too many works in the same hands. If you were friends with him, you were part of the club. If you were not friends with him, you were not part of the club. It was an extraordinary phenomenon! Leo was an intellectual, but in Leo's gallery, there was no sense of art history. The dealer I respected the most was Janis, he had a Schwitters show, a Léger show, and I came for weekends just to see them. But Leo was a social climber, even if he did it with great style."[36] The kind of success Castelli had made look so easy in the fifties was threatening to become, by the end of the sixties, a catfight among rival gallerists.

This is not to say Castelli rested on his laurels. Darting as ever among the collectors, the artists, the museums, he went on negotiating, pondering, recalibrating. Bil Ehrlich's acquisition of a huge Frank Stella, a graduation present from his mother, perfectly illustrates that the ever-agile Castelli had not lost a step in turning tricky corners: "When I told him that I would love a Frank Stella," Ehrlich remembers, "Leo took out a sheet of drawings, and I selected one from the three possible variations. Leo said that the only problem was that that painting was promised to Henry Geldzahler. 'But that painting is never going to fit in Henry's apartment!' I said. 'Would you talk to

him?' Leo did, and I got the painting. What was so sweet about it, was that Leo respected *my* desire to have a special work of art and that he cared enough to go out of his way to do it. I mean, I was a *kid*! Not a mega collector. He could have intimidated me into buying something else . . . but he was this caring and gentle soul, and wanted to do his best for everybody."[37] Castelli's partisans would find themselves reinforced as early as 1970, with his decision to open a new gallery in SoHo, at 420 West Broadway, and to begin working more closely with Ileana Sonnabend. For ten years, with the support of her husband, Michael, and her manager, Antonio Homem (who would become their adopted son), she had acrobatically juggled galleries in both Europe (Paris and Geneva) and the United States, and for nearly three decades she had maintained a stunning professional complicity with her ex!

For the time being, however, Leo would bridle at being defined in relation to the younger man he regarded a pretender to the throne. Robert Storr, then a young student and later a curator at MoMA, is no respecter of legends. "Leo had no idea, no vision of his own," he claims, though admitting that "he was a gentleman, a go-between with an exceptional gift for public relations." His sense of Castelli's motivations remains less judgmental. "It wasn't money that interested him but *power.* He was a dealer, like a dealer in luxury goods, who guaranteed his clients quality and *cachet*; it was totally safe to buy from him! Leo also wanted to be an aristocrat among aristocrats, and in the U.S., there's enough social mobility for that to happen. It was really all about manners, because Leo had *both* European manners and American *chutzpah*." Manners and *chutzpah*: a potent and original formula. Intriguingly, when Storr finds in Castelli's character a profound awareness of the past, he cannot quite reconcile it with Castelli's personality as a whole: "As for history, it's rather paradoxical that a man so involved with the art of his day," he argues, "should have such a sense of history. And Leo *did* have a sense of history. He anticipated the market, he always cultivated and built a history for his artists, wondering who he could put into history, and who could put *him* in it." Here, a student of Castelli's past—and his obfuscation of it—might note that historical awareness and the Castelli agenda only seemed contradictory. Knowing what a brutal mistress Clio could be, Castelli gave the impression of having internalized Orwell's insight that history is written by the winners. And so he determined to write his own part in it, and that of his artists. In this respect, does not Rob Storr miss some

Paddie, Castelli's famous Dalmatian, a Westminster Kennel Club champion. "There are many who can remember climbing the elegant spiral staircase to the gallery at East 77th Street. Paddie's beautiful white and black spotted coat contrasted elegantly with the red carpeting where he arranged himself, at the top of the stairs." (Bob Monk)

essential piece of Castelli's puzzle? "If I had to differentiate between Leo's approach and Henry's approach," Storr observes, "I would say that Henry thought in terms of historical currents, like a curator, while Leo, who was never *that* interested in the big picture, thought in terms of a clan, 'us against them,' like a dealer. It was Leo and his own."[38] Leo Castelli had indeed imagined a tribe of sorts, but one whose election promised a great destiny.

27. CASTELLI'S NETWORK AS THE HOUSE OF SAVOY

The Dukes of Savoy seldom lost a battle. But more importantly, they never lost the war. They would send their armies not to stop the war but to collect the spoils. Leo would always make sure that he was near the battlefield, almost always managing to survive the situation. Leo always kept in control. He rarely tried to kill his enemies, rather he co-opted them.[1]

<div align="center">JOE HELMAN</div>

"WE WERE FAITHFUL allies fighting at his side" (Gian Enzo Sperone), "his satellites" (James Mayor), "his outposts" (Ronnie Greenberg), "his apostles" (Tony Shafrazi). If the Castelli clan had reached its apogee by the dawn of the seventies, in 2010, more than a decade after the gallerist's death, all his former liege men still hastened to sing his praises, in (nearly) always dithyrambic terms, often tellingly invoking dynastic, political, or military metaphors. The annals of the Castelli Gallery from 1957 to 1990 certainly reveal a succession of territorial expansions, of strategic alliances, of grand bargains, as well as of dissensions, of betrayals (inevitably) followed by negotiated peace and redrawings of the map. One is reminded in Castelli's maneuvers, perhaps not accidentally, of the House of Savoy dynasty and its stranglehold over the Alps from the Middle Ages through the twentieth century, a hegemony achieved by playing antagonists against each other—the French court vs. the Austrian court, the popes vs. the emperors, the Capetians vs. the Habsburgs—all the while preserving their own territorial integrity. And even if Castelli never quite took up arms against a sea of potential rivals, as the counts and the dukes of Savoy had done, he never fought less than fiercely, making war by other means. By his lights, the stakes were comparable.

"Leo oversaw the new legend that was American art," Sperone remarks. "Yet, curiously, he approached it not with the business genius of Vollard or

Duveen, but with something completely new: the firm conviction of serving a higher cause." There was, as Castelli had intuited, a new political economy of cultural objects, and like all value systems it depended upon upholding a consensus."Why should anyone want to buy a Cézanne for $800,000? What's a little Cézanne, a house in the middle of a landscape? Why should it have value? Because it's a myth. We make myths about politics, we make myths about everything . . . My responsibility is the mythmaking of myth-making material—which handled properly and imaginatively is the job of a dealer—and I have to go at it completely."[2] While Castelli was quite ready to admit that he first invented himself as a creator before inventing the mythology of what he created, there is no denying that underlying his suc-cess at promoting his artists and their work—his uncanny *maestria*—was an extremely sophisticated understanding of an economic and symbolic sys-tem. The creation of, as it were, totemic start-up capital was not mysterious, but it was novel: by painstakingly maintaining his archives and routinely granting access to them, by generously doling out photographs of available work, by issuing catalogues that shrewdly conceptualized and contextual-ized his artists' productions in relation to a European sense of history, Castelli turned himself into an institution, effectively rivaling the presumptive authority of critics and museums. But while the critic and the curator had earned their bona fides through submission to scholarly training, Castelli, the autodidact, had, like Napoleon, crowned himself. Having assumed the power to coin his own credibility, Castelli was able to impose a new rhythm on the art market, that of a "constant whirlwind of invention,"[3] accelerating the emergence of new trends with promotional campaigns inspired by the world of advertising.

In American society during the seventies, the Castelli Gallery's post-Dadaist and Pop offerings appealed directly to sensibilities behind the new fortunes being made in Los Angeles, Miami, Chicago, Minneapolis, Hous-ton, Kansas City, and Vancouver, far from the East Coast's cultural and social establishment—or what remained of it—and its tastes. The public sector had created a propitious environment, too. As early as 1965, President Lyndon B. Johnson signed a bill creating the National Endowment for the Arts, while the federal government offered tax breaks for philanthropic donations of art and corporations began to develop unprecedented art collections. At the same time, grants allowed universities to expand education in the arts, and underwrote public events aimed at showing off the country's investment in

culture—in all, a far cry from the public philistinism of the prewar years. All of this activity was made possible by an American economy that, at least until the oil shocks of 1973, was thriving. Businessmen were concentrating personal wealth as they hadn't in decades, a foretaste of the eighties boom times, and already the landscape was littered with potential collectors, ready consumers of status symbols. A Lichtenstein, a Johns, a Warhol became a trophy for those already possessed of most other trappings of huge success. And so as the exclusive source of these prizes, one who chose his clients almost as carefully as his artists, and lavished the preferential buying opportunities strategically, Leo Castelli became a sort of social gatekeeper. By permitting someone to buy he single-handedly confirmed or even bestowed status. Faced with greater demand than supply, the consummate Austro-Hungarian strategist would soon enjoy the ultimate luxury of bending the market to his will. "I wanted the *Gloria Vanderbilt* painting by Rauschenberg, but Leo had promised it to someone else, so in the end I never bought a Rauschenberg,"[4] Barbara Jakobson remembers. The financier and collector Donald Marron describes his encounter with the Castelli machine: "I'd go all kinds of places, to St. Louis or L.A., and I'd walk in, and I'd say, 'This is Leo's artist.' Leo allowed his artists to be shared in a way that no one else did. Leo sort of franchised his artists, he was an early creator of global art."[5] Franchized they were, but still under careful regulation.

It is hard to say whether more credit is due the gallerist's personal charisma or the particular accessibility of the Pop aesthetic. Perhaps there is no disentangling the two in considering the frenetic hunger for Castelli's product, but he certainly affiliated himself wisely. "Only when I discovered pop art did I become really involved," the American collector Leon Kraushar stated. "Here was a timely and aggressive image that spoke directly to me about things I understood. The paintings from this school are today. The expression is completely American, with no apologies to the European past. This is my art, the only work being done today that has meaning for me."[6]

The would-be clients poured in, and Castelli had only to size them up. "It's easy to spot the collector with a capital C, because they go at it with a certain fantastic violence," Castelli mused. "You can see them really shining with desire, the art kind of desire. When you must have something, there is a real, deep stress when somebody else [gets it instead]. There are some really very primitive compulsions there. There are all kinds of human passions displayed. In my business, the stakes are high and the passions are

high . . . My collectors don't come to the gallery to find paintings they can hang on their walls. They come to participate in a great historical adventure, a great moment in art."[7] In fact, the gallerist was often criticized for allowing his ideals to impede pure commerce: "he wasn't able to close a deal" (Blum); "he would never give me an accounting of the money" (Helman). In this vein, Ivan Karp was often touted as "a major player on the gallery, the front of the house, and a very important part of the selling machine" (Mayor). But if Leo sometimes seemed a muddled merchant, it is because he never meant to become one. As Bil Ehrlich put it, "Leo had a banking head. He had banking experience, he certainly was sophisticated enough to know and to learn from his father-in-law and the world he traveled in how things were done."[8] The individual transaction was always at most a move on the chessboard.

His deftness at maneuvering had been perfectly evident in 1959 and 1960 during negotiations with Barr and Panza over Rauschenberg's Combines: he had aggressively (albeit vainly) stoked the interest of the first party (ever covetous of that MoMA prestige) while temporizing with and tantalizing the second. "Leo certainly conveyed that *each and every* work of art was precious and rare," Donald Marron says, explaining the psychological manipulations of Castelli's marketing strategy. "Of all the artists, certainly no one was in more demand than Jasper in those days. You never quite knew with Leo *what* was available when you went there. So you went and you talked and he thought and you saw how it all happened, and he was working out in his own head, I think, mainly what was best for the artist, what should go where. After deciding *which artists* to show, he enhanced their careers, raised their status to a different level both in perception and reality, and decided *where* the pictures should go, under what circumstances. He was placing pictures. Even though everything was relatively young, you had a sense of history then."[9]

While planting new markets for his artists in Texas, Florida, and California, as well as in the Midwest, on the East Coast, and in New York particularly, Castelli continued to disperse the heady fragrance of exclusivity. By turns discreet, flamboyant, obliging, and brusque, he dealt with each situation by some ultimately undefinable subjective logic. Balancing the needs for symbolic and financial capital, he could be quite flexible. In some cases, as with young Wynn Kramarsky, Castelli accepted payment over a few months' time: "Leo recognized people who were serious about what they were collecting," Kramarsky remembers. "He had an *instinct* for that, and he would favor them. I was totally unknown, and it took me six months to pay for that

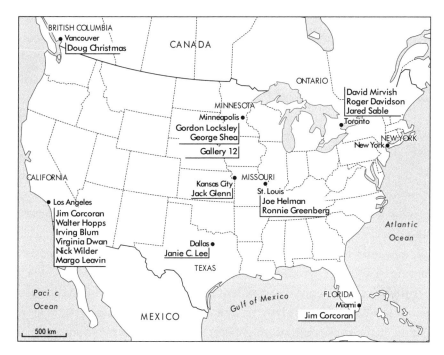

Map of Castelli's satellite galleries in North America

$175 Jasper Johns . . . that was two months' rent at that point! But Leo said, 'Sure, take it home.' "[10] In other cases, Castelli might favor a buyer who could bankroll the stipends the gallery gave to artists; this practice, though less common, was justified in terms of supporting quality and quantity of production, though it would seem to contradict his basic philosophy. His relationship with Robert Scull is a case in point. "As a collector, Scull had undeniable enthusiasm," Castelli admitted. Still, the two men's relations were ambivalent at best: while Castelli needed Scull's money, he was put off by the man's arrogance, rudeness, parasitic demands on the artists, and competitiveness with other collectors. "The Sculls were very vulgar, difficult, new money, but they paid," recalled Irving Blum. "Scull would come in with hundred-dollar bills in his pocket. I watched him once: they would pay $5,000, $8,000, $12,000, in cash, like a cashier at the bank. And Leo always needed money, so those dollars were welcome. And Scull got what he got. There was no secret about it!"[11] Not a secret, but it was an exception.

"The Sculls wanted to get priority. They wanted to be the first to buy the best," said Castelli. "At Jasper's second show, the Tremaines [collectors Bur-

ton and Emily] picked *Device Circle,* while Scull picked two others for a start. But when he found out that the Tremaines had picked *Device Circle,* he got very mad that he had not picked it. A similar thing happened with *Map*: the Tremaines wanted it very badly, and Scull wanted it very badly. So, to cut the Gordian knot, Jasper said nobody can have it. It has to go to a museum, and whoever offers better conditions will get it during their lifetime. Scull got it and eventually gave it to MoMA, and he got himself a nice tax deduction for doing that. The Tremaines were mad with the Modern and didn't want to give anything to the museum, and for a long time they reproached me with having done that to them. Scull got very angry whenever he wasn't shown everything that Jasper was producing, and Jasper began to resent this kind of thing. He felt that there was no reason why the Sculls should have all the paintings, and finally he didn't want to see them anymore. He painted a painting called *Riot Depart* in which a skull appears, the figure of a skull!"[12]

A similarly fierce competition played out over another Johns *Map,* resulting in a sale that the dealer later recounted with guilty relish: "That *Map* was hanging in the back room of the gallery; and Mrs. List came in and said, 'Ah, that's the one I want.' So I said, 'I'm sorry. You can't have that because I promised it to Wiseman.' 'How much was it?' she asked. I said it was $15,000. 'Well,' she said, 'you tell him that I'm offering him $25,000 for the painting. I offer him a $10,000 profit on the painting if he wants to relinquish it.' Just a few minutes later, Wiseman walked in, and I said, 'Here is Mrs. List, who wants your painting. Talk to her about it.' She repeated that and he laughed and said of course he would not give it up for love or money. Then she said, 'What do I buy now?' There was that fantastic *Diver* painting, that very large painting in the other room. There was really nothing else available; everything had been bought. So I said, 'There is this large painting. It's very beautiful.' 'All right,' she said, 'I'll buy it. How much is it?' So I said, 'That's $30,000.' Her husband, Abe, was there, as usual sleeping away. She said, 'Abe, we're going to buy this painting.' He said, 'Yes, we're going to buy this painting, and how much is it?' I said, 'It's $30,000, Abe.' He said, 'Could you give me a little discount on it?' I said, 'No, no, I wouldn't want to do that. I know you've got it.' So he said, 'All right, if Vera wants to buy it.' Then I felt a little bit guilty about the whole procedure. It was so odd. She said to me that she had just bought it out of spite because she couldn't get that other one."[13]

In this frantic chase for the one-of-a-kind, we may see the continuing power of the work of art as fetish in what Benjamin termed the Age of

Mechanical Reproduction. But the ferocity of acquisition as seen in bidding wars and battered egos is something new, something emblematic perhaps of the hyperconsumerism that overtook America following the disenchantments of Vietnam and then Watergate. As values became disposable and consumables more abundant, the quest for the sacred in some form was expressed not only in new spiritualities but in the will to possess the relics of modern saints and seers. In this world of bids and counter-bids, Castelli became the peerless master of the rhythm of the hunt, reacting intuitively in real time.

It was different when the buyer was not playing for keeps. With a work of art that they knew the collector intended to donate to a museum, Castelli and Karp would follow up the sale by maneuvering with the Art Dealers Association to inflate the value and secure the collector not only the prestige of acquisition but a hefty tax refund besides! Changes to the U.S. tax code in 1965 raised the exemption for donating art, allowing America quietly to absorb the world's treasures. The dealer Joe Helman describes the transfer of spoils, driven by the brutally high top marginal rate: "After a war, traditionally what happens is the winning country takes the icons of the loser, and replaces them with its language and traditions. But rather than send our armies into the museums of Europe, what America did was pass the tax law that made it advantageous to give things to museums. The [individual] tax rates got as high as 78 percent. So you would have a picture for, say, $100,000, and you'd get a $200,000 appraisal on it, and you'd get seventy-eight times two is a $156,000 tax write-off for this $100,000 picture!"[14]

Stimulated by these new exemptions, which favored the rich (by encouraging them to buy and then to donate art while pocketing a comfortable profit), demand escalated and Castelli became a high priest for accountants as well as collectors. A cruder operator might simply have raised all his prices—it would have been a favor of sorts to many rich clients—but the trafficker in auras chose a different way, fattening sales with his famous waiting list, reserving to himself the option not to take the top bid. He had already worked that trick with Panza, with Leonard Lauder, with Jean and Dominique de Menil. Larry Aldrich, who donated his contemporary art collection to MoMA, recalled with some acrimony: "In 1959, I went to see Ivan Karp, then at Castelli, and said I was looking for an artist for that year . . . There was a show at MoMA, and one of the things that I liked very much was a Jasper Johns, a flag. I told Dorothy Miller I wanted to acquire it, but she

said it was reserved for Mr. Nelson Rockefeller, and until he got around to seeing it they couldn't let me have it. I would contact Dorothy Miller about every two weeks and she'd say, 'Larry, Mr. Rockefeller hasn't gotten around to seeing it yet.' Well, the exhibition closed, and about two or three weeks after that I was told finally that Mr. Rockefeller was taking it. So I contacted Mr. Castelli, whom I really didn't know very well, and he said, 'Mr. Aldrich, all I can do is put you on the list, and I want to tell you that you'd be about number 36 or 37.' So that ended that, and it wasn't very long after that Mr. Johns's prices went up, up, up, and up. Much to my regret, I do not have the Jasper Johns in the collection."[15]

Perhaps no Castelli strategem has been more commented upon. "The waiting list, as you know . . . it didn't exist, but of course it existed," explains Bob Monk, who worked for ten years at Castelli's. "You're going to sit there and he's going to be charming but you're not going to get the piece. And then he'd say, 'Well, you know, Jasper works very slowly, and very carefully, so let us see . . . ' "[16] Eli Broad, the collector and philanthropist from Los Angeles, reflects philosophically: "You had to earn your way with Leo, he wouldn't sell to people who were not really involved. He would be polite: if he did not want to sell, he'd put you on the waiting list."[17] No one was rushed to the head of the queue, it seems. "I met Leo at a Johns show where *Tennyson* was," S. I. Newhouse, the legendary collector and media tycoon, recalls. "I tried to buy *Tennyson*. Of course, Leo didn't take me seriously and that was it. Then I went back to the gallery in order to buy a Roy Lichtenstein several years later. By that time, I knew Leo. Once you knew Leo, he was quite easy to deal with. After I bought the big Lichtenstein, I was able to get many other things."[18] There was a courtliness, even in the bum's rush. According to Donald Marron, "Leo never really refused [to sell], he would somehow make you feel good, even if you were not going to get perhaps the first thing, but he always made you feel good."[19] Still, as Angela Westwater, a colleague of Castelli's observes: "It had to be the right person. In certain ways, these people had to jump through hoops."[20]

If, for the collectors, the system induced both heartache and heartburn, it worked beautifully to the advantage of Castelli and his stable. The economist Olav Velthius has commented perceptively on how the waiting list "enables art dealers to accumulate symbolic capital" by expressing a sort of contempt for the material economy. "By claiming they are not interested in selling to the highest bidder, dealers are, as Bourdieu would put it, denigrat-

ing the economy . . . This, in turn, enables them to consecrate, or bestow legitimacy and value on, the artists they represent." And what would certainly seem a thorn in the side of any collector, once accepted, can become "an extremely efficient instrument for the management of client relationships. The most precious favor a dealer can bestow is to let a collector jump the list, granting him or her first choice before the opening of a much-anticipated exhibition of new work. And this gives them the leverage to request favors in return."[21] With each passing year, Castelli's election process for favored client status became more and more draconian. The experience of Jane and Bob Meyerhoff, important collectors from Baltimore, provides an illustration. "Jane Meyerhoff went to see Leo to buy some works," Dorothy Lichtenstein related. "But Leo said, 'Who are you? I don't know you. Why should I sell you these paintings? There are people waiting, a waiting list. You have to prove that you're a serious collector.' And Jane understandably felt rather insulted! Finally, Irving Blum brought the Meyerhoffs to Roy's studio, and they started buying directly from Roy through Leo. But Jane never forgot that brush-off."[22] Later still, the television producer Douglas Cramer good-humoredly recalled needing two introductions to Leo Castelli, a visit to the artist's studio, and subsequently a lunch with the dealer and the artist before he could buy a work by Jasper Johns. "That was the closest thing to a papal appointment in those days."[23] If Castelli ever watched *Love Boat, Dynasty, Wonder Woman,* or any of Cramer's other period blockbusters, the evidence is lost.

Territorial expansion, diversification of demand, minting symbolic capital, a control of supply to rival OPEC. There is one more element to the Castelli equation, and it had been present from the start: the value added by his personal touch as mythmaker. "People tend to think of Leo as springing forth fully formed," the heavyweight collector Gordon Locksley observes. "It's not true at all: he invented himself."[24] And that invention was a new order of being. Let us listen to Joe Helman, whose experience reflects the social, economic, and cultural transformations wrought by the Castelli system. We are in St. Louis, Missouri, on the eve of the sixties: "I was getting a haircut, and I picked up a magazine and saw this painting, *Painting with Ruler and Gray* by Jasper Johns. And I turned to the barber and said, 'Look, it's like the olden days; there's a great artist in our time.' And I more or less jumped out of the barber's chair and went to New York to buy a painting—I was really turned on by this guy." At the time, Helman was a twenty-three-year-

old real estate developer, already a successful self-made man. Clumsily but persistently, he tracked down Jasper Johns, ultimately finding himself at Castelli's door. He bought *Painting with Ruler and Gray* for cash on the barrel, and with monthly checks of five hundred dollars which secured him a priviledged status of gallery sponsor. "I always had a credit there, and whenever I would go, Leo would always give me great choice of everything," Helman continues. "It was adventurous to buy American art at that time. Americans were still buying Matisse, Picasso, Miró. I remember there was a collector from St. Louis who warned me, 'Kid, you're wasting your time with these American things. You should be buying Picasso and Giacometti and Miró.' I bought my first Lichtenstein from Leo in 1963, *Baseball Manager,* the iconic American male, and on the facing wall at Castelli's gallery was *Drowning Girl,* the iconic American female. When you entered the front room, on the left was the painting *Whaam!* that the Tate got, and to the right was *In the Car* that's at the Scottish National Gallery. Everything else was sold, but I was very happy to get *Baseball Manager.* At the time, it was the most severe picture, very blunt. But that's why I loved it."[25] From St. Louis to New York City, young Helman's path would take him closer and closer to the center of the action, and he had barely got started. And so the regime authored by Castelli—of restricted access to the artist and to information about the work—would continue as the norm, a calculated imbalance of power between dealer and collector.

Perhaps even a velvet rope can leave its rope burns. Might this be one reason why several of Castelli's clients decided to become dealers in their own right—the hope of attaining for themselves access to what Leo guarded so jealously? So it was with Gordon Locksley, with Connie Glenn, and with Ronnie Greenberg. So, too, with Joe Helman, who opened his own St. Louis gallery in 1970. The planting of satellite galleries, one after the next, was from the beginning part of Castelli's self-generative mystique and the success it bred—from the earliest partnerships with Ileana Sonnabend and Daniel Templon in Paris; to that with Gian Enzo Sperone in Turin; Gordon Locksley, George Shea, and Felice Wendler in Minneapolis; Rudolf Zwirner in Cologne; Janie C. Lee in Dallas; Doug Christmas in Vancouver; Jared Sable in Toronto; Robert Fraser and James Mayor in London; Bruno Bischofsberger in Zürich; Konrad Fischer in Düsseldorf; Heiner Friedrich and Franz Dahlem in Munich; Joe Helman and Ronnie Greenberg in St. Louis; Jim Corcoran in Miami; Irving Blum, Nick Wilder, Margot Leavin, and Connie Glenn in Los Angeles; Attilio Codognato in Venice; and Eva Buren in Stock-

Letter from Ileana Sonnabend, Paris, February 23, 1967

holm. A singular feat of self-projection, of self-replication akin to spontaneous generation—a virtual genealogy of gallerists all begotten from the prestige of a single man.

Janie C. Lee, who opened her gallery in Houston in 1967, had got her start by paying a visit to Castelli, having been introduced by Barbara Rose. "Leo was incredibly generous; he always sent the works I asked for. There wasn't much of anything in Texas at the time, and Leo was happy to have these outposts in Texas, Minneapolis, L.A., St. Louis. I went to New York at least once a month; that was a *must,* so I could see what was coming up. His advice? He said to me, 'Janie, the most important thing is to use your intelligence and your compassion. Work out a small profit, not a big profit.' He never mentioned the selling. The artists always came first."[26]

Jim Corcoran, who met Castelli through his friend Charlie Cowles, tells a

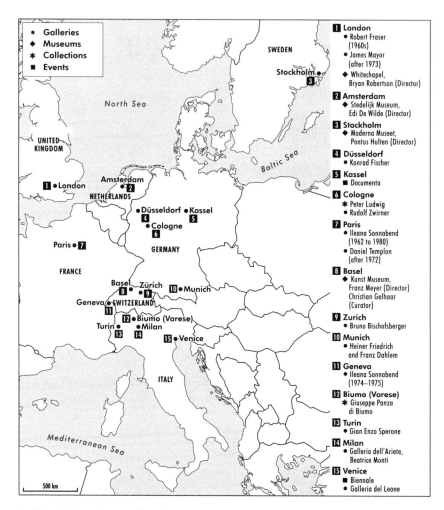

Satellite galleries and contacts throughout Europe

similar story: "I was starting a gallery in Miami. I was twenty-six years old, and I told Leo I wanted to have a show of his artists, focusing on Pop Art. So he said, 'What would you like?' And I said, 'Well, I'd like Cy Twombly, Rauschenberg, Johns, Warhol . . . ' He said, 'Okay, go pick it out.' I picked out what I wanted, and he gave me some sort of percent discount, and sent them down to Florida without any sort of reference. That was my first show at this gallery, and I fared pretty well. Because back then, opening up in Miami was a *very* offbeat thing to do. But there were some people there who became collectors. Leo's generosity was a *huge* help."[27] Things would con-

tinue going well for Corcoran when he left Miami for Los Angeles soon afterwards. "There were three big collectors in California: Robert Rowan, Edwin Janss, and the Weismans. Somehow, when I opened my gallery, all three of them walked in and immediately became my clients."[28]

John Coplans, curator at the Pasadena Art Museum, describes the arrival of Castelli's artists in Southern California: "We organized exhibitions of Johns, Stella, Lichtenstein, and Warhol. When [Virginia] Dwan closed down, there were only two dealers who represented New York artists. One was Irving Blum and the other was Nicholas Wilder. If you went to one, you got Castelli artists and if you went to the other, you got Castelli artists! Emmerich and Janis didn't have any connections in Southern California. Castelli was terrific: he was enormously agreeable about working with a museum, particularly when the president of the museum was a heavy buyer of his artists. New York was closed to him in the early days, and he immediately took to the idea of a California museum initiating an exhibition, doing all the dog work, and Castelli taking the exhibition forward into Europe. The Lichtenstein exhibition was typical. Castelli proposed it. I arranged and did the exhibition, wrote the catalog, did all the work, and the exhibition then moved to Chicago under Pasadena's aegis. Then it was picked up by the Stedelijk, who merely took the catalog and put their own picture on it. And the Tate Gallery did the same thing, except the Tate wrote a completely new essay. Lichtenstein or Stella have shows every year in Los Angeles, San Francisco, New York, Paris, London, Düsseldorf, Milan, Minneapolis, St. Louis. So instead of the work being sold through Leo Castelli in New York to collectors in these areas, you have local galleries arranging local shows selling to their own collectors. Which is absolutely new."[29] The Castelli prestige could mint symbolic capital not only for affiliated painters, but likewise for dealers, conferring the magic of a royal warrant.

Imperial reach never distracted him, however, from training an eye on the delicacies of business in New York, and he continued to be relentless in his scouting, advising, recommending, negotiating, and as always, closing. "These people had needs, they wanted what they wanted, and Leo would accommodate them," says Irving Blum. "Leo once told me, 'I'll give you an idea. Harriet Peters is getting divorced and she owns Jasper's painting *Tennyson.*' I went to see her, and I was able to buy it for $7,000. Then I sold it to Don Factor, who later sold it at Sotheby's, and now it's at the museum in Des Moines."[30] As surely as the dukes of Savoy had wholly owned and controlled

access to the Alps, Castelli held dominion over the commanding heights of American contemporary art, virtually monopolizing the market.[31] With openings at nearly two dozen satellite galleries throughout the world, with museum exhibitions, with art fairs and international shows—the Venice Biennale and Documenta in Kassel—Castelli's datebook was never less than bristling with engagements, as his affiliates, his artists, his collectors, joined by the scores of museum directors and critics most favorably disposed towards him, converged for cocktails, glamorous who's who dinners, and other ritual celebrations over which Leo presided, as cynosure of his world. His convivial generosity was contagious. In Minneapolis, everybody was welcomed at the Daytons'; in Basel, at Ernst Beyeler's; in Los Angeles, at Eli Broad's; in Cologne, at Peter Ludwig's; in Venice, at Attilio Codognato's; in St. Louis, at Amy Pulitzer's. "At the second Basel art fair, I gave a dinner for Leo in a restaurant long gone called Le Pont d'Or," Gordon Locksley recalls. "The most exclusive restaurant of its time, very elegant menu. Leo asked for oil and vinegar and made a special dressing with great style. He was being very Leo Castelli. It was a golden period."[32] "In Venice," adds Corcoran, "we'd meet pretty much every day for drinks at the Gritti bar. The whole place would be filled with friends of Leo's. And all he wanted to do was get out of there before the check came—$2,000 for drinks!"[33] It was during her European trips that Janie C. Lee truly came to appreciate Castelli's magical comfort in his own skin. "Leo was ambidextrous; he could move easily in Europe and that put American collectors at ease. His wisdom, the way he acted in life, his curiosity, his generosity—he came from another viewpoint, another culture."[34] He'd come a long way from Trieste, but in a sense had never left.

Geographical expansion, diversification of demand, creation of symbolic value, regulation of supply, accumulation of symbolic capital, transformation of the gallery clients into resellers . . . and *still* there was more. Perhaps one of the most ingeniously forward-looking and lucrative of Castelli's innovations was his practice of market segmentation, whereby he would soon greatly broaden his client base, and create an outlet for slow-moving inventory, all the while only enriching the Castelli brand as well as its coffers. From 1958 to 1978, while "Roy and Jasper kept the place running," the Gemini artists' cooperative[35] fed a burgeoning market for etchings, prints, and works in series, and was successful enough to open a gallery in Los Angeles in 1966. Infinitely more affordable than originals, these subsidiary works would cre-

ate a whole new clientele for Johns, Rauschenberg, Lichtenstein, Kelly, and Oldenburg, exponentially broadening the product line of the Castelli Gallery. In 1968, the gallerist opened both Castelli Graphics (managed by Toiny Castelli) to handle that particular line of business and the Warehouse, at 103 West 108th Street, to show oversized sculptures. As Bob Monk recalls, Toiny's financial sense served Castelli Graphics well. "In 1964, with Castelli Graphics, Toiny found a niche and a new market. Financially, Castelli Graphics did very well, first because we got the young and upcoming businessmen like Donald Marron (in 1974, for example, a Jasper Johns print sold for $2,500), and also because, on the economic side, Toiny handled things extremely well. While with Ileana, the finances always looked pretty mushy."[36] Located in Harlem, on a relatively quiet, residential street with no art galleries in sight, 103 West 108th Street had been Castelli's storage space until 1968. By converting it into a gallery, Leo was beckoning art followers to an adventure, creating, in effect, the first "alternative" art space.[37]

Meanwhile, in Europe, following a strategy completely unlike that of their U.S. counterparts, the two largest Pop Art collectors, the chocolatier Peter Ludwig and Leo's early client Giuseppe Panza di Biumo, pursued visionary plans for museums intended to transform the perception of Pop Art, at least as it was understood by most Americans. "Ludwig's collection," the dealer Rudolf Zwirner tells us, "had begun with medieval art, pre-Columbian art, Picasso, and so on. So once he started buying Pop Art, people began thinking that maybe Pop wasn't just junk after all. American and European art historians realized that it was real art."[38] On Ludwig's death in 1996, a dozen institutions in several countries reaped the benefits of his largesse and carried on his name. Earlier, in the stodgy town of Darmstadt, an iconoclastic and provocative character, Karl Ströher, heir to the Wella beauty products fortune, had turned to contemporary art at the age of sixty. Then, during his first trip to the United States in 1966, he realized that everything he had "already collected paled in contemporary significance when compared to the newly rising star of Pop Art . . . It soon became obvious to me what I had been missing and needed to catch up."[39] The following year, Ströher, now seventy-six, heard from two Munich dealers (Heiner Friedrich and Franz Dahlem) that the collection of Leon Kraushar was for sale. (Kraushar had been an early collector of Warhol; a photo of him in *Life* in 1965 had run with the headline "You bought it, now live with it"!) Ströher hopped a plane for New York, and decided on the spot to acquire the whole

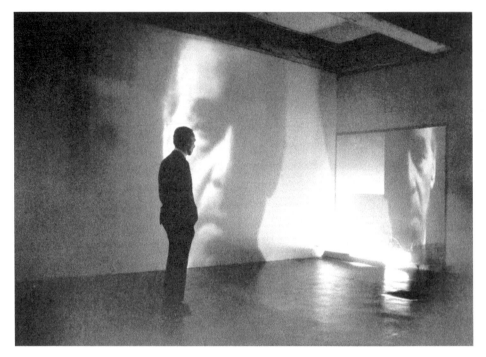

HARLEM WAREHOUSE, NEW YORK, 1969
In front of a Keith Sonnier installation

lot. On his return, he organized a traveling exhibition in his home country. "I want this to have a stimulating effect on the German art scene; this too should be seen as the act of a patron,"[40] he stated at the time.

Not long after setting up the postwar and contemporary department at Sotheby Parke-Bernet, James Mayor, who, at twenty-one, was described by Calvin Tomkins in *The New Yorker* as "the youngest art expert in . . . the world," organized the Madison Avenue auction house's first sale of contemporary art in November 1970. The date would perhaps mark the birth of the art auction as a scene of glamour. "Leo worked closely with me to assure the success of the evening," Mayor remembers. "The elevators broke down from overuse, the fire department nearly cleared the building for overcrowding. *Le tout* New York was there: a new world had begun."[41] At the end of 1972, however, Mayor was obliged to take over the Mayor Gallery in London from his dying father, who had been at the center of the European avant-garde in the twenties and thirties. Leo had agreed to help him to show Castelli artists who had as yet no representation in England. At the time,

British collectors were not queuing around the block to buy art. Mayor's early exhibitions represented the English (if not European) debuts of artists such as Lichtenstein, Warhol, Chamberlain, Rosenquist, Agnes Martin, Eva Hesse, and Twombly. It is not surprising that Castelli would have needed a partner at that moment to help defray the heavy production costs for Roy Lichtenstein which he was then carrying, particularly as summer loomed, typically the long dry season for sales. And so, having already run the contemporary art department of Sotheby's, New York, at twenty-three James Mayor decided to return to London: "I realized working with Leo was the key to everything. I told him I'd like to represent his artists, and he was in full agreement. In London I showed Twombly, Rauschenberg, Rosenquist, Lichtenstein, Warhol, Oldenburg, Chamberlain."[42]

Relations with Sotheby's continued to figure importantly. On October 18, 1973, at 8 p.m., sale number 3558 took place at the august auction house's New York headquarters. On the block: the fabulous Scull Collection. If the Sotheby's sale of 1970 heralded the age of glamour, the Scull auction ushered in the era of frenzied speculation, of price swings gyrating with the stock market, the dynamics that persist to this day. The human face of this new order was undoubtedly Leo Castelli, who for fifteen years had battled mostly uphill to remake collectors' tastes, along the way setting up the circumstances whereby the well-heeled would now fight over what, only a few years before, no one had wanted. "That day, Castelli was King Leo. At the front row, smiling and cheerful, he was holding court," recalls Linda Silverman, then assistant to Sotheby's head of contemporary art. "Everybody was greeting him, bowing and scraping, paying tribute, since it was about so many of his artists. Every single collector, every dealer was there, and Leo responded to each of them with infinite grace and courtesy. I was in my early twenties and I found it all very odd. I had to laugh looking at the Sculls, their hoopla and thirst for publicity. It was like Hollywood! The auctioneer, John Marion, whose father had already occupied the position, was tall, enthusiastic, perfectly comfortable with all this. And he electrified that sale!"[43]

The great novelty that day, compared with all previous auctions of this scope, was that all the artists were American; and all, except for Franz Kline and Barnett Newman, were living, indeed young, the median age being around forty. One by one, the fifty lots paraded by. The first few stalled at the low or middle range of their appraisals, but then Marion announced: "Lot 15, *Double White Map* by Jasper Johns, valued between one hundred fifty and two

hundred thousand dollars." One bid topped another and then another after that, before the gavel fell and the piece finally went to Ben Heller for $240,000. After that, the numbers soared: lot 21, Franz Kline's *Orange and Black Wall,* valued at 80 to 100,000 dollars, went for $125,000 to the Baron Thyssen-Bornemisza; lot 24, Barnett Newman's *L'Errance* (90 to 120,000), for $140,000 to Harold Diamond; lot 25, Newman's *White Fire II* (80 to 100,000), for $155,000 to Franz Meyer; lot 32, Robert Rauschenberg's *Thaw* (50 to 75,000), for $85,000 to Ernst Beyeler; lot 43, Cy Twombly's *A* (25 to 30,000), for $40,000 to Castelli himself. Lot 45, Andy Warhol's *Red Airmail Stamps* (valued at 8 to 10,000), went for $18,000 to Paul Kantor. The sales total: $2,242,900! With *Double White Map,* moreover, the record for a living American artist (held by Georgia O'Keeffe's *Poppies,* which had sold for $120,000 only seven months earlier) was broken—shattered!—before a flabbergasted public.

Meanwhile, outside on Madison Avenue, demonstrators were blocking the entrance of Sotheby's Parke-Bernet, protesting the cutthroat practices of the taxi fleet baron Scull. "Robbing Cabbies Is His Living, Buying Artists Is His Game" and "Never Trust a Rich Hippie," the banners of the Taxi Rank and File Commission blared. Also present was another aggrieved labor constituency: members of the Art Workers' Coalition and Women in the Arts, all denouncing the immorality of the system, the "way in which contemporary object-art functions as inflated commodity stuff to be traded by the wealthy for their own potential profit and status."[44] At the exit, a somewhat inebriated Bob Rauschenberg came up and shoved Bob Scull: "I've been working my ass off for you to make that profit," he shouted; the collector retorted that he'd "done only good for the artists by raising their prices."[45] Months later, the debate was still raging. " 'From now on, I want a royalty on the resales and I am going to get it,' says Mr. Rauschenberg," reported *The Wall Street Journal.* "Rauschenberg and others have started going to Washington to lobby for a federal law that would make royalties mandatory for all sales over a certain amount . . . 'I am sufficiently interested to look into it very carefully,' says Sen. Jacob Javits . . . Mr. Castelli, the dealer, says he likes the royalty idea but only if it's voluntary. 'Some collectors who are civic-minded and have gentle attitudes may sign it joyfully!' he says with a straight face."[46]

The straight face doubtless concealed a Cheshire cat grin within. Leo may have been the grand duke of the House of Castelli, but in relation to the Savoyan predecessors whose histories he knew well, was his preeminence that of a strategist, like Humbert the White-handed (1032–1048)? A political

opportunist, on the order of Charles Emmanuel I (1580–1630)? A pragmatic
diplomat, in the mold of Victor Amadeus II (1675–1730)? "The guy was a rav-
ing genius, and I think he knew what he was doing, he knew everything that
was going on," Joe Helman sums up, as though capitulating to an imponder-
able.[47] Indeed, throughout his colleagues' encomia to a peerless political acu-
men, one hears a recurrent reluctance to isolate Castelli from the alchemy
imputed to his success. And if some manner of cryptic chemistry it was, it is
not unreasonable to look for the formula in that crucible of his earliest trans-
mutations, his native Trieste. Trieste, the worldwide capital of the insurance
industry, where, at the Generali, the young Leo Castelli, selling life insur-
ance, first learned the art of trafficking in a commodity beyond immediate
material desire, a hedge against the onslaught of time, a defiance of mortal-
ity. "In the insurance field, a success is a much more complex and difficult
phenomenon than it appears at first blush," noted Arnoldo Frigessi di Rat-
talma. "Our work intersects with every economic institution, and requires a
wide range of theoretical and practical knowledge, as well as other, more
specific qualities, like a knowledge of cultures and people. We are not selling
merchandise; we do not really know—or we know only very approximately,
and rarely off the top of our heads—the value of our product."[48] To say, in
the context of an American culture so long indifferent if not immune to the
power of art, that Leo Castelli sold paintings seems a *reductio ad absurdum.*
Few sellers of anything have so fully determined the longing for what they
offered; fewer still have stirred such a longing for something ultimately
immaterial. Having largely created a new species of sanctity, Castelli deftly
navigated the crosscurrents of the sacred and the profane as they washed
over an already sated consumer society. Conferring on contemporary Amer-
ican art a new cultural valence, that of a potent symbolic marker, the
supreme sorcerer stirred a whirlwind of desire around those fetish objects he
had charmed, and the frenzy has continued unabated ever since.

28. A PROMISED LAND SOUTH OF HOUSTON STREET

SoHo was a wonderful place to be! It was a Renaissance, a paradise. Going there was like going to the museum, since you found only very serious galleries and very serious people.[1]

CHRISTOPHE DE MENIL

When 420 opened, on a sunny Saturday afternoon, I remember a big crowd, champagne for everyone. It became the first department store of art: an amazing event! G & G were unbelievable! I had no idea who they were, and suddenly SoHo became where everything was, where you lived; the art world just moved there.[2]

BILLY SULLIVAN

Pavement is our pillow
No matter where we stray
Underneath the arches
We dream our dreams away.

STANDING ON THEIR PEDESTAL, hands and faces gilded, one wearing a glove, the other carrying a cane, Gilbert & George (then a little-known British duo) created a *Singing Sculpture,* miming robotic gestures in time to the ditty "Underneath the Arches." No sooner had they finished than they climbed down from the table, swapped attributes, climbed back up, and started over again. "They did that for five hours straight," Ileana Sonnabend recounts. "People had cautioned us not to inaugurate our space with European artists, they said it was crazy and that we had to show an American, since Americans weren't interested in foreigners. To my mind, that was a perfect reason to start with Gilbert & George, bucking the tide, as I had done in Paris in 1963, when people had warned me against opening my gallery with Jasper Johns!"[3]

420 WEST BROADWAY, NEW YORK
A legendary destination, with the Castelli Gallery on the second floor and the Sonnabend Gallery
on the third

September 25, 1971, 420 West Broadway. Four new galleries—Castelli on the second floor, Sonnabend on the third, John Weber on the fourth, André Emmerich on the fifth—opened their doors to the public. Unexpectedly, Ileana Sonnabend stole the show, and even today, many who remember Gilbert & George's performance piece have forgotten Castelli's Group Film Exhibition, including John Jonas, Bob Morris, Bruce Nauman, Richard Serra, and Keith Sonnier. "By the end of the evening, both Gilbert & George and the gallery were public sensations,"[4] wrote Barbara Pollack in the *Village Voice*. "Painted gold, Gilbert & George were startlingly original. It was indelibly memorable,"[5] recalls Barbara Jakobson to this day. *The New York Times* reported one heartened spectator's comment that somebody had "finally dared to show what the art world is—vaudeville without pay."[6] Still, given the recession and somber mood of the previous year, no one had expected such success. "We were worried because we all came from uptown and this was a big risk," John Weber recalled. "Everyone put out wine and cheese and stood around, nervous that no one would be there." But peering out the window, Weber was amazed to see a throng gather outside, waiting for the doors to open. "I think we clocked in 12,000 people that opening day, everything was gone in 12 seconds, and the place was in the art world from that point on."[7]

During the sixties, the Castelli Gallery had been affected by—even created by—the great transformations of the American culture and economy. No one had done more than Castelli himself to introduce major new currents into the flow of art history, or to win for the American artist a new stature at home and abroad. At the dawn of the seventies, however, when he was virtually on top of the world, he would venture to steer his life, both emotional and professional, into a new urban terrain, launching an entirely new phase in his career. Was he quite aware at the time of what a spectacular metamorphosis Ileana Sonnabend had undergone during her Parisian years? Did he grasp that his ex-wife had now become a full-fledged gallerist in her own right, even one who would start to challenge him? The whole SoHo adventure had started in such a casual way! "One day," Ileana Sonnabend recalls, "Leo and I heard from our art handlers about a building for sale on West Broadway; we could get a great deal, if several of us bought it together as a co-op."[8] The advice was timely, for Frits de Knegt and Wouter Germans (of Hague Art Deliveries, Fine Arts Movers & Packers) had for years been expertly packing and shipping art objects around the world, and had come to

know everyone and every angle in the business.[9] And so for $275,000, the gallerists bought the building at 420 West Broadway, formed a cooperative, and divided the real estate into equal parts. One is tempted to see more than just happenstance in the fact that the august Castelli Gallery's next move was initiated by a transport company. Was it mere coincidence that the Trieste-born gallerist would, by relocating a few miles south in Manhattan, plant himself squarely in the district long synonymous with the wholesale trade? In fact, he was committing his enterprise to a territory as bustling with international commerce as the Molo Vecchio of Trieste, where Guido and Giacomo Castelli had once established themselves. It seems almost fated that Castelli would help turn this gloomy quarter that time had forgotten into the international art world's white-hot center!

After the Civil War, when New York was the country's most active port, SoHo, the area south of Houston Street between the South Street docks (where cargo arrived) and the Pearl Street markets (where the goods were sold), had quickly become, for the local merchants, the wholesale mecca of the city.[10] Its two main axes, Canal and Houston, could accommodate heavy trucking traffic; furthermore, the proximity of the Lower East Side, packed with immigrant tenements, provided abundant cheap labor. By 1960, however, the area that had been so central to the economic life of the city was under threat of extinction. After decades of decline in textile manufacturing and other light industry once vital to the city's economy, SoHo, with its cobblestoned streets and fabulous cast-iron architecture, had come to be seen as an anachronism at best, an eyesore at worst. As such, it would become a test case for the fate of the prewar urban landscape in the postwar period.

Few debates over land use in U.S. history have inspired such out-and-out conflict: a city version of the cattleman vs. sheep rancher. Few neighborhoods have given rise to such a public psychodrama, or have been so directly implicated in the debate concerning what Jane Jacobs would call "the death and life of great American cities." The voice that then seemed progressive sounds horrifying today. "We simply repeat that cities are created by and for traffic. A city without traffic is a ghost town," Robert Moses, New York's parks commissioner and the master builder of its highways, had decreed. "The area between Canal Street and Third Street, a strip three-quarters of a mile wide, is the most depressed area in lower Manhattan and one of the worst, if not the worst, slums in the entire city, a ghetto, with the rate of turnover of 14 percent a year."[11] It didn't help matters that this ruined quarter

had no name. Its current residents vaguely referred to it as "downtown," ladder companies called it "Hell's Hundred Acres" for the high incidence of fires, while others dubbed it "the Valley," alluding to the modest elevation of its rooftops amid the surrounding high-rises. Rightly, many deplored the notorious sweatshops that remained, in which undocumented and underpaid laborers put in fourteen- to eighteen-hour days doing piecework, amid the ghosts of the legions more who had toiled there when work conditions were even more horrific but the profits much greater. "We Americans have a strange relation to our past," observes the historian Stephen Koch. "We wish to deny its existence. We must be forever young, forever the New World. The national nausea over history perhaps played some role in the city commission's 1959 suggestion that SoHo be razed. It seemed so unforgivably 19th-century. Neither modern nor quaint, it was therefore ugly. Worse, it was the landscape of some of America's most unpleasant 19th-century memories."[12] With his proposal to displace fewer than two thousand families, and with his guarantee of federal support, Moses's plan to make room for a Lower Manhattan Expressway through SoHo seemed unstoppable.

Among the residents to be cleared out was a small group of artists, most of them squatters; by 1960, they had organized to resist the plan, and the SoHo Artists' Tenants' Association (ATA) was making itself heard. The following summer, to protest their forced evictions, they threatened to boycott every art opening in the city. But the real momentum to halt the Moses plan and to preserve much of New York's architectural heritage came in the wake of a cultural tragedy: the demolition of McKim, Mead, and White's Beaux Arts masterpiece Pennsylvania Station in 1964. When John V. Lindsay was elected mayor two years later, the debate was still raging, and initially Lindsay favored the expressway initiative. But the liberal Republican soon became an opponent of Moses's dystopic modernist vision of urban life, and he relaunched the Landmarks Preservation Commission.[13] An early environmentalist, Lindsay closed Central Park to automobile traffic on Sundays; he also established the City Planning Commission, a pioneering entity that adjusted zoning ordinances so that artists could legally occupy their lofts, till then not zoned for residential use. "We had in the mayor a cultured, sensitive, educated man who understood the value of art in the life of this city," explained a representative of the ATA. "The Lindsay administration was absolutely vital to our success. Throughout the struggle, we had the support of Lindsay and his personal aides. It was aides to the mayor who told us how

to argue our case before the Planning Commission."[14] On July 16, 1969, in defiance of Moses the Power Broker, Lindsay announced that the plan for the Lower Manhattan Expressway was "a dead duck." Killing the highway project put an end to years of rancor between planners and residents, while giving one group, the New York artists, their first taste of activism's potential. Finally, in 1970, the Friends of Cast Iron Architecture (FCI), an association of architects and consultants, lobbied to have SoHo declared a historic district.

Three years later, the mayor's office granted SoHo—bounded by Houston, Canal, West Broadway, and Crosby Street—protected status.[15] The official release read: "The hyphenated name 'SoHo–Cast Iron' was chosen for the designation of New York City's twenty-third Historic District in order to suggest some of the diversity of the area. The 'Cast Iron' portion of the name refers to the unique collection of cast-iron structures located within the District. 'SoHo,' meaning 'South of Houston,' is the acronym adopted by a group of artists who moved, in the 1960s, into what seemed to be a doomed neighborhood. They have given it new life, making feasible the preservation of an irreplaceable part of our cultural heritage."[16] Therefore, the preservation of SoHo and its conversion into an artists' quarter was partly due to local politics, and partly to the new cultural ecology that had flourished in America since the mid-sixties. In 1962, President Kennedy had appointed August Heckscher as special consultant on the arts (citing his report *To Establish a U.S. National Arts Foundation* in a Congressional address) and created the President's Arts Council. Four years later, John Lindsay appointed the same Heckscher to be commissioner of parks and recreation and administrator of cultural affairs; he also cultivated relations with the Rockefeller family, bringing together the worlds of business, politics, and philanthropy on culture's behalf.[17]

Finally, in 1968, a simple press release set things in motion: "Paula Cooper, former director of Park Place Gallery, announces the opening of a large new loft gallery at 96–100 Prince Street, New York (one block south of Houston Street and one block west of Broadway). Much current painting and sculpture is unsuited by intent and size to intimate indoor space. The opening of this spacious 5,000-square-foot loft as an exhibition space is a move towards bridging the gap between the usual gallery context and artists' increasingly public orientation."[18] Well known for her activism against the Vietnam War, Cooper had been among the first to propose an approach to the exhibition

of art that would be nonpartisan, community-based, interdisciplinary, flexible, and exploratory. Another SoHo pioneer, some time later, was Ivan Karp, Castelli's gallery director for ten years, who set up OK Harris, a big space on Broadway, where, with his customary joviality, he continued to organize amazing social events around his signature passions for cigars, poker, and collecting. As a communal experiment, while SoHo developed in a historically specific political atmosphere (that of the antiwar movement), it strategically united many groups with disparate concerns. Some, such as Cooper, were primarily motivated by politics; others, such as cooperative galleries like the AAE [the Association of Art Editors], had civic-minded agendas; while others still, including the Fluxus group (among its members the Lithuanian George Maciunas and the Korean-born Nam June Paik), subscribed to revisionist aesthetics.

At first, while Paula Cooper and others were colonizing the southeast side of the city in the wake of the worldwide upheavals of 1968, Castelli, for his part, was wandering a different path, though in a neighborhood no less unexpected than SoHo. He had set up his sculpture gallery in a vacant warehouse between Amsterdam and Columbus, at 103 West 108th Street, which he had discovered with the help of the Hague Art Deliveries, his transporters, whose offices were downstairs. Castelli's development of new spaces (first on the fringes of Harlem, then in SoHo) in the late sixties was simply another phase of what he had always done—crossing boundaries, planting satellites, making new places synonymous with the future of the art world. His moves had seemed no less transgressive when, in the early fifties, he helped to reinvent the cultural landscape of the city, and planted the Castelli flag in East Hampton and Paris, connecting artists, critics, collectors, curators, and dealers. Now, twenty years later, he was on the move again, as ever improvising to give his artists the best possible showcase for the new form of art that they were producing. " 'I want you to do this show at the warehouse,' Leo said to me when I brought him my television work," Keith Sonnier remembers today. "The space was still very raw. We spent a month preparing the work in the space. It was like a real exercise and seemed like a rehearsal because it was the first time that we were actually showing a television work, a huge video projection which had been started in glass and light and mirrors. While preparing the show, Leo wondered 'What are we selling? How do we sell these pieces? Do we sell the TV set? Do we sell the tapes?' I suggested to photograph them, to disassemble them and to ship them in parts."[19]

The perils of stasis and complacency had been planted in his earliest memories by Ernesto Krausz's example. And so Castelli, who ten years earlier would have preferred to widen a doorway than force Frank Stella to shrink his vision, was, at the age of sixty, still adapting. In the 1970s, with little left to prove except the evergreen vitality of his enterprise, he was still adjusting to the needs of his artists, reinventing his function as gallerist, assimilating aesthetic wave after aesthetic wave (Minimalism and Conceptual Art following post-Duchamp and Pop). These changes sometimes entailed huge increases in his overhead, even to the point where the status of the work of art as a saleable object became problematic. "The whole group of us came in at the same time," continues Keith Sonnier. "Bruce Nauman was first, then Richard Serra and myself, then Joseph Kosuth, Lawrence Weiner, Robert Barry, while Ileana was taking similar artists at the same time! Donald Judd and Dan Flavin came before us and they hated us! Flavin would ask, 'Why are you letting these Dada homosexuals into the gallery?' Flavin was just terrible. The new pieces were expensive to fabricate, and Leo was paying those fabrication bills. Richard Serra would not have been able to be Richard Serra without this production money. But Leo did what he wanted to do, it was not a problem. In the end, it all worked out fine." If "Leo made everything work," was it not by inventing new solutions to sell the new art? "The problem was that I was dealing with electronic work, and that you had to plug it in," Sonnier continues. "The pieces were not easy to sell. I was of the younger generation . . . and the people from the generation before me, such as Flavin and Judd, weren't selling either. Leo provided us with full support and he found a way to sell our art."[20] For a period of three years, Castelli would use the 108th Street warehouse to show the larger-scale works that his artists brought him, including the famous "9 at Castelli" show, before finally decamping to SoHo with Ileana in 1971.

Certainly, by establishing a new gallery in SoHo, Castelli was entering a territory already explored by others, one rich in aesthetic and political ferment. But it was his unique status as the ultimate art insider (who was nevertheless perennially looking to the margins) that marked SoHo's arrival, his fame and his imprimatur that attracted intense media attention to the artists' subculture south of Houston. Within weeks, he would become an organic feature of the landscape, though the first notices focused less on Castelli than on his ex-wife's *coup de théâtre,* and even more on the architecture and overwhelming spaces of the newly discovered neighborhood. Words, it seemed,

could scarcely do justice to its impressive size—"420 West Broadway, a former paper warehouse . . . ran back 200 feet to Thompson Street, with perhaps 10,000 square feet of space to a floor for exhibitions and support offices"[21]—or to its architecture, a "five-story building, a 19th-century architectural gem with cast-iron pillars, flanked by a flooring company and a hardware concern." Grace Glueck described the new space with admiration: "Once a warehouse for the A. G. Nelson Paper Company, it was remodeled at a cost of nearly $500,000 . . . Each occupant has 8,000 square feet of the floor space, vast by uptown standards. Mr. Castelli divided his premises into three handsome exhibition areas and installed a projection room for films. He views his downtown operations as 'a more open situation, a shot in the arm for us.' Mrs. Sonnabend, afraid of 'spoiling the beautiful space,' left partitioning at a minimum to achieve a wide-open arena."[22] Artists like George Segal and Roy Lichtenstein, energized by the possibilities, joined in the general euphoria and declared themselves captured by "the space, the vitality, the people," and by the possibility "for the kind of art that isn't just pictures."[23] Jim Rosenquist, finding the ceiling too low, was alone in complaining publicly that he did not like it.

In the tabula rasa that was postwar Paris, St.-Germain-des-Prés, with its cafés and its forums for Existentialist philosophy, became a place of artistic and cultural ferment. Reprising the tradition of messianic bohemianism from eighteenth-century café intellectuals, this village formed around the eponymous church would attract countless tourists searching for the legendary figure of Jean-Paul Sartre, who might be writing in the Café de Flore or organizing the latest issue of his magazine *Les Temps Modernes* at Les Deux Magots. SoHo, by contrast, had no indigenous blueprint to follow—no surprise in a country that had always looked askance at art! Where a church had served as focal point in the European instance, the American case had only a profusion of industrial buildings, places of commerce and industry, though hardly temples even to those strange gods. The area rested on many strata of historical memory: there were the painful traces of nineteenth-century industrial abuse and more recent bureaucratic greed, but also vestiges of incipient labor activism. The singular architecture attracted a profusion of creative types and so, even lacking quite the tradition of St.-Germain-des-Prés, a convivial atmosphere of coffee houses and of public spaces sprang up, encouraging all sorts of exchange among individuals who found themselves suddenly thrown together.

SoHo gathered and developed the realizations of the sixties into a model of community entirely unprecedented in the United States, mixing the public financing that sustained numerous artists' collectives[24] with the private interests of the galleries. With its seemingly limitless possibilities, its social order in progress, SoHo allowed all sorts of nonconformist elements to coalesce and thereby engendered a new collector class with new attitudes, one who treated art as something more accessible, less intimidating. By the same token, Castelli lent cachet to the whole enterprise. "From the end of World War II to the mid-1960s, the New York artist community was a cosmopolitan community; it was not a territorial community," wrote the sociologist Charles Simpson. "As artists took over outmoded loft spaces in manufacturing buildings, they assumed a common interest in the political as well as economic availability of such structures, and . . . established a protest organization."[25] And so, rather paradoxically, as SoHo was progressively "taken over," it became more and more an open republic of arts, a free zone, a city within the city, a safe haven in a hostile environment—as Alfred Stieglitz's 291 gallery and Santa Fe, New Mexico, once were—a theater in which the new identity of American creators could play out.

Starting in the fall of 1971, every Saturday, from September through May, a new public beat a path to SoHo and strode down the cobbled streets of the shabby urban grid, learning to appreciate not only the art in galleries but also gargoyles and Corinthian columns, odd geometric alignments, oblique staircases and rounded arches, brick and cast-iron and stone façades; they would welcome the refreshingly incongruous juxtapositions, this unlikely marriage of aesthetic truth-seeking and ghostly industrial design. It would be some years before this urban frontier boasted all the comforts of the consumer culture and drew in young bankers as neighbors to artists. But from the start, as exhibitions, galleries, restaurants, and bookstores opened, the landscape transformed the art market just as the market transformed the landscape. "Its streets lined with the white, Palazzo-style 'cathedrals of industry,' SoHo was supposed to be a Venice, but a Venice of the New World triumphantly revealing through its arcades the American dynamo," writes Stephen Koch. "One was supposed to walk down West Broadway to see the beauty of the Renaissance recreated in modern iron."[26]

And so, the experience of Saturdays in SoHo gradually became a kind of pilgrimage, a comprehensive artistic, architectural, and historical education, eventually taking the form of a myth: the myth of New York's complete

usurpation of an entire realm of Western visual culture that had once been the exclusive province of Europe. The collectors Dick and Barbara Lane recall the excitement of entering the arts underworld below Fourteenth Street, particularly with Leo as their Virgil: "Leo introduced us to the Minimalists, and we bought three Flavins," they rave today. "We were in the depth of our passion, he told us, 'A collector can only be a collector in the same way for seven years, you'll see.' He meant that you cannot keep the level of passion and commitment for longer than seven years. Anyway, we had so much fun every Saturday in SoHo!"[27] Donald Marron also bore witness to the cultural shift Castelli helped to bring about in SoHo: "When Leo opened his gallery, 420 West Broadway became an art center. Ileana was right above him, John Weber and André Emmerich were upstairs, and later Mary Boone opened up across the street. Leo's move downtown showed the way that he could sense and, in some cases, set trends. Some of the growth in SoHo can really be attributed to Leo. Four Twenty West Broadway became a destination gallery, where people looked forward to spending Saturdays. I still remember running up and down the stairs, together with artists, collectors, curators. First, I would visit the other galleries because I knew that once I got to Leo's, I wouldn't leave."[28]

But at sixty-four, was Leo Castelli really still up to playing the role of ringmaster to the hodgepodge of countercultural elements that had piled into what was recently a no-man's-land? Before long, observers would start asking. "So-called SoHo appears to be making its bid this season," the *Times*'s journalist Peter Schjeldahl wrote in October 1971. "The landmark loft district south of Houston Street, which two years ago had nary a gallery, today boasts about twenty, including lavish new branches at 420 West Broadway . . . Judging from the over-all quality and panache of recent openings . . . SoHo now qualifies as something more than an eccentric epicenter of the traditional Madison Avenue–57th Street axis."[29] But a year later, the same critic, while still agog at "the four one-season-old galleries in the handsomely done-up SoHo loft building at 420 West Broadway . . . [where each] of the four galleries . . . has a different stylistic flavor," also noted that "Castelli is burdened with a glorious past. The premier gallery of Pop and early Minimal . . . has haplessly followed the vanguard into increasingly arid climes. If its current show (which opened too late for this review) reflects its current roster, it will contain, besides some strong work, a good deal of stuff by older artists repeating or parodying themselves and stuff by younger

artists doing to death some originally lifeless idea . . ." In the same piece, Schjeldahl ventured a possibly more painful cut: "[Sonnabend] is perhaps the closest thing in town right now to a top avant-garde gallery that is, in an old-fashioned way, at once sensation-seeking and doctrinaire. It's a gallery, that is, on the lookout for precisely the kind of alternatively nihilistic and Utopian raids on the future that define the principle of permanent revolution in avant-garde art."[30]

At the same time, Castelli's renewed bond with his ex-wife, as well as his never-ending string of younger girlfriends, caused an inevitable strain on his wife. In the words of Bob Monk, "Toiny's two real enemies were Ileana and other women. When Leo was uptown, Toiny was sober. When he was downtown, she started drinking. Ileana was always the biggest threat, much more so than the young girls. When people, Toiny's so-called friends, used to tell her everything that was going on between Leo and his girlfriends, that tortured her."[31] Had Castelli finally become passé, trailing behind his ex-wife, as Schjeldahl suggests? Can it be said in retrospect that "the sixties were Leo's high point [and that] by the seventies [he had become] a figurehead," as James Mayor would have it?[32] If one was ever tempted to count out Leo Castelli, it was always at one's peril, and would continue to be even as cultural changes made it impossible for anyone to claim the sort of primacy he once enjoyed.

Today, Tony Shafrazi recalls the atmosphere among those subversives of the seventies, a group of artists he was part of. "The world was changing. It started in 1966–67, got more aggressively dominant in '68–'69 and by '70, '71, '72, paralleling the disastrous escalation of the Vietnam War; it had gradually led to alternative spaces. In '72, Castelli and Sonnabend were forced to address the situation because all the focus was [on] downtown industrial places, and in SoHo there were maybe a hundred artists living in very poor empty spaces, so they moved to West Broadway and the 420 opened. Suddenly, the gallery identity shifted to a more industrial warehouse–looking space, which eventually was part of a bigger phenomenon. All art moved away from [its former] position, which was a celebration of the cultural media of the fifties (comic books, advertising, printing, and photographic imagery like Warhol), which you could hang in a gallery; it moved to much more industrially fabricated materials, manufactured things like metal plates, and little by little dealing with debris, trash, bricks, earth on the part of the artists forced the function of the gallery to change. It is as if the art

came off the wall and went to the middle of the floor, as if it could be dis-mantled and remantled [*sic*] again. It went out from the gallery into the street, and from the street to the outskirts of the city (which was the case of Robert Smithson's art), and from the outskirts of the city into the desert, and from the desert also at the same time it would go into the newspaper and the written texts, in every way. Then, the whole parameters of art changed dramatically."[33]

Angela Westwater, who was then working in John Weber's gallery, remembers that atmosphere, too: "SoHo was a smaller, much more friendly art collective. Which is not to say that Leo wasn't at the top of it, he was! It was an open, generous time. On Saturdays, people were always talking about the evening's events, saying, 'There's a performance tonight, Philip Glass is doing a concert on Bleecker Street. Come! Bring a blanket!' I was able to go to an early Joan Jonas performance. There were so many new, wild things going on. People would say, 'Hey, sounds good to me!' and join in. SoHo was an exciting experience, a new part of town."[34]

Castelli's spaces of the future, in Harlem first, then in SoHo, had wel-comed and even cherished these kinds of assaults on the center from the mar-gins, every compelling challenge and transgression against the traditional order of art itself. The scene must have stirred his memories of Dadaist Bucharest and of Surrealist Paris, but he could no more contain the ferment in SoHo than he could as a younger man overmaster those scenes. Such concen-trated authority as he had once wielded in New York was rather out of fash-ion, even suspect, and he left it uptown like an unfashionably narrow tie. Together with Sonnabend on the floor above, Castelli evolved during the SoHo years into a new type of cultural broker. Beyond the first room, a vast and peaceful space, where the visitor could first devote his time to contem-plating the art, a soon mythical red velvet rope cordoned off an inner area fur-nished with a sofa, a space that represented an interesting organization of functions, of different levels of power. And further inside still, in his own little niche, visible yet altogether protected, seemingly available yet always in con-trol, multitasking, as ever magically smiling and shifting among several lan-guages, sat the gallerist, surrounded by photos and little else to define this hip downtown version of a sanctum sanctorum. Around him, Castelli assembled a formidable team—Betty Cahen, Mimi Thompson, Debbie Taylor, Patti Brundage, Susan Brundage (the manager), Michelle Dreyfuss, Mame Kennedy, Tery Wilson, Bob Monk, John Good, Tom Pelham, Morgan Span-

gle, Pat Caporaso—a colorful cast that Meryl Secrest described as "a troupe of commedia dell'arte characters masquerad[ing] as gallery assistants." Within this "kaleidoscopic scene," Castelli seemed ever the calm in the eye of the hurricane. "The sense of random juxtaposition," she observes, "is heightened by the outward appearance of this art dealer, a mercurial and magical [that word again!] purveyor of the precious and rare, a man who has triumphed in the most tenuous of all worlds, with patience, skill, charm and the surefootedness of a mountain goat. Castelli is a short slim figure, graying, with a sharply angular face that seems, like that of Cocteau, designed to be seen in profile; he is wearing his classic, understated banker's clothes, absorbed in the logistics of appointments, occasionally adjusting his tinted glasses with their fastidious gold frames. Around him, movement jerks, bursts, fragments and splatters. The canvases are now hanging from walls, and the march of modern art advances one small step."[35]

By 1969, thanks to the suggestion of Dick Bellamy, Castelli had mined a whole new vein of radical artists, both Minimalist and Conceptualist. Bellamy had closed his gallery, though he maintained a back room at Noah Goldowsky. Leo's son, Jean-Christophe, seven at the time, remembers fondly all the fun of those SoHo shows. "I would go downtown to the openings on Saturday afternoon, and there were Richard Serra's constructions, Dan Flavin's environment pieces, Bruce Nauman's corridors, Joseph Kosuth's writings from Sigmund Freud, Larry Weiner's works which did not sell, Phil Glass and John Cage's concerts with twelve radios, Jonas Mekas's videos, William Wegman's photographs as well as the architecture shows . . . it was totally unforeseen and, certainly, as a child I picked up the playfulness of those rough experiments at once! The gallery exuded a good karma, with the feeling of a family about it, with all those women surrounding my father; he was certainly a very good boss and treated his staff with unusual care."[36] Indeed, it was Castelli's relationships not only with his staff but also with artists in general that enabled him to play his part with his accustomed magisterial air despite the anarchic place and times.

In 1974, Tony Shafrazi had made headlines by spray-painting the words "KILL, LIES ALL" on Picasso's *Guernica* at MoMA, in a gesture of despair and of love, to protest the My Lai massacre and attract public attention to the plight of the artist. Thanks to Castelli, as we have already seen, the artist Shafrazi had turned into a collector shortly after his arrival in New York. And his *mitteleuropäische* sensibilities notwithstanding, Castelli had always treated

such subversive gestures with respect and patience. One day, after the *Guernica* event, Shafrazi stumbled into the Castelli uptown gallery while a magificent Jasper Johns show was up. "Another crazy idea came to my head," he recalls. "And I went uptown, saw Leo, the Jasper Johns show. There are four paintings in that room. I walk into the room, I have a spray can in the pocket of my leather jacket. I look at those paintings. Right away, I have thoughts in my head, and I say: 'Truth, Honor, Power, Glory.' These are the words that come to my mind. Leo comes out and I say: 'Leo, I'm here' and of course he knows the *Guernica* story, and I say: 'Leo, I'm here, I see these *wonderful* paintings of Jasper, and I have in mind to write four words, one on each painting.' He says: 'Yes? What?' I say: 'Truth, Power, Honor, and Glory.' He says: 'Tony, that's very interesting, but really? Well, I would like to talk to you further about that. Let me just finish what I'm doing, and I'll go downtown with you, because I want to give you *complete* attention, so we can talk together.' I said: 'Leo, but I want to write these words.' 'Yes, just give me a few minutes to finish what I am doing now.' He turns around, goes into his office, and leaves me alone in the gallery. I am in the middle of the room; he is gone maybe for five minutes, four and a half, five minutes at least. And I wait, and I don't do anything. I waited, you see. But the fact that he trusted me was remarkable. Calm. Cool. And he comes back, with his briefcase, and we go down, we take a taxi together, and we go around, all the way to the East River, all along the East Side, all the way across to Houston. Come to SoHo. And go up to his gallery. And we sit there. We talk all the way through the cab ride, and all the way, so that's twenty minutes, half an hour, and all the way upstairs. We bring a coffee, we sit down, we have a coffee, and then I say goodbye and I leave. That was Leo. Amazing!"[37]

In 1977, Castelli fully committed to SoHo, definitively closed his uptown gallery, then three years later opened another new space, even larger, even bolder, at 142 Greene Street, in order to show James Turrell, Richard Serra, and the sculptures of Kelly, of Judd, and of Nauman. By that point, SoHo had become sufficiently hallowed ground for him to show all his artists—past, present, and future—there. Who could be better at integrating Pop, Minimalism, and Conceptual Art, Americans and Europeans? He was able to absorb every genre, from painting and sculpture to video, performance, design, and even music and architecture. As Barbara Jakobson recalled: "Towards the end of the seventies, I was able to organize two architecture shows, 'House for Sale' and 'Follies,' in Leo's gallery, as if in a museum. I

commissioned designs for houses from architects. The idea was to sell a house in an art gallery the same way you could sell an artwork—an idea that was a critical but certainly not a financial success. Leo was as generous as ever, he paid for everything. He published the catalogues with Rizzoli and helped tour the shows around the world."[38] (As always, support for his artists remained paramount; since first setting up shop in 1957, Castelli had always reinvested the money he made, so he experienced a return on capital far below many other dealers. "Every month, I need to put out a quarter million dollars for operation expenses," he would often say.) What was buttressing the nascent revolution in SoHo? The interest in industrial architecture, an allegory of the past? Or just another instance of Castelli as the model gallerist, as the "artist's dealer" par excellence, who always showed the way? "In 1977, when we sold these *big* Stella paintings," Janie C. Lee recalled, "when others would have said, 'Cut down the picture!' Leo simply said: 'Take the door down!' "[39]

"At the time when Minimal and Conceptual art were first being recognized, works by people like Judd, Flavin, Kosuth, and Nauman weren't always in great demand, but Leo never wavered in his affection for his artists," Jakobson continued. "Even if they didn't sell much, he always supported them, and I never heard him say anything against them."[40] As for Robert Storr, he remembers that "Bruce Nauman stayed with Leo the entire time, even though Leo only came twice to see videos in his studios and fell asleep! During the first period, Bruce emerged thanks to Leo; then, in 1972, he was trashed by the press and his rise plateaued, and it was thanks to Leo, Konrad Fischer, Panza, and the interest of the European market that he was kept alive. In '82, it was again Leo who put him back on the map, by showing *Big Tunnel Pieces* at the Greene Street gallery. Later, at the Reina Sofia in Madrid, for his opening Bruce went out of his way to greet Leo, to show gratitude for his exceptional loyalty."[41] As for Dan Flavin, he would choose to immortalize his gratitude to the gallerist with the title of one of his works— *Untitled (For you, Leo, in long respect and admiration)*.

In a new setting, but still true to his elegant, unalterable self, the sexagenarian Castelli embarked upon the most intense (if not the most creative) years of his professional and emotional life, gradually and in three phases, occupying his new domain quarter-time, half-time, and finally full-time. At first, with his usual measure and circumspection, he regarded 420 West Broadway as "sort of an outpost," which he enjoyed but to which he went,

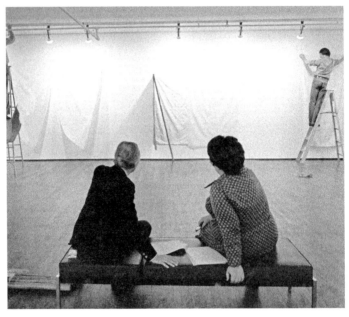

420 WEST BROADWAY, 1975
Consulting Ileana Sonnabend, while Rauschenberg's Jammers show is being installed

"like a visitor," only "three or four times a week." For seven years, from 1971 to 1977, he divided his time between Castelli uptown and Castelli downtown. On Seventy-seventh Street, he went on showing canvases by his marquee artists, while at Castelli Graphics, with his second wife, Toiny, he developed the lower-end if burgeoning market for photographs, prints, drawings, and posters. Meanwhile in SoHo, spurred on by his first wife and eternal collaborator, Ileana, he probed the new boundaries of experimental art with films, videos, and performances. If, via the satellite galleries, Castelli had changed a basic feature of representation by extending his geographical reach and by offering his first artists greater visibility, so too was he now innovating synergies between emergent and traditional styles of selling art, between, as it were, the raw and the cooked. Rough experimentation bubbled up from downtown, where art drew life from direct contact with the here and now; the accepted and blue-chip properties still issued majestically from the flagship location; and reproductions and lesser avatars of both strains were churned out in deference to the reality of the machine age and of art's new easy flow in the mainstream of a culture that only recently had had little use for it. Even personally, the inveterate East Sider was electing new affinities.

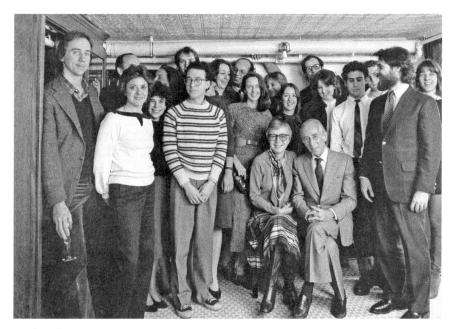

CAFÉ ODÉON, NEW YORK, FEBRUARY 1, 1982
Twenty-fifth anniversary of the Castelli Gallery. Castelli and his wife, Toiny, SEATED IN FRONT. AROUND THEM, LEFT TO RIGHT, Miles Manning, Hope Kaufman, Pat Caporaso, John Good, Arthur Solway, Susan Brundage, Marvin Heiferman, Sandra Triggs, Janelle Reiring, Betsy Richbourg, Tom Pelham, Patty Brundage, Michael Hord, Bob Monk, and Debbie Taylor. IN BACK ROW, PARTIALLY OBSCURED, David Whitney, Mimi Thompson, and Michelle Dreyfuss. Photograph by Hans Namuth.

"Downtown is just so much more exciting," he declared. "There really is a lot going on, apart from the fact that there is this whole building to see and that there is an opening every week somewhere. And there are also nice places to eat down there now, which years ago there weren't. It's beginning to grow. There'll be more eating places and I guess more galleries."[42] If the transplant seems simple, it's instructive to compare Castelli's experience with that of André Emmerich, whose more staid dealership continued to show the Color Field painters championed by Clement Greenberg. Not surprisingly, Emmerich's graft onto SoHo never really took, and he soon sold his space and moved back uptown. Castelli, on the other hand, pursued his forward march: in 1974, with Ileana, he created Castelli Sonnabend Videotapes and Films, a production and distribution company specializing in artists' videos.

"When I interviewed with Leo, I expected that he would ask how fast I typed, but he only said, 'Debbie, are you *sure* that you can be awake and at

work by ten o'clock?' I replied, 'Yes, I am positive,' and he said I was hired,"
remembers Debbie Taylor, who started working at the gallery at the age of
twenty-four, in September of 1976. "The position was at the counter, my
main job was as an archivist, and everybody knew that our system of
archives was unique in the art world. We lent the documents to curators,
scholars, writers, never charging any money, but just asking that they be
returned. It was an incredible resource which was already putting artists in
history. As for the finances, which were always so shaky, Leo recycled the
money he made with Roy and Jasper in order to provide stipends for the new
artists."[43] According to most of them, the Castelli staff enjoyed a very
unusual work arrangement. Mimi Thompson, who fondly recalls that "the
gallery really felt like a family; people looked out for one another, Leo
looked out for us. There was never a sense of hierarchy. The really true con-
nections he made were more than business arrangements."[44] Debbie Taylor
adds, "No one was really our boss. We all worked together. We were work-
ing from ten to six, but sometimes Leo would leave and we would lock the
elevator, call our boyfriends or husbands and stay in the gallery, eating and
drinking until midnight or one in the morning! We were all quite proud to
work for this man."[45] Amy Poll-Schell, who began as an intern in the gallery,
reflects, "As a young person, it was just amazing. Leo was very accessible to
everybody, his door was always open. It was a very relaxed atmosphere for
such a powerful place."[46]

Morgan Spangle, the young gallery manager from Chicago, who began at
the Castelli Gallery in the early 1980s, describes how only a daub of the
Castelli magic would usually suffice. "Leo and I worked as a tag team," Span-
gle explains. "I used to sit right by the entrance to the back room so every-
body had to walk past me. Because I was 'the man,' I could say, 'You can't
come in here.' When new collectors would visit the gallery and say they
wanted to talk to Leo, I would tell them Leo was busy, but I would invite
them to come in and chat with me. Somehow, when I understood that they
were serious, I would introduce them to Leo. 'You stay with Morgan,' he
would say. 'If you need to speak to me again I'll be right here, but Morgan
takes very good care of you.' Then, Leo would just disappear! I would go in
the back and work on the sale, sometimes we would sell a couple hundred
thousand dollars' worth of art. After, I would grab Leo and he would come
out and say, 'Oh, Morgan showed you that? That's fantastic! That's perfect
for you! I know you'll love that! I was going to keep that for myself but for

you, it's great, so Morgan will take care of the details. It was great to see you, I have to go now. Bye bye!'"[47]

In 1967, one of Castelli's favorite younger colleagues, the Italian dealer Gian Enzo Sperone, had opened in Turin Il Deposito d'Arte, which he describes today as "a squalid, brutal, unattractive space, a single room of six thousand square feet, which meant to kill the idea of art as consolation and of the gallery as a commodity boutique. The philosophy of Arte Povera was an attack on the consumption society and considered art as *important* as philosophy. Leo and Ileana came to the opening and left, very impressed."[48] Sperone ardently wished to join Castelli's operation, but upon receiving the master's artfully flattering rebuff—"I don't need a proconsul!"—at the end of 1972, he decided (he was then thirty-two) to open his own space on 142 Greene Street. With the U.S. economy in the grip of stagflation, it was the start of an excellent time for holders of European currencies, and so artists and dealers flocked from the Continent, alighting in particular on an area south of Houston, to stake their own claim in what seemed an as yet unclaimed Promised Land. Bolstered by the huge wealth they had amassed in Germany, two talented young dealers burst onto the scene, Heiner Friedrich from Munich and Konrad Fischer from Düsseldorf. "The Germans are coming! The Germans are coming!" Tom Hess sounded the alarm in *New York* magazine, announcing the Teutonic gallerists as "brash expansionists dedicated to American-style radical art."[49] As for Castelli, this moment would signal the start of his own second phase, which would refresh his lifelong empathy for European artists—perhaps under the influence of Sonnabend, who took manifest delight in mixing up cultures and satisfying her taste for provocation with ever greater doses. With *Seedbed* by Vito Acconci, she presented as live performance an act of masturbation (literal), during which the Bronx-born artist, concealed beneath a ramp, vocalized his fantasies through a loudspeaker; and for an installation by the Greek-born Jannis Kounellis, she agreed to the daily presence of a live horse, to be hauled up every morning and back down every evening on the freight elevator.[50] At that time, recalls Antonio Homem, director at Sonnabend since 1968, "behind the scenes, [Frits] de Knegt and the [Hague art movers] were still playing an important role, managing the building, supervising the deliveries, handling the freight lift."[51] But even the draconian Dutch building managers could do nothing in the face of Ileana's determination to show a horse in SoHo!

Was Castelli part of this rediscovery of the Old World? In 1976, in association with John Weber, he showed the French Conceptual artist Daniel Buren, whose striped columns (*To Transgress*) traversed the entire width of 420 West Broadway. He also showed other Europeans such as Jan Dibbets, Laura Grisi, and Hanne Darboven. It was a fitting turn back to the future for one who, two decades earlier, had precociously engineered an art match between Europe and the United States. Now, however, thanks to the international mystique of SoHo, the Europeans were coming to him. As Douglas Davis put it, "America and Europe are—at least in SoHo—in a state of equilibrium."[52] SoHo, a "European metropolis" on Manhattan soil, with its "ostentatious elegance" so contrary to American tastes, had it all: art most evidently, but also a devotion to design, typified by the ubiquity of wicker and metal-tube Breuer chairs, and even the café culture. At the Spring Street Bar on the corner of Spring and West Broadway, or Barry, a simple, prewar-style Irish pub, any budding artist could run into Castelli—as once, at the Café de Flore or Les Deux Magots, any philosophy student could approach Sartre.

In SoHo, Castelli rejuvenated himself. Rather than playing the establishment gallerist who, growing older, recycled the old stock, Castelli shone as an adolescent sexagenarian, investing in new turf and new trends, staying abreast of all the movements of the younger artists and dealers. Over the years, he would become a living landmark of the small town that sprang up where Moses's automotive dystopia was stopped. Castelli the pedestrian of SoHo, Castelli the eternal Italian, hoofing it at lunchtime to his favorite restaurants—Da Silvano at the corner of Sixth and Bleecker, Ballato on Houston Street off Mott, or Mezzogiorno on Spring between Thompson and Prince. Refreshed by this second youth, Castelli would undergo yet another metamorphosis. At age fifty, he had invented a new array of possibilities for his young artists; at seventy-plus, he would reimagine the prospects for young dealers—eventually to pass the torch! First to Mary Boone, who started her career at age nineteen and would open a gallery in a vacant space on the ground floor of 420 West Broadway; then to Larry Gagosian, who having got his start selling posters at UCLA, would take the power of personality to a whole new level.

"I first approached Leo in the fall of 1979 to see if he'd organize a Julian Schnabel show with me," Boone recalled of her first, difficult interactions with the elder gallerist. "'Absolutely not,' he said. 'The last artist I took on

was Richard Serra and that was ten years ago. My artists would be up in arms if I showed Julian Schnabel!' So I went to Barbara Jakobson and told her it wasn't going to happen, but she said, 'Leave it to me.' Over the next year she talked to him, and of course Leo, being a very smart man, asked all of his collectors. He was everything I wasn't: he was established, cultured, older, and he was male. I always used to think he could do with one phone call what it took me a month to do. But, on the other hand, I think that I made him feel younger. We worked together; I gave Leo half of all the commissions. Leo was generous enough not to step on my feet. This is another thing that was very smart and I think could only have happened because we were so different in age. He was never competitive with me. He always wanted to push me further. Leo was never driven by money anyway. He loved the excitement. I remember when I sold the first painting to the Schwartzes, he said, 'They haven't bought a painting from me in twenty years!' "[53] Galvanized by Castelli's confidence in her talents, the pretty, dark-haired, and stylish twenty-eight-year-old dealer from Erie, Pennsylvania, would prove herself with her unsuspected force and be crowned "The New Queen of the Art Scene" by *New York* magazine in 1982, after an astonishing success with her first two artists, Schnabel and David Salle.

Another aspiring dealer, Jeffrey Deitch, very bright, very businesslike, with a creative mind, looked to Castelli as the ultimate model of a gallerist. "By the time I graduated from Wesleyan, in June 1974, I knew exactly what I wanted to do," recalls Deitch. "I wanted to work for Leo Castelli as his assistant. The day after graduation I drove down from Connecticut, parked my car, walked up to the second floor of 420 West Broadway and said, 'Hi, I'd like to work here, can I have a job?' Of course, there was no job for me!" But Deitch persevered, eventually getting a position with John Weber, whose gallery was located two floors above Castelli's. Slowly, over many years, a relationship between Castelli and Deitch would develop, and although at first it did not carry such familiarity as with Boone and Gagosian, it did figure decisively in an important new career. "There were several stages to approach Castelli, and I cannot help thinking in terms of his inner circle," Deitch goes on. "There were several stages, and you really had to earn your place. In the first stage, you went up to the velvet rope, but nobody opened it up for you, you weren't allowed in. In the second stage, one of the Brundage sisters would see you, open the velvet rope, and invite you in. In [the] final stage, *you* had the access, you could just lift the velvet rope yourself and walk

in. Eventually I became a member of [the] inner circle and I was able to ask him how he defined his aesthetic vision. Leo gave me one of the most concise, most insightful answers I have ever heard. He said, 'My aesthetic vision is a fusion of Marcel Duchamp and Piet Mondrian.' Someone could write an entire book of interpretation on that one sentence! That conversation has had a great influence on me. Leo was for me a model, an inspiration, but not a mentor. He never wanted that."[54]

The one young gallerist who seemed almost magically able to jump the infamous velvet rope was Larry Gagosian. Tall and handsome, the whip-smart thirty-five-year-old with the killer blue eyes and even more lethal charm showed a promise that Castelli responded to intuitively. Gagosian's own account of his path to the Castelli Gallery is full of the brash but endearing manner that would eventually make him one of the international art world's mightiest powerhouses: "I had never been in New York, I had no idea what a dealer was, I was just selling posters in L.A., and I started reading art magazines, like *ARTnews*. One day, I saw a photo that I liked, by Ralph Gibson. I started looking for his information, found his number, and called him. 'I saw a photo by you and it looks cool—can I do an exhibition?' I asked. 'I don't know, maybe. Come to my studio,' he answered. So I bought a plane ticket to New York; it was my first trip! I had never been to an artist's studio before! It was a loft and Ralph was a very nice guy, not at all infatuated. This was the turning point, because Leo was his dealer—or actually it was Toiny—but I might have met Leo because of Ralph!"[55] It was not until some time later, however, that Larry Gagosian, having moved into a loft across from 420 West Broadway, would become friendly with Castelli. By 1982, as Robert Pincus-Witten recalls, "Leo and Ileana were speaking about this young man, very ambitious, who had a loft on the top floor across the street, a very elegant space with a big Eric Fischl. He had been an intermediary and in Los Angeles he had already done significant shows of Fischl and Basquiat."[56]

The warmth was not only cherished but fully, and rather touchingly, reciprocated. As the protégé remembers: "I had a reputation, for no particular reason—[what with] my family background, my lifestyle, the fact that I sold posters—but Leo legitimized me. He would call me to go have a margarita with him at Tre Merli after work and would tell me all the bad things people said about me—it made him laugh! If I ever had a lot of success, I owe it to Leo. He was a *gold mine* for me." In fact, Castelli was not evincing mere avuncular generosity: it was in a moment of financial distress, when he could

Taken by Castelli's longtime friend Ralph Gibson, this portrait of the gallerist's Legion of Honor decoration was proudly hung over his desk at 420 West Broadway.

not find a market for some of his Minimalist artists, that he recognized the newcomer's strengths. "In a way," Bob Monk adds, "their stars crossed, and Leo was very happy to have Larry place in good collections the works he himself had not been able to sell. At a time when the New York art scene had become very clubby, Larry was exotic, and learned a lot from Leo."[57] Gagosian continues: "In '82 Leo gave me an exhibition of new paintings by Frank Stella to sell in L.A. and gave me access also to Lichtenstein and to Warhol. As long as he was seeing results, Leo was happy, and as I did not do a lot of bla-bla-bla, I think that my *bluntness* appealed to him." The extravagant favoritism did come at a cost: as Pincus-Witten confirms, the popular sport of trashing "Go-Go" Gagosian had much to do with his privilege. "The other younger dealers were already envious of Larry. If people were bad-mouthing Larry, it was pure jealousy."[58]

During the time he had left, Castelli juggled a rather complicated love life. In addition to Toiny, his uptown official wife, and to Ileana, his downtown ex

ANTIBES, AUGUST 1968
On a visit to the Castellis' in the South of France, the gallerist Bob Elkon, IN FAR BACK, and his wife,
Dorothea, KNEELING, enjoy an afternoon at the beach with Toiny, LEFT, Leo, RIGHT, and Jean-Christophe,
age four, FRONT RIGHT.

and perpetual collaborator and guardian, he would continue with a pattern
established in his earliest days as a married man, entertaining a bevy of mis-
tresses. "Leo liked girls; he was tortured by girls," observes Gagosian, per-
haps suggesting something beyond the usual reasons for womanizing:
simple lust, or even the demands of his self-image (what sort of ultimate
European man would he be without a mistress?). The extravagance of indul-
gence suggests something more than "the man who loved women." For like
many guarded, self-created charmers, Castelli was always in need of confir-
mation of his powers. Gagosian recalled, "There was a girlfriend with lip-
stick waiting on a couch in his office for two hours and he said to me, 'Come,
let's have a drink with her, and we'll go to her studio and you can tell her you

like her paintings.' And I said, 'Leo, that's a bit much for me'—they were unspeakably bad."

As for close friends, the untimely death in 1972 of Alan Solomon at the age of forty-two left no small void. Castelli still had the Belgian gallerist Bob Elkon, who would also die prematurely. Castelli and Elkon had found each other through friends in common on the Upper East Side. Elkon moved in the same circles as Henry Geldzahler, another Antwerp native from a family of diamond dealers, art and classical music lovers, as well as French speakers. Elkon was eleven when he arrived in the United States in 1939; he would train as a pianist and graduate from Harvard Law School before taking a job at Doubleday while selling art from time to time on the side. " 'You cannot go on like that, selling paintings from your home,' Castelli insisted. 'You have to open a gallery, and I'll give you your first artist.' " That seed was Agnes Martin, who was followed by Sam Francis, and others, until, in 1961, Elkon did open a gallery at 1063 Madison Avenue. The Castelli-Elkon duo carried on this way, a daily exchange of confidences and business matters, always in French, until, like Alan Solomon, Elkon too died prematurely in 1983. "Between them, there was such complicity and love," explains the widowed Dorothea Elkon, "that, after Bob passed away, Leo once told me, 'I should have been the one to go, when Bob died. He was too young, and he should be alive today.' "[59]

It was during this period that he encountered the young French dealer Daniel Templon. "I met Leo in Castellaras (in the south of France), where we both spent our vacations; from then on, I saw him every summer for twenty years. He went away for two months without calling home—those were Toiny's wishes. But he was bored, spent his time staring at the bare-breasted women at the poolside, went down to the village to call his girl-friends, and read a lot. He saw all the Frenchmen in the area. I'd go with him to good local restaurants (like the Oasis and Chez Vergé), or to the museum in Nice or the Maeght Foundation in Saint-Paul de Vence."[60] Among other French friends in Castellaras, there was also Gabrielle Bryers, a warm and cheerful young woman from the South, very close to Toiny, who would open a gallery in New York, and would remain a friend of the couple (almost) until the end. Still, though Leo seemed to know everyone, he had few intimates.

Regenerated by SoHo, Castelli in his maturity would continue to stock-pile friendships, travels, discoveries. "We were all in Basel together for the first Biennale that Julian Schnabel was in," relates Mary Boone, "all sitting at

NEW YORK, 1981
With James Rosenquist in front of his *Star Thief*

Donati out on the terrace. There were two lovers down below in the river. All I could think was, 'That water is so dirty and so cold, what could those people be doing, bathing in that water?' Leo looked down, raised his glass of champagne and said in Italian, *'La vita inizia domani!'*—'Life begins tomorrow'—to toast the couple. That was Leo's attitude towards life: he always looked at the positive side of everything."[61] One is tempted also to say that even as the ultimate insider he never ceased looking towards some moment of arrival . . .

29. BAD TIMES FOR LEO

It was in May 1979 at the Whitney, for the opening for Twombly's draw-
ings show. Everyone was in black tie, slapping each other on the back,
when all of a sudden Leo collapsed and fell on the floor. We called the
police, and they put him on a stretcher. Nicola Bulgari and I escorted him
to the hospital where soon he was much better. But, on that evening,
everyone thought that Leo had died![1]

GIAN ENZO SPERONE

ON MARCH 8, 1975, the New York County Surrogate Court found Frank
Lloyd, owner of the Marlborough Gallery, guilty of engaging in conflicts of
interest for conspiring with the executor of the estate of Mark Rothko; he
was fined $9.25 million in damages, payable to the artist's children, in what
became the most publicized legal action ever to hit the art world. Two
years later, the New York State Appellate Court upheld the decision,
describing Lloyd's conduct as "manifestly wrongful and indeed shocking."
Lloyd then faced criminal prosecution, accused of evidence tampering in
the civil trial. Found guilty again, he was sentenced on January 6, 1983; in
lieu of the recommended four-year sentence Supreme Court justice Her-
bert I. Altman ordered the Vienna-born Lloyd, whose gallery was then the
world's richest, to set up a scholarship fund for disadvantaged youngsters
and to organize a series of lectures and viewings for public school students
in New York. The ruling put an end to a trial that had dragged on for a
dozen years and held in limbo 798 of the painter's works, which the Marl-
borough Gallery had obtained after Rothko's apparent suicide in 1970. Ulti-
mately, management of the Rothko estate was transferred to the Pace
Gallery. But the publicity generated by the suit, which was initiated by the
artist's children as early as 1971, had left not only Lloyd but the entire art
dealers' profession in disrepute.

Perhaps owing in part to his proven indifference to becoming the richest player in the game, Castelli emerged untarnished, and throughout the seventies and eighties, in the United States as well as in Europe, the prestige and good name of his network endured. James Mayor showed Lichtenstein's sculptures in London; Gian Enzo Sperone remained involved in the secondary market; Daniel Templon presented Donald Judd in Paris, and Gordon Locksley showed Warhol in Minneapolis. In Los Angeles, Margo Leavin had an exclusive on Claes Oldenburg and Everett Ellin repped Richard Serra, while in New York the three home-office galleries advanced their program of diversified offerings. The whole organization, employing nearly fifty people, pulled in several million dollars a year—hardly making Leo's operation the leader of the pack in this regard. Its cachet continued to depend on having the most eminent artists in America, and being tightly bound to its founding figure, the gallerist himself. As in the early days, it was still Roy Lichtenstein and Jasper Johns, respectively the gallery's most prolific artist and the one who commanded the highest prices, who brought in virtually all the cash. Lichtenstein's sales figures tell the tale: in only a few years, they had increased tenfold! Yet all was not so serenely stable as it appeared in the House of Castelli. "In 1977, when I showed Roy's first sculptures," James Mayor relates, "I cofinanced it with Leo because he couldn't do it alone—he didn't have the money."[2] Janie Lee recalls that things "sometimes went crazy" in the early seventies: "On one hand, Leo had to pay the overhead, the monthly payments for the artists; on the other hand, people would buy from him and not pay right away; therefore, he had financial difficulties. Leo could have been much richer if his priorities had been different, but he came from another viewpoint, from culture. 'You should never be greedy,' he would advise me. 'Even if a client is willing to go to a hundred thousand dollars, ask only eighty-five thousand. You'll make up the difference in the long run.' "[3]

Far in the background, behind all the marquee names and the projected glitter of success, Castelli's finances had always been precarious, and the satellite galleries were often asked to help finance the shows. "In the eighties, Donald Judd was not selling well at all," said Ronnie Greenberg, Castelli's correspondent in St. Louis. "And one day Leo said he'd like me to share Judd with him. He said we'd each put up $1,000 a month. So I sent him $1,000 a month for maybe two years, and I couldn't sell it. I was trying different cities, trying to get artists, gallery owners to show the art. I finally told Leo it just

wasn't working out. And we decided we were going to cut him loose, and if Judd needed money we would buy pieces one by one instead of sending monthly checks."[4] Joe Helman, from the beginning a shrewd businessman who could readily raise cash, would also help, first as a collector, then as a dealer, supporting Castelli's operation with monthly checks. "When I was in St. Louis, I [contributed to stipends for] Don Judd and Richard Serra and Bruce Nauman, and part of the Stella payment. This was an outgrowth of my paying him $500 a month. Then after I became a dealer, we started sharing artists. We shared Serra and Judd and what he had left of Stella. He had pretty much lost Stella by then to Larry Rubin."[5]

During this period, in fact, a confluence of various forces would indeed rattle the seemingly imperturbable "Castelli order" that had reigned over American art since 1958: upheavals in the market, economic recession, resistance to certain aesthetic trends, the arrival of new gallerists and of new artists, and a new snarkiness in the press, once Castelli's partisans but now growing weary of the art scene's more-fabulous-than-thou aura. Some observers even mark these years as the start of a tragic downturn for Castelli, who, among those close enough to see, was definitely losing ground, both in terms of the financial footing of his empire and in his once-peerless instinct for seizing opportunity. It was disturbing though not surprising that he had also collapsed several times in public, suffering from a serious heart ailment that would require open-heart surgery and eventually the implantation of a pacemaker. Still, he carried on as best he could. "Old soldiers never die," MacArthur had told Congress six years before Castelli had first set up shop, "they just fade away." But was Leo out of reinventions, at last reduced to a lion in winter, marginalized if not overwhelmed by the new ecology developing in the world that he, as much as anyone, had created? He was, after all, now seventy.

It hardly helped that his latest cause, the Minimalist and Conceptual artists—Judd, Flavin, Serra, Kosuth—garnered minimalist sales, and that efforts to promote them rarely paid off; though not ordinarily given to complaint, Castelli would come to regard them as a "real ball and chain."[6] "Judd and Morris were not exactly big hits at first!" Janie Lee noted with colossal understatement. "And since Texans never really had a call for Pop, Leo's artists weren't exactly stars in the seventies. Rauschenberg sells beautifully now, but he didn't use to. When I showed Lichtenstein, it was very rare to find a buyer in Texas. And then I had a Flavin exhibit, and people would

NEW YORK, 1975
With the artist Richard Serra, LEFT, and the collector Giuseppe Panza di Biumo

come in and say, 'So where's the show?' "⁷ Richard Feigen remembers going "to Leo's gallery in '77. He had racks of Scarpetta, racks of Twombly, and he couldn't sell them. He kept buying up the artists' productions even though they didn't sell."⁸ Indeed, the satellite galleries often served as outlets for works proving too difficult for the New York market. "You're selling better than I am!"⁹ Leo often assured his far-flung correspondents. This was especially true of Sperone: first in Turin, then in Milan, he found in Panza a client who would buy entire collections of an American artist, such as Flavin, for his mansion in Varese.

It was relations with artists like Joseph Kosuth, and especially like Donald Judd, that Castelli found most wearing. "I remember that by 1970, Kosuth had already bought a house; then he got himself a vintage Porsche," Sperone remembers. "Moreover, it was Kosuth who invented the concept of 'object definition' for works that could be resold ten times over, in different languages. He tried to take advantage, wanting to multiply his works because he hoped it would multiply his profits by as much. I still have about forty pieces by Kosuth that I can't get rid of, and I think Leo had as many himself!"¹⁰ In the case of Judd, with his "progressions" reiterated in every possible hue and

shade at exorbitant cost, the problem was even more dire. "Leo had some very heated arguments with Judd," Sperone continues, "because after years of accounts, the question came up of who should foot the bill to produce the works. Usually it's split fifty-fifty between artist and dealer, but Judd saw things differently, figuring the dealer should assume the whole cost. 'To date, Judd owes me $250,000 in labor—that's huge,' Leo told me one day. And then Judd came in, showed *his* accounting, and concluded that it was the opposite: that Leo owed *him* $250,000! Leo was fit to be tied. They had a real blowout; not long after that Leo was hospitalized and they put in the pacemaker."[11]

In 1974, the opening in New York of one new gallery disturbed Leo Castelli deeply. Up until then, he had acted as a kind of wholesaler, retaining exclusive rights for his artists in New York and on the East Coast while sharing with the galleries in his distribution network (who had exclusive local rights to the new works) the commissions on their own sales. But in 1974, Irving Blum and Joe Helman (two of his satellite dealers) decided to open a space in New York, and Castelli took pointed exception to their treading on *his* turf, entering into direct competition with him, violating the hierarchy that had always regulated the main gallery and the satellites whose very existence Leo had enabled; the conflict, Morgan Spangle remembers, was "intense."[12] As Irving Blum tells it: "Only once in my whole relationship with Leo did we have a confrontation, and that's when I moved to New York and opened a gallery with Joe Helman. Leo became very cool towards me. He became much tougher professionally. And you could see that side of him, which up until then I had never seen. So I had to rethink our relationship, I just understood that there were certain borders I couldn't cross. Our argument was over Roy. I was close to Roy, and I wanted to do something with him. And Leo wouldn't allow it. But I went and spoke to Roy, and we did a show of his paintings. And for a while, Leo became much colder than he'd ever been with me—understandably so."[13]

As for Joe Helman, he describes the episode in terms of his biography. Born "in the heartland, raised by Walt Disney," he received his training in American art through the Castelli Gallery, becoming one of its collectors and financial backers, then a vital franchise holder. But the Castelli-Helman relationship was an intricate compound of friendship and mistrust, of complementarity and rivalry. "Helman was totally different from us," Sperone remarked, "but in his way, he understood some fundamental things. I can honestly say he's a visionary: he bought works that he liked and that he's

kept."[14] Helman was a natural businessman with a native financial aptitude, and in the gravitational field of Castelli's charisma he had metamorphosed into a figure of true cultivation, developing real taste, building up his collection, and extending his expertise. He had even discovered Europe, for a time moving to Rome, before coming back to New York just to open the Blum Helman Gallery. He would try to work with Castelli as he had done, but soon their initial understanding would collapse. "After I opened in New York, I started by working with Leo in the same way [as before], sharing the commissions. But I did most of the Kellys. I did a lot of the Lichtensteins. And Judd, and Serra. And to a certain extent Nauman. So after a while I said, 'Leo, I'm sorry, I've already got a partner in Blum, and I'm happy to show the artists that you're showing, but I don't want to share my commission with you. I'm just getting half of a half, and I'm doing all the work, and it just isn't good for me.' And he was upset by that. Because he thought he was in a position to be Leo Castelli, to just pick up the phone and start selling paintings. But he wasn't—he had passed that."[15]

The sparks started to fly between Castelli and Helman over sales tactics, too, the confrontational spells alternating with shorter cease-fires. "Leo realized he knew somebody who was stronger at selling than he. He used to say very nice things about me to people, but then there were times when he wanted to have me killed," Helman related. "One day, Leo called me up and said, 'I've got to meet you. I want to come to your office.' So we sat down, I closed the doors, and Leo said, 'Don't you have enough? You have everybody, you have everything. Isn't there room for both of us?' And I asked, 'Leo, what are you talking about?' I was his rival, sure, but it never even dawned on me that he would consider I had shut him out. This was in the early eighties, and I think maybe his artists were giving him pressure because Blum Helman was being aggressive."[16]

Indeed the tempo was changing in the art scene. As Good describes, "it was the beginning of the end of the gentlemen's business; Blum and Helman were trying to work on Leo's turf. As for Larry Gagosian, he was part of the new generation and wanted to be on Leo's side. Leo and Larry used each other's strengths; their gallery at Thompson Street was the place where they formalized their partnership." In 1990, two years after closing Greene Street, Castelli and Gagosian had opened 65 Thompson Street, a partnership that surprised many. "On Leo's part, Thompson Street was an indication, a warning to the other dealers. 'If you want to mess around, if you want to take

advantage, you've got to deal with this guy!' Leo needed someone on his team who could deal with the sharks that were circling."[17] While playing Leo's enforcer, Gagosian was also striking out solo, heading to the undiscovered country of Chelsea, to open a space of his own. "Leo did not know that Twenty-third Street existed," Bob Monk remembers, "and suddenly, out of the way, in his new Chelsea space, Larry showed first the Tremaine collection, then Susan Rottenberg's *Horses*. Leo came and said, 'Wow!' It was magnificent. Larry [had] picked up from Leo the importance of making a real catalogue with a show, which was a very smart idea."[18] By and by the Gagosian relationship allowed Leo the fulfillment of professional fantasies. As Robert Pincus-Witten puts it, "Leo had a *faible* for Larry. He saw him as the audacious *alter ego* that he himself never dared to be. His gallery was splendid. He was brash and audacious with a romantic swashbuckler side that appealed to Leo."[19]

The reality would be spelled out when Robert Sam Anson wrote an article entitled "The Lion in Winter," a very well-documented piece of reportage, recounting the painful progress of Castelli's ungentle descent. "The emperor of the art world faces fierce competition," Anson wrote. "But he's determined to hold onto the mantle of power." Queried about the Blum Helman Gallery, Castelli answered simply: "They think that I have one foot in the grave. But I am not dead yet. I am drawing the line."[20] Part of the fight Castelli put up involved forming some promising new alliances, such as the venture he launched with Richard Feigen and Jim Corcoran. "When Leo, Feigen, and I bought the Joseph Cornell estate, there was a deep recession because of the oil crisis," recalls Corcoran over a Bellini at Cipriani. "And much to everybody's surprise, we did *extremely* well with it by selling the works to François de Menil."[21] But Castelli's finances remained decidedly shaky, as James Mayor, who preserved a strong emotional bond with Leo, remembers. "Two and a half years after the move to SoHo," he explains, "there was a huge recession, the big collapse of 1974; then, it was Tony Shafrazi who looked after Leo's gallery during the seventies. With enthusiasm, he got the Iranians going and developed the market in Tehran. It was a *huge* lift to the whole art world! Tony is a soldier saver."[22]

Over the course of a few years, Shafrazi would indeed accomplish a considerable feat, transforming himself yet again, this time from subversive artist into dynamic art dealer, and opening up for the Castelli network a virgin market in the newly flush Middle East. "I'd heard that maybe there was a

move towards building a museum in Tehran. I understood that there would be my role, and if they were going to do it they should do it right, they should do it well, they should do it great. I didn't trust anybody in Iran. So I came back [to New York] with an idea in my head: 'Why don't I go to all of the galleries that I respect the most and have the gallery directors write a letter?' So I went to Leo, and I said: 'Leo, I was in Iran, and I got the feeling that possibly there's a plan to build a museum, and I would like to be the one to recommend, to tell them what to buy, since I know the whole art world so well. Because I would like to build that collection absolutely great, first rate. I don't know who's going to be the director, who's going to be anybody, just say on the letter "To whomever it may concern." ' Leo said, 'It would be my pleasure.' His letter was one long paragraph, but the strongest and the best and the most dynamic of all the letters. Even at letter writing he was the best. It said, 'I've known Tony Shafrazi for a number of years. I can vouch for the fact that he is the most knowledgeable person, the most committed friend of the gallery, and of all the artists of the gallery, as well as all the artists in New York. He has the most dedicated understanding and commitment to the art scene, and undoubtedly he would be the best person to make the best possible recommendation in the making of any museum collection,' or something like that, but much more clean and strong, and to the point, and great. Oh it was remarkable! Then, of course it didn't happen quickly. I would go to Leo, and say, 'Leo, I'd love to go there with a suitcase full of transparencies from you.' That's how I was able to choose the best pieces with Leo, great pieces, incredible pieces, and to assemble a first-class contemporary art collection in Tehran with the architect who would build the museum, Kamran Diba, the cousin of Farah Diba. In a way, his letter was a *guarantee* that nothing wrong could happen to me!"[23] At the same time, Akira Ikeda, the son of an antiques dealer from Tokyo, and, according to Castelli, "the only dealer in Japan who understood the art world," set about in a notably grand and imposing way to develop a market for Castelli's artists in Japan. Having purchased Richard Serra's largest indoor sculpture, entitled *Marilyn Monroe–Greta Garbo,* he built an airplane hangar just to exhibit it![24]

The harbinger of losses to come was the departure of Robert Rauschenberg for Knoedler; the artist unceremoniously informed Castelli and Sonnabend

by mail, much to the pair's consternation. Besides, Julian Schnabel, who had been showing at both Castelli and Mary Boone, deserted the old gallerist for his younger counterpart. Arnie Glimcher remembers those days of attrition: "I called Leo at one point. I said, 'I know that Judd is going to leave you' and Leo answered, 'Judd wants twenty thousand dollars a month, but I won't give that to him.' I said, 'Let's share Judd.' Leo said, 'No, no, it's impossible.' It was after the Schnabel situation. I said, 'Leo, think about it.' The next week, Judd went to Paula Cooper, then he left her to come to me. In this story, the problem was Leo's ego. He did not co-opt me, I was not his enemy, but I was in competition with him. After the Schnabel story, I said, 'Leo, I'll take you to lunch with Ileana.' Leo said, 'No, I'll take you to lunch.' The three of us went to Da Silvano and I said, 'Rauschenberg is leaving you.' Ileana said, 'No, that's impossible, look at this Life Saver, Rauschenberg will never leave us.' I said to them, 'Armand Hammer [has] just bought Knoedler, and offered Bob a lot of money for ROCI.'[25] Leo was in love with Jasper, who is a beautiful artist, but Bob is a force of nature. We argued at the table. I said, 'Let's do it together, I can sell Rauschenberg, I have new collectors.' Leo said, 'No, you don't have new collectors.' Time went by, Judd, Schnabel, Rauschenberg, they all left. When artists are not happy, they leave. Julian Schnabel was the hottest artist of the eighties. He wanted to be in the gallery that was showing Picasso and Dubuffet. The first year, I made nine million dollars on Schnabel. Leo was very angry, and hardly spoke to me after that."[26]

Whether the gallerist was simply out of steam or still adjusting to a changing world, from now on Castelli would be a partner on equal footing with various colleagues, sharing many artists and many exhibitions, where in his prime he would have kept the lion's share. With Ileana Sonnabend, old time's sake had furnished the pretext for sharing Rauschenberg before his departure; with Mary Boone, avuncular generosity had justified diminished status vis-à-vis Schnabel and Salle until they, too, left; Flavin was shared with Virginia Dwan; Daniel Buren with John Weber; with James Goodman, it was Ruscha and Rosenquist; with Sperone, Westwater, and Fischer, it was Nauman and Merz; and so on. With Tony Shafrazi, to whom Leo had been a surrogate father since 1965—so strong was their common devotion to protecting and supporting artists that to this day Shafrazi declares, "Leo and I are of the same blood"[27] and keeps his picture by his bedside—it was Keith Haring, of whose sculpture both galleries mounted simultaneous shows from October 26 to November 23, 1985. This new relationship with an emerging, cutting-edge

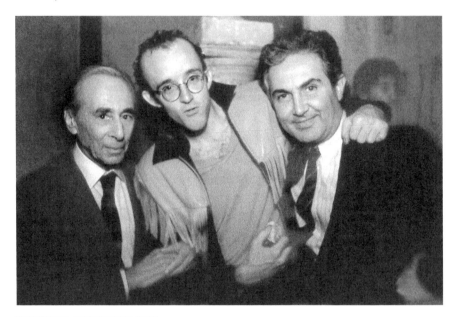

NEW YORK, NOVEMBER 1985
With dealer Tony Shafrazi, RIGHT, who "saved" his gallery in 1974 by finding a market for Pop art in Iran.
Castelli organized an exhibition of sculptures by Keith Haring, CENTER, which ran in their two galleries
simultaneously.

artist positively delighted the grizzled gallerist. "The sculptures were quite marvelous, but the great surprise was when Keith said, 'I want to paint a frieze all around the gallery,' " Castelli recalled. "The way he did it was fantastic—I should have filmed it. I mean, he painted these cartoon characters all along the walls, which measure over one hundred feet, and he did this in one day! Incredible. I saw him at work, just inventing as he went along . . . In a way, in 1960 or 1961, I would have found Keith easier to take on than Roy Lichtenstein . . . There would have been no hesitation at all!"[28] Definitely, there was less and less space in which to deny that the era of Castelli's invincibility had ended.

Adding fuel to the fire, a mean-spirited article in *The New York Times,* entitled "Making the Buyer Beg—And Other Tricks of the Art Trade," abounded in insinuations about the gallerist. "It is said that throughout the late sixties Castelli had collectors bidding up works on his behalf at auction in order to call attention to high prices for works by 'his' artists and that he offered special financial arrangements in return," claimed the reporter. The stinging accusation was hardly relieved by factual inaccuracies: for one thing, there had been no art auctions before 1970! "To be sure, Castelli's operation is not typical,"

the piece continued, "and yet he has proved such a master of the techniques other dealers strove to perfect [in order to] anticipate shifts in the cultural wind and then stimulate prices, attract customers and clinch sales . . . The ever-rising prices for works by Castelli's artists are not necessarily a result of free-market forces alone. Dealers in contemporary art are notorious for the little tricks they employ to give prices an extra boost: that, after all, is part of the game. And Castelli is a reputed master of at least two such tricks."[29] Example followed example of Castelli "manipulating" prices, "manipulating" the press, "manipulating" buyers, like some grasping rug merchant.

A few days later, Castelli took up his pen in reply: "I categorically deny that I have ever been party to an arrangement with any of my customers," he shot back at the *Times*. "Such an arrangement would have been immoral and possibly even illegal . . . As a dealer in contemporary works of art, it is my right and privilege to sell them at any prices I determine and to make different prices to different prospective purchasers as I may determine in my own interest or in the interest of the artist. Various factors influence my determination—the distinction of the purchaser and his collection, the frequency with which the purchaser makes purchases from me, my personal relations and friendship with the purchaser, etc. Anybody who does not understand this attitude by a dealer is indeed naive."[30] Then the psychiatrist Bernard Brodsky, a close friend, rose to the gallerist's defense, writing the newspaper to express his "sadness bordering on dismay" upon reading the profile and to question why the reporter had presented "such a skewed and distorted picture [of] the kind of gallery that struggles for its artists' recognition. Certainly, [Castelli] has sold works for munificent sums. But rather than use these funds to line his own pockets, he has placed his profits at the disposal of young artists, thereby supporting experimental developments in conceptual art as well as videotapes . . . Rather than be characterized as a notorious money-maker, Leo Castelli should be honored as an American who has no minuscule share in bringing to the fore what is great in America in the age of Vietnam and Watergate."[31] Perhaps the reporter had intuited that current events had primed the public more for stories of malfeasance and corruption than for a portrait of an idealistic art devotee. But if Castelli was indeed occasionally guilty of self-aggrandizement, he never could find the drive to lay up riches for himself. The trouble was more that, in the world he created, those who followed in his footsteps were not as measured in seeking profit. Indeed, Castelli saw his own role as historical, and in an excellent interview with journalist Barbaralee Diamonstein he described the posi-

tion of the gallerist in the chain of different actors around the artist. "The function of an art dealer," he said, "of a good art dealer, a dealer who really cares about art and not about making money, should be to find new artists, to make them known to the public, before museums can do it—because they function in a much more cumbersome way. We are the real vanguard."[32]

The controversy continued to boil for months, with another article headed "How Do You Price Art Works? Let the Dealers Count the Ways," featuring two rather mannered photos whose juxtaposition hinted at some absurdity of contrast: in one, smiling with his customary seductive charm, Castelli was seated on a Warhol Brillo box in front of a Jasper Johns flag, affectionately petting his Dalmatian, Paddy; in the second image, a more serious, even austere-seeming Glimcher, his hand on an open book, posed in front of a Dubuffet painting and a Louise Nevelson sculpture. "There is, of course, such a thing as a market price, but that price is often based on imponderables," Castelli declared to Grace Glueck, who commented that "some dealers professed shock at this revelation . . . Asked if he priced works in similar fashion, Arnie Glimcher, owner of the Pace Gallery, shook his head. 'Our prices are the same for everybody.' "[33]

But the truly poisoned shaft—the one that pierced the gallerist in the heart—would strike without warning a few years later: the million-dollar sale to the Whitney Museum of Jasper Johns's *Three Flags* from the Tremaine collection, the deal arranged behind Castelli's back by none other than Arnie Glimcher. Of course, the work was now on the secondary market, and of course many galleries had been handling his artists at this point. But to touch Jasper, his fetish artist, without so much as the courtesy of notification, to bypass him entirely! What could he make of such a betrayal by the Tremaines—a couple who figured among his most famous early collectors, among his historic clients? "The Tremaines didn't like Leo," claims the dealer Jeffrey Deitch. "Everybody liked Leo. But the Tremaines didn't."[34] Was the Tremaines' contemptuous treatment a fit of momentary pique or a sign of deeper, more long-standing tensions? What really happened between Johns's discoverer and the artist's first collectors? Was it payback for Castelli's having favored Scull in the sale of *Map*? That preference was surprising given Scull's hard-grabbing arriviste vulgarity, which could not have stood in sharper contrast to Emily Tremaine's patrician bearing and background. She was the very embodiment of all the elegance, sophistication, and snob appeal to which Leo had always aspired in his adoptive country—even if many

deemed the woman complicated, enigmatic, demanding, and "difficult." "I just went along and agreed with what she was doing," the dealer said of her. "She was very happy about her choices. It's not that she would discuss them. It was she who initiated the choices and made her selections. In the 1960s there were some galleries like mine that had 'the right stuff,' and that's where she found [it] . . . She was pretty reserved. She did not have a good sense of humor, but she was really wonderful to talk to and deal with because her taste and understanding were so good."[35]

"Emily was an original eye," the architect Philip Johnson recalled. "People with an original eye and all the money in the world—it never happens. But she was also highly whimsical in her twists and turns. She was both ornery and generous. [Art] was her universe."[36] The taste of Emily Tremaine and the taste of Leo Castelli: the two of them near exact contemporaries and both autodidacts in art (in Tremaine's case, the tuition having been accomplished in Europe, California, and various American museums). Might one have sensed in their symmetrical development, their like-minded quest for excellence, a certain tacit rivalry? Castelli had come under the influence of Surrealism in Paris; for Tremaine it happened in the form of Duchamp via the Arensberg Collection. His knowledge of European modernism was derived from Alfred Barr's acquisitions at MoMA; her modernist initiation occurred at the Wadsworth Atheneum in Hartford, under Chick Austin. From then on, their reading of twentieth-century art would follow the same road: both would establish at the core of their collections great European modernists like Mondrian and Delaunay, before evolving towards postwar Americans such as Pollock and Newman. Little wonder then that the Tremaines should present themselves among Castelli's first clients, or that the dealer should esteem theirs "the best collection of twentieth century art outside of the Museum of Modern Art." Their early purchase of Mondrian's last, unfinished masterwork, *Victory Boogie-Woogie* (the culmination of efforts undertaken with De Stijl in Holland), had heralded the sublimity of their taste, the choice entirely of a piece with that of their first Jasper Johns, *White Flag,* from Castelli. Their subsequent preemptive discovery and purchase of *Three Flags* in the artist's studio showed an equal measure of perspicacity.[37]

"Painting by Jasper Johns Sold for Million, a Record," blared the front page of *The New York Times* on the morning of September 27, 1980. In her report, Grace Glueck quoted Tom Armstrong, the Whitney's director, who puffed with pride at snaring "a monument of 20th-century art";[38] Leonard Lauder,

president of the board of trustees and an underwriter of the purchase (and, by coincidence among those perennially stalled on Castelli's famous waiting list);[39] and Arne Glimcher, the architect of the sale, who detailed his strategy: "[I had sold] many paintings to and for the Tremaines over the years . . . The Johns work was one of the most important paintings they owned, and this summer, in discussing the sale of other works, I urged that it be placed during their lifetime, so they'd know where it was. I suggested the Whitney because it's the quintessential American painting—a masterpiece that speaks of Johns, American painting and the Pop movement. Then I went to the Whitney. Tom Armstrong was excited by the idea, and made its acquisition a priority." A few days before negotiations over *Three Flags* were concluded, Tom Armstrong felt it proper to visit Castelli at home, only to be nonplussed at the great gallerist's strange behavior. " 'Leo,' I said, 'the *Three Flags* has been offered to us through Arnold and I'm going to try to buy it for the Whitney Museum.' He replied, 'You'll never be able to do that. The Japanese will be able to buy it,' from which I inferred that he had a Japanese client for it. I was sort of hurt because he didn't think I could accomplish the purchase and because he didn't thank me for telling him that it was on the market. His attitude was kind of 'forget it, whippersnapper, I've got other plans for the picture.' "[40]

Today, still intrigued by the whole affair, sitting in the beautiful restaurant La Grenouille at 3 East Fifty-second Street, Glimcher is happy to go over the story with me: "Leo had no right to be so angry when I sold *Three Flags*," he states. "The Tremaines were getting older. They had decided to give works to the National Gallery. They gave seventeen paintings to the National Gallery, which never showed them. So they were furious. Originally, *Three Flags* was supposed to go to the National Gallery. Emily Tremaine told me, 'Museums do not appreciate art unless they pay a lot of money for it! Peter Ludwig [the German collector] visited us and offered us half a million dollars for *Three Flags* and I'm going to sell it to him.' I said, 'You must not sell it to Ludwig, because it will leave America. It should not leave America. It is an American landmark.' I then went to see Leonard Lauder and I told him, 'Do you want to buy *Three Flags* for a million dollars?' He said, 'No living artist, not even Picasso, ever sold a work for that price.' I said, 'You should have it at the Whitney, it belongs to the Whitney, it is quintessentially American.' In two days, we raised a million dollars. Taubman put 250, Lauder put 250, Gilman put 250 to start with. Leo wouldn't have done that. It was too much

NEWARK, SEPTEMBER 1988
FROM LEFT TO RIGHT: Jeffrey Deitch, Barbara Jakobson, Leo Castelli, and Laura Grisi boarding Odette and Tom Worrell's private plane to visit collectors in Florida

work for him. Leo was lazy."[41] Castelli, ordinarily unflappable, could not entirely contain his dismay at being left out of the transaction, and at the time he betrayed in his comments a certain bitterness most unusual for him. He had called Mrs. Tremaine about another matter, he explained, only to learn that she had a buyer for the painting. "She said she would let me know," he added. "This week, she called to ask me for Jasper's number, and I again inquired about the painting. She said it had been sold. My lifeblood has been my relationship with Jasper and his paintings—and it has been a faithful, loyal relationship. My selling the work was a matter of principle, not a commercial thing."[42] But business went on: as soon as *Three Flags* sold for a million dollars, Scull contacted James Mayor, in order to sell *False Start* for more than a million, which he did immediately.

At the dawn of the 1980s, one could hardly have foreseen the frenzy that would soon engulf the American art scene, as investment banking profits and individual compensation reached levels unimaginable a decade before.

Still, it was evident that new actors were continuing to enter the arena and that the balance of power that had obtained during the past twenty years had shifted decisively. Gone were the days when, with his friend Alan Solomon, Castelli could pull the strings at MoMA, the Jewish Museum, or the Venice Biennale! He now had to contend with challenges from upstarts and dismissals from acquaintances of long standing. Courted by MoMA, by the National Gallery, by the Whitney Museum, and finally by Arnie Glimcher's Pace Gallery, the Tremaines were determined to secure the best possible home for one of their most prized masterpieces, as well as to create a monument to their own glory as collectors; in their calculations, Castelli—whom, evidence suggests, they had never loved, and whom nowadays everyone had less reason to fear—had unceremoniously fallen by the wayside! For the gallerist, the price fetched by a major work of his signature artist (bought for a mere nine hundred dollars twenty years earlier) should have been a validation of his own talent for discovery, a feather in his cap. So why did the affair leave him with such a bitter taste in his mouth? He hated not being at the center of the action, which was more and more the case as the secondary market was slipping away from him. But he also disliked any implication that he could no longer juggle all the balls he liked to keep aloft. Busy managing his association with Mary Boone, busy working with the architect on extensive renovations to the new Greene Street space, busy producing films and videos of his new artists with Ileana, he may still have believed he could do it all.

Despite the series of setbacks, the gallery's twenty-fifth anniversary in 1982 would provide excuse for the sort of ritual celebrations he loved to shine at: lunch at Café Odeon, an exhibition in SoHo, and some warmly positive notices to mark the occasion—like the one that appeared in *ARTnews* with the observation: "One of the world's most successful dealers, Castelli seems uncomfortable as a businessman. 'I am the servant of all their needs,' he says of his relationship with his artists. 'That is my role.' " Plain to see is the gallerist's will to rationalize his string of defeats by taking refuge in his reputation as an "artist's dealer." "I've always had a certain involvement with hero worship," he confided to the journalist, Meryle Secrest. "You are not the boss; the artists are. You have to deal with so many disparate personalities that if you are not ready to be flexible you can't run a large enterprise at all."[43] The photo spreads showed Castelli basking in the glow of his artists' satisfaction—facing Rosenquist, like a kid with arms outstretched trying to defy gravity, posing languidly before one of Stella's first canvases. Or, in for

the kill: in a hotel lobby, pitilessly negotiating with Pontus Hulten; all smiles with Peter Ludwig; caught unawares in the middle of a phone conversation. ("Castelli spends much of his working life on the telephone," reads the caption. "At 74, he has no plans to retire.") As adored paterfamilias: with Jean-Christophe and Toiny; chatting affectionately with Ileana; giving orders to his staff surrounding him on West Broadway. And of course, Castelli the sage, offering pronouncements on Italian TV for a program about de Chirico.

After the low blows, after the nasty gossip, it was a chance to be himself again: hyperactive, elegant, talkative, playful, narcissistic, frivolous, serious. He showed Secrest all sides, beginning with Castelli the sorcerer, who described his job as "the myth-making of myth material . . . I have to deal with myths from 10 a.m. to 6 p.m. every day. And it becomes harder and harder. We live in an age of such rapid obsolescence." (It was depressingly true: renown had had a much longer shelf life back when Castelli had first begun to mint it.) Castelli, the savior of his artists, to whose generosity Richard Serra testified: "Leo came to me and offered to give me a regular monthly stipend, guaranteed for three years, and told me that he would not expect to sell anything during that time. I never expected to find anyone willing to support experimental work. I could not believe it. It was like getting a Rockefeller grant. Leo has always been generous, supportive, intimate, and friendly, a throwback to another century." After several hours of questioning, the interviewer, frustrated by the Castelli gift for glib evasions, made a last, frontal attempt to penetrate the mask. "Are you the most elusive man in the world?" she asked him point blank. "He is surprised, even a little indignant," she reported, adding, "It breaks the ice."

The article offered quite a thorough report of operational statistics: the "staff of eighteen," the operating costs of $200,000 a month, the total annual revenue for 1981: $3 million. "Until fairly recently, it was really a giant shoestring operation," explained the gallery's bookkeeper. Even the baser accusations were aired out:

> As he left his Greene Street gallery one morning recently, Castelli stopped to consult with some workers removing some Andy Warhol canvases, then noticed that a sign had been jauntily spray-painted in luminous pink in several places on the exterior walls. It read:

<div style="text-align:center">

ART$

WHAT

ELL

He frowned and said, "See that it's removed."[44]

</div>

Ultimately, despite it all—the encroachments of upstart dealers, younger, more cynical, and aggressive; the brutal economic recession; the tight finances, the health scares; the rise of greedy speculators, the malaise of a country disenchanted by Vietnam and Watergate—Castelli emerged to fight another day. "At the time," Joe Helman recalls, "the rallying cry around him was, 'Poor Leo,' whether his girlfriend was being bad to him, or Toiny was being bad to him, or a collector was being bad to him. Everybody was being bad to Leo. But the reality was that he was very strong through his vulnerability: he was the most powerful dealer in the world, and he knew it." Tapping into the cultural background that had formed Castelli and would remain the best context in which to understand him, Helman adds: "Leo had the survival instincts of an Italian diplomat. While everyone else was about competition, he was about alliances. He had the talent of a statesman able to make not so much strategic decisions as opportunistic ones, with a keen sense of casuistry. Anyone else would have drawn a line in the sand, but not him. He kept shifting between Lombardy and France without ever losing the war, always on the winning side, making strategic alliances. He made an alliance with Rubin for Stella, one with Hughes for Warhol, with Mary Boone for Schnabel, with me for Kelly and Serra, and one with Ileana, who understood the stakes, the importance and the value of art. Leo knew what he was doing; he preempted his enemies. He made pacts with them and continued to survive. He seldom declared war—he did on me, but only once. He had a sense of the zeitgeist, and that was his genius. And unlike [us] Americans, who have been raised in nature and taught to survive on our own, he was a real Italian: he needed to be at the *center* of things."[45]

He would need every bit of his Machiavellian acumen, for troubles continued to stalk Castelli into the 1980s, and he would reach a low point in the summer of 1988, when he was forced to close Castelli Graphics, the uptown branch he had built with Toiny. Jeffrey Deitch, who had in the meantime left John Weber's gallery, graduated from Harvard Business School, and become a vice president at Citibank, was planning to launch his own art business. He stepped in to rescue Leo. "Castelli Graphics had an enormous inventory of

prints that would have taken fifteen years to sell," explains Deitch. "I came up with the idea to sell a representative selection of its holdings to a group of Japanese investors, who were, at the time, mad for anything that had to do with Castelli. We agreed that I would sell three quarters of the inventory of Castelli Graphics to the Japanese investors for two million dollars. When I told Leo the deal was done, he said, 'We must get you a commission. How much do you want?' I replied, 'But Leo, I don't know, what's the right commission?' 'You tell me,' he said. 'Ten percent?' I asked. 'It would be a pleasure to give you ten percent.' That was two hundred thousand dollars, which I used as the capital to start my business."[46] And so, even as his fortunes declined, the great gallerist showed himself as ever eager to plant the seeds of the rising generation of dealers. "Around the same time," Deitch continues, "Leo realized I would need a list of contacts, so he instructed his assistants to run up a copy of his mailing list and just *gave* it to me. This was *unimaginable,* the most entrusting gesture that nobody else would ever do! I can't think of a better example of his generosity."[47] Always interested, above all, in the game and in his stature as a player, Leo remained ready to give the shirt off his back, provided he was accorded due respect. But to be dispossessed by those ready to count him out was something he would not abide.

In the meantime, Larry Gagosian had definitively made his "splash in New York" (John Good). In 1979 he opened a new space uptown on Madison Avenue. "At the time when Leo was becoming frail," recalls Bob Monk, "when artists were starting to migrate to other galleries, Gagosian's evolution made it more and more clear that Larry was Leo's heir. Larry was first learning from Leo, then he was pantomiming Leo. Certainly, he had his spunk side, his 'get up and go' side, but what he learned from Leo was to do things differently, with great class."[48] That determination was manifest in Gagosian's hiring of a great scholar to serve as senior curator for his Madison Avenue gallery. Robert Pincus-Witten's association with the Castellis went way back: he first met the family as Nina's school friend, later remaining in touch with them as a critic for *Artforum,* a gallerist with Sonnabend in Paris, a professor of Art History at Queens College and the CUNY Graduate Center, all the while serving as an advisor to collectors. An academic used to dealing with museum curators, but also at home in contemporary art galleries, Pincus-Witten would play a consistently important role at Gagosian Madison Avenue, producing historical shows on subjects as varied as Brancusi, Yves Klein, and Rubens.[49] Such magnificently memorable exhibitions,

VENICE, SUMMER 1988
With Larry Gagosian, his SoHo partner

the excellent conceptions matched by the beauty of the catalogues, immea-
surably enhanced Gagosian's status. Quite unconventionally there might
have been only one work for sale in each of these shows, this quirk perhaps a
shrewd bit of branding to show that, like Leo, Gagosian was not in it only for
the money. Indeed some of these gestures were more self-styling than the
soul of the operation. "If Castelli was an 'artists' gallery,' " Sonnabend direc-
tor Antonio Homem remarks, "Gagosian is a 'collector's gallery.' " Even a
member of Gagosian's staff allows that "Larry did beautiful historical shows
while aggressively negotiating in the backroom." And so while it was possi-
ble to replicate the Castelli panache, there was no equaling Leo at solicitude
for artists or in his love of the game for the game's pure sake.

30. TRIBUTES, HONORS, A NAME CARVED IN HISTORY

Beyond your work as a pioneer and discoverer, we all know the qualities of heart, of passion, which are yours, a way of existing in the world . . . Leo Castelli, we hereby appoint you an officer of the Legion of Honor.

FRANÇOIS MITTERRAND

"I NEVER THOUGHT it would come to this. I've always believed in development, one movement following another, the Cubists on the heels of the Fauves, Minimal after Pop, and so forth. But everything today is very much in flux. There's so much happening now that it's difficult to sort things out." On the thirtieth anniversary of his gallery, the year of his eightieth birthday, Castelli unburdened himself of his doubts and weariness. "I did enjoy finding new artists," he told Grace Glueck, "but now it's not so easy." He also confided that while he had made "a few mistakes," such as neglecting the Color Field painters, he was thrilled that any serious collection of contemporary art had to include a good fifteen or twenty of his artists. Finally, he admitted to some "laziness" in keeping up with the latest trends and in relying so heavily on Ileana, "whose ideas and influence I've always respected."[1] Between Castelli and Sonnabend, a rare and surprising relationship had developed since the move to SoHo. Was this a late-onset adolescence in a couple who had never grown up? It was as if they were finally allowing themselves the pleasure of each other's company, in a way that had not been possible during the course of their marriage, at age twenty, thirty, and forty. One would often see them, à deux or with friends, lunching or dining at Mezzogiorno, Les Pléiades, or Da Silvano, bursting out in a fit of giggles over the latest outrage Sonnabend had perpetrated, such as her introduction of Jeff Koons or Vito Acconci. "They were devoted to each other. They had

a very happy life together in those last years," recalled Susan Brundage, the gallery's manager. "They even celebrated their fiftieth wedding anniversary!" added her sister Patti.[2] For Agnes Gund, a prominent collector, president of MoMA's board of trustees, and gallery habituée, "the complicity between Leo and Ileana was one of their greatest successes."[3]

The death of Toiny Castelli in September 1987, after a long battle with cancer, would further strengthen the bonds between Castelli and Sonnabend. "Toiny was extremely wise," relates her friend Ursula Helman, a fellow European and cultural accomplice. "She was the one who advised Leo to purchase works from each of his shows and create a collection for Jean-Christophe, and who ordered me to return the Chanel blouse that I had just purchased. 'That's pure foolishness,' she told me. 'If you feel like spending money, invest in art!' "[4] And while Castelli and his wife had endured a fraught relationship, her sickness had reaffirmed their bond, though perhaps belatedly. Bob Monk remembers, "When Toiny passed away, Leo organized a service at Frank Campbell. I flew back from Cape Cod, where I usually spend my vacation, but I was a little late. When I arrived, the service had ended, but the crowd was still there and I saw a beautiful bunch of tiny baby red roses on Toiny's coffin. When Leo saw that I had arrived, he lit up, came to me, and said, 'You must see Toiny, you must see Toiny, she is *beautiful*.' He then went to the guys from Frank Campbell and asked, 'Can we reopen the coffin?' They removed the red roses, undid the screws, opened the top, and we looked at Toiny together. 'Doesn't she look *beautiful*?' Leo asked."[5] Now a widower and in the final lap of his career, Castelli freed himself from competitive resentments, enjoying the public events and personal pleasures that had always delighted him. His friendships with some collectors, even those of a different generation, developed into something stronger and more profound, as if the dealer-collector bond were something beyond a practical contingency. "For someone like me who never even took an art history course," says Eli Broad, who'd become one of Castelli's most important collectors and a major force on the art scene in Los Angeles, "going to museums, to shows, to studios, was an education. Leo was very helpful and very kind in this respect. I would often visit studios with him, like that of Roy Lichtenstein and Jasper Johns."[6] Peter Brant, who, with Castelli, had immersed himself in Andy Warhol's career, went so far as to name a prized racehorse after his dealer. "Leo was interested in horses, because he used to be a good rider in Trieste as a child," remembers Brant. "One day I offered, 'Leo, how would you like if I named a

BELMONT PARK, NEW YORK, MAY 24, 1987
At the Peter Pan Race, the horse Leo Castelli finishes first. FROM LEFT TO RIGHT: LeRoy Jolley (trainer), Peter M. Brant (owner of the horse), Jose Santos (jockey) accepting the trophy from Ogden Phipps, (former chairman of the Jockey Club), with Leo Castelli, RIGHT, holding the horse's saddle towel, which bears his name.

horse after you?' He loved the idea, so I got a horse and named it Leo Castelli. He was so successful that in 1987 he came in fifth or sixth in the Kentucky Derby. Later, when we brought him back to New York to run in the Dwyer Stakes, I took Leo to see the race, and Leo Castelli—the horse—won! Leo always loved the idea that this horse was named after him!"[7] The gallerist's relationship with longtime collector Bil Ehrlich, too, continued to deepen. "My wife gave me a surprise party for my fiftieth birthday which Leo attended," he recalls. "I had lost my father at twenty-one, and in a funny way, even though we were friends, Leo became a father figure to me. When Leo spoke at the party, I had this wonderful feeling that somehow my father was there."[8]

Castelli also continued to travel extensively. The Triestine gallerist Nadia Bassanese was the force behind his bittersweet reunion with the city of his birth. After conducting a telephone interview with him in February 1984, she flew twice to New York, just to see him. Castelli was charmed by the expertise of this young colleague, who was so attuned to his career and eager to

increase his visibility in Trieste. Might he be interested in a career retrospec-
tive through a show of posters, of photos? He was, of course, thrilled. It was
in fact perfect timing, as he was feeling rather out of step in New York. At
this peculiar stage in his career, why not be lionized in Trieste? Six exhibitions
followed: Posters of the Castelli Gallery in October 1986; two of prints, Pop
Art in November 1987 and The Seasons of Jasper Johns in June 1988; two of
photographs, Post Pop Art in October 1990 and Homage to Leo Castelli in
December 1993; and finally, in November 1995, A Life for Art, featuring pho-
tos, two drawings, and two portraits of Leo by Johns and Warhol. These pro-
vided welcome excuses for the gallerist to visit Trieste: to give interviews,
catnip for any proper narcissist; to be photographed and rephotographed,
delightedly holding books dedicated to him, in front of the Andy Warhol
portrait; and to reminisce with his cousin Piero Kern and his old school-
mates. Still, the naturalized American gallerist, whose own *campanilismo* had
diminished over the years, had forgotten what administrative nightmares
plagued a small Italian city, and was in for a rude awakening.

The journalists had hailed him as the "great gallerist," the "famous gal-
lerist," the "king of gallerists," the "lord of art," the "magnificent Triestine,"
or simply "Leo." They pressed him over and over again to repeat for the nth
time the same shopworn anecdotes about his "sentimental" journey, which
some exaggerated as a "return to his roots" (drawing from him only courte-
ous detachment: "As a child, one doesn't yet know how to see the world," he
remarked generically. "Now that I've spent so many years digesting architec-
tural culture, I can see my birthplace with fresh eyes").[9] The cameramen
snapped away at him, hands in his pockets, in the courtyard of his high
school, Il Dante, and everyone seemed delighted that the city should reserve
for its guest of honor some "dry, light, windswept weather, which sharpens
corners, brings out the crags on monument surfaces, brings to life the places
of memory, and swells hundreds of sails off the coast." In the midst of all
this, a misunderstanding suddenly sent the whole homecoming off the rails
as Castelli, letting down his guard and betraying a slight touch of arrogance,
or perhaps naïveté—who can say?—publicly declared: "I'd gladly help orga-
nize an exhibition of the artists I've launched next September at the
Revoltella Museum. It would make my return to Trieste coincide with an
important milestone: my thirtieth birthday. I mean my gallery's, of course—
I wish it were mine!"

To appreciate the faux pas, let's backtrack a bit: in addition to Nadia Bas-
sanese, a second figure had a hand in Castelli's return to his native city, and

that was Piero Kern. This habitué of the city's cafés, a virtual *genus loci* of Trieste, had lobbied hard to secure for his cousin the prestigious San Giusto d'Oro prize, presented yearly to a favorite son who had brought prestige to Trieste (other recipients include Leonor Fini, Claudio Magris, Giorgio Strehler, Gillo Dorflès, and Giorgio Voghera). "After enormous effort, and owing to my excellent connections with numerous journalists, I finally got it through—but what a headache!" Kern now admits.[10] The award furnished Castelli a second opportunity to visit in November 1987, when he would thank the jury "for having put the lie to the adage 'no man is a prophet in his own country' " and reiterate his hope of "returning [to Trieste] for a show of [his] artists."[11] Finally, the award was a chance for Giorgio Cesare, the jury president, to stoke local rivalries and insecurities by emphasizing that "for twenty years, Trieste has been waiting to have a modern art museum of its own."

At the suggestion of the mayor, the Trieste city council decided to award Castelli the title of honorary director of the Revoltella Museum as a prelude to proceeding with plans for an exhibition of his artists. Castelli of course rejoiced when the official letter arrived at 420 West Broadway. But the Revoltella Museum's actual director, Giulio Montenero, when consulted about the possibility of a Castelli artists exhibition, had been very clear: "No merchants in the temple!" And so, this project, which would have sealed Castelli's triumph as a local boy made good, and perhaps eventually have led the gallerist to make a gift of artworks "out of love for his native city,"[12] became mired in a tangle of rivalries, a turf war among municipal, regional, and provincial authorities, all claiming cultural jurisdiction. Who was to blame—obtuse politicians? petty museum tyrants? philistine civil servants?—would never be quite clear. "I'd said I'd gladly make a gesture—that's how I put it, a bit vaguely," an embarrassed Castelli told a reporter soon afterwards. "I said I was more than willing to participate in such a project. It would give me great pleasure to make this kind of gesture for my birthplace."[13] In October 1986, Castelli finally got word in the form of a rather pompous letter from Arnaldo Rossi, which read, *"Illustrisimo Maestro,* I have the greatest honor to communicate to you that in our meeting of the 21st current, the Municipality of Trieste has approved, unanimously, the proposition of designating you the honorary President Curator of the Civico Museo Revoltella—Galleria d'Arte Moderna."[14]

In the end, there would be no official exhibition of the Castelli artists in the Trieste museum, nor any gift from the gallerist. But not irreparably

offended, he would return to the city four more times, always in the company of a woman: in 1986 with the American critic Judith Goldman, in 1987 with his friend Barbara Jakobson, in 1993 with the Franco-British art critic Ann Hindry, in the company of her husband, and in 1995 with the Italian critic Barbara Bertozzi.

If Castelli did not quite recapture the city of his youth, it was no matter. In those years he was welcomed as an honorary citizen of Milan at a ceremony organized by his friend Alfredo Di Marzio, director of the publishing house Rizzoli, to coincide with the city's art triennial. "Aware that his star was falling in New York, Leo tried to broaden his horizons," explains Nadia Bassanese. "He turned to people with whom his prestige remained intact, traveled to countries like Israel, Spain, or Japan where he wasn't such a familiar presence. A bit like an actor who can't bring himself to get off the stage!"[15] Besides, in his Paris gallery near Beaubourg, Daniel Templon organized an Homage to Leo Castelli, featuring several works from the dealer's private collection, including a magnificent group of drawings by Jasper Johns. "Leo Castelli, prince of dealers," read *Le Monde*'s headline, above an article in which Philippe Dagen noted that the gallerist, "like Kahnweiler, and like Vollard before him, joined his name to an art movement, and it is to this movement—Pop Art in the widest sense—that he owes his fame and fortune." In the "constant turnover of the commercial system," wrote Dagen, it was Castelli who "knew best how to play on the love of novelty, even if risky"[16]— a comment that must surely have warmed the subject's heart. A short time later, in collaboration with the film producer Claude Berri and Ann Hindry, a fascinating documentary, complete with a bilingual companion volume, introduced French audiences to the highlights of Castelli's career.

It was hardly preaching to the choir. For while the Castelli artists were very well represented in most European countries—in Ludwig's collection in Germany, Panza's in Italy, the Tate Gallery in England, the Moderna Muséet in Sweden, the Reina Sofia in Spain, the Stedelijk Museum in Holland, the Basel Museum and Beyeler Foundation in Switzerland: so many lands through which Castelli circulated like a lord overseeing his dominion— France remained a conspicuous holdout. Apart from Claude Berri's (and, to a lesser extent, André Bernheim's) personal collection, and despite the creation of the Museum of Contemporary Art (CAPC) in Bordeaux, the combined efforts of Ileana Sonnabend, Daniel Templon, and Yvon Lambert had never made much headway with the officials who acquired art for French state museums, and the hard line taken at the 1964 Biennale had never really

softened. Despite his showing such artists as Garrouste, Buren, Combaz, Lavier, and Raynaud, one still heard that Castelli "does not like French artists," that he is an "enemy of France," and, more seriously, that he "killed French art."

Among the cultural services officials of the French embassy in New York, where Castelli was a regular (I was there serving as cultural counselor), the prolonged delay in the acquisition of contemporary American art for France's public collections remained a worrisome frustration. The natural solution was to find some way to encourage this Francophile, with so many strong ties to France, with a house in the South where he spent every summer, to take the first step. And at last Leo himself proposed the way. "The other day at the Crillon," he confessed to me at the time, "I saw Felix Rohatyn wearing his rosette [the decoration of an officer of the Legion of Honor]. I had only my *barrette* [the ribbon of a chevalier, a lesser distinction]—I was mortified." After several options were considered, it was decided that Castelli would donate to the Centre Pompidou an entire collection of prints by Jasper Johns, an artist then not represented in a single French museum! Dominique Bozo (the museum director) and Jasper Johns were both enthusiastic about the prospect, and it was only for Hubert Védrine, the chief of staff at the Elysée Palace, to seal the deal: Castelli would receive the officer's rosette from President Mitterrand himself.

Paris, May 23, 1991: beneath the imposing chandeliers in the Elysée Palace's grand salon, hands sagely folded like a schoolboy's, his expression uncharacteristically grave, Castelli, alongside Hervé Bazin, Charles Torem, Luc Montagnier, René Peyre, Lydie Dupuy, Pierre Uri, Jean Ellenstein, and Pierre Laroche, savored every moment of the ceremony. That day, the others wore dark blue suits with red or multicolored ties—but not he, opting instead for tones of grey and blue, understated and elegant. Castelli liked men of power, and favored a style more befitting a foreign minister than a merchant. On June 14, 1963, to celebrate Flag Day, he had gone to meet President Kennedy, carrying Jasper Johns's bronze of the American flag under his arm. And while, in these final years, he took pleasure in all the honors he garnered, this particular ceremony, celebrated with a strict observance of protocol, and according to Napoleonic tradition, by the president of the French Republic, held particular cachet for the American gallerist. Mitterrand and Castelli, both erudite scholars of history, and both peerless exegetes of the Italian Renaissance—needless to say, they got on famously. Mitterrand, who spoke without notes, was a master in the art of Legion of Honor citations,

PARIS, ELYSÉE PALACE, MAY 23, 1991
Legion of Honor recipients await President Mitterrand's speech.

and relished delivering capsule biographies of his honorees. He spoke slowly and without rhetorical flourishes, pausing deeply after each sentence and weighing each of his words: a presidential prerogative. "Ladies and gentlemen, in a few moments I shall confer these distinctions—these important distinctions—from the two great orders of our nation, the Order of the Legion of Honor and the Order of Merit. For me, it presents an opportunity to tell the individuals about to receive them the value I place, and that the Republic places, on their efforts, the actions of their lifetimes, their civic devotion, their teachings, or simply on the examples they have set . . . From the most celebrated writers in France today to civil servants who have never sought special distinction—other than by the conscientiousness with which they performed their duties, whatever these may be— each has set an example of service that the government is proud to call attention to. And alongside these are several foreigners who have made signal contributions to the fields of law, the arts, and literature, and who above all have helped spread the glory of France." This preamble concluded, President Mitterrand then proceeded to honor a French writer, an American corporate lawyer, the scientist who had isolated the AIDS virus, the head of the French veterans' association, a human rights activist, an economist who helped found the European Union, a historian of the Soviet Union, the

ELYSÉE PALACE, PARIS, MAY 23, 1991
With President François Mitterrand being made an officer of the Legion of Honor

French navy's chief administrator, and one gallerist, placing on each the cruciform medallions, whether of commander, officer, or chevalier, whether of Honor or of Merit. While the president stressed his admiration for creative artists and civic activists, it was in another category that he placed Castelli, sui generis: in the "world of inventors, those who discover works of art."

After his stately and presidential introductory remarks, Mitterrand reached into the depths of his former role as lawyer for forensic verve and even lyrical oratory to describe Castelli's accomplishments—as a pioneer, as a committed gallerist, and servant of the arts—the very antithesis of a speculator or merchant. "Well might we think," he intoned, "that the man who sees, who distinguishes, who recognizes things, ten years, twenty years before everyone else, possesses a rare knowledge, an intuition, a taste that can serve as an example to us all. Everyone agrees to recognize in you someone who always rose above mere salesmanship to serve what he loved: works of art and those who create them." Then, by way of allusion to the Italian Renaissance, the president of the Republic ventured a reflection rather intimate given the ceremonial context, lifting a corner of the veil Castelli had drawn over his past, to advance a subtle but startling hypothesis: "Rereading certain of your statements and of your writings, I noted a kind of personal

and subjective profession of faith, which said, 'I am of Jewish origin and I
have always, [or rather] but I always, dreamed'—and I intentionally stress the
but in order to emphasize your concern for the universal—'but always
dreamed of participating in a kind of Renaissance, of being a Renaissance
man.' In other words, not simply expressing one's own culture—not even, as
in your case, one's dual or triple culture—but also all that can be dreamt, all
that can be imagined, all that can be created in one's lifetime. Beyond your
work as a pioneer and discoverer, we know the qualities of heart, of passion,
which are yours, a way of existing in the world and, with respect to my coun-
try, France, an affection that has never flagged. Leo Castelli, we hereby
appoint you an officer of the Legion of Honor."[17]

Sometimes with, sometimes without the much-longed-for rosette en-
sconced in his buttonhole, Castelli continued his travels, seeking in the outer
reaches of his world the honor now less abundantly his at the center. But New
York still had some revelations in store. In January 1987, he presented *The
Seasons* by Jasper Johns in SoHo: four paintings, seventeen drawings, and
two prints, the product of two years' labor; a work so rich, hermetic, and
complex that it will take scholars years to decipher it completely.[18] The four
canvases, abounding, as always, in private references, offer an outsize synthe-
sis of Johns's whole oeuvre: visual samplings (Picasso, Duchamp, Cézanne,
Munch, Dürer, Leonardo, Grünewald, Braque, Man Ray), literary allusions
(Melville, Wittgenstein, Beckett, Céline, Hart Crane), musical and choreo-
graphic references (Cage, Cunningham), various other cultural borrowings
(*Tantric Detail, Usuyuki,* ceramics by George Ohr), self-quotations (*Flag,
Savarin Logo, Dancers on a Plane, Voice, Wife/Mother-in-Law, Perilous Night,
Skull*—a pun on his former collector), and, amidst it all, the mysterious form
of the artist, a monochromatic silhouette floating in effigy. These multitudi-
nous references had personal meaning for an artist in transition. "Each paint-
ing refers to a studio . . . [At that time,] I was moving. I had just moved into a
studio in the Caribbean. And I had moved back into town from the country,
and then I was moving another studio from downtown to uptown. I was
doing a lot of shifting of things from place to place,"[19] the artist recalled,
explaining his appropriation of Picasso's *Minotaur Moving His House. The Sea-
sons* can be read as a meditation on the stages of life, a progress from *Spring*
(childhood and adolescence) through *Summer* (adulthood) and *Fall* (middle
age) to *Winter* (old age). The man portrayed is at once Everyman and Johns,
who for once lowers his guard just a little to deliver a piece of himself—for
The Seasons is also the masterpiece of the artist's maturity, as in 1964 *The*

Words had been for Sartre, the self-described "whole man, composed of all men and as good as all of them and no better than any."

"A benchmark in the history not only of American art, but of American autobiography,"[20] John Russell wrote in *The New York Times*. The exhibition was roundly hailed as a tour de force, but no one would capture its glory as ably as Hans Namuth in his portrait of Johns and Castelli. Here we see the artist and his dealer, conjoined in the magic of the photographer's gaze. In the background, visible on the gallery wall, are part of *Summer* and all of *Fall*. The artist stands upright, two brushes in hand, before the silhouette in *Fall* (his own?), his body masking the bottom half. Slightly forward, as if coiffed by the canvas behind him (the arc and compass of *Device Circle*), the gallerist sits calmly on a stool, fingers interlaced. Both men stare intently at the camera. Although their dress in entirely dissimilar—the artist in a shirt of light blue (like his eyes), a bit rumpled at the waist, sleeves rolled up, with black slacks, and clogs; the dealer in beige suit, pale blue shirt, dark tie, and spit-shined loafers—the two men nevertheless embody the placid mimicry that obtains between the two halves of all long-term couples, the harmony forged over three decades, the easy assurance of a well-oiled machine.

Melding Castelli and Johns with the artist's work—as they echo each other with their matching blue shirts and synchronous poses, the artist's hand and forearm rhymed with those of his painted avatar, his silhouette hovering protectively over the gallerist—this photo itself becomes a work of art, an allegory of two men's success and apotheosis. In those beleaguered days of Castelli's career, might *The Seasons,* Jasper Johns's masterwork, have represented an offering of sorts to his declining gallerist, a brilliant and definitive affirmation of *their* collaborative genius, to ward off the vultures circling overhead?

One year later, with the Philadelphia Museum of Art's Mark Rosenthal as commissioner, Johns represented the United States at the Venice Biennale. "The United States has sent Rembrandt,"[21] the word went around the jury that June of 1988. "At a time when the international arts community wonders if the United States is ready to engage in global activities, the exhibition 'Jasper Johns: Works since 1974' sends a powerful signal . . . It is superbly installed and sets the tone for the Biennale as a whole,"[22] wrote Michael Brenson, adding: "No one else in the 43rd Biennale approaches him in stature."[23] And in fact, there were few discordant voices in the concert of praise showered on Castelli's totem artist: now hailed an "old master,"[24] a "heavyweight," the "deepest of living American artists."[25] Few neglected to

420 WEST BROADWAY, NEW YORK
Artist and gallerist in front of two of Jasper Johns's *Seasons*. Photograph by Hans Namuth.

invoke the Rauschenberg Biennale of some twenty-four years earlier, remarking the irony in comparison: in 1964, a young artist on roller skates, a turbulent and much-decried election, a hyperactive dealer verging on impropriety; in 1988, a mature, mainstream artist, an uncontested election, a gallerist certainly still exuberant but slightly above the fray.

The only sour note came from a French critic, who remarked sarcastically that "this summer, awarding the Golden Lion to anyone but Jasper Johns—who occupies the American pavilion 24 years after his colleague and friend—would have been tantamount to a diplomatic scandal. Indeed, no challenger

could hope to measure up against this heavyweight of contemporary art, crowned with the title 'the world's most expensive living artist'—an artist in the best Duchamp tradition and a good painter to boot."[26] For twelve years, from 1972 to 1984, the Biennale, bowing to student protests over the "commodification of art," had ceased awarding prizes, only recently reverting to the practice—to Castelli's delight. "I'm in favor of going back to prizes," he explained. "It keeps the atmosphere lively. The Biennale has an enjoyable nonchalance that you don't find in Kassel or anywhere else."[27] Venice '88 was also the chance for Tom Krens, the Guggenheim's new director, to encounter Castelli for the first time. "Leo had a vision about the future of the art world," Krens said. "What you see today to a certain extent is part of the educational foundation that he laid down. He made it exciting, he made it accessible; he made it dramatic, theatrical. Leo was not about possessing things, he was about facilitating things. He enjoyed being the mechanism by which artists began to achieve a certain success. Cooperation between him and us was always a given. Anytime I called, it was always, 'Wherever you want, whatever you want.' There was never any discussion or negotiation. It was part of Leo's style—not corporate, much more personal and laid-back. Always totally enthusiastic, and with a big sense of history."[28] In every respect, following the Venice Biennale, 1988 continued as a major year for Johns and Castelli. The auctions of May and November reached new speculative peaks, and Johns became the world's costliest living artist. The prices speak for themselves: in May, *Diver* (1962) went for $4.18 million; on November 9, *White Flag* fetched $7 million; on November 10, S. I. Newhouse bought *False Start* for $17 million.

Another major cultural event kept Castelli in the public eye during 1989: his spectacular bequest of Rauschenberg's *Bed* to MoMA. As Calvin Tomkins rightly points out, "MoMA and Rauschenberg never quite hit it off."[29] Despite Castelli's repeated attempts, Alfred Barr had never warmed to Rauschenberg as he had to Johns. The first Combine to enter MoMA was *First Landing Jump*, donated by Philip Johnson in 1974; and under Bill Rubin, who seconded Greenberg's definition of art as flat surface, there was little chance the situation would improve. Certainly, Castelli's friendship with Barbara Jakobson, a museum trustee and member of the painting and sculpture committee, seemed to help. But in 1988, when Kirk Varnedoe took over the department of painting and sculpture, Castelli and his artists got a new lease on life at the Modern. Actually, according to Morgan Spangle, the situation had started to improve in the late 1980s, and Rubin, softening his previous

judgment, had even tried to take an active part in the acquisition of *Bed.* Spangle, manager of the Castelli Gallery at that time, became involved partly through family connections. "Bill Rubin is my wife's uncle," Spangle explains. "I took Bill in a limousine up to my father-in-law, Richard's, house for Thanksgiving dinner. On the way there, Bill was on me to talk to Leo about donating *Bed.* Bill told me Leo had promised *Bed* to MoMA. Even though the tax law had just changed, he said, 'Morgan, you must talk to Leo, you must make him call me.' I told Leo that Bill was on my case, that he wasn't going to give up. Bill had called me five times over the Thanksgiving weekend to see if he could meet with Leo, or if I could push Leo, if I could do something! Leo and I discussed it, and I'm sure he talked with many other people, then he went ahead and donated *Bed.* Bill told me later that if Leo had not made the donation, so many other elements of the collection would not have been possible. *Bed* was the anchor."[30]

Everything about Varnedoe appealed to Castelli: his Georgia breeding ("Southerners, like Jasper and Cy, are aristocrats," the gallerist sniffed with typical snobbery); his academic pedigree and his precocity, almost the equal of Barr's (his Ph.D. on Rodin, several hundred of whose unknown drawings he had discovered in Paris, had led to his curating an exhibition at the National Gallery at age twenty-five); the breadth of his culture (which ranged from nineteenth-century art and architecture to fin de siècle Vienna to Scandinavian painting and even Pop Art); and finally his position of power as a professor at Columbia University and at NYU's Institute of Fine Arts. Even better, Varnedoe, though brought into MoMA by Bill Rubin, was not wearing the latter's blinders: no sooner was he appointed than he started revising the narrative of MoMA's permanent collection.

After shifting around the Brancusis, separating the Giacomettis, and weeding out some Mondrians, he decided to dedicate several galleries to American art of the fifties and sixties (which Rubin had ignored). He told *The New York Times*'s William Grimes that he would "keep tinkering until 'we get the story right.' "[31] Like Castelli, Varnedoe professed a special affinity for creators and launched a series called "Artist's Choice," in which an artist could fashion a temporary installation from the museum's permanent holdings— because, as he said, "I would really like the public to see the collection through the eyes of the people to whom it means the most." Finally, it didn't hurt that Varnedoe was as media-friendly as Castelli; he had recently appeared in the *Times,* with his fetchingly tousled mane, as part of a Barneys ad campaign featuring "real New Yorkers." Were Castelli and Varnedoe

about to reprise the drama of Castelli-Barr or Castelli-Solomon? In one sense, yes: out of the two men's mutual esteem there would be created a milestone in the museum's history.

"Castelli Gives Major Work to the Modern," led Grace Glueck's front-page article for the *Times* on May 10, 1989. "The art dealer Leo Castelli has given the Museum of Modern Art a major work of postwar American art, Robert Rauschenberg's 1955 'Bed.' "[32] Varnedoe in turn described *Bed* as "a work of unique stature and importance [that] brings together the painterly style of Abstract Expressionism and a new openness to found materials . . ." "It is a singularly arresting and still unsettlingly vivid work of art," he added, in a pronouncement as impassioned as that of Barr welcoming *Les Demoiselles d'Avignon*. "Kirk had tried to fill some gaps in the collection by acquiring two of Bob's Combines, *Rebus* and *Rhythm*," notes Agnes Gund, "but the gift of *Bed* was crucial."[33] The arrival of a piece as significant as *Bed* ended the lockdown imposed during the Rubin years and radically recast MoMA's story of contemporary American art. "*Bed* was the absolute, quintessential opposite of what Greenberg considered pure art," comments Robert Storr, who became Varnedoe's assistant around that time. "A bed is horizontal, whereas *Bed* had to be hung on the wall; it was a relief, not flat. A kind of readymade, with a pillow and a quilt, to which Bob had added Twombly-like scribblings. It satirized Abstract Expressionism and Josef Albers, his teacher at Black Mountain."[34]

But the true significance of this major bequest, after which Castelli would emerge glowing with prestige, lies in the timing. A 1965 modification of the tax code had helped savvy collectors to amass tidy fortunes—in addition to their good name as public benefactors—by subtracting from their taxable income the inflated value of donated artworks. But as part of Ronald Reagan's efforts (in 1981 and again in 1986) to give a shot in the arm to the ailing economy with tax reform, a revenue offset was created by dropping the allowable deduction from 78 to 50 percent, then to 28, and finally to 21. Moreover, the Alternative Minimum Tax (AMT), which had been designed to prevent the rich from avoiding taxes altogether, had never been indexed to inflation; and so increasing numbers of the well-heeled but by no means super-rich were suddenly being disallowed a number of other former deductions. The sixties and seventies, it turns out, were a golden age not only for American art but for tax write-offs! Worse still, for a collector subject to the AMT, the deduction would now be only 21 percent of the purchase, rather than selling, price.[35] Castelli had acquired *Bed* at the first Rauschenberg show for $1,100—it was one of the few works in that show to sell, apart from

NEW YORK, MUSEUM OF MODERN ART, MAY 8, 1989
The director Richard E. Oldenburg thanks the gallerist for donating
Robert Rauschenberg's prestigious *Bed* to the museum's permanent
collection.

another Ileana Sonnabend bought. In 1989, when he decided to make the gift, Castelli knew perfectly well the appraised value of the work (around $11 million), and that the tax code would now, far from lining his pocket, make the transaction a dead loss. His decision to donate *Bed* nevertheless, rather than to sell it as sound financial management would have advised, was the ultimate expression of himself as a gallerist rather than a dealer. The munificence born of prizing principle over profit gave the lie to those insinuations of price manipulation, and indisputably impressed the entire arts community.

"His accountants believe Mr. Castelli is not likely to have any tax benefit from his gift," wrote Grace Glueck, who compared Castelli's largesse to Sidney Janis's, also to benefit MoMA, in 1967: "The value of *Bed*, a single artwork, is between three and four times that of [Janis's] entire collection of 103 works . . . which included five Picassos, eight Mondrians, two Klees, six Dubuffets, three de Koonings, and three Warhols." Gifford Phillips, chair of MoMA's painting and sculpture committee, was exultant: "Now that art

prices have risen so sharply and the financial incentives for giving have been greatly diminished by changes in the tax laws, we have special reason to celebrate the exemplary generosity of Leo Castelli in donating this masterwork." Castelli expressed a proud hope that "at a time when the high prices in today's art market make people reluctant to give, this may perhaps set an example." But he was not unrewarded: there was the iconic handshake between Castelli and Dick Oldenburg, the museum's director, then the dinner to toast the event a few days later, during which Castelli, Rauschenberg, and Gund posed in a rare moment of high spirits. "I think I've said many times," Castelli told the guests, "that the Modern, and of course Alfred [Barr] who created it, were my great teachers. Without them, I wouldn't be standing here giving the Museum a masterpiece of that kind."[36]

It was not merely an art lover's generosity that the gift represented, but also an unflagging devotion to the cause of one creative genius in particular. For in choosing *Bed* from his private collection, the gallerist was standing up for an unloved work of art, one that had even been quarantined in the storage sheds in 1957 at the Festival des Deux Mondes in Spoleto, and in April 1959 at Documenta II in Kassel, when its (wrongly) presumed subject matter—a scene of a murder or rape—had offended the sensibilities of most art aficionados. In other words, he chose a work that had proven to be a hard sell with the public but that he considered essential to the history of art, an importance that nothing could certify more forcefully than placement in MoMa's permanent collection. Furthermore, by explicitly acknowledging the debt to his mentor Alfred Barr and (in a typically American gesture) to the institution that had nurtured his success almost as an alma mater, Castelli had also managed to inscribe *himself* in the great narrative of art history he had always attended so closely, thereby closing a circle. "*Bed*. 1955. Combine painting: oil and pencil on pillow, quilt, and sheet on wood supports. Gift of Leo Castelli in honor of Alfred H. Barr, Jr., 1989," reads the laconic label on the wall.

It was in a sense the start of a new golden age of relations with the institution he revered above all others, as attested by the curatorial trajectory. *Bed* was given a central place in the exhibition High and Low: Popular Culture and Modern Art, jointly curated in 1990 by Kirk Varnedoe and Adam Gopnik. And in 1994 and 1996 the Twombly and Johns retrospectives offered further occasions for Varnedoe to strengthen his ties to Castelli, to pay homage to the gallerist's artists, and to offer him, via exhibitions of exceptional quality,

the most compelling of vindications. Meanwhile, business prospects were cropping up everywhere for the newly beatified Castelli. "Leo was interested in doing something with another gallery and Wildenstein was interested in doing something in contemporary art," Peter Brant recalls. "I took Guy Wildenstein to see Jasper Johns's *Four Seasons* at 420 West Broadway. Guy loved the show and asked me to set up a dinner with Leo at their mansion; I arranged it and went there with Leo, who met Daniel Wildenstein, Alec Wildenstein, and Guy Wildenstein. It was there that Leo realized that he did not want to fade out of the gallery scene. For my part, I realized right away how much he loved his gallery, his exposure, and that he was not prepared to let go."[37] "Back when we were trying to broaden our presence in the contemporary art market," Guy Wildenstein adds, "I met with Leo to ask his advice and perhaps discuss buying his gallery, which at the time was far and away the most prestigious in New York, if only because of the artists it had under contract. So we chatted about it for a while, and he said, 'It would be dishonest of me to say that if you bought my gallery, you'd also get my artists. They're only here because of me, and since you're a newcomer to the scene, there's no guarantee they would stay with you.' I realized what I needed to do was not buy a gallery but partner with one. So instead we acquired a half-interest in the most active gallery in the States: Pace. The future proved Leo right, and I value the quality of the advice he gave me. I'll always remember him as a great gentleman."[38]

The press was back in his corner now too. For despite the rise to power of Arnie Glimcher and of Larry Gagosian, journalists were now once again eager to rehash the brilliance of Castelli's early choices. John Russell, for instance, stressed that "Johns and Rauschenberg in their art are classic antitheses . . . We need Jasper Johns around us as much as we need Robert Rauschenberg, and we're fortunate to have lived in a time when Mr. Inside and Mr. Outside have had so much to give."[39] The gallerist continued to cultivate relationships, to meet with artists, dealers, and collectors, to stay alive in the only way he could, as a shark must continue swimming to survive—although he was far from predatory now, if he ever had been. At Da Silvano, he lunched with Sally Ganz, whose collection was among the finest in New York. One day, relates Robert Storr, "there was Jasper, Sally Ganz, Leo, and me. Sally's hearing was going and so was Leo's, and the restaurant was very loud, but they knew each other so well it was like a pantomime ballet. Each one was reading the other's lips, but there was so much charm and elegance

VENICE, SEPTEMBER 4, 1992
At his eighty-fifth birthday party, with daughter, Nina Sundell, and her mother, ex-wife Ileana Sonnabend

on both sides."[40] With Jeffrey Deitch, who in the meantime had made his own mark in the over-oxygenated art market of the eighties, Castelli began by accepting some suggestions on the future of his galleries. "I started putting together a business plan for Leo, in which 420 would remain Leo Castelli's space, one hundred percent owned by him, but in which Greene Street would include myself and other investors, and would be used for all the artists who were not fully served. It would be a new modern gallery for the outside, and nobody except Leo and me would know, which would have been a perfect solution for him. I brought Leo a very impressive business plan, very well typed, impeccable. We had a very exciting period discussing that over a year, but in the end, as it was not going anywhere, I gave up, because I understood that after Leo there is no Castelli Gallery."

Among his close male friends at the time, those who would join him in boys' nights out and talk of women, was Ralph Gibson, the warm and cheerful photographer from California. "I think of Leo every day," Gibson recalls today. Castelli continued to travel, and as a widower could now gad about more openly with female companions; first the American journalist Laura de Coppet, then the English architect Catherine Morrison was regularly to

be seen on his arm. In Paris, he had also met a very beautiful art historian, Ann Hindry, dark-haired and blue-eyed, whom he hopelessly tried to seduce, the failure to remain one of his great regrets. In 1993, the arrival of the Italian critic Barbara Bertozzi, who came to interview Castelli about Johns, put an end to such courtship rituals: a relationship would evolve, leading to marriage in 1995. At the same time, the gallery was shuttered under rather turbulent conditions. "Leo's will was to give his third of the gallery to Mary Jo, Patti, and myself," explains Susan Brundage. "When Barbara showed up, everything changed. She took away Leo's Hermès appointment book, then they locked the doors of the SoHo gallery in July 1997."[41] A final, smaller space opened uptown shortly afterwards and closed a few months later. Some people felt that "Barbara took good care of Leo," who as an elderly man had an increasingly complicated life, while others resented the new regime. Asked about her ex-husband's late marriage, Ileana Sonnabend remarked simply, "I have an opinion, but I don't have a comment." Castelli continued to lunch at Saint Ambroeus on Madison Avenue, to frequent galleries and museums, and to see friends—but only those his young wife approved of.

Among the most relished laurels of those years was the creation in 1990, by the ICI (Independent Curators International), of the Leo Awards in recognition of extraordinary accomplishment in the field of contemporary art. "What could have been more natural than to name these awards after Leo? Who else in the art world is instantly recognisable by first name?" Gerrit Lansing wrote in *The Leo Book*, a beautiful series of homages published in 1997 on the occasion of Castelli's ninetieth birthday. It should come as no surprise to find the name of Nina Sundell, Leo's daughter with Ileana Sonnabend, among the ICI founders. Art was always a family affair. The 1997 Leo recipients were Dorothy Lichtenstein and the collector and TV legend Doug Cramer. Roy, who had passed away three weeks before, was posthumously recognized, and the ceremony became a sort of tribute to his memory. "When you say Leo, everybody knows what you talk about," Sandra Lang, the executive director of ICI, wrote in the book. Some unusual contributions made for a most emotionally charged volume. Connie Trimble, one of Leo's favorite assistants from the early years, reminisced, "Every three weeks the space held wonderful exhibitions of young artists' work—contrasting shows which set off one another theatrically. The Gallery had begun to gather sharp minds wanting to explore new art—a magnetic center had formed."

NEW YORK, JULY 19, 1998
With his third wife, Barbara Bertozzi-Castelli

As for Patterson Sims, he confessed, "Like legions of people, I feel as if Leo Castelli invented me. The fall of my junior year of college, I was assigned by Sam Hunter to write a paper on a major twentieth century movement or artist; I picked Leo Castelli Gallery . . . My professor deferred to what he considered an odd but deeply felt conviction, and over the next few months thanks to Leo's enormous indulgence the Castelli Gallery became my living room. Besides the art and artists, the liveliness of the tiny confines of 4 East 77th was astonishing. Collectors like Bob Scull, Victor Ganz, and Dr. Ludwig would stride up the plush carpeted steps to the second floor with the frequency of genteel addicts. Museum directors, curators, and writers would visit show after show and the civilized Saturday afternoon openings almost as eager to encounter one another as the art on view. Leo, Ivan, and the gallery gave us a community and a world." Bob Monk chose to honor Paddie, Leo's famous Dalmatian: "There are many who can remember climbing the elegant spiral staircase to the gallery at 4 E 77th St. A Westminster Kennel Club Champion, Paddie's beautiful white and black-spotted coat contrasted elegantly with the red carpeting where he arranged himself at the top of the stairs."

Kirk Varnedoe declared, "It has been one of the great privileges of my years in New York to walk the streets he walked, enjoy the art he supported, and occasionally share the tables he graced." And the scholar John Brademas, sometime politician and then president of NYU, recalled their first meeting, of which he told Leo, "You were gracious enough to open your gallery for a reception encouraging friends to contribute towards my 1974 campaign for re-election to Congress in Northern Indiana. You knew that in Congress I was a champion of the arts—and of artists—and you know that since coming to New York University sixteen years ago, I have continued to be, now as Chairman of President Clinton's Committee on the Arts and the Humanities. Through your lively imagination, great enthusiasm and exemplary taste, you have contributed powerfully to the place of the arts in American life and the power of American art in the world." Finally, Castelli's accountant, Jerald Ordover, reflected, "I worked with Leo for more than forty years as his lawyer and as counsel to Leo Castelli, Inc. . . . I soon learned that 'his' artists and their needs came first. In working with other dealers, particularly those new to New York, he went out of his way to help, giving them access to important artworks, allowing discounts and sharing the commission equally when he could easily have sold the work himself. And when it came to collecting debts, he would wait years before turning a matter over to me, by which time the debtor was usually bankrupt, ill, or deceased. Leo would usually meet such news or criticisms of his generosity with a shrug and a smiling 'So be it.' "[42] If, as Andrew Carnegie had observed, the man who dies rich dies disgraced, Leo Castelli was already assured of leaving this long life with the blessings of the multitude to whom he had given of himself freely.

When he died on August 21, 1999, peacefully at home with his wife Barbara in his Fifth Avenue apartment, the newspapers completed the canonization of "the most influential of art dealers," "the Italian who invented American art," and "the prince of dealers." On October 13, Kirk Varnedoe officiated with extreme elegance over a memorial service held in the auditorium of MoMA, the space adorned with large arrangements of white flowers, and the strains of a Beethoven quartet heard as the crowd gathered. Ten years after the bequest of *Bed,* it was only fitting that this place where the gallerist's career had begun should also be where it ended, just as the most fortunate of human lives begin and end in a bed. "Where did Leo Castelli end and where did my father begin?" Jean-Christophe asked in a eulogy, trying to unravel the complex personality of the genial gallerist-cum-patriarch. "Most professional relationships were, for him, by definition, personal ones. My

VENICE, SEPTEMBER 4, 1992
At his eighty-fifth birthday party, with son, Jean-Christophe

father has always been regarded as a father to the New York art world—is this the same as my father? I still feel an ambivalence about the art world— you could call it jealousy. Because the art world was *his* world, and I never felt that I quite belonged there (or really wanted to). But that's where I grew up, and in the end, perhaps I *do* belong—in spite of myself and because of my father . . . Instead of baseball, my father gave me the Italian Renaissance . . . Despite his depth of historical knowledge, my father never lectured about art. Rather, he was showing me his enthusiasm about art—his love. And since he was never good at communicating his emotions, I'd like to think that showing his love of art was his way of communicating his love for me." The son's last words would suffice for a great many: "The art world was *his* world, and it included me if I wanted to be included . . . My father was Leo Castelli. Leo Castelli was my father. He dragged me through museums. He taught me how to look—but most importantly, he let me see for myself."[43]

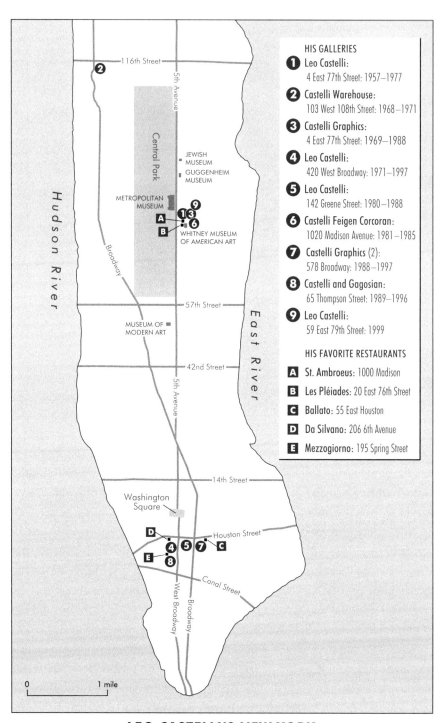

HIS GALLERIES

❶ Leo Castelli:
4 East 77th Street: 1957–1977

❷ Castelli Warehouse:
103 West 108th Street: 1968–1971

❸ Castelli Graphics:
4 East 77th Street: 1969–1988

❹ Leo Castelli:
420 West Broadway: 1971–1997

❺ Leo Castelli:
142 Greene Street: 1980–1988

❻ Castelli Feigen Corcoran:
1020 Madison Avenue: 1981–1985

❼ Castelli Graphics (2):
578 Broadway: 1988–1997

❽ Castelli and Gagosian:
65 Thompson Street: 1989–1996

❾ Leo Castelli:
59 East 79th Street: 1999

HIS FAVORITE RESTAURANTS

🅐 St. Ambroeus: 1000 Madison

🅑 Les Pléiades: 20 East 76th Street

🅒 Ballato: 55 East Houston

🅓 Da Silvano: 206 6th Avenue

🅔 Mezzogiorno: 195 Spring Street

LEO CASTELLI'S NEW YORK

EPILOGUE

Leo was always very generous, very shrewd, and very, very loyal. There's such a big change in the art world now: it became a business, it is much more global, and the prices are so different! When False Start *sold for $15 million, that was considered stratosphere, but now there's information technology, you can e-mail a painting to Moscow and they e-mail you back the money, instantly! I'd love Leo to be alive and watch it today!*[1]

LARRY GAGOSIAN

New York, Monday, October 27, 2008, 6:30 p.m. On this warm fall evening, emptied of its hordes of visitors, the Metropolitan Museum looked unusually dressed up: immense bouquets of purple foliage decorating the entry, an honor guard in black lining up in rows. In the south wing, the Greek and Roman statues were forlornly radiant in the fading evening light. It was the second homage to Bob Rauschenberg since his death five months earlier, following one at MoMA the day before. Printed on a white square of cotton, the invitation carried an image of an empty chair, and bore the artist's irresistible aphorism: "There must be a more interesting way to grow than older." From the moment they set foot in the museum, the guests sensed that every moment of this evening would be unusual; they did not, however, yet know that it would be spectacular. They were seated in one of two spaces in which the evening's speeches would be presented alternately—the Grace Rainey Rogers Auditorium and the Temple of Dendur, each equipped with large screens to telecast the remarks from the other space. All attending received a booklet, *Robert Rauschenberg, 1925–2008*, at once simple and elegant, with a cardboard cover and twenty pages of photos and quotes.

The two hours of the ceremony brought surprise after surprise: remarks from the artist's family, from his assistants, from those close to him (such as Janine Boardman, the nurse who assisted him during his last moments and

who, accompanied by a flutist, sang "Nature Boy" by Eden Ahbez, as she had sung it at his bedside just before he passed away), from his friends (the artists Jim Rosenquist and Chuck Close, the choreographer Trisha Brown), from curators and museum directors (Nan Rosenthal, Tom Krens), from collectors (Christophe de Menil), each one exulting at having been invited to "enjoy the party" in the heart of the Metropolitan for as long as he liked, just as Bob would have wanted. But one surprising speech—announced by one of the artist's assistants as "a petal from the most beautiful autumn rose"— would be the focus of the entire evening. Who, in the world of American culture, traditionally so closed off from the world of politics, could have expected to hear from President Bill Clinton? "I felt extremely grateful when I learned that Bob had decided to leave one of his sculptures, *Ancient Incident,* to the White House garden," Clinton explained, resplendent in a rich purple tie. "Jackie Kennedy had created it as a rose garden and Hillary, with her strong support, transformed it into a sculpture garden, which totally changed the whole feel of the White House. Bob's art ought to be there, because America has no better." Later in the evening, as everyone commented on the upcoming presidential election, on the presence of President Clinton, or on the reference to Jackie Kennedy, happy predictions reverberated through the crowd. The name of Ileana Sonnabend was mentioned often, as well as that of Leo Castelli, whose figure, like the statue of the Commendatore invited to dinner, was on everyone's mind. For wasn't it Castelli, whose unremitting tenacity had, with his ex-wife's help, made the entire world recognize Rauschenberg in 1964 at the Venice Bienniale, and who, even more, had made possible, in this of all countries, such a stunning tribute to, of all figures, *an artist?*

Nearly ten years after the gallerist's death and eleven years after 420 West Broadway had closed its doors, Castelli's name still lived on. Indeed, little by little, fed by his most faithful colleagues, a virtual cult had developed around the memory of this man, whom I had gotten to discover differently during the four years over which this book developed. James Mayor of London and Gian Enzo Sperone of Turin, who traveled to New York in February, May, and November for the auction sales, would inevitably call to learn about the progress of the manuscript, tell me the latest Castelli news, the progress of the afterlife of the man whose memory was ardently kept (a catalogue here, an exhibition there), providing me freshly remembered details (in Mayor's case to reconstruct for the umpteenth time the map of Castelli's satellite

galleries, in Sperone's to rectify this or that date, or to introduce me to new friends). As for Tony Shafrazi, who was henceforth the most devoted apostle, he would insist that all gestures in Leo's honor uphold the gallerist's standards.

A few days after the ceremony at the Metropolitan Museum, there they were—the Englishman, the Italian, the Armenian from Iran—his three lieutenants, at the autumn ritual of auctions at Christie's and Sotheby's, each one turned out true to the master's form, in elegant suits conveying sobriety rather than the more ostentatious idiosyncrasy of other dealers. Three liege men still bound to Leo's memory, ten years after the end of his era, and linked by an uncommon undying affection, also weaving the threads of his story. Other gallerists, such as Angela Westwater, still recalled that Castelli had never been a speculator: "He was the most respected gallerist in the world, we all saw him as a model."[2] A few weeks later, Akira Ikeda, shuttling among his spaces in Berlin, Tokyo, and New York, avowed simply that Leo Castelli had "shaped"[3] him as a dealer. Some, like Toronto gallerist David Mirvish, never tired of reminding people that "according to Leo, the function of a gallerist was different from that of the critic: we were not supposed to describe or analyze the art, but rather to open the world for the artist."[4] Last but not least, Jeffrey Deitch was insightfully deconstructing the sui generis celebrity of Leo Castelli; what had made it possible, he rightly divined, was immense substance underlying such meticulous attention to style: "Even though his responses seemed sometimes superficial, Leo was someone who had thought deeply and profoundly about art. As in the case of Andy Warhol, he created a façade, but there was something very deep that he was not comfortable sharing with people."[5]

This cult, crossing all sorts of social strata, continued to take me by surprise. Whenever anyone from the art world would ask about my work, as soon as I pronounced Leo's name, the emotion surfaced. The nostalgia, the fervor, the "magnetic memories"[6] (Bob Monk) seemed to well up endlessly. Truly, Castelli's influence on American culture had far surpassed what I had expected when I started my inquiry, and even as I finished my book. Why these effusions? Why this cult? What exactly had made such a lasting impression, engendering not mere fond recollection, which fades, but a devotion to one with whom so many yearned to be identified? Listening to all these voices, in a country swept by a radical change whose face was Obama, Castelli's image was for some becoming, not dissimilarly, the icon of an

ideal, an unending work in progress, a tapestry woven by many hands, chief among them his artists, who were of course a fraternity unto themselves. "If I had status in America, it was because I showed with Leo and that the public was forced to take my art seriously,"[7] insisted Keith Sonnier. Jim Rosenquist was similarly categorical: "Leo's mission was to take young and unknown artists and put them in good collections to launch their careers. He radically transformed the relationship between collectors and artists: by bringing prestige to the artists, even in a young country where there is little audience for the arts, the collectors were able to realize that we were not bums."[8]

This cult included among its diaconate the gallery's staff, whose manifold involvements in museums, foundations, or other galleries would keep them in touch during the afterlife, supporting one another, exchanging memories, and not least . . . advising me! Thus the network lived on, through the inexorable workings of time and its displacements, each member remaining conscious of having shared in a sort of treasure, seeking to preserve a common heritage, to transmit it, adding information, layer after layer, making it my work to hear a hymn of which there was never a final verse. "We all were quite proud to work for this man," explained Debbie Taylor, who worked at the gallery for five years. "We loved him!"[9] But it is the collector Bil Ehrlich who found perhaps the most fitting words to describe the relationship between Castelli and his artists: "He stood by them and supported them, not only financially, but spiritually and emotionally. He was the rock that held them up so they could become the heroes they are today. Besides, he made the Americans absolutely relevant and vital to the understanding of art history."[10] The collectors Richard and Barbara Lane presented me with a no less eloquent though wordless epitaph—their *Leo Mug,* made by Meyer Vaisman in 1993 and edited by them since then, a ceramic cup bearing the image of the gallerist surrounded by his totemic pieces, a priceless piece of kitsch that occupies a place of honor in their living room.

Following the incessant litany of praise—of his integrity, his courtesy, his generosity, his passion, his impartiality, his demand for excellence—would invariably come a profession of his singular place, variously described as a "Pope" (Glenn O'Brien), or "a compass" (Pat Caporaso), among other titles, with those who followed him called his "disciples" (Bob Monk). Some critics, too, took part in the apotheosis. Betsy Baker, for example, attempting to summarize the "Castelli magic," was entirely convinced that "he based his work not only on business but also on mutual affection,"[11] while Glenn

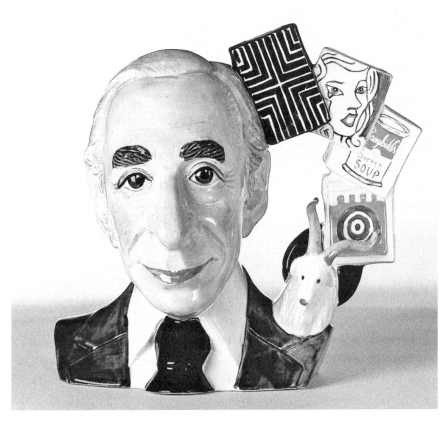

MEYER VAISMAN: *LEO MUG,* 1993
Ceramic mug depicting Leo Castelli surrounded by works from his artists. FROM TOP TO BOTTOM, images
represent the work of Frank Stella, Roy Lichtenstein, Andy Warhol, Jasper Johns, and Robert Rauschenberg.
The mug was produced by Artes Magnus, a company owned by Barbara and Richard Lane as well as Bil
Ehrlich and Ruth Lloyds that issues limited-edition utilitarian objects by contemporary artists.

O'Brien saw something majestic in the gallerist's placement of his artists:
"Unlike his colleagues who only thought about maximizing their profits,
Leo took the long view, adopting a strategic vision of history."[12] Even among
the great collectors, Castelli's clients and not nearly such beneficiaries of his
modus operandi as his artists, there seemed to be, strangely enough, a fervor
no less vibrant. "When I was with him, I always felt that I was in the king's
presence,"[13] declared Bil Ehrlich. "Being part of Leo's group was very stimu-
lating intellectually," Wynn Kramarsky explained. "When you entered 4 East
Seventy-seventh Street, you felt you were being welcomed into a private
home. Leo recognized the collectors who were serious, he had an instinct for
them, he favored them."[14] "With Leo, you had to earn your way," Eli Broad

recalled. "He wouldn't sell to someone who simply had money and wanted to buy but didn't appreciate the art. He wanted to place paintings with people who loved the art, who were willing to learn."[15] Even those Leo would come to acknowledge as collectors without peer had their forty days and nights in the desert.

If the strong bonds the gallerist had cultivated with his collectors continue to be felt, it is perhaps because those that Castelli guided towards art have now become American cultural leaders themselves. Peter Brant, for instance, who met Castelli at the age of nineteen and considered the gallerist his mentor from that moment on, would, like S. I. Newhouse, oversee a stable of publications that have helped define American aesthetic sensibilities. Both men, like Castelli, would pride themselves on the right way of doing things: "When I asked for advice about the auction sales," Brant recalls, "Leo would never use my questions to his own advantage; it had to do with trust, not with power. The most important elements for Leo were the relationships with artists, the exchange of ideas, the quality of the work. Everything that he did, he did with the greatest integrity."[16] But those like Eli Broad, whose business operations were not involved with culture, showed an equal intensity of admiration: "Being with Leo was like watching history take place. Leo was a great treasure as a dealer, a great representative of the artist. I really felt I could talk to him, even if it was not about business. We had lunch once a month on Saturdays, I considered him a friend. They don't make Castellis anymore!"[17]

If they don't make Castellis anymore, it is perhaps because they can't. There are cultural figures who, like the movie stars of the golden age of Hollywood, will always enjoy an unassailable status simply because such status is no longer to be had, no matter one's will or talent to achieve it. Castelli shrewdly understood at the end of his career that even he could no longer be Leo Castelli, at least not in the very center of his world. As Morgan Spangle, manager of the SoHo gallery between 1988 and 1994, observes, "Leo had the talent to take advantage of the unique confluence of events in the late 1950s. With this new society came the ability to travel overseas quickly by plane, to transfer money anywhere in the world. Madison Avenue advertising was in its nascent stage, with all of the magazines, all of the art presses, all of the publicity. Everything came together at the exact same moment, when Leo developed a fantastic coterie of artists. Five years earlier, this could not have happened; five years later, it would have been too late. He had the antennae so he was able to surf the wave of that moment."[18] Donald Marron describes

the same gift for seizing historical opportunities. "Leo identified a time that was coming, he identified a number of the great players, and then he created an atmosphere in which they would flourish, an atmosphere of discovery and success. He made American art global. When he moved to SoHo, his gallery became a *destination* because Leo was showing the way."[19] And what if the sculpture garden, now a fixture of the White House and praised by Bill Clinton, embodied but another of our hero's destination galleries, a landmark in the new cultural ecosystem of the United States at the dawn of the twenty-first century?

Bob Monk, for his part, would give an example of the profound sociological transformations he ascribed to Castelli, far beyond anything attributable to an ordinary dealer: "In the United States that remained, until the late sixties and early seventies, a somewhat philistine society, when a man could quote poetry or look at a painting, he was considered feminine, a fop. But Leo showed a whole group of businessmen (among them John Powers) that one could epitomize masculinity and at the same time love art and culture. Then, from what he learned from Leo, John Powers in turn influenced a group called the Young Presidents, an organization of young CEOs. He showed them that they could watch baseball and still appreciate Jasper Johns. These men would come to me and say, 'I'm not afraid to love art, my wife and I collect, Leo Castelli changed my life!' "[20] Some surrogate fathers teach their boys to throw a baseball; Castelli taught his to love art.

Crossing so many boundaries—societal, cultural, generational—Castelli had shown himself, from the very beginning, to possess a knack for putting others at ease, even though a lifetime's experience had not been enough to make him entirely comfortable in his own skin. His will to play the part of his invented self remained unremitting. He was "incredibly talented in his social interactions . . . distinguished him from his colleagues,"[21] according to Mimi Thompson, who worked in the archives of 420 West Broadway before marrying Jim Rosenquist. He was, to the last, a complex character, fascinating, mysterious, full of paradoxes: living the life of an amateur and of a "good-for-nothing" until the age of fifty, yet managing to launch himself on a singular career; an inconstant family man, unfaithful husband, distant father, and mostly "abstract" grandfather (according to Margaret Sundell), but presiding devotedly over an alternative family in the gallery, looking after staff, artists, and collectors alike; reconciling himself to his ancestry by unreflective and absolute erasure of his Jewishness, even as he must have known that his "genius" lay in a family tradition, which he never forgot even if he

never spoke of it; a figure happily abounding in European idiosyncrasies while becoming a sort of exemplary postwar American.

We might turn yet once more to Jean-Christophe Castelli in looking for the Rosebud to bring us to the heart of a life in which such divergent elements—from the Italian Renaissance to American Pop—come together. "While reading your manuscript," Jean-Christophe abruptly told me, "I understood that my father discovered an extremely elaborate economic system; and that he was a true dealer, without seeming to be one. How strange, because, when I would visit the gallery as a child, I never had the impression that my father really worked. He would talk on the phone, taking his time, he would welcome visitors with a smile, he would disappear for long and leisurely lunches, always courteous and available for everyone. There was never any rush, any agitation, any stress, any frenetic tracking of the Dow Jones. And then, at the end of the day, before going to bed, he would read Proust."[22]

Beyond the cult, beyond the blinding flashbulbs, beyond the adrenaline rush of negotiating and transacting, it is clear that Castelli's career was so astonishing because he never ceased to regard it in the context of *l'Histoire de la longue durée,* according to Fernand Braudel, so that finally his example bears comparison less with even the most eminent modern dealers in art such as Duveen than with Francesco Feroni in his connections with Cosimo III de Medici, one who saw himself involved in a great human enterprise which had started before him and which would long survive him.

Of course, Castelli's legend owes its existence not only to his principled devotion to an ideal but also to the ways in which he went about serving what he venerated. Here, too, we might compare Duveen, who arguably did as much, if not more, to enhance the value of Old Masters in the prewar period as Castelli would do for American contemporary art in the postwar. But while Duveen preceded Castelli in building a vast network of go-betweens, scouts, and critics, the innovations he brought to the business were often scandalously cynical and even philistine—from pressuring Bernard Berenson to opine against his conscience to revarnishing the treasures of Europe to fetch a better price in America, they could not be more alien to Castelli's ethos. Nor could such shamelessly mercenary Duveenisms as "when you pay high for the priceless, you're getting it cheap."

Indeed, Castelli's experience as a man of commerce was no less essential to his success than to the life of art. Indeed, he himself may have thought it

paramount. In the introduction to a conference paper presented in 2006 entitled "Agents in Early Modern Europe," the Dutch historian Marika Keblusek seemed to echo the observations of Jean-Christophe Castelli. "The history of political and cultural transfer in the early modern period," she argued, "cannot be written without acknowledging the significance of merchants as key figures in the system of agency . . . Both as active participants and as facilitators, [they can be] defined through practices of mediation and representation, building and maintaining international financial as well as postal networks and distribution routes. We should understand the term 'agent' in the beginning of the modern era as a reference to a *function* rather than a *profession*."[23] Hearing that, I could not help but think that there might have been something both subconscious and premonitory about Leo Castelli's suggestion, back in 1991, that I travel to Monte San Savino to inquire about his Tuscan roots!

ACKNOWLEDGMENTS

How could I date this project, which started so long before the moment I signed a contract with my editors? "You owe us a book on Castelli!" Raymonde Moulin commanded, in her legendary persuasive tone, at the end of my final thesis defense. But at the time, in November 2001, I hesitated still. Indeed, if I trust my memory, the story truly began with our first encounter in New York, in October 1989, during a dinner at Monina von Opel's, when I immediately felt intrigued by the character of Castelli—his achievements and his charisma, of course, but also his roots and his mysteries. How else could I account for the innumerable questions that I grappled with from our first meeting? Displacements, wars, passages between cities, countries, languages, and cultural identities, all the same elements that Castelli mastered so brilliantly in order to create his persona as an émigré to America—graceful, polished, suave—also formed my own history. Yet beyond the correspondences between Monte San Savino and Cortona, between Trieste and Algiers, between the surnames shared by these two worlds (were the psychoanalyst Edoardo Weiss or the knight Alessandro de Daninos vague ancestors of Albert Waïss, my grandfather, or Elie Daninos, my great-uncle?), a deeper connection still persisted. In short, within this systematic enterprise of historical and social deciphering, there also seemed to lie something like a quest for origins.

My thanks go first to Gregory and Regina Weingarten, themselves great voyagers between cultures, who believed in this book with unadulterated enthusiasm from very early on and permitted me to conduct, in the United States for four years, the groundwork that is indispensable to a project such as this. Their own histories—that of Gregory, painter and patron between California and Europe, and that of Regina, comparative literature scholar and woman of letters between Portugal, Brazil, the United States, and France—does it not read like an echo of the gallerist's? My gratitude goes also to John and Mary Young, for their unwavering support, for their loyalty during our common projects over so many years, and for this new develop-

ment in our transatlantic friendship; to my anonymous friends, for the magic of Further Lane that supported the writing of the first chapters; to François Delattre, Micky Palmer, James and Liliane Rubin, Bud Trillin, Danielle and Serge Bellanger for giving me the opportunity to return to New York, as if I had never left, and to reestablish myself in the city in magnificent conditions; to Charles Masson, in particular, for unforgettable moments at La Grenouille, the most refined space one can possibly dream of; to Lyne Cohen-Solal and Martin Lévy, for the magic of the Place du Panthéon and for setting up my research in Paris during the summer months; to Charlie Bergman of the Pollock-Krasner Foundation, for the songbirds of Accabonac Creek, who serenaded me during a yearlong research fellowship at Springs; to Gerald and Katie Peters, as well as to Alice Duncan, for the spell cast by the lights of Camino Viejo in Santa Fe, where the final chapters were reread; to Bob Wilson, for the tropical trees and the totems of Watermill that presided over the first public presentation of the text, in August 2008; to Raymonde Moulin, for her pioneering work in the sociology of art, especially her research on Leo Castelli, whom she interviewed in New York—her initial analysis was essential to my research and her advice constantly nourished this work.

My gratitude goes as well to everyone who, within the framework of the Annenberg Foundation, the Florence Gould Foundation, the Pollock-Krasner Foundation, and the Byrd Hoffman Watermill Foundation, also worked on this enterprise. Alain Coblence, Carsten Siebert, Jörn Weisbrodt, Maria Kucinski, Rachel Goldbaum, Helen Harrison, Ruby Jackson, and Cile Downs are among them. The concrete idea of this book took shape in the office of my agent, Georges Borchardt; his support, with Valerie and Anne, was key, and I thank him warmly for his work, as well as Michelle Lapautre. My gratitude also goes to all my editors, Alfredo de Marzio, Jean-Loup Champion, and Giovanna Forlanelli, as well as all of their teams, who assisted me to the very end with faultless professionalism during this often arduous process: Béatrice Foti, Françoise Issaurat, Nathalie Chauvin, Audrey Gregorczyk, Vanessa Gennari, and Micaela Acquistapace. Finally, for Giovanna Citi-Hebey, a fantastic ally, *un abbraccio particolare.*

How can I describe the role that the Krausz, Castelli, and Shapira families played in the composition of this work? Their presence by my side surpassed a few simple interviews. I warmly thank Ileana Sonnabend, Nina Sundell, Jean-Christophe Castelli, Margaret Sundell, Dr. George Crane, Piero Kern, Giulio Levi-Castellini, Robert Reitter, Paul Reitter, Antonio Homem, Mar-

ième Rugo, Dominique Martin-Rovet, and Maria Eugenia Deheinzelin, who agreed to share their memories, to reopen their photo albums, and to reread their old letters, expressing at every turn their emotions and surprises, little by little, as the investigation developed. Two of them have passed away since the beginning of the work: Ileana Sonnabend, who I always considered like a friend of my own age, insolent, provocative, and with whom the conversation constituted moments of great pleasure, and Piero Kern, Leo Castelli's first cousin, a magnificent scholar and a fascinating raconteur of inexhaustible resources on the colorful and complex history of the Castelli family, who initiated me into the mysteries of Triestine families, with their fluctuating identities, names, religions, homes, and nationalities. My great thanks to Nina Sundell, who generously gave me access to all the older members of the family and recalled with tenderness her memories of exile, and Jean-Christophe, who, acting as more than a simple witness, played the role of an editor and reader, always available, showing a capacity to listen and to offer excellent suggestions, without the least bit of pressure, maintaining with tact the role of an attentive and critical intellectual. Antonio Homem, whose infallible memory, patience, and unending generosity provided me with invaluable information. Barbara Bertozzi-Castelli, finally, kindly gave me access to some information and important documents. As for Leo's close friends, such as Barbara Jakobson—with her luminous memory continually awakening, over regular meals, which she called "my contribution to the book"—and Attilio Codognato, James Mayor, Gian Enzo Sperone, and Tony Shafrazi: they invested in this work with an immoderate energy, as a reflection of their regard and affection for Leo, and my gratitude for them is immense.

I would also like to thank all those who accompanied me, so patiently and so generously, in deciphering often complex situations. In Monte San Savino, Silvano Materazzi, the mayor; Renato Giulietti, the archivist and *Assessore alla Cultura;* and also Renzo Funaro, Jack Arbib, Roberto Salvadori, Lionella Neppi Modona Viterbo, Marco Caneschi, and Alessandra Roggi, who gave me access to her thesis "L'identità ebraica ed il viva Maria." Thanks to them, the memory of the city's Jewish community could develop and leave its mark on their daily life. In Trieste, Francesco Montenero, the ideal companion to lead the expeditions in his city between Monfalcone, Gorizia, and the Carso; Augusto Debernardi, who, with a rare talent as a researcher, flushed out a wealth of historical documents; Edoardo Kanzian, who taught me so

much about local writers; Nadia Bassanese, who generously opened all of her archives to me; Christia Leggeri, to whom I owe amazing discoveries, such as an encounter with the Turm und Taxis family at the Duino Castle; Liliana Weinberg-Stock, who opened for me all the doors of Jewish cultural life in Trieste; and also John Berger, Anna Milo, Tullia Catalan, Jeffrey T. Schnapp, Maria Carla Triadan (Archivio di Stato di Trieste), Pierpaolo Dorsi (Sovrintende archivistico), Rabin Ariel Haddad, Mariu Hassid, Aldo Ancona (Comunità Ebraica di Trieste), Mario Cerne (Libreria Umberto Saba), and Riccardo Cepach (Museo Sveviano), as well as Claudio Magris, Ricardo Calimani, Giulio Montenero, Renzo Zambonelli (for the document on the Alpe Giulie), and Bianca Cuderi and Franco Levi (Servizio Bibliotecario Urbano di Trieste). I cannot forget the two "Triestines d'honneur," Marie Tramuta, who initiated me to the city's magic, and Manuela Bertone, who led me to discover so many new texts and new trails. In Vienna, Liesl Frank, Gerhardt Schwarzacher, Marc Perrin de Brichambaut, Sheila Coutts, Paul Reitter, Leo Lensing, Percy B. Lehning. In Milan, Francesca Pino, Alberto Gottarelli assisted by Fabio Confalonieri (Archivio Storico di Intesa Sanpaolo SpA), as well as Giuseppina and Alessandro Panza di Biumo and Alfredo d'Amore, who gave me access to his thesis "Gli ultimi giorni della Banca Commerciale Triestina" (Università Cattolica del Sacro Cuore, Facoltà di Economia e Commercio). In Rome, Felice d'Alfonso del Sordo. In Bucharest, Sandra Pralong, Michel Farine, and Alejandru Ofrim. In Budapest, Zoltan Lengyel, Laszlo Karsai, and Judit Molnar. In Paris, Véronique Borgeaud, Jean Cronier, Christian Derovet, Jean-Claude Drouin, Janine Lecourt, Alan Riding, Raphaël Sorin, and Maurice Vaisse. In East Hampton, Denise Lassaw, Domna Samnis (Stony Brook University Library), and Pat Caporaso. In New York: Bruce Altshuler, Ursula Helman, Maurice Kanbar, Sandra Lang, Julian Lethbridge, Susan Lorence, Mark Polizzotti, Robert Pincus-Witten, Felix Rohatyn, Mary Schmidt Campbell, Alexander Stille, Sarah Taggart, and Elyn Zimmerman.

I am very grateful, for their stories from the "Leo years," to the artists: Jeanne-Claude and Christo, Jasper Johns, Dorothy Lichtenstein (for Roy), Robert Rauschenberg, Jim Rosenquist, Ed Ruscka, David Salle, Keith Sonnier, Frank Stella, and Billy Sullivan. To the staff who constituted the Leo Castelli galleries over the years: Kay Bearman, Patti Brundage, Susan Brundage, Pat Caporaso, John Good, Bob Monk, Amy Poll-Schell, Morgan Spangle, Debbie Taylor, Mimi Thompson, Connie Trimble, David White,

and Barbara Wool. To the gallerists and dealers: Mary Boone, Irving Blum, Gabriella Bryers, Paula Cooper, James Corcoran, Jeffrey Deitch, Dorothea Elkon, André Emmerich, Richard Feigen, Heiner Friedrich, Konrad Fisher, Larry Gagosian, Constance Glenn, Arne Glimcher, Ronnie Greenberg, Joe Helman, Akira Ikeda, Carroll Janis, Ivan Karp, Margo Leavin, Janie C. Lee, Gordon Locksley, David Mirvish, Linda D. Silverman, Daniel Templon, Angela Westwater, and Rudolf Zwirner. To the critics: Betsy Baker, Achille Bonito Oliva, Ann Hindry, Samuel Hunter, Glenn O'Brien, Calvin Tomkins, Leo Steinberg, and Rona Roob. To the collectors: Peter Brant, Eli Broad, Beatrice Dupont, Bil Ehrlich, Agnes Gund, Wynn Kramarsky, Dick and Barbara Lane, Leonard Lauder, Donald Marron, Steve Mazoh, Christophe de Menil, Bob Meyerhoff, Beatrice Monti, S. I. and Victoria Newhouse, and Mr. and Mrs. Giuseppe Panza di Biumo. To the museum directors: Tom Armstrong and Tom Krens.

My assistants, who, over these four years, have followed and developed the investigation, often unearthed precious documents with great passion and enthusiasm, and have given me some of the best moments of this period. They are Julie Verlaine, Ekaterina Kotchetygova, Valerie Hellstein, Abby McEwen, Terry Taffer, Clémentine Stip, Elisa Mogavero, Fleurianne Maria Schoonhoven, Charlotte Harion, Natalia Fuller, Clelia Simpson, Quentin André, Liliane Erhardt, Jennifer Cohen, Natasha Bunten, Aline Sara, Jisoo Kim, France Costrel, Ipek Ulusoy, Mayssa Jaroudi, Kayla Rakowski, Artemis Baltoyanni, and Teresa Callejo-Pajares. Among so many other close friends, without whom this book could never have been brought to fruition, I would like finally to mention, for their ceaseless trust by my side, Sante Miceli, Natalie Audrey Ruchat, and Antoine de Tarlé. As for Kara Donnelly, her writing expertise became key to the final version of the English text: thank you for enriching my knowledge of the English language!

In the last phase of the work, the Cultural Services of the French Embassy in the United States, Kareen Rispal, Christophe Musitelli, and Fabrice Gabriel offered their wonderful support team, and I sincerely thank them for it; the unfailing support of Tony Shafrazi's entire staff proved immensely helpful: I would like to express my gratitude to Kiroko Onoda, George Horner, James Walton, John Czaplicki, Elizabeth Wallace, and Sara Nelson, who sometimes seemed to turn 544 West 26th Street into an extension of my own office! Such was also the case at the Richard Feigen Gallery, and I am very thankful to its director, Frances Beatty Adler, as well as to Françoise

Newman, Richard's assistant. As for the Gagosian Gallery, I sincerely appreciate the dedicated work of Vanessa Lazarov, Virginia Coleman, and Kimberly Higgs, who all went out of the usual way to provide essential missing data. For specific archival material, I am indebted to Michelle Elligott (MoMA), Virginia Mokslaveskas (Getty Foundation Archives), Jean Bickley (The Brant Foundation, Inc.), Cassandra Lozano (Roy Lichenstein Archives), Barbara Nicolini (Ugo Mulas Archives), Gina Guy and Matt Magee (Robert Rauschenberg Archives), Greg Burchard (Andy Warhol Foundation), and Georges Saunier (Institut François Mitterrand).

At Alfred A. Knopf, Lily Evans's considerable help in putting all the pieces together proved indeed to be an extraordinary success; early on, Lena Khidritskaya's production of the Leo postcard helped carry over the mention of the book to future readers. As for Kathy Zuckerman, who already supported *Painting American,* her input on *Leo Castelli and His Circle* conveyed to the project both talent and energy in a very creative way. Roméo Enriquez (senior production manager), Maggie Hinders (senior designer), Lydia Buechler (copy chief), and Victoria Pearson (stupendous production editor)—displayed both impressive expertise and unusual commitment to the book at every stage of production; by accepting late changes, late additions, and unexpected late shake-ups, while keeping to the publication schedule, they literally helped my words stay alive and accurate up to the last minute. I am extremely grateful for their generosity. And finally, George Andreou, my editor: how can I begin to describe his impact on the text? A friend in Paris mentioned that he was "the best line editor in the United States." Indeed, I feel very privileged to have benefited from his erudition, his clarity, and his stylish eloquence.

As the names and places on these pages surely affirm, this project, like Leo's life, crossed every kind of border, linked people throughout the world, dug deep into the past while imagining the future, weaving together in the end the most marvelous tapestry of friends and supporters. Everyone mentioned here has enlarged *Leo Castelli and His Circle* in this way.

NOTES

ENVOI

1. Roy Lichtenstein.
2. Jasper Johns.
3. Robert Rauschenberg, Frank Stella, Jim Rosenquist, and Ellsworth Kelly.
4. Marika Keblusek, "Profiling the Modern Agent," in Hans Cools, Marika Keblusek, and Badeloch Noldus, eds., *Your Humble Servant: Agents in Early Modern Europe* (Hilversum, Netherlands: Uitgeverij Verloren, 2006), pp. 11–12.

PROLOGUE: BORN ON A POWDER KEG

1. Trieste, January 1, 1831.
2. Rhyme in the dialect of Trieste: "With a gust of the *bora* / The man loses his hat / And the skirts of the women / Fly in the air / It flys everywhere / But the most beautiful / It's the one that you find / At the bottom of your pocket / Auntie, what a *bora*! / Auntie, what hell! / By the devil the *bora* / By the devil the winter!"
3. "Is the bora blowing today?"
4. *Racing Thoughts* (1983), sold to the Whitney Museum; see catalogue, Kirk Varnedoe, *Jasper Johns* (New York: MoMA 1996), pp. 328–29.
5. Stefan Zweig, *Die Welt von Gestern, Erinnerungen eines Europäers* (Frankfurt: Fischer, 1998), pp. 10–11. The continuation of the quote reads: "The one before the World War, before the First World War or the Second, or the life I live today? Then I again find myself saying 'my house' and not actually knowing right away which one from the past I mean, the one in Bath, or Salzburg or my parents' house in Vienna . . . We have run the gamut of every possible catastrophe imaginable, and to the limit (and it isn't over yet). In my own lifetime, I have lived through the two greatest wars of all time and even experienced them from different sides, one from the German side, the other from the anti-German side. Before the war, I experienced the most elevated form of individual liberty, and afterwards, its lowest point for hundreds of years; I have been both celebrated and censored, free and deprived of freedom, rich and poor."

6. Laura de Coppet and Alan Jones, *The Art Dealers* (New York: Carkson Potter, 1984), p. 81.

7. Archives of the city of Trieste.

8. Robert Bazlen, *Scritti Intervista su Trieste,* ed. Roberto Calasso (Milan: Adelphi, 1984), pp. 246, 250, 252, 254.

9. Umberto Saba, Italo Svevo, Claudio Magris, but also Carolus Cergoly, Srečko Kosovel, Scipio Slataper, Giani Stuparich, Roberto Bazlen, Giorgio Voghera.

10. Chateaubriand, Nerval, Stendhal, Rilke, Kafka, Joyce.

11. Corrado Beki, *Il libro della bora* (Trieste: LINT-Editoriale Associati, 2003), p. 32.

12. Ibid., p. 25.

13. Ibid., p. 35. *Nera* means "unleashed."

14. Ibid., 126.

15. "Voi Triestini—mi diceva ieri Giacomo Debenetti—siette veramente figli del vento. E per questo che amate tanto moralità e apologhi, favole e favolette: E perchè sei nato nella città della bora che scrivi Scorciatoie . . ."; Umberto Saba, *Scorciatoie e raccontini* (Milan: Mondadori, 1946); *Tutte le prose* (Milan: Mondadori, 2001), p. 18.

16. Angelo Ara and Claudio Magris, *Trieste: Un'identità di frontiera* (Turin: Einaudi, 1982), p. 4.

17. Carolus Cergoly, *Il complesso del l'imperatore* (Milan: Mondadori, 1979).

18. See Ara and Magris, *Trieste: Un'identità di frontiera,* p. 4.

19. François-René de Chateaubriand, *Itinéraire de Paris à Jérusalem, 1810–1812* in *Le Goût de Trieste,* Gérard-Georges Lemaire, ed. (Paris: Mercure France, 2003), pp. 13–14.

20. Letter of Stendhal to Frédéric Mercey, November 1830.

21. Gérard de Nerval, *Voyage en Orient* in *Le Goût de Trieste,* p. 13.

22. Ibid., p. 14.

23. See Ara and Magris, *Un'identità di frontiera,* p. 4.

24. For Hermann Bahr, *Voyages Dalmates* (Berlin, 1909), see ibid., p. 187.

25. Filippo Marinetti, *Le Futurisme* (Paris: Sansot, 1911).

26. For Raffaele Cusin, "Il ghetto e la citta," in *Shalom Trieste, gli itinerari dell'ebraismo,* Municipal Archive of Trieste (Trieste, 1999), p. 34.

27. Jean-Christophe Castelli, interview by the author, New York, September 25, 2008.

1. AROUND THE HALL OF MERCHANTS

1. September 25, 2008.

2. "The Jew is treacherous, just as the Christian Church says he is an enemy of the faith, he has hatred for the faithful of Christ, this is why one must be suspicious of him." From CC 1180 in the archives of Monte San Savino, c. 1740.

3. A.PRE.M., "Deliberazione dei deputati sopra la conservazione della sanità,"

cited by Renato Giulietti and Giovanni Romanelli, "Una 'nazione' dentro le mura," in *Gli Ebrei a Monte San Savino* (Quaderni Savinesi III, Commune di Monte San Savino, 1994), pp. 51–88.

4. Roberto G. Salvadori, "Quattro secoli di storia ebraica a Monte San Savino," in *Gli Ebrei a Monte San Savino*, p. 23.

5. Giulietti and Romanelli, "Una 'nazione' dentro le mura," p. 58.

6. Renato Giulietti, *Monte San Savino, Itinerari storici-artistici*, Municipal Archives of Monte San Savino, 2004, p. 12.

7. Ibid., pp. 21–22, n. 46.

8. Salvadori, "Quattro secoli," p. 29.

9. Ibid., p. 32.

10. Ibid., p. 29.

11. Ibid., p. 24.

12. Ibid., p. 30, n. 94.

13. Giulietti and Romanelli, "Una 'nazione' dentro le mura," p. 65, n. 65.

14. Ibid., p. 58, n. 20 and 21.

15. Ibid., n. 28 and 29.

16. Ibid., p. 24.

17. Salvadori, "Quattro secoli," p. 30, n. 90.

18. Ibid., p. 33, n. 105.

19. Ibid., p. 33.

20. Ariel Toaff, *Il vino e la carne: Una communità ebraica nel Medioevo* (Bologna: Il Mulino, 1989), p. 120.

21. Giulietti and Romanelli, "Una 'nazione' dentro le mura," pp. 67–68, n. 77.

22. Ibid., p. 65, n. 61.

23. In October 1720; see Salvadori, "Quattro secoli," p. 29, n. 86.

24. Ibid., p. 29, n. 83.

25. Giulietti and Romanelli, "Una 'nazione' dentro le mura," p. 65, n. 56.

26. Ibid., p. 24, n. 50.

27. *Discorso pronunziato da Elia Morpurgo capo della nazione Ebrea di Gradisca nel participare a quella comunità la clementissima sovrana risoluzione 16 maggio 1781* (Gorizia, 1782); reviewed in *Novelle Letterarie* 51 (December 20, 1782), cols. 811–13.

28. They criticized, among others, an anonymous book published in Ancona in 1775, *Degli errori dei Giudei*, or the text by Giovanni Battista Benedetti, *Dissertazione della religione e del giuramento degli ebrei*, published in Mantova the same year. See *Magazzino Toscano* 28 (1776): 107–11.

29. Alfredo S. Toaff, "L'opera ebraica di Salomone Fiorentino (col ritratto del poeta)," in *La Rassegna Mensile d'Israele*, vol. XV (May 1949), p. 197.

30. Without a doubt, he was friends with the members of the Accademia Etrusca in Cortona, as well as part of the group of the Maskilim, the intellectual Jews who founded the Haskalah, a movement which, as the Venetian historian Riccardo Calimani explains, "showed sympathy for the ideas of the French

Revolution, strongly believed that its ideas of revolt against authority, its faith in the rights of man, and its hatred of traditions that opposed social progress were in perfect harmony with Jewish thought." See R. Calimani, *Storia dell'ebreo errante* (Milan: Rusconi, 1987), p. 402.

31. Letter from Salomone Fiorentino, cited by Sergio Romagnoli in "Salomone Fiorentino tra fede, impegno civile ed elegia," in Italia Judaica, *"Gli Ebrei in Italia dalla segregazione alla prima emancipazione,"* Atti del Convengno Internazionale, Tel Aviv, June 15–20, 1986," Roma Ist. Poligrafico.

32. Carlo Capra, *L'età rivoluzionaria e napoleonica in Italia 1796–1815* (Turin: Loescher, 1978), p. 97.

33. Carlo Cattaneo, *Interdizioni israelitiche, 1796–1815* (Turin: Loescher, 1978), p. 273, cited in the thesis of Alessandra Roggi, *Il dilemma identitario ebraico in età moderna: Riflessioni sull'insurrezione antigiudaica di Monte San Savino nel 1799*, Università degli Studi di Siena, Facoltà di Lettere e Filosofia di Arezzo, December 2006.

34. Sergio Romagnoli, "Salomone Fiorentino tra fede, im pegno civile ed elegie" in *Gli Ebrei in Italia*, p. 38.

35. Roberto G. Salvadori, "Quattro secoli," p. 38, n. 124, and p. 40, n. 138.

36. Ibid., p. 38, n. 128.

37. Toaff, "L'opera ebraica," p. 199.

38. Lionella Neppi Modona Viterbo et Sonia Oberdorfer, "1799: Un pogrom in Toscana," *La Rassegna Mensile d'Israele* LIII, no. 3 (1987): 248.

39. Roberto G. Salvadori, "Quattro secoli," p. 41, n. 44.

40. In the year 1795 according to the Christian calendar.

2. AT THE SAN CARLO PIER

1. Theresian diploma, April 19, 1771. Lois C. Dubin, *The Port Jews of Habsburg Trieste: Absolutist Politics and Enlightenment Culture* (Stanford, Calif.: Stanford University Press, 1999), pp. 45–46 and n. 17–18.

2. J. K. Heer, *Ferien an der Adria Bilder aus Sud Österreich* (Frauenfeld and Leipzig: Huber, 1888).

3. Umberto Saba, "Corriere della Sera," November 6, 1946, in *Le Goût de Trieste*, p. 70.

4. Alexander Warsberg, *Odysseische Landschaften* (Vienna: Gerold's Son, 1878).

5. Dubin, *The Port Jews of Habsburg Trieste*, p. 14.

6. Ibid., p. 14, n. 12.

7. Joseph Lavallée, *Voyage pittoresque et historique de l'Istrie et Dalmatie, rédig d'après l'itinéraire de Louis-François Cassas* (Paris: Didot, 1802).

8. Dubin, *The Port Jews of Habsburg Trieste*, p. 14.

9. Elia Morpurgo, 1781, cited in ibid., p. 15.

10. Tullia Catalan, *La Communità ebraica di Trieste, 1781–1914: Politica, società e cultura* (Trieste: Lint, 2000), p. 19.

11. Umberto Saba, "Le ghetto de Trieste en 1860," in *Couleur du temps* (Marseille: Rivages, 1986).

12. Catalan, *La Communità ebraica,* p. 33.

13. Ibid.

14. Saba, "Le ghetto de Trieste en 1860," pp. 33–38.

15. AST, I. R., Governo del Litorale, Atti Generali, b. 988, Supplica cds capi della communità ebraica, Angelo Gentilomo, Matteo Coen, V.B. Cusin all I.R. Presidenza di Governo, Trieste 21 Luglio 1845, cited in Tullia Catalan, *La Communità ebraica,* p. 45.

16. Saba, "Le ghetto de Trieste en 1860," p. 66.

17. Piero Kern, interview by the author, Trieste, May 3, 2005.

18. Warsberg, *Odysseische Landschaften,*

19. Umberto Saba, "A la guerre en rêve," *Couleur du temps* (Marseille: Rivages, 1986), p. 65.

20. Umberto Saba, "Les numéros du loto," *Couleur du temps* (Marseille: Rivages, 1986), pp. 38–39.

21. Elio Schmitz, *Diario* (Palermo: Sellerio, 1997), cited by Catalan, *La Communità ebraica,* pp. 169–70. Schmitz is Svevo's real name.

22. Alessandro Stebel, "Banchieri ebrei a trieste nell prima metà dell Ottocento," in *Shalom Trieste, gli itinerari dell'ebraismo* (Commune di Trieste, 1998).

23. Anna Millo, "La presenza ebraica nella società triestina durante l'età dell'emperio," in *Shalom Trieste, gli itinerari dell'ebraismo* p. 43.

24. Vito Levi, "Trieste musicale del passato," RAI, Stazione di Trieste, September 11, 1956, and Baccio Ziliotto, "Trieste Musicale alle fine dell'800: Ricordo di Castelli," *Il Piccolo.*

25. Anna Millo, "Un porto fra centro e periferia (1861–1918)," in *Storia d'Italia dall'Unità a oggi, Le regioni: Il Friuli-Veneziana-Giulia,* a cura di Roberto Finzi, Claudio Magris, Giovanni Miccoli (Milan: Giulio Einaudi, 2002), p. 184.

26. Ibid., p. 199.

27. Biagio Marin, *Strade e rive di Trieste* (Milan: Pesce d'oro, 1986), pp. 45–46.

28. Levi, "Trieste musicale del passato," Ziliotto, "Trieste Musicale alle fine dell'800," Barison, "Trieste città musicalissima."

29. Ibid.

30. Federica Vetta, "Musica, salotti e famiglie birghesi ebraiche a Trieste tra il 1814 e il 1914," in *Shalom Trieste,* pp. 219–33.

31. Levi, "Trieste musicale del passato."

32. See Albert Cohen, *Solal* (Paris: Gallimard, 1930).

33. Catalan, *La Communità ebraica,* p. 221.

34. M. Luzzatti, *Ebrei di Livorno tra due censimenti (1841–1938), memoria familiare e identità* (Livorno, 1990), p. 111, cited in ibid., p. 227.

35. Moni Ovadia, *La porta di Sion, Trieste, ebrei e dintorni* (Gorizia: Libreria editrice Goriziana, 1999), p. 83.

36. Letter of Piero Kern, archives of Annie Cohen-Solal.

3. ERNESTO KRAUSZ MAKES HIS ENTRANCE

1. Ann Hindry, ed., *Claude Berri rencontre Leo Castelli* (Paris: Renn, 1990), p. 73.

2. Dr. George Crane, interview by the author, San Francisco, November 29, 2005.

3. Archives of Annie Cohen-Solal.

4. Dr. George Crane, interview by the author, San Francisco, November 29, 2005.

5. Hindry, ed., *Claude Berri rencontre Leo Castelli*, p. 73.

6. Son of Israel.

7. Robert Reitter, "The Vineyard" (unpublished memoir), archives of Annie Cohen-Solal.

8. Francois Fejtö, *Hongrois et Juifs* (Paris: Editions Balland, 1997), p. 49; see also Yehuda Don, "Jewish Integration into the Hungarian Economy," in Anna Szalai, ed., *In the Land of Hagar: The Jews of Hungary, History, Society, and Culture,* Beth Hatefutsoth, The Nahum Goldmann Museum of the Jewish Diaspora, Tel Aviv, 2002; as well as *Vienne-Budapest 1867–1918 : deux âges d'or, deux visions, un Empire* (Paris: Autrement, 1996).

9. Ibid., p. 50.

10. Jacques Le Rider, "L'aigle à deux têtes," in *Vienne-Budapest 1867–1918: deux âges d'or, deux visions, un Empire* (Paris: Autrement, 1996), pp. 49–58, and Jacques Le Rider, *Modernité viennoise et crises de l'identité* (Paris: Quadrige, Presses universitaires de France, 1990), pp. 222–23.

11. Fejtö, *Hongrois et Juifs*, p. 54.

12. Ibid., p. 71.

13. Ibid., p. 142.

14. Ibid., p. 143.

15. See, for example, Jacques Le Rider, "L'aigle à deux têtes," in *Vienne-Budapest 1867–1918,*: pp. 49–58.

16. In 1840; see Fejtö, *Hongrois et Juifs*, p. 64.

17. In 1790; ibid., p. 67.

18. In 1840; ibid., p. 67.

19. Anatol Murad, *Franz Joseph I of Austria and His Empire* (New York: Twayne, 1968), p. 10.

20. Alexander Gerschenkron, *An Economic Spurt That Failed: Four Lectures in Austrian History* (Princeton, N.J.: Princeton University Press, 1977), pp. 23–24 and 30.

21. Ibid., pp 39–44.

22. Carl Schorske, *Fin de siècle Vienna* (Princeton, N.J.: Princeton University Press, 1980), p. 243.

23. Gerschenkron, *An Economic Spurt,* p. 149.

24. Ibid., p. 87.

25. Ibid., p. 120.

26. Fejtö, *Hongrois et Juifs*, p. 151.

27. Anna Millo, *Trieste, le Assicurazioni, l'Europa, Arnaldo Frigessi di Rattalma e la RAS* (Milan: Franco Angeli Storia, 2004), p. 53.

28. Yehuda Don, "Jewish integration into the Hungarian Economy," p. 52.

4. MIRACULOUS YEARS IN TRIESTE

1. Robert Bazlen, *Scritti: Intervista su Trieste* (Milan: Adelphi, 1984), p. 244.

2. Account of Piero Kern, the son of Ortensia Castelli and of Max Kern, interviews by the author, Trieste, March 31, April 2, May 2 and 3, June, July 27, 28, 30 of 2005.

3. Dr. George Crane, interviews by the author, San Francisco, November 29 and 30, 2005.

4. Italo Svevo, *Ulysse est né à Trieste* (Bordeaux: Finitude, 2003), p. 11.

5. To Grant Richards, February 28, 1906; Stuart Gilbert, ed., *Letters of James Joyce,* vol. II (London: Faber and Faber, 1966), p. 130.

6. Their pro-Austrian feelings.

7. Antonio Saccone, *Martinetti e il Futurismo* (Naples: Liguori editore, 1984), p. 32.

8. See the writing of Silvio Benco, art critic of *Il Piccolo,* ibid., pp. 27 and 117.

9. Filippo Tommaso Marinetti, *Le Futurisme* (Paris: Sansot, 1911), and *Le Goût de Trieste,* Gérard-Georges Lemaire, ed. (Paris: Mercure France, 1997), pp. 45–48.

10. Corrado Belci, *ll libro della bora* (Trieste: LINT-Editoriale Associati, 2003), p. 66.

11. $54.4 million in today's figures.

12. Bernard Michel, *Banques et banquiers en Autriche au début du XX^e siècle* (Paris: Presses de la Fondation Nationale des Sciences Politiques, 1976), p. 129.

13. In the words of George Mosse, cited in Paul Reitter, *The Anti-Journalist: Karl Kraus and Jewish Self-Fashioning in Fin-de-Siècle Europe* (Chicago: University of Chicago Press, 2008), p. 7.

14. Michel, *Banques et banquiers,* p. 315.

15. Stefan Zweig, *Le Monde d'hier* (Paris: Belfond, 1982), pp. 125, 143–45.

16. Thus, the two local banks, the Banca Commerciale Triestina (founded in 1859) and the Banca Popolare Triestina (founded in 1868), fell under the control of Viennese banks. In November 1904, the Wiener Bankverein took over the Banca Commerciale Triestina, the last independent institution in the city, under very favorable conditions (30 percent of the capital, 45 percent of the profits). As for the Banca Popolare Triestina, it was forced to close its doors in September 1910. See Anna Millo, *Trieste, le Assicurazioni, l'Europa, Arnaldo Frigessi di Rattalma e la RAS* (Milan: Franco Angeli, Saggi di Storia, 2004), p. 246.

17. The Blum family included Julius Blum-Pacha, who became undersecretary of state for finance of the Egyptian government. See Michel, *Banques et banquiers,*

p. 320, and Archivio di Stato di Trieste, *Imperial Regia Luogotenenze del Litorale-Atti presidiali,* busta 207, 1/24.

18. "To my dear little lion."
19. Letter from Carlo L. Blum Gentilomo to Piero Kern, March 27, 2003, archives of Annie Cohen-Solal.
20. Giulio Sapelli, *Trieste Italiana: Mito e destino economico,* (Milan: Franco Angeli, 1990), p. 27.
21. The project guaranteed the port of Trieste a key trade position, thanks to a very advantageous system of protective rates that would last until 1915. When the ordinary price of transporting a load of cotton by rail from Vienna to Trieste rose to 973 crowns, the Adriatic tariff remained at 200 crowns; for glass, it was 95 crowns instead of 336. There were clauses for returning goods; storage was not allowed for more than six months. Under such conditions, huge world markets such as coffee and sugar grew exponentially, and after the Triestine banks, the Triestine industries in turn fell under the control of Viennese investment. See Elio Apih, *Trieste* (Rome: editori Laterza, 1988), p. 68.
22. Almerigo Appolonio, *Dagli Asburgo a Mussolini: Venezia Giulia 1918–1922* (Gorizia: Istituto Regionale per la Cultura Istriana, 2001), p. 139.
23. Apih, *Trieste,* pp. 68–69.
24. Ibid., p. 67.
25. Ibid., p. 87.
26. Ibid. p. 81.
27. Michel, *Banques et banquiers,* pp. 70–76.
28. *L'Osservatore Triestino,* July 2, 1914.
29. Bazlen, *Scritti,* p. 250.

5. IN THE HIETZING BUBBLE, VIENNA, WORLD WAR I

1. Stefan Zweig, *Le monde d'hier* (Paris: Belfond, 1982), p. 260.
2. Arthur Schnitzler, *Tagebuch, 1913–1916* (Vienna: Verlag der Österreichischen Akademie der Wissenschafter, 1983), p. 123.
3. Zweig, *Le Monde d'hier,* pp. 256–58.
4. Christa Hämmerle, *Kindheit im Ersten Weltkrieg* (Vienna, Cologne, Weimar: Böhlau Verlag, 1993), p. 248.
5. Oskar Kokoschka, *Mirages du Passé* (Paris: Gallimard, 1966), p. 31.
6. Schnitzler, *Tagebuch,* p. 128.
7. Zweig, *Le Monde d'hier,* pp. 264–67.
8. Dr. George Crane, interview with the author, San Francisco, November 2005.
9. Schnitzler, *Tagebuch,* p. 311.
10. Ulrich Weinzierl, *Hofmannsthal: Skizzen zu einem Bild* (Vienna: Paul Zsolnay Verlag, 2005).

11. Christoph Graf von Schwerin, *Als Sei Nichts Gewesen: Erinnerungen* (Berlin: Das Neue Berlin, 1997), p. 344.

12. Ann Hindry, ed., *Claude Berri rencontre Leo Castelli* (Paris: Renn, 1990), p. 14.

13. Ibid., p. 14.

14. Hämmerle, *Kindheit im Ersten Weltkrieg,* p. 46.

15. Schnitzler, *Tagebuch,* p. 276.

16. Dr. George Crane, interview with the author, San Francisco, November 29 and 30, 2005.

17. Hämmerle, *Kindheit im Ersten Weltkrieg,* p. 46. Ludwig Uhland, "Der gut Kamerad" ("The Good Comrade"): "I once had a comrade, / you won't find a better one. / The drum rolled for battle, / he marched at my side / in the same pace and stride. / / A bullet came flying / for him or for me? / It tore him away, / he lay at my feet / like a piece of me. / / He stretched out his hand / while I loaded my gun. / I can't give you my hand— / you rest eternally / my good comrade!"

18. Maureen Healy, "Mobilizing Austria's Children for Total War," in *Vienna and the Fall of the Habsburg Empire : Total War and Everyday Life in World War I* (Cambridge: Cambridge University Press, 2004), pp. 211–57.

19. *Der Brief Sr. Majestät unseres allerdignädigsten Kaisers Franz Joseph I. an die Kinder in Weltkriege, 1914–1915,* quoted in Hämmerle, *Kindheit.*

20. Ibid., pp. 334–35.

21. "Den Waisen von Konopischt," *Neue Freie Presse,* June 30, 1914.

22. "Peter, du blöder": "Peter, my old pal, with your two children / We're going to tear you to shreds!" "Heil Wien!": "Hello Vienna! Hello Berlin! In two weeks / We will be in St. Petersburg!"

23. Piero Kern, interview by the author, Trieste, May 2, 2005.

24. Hämmerle, *Kindheit im Ersten Weltkrieg,* p. 248. *Katzelmacher* is an undesirable foreigner, literally a man who behaves like an unneutered tomcat, fathering many kittens.

25. Stefan Zweig, *Le monde d'hier,* p. 290.

26. Bernhard Denscher, *Gold gab ich für Eisen: Österreichische Kriegsplakate 1914–1918* (Vienna: Jugen & Volk, 1987).

27. Hämmerle, *Kindheit im Ersten Weltkrieg,* p. 81.

28. Ibid., p. 248.

29. Ibid., p. 81.

30. *Die Fackel,* no. 404 (1914), p. 1. See also a fascinating study of Karl Kraus by Paul Reitter, Leo Castelli's great-nephew: *The Anti-Journalist: Karl Kraus and the Jewish Self-Fashioning in Fin-de-Siècle Europe* (Chicago: University of Chicago Press, 2008).

31. "In dieser grossen Zeit," *Die Fackel,* no. 414, p. 18.

32. Act I, scene 9.

33. Jean-Louis Guillemin, *Egon Schiele, Narcisse écorché* (Paris: Gallimard, Découvertes, 2005), p. 107.

34. "Even if I cannot bear arms / I can help fight the enemy."
35. Schnitzler, *Tagebuch,* p. 333.
36. Stefan Zweig, *Le monde d'hier,* pp. 334–35.
37. Hämmerle, *Kindheit im Ersten Weltkrieg,* p. 81.
38. Ibid., p. 248.
39. Ibid., p. 255–56.
40. Ibid. pp. 255–56: "My beautiful, my sacred Wienerwald, you can see by looking at you that the people of Vienna were cold."
41. Dr. George Crane, interview by the author, San Francisco, November 29 and 30, 2005.
42. Piero Kern, interview by the author, Trieste, May 2, 2005.
43. Stefan Zweig, *Le monde d'hier,* p. 330.
44. Guillemin, Egon Schiele, p. 115.
45. Robert Pincus-Witten, *Leo Castelli: Gentle Snapshots* (Zurich: Bruno Bischofberger, 1982), pp. 13–14.
46. Arthur Schnitzler, *Der Weg ins Freie* (Heidelberg: C. Winter, 1989).

6. A FAKE MOUSTACHE FOR THE EMPEROR

1. Anna Fano, *Giorgio e io* (Venice: Marsilio, 2005), p. 71.
2. Ibid., pp. 69–71.
3. *Trieste, Cent'anni di storia,* vol. 2 (1915–1922) (Trieste: Publisport, 1998), pp. 208–10.
4. *Neue Freie Presse,* November 2, 1918; see Angelo Ara and Claudio Magris, *Trieste: un'identità di frontiera* (Turin: Einaudi, 1982), p. 109.
5. As well as the Soc. An. Triestina di Commercio Afenduli, the Soc. An. Triestina per l'Industria Meccanica, the Soc. Finanziaria Cosulich, the Soc. Industriale dell'Olio Weiss. *Archivio Storico di Banca Intesa, patrimonio Banca Commerciale Italiana (ASI-BCI),* Direzione Centrale della BCI. Carte di singoli Direttori Centrali (DC,d), Carte di Giovanni Malagodi (DC, Malagodi), cart. 5, fasc. "Krausz Ernesto."
6. Dr. George Crane, interview by the author, San Francisco, November 29 and 30, 2005.
7. See directory of Liceo Dante, Trieste, p. 82.
8. "In this place his students wanted to celebrate his memory as the first among Italian prophets."
9. Archives of Liceo Dante, Trieste, thanks to Augusto Debernardi.
10. Dr. George Crane, interview by the author, San Francisco, November 29 and 30, 2005.
11. Renzo Cigoi, *Quatrocente domande a un vecchio ebreo triestino, colloqui con Giorgio Voghera* (Rome: Semar, 1996), pp. 181–83.

12. Piero Kern, interview by the author, Trieste, May 2, 2005.

13. Ann Hindry, ed., *Claude Berri rencontre Leo Castelli* (Paris: Renn, 1990), p. 15.

14. Hindry, ed., *Claude Berri rencontre Leo Castelli*, p. 14.

15. Dr. George Crane, correspondence with Annie Cohen-Solal, March 7, 2007.

16. Piero Kern, interview by the author, Trieste, August 20, 2005.

17. Dr. George Crane, correspondence with Annie Cohen-Solal, March 7, 2007.

18. Piero Kern, *Ricordi per Leo* (unpublished memoirs), s.d.

19. Dr. George Crane, interview by the author, San Francisco, November 29 and 30, 2005.

20. Hindry, ed., *Claude Berri rencontre Leo Castelli*, p. 13.

21. Ibid., p. 14.

22. Dr. George Crane, interview by the author, San Francisco, November 29 and 30, 2005.

23. Ibid.

24. Fano, *Giorgio e io*, pp. 75–79, 81–96.

7. THE IRREPRESSIBLE RISE OF ERNESTO KRAUSZ

1. "Who will own Fiume? We will! Who will own Fiume? We will! Who will own Fiume? We will!"

2. *Vedette fiumane: l'occupazione vista e vissuta da Madeleine Witherspoon Dent Gori-Montanelli, crocerossina americana, e da Francesco Gori-Montanelli capo del Genio e del Reparto fotografico, a cura di Jeffrey T. Schnapp* (Venice: Marsilio, 2000), pp. 41–42.

3. Letter of Ernesto Krausz to Oscar Cosulich, Trieste, September 22, 1922, Archivio Brocchi, fasc. 40, Archivio di Stato di Trieste, thanks to Maria Carla Triadan and Dr. Pierpaolo Dorsi, Senior Archivist.

4. The "clearing system" is the part of the operation that reconciles debit and credit daily.

5. Anna Millo, *Giorgio e io* (Venice: Marsilo, 2005), p. 93, and Antonio Confaloniere, *Banche miste e grande industria in Italia (1914–1933)*, vol. 1 (Milan: BCI, 1994–1997), p. 629.

6. For the entire paragraph, see Almerigo Apollonio, *Dagli Asburgo a Mussolini: Venezia Giulia 1918–1922* (Gorizia: Istituto Regionale per la Cultura Istriana), pp. 135–44.

7. Giulio Sapelli, *Trieste Italiana: Mito e destino economico* (Milan: Franco Angeli, 1990), p. 31.

8. Ibid., p. 31.

9. Ibid., p. 213.

10. Archivio Brocchi, fasc. 100, Archives of the city of Trieste.

11. Aldo Oberdorfer, *Il socialismo del doppoguerra a Trieste* (Firenze, 1922), pp. 93–93.

12. Srečko Kosovel, "Uno è l'orrore," *Il mio canto, Moj pesem* (Trieste: It Ramo d'Oro Editore, 2002), p. 12.
13. Licio Bossi, ed. *Trieste 1900–1999: Cent'anni di storia,* vol. 2 (1915–1922) (Trieste: Publisport, 1998), pp. 198–99.
14. Milza, Pierre. *Mussolini.* (Paris: Fayard, 1999), pp. 242–55.
15. Ibid.
16. Milza, *Mussolini,* pp. 360–66.
17. *Il Piccolo,* November 27, 1925.
18. *Il Piccolo,* December 1, 1925, and Archivio Storico di Banca Intesa, patrimonio Banca Commerciale Italiana (ASI-BCI), Banca Commerciale Triestina (BCT), cart. 2, fasc. 2, "Confederazione Generale Bancaria Fascista; 1925–1929, limitatamente ad alcuni giornali quotidiani, e a due stampati della Banca Commerciale Triestina; thanks to Albert Gottarelli, Roberto Confalonieri, and Dr. Francesca Pino.
19. Dr. George Crane, interview by the author, San Francisco, November 29 and 30, 2005.
20. Ann Hindry, ed., *Claude Berri rencontre Leo Castelli* (Paris: Renn, 1990), p. 15.
21. Angelo Ara and Claudio Magris, *Trieste: Un'identità di frontiera* (Turin: Einaudi, 1982), pp. 71–74.
22. James Joyce to Frank Budgen, Trieste, January 3, 1920, *Oeuvres complètes,* vol. 2, (Paris: Pléiade, 1982), p. 893.
23. James Joyce to Stanislaus Joyce, Paris, March 20, 1922, ibid., p. 962.

8. TURNING TWENTY UNDER FASCISM

1. "We are the eternal youth / That conquers the future / Armed with iron thought. / We will march where Il Duce wants / Through the paths of the New Empire / Which stretch along the sea, / Where Rome once called." Quoted in Alexander Stille, *Benevolence and Betrayal: Five Jewish Families under Fascism* (New York: Summit Books, 1991), p. 44.
2. See Pierre Milza and Serge Berstein, *Le fascisme italien 1919–145* (Paris: Editions du Seuil, 1980), p. 195.
3. Stille, *Benevolence and Betrayal,* p. 98.
4. Renzo De Felice, *Storia degli ebrei italiani sotto il fascismo* (Milan: Einaudi, 1987), p. 78, and Marie-Anne Matard-Bonucci, *L'Italie fasciste et la persécution des juifs* (Paris: Perrin, 2007).
5. Dr. George Crane, interview by the author, San Francisco, November 29 and 30, 2005.
6. Leo Castelli, interview by Andrew Cummings, Archives of American Art, Washington, D.C., May 14, 1969.
7. Stille, *Benevolence and Betrayal,* p. 98.

8. *Trieste 1900–1999: Cent'anni di storia,* vol. 3 (1923–1930) (Trieste: Publisport, 1998), p. 165.

9. See R. J. B. Bosworth, *Mussolini's Italy: Life Under the Fascist Dictatorship, 1915–1945* (New York: Penguin, 2006), pp. 154–58.

10. *Il Piccolo* (October 2, 1926), in *Trieste 1900–1999,* vol. 3, p. 128.

11. Ibid., p. 122.

12. Leo Castelli, interview by Andrew Cummings, AAA.

13. "Vingt jours d'escalade sur les Dolomites," *Alpi Giulie,* Trieste section of the Italian Alpine Club, Gruppo Rocciatori e Sciatori dell'Alpina delle Giulie, 31st Year, July 1930, no. 2, p. 337. My thanks to Renzo Zambonelli and Augusto Debernardi.

14. Leo Castelli, interview by Andrew Cummings, AAA.

15. Giovanno Ferro, *Milano capitale dell'antifascismo* (Milan: Mursia, 1985), p. 80.

16. Dr. George Crane, interview by author, San Francisco, November 29 and 30, 2005.

17. See *Trieste 1900–1999,* vol. 3, pp. 74–75.

18. Amerigo Apollonio, *Venezia-Giulia e fascismo, 1922–1935: Una società post-absburgica negli anni del consolidemento della dittatura mussoliniana* (Gorizia: Istituto Regionale Culturale Istriana, Libreria Editrice Gorgiana, 2001), pp. 221–31, and "La Cassa di Risparmio a Trieste fra il 1918 e il 1945," in *La Cassa di Risparmio di Trieste 1842–2002* (Rome: Laterza, 2004), pp. 147–89: See also: Antonio Confalonieri, *Banche miste e grande industria in Italia 1914–1933,* vol. 1 (Milan: Banca Commerciale Italiana, 1994–97), pp. 376–8, and Alfredo d'Amore, *Gli ultimi anni della Banca Commerciale Triestina,* Universita Cattolica del Sacro Cuore, Milano, Facolta di Economia e Commercio, anno Accademico 1991–1992 (unpublished thesis).

19. Pierre Milza, *Mussolini* (Paris: Fayard, 1999), p. 395.

20. Milza and Berstein, *Le fascisme italien,* p. 233.

21. Giulio Sapelli, *Trieste Italiana: Mito e destino economico* (Milan: Franco Angeli, 1990), p. 36.

22. George Crane, interview by the author, San Francisco, November 29 and 30, 2005.

23. See Apollonio, *Venezia-Giulia e fascismo,* p. 227, and d'Amore, *Gli Ultimi . . .*

24. Ibid.

25. Archivio Storico di Banca Intesa, patrimonio BCI (ASI-BCI), BCT, cart. 5, fasc. 8, sottofasc. 4, "BCT. Personale-riservato Fusione pe incoporazione nella BCI," 1931–1933, limitatamente a tre circolari della BCT (al suo personale) e ad un prospetto; see also the thesis by Alfredo d'Amore, Università Cattolica di Milano.

26. Archivio Storico di Banca Intesa, patrimonio Banca Commerciale Italiana (ASI-BCI), verbali del Consiglio di Amministrazione della BCI (UCA, vol. 13, fogli 152–60).

27. Ibid.

28. Angelo Ara and Claudio Magris, *Trieste: Un'identità di frontiera* (Turin: Einaudi, 1982), p. 130.

29. Apollonio, *Venezia-Giulia e fascismo,* pp. 131–32.

30. Leo Castelli, interview by Paul Cummings, AAA, New York, May 14, 1969.

31. Ibid.

32. Leo Krausz file, Assicurazioni Generali.

33. Letter of January 9, 1931, archives of the Assicurazioni Generali.

34. Letter of June 15, 1931, archives of the Assicurazioni Generali.

35. Leo Castelli, interview by Paul Cummings, AAA, New York, May 14, 1969.

9. BUCHAREST: FIRST BRUSH WITH THE AVANT-GARDE

1. Paul Morand, *Bucarest* (Paris: Plon, 1965), p. 291.

2. The title means "the procrustean bed." Camil Petrescu, *Patul lui Procust* (Bucharest, 1933).

3. Ioana Vlasiu, "Bucharest," in Timothy O. Benson, *Central European Avant-Gardes: Exchange and Transformation 1910–1930* (Cambridge, Mass.: MIT Press, 2002), pp. 248–54.

4. Ibid.

5. Luminita Machedon and Ernie Scoffham, *Romanian Modernism: The Architecture of Bucharest, 1920–1940* (Cambridge, Mass.: MIT Press, 1999), p. 33.

6. Sasha Pana, quoted in Vlasiu, "Bucharest," p. 251.

7. In 1928: ibid.

8. Steven A. Mansbech, *Modern Art in Eastern Europe: From the Baltic to the Balkans,* (Cambridge: Cambridge UP, 1999), n. 50, p. 260. See also *!Avant garden! in Mitteleuropa 1910–1930, Transformation und Austausch,* Timothy O. Benson and Monika Król, eds. (Leipzig: E. A. Seemann, 2002).

9. Louis Aragon, "Projet d'histoire littéraire contemporaine" (1923), in *Digraphe* (Paris: Gallimard, 1994); see also François Buot, *Tristan Tzara, l'homme qui inventa la Révolution Dada* (Paris: Grasset, forthcoming).

10. Leo Castelli, interview by Paul Cummings, New York, May 14, 1969. Archives of American Art, Washington, D.C.

11. Mariève Rugo, unpublished memoirs.

12. Ibid.

13. Countess Waldeck, *Athenee Palace Bucharest* (London: Robert M. McBride, 1942).

14. Rugo, unpublished memoirs.

15. Ileana Sonnabend, interview by the author, New York, November 25, 2005.

16. Dr. George Crane, interview by the author, San Francisco, November 29 and 30, 2005.

17. Ibid.

18. Ileana Sonnabend, interview by the author, New York, November 25, 2005, and 2006.

19. Leo Castelli, interview by Paul Cummings, AAA.

20. *Banca Commerciale Italiana,* Archivio Storico BCI, p. XXII.

10. FROM NEUILLY TO PLACE VENDÔME

1. Mercier, *Tableau de Paris,* quoted in Eric Hazan, *L'invention de Paris, Il n'y a pas de pas perdus* (Paris: Seuil, 2002), p. 30.

2. Paul Valéry, "Discours de l'Histoire" (July 13, 1932), in *Oeuvres,* vol. 1 (Paris: Gallimard, 1957), p. 1136.

3. Daniel-Henry Kahnweiler with Francis Crémieux, *My Galleries and Painters,* trans. Helen Weaver (Boston: MFA Publications, 2003), pp. 103–4.

4. Jacques Marseille, quoted in Danielle Tartakowsky, *Le front populaire, la vie est à nous* (Paris: Gallimard, 1996), p. 16.

5. Pierre Girard, "Le goût du ministre," in *Le front populaire et l'art, hommage à Jean Zay* (Orléans: Musée des Beaux Arts, 1995), pp. 67–72.

6. Annie Cohen-Solal, *Sartre 1905–1980* (Paris: Gallimard, 1985), p. 214.

7. Michel Giroud, "Le mouvement des revues d'avant-garde," in *Paris-Paris, 1937– 1957* (Paris: Centre Georges Pompidou, and Gallimard, 1992), pp. 261–69.

8. Ghislaine Wood, "Making 'the Fantastic Real,' " in *Surreal Things: Surrealism and Design* (London: Victoria and Albert Museum, 2007), pp. 2–15.

9. Ileana Sonnabend, interview by the author, New York, November 25, 2005.

10. Dilys Blum, "Fashion and Surrealism," in *Surreal Things,* pp. 139–59.

11. Archives of the city of Trieste.

12. Dr. George Crane, interview by the author, San Francisco, November 29 and 30, 2005.

13. Archivio Storico di Banca Intesa, patrimonio Banca Commerciale Italiana (ASI-BCI), Direzione Centrale della BCI. Carte di singoli Direttori Centrali (DC,d), Carte di Giovanni Malagodi (DC, Malagodi), cart. 5, fasc. "Krausz Ernesto."

14. Ibid.

15. Archivio Storico di Banca Intesa, patrimonio Banca Commerciale Italiana (ASI-BCI), Servizio Estero della BCI. Segretaria (ES,s) cart. 42, fasc. 1.

16. In other words, the Riunione Adriatica di Sicurtà, one of Trieste's two largest insurance companies.

17. Archives of the Banca Commerciale Italiana, Milan.

18. Ileanna Sonnabend, interview by the author, New York, November 25, 2005.

19. Ibid.

20. Piero Kern, interview by the author, Trieste, May 2, 2005.

21. Leo Castelli, interview by Paul Cummings, Archives of American Art, Washington, D.C.

22. Ileana Sonnabend, interview by the author, New York, November 25, 2006.

23. Marcel Zahar, "Galerie Drouin," *The Studio* 118 (October 1939): 179–80.

24. "From the Paris Openings," *Harper's Bazaar* (September 1, 1939): 64–67.

11. DRAMATIC AND PERILOUS, AN EXODUS TO THE UNITED STATES

1. Claude Lévi-Strauss, *Tristes Tropiques*, trans. John and Doreen Weightman (New York: Atheneum, 1974), pp. 24–25.

2. Paul Nizan, *Russie d'aujourd'hui* (August 1935).

3. Paul Nizan, *Ce Soir*, November 3, 1938.

4. Ileana Sonnabend, interview by the author, New York, November 25, 2005.

5. Jean-Paul Sartre, *Carnets de la drôle de guerre* (Paris: Gallimard, 1996), pp. 235–36.

6. Annie Cohen-Solal, *Paul Nizan, communiste impossible* (Paris: Grasset, 1980), p. 254.

7. Gérard Loiseaux, *La littérature de la défaite et de la collaboration* (Paris: La Sorbonne, 1984).

8. Ernst Jünger, *Premier journal parisien, 1941–1943* (Paris: Christian Bourgois, 1980), p. 15.

9. Account of Mariève Rugo, unpublished memoirs.

10. Ibid.

11. Ann Hindry, ed., *Claude Berri rencontre Leo Castelli* (Paris: Renn, 1990), pp. 19–20.

12. Jean-Claude Drouin, interview by the author, Tours, December 22, 2005.

13. Robert O. Paxton, *Vichy France* (rev. ed.; New York: Columbia University Press, 2001), p. 45.

14. Ibid., p. 51.

15. Ileana Sonnabend, interview with author, New York, November 25, 2005.

16. Bernard Noël, *Marseille–New York 1940–1945: Une liaison surréaliste* (Marseille: André Dimanche, 1985), pp. 14–22.

17. Agnes Angliviel de la Beaumelle, "La dispersion des Surréalistes: Marseille," in *Paris-Paris 1937–1957* (Paris: Centre Georges Pompidou and Gallimard, 1992), p. 32.

18. Noël, *Marseille–New York*, pp. 25–26.

19. Anna Seghers, *Transit*, trans. James A. Galston (Boston: Little, Brown, 1944), pp. 72, 43, 55–56.

20. Noël, *Marseille–New York*, p. 12.

21. Seghers, *Transit*, pp. 167–68.

22. Christa Wolf, "Postface," in Seghers, *Transit*, pp. 362–63.

23. Ileana Sonnabend, interview by the author, New York, November 12, 2005.

24. Nina Sundell, interview by the author, New York, February 7, 2006.

25. Hindry, ed., *Claude Berri rencontre Leo Castelli*, pp. 19–20.

26. Ibid., pp. 19–20.

27. Leo Castelli, interview by the author, November 24, 1991.

28. Noël, *Marseille–New York*, pp. 56–57.

29. Nina Sundell, interview by the author, New York, February 7, 2006.

30. Nina Sundell, interview by the author, New York, November 12, 2005.

31. Museum of Modern Art Archives, Early Museum History, Box 10/22f.

32. The painting was briefly exhibited in Paris in 1916 at the salon d'Antin in an exhibition organized by André Salmon. Later acquired by the collector Jacques Doucet in 1924 on André Breton's advice, *Les Demoiselles d'Avignon* was among the paintings that Doucet hoped to bequeath to the Louvre, but the work was rejected by the collections committee of the Musées Nationaux, which had dominion over purchases and gifts for the French national museums. On the other hand, the canvas had been noticed in August 1929 by Conger Goodyear, the president of MoMA, who regularly toured the Paris private collections. Three days after his visit, Goodyear thanked Doucet and added, "I hope one day we'll have the pleasure of seeing you in America, where perhaps we could mount an exhibition under your direction that will demonstrate as never before the possibility of reconciling the beautiful with the modern." Several years after Jacques Doucet's death, in the summer of 1935, Alfred Barr went to Paris to borrow works for his show Cubism and Abstract Art, which would open the following year. He met with Mme Doucet, but she refused to lend the *Demoiselles*. Then, in September 1937, Mme Doucet decided to sell a lot of five Picasso paintings, including *Les Demoiselles d'Avignon,* to the New York dealer Jacques Seligmann, who paid 150,000 francs for the work. *Les Demoiselles d'Avignon* left France via Le Havre on October 9, 1937, on board *La Normandie.*

33. See Hélène Seckel, "Eléments pour une Chronologie de l'histoire des Demoiselles d'Avignon," in *Les Demoiselles d'Avignon, Guide de l'Exposition,* vol. 1 (Paris: Musée Picasso, Paris, 1988).

34. Dolorès Vanetti, interview by the author, New York, January 27, 1996.

35. "Jackson Pollock: An Artist's Symposium, Part 1," *ARTnews* (April 1967): 29, quoted in Dore Ashton, "The City and the Visual Arts," in Leonard Wallock, ed., *New York, Culture Capital of the World 1940–1965* (New York: Rizzoli, 1988), pp. 123–55.

36. Ibid.

37. Julien Levy, *Memoir of an Art Gallery* (New York: Putnam, 1977).

38. Leo Castelli, interview by Paul Cummings, New York, May 14, 1969. Archives of American Art, Washington, D.C.

39. Ibid., AAA.

40. Hindry, ed., *Claude Berri rencontre Leo Castelli,* pp. 21–23.

41. Nina Sundell, interview by the author, New York, February 7, 2006.

12. BUCHAREST REDUX: FIRST FROST OF THE COLD WAR

1. Paul Morand, *Bucarest* (Paris: Plon, 1965), p. 291.

2. Robert Reitter, interviews with the author, New York, January 5, 2006, and November 11, 2007.

3. Archives of Robert Reitter.

4. See Robert Reitter, *Yellow Star* (2004), and interviews with the author, New York, November 11 and 18, 2007.

5. Kristztian Ungvary, *The Siege of Budapest: 100 Days in World War II* (New Haven and London: Yale University Press, 2002).

6. Reitter, *Yellow Star.*

7. Ibid.

8. Files discovered by Drs. Lazslo Karzai and Judith Molar in the Municipal Archives of Pécs, Baranya County, 5808/1941.

9. Morand, *Bucarest,* p. 291.

10. Guillaume Apollinaire, *Les onze mille verges* (Paris: Régine Desforges, 1970).

11. Robert Reitter, interview by the author, New York, January 5, 2006.

12. Lynn Etheridge Davis, *The Cold War Begins: Soviet-American Conflict over Eastern Europe* (Princeton, N.J.: Princeton University Press, 1974), pp. 256–66.

13. W. Averell Harriman and Elie Abel, *Special Envoy to Churchill and Stalin 1941–1946* (New York: Random House, 1975), p. 529.

14. Joseph M. Siracusa, "The Night Stalin and Churchill Divided Europe: The View from Washington," *The Review of Politics* 43, no. 3 (July 1981): 381–409.

15. Cortland V. R. Schuyler, "The View from Romania," in Thomas Hammond, ed., *Witnesses to the Origins of the Cold War* (Seattle and London: University of Washington Press, 1982), pp. 123–60.

16. Hammond, *Witnesses,* p. 287. See also John Lewis Gaddis, *The United States and the Origins of the Cold War 1941–1947* (New York: Columbia University Press, 1972); Paul D. Quinlan, *Clash over Romania: British and American Policies towards Romania 1938–1947* (Los Angeles: American Romanian Academy of Arts and Sciences, 1977); Liliana Saiu, *The Great Powers and Romania 1944–1946* (New York: Columbia University Press, East European Monographs, 1992); Eduard Mark, "The OSS in Romania 1944–1946," *Intelligence and National Security* 9, no. 2 (April 1944): 320–44; Tim Weiner, *Legacy of Ashes: The History of the CIA* (New York: Doubleday, 2007).

17. Harry S. Truman, *Memoirs* (New York: Doubleday, 1955), p. 253.

18. *Les Temps Modernes* (September 1, 1945).

19. On May 24, 1945, Janet Flanner, *Paris Journal* (New York: Harcourt, Brace, Jovanovich, 1988), pp. 30–31.

13. PLAYING HOOKY AT MoMA

1. Nina Sundell, interview by the author, New York, February 7, 2006.

2. Ibid.

3. Mariève Rugo, unpublished memoirs.

4. Ann Hindry, ed., *Claude Berri rencontre Leo Castelli* (Paris: Renn, 1990), p. 22.

5. Interview with Sharon Zane, October 24, 1991, Oral History Project, Museum of Modern Art Archives, New York.

6. Leo Castelli, interview by the author, New York, November 5, 1995.

7. Leo Castelli, interview by the author, New York, October 24, 1991.

8. "Dutch Letter," *The Arts* (January 1928).

9. See Irving Sandler, ed., *Defining Modern Art: Selected Writings of Alfred H. Barr, Jr.* (New York: Harry N. Abrams, 1986), pp. 69–76.

10. Lloyd Goodrich, "A Museum of Modern Art," *The Nation* (December 4, 1929): 665.

11. Nicolas Calas to Alfred Barr, January 27, 1941, Museum of Modern Art Archives, Nicolas Calas Papers, Box 11, File 9.

12. Samuel Kootz, "Bombshell Clarified: Mr. Kootz Elaborates His Point of View, Pointing Up Issues in the Controversy," *New York Times,* October 5, 1941, page X9.

13. Ibid.

14. Martica Sawin, *Surrealism in Exile and the Beginning of the New York School* (Cambridge, Mass.: MIT Press, 1995).

15. Dickran Tashjian, *A Boatload of Madmen: Surrealism and the American Avant-Garde* (New York: Thames and Hudson, 1995).

16. See especially Serge Guilbaut, *Comment New York a 'volé' l'art moderne à Paris* (Paris: Jacqueline Chambon, 1987); however, this kind of purely ideological and geopolitical analysis neglects the fact that the artist is also shaped by his social context.

17. Leo Castelli, interview by the author, New York, November 5, 1995.

18. Leo Castelli, interview by Barbara Rose, New York, July 1969, Archives of American Art, Washington, D.C.

19. Leo Castelli, interview by Paul Cummings, New York, May 22, 1969, Archives of American Art, Washington, D.C.

20. Ibid.

21. Ibid.

22. Ibid.

23. Hindry, ed., *Claude Berri rencontre Leo Castelli,* p. 83.

24. Leo Castelli, interview by the author, New York, November 5, 1995.

25. Hindry, ed., *Claude Berri rencontre Leo Castelli,* p. 83.

26. Leo Castelli, interview by Jeffrey Potter, New York, October 21, 1982, Pollock-Krasner House and Study Center, Springs, New York.

27. Leo Castelli, interview by Paul Cummings, AAA.

28. Ibid.

29. Leo Castelli and Nina Sundell, interviews by Andrew Decker, New York, May 22 and September 2, 1997, Archives of American Art, Washington, D.C.

30. Hindry, ed., *Claude Berri rencontre Leo Castelli,* p. 82.

14. *PASSEUR* TO THE NEW WORLD

1. Leo Castelli, interview by Andrew Decker, New York, Archives of American Art, Washington, D.C., May 22, 1997.
2. Christian Derouet, "Kandinsky in Paris 1934–1944," in *Kandinsky in Paris, 1934–1944* (New York: Solomon R. Guggenheim Museum, 1985), p. 59.
3. Letter to Hilla Rebay, May 2, 1949, in Joan M. Lukach, *Hilla Rebay: In Search of the Spirit in Art* (New York: George Braziller, 1983), p. 259.
4. Ann Hindry, ed., *Claude Berri rencontre Leo Castelli* (Paris: Renn, 1990), p. 82.
5. Letter to Hilla Rebay, May 22, 1947, Lukach, *Hilla Rebay,* p. 244.
6. Letter to Hilla Rebay, May 15, 1947, Lukach, *Hilla Rebay,* pp. 242–43.
7. Bibliothèque Kandinsky, Centre Georges Pompidou, Paris, Fonds Kandinsky (hereafter "BK").
8. Derouet, "Kandinsky in Paris," p. 22.
9. BK, November 23, 1947.
10. BK, November 30, 1948.
11. BK, December 13, 1948.
12. BK, February 13, 1949.
13. BK, letters of March 4 and 22 and April 25, 1949.
14. Sidney Janis, interview by Paul Cummings, New York, September 26, 1972, Archives of American Art, Washington, D.C.
15. BK, December 13, 1948.
16. BK, May 23, 1952.
17. BK, n.d.
18. BK, August 21, 1952.
19. BK, December 26, 1952.
20. BK, January 25, 1953.
21. BK, February 16, 1953.
22. BK, November 11, 1955.
23. Thomas M. Messer, "Introduction," in *Wassily Kandinsky 1866–1944 in the Collection of the Solomon R. Guggenheim Museum* (New York: Solomon R. Guggenheim Museum, 1972), pp. 11–12.
24. Sidney Janis, interview by Paul Cummings, AAA.
25. Hindry, ed., *Claude Berri rencontre Leo Castelli,* p. 84.

15. "A TOUCH I AM GLAD NOT TO HAVE"

1. "Paris–New York, New York–Paris" (1941), in Fernand Léger, *Mes Voyages* (Paris: L'Ecole des Lettres, 1997), pp. 55–56; interview in *Les Lettres Françaises* (April 12, 1946).
2. "Seeing the Young New Yorkers," *ARTnews* (May 1950): 23.

3. Clement Greenberg, *The Collected Essays and Criticism, Vol. 1: Perceptions and Judgments 1939–1944,* ed. John O'Brian (Chicago: University of Chicago Press, 1986), p. 133.

4. Ibid., p. 171.

5. "Decline of Cubism," *Partisan Review* 3 (1948): 369.

6. Enzo Di Martino, *La Biennale di Venezia* (Milan: Mondadori, 1995).

7. Sidney Janis, interview by Paul Cummings, New York, September 26, 1972, Archives of American Art, Washington, D.C.

8. Leo Castelli, Daniel Cordier, and Ileana Sonnabend, "Le rôle des galeries," interviewed by Alfred Pacquement, August 1976, in *Paris–New York, 1908–1968* (Paris: Gallimard/Centre Georges Pompidou, 1991), pp. 271–77.

9. Emile de Antonio and Mitch Tuchman, *Painters Painting: A Candid History of the Modern Art Scene, 1940–1970* (New York: Abbeville Press, 1984), p. 90.

10. Feigl, Modern Europeans and Americans: Discoveries; Doris Meltzer, Americans and Europeans: Paintings, Sculpture; Obelisk: Inspired Artists from France and America; Galerie Modern, Contemporary Americans, Contemporary Europeans. See *Artforum* (February 1955).

11. *ARTnews* (May 1950): 47.

12. Lecture at Yale University, January 1946, archives of Annie Cohen-Solal.

13. "Paris-New York," *Art d'aujourd'hui* (March 17, 1951): 4–12.

14. Jacques Lipschitz, interview, 1946, Museum of Modern Art Archives.

15. "The Western Round Table on Modern Art," San Francisco, April 8–10, 1949, in *Modern Artists in America, First series* (New York: Wittenborn Schultz, 1951), pp. 25–38.

16. "Artists' Sessions at Studio 35," New York, April 21–23, 1950, in *Modern Artists in America, First series,* pp. 10–21.

17. "Gorky, de Kooning, Pollock," *ARTnews* (summer 1950).

18. "Pollock Paints a Picture," *ARTnews* (summer 1950).

19. Michel Seuphor, "Paris–New York 1951," *Art d'aujourd'hui* (June 1951).

20. Leo Castelli, interview by the author, November 5, 1995.

21. Seuphor, "Paris–New York 1951."

16. THE RIGHT MAN FOR THE JOB, OR JUST A TANGO DANCER?

1. Leo Castelli, interview by Paul Cummings, New York, May 22, 1969, Archives of American Art, Washington, D.C.

2. Natalie Edgar, *Club Without Walls: Selections from the Journals of Philip Pavia* (New York: Midmarch Arts Press, 2007), pp. 79–80.

3. For a detailed study of the Club, see Bruce Altshuler, whose work I found informative and inspiring, especially "Downtown, Ninth Street Show, New York, May 21–June 10, 1951," in *The Avant-Garde in Exhibition: New Art in the 20th*

Century (New York: Harry N. Abrams, 1994), pp. 156–73; Irving Sandler, *The Triumph of American Painting: A History of Abstract Expressionism* (New York: Harper & Row, 1976), and "The Club: How the Artists of the New York School Found Their First Audience—Themselves," *Artforum* 4 (September 1965): 27–31; Fred W. McDarrah, *The Artist's World in Pictures* (New York: Dutton, 1961). Unless noted otherwise, all interviews are from recordings generously provided by Bruce Altshuler.

4. *Horizon* (1947), cited in Dore Ashton, "The City and the Visual Arts," in *New York: Culture Capital of the World, 1940–1965,* ed. Leonard Wallock (New York: Rizzoli, 1988), p.135.

5. Esteban Vicente, interview by Irving Sandler, Bridgehampton, New York, August 26, 1968, Archives of American Art, Washington, D.C.

6. Ludwig Sander, interview by Paul Cummings, New York, February 4–12, 1969, Archives of American Art, Washington, D.C.

7. Ernestine Lassaw, interview by the author, Springs, New York, February 25, 2006.

8. Archives of Annie Cohen-Solal.

9. Ileana Sonnabend, interview by the author, New York, November 26, 2005. She appears to have combined the names of two of Griffith's films, *Broken Blossoms* and *The Faded Lilies.*

10. Nick Carone, interview by Paul Cummings, New York, May 11–17, 1968, Archives of American Art, Washington, D.C.

11. Adlai E. Stevenson, *Major Campaign Speeches of Adlai E. Stevenson* (New York: Random House, 1953), pp. 126–28.

12. Ernestine Lassaw, interview by the author, Springs, N.Y., February 25, 2006.

13. Esteban Vicente, interview by Irving Sandler, August 26, 1968, AAA.

14. Ibram Lassaw, interview by Irving Sandler, New York, August 26, 1968, Archives of American Art, Washington, D.C.

15. Jack Tworkov, "Notes on My Painting," *Art in America* 61 (September–October 1973): 66–69.

16. Steven Naifeh and Gregory Smith, *Jackson Pollock: An American Saga* (New York: Clarkson Potter, 1989), p. 658.

17. Ibid.

18. Ibid., p. 637.

19. Conrad Marca-Relli, interview by Dorothy Sekler, New York, June 10, 1965, Archives of American Art, Washington, D.C.

20. Esteban Vicente, interview by Irving Sandler, Archives of American Art, Washington, D.C.

21. Conrad Mara-Relli, interview by Dorothy Sekler, New York, June 10, 1965, Archives of American Art, Washington, D.C.

22. Altshuler, "Downtown, Ninth Street Show," p. 161.

23. Hindry, ed., *Claude Berri rencontre Leo Castelli,* p. 85.

24. *ARTnews* (Summer 1950).

25. Ileana Sonnabend, interview by author, New York, November 25, 2005.

17. FROM POLLOCK TO DE KOONING: TOWARDS THE GALLERY OPENING

1. Leo Castelli, interview by Paul Cummings, New York, May 22, 1969, Archives of American Art, Washington, D.C.

2. Robert Reitter, interview by the author, New York, October 12, 2007.

3. Jean-Paul Sartre, "Les animaux malades de la peste," *Libération* (June 22, 1953), reprinted in Michel Contat et Michel Rybalka, *Les Ecrits de Sartre* (Paris: Gallimard, 1970) pp. 704–8.

4. Leo Castelli, interview by Jeffrey Potter, October 21, 1982, Pollock-Krasner Foundation.

5. Ibid.

6. Ibid.

7. Ibid.

8. See Mark Stevens and Annalyn Swan, *De Kooning: An American Master* (New York: Alfred A. Knopf, 2005), p. 185.

9. Ileana Sonnabend, interview by the author, New York, November 25, 2005.

10. Leo Castelli, interview by Jeffrey Potter, October 21, 1982, Pollock-Krasner Foundation.

11. Ileana Sonnabend, interview by the author, New York, November 25, 2005.

12. Ibid.

13. Ibid.

14. Leo Castelli, interview by Paul Cummings, AAA.

15. Museum of Modern Art Archives, Alfred H. Barr, Jr. Papers, Roll 2181.

16. Ibid.

17. Leo Castelli, interview by the authors, New York, November 5, 1995.

18. NEW YORK AS A MAGNET

1. Leo Castelli, interview by the author, New York, November 5, 1995.

2. From "Stones" (with Larry Rivers), Richard J. Gray, *A History of American Literature* (Malden, Mass.: Blackwell, 2004), p. 643.

3. The first panel, on March 7, was titled "A Group of Young Painters" and dealt with Abstract Expressionism. The panelists were Jane Freilicher, Grace Hartigan, Larry Rivers, Al Leslie, Joan Mitchell, and O'Hara—the last the only writer on the panel and, as a poet, less threatening in Pavia's view than a critic. Before this, a debate on Cézanne's relations with Baudelaire and Mallarmé had

sketched out the French tradition in which these interests were inscribed. "You know how / I feel about painters. I sometimes think poetry / only describes," O'Hara wrote at the time. The second panel, on April 11, during which O'Hara retraced the tradition of contemporary poetry, was devoted to the theme of "the image in poetry and painting." That evening, he defined poetry as that "which liberates certain forces in language, permits them to emerge upon the void of silence," in terms much like Thomas Hess's definition of abstract painting. The third panel, on May 14, was titled "New Poets." See Brad Gooch, *City Poet: The Life and Times of Frank O'Hara* (New York: Alfred A. Knopf, 1993), pp. 214–17.

4. "To the Mountains in New York," in *The Collected Poems of Frank O'Hara,* ed. Donald Allen (Berkeley: University of California Press, 1995), pp. 198–99.

5. See Annie Cohen-Solal, *Painting American: The Rise of American Artists, Paris 1867–New York 1948* (New York: Alfred A. Knopf, 2001).

6. "Eakins is not a painter, he is a force," Whitman opined.

7. "To Larry Rivers," *Collected Poems of Frank O'Hara,* p. 128.

8. I. F. Stone, *The Haunted Fifties* (Boston: Little, Brown, 1989), pp. 178–82.

9. Barbara Jakobson, interview by the author, New York, February 4, 2006.

10. Together with her husband, Donald, Harriet Peters was a solid New York collector.

11. Ann Hindry, ed., *Claude Berri rencontre Leo Castelli* (Paris: Renn, 1990), p. 89.

12. Emile de Antonio and Mitch Tuchman, *Painters Painting: A Candid History of the Modern Art Scene, 1940–1970* (New York: Abbeville Press, 1984), pp. 18–19.

13. Ivan Karp, interview by Paul Cummings, New York, March 12, 1969, Archives of American Art, Washington, D.C.

14. Barbara Jakobson, interview by the author, New York, December 13, 2007.

15. Leo Castelli, interview by Paul Cummings, New York, May 22, 1969, Archives of American Art, Washington, D.C.

16. The only exception would be "Yves Klein: Monochromes" in April 1961.

17. Robert Rauschenberg, interview by Dorothy Seckler, New York, December 21, 1965, Archives of American Art, Washington, D.C.

18. The local electricity company.

19. Robert Rauschenberg, interview by Dorothy Seckler, New York, December 21, 1965, Archives of American Art, Washington, D.C.

20. Claude Lévi-Strauss, *The View from Afar,* trans. Joachim Neugroschel and Phoebe Hoss (New York: Basic Books, 1985), pp. 258–59.

21. Ibid., pp. 260, 266–67.

22. de Antonio and Tuchman, *Painters Painting,* pp. 18–19.

23. *Robert Rauschenberg: Man at Work,* BBC/RM Arts in association with the Guggenheim Museum and Ovation; dir. Chris Granlund (Chicago: Home Vision Arts, 1997).

24. Ibid.

25. Ibid.

26. "Foreword," *Artists of the New York School, Second Generation,* exhibition catalogue (New York: Jewish Museum of the Jewish Theological Seminary of America, 1957).

27. "Introduction," *Artists of the New York School,* pp. 4–8.

28. Jasper Johns, interview by the author, Sharon, Conn., April 28, 2008.

29. Ibid.

30. Ileana Sonnabend, interview by the author, New York, October 24, 1991.

31. Hindry, ed., *Claude Berri rencontre Leo Castelli,* p. 90.

32. Ileana Sonnabend, interview by the author, Cortona, August 14, 2005.

33. Ileana Sonnabend, interview by the author, New York, November 25, 2005.

19. TRIAL SHOT AND MASTERSTROKE: THE JASPER EPIPHANY

1. Jasper Johns, interview by Sharon Zane, August 23, 1991, Oral History, Museum of Modern Art Archives.

2. Castelli Gallery Papers, Archives of American Art, Washington, D.C.

3. Leo Steinberg, *Other Criteria: Confrontations with 20th Century Art* (Chicago: University of Chicago Press, 2007), pp. 19, 21–22.

4. Robert Rosenblum, "Month in Review," *Arts* (January 1958): p. 55.

5. Fairfield Porter, *ARTnews* (January 1958): p. 20.

6. Leo Steinberg, interview by the author, New York, January 10, 2008.

7. Jasper Johns, interview by Sharon Zane, August 23, 1991, Oral History, Museum of Modern Art Archives.

8. Jasper Johns, interview by the author, Sharon, Conn., April 28, 2008.

9. Alfred Barr to Jasper Johns, August 27, 1959, quoted in Michael Crichton, *Jasper Johns* (New York: H. N. Abrams/The Whitney Museum of American Art, 1994), pp. 67–68.

10. Raymonde Moulin, *L'artiste, l'institution et le marché* (Paris: Flammarion, 1992), p. 50.

11. Leo Castelli, interview by Milton Esterow, *ARTnews* (April 1991), pp. 73–77.

12. "What Appears to Be Yours," in Frank O'Hara, *Poems from the Tibor de Nagy Editions, 1952–1966* (New York: Tibor de Nagy Editions, 2006), p. 68.

13. Ileana Sonnabend, interview by the author, New York, November 25, 2005.

14. Letter to Hilton Kramer, *Arts* (May 1958), quoted in Leo Steinberg, *Encounters with Rauschenberg* (Chicago: University of Chicago Press, 2000), p. 6.

15. Internal correspondence, Painting and Sculpture Center, Museum of Modern Art Archives.

16. Nina Sundell, interview by the author, New York, February 2006.

17. Archives of Robert Pincus-Witten as reported to the author.

18. Ivan Karp, interview by the author, New York, April 19, 2007.

19. Ileana Sonnabend, interview by the author, New York, February 27, 2006.

20. Betsy Baker, interview by the author, New York, January 26, 2009.

21. Leo Steinberg, interview by the author, New York, January 10, 2008.

20. A WHIRLWIND OF INVENTION: "DISCOVER A GENIUS A WEEK!"

1. Leo Steinberg, interview by the author, New York, January 10, 2008.

2. The expression comes from Raymonde Moulin, *L'artiste, l'institution et le marché* (Paris: Flammarion, 1992), p. 49.

3. Emile de Antonio and Mitch Tuchman, *Painters Painting: A Candid History of the Modern Art Scene, 1940–1970* (New York: Abbeville Press, 1984), p. 34.

4. Bil Ehrlich, interview by the author, New York, February 6, 2009.

5. Donald Marron, interview by the author, New York, January 28, 2008.

6. Ivan Karp, interview with the author, New York, April 19, 2007.

7. Wynn Kramarsky, interview by the author, New York, February 3, 2009.

8. Ivan Karp, interview by Paul Cummings, New York, March 12, 1969, Archives of American Art, Washington, D.C.

9. Ann Hindry, ed., *Claude Berri rencontre Leo Castelli* (Paris: Renn, 1990), p. 98.

10. Leo Caselli, interview by Paul Cummings, AAA.

11. Lynn Zelevansky, "Dorothy Miller's 'Americans,' 1942–1963," *Studies in Modern Art* 4 (New York: Museum of Modern Art, 1994).

12. Frank Stella, interviews with Sidney Tillim and Alan Solomon, New York, 1969, Archives of American Art, Washington, D.C.

13. Leo Steinberg, interviews by author, New York, January 10, 2008.

14. Cy Twombly, interview by the author, New York–Paris, November 27, 2003.

15. Ivan Karp, interview by Paul Cummings, New York, March 12, 1969, Archives of American Art, Washington, D.C.

16. Ibid.

17. Ileana Sonnabend, interview by the author, New York, November 25, 2005.

18. Ibid.

19. Leo Castelli, interview by Paul Cummings, AAA.

20. Leo Castelli, interview by Andrew Decker, New York, May 22, 1997, Archives of American Art, Washington, D.C.

21. Dorothy Miller to Alfred Barr, December 18, 1959, Object Files, Painting and Sculpture Center, Museum of Modern Art.

22. Castelli invoice, Object Files, Painting and Sculpture Center, MoMA.

23. Leo Castelli to Dorothy Miller, February 2, 1960, Object Files, Painting and Sculpture Center, MoMA.

24. Internal memo, Dorothy Miller to Alfred Barr, February 8, 1960, Object Files, Painting and Sculpture Center, MoMA.

25. Internal memo, Dorothy Miller to Miss Dudley, November 2, 1960, Object Files, Painting and Sculpture Center, MoMA.

26. Internal memo, William C. Seitz to Alfred Barr and Dorothy Miller, January 19, 1962, Object Files, Painting and Sculpture Center, MoMA.

27. Moulin, *L'artiste, l'institution,* p. 49.

28. Leo Castelli, interview by Paul Cummings, AAA.

21. THE SOLOMON YEARS

1. Frank Stella, interview by the author, New York, January 28, 2008.

2. Matthew Israel, "A Magnet for the With-It-Kids," *Art in America* (October 2007): 72–83.

3. According to Robert Pincus-Witten, interview by the author, New York, January 31, 2008.

4. Ivan Karp, interview by the author, New York, April 26, 2007.

5. Frank Stella, interview by the author, New York, January 27, 2008.

6. Robert Pincus-Witten, interview by the author, New York, January 31, 2008.

7. Leo Castelli, interview by Paul Cummings, New York, June 18, 1969, Archives of American Art, Washington, D.C.

8. Christophe de Menil, interview by the author, New York, January 27, 2008.

9. Robert Pincus-Witten, interview by the author, New York, January 31, 2008.

10. Barbara Jakobson, interview by the author, New York, January 27, 2008.

11. Leo Castelli, interview by Paul Cummings, AAA.

12. Ann Hindry, ed., *Claude Berri rencontre Leo Castelli* (Paris: Renn, 1990), p. 81.

13. Alan Solomon, *Robert Rauschenberg* (New York: The Jewish Museum, 1963).

14. Brian O'Doherty, "Robert Rauschenberg," *New York Times,* April 28, 1963.

15. J. J., "Reviews and Previews," *ARTnews* 62, no. 2 (April 1963).

16. G. R. Swenson, "Rauschenberg Paints a Picture," *ARTnews* 62, no. 2 (April 1963), pp. 43–56.

17. Jasper Johns retrospective, Jewish Museum, February 16–April 12, 1964, Alan Solomon Papers, Archives of American Art, Washington, D.C.

18. Thomas B. Hess, "The Phony Crisis in American Art," *ARTnews* 62 (Summer 1963), 25–27.

19. Leo Castelli, interview by Paul Cummings, AAA.

20. Ibid.

21. Ibid.

22. James Mayor, interview by the author, New York, November 14, 2008.

23. Frank Stella, interview by the author, New York, January 28, 2008.

24. Ivan Karp, interview by Paul Cummings, New York, March 12, 1969, Archives of American Art, Washington, D.C.

25. Jim Rosenquist, interview by the author, New York, January 29, 2009.

26. Grace Glueck, "Art Rite—Opening Night," *New York Times,* December 13, 1964.

27. Castelli became Warhol's official gallerist in November, 1964, after the artist's attempt to show with Eleanor Ward did not work out.

28. Hindry, ed., *Claude Berri rencontre Leo Castelli*, p. 51.

29. Ibid.

30. Ibid.

31. Ibid.

32. Tom Wolfe, "Bob and Spike," in *The Pump House Gang* (New York: Farrar, Straus & Giroux, 1968), pp. 139–60.

33. Angela Westwater, interview by the author, New York, January 31, 2009.

34. Rosalind Krauss, interview by the author, Paris, July 26, 2008.

35. Frank Stella, interview by the author, New York, January 28, 2008.

36. Archives of Jean-Christophe Castelli.

37. Leo Castelli, interview by Paul Cummings, AAA.

38. Jasper Johns, interview by the author, Sharon, Conn., April 28, 2008.

39. Frank Stella, interview by the author, New York, January 28, 2008.

22. THE "BEATLES BIENNALE"

1. Robert Rauschenberg, interview by Alan Solomon, National Educational Television, February 21–22, 1966, Archives of American Art, Washington, D.C.

2. Leo Castelli, interview by Paul Cummings, New York, March 2, 1973, Archives of American Art, Washington, D.C.

3. Quoted in Calvin Tomkins, *Off the Wall: Robert Rauschenberg and the Art World of Our Time* (New York: Doubleday, 1980), p. 7.

4. Alan Solomon to Lois A. Bingham, n.d., Alan Solomon Papers, Archives of American Art, Washington, D.C.

5. Pierre Restany, "XXXII Biennale di Venezia, Biennale della Irregolarità," *Domus* (August 1964): 27–42.

6. Among the many accounts of these events, I would cite the article by Calvin Tomkins, "The Big Show in Venice," *Harper's* 230 (April 1965): 98–104, reprinted in *Off the Wall*, p. 7.

7. Diego Valeri, "La Biennale dei Beatles," *Il Gazzetino di Venezia*, June 24, 1964.

8. Ibid.

9. As Pierre Bourdieu puts it, the French and the Americans have long engaged in a "confrontation of two universalist imperialisms."

10. Restany, "XXXII Biennale," pp. 27–42.

11. *Paris–New York, 1908–1968* (Paris: Centre Georges Pompidou / Gallimard, 1992).

12. Alan Solomon Papers, AAA.

13. Donald Wilson to Alan Solomon, November 7, 1963, Alan Solomon Papers, Jewish Museum Archives.

14. Alan Solomon, "Report on the American Participation in the XXXII Venice Biennale 1964," June–October 1964, Archives of American Art, Washington, D.C.

15. Alan Solomon to Lois Bingham, December 9, 1963, Alan Solomon Papers, Jewish Museum Archives.

16. Alan Solomon to Donald Wilson, December 20, 1963, Alan Solomon Papers, Jewish Museum Archives.

17. Alan Solomon to Lois Bingham, n.d., Alan Solomon Papers, Jewish Museum Archives.

18. Solomon, "Report on the American Participation."

19. Gian Alberto Dell'Acqua, "Presentation," *XXXII Biennale de Venise,* pp. xvii–xxi.

20. According to Gian Enzo Sperone, interview by the author, New York, February 25, 2008.

21. Leo Castelli, interview by Paul Cummings, AAA.

22. Undated note by Alan Solomon, Alan Solomon Papers, Jewish Museum Archives.

23. According to Gian Enzo Sperone, interview by the author, New York, February 25, 2008, and Attilio Codognato, interview by the author, Venice, February 24, 2005.

24. See Peter de Ruiter, *A. M. Hammacher, Kunst als levensessentie* (Baarn, Netherlands: de Prom, 2000).

25. Sam Hunter, interview by the author, Princeton, N.J., February 25, 2008.

26. Milton Gendel, "Hugger-Mugger in the Giardini," *ARTnews* 63 (September 1964): 32–35.

27. Undated note by Alan Solomon on letterhead of the "XXXII Biennale di Venezia," Alan Solomon Papers, Jewish Museum Archives.

28. On August 3, 1964, Solomon wrote to Castelli: "I don't know whether I told you or not that I got a letter from Ileana saying that she had decided upon reconsideration that the statement about Paris and New York was not, after all, a tragic error. I have no idea what their subsequent experience have [*sic*] been which led them to change their minds; perhaps you have heard something about this and can tell me." Alan Solomon Papers, Jewish Museum Archives.

29. Paolo Rizzi, "Quelques mots avec le vainqueur, Rauschenberg qui explique ce qu'est le Pop Art," *Il Gazzetino di Venezia,* June 21, 1964.

30. Attilio Codognato, interview by the author, Venice, February 25, 2005.

31. Alan Solomon to Leo Castelli, August 3, 1964, Alan Solomon Papers, Jewish Museum Archives.

32. Willi Bongard, "When Rauschenberg Won the Biennale," *Studio International* 175 (June 1968): 288–89.

33. Gendel, "Hugger-Mugger," pp. 32–35.

34. Bongard, "When Rauschenberg Won," pp. 288–89.

35. Alan Solomon to Leo Castelli, August 3, 1964, Alan Solomon Papers, Jewish Museum Archives.

36. Ibid.

37. Restany, "XXXII Biennale di Venezia," pp. 27–42.

38. "Report on the American Participation in the XXXII Venice Biennale, 1964," 1964, Alan Solomon Papers, Jewish Museum Archives.

39. Jean-François Revel, "XXXIIe Biennale de Venise. Triomphe du Réalisme Nationaliste," *L'Oeil* (July 1964): 2–11.

40. Leo Castelli, Hermès notebook, September 4, 1963–June 30, 1964, archives of Jean-Christophe Castelli.

41. Francis Haskell, *Patrons and Painters: A Study in the Relations Between Art and Society in Baroque Italy* (New Haven: Yale University Press, 1980), p. 276.

23. THE FREE-SPIRITED TEENAGER AND THE DEVILISH IMP

1. The expressions used in the chapter title are borrowed from Robert Pincus-Witten and Michel Ragon, "Témoignages," in *Collection Sonnabend* (Bordeaux: Musée d'Art Contemporain, 1988), pp. 83–85. The epigraph is from the same source, p. 87.

2. Bill Ehrlich, interview by the author, New York, February 6, 2009.

3. Pincus-Witten and Ragon, "Témoignages," p. 86.

4. Ileana Sonnabend, interview by the author, New York, November 25, 2005.

5. Pincus-Witten and Ragon, "Témoignages," pp. 83–85.

6. Ileana Sonnabend, interview by the author, New York, November 25, 2005.

7. Serge Guilbaut, "Comment la Ville lumière s'est fait voler l'idée d'art moderne," in *Paris 1944–1954, Artistes, intellectuels, publics: la culture comme enjeu* (Paris: Autrement, 1995), pp. 45–60.

8. Michel Bourel, "Les galeries d'Ileana Sonnabend," in *Collection Sonnabend,* pp. 11–75.

9. Rodolphe Stadler to Jean-Pierre Moulin, "Galerie Stadler," *Cimaise,* no. 77, August–September 1966, p. 30.

10. Michael Sonnabend, interview by André Parinaud, in *Arts,* December 1964, p. 64.

11. Bourel, "La galerie d'Ileana Sonnabend," p. 20.

12. This alludes to the French critic Pierre Restany.

13. Antonio Homem Papers, Archives of American Art, Washington, D.C.

14. See Annie Cohen-Solal, "Sartre et les Etats-Unis," in *Sartre dans son siècle* (Paris: Gallimard, 2005).

15. Otto Hahn, "Pop art et happenings," *Les Temps Modernes* (January 1963): 1318–31.

16. Pincus-Witten and Ragon, "Témoignages," in *Collection Sonnabend,* p. 84.

17. Alan Solomon Papers, Jewish Museum Archives.

18. Alan Solomon to Lois A. Bingham, n.d., Alan Solomon Papers, Jewish Museum Archives.

19. Annie Cohen-Solal, *Painting American: The Rise of American Artists, Paris 1867–New York 1948* (New York: Alfred A. Knopf, 2001).

20. Alain Bosquet, "Trahison à Venise," *Combat* (June 23, 1964), Venice file, archives of Pierre Restany.

21. José Pierre, "Les Ravaudeuses contre le Pop," *Combat* (July 1964), Venice file, archives of Pierre Restany.

22. Michel Ragon, "Trahi par ceux qu'elle a lancés, mise en question à Londres, Venise et New York, L'Ecole de Paris va-t-elle démissionner?" *Arts* 969 (July 1–6, 1964), Venice file, archives of Pierre Restany. See also Gérald Gassiot-Talabot, "La panoplie de l'Oncle Sam à New York," *Art d'aujourd'hui* 47 (October 1964): 30; and Pierre Cabanne, "L'Amérique proclame la fin de l'Ecole de Paris et lance le Pop'Art pour coloniser l'Europe," *Arts* (June 24–30, 1964).

23. Alan Solomon Papers, Archives of American Art, Washington, D.C.

24. Alan Solomon Papers, Jewish Museum Archives.

25. Pierre Restany, "XXXII Biennale di Venezia, Biennale della Irregolarità," *Domus* (August 1964): 27–42.

26. Pierre Restany, "Paris n'est plus roi," *Planète* 19 (November–December 1964): 152–54, archives of Pierre Restany.

27. Pierre Restany Papers, Archives de la critique d'art, Châteaugiron.

28. Leo Castelli, interview by Paul Cummings, New York, June 18, 1969, Archives of American Art, Washington, D.C.

29. Hiroko Ikegami, *Dislocations: Robert Rauschenberg and the Americanization of Modern Art, circa 1964,* dissertation presented to the faculty of the Graduate School of Yale University, May 2007, p. 167.

30. Christo, interview by the author, New York, June 6, 2007.

31. Pincus-Witten and Ragon, "Témoignages," in *Collection Sonnabend,* p. 86.

32. Ibid., pp. 87–89.

33. Ibid., p. 83.

34. Ibid., p. 87.

35. Ibid.

36. Ibid., pp. 86–87.

37. Ibid., p. 87.

38. Ibid., pp. 83–85.

39. Ibid., pp. 88–89.

40. Ibid., pp. 89–90.

41. Raphaël Sorin, *Pop Art 68, Produits d'entretiens* (Caen: Raphaël Sorin/L'Echoppe, 1996), p. 9.

24. THE CONQUEST OF EUROPE

1. Pincus-Witten and Ragon, "Témoignages," in *Collection Sonnabend* (Bordeaux: Musée d'Art Contemporain, 1988), p. 86.

2. Alan Solomon to Ileana Sonnabend, August 4, 1964, Alan Solomon Papers, Archives of American Art, Washington, D.C.

3. On this subject, see Gary O. Larson, *The Reluctant Patron: The United States*

Government and the Arts 1943–1965 (Philadelphia: University of Pennsylvania Press, 1983); Charles A. Thomson and Walter H. C. Laves, *Cultural Relations and U.S. Foreign Policy* (Bloomington: Indiana University Press, 1963); see also Eva Cockcroft, "Abstract Expressionism: Weapon of the Cold War," *Artforum* (June 1974): 39–41.

4. Alan Solomon Papers, AAA.

5. Pontus Hulten to Leo Castelli, January 22, 1962, "Four Americans" Files, Box F1:14, Leo Castelli Gallery Records, Archives of American Art. In a subsequent letter to Castelli, dated April 9, 1962, Hulten added that the museum had received a government subsidy: see Hiroko Ikegami, *Dislocations: Robert Rauschenberg and the Americanization of Modern Art, circa 1964,* dissertation presented to the faculty of the Graduate School of Yale University, May 2007, p. 157.

6. Edi de Wilde to Alan Solomon, May 14, 1964, Alan Solomon Papers, AAA.

7. Udo Kultermann to Alan Solomon, May 22, 1964, Alan Solomon Papers, AAA.

8. Castelli-Panza correspondence, letters of April 7 and 15, 1959; January 30, April 15 and 23, and September 24, 1960; and March 20, 1961, Panza di Biumo Archives, Getty Foundation, Los Angeles.

9. Leo Castelli, interview by Paul Cummings, New York, June 18, 1969, Archives of American Art, Washington, D.C.

10. Giuseppe Panza di Biumo, interview by the author, Milan, June 27, 2007.

11. Gian Enzo Sperone, interview by the authors, New York, May 14, 2007.

12. Gian Enzo Sperone, interview by the author, New York, March 24, 2008.

13. Ettore Stottsass, Jr., "Pop et pas Pop, A propos de Michelangelo Pistoletto," *Domus* 414 (May 1964): 32–35.

14. Gian Enzo Sperone, interview by the author, New York, May 14, 2007, and February 25, 2008.

15. Leo Castelli, interview by Paul Cummings, AAA.

16. Giuseppe Panza di Biumo, interview by the author, Milan, June 27, 2007.

17. Ibid.

18. Ibid.

19. Gian Enzo Sperone, interview by the author, New York, May 14, 2007.

20. Ibid.

21. Leo Castelli to Panza di Biumo, March 22, 1962, Leo Castelli Papers, Archives of American Art, Washington, D.C.

22. Rudolf Zwirner, interview by the author, Berlin, July 2, 2007.

23. Ibid.

24. Ileana Sonnabend, interview by the author, New York, November 25, 2005.

25. Rudolf Zwirner, interview by the author, Berlin, July 2, 2007.

26. According to James Mayor, "Bryan Robertson at the White Chapel Gallery was immensely important, he was the only person in England doing anything like that, for fourteen years he was the only one, an amazing person but not a self-promoter. He left in 1969."

27. Raphaël Sorin, interview by the author, Paris, February 19, 2008.

28. Leo Castelli, interview by Paul Cummings, AAA.

25. THE "SVENGALI OF POP"

1. John Canaday, "Pop Art Sells On and On—Why ?" *New York Times,* May 31, 1964, p. SM7.

2. André Kaspi, "La 'Grande Société' (1964–1968)," in *Les Américains, 2: Les Etats-Unis de 1945 à nos jours* (Paris: Editions du Seuil, 1986), pp. 475–513.

3. Ivan Karp, interview by the author, New York, April 19 and 26, 2007.

4. Grace Glueck, "Art Rite—Opening Night," *New York Times,* December 13, 1964.

5. Canaday, "Pop Art Sells On and On."

6. Ivan Karp, interview by Paul Cummings, New York, March 12, 1969, Archives of American Art, Washington, D.C.

7. Donald Marron, interview by the author, New York, January 28, 2009.

8. Josh Greenfeld, "Sort of the Svengali of Pop," *New York Times,* May 8, 1966, p. SM18.

9. Ibid.

10. Leo Steinberg, interview by the author, New York, January 10, 2008.

11. "Is He the Worst Artist in the U.S.?" *Life* (January 31, 1964).

12. Ileana Sonnabend, interview with author, New York, November 26, 2005.

13. Robert Rosenblum, interview with Avis Berman, New York, November 20, 2004, Roy Lichtenstein Foundation.

14. Roy Lichtenstein, interview by Bici Hendricks, New York, December 7, 1962, Roy Lichtenstein Foundation.

15. Roy Lichtenstein, interview by David Sylvester, New York, 1966, Roy Lichtenstein Foundation.

16. Robert Storr, interview by the author, New York, April 4, 2008.

17. Ileana Sonnabend, interview by the author, New York, December 8, 2008.

18. Leo Castelli, interview by Paul Cummings, Archives of American Art, Washington, D.C. June 18, 1969.

19. Raphaël Sorin, "J'ai bien connu Andy Warhol," *Produits d'entretiens* (Bordeaux: Finitude, 2005).

20. Thomas Crow, *The Rise of the Sixties* (New York: Harry N. Abrams, 1996), pp. 84–85.

21. Christophe de Menil, interview by the author, New York, November 18, 2008.

22. Jim Edwards, David E. Brauer, Christopher Finch, and Walter Hopps, *Pop Art: US/UK Connections, 1956–1966* (Ostfildern-Ruit: Hatje Cantz, 2000), p. 44.

23. Henry Geldzahler, *Making It New: Essays, Interviews, and Talks* (New York: Turtle Point Press, 1994), p. 248.

24. Irving Blum, interview by the author, New York, May 3, 2007.

25. Ed Ruscha, interview by the author, New York, October 6, 2009.

26. Tony Shafrazi, interview by the author, New York, November 16, 2008.

27. Thomas Crow, "Saturday Disasters: Trace and Reference in Early Warhol," in Serge Guilbaut, ed., *Reconstructing Modernism: Art in New York, Paris and Montreal, 1945–1964* (Cambridge, Mass.: MIT Press, 1992), pp. 311–21.

28. Christophe de Menil, interview by the author, New York, April 4, 2007.

29. Jean-Jacques Lebel, "Constat d'accident," November 8, 1963, in *Warhol* (Paris: Ileana Sonnabend, 1964).

30. Alain Jouffroy, "White Car Crash," November 10, 1963, in *Warhol.*

31. Gérard Gassiot-Talbot, "Lettre de Paris," *Art International Magazine* 8, no. 2 (March 1964): 78.

32. John Ashbery, "Pop Artist's Horror Pictures Silence Snickers," *New York Herald Tribune,* January 15, 1964.

33. Andy Warhol, *America* (New York: HarperCollins, 1985), p. 176.

34. Peter Brant, interview by the author, New York, December 16, 2008.

35. Ibid.

36. Glenn O'Brien, interview by the author, New York, December 16, 2009.

37. Maurice Kanbar, interview by the author, New York, December 1, 2006.

38. Leo Castelli, interview by Paul Cummings, AAA.

39. Kay Bearman, interview by the author, New York, March 1, 2006.

40. Barbara Wool, interview by the author, New York, February 5, 2010.

41. David White, interview by the author, New York, March 27, 2007.

42. Ivan Karp, interview by Paul Cummings, New York, March 12, 1969, Archives of American Art, Washington, D.C.

43. David White, interview by the author, New York, April 8, 2008.

26. HENRY'S SHOW

1. Leo Castelli, interview by Paul Cummings, New York, October 1, 1969, Archives of American Art, Washington, D.C.

2. Frank Stella, interview by the author, New York, January 28, 2008.

3. André Emmerich, interview by the author, New York, June 7, 2007.

4. Christophe de Menil, interview by the author, New York, April 4, 2008.

5. Leo Castelli, interview by Paul Cummings, AAA.

6. Henry Geldzahler, interview by Paul Cummings, January 27 and February 16, 1970, Archives of American Art, Washington, D.C.

7. Ibid., p. 46.

8. Ibid.

9. Ibid.

10. See Thomas Crow, *The Rise of the Sixties* (New York: Harry N. Abrams, 1996), p. 92.

11. Henry Geldzahler, interview by Paul Cummings, AAA, pp. 39–42.

12. Hilton Kramer, "Art: No Sun in Venice. Biennale Turns Out as a Dismal Survey of Mediocre Contemporary Work," *New York Times,* June 18, 1966, p. 19.

13. For all quotes from the exhibition catalogue, see *Leo Castelli: Ten Years* (New York: Leo Castelli, 1967).

14. Robert Pincus-Witten, interview by the author, New York, January 31, 2008.

15. Calvin Trillin, interview by the author, New York, April 8, 2008.

16. *Who Gets to Call It Art?* Peter Rosen Productions & Muse Film and Television, 2005.

17. Robert Storr, interview by the author, New York, April 4, 2008.

18. Frank Stella, interview by the author, New York, January 28, 2008.

19. Henry Geldzahler, *New York Painting and Sculpture, 1940–1970* (New York: E. P. Dutton/Metropolitan Museum of Art, 1969), pp. 15–40.

20. Henry Geldzahler, *Making It New: Essays, Interviews, and Talks* (New York: Turtle Point Press, 1994), p. 211.

21. Thomas Hoving, *Making the Mummies Dance* (New York: Simon & Schuster, 1993), p. 206.

22. Henry Geldzahler, "The Sixties as They Were," in *New York Painting and Sculpture, 1940–1970,* The Metropolitan Museum of Art, 1969, pp. 337–56.

23. Leo Castelli, interview by Paul Cummings, AAA.

24. Philip Leider, "Modern American Art at the Met," *Artforum* VIII, no. 4 (December 1969).

25. Calvin Trillin, interview by the author, New York, January 31, 2008.

26. Henry Geldzahler, interview by the author, New York, April 8, 2008.

27. Henry Geldzahler, interview by Paul Cummings, AAA, pp. 45–46.

28. Ibid.

29. Frank Stella, interview by the author, New York, January 28, 2008.

30. Jim Rosenquist, interview by the author, New York, January 29, 2008.

31. Jasper Johns, interview by the author, Sharon, Conn., April 28, 2008.

32. Frank Stella, interview by the author, New York, January 28, 2008.

33. Robert Pincus-Witten, interview by the author, New York, January 31, 2008.

34. Calvin Trillin, interview by the author, New York, January 31, 2008.

35. Henry Geldzahler, interview by the author, New York, April 8, 2008.

36. Arnold "Arnie" Glimcher, interview by Paul Cummings, Archives of American Art, Washington, D.C., pp. 66–67.

37. Bil Ehrlich, interview by the author, New York, October 17, 2008.

38. Robert Storr, interview by the author, New York, February 6, 2009.

27. CASTELLI'S NETWORK AS THE HOUSE OF SAVOY

1. Joe Helman, interview by the author, New York, May 13, 2007.

2. Gian Enzo Sperone, interview by Paul Cummings, AAA, quoted in Joni Maya Cherbi, "Pop Art: Ugly Duckling to Swan," in *Outsider Art: Contesting Boundaries in Contemporary Culture*, ed. Vera Zolberg and Joni Maya Cherbo (New York: Cambridge University Press, 1997), pp. 85–97.

3. The expression comes from Raymonde Moulin, *L'artiste, l'institution et le marché* (Paris: Flammarion, 1992).

4. Barbara Jakobson, interview by the author, New York, May 21, 2008.

5. Donald Marron, interview by the author, New York, January 28, 2008.

6. Quoted in John Rublowsky, *Pop Art* (New York: Basic Books, 1965), p. 157.

7. Leo Castelli, interview by Paul Cummings, New York, April 19, 1970, Archives of American Art, Washington, D.C.; Cherbi, "Pop Art: Ugly Duckling," pp. 85–97.

8. Bil Ehrlich, interview by the author, New York, February 6, 2009.

9. Donald Marron, interview by the author, New York, January 28, 2008.

10. Wynn Kramarsky, interview by the author, New York, February 3, 2009.

11. Irving Blum, interview by the author, New York, May 3, 2007.

12. Leo Castelli, interview by Paul Cummings, AAA.

13. Ibid.

14. Joe Helman, interview by the author, New York, May 3, 2007.

15. Larry Aldrich, interview by Paul Cummings, April 25, 1972, Archives of American Art, Washington, D.C.

16. Bob Monk, interview by the author, New York, January 22, 2009.

17. Eli Broad, interview by the author, New York, February 6, 2009.

18. S. I. Newhouse, interview by the author, New York, January 12, 2009.

19. Donald Marron, interview by the author, New York, January 28, 2008.

20. Angela Westwater, interview by the author, New York, January 31, 2009.

21. Olav Velthuis, "Accounting for Taste," *Artforum* (April 2008): 308; and *Talking Prices: Symbolic Meaning of Prices on the Market for Contemporary Art* (Princeton, N.J.: Princeton University Press, 2005).

22. Dorothy Lichtenstein, interview by the author, New York, May 24, 2008.

23. Christie Brown, "Collecting Aspirational Art, Dealer Sells Look, Lifestyle: Are Clients Fashion Victims or Visionaries?" *Wall Street Journal,* March 27, 1998, quoted in Velthuis, "Accounting for Taste," p. 95.

24. Gordon Locksley, telephone interview by the author, May 8, 2007.

25. Joe Helman, interview by the author, New York, May 13, 2007.

26. Janie Lee, telephone interview by the author, May 18, 2007.

27. Jim Corcoran, interview by the author, New York, May 13, 2007.

28. Ibid.

29. John Coplans, interview by Paul Cummings, April 4, 1975, Archives of American Art, Washington, D.C.

30. Irving Blum, interview by the author, New York, May 3, 2007.

31. This was clearly understood by Calvin Tomkins, who in a *New Yorker* profile titled "A Good Eye and a Good Ear" (May 26, 1980) credited Castelli with both.

32. Gordon Locksley, telephone interview by the author, May 8, 2007.

33. Jim Corcoran, interview by the author, New York, May 13, 2007.

34. Janie Lee, telephone interview by the author, May 18, 2007.

35. Gemini G.E.L. (Graphic Editions Limited) is a publishing workshop in Los Angeles founded in 1966. Many of the artists Castelli represented, including Robert Rauschenberg, Jasper Johns, Roy Lichtenstein, and Richard Serra, produced works in collaboration with Gemini.

36. Bob Monk, interview by the author, New York, September 2, 2009.

37. The unfinished interior was itself a kind of blank canvas inspiring installations that could be set directly on the bare walls, floor, and even the staircase. The space was cavernous and lacked the most basic gallery amenities, including heat, as the first visitors noticed when at the opening in the early winter of 1968. But no matter: the inaugural exhibition that December, 9 at Leo Castelli, would prove momentous. Though neither Castelli himself nor Ivan Karp were at the show; Dorothy Lichtenstein oversaw it. (Leider, Philip, "The Properties of Materieals: In the Shadow of Robert Morris," *New York Times,* Dec. 22, 1968, D31.)

 Organized by the sculptor Robert Morris around his Anti-Form theses (as expounded in the previous April's issue of *Artforum*), the show was launched under a confusing misnomer. There were only seven, not nine, artists: William Bollinger, Eva Hesse, Stephen Kaltenbach, Bruce Nauman, Alan Saret, Richard Serra, and Keith Sonnier. The work of Giovanni Anselmo and Gilberto Zorio, mentioned on the invitation to the opening, was not delivered in time. The show was open for just a few hours daily over fifteen days (December 4–28), and relatively few people actually saw it, but its impact was long-lasting. Along with an exhibition entitled Earthworks at the Dwan Gallery, it would be remembered as a landmark of "Phase One," of "the adventure that has been called 'Minimal,' 'Object,' or 'Literalist' work," inspiring some of the earliest performance and installation art. All the pieces were concerned with process, the nature of materials, and the exhibition site itself, installed as they were directly on the warehouse's bare surfaces, defying conventions of presentation, form, and materials. Richard Serra splattered paint on the bare walls and floor, and scattered latex and rubber inside a designated space on the floor. Kaltenbach placed a large piece of felt on the floor, rearranging it every day to show the essential formlessness of his material. Bruce Nauman's piece incorporated audio recordings. And Rafael Ferrer, though not officially part of the exhibition, participated extemporaneously. He had collected 87 bushels of autumn leaves from Philadelphia with the help of some students, whom he instructed to distribute them mysteriously ("avoid interaction" he directed, "and move away rapidly") at various gallery sites: at the time of 9 they had filled an elevator at Dwan with leaves, arranged a large mound of them amid a Twombly show at Castelli's 4 East 77th Street location; and at the Warehouse, Ferrer's leaf blowers filled a staircase with what was left. (Rafael Ferrer in *9 at Leo Castelli,* 11, ed. Mario Garcia Torres [San Juan, Puerto Rico: Instituto de Cultura Puertorriqueña, 2009]).

38. Rudolf Zwirner, interview by the author, Berlin, July 2, 2007.

39. James Stourton, *Great Collectors of Our Time* (London: Scala Publishers, 2007), pp. 251–55.

40. Ibid., p. 254.

41. James Mayor, interview by the author, New York, November 15, 2008.

42. James Mayor, interview by the author, New York, May 24, 2008.

43. Linda Silverman, interview by the author, New York, May 22, 2008.

44. Baruch D. Kirschenbaum, "The Scull Auction and the Scull Film," *Art Journal* 39, no. 1 (Autumn 1979): 50–54.

45. Kirschenbaum, "The Scull Auction," pp. 50–54.

46. "Artists Decide They Should Share Profits on Resale of Paintings," *Wall Street Journal*, February 11, 1974, p. 1.

47. Joe Helman, interview by the author, New York, May 18, 2007.

48. Viviana A. Zelizer, *Morals and Markets: The Development of Life Insurance in the United States* (New York: Columbia University Press, 1979); Viviana A. Zelizer, *The Social Meaning of Money* (New York: Basic Books, 1994).

28. A PROMISED LAND SOUTH OF HOUSTON STREET

1. Christophe de Menil, interview by the author, New York, June 6, 2008.

2. Billy Sullivan, interview by the author, New York, November 25, 2008.

3. Ileana Sonnabend, interview by the author, New York, November 2005.

4. Barbara Pollack, "The Life and Death of SoHo's Gallery Cornerstone," *Village Voice*, July 11, 2000.

5. Barbara Jakobson, interview by the author, New York, June 11, 2008.

6. Grace Glueck, "4 Uptown Art Dealers Set Up in SoHo," *New York Times*, September 27, 1971.

7. Pollack, "The Life and Death of SoHo's Gallery Cornerstone."

8. Ileana Sonnabend, interview by the author, New York, November 25, 2005.

9. They had already found for Castelli his first warehouse-gallery at 108th Street.

10. In 1890, dry goods predominated. Cheney Brothers, one of the world's most prestigious silk manufacturers, worked out of 477–479 Broome Street, a cast-iron building designed by Elisha Sniffen. Mills & Gibb, the nation's largest novelty wholesaler, owned the John Correga building at the northeast corner of Grand and Broadway. W. G. Hitchcock & Co., a venerable import-export firm specializing in deluxe fabrics, had started in 1818 in the Griffin Thomas building at 453–455 Broome Street. And Jennings Lace, which had introduced Americans to Chantilly, Alençon, and other fine needlepoint, had its headquarters at 77 Greene. See Charles R. Simpson, *SoHo: The Artist in the City* (Chicago: University of Chicago Press, 1981), p. 114.

11. Robert Moses, *Public Works: A Dangerous Trade* (1970), quoted in Ric Burns and

James Sanders, *New York: An Illustrated History* (New York: Alfred A. Knopf, 2003), p. 530.

12. Stephen Koch, "Reflections on SoHo," in Alexandra Anderson and B. J. Archer, eds., *SoHo: The Essential Guide to Art and Life in Lower Manhattan* (New York: Simon and Schuster, 1979), pp. 9–17.

13. One of the first such organizations in America, it would save many urban treasures from blind destruction.

14. Sharon Zukin, *Loft Living, Culture and Capital in Urban Change* (New Brunswick, N.J.: Rutgers University Press, 1982), p. 117.

15. Ibid., p. 116.

16. *SoHo–Cast Iron Historic District Designation Report,* 1973, City of New York, John V. Lindsay, Mayor, p. 1.

17. Zukin, *Loft Living,* pp. 101–110. See also Arthur M. Schlesinger, Jr., *A Thousand Days: John F. Kennedy in the White House* (New York: Houghton Mifflin, 1965), pp. 669–79.

18. Park Place Art Research records and the Paula Cooper Gallery records, 1965–1998. Archives of American Art.

19. Keith Sonnier, interview by the author, New York, January 29, 2009.

20. Ibid.

21. Richard Kostenaletz, *SoHo: The Rise and Fall of an Artists' Colony* (New York: Routledge, 2003), p. 61.

22. Glueck, "4 Uptown Art Dealers."

23. Ibid.

24. From federal programs of the Kennedy years, like the NEA, to state and city councils endorsed by Governor Rockefeller and Mayor Lindsay.

25. Simpson, *SoHo: The Artist in the City,* p. 127.

26. Anderson and Archer, *SoHo: The Essential Guide.*

27. Dick and Barbara Lane, interview by the author, New York, March 3, 2009.

28. Donald Marron, interview by the author, New York, January 28, 2008.

29. Peter Schjeldahl, "Sculptors Make It Big Down in SoHo," *New York Times,* October 3, 1971.

30. Peter Schjeldahl, "The Malaise that Afflicts SoHo's Avant-Garde Galleries," *New York Times,* June 11, 1972.

31. Bob Monk, interview by the author, New York, September 2, 2009.

32. James Mayor, interview by the author, New York, November 14, 2008.

33. Tony Shafrazi, interview by the author, New York, November 16, 2008.

34. Angela Westwater, interview by the author, New York, February 6, 2009.

35. From Meryle Secrest, "Leo Castelli: Dealing Myths," *ARTnews* (Summer 1982): 66.

36. Jean-Christophe Castelli, interview by author, New York, September 25, 2008.

37. Tony Shafrazi, interview by the author, New York, September 25, 2008.

38. Barbara Jakobson, interview by the author, New York, November 16, 2008.

39. Janie Lee, telephone interview by the author, New York, May 18, 2007.

40. Barbara Jakobson, interview by the author, New York, June 5, 2008.

41. Robert Storr, interview by the author, New York, April 14, 2008.

42. Leo Castelli, interview by Paul Cummings, New York, January 16, 1975, Archives of American Art, Washington, D.C.

43. Debbie Taylor, interview by the author, New York, February 24, 2009.

44. Mimi Thompson, interview by the author, February 25, 2009, New York.

45. Debbie Taylor, interview by the author, New York, February 24, 2009.

46. Amy Poll-Schell, telephone interview by the author, March 9, 2009.

47. Morgan Spangle, interview by the author, New York, April 14, 2009.

48. Gian Enzo Sperone, interview by the author, New York, November 16, 2008.

49. Thomas B. Hess, "The Germans Are Coming! The Germans Are Coming!" *New York* (June 1974): 54.

50. Acconci's performance took place in January 1972, Kounellis's in 1975.

51. Antonio Homem, interview by the author, New York, May 26, 2008.

52. "Europe in SoHo," in *New York–Downtown Manhattan, SoHo* (Berlin: Akademie der Künste, 1976), pp. 34–103.

53. Mary Boone, interview by the author, New York, May 19, 2007.

54. Jeffrey Deitch, interview by the author, New York, March 20, 2009.

55. Larry Gagosian, interview by the author, New York, April 25, 2008.

56. Robert Pincus-Witten, interview by the author, December 12, 2009.

57. Bob Monk, interview by the author, New York, December 14, 2009.

58. Robert Pincus-Witten, interview by the author, December 12, 2009.

59. Dorothea Elkon, interview with the author, New York, December 11, 2007.

60. Daniel Templon, interview by the author, New York, May 28, 2007.

61. Mary Boone, interview by the author, New York, May 19, 2007.

29. BAD TIMES FOR LEO

1. Gian Enzo Sperone, interview by the author, New York, May 15, 2007.

2. James Mayor, interview by the author, New York, June 1, 2007.

3. Janie Lee, telephone interview by the author, May 18, 2007.

4. Ronnie Greenberg, interview by the author, New York, May 2, 2007.

5. Joe Helman, interview by the author, New York, May 13, 2007.

6. Laura de Coppet and Alan Jones, *The Art Dealers: The Powers Behind the Scene Tell How the Art World Works* (New York: Clarkson N. Potter, 1984), p. 102.

7. Janie Lee, telephone interview by the author, May 18, 2007.

8. Richard Feigen, telephone interview by the author, May 18, 2007.

9. Comment by Ronnie Greenberg, interview by the author, May 2, 2007.

10. Gian Enzo Sperone, interview by the author, New York, May 15, 2007.

11. Ibid.

12. Morgan Spangle, interview by the author, New York, April 4, 2009.

13. Irving Blum, interview by the author, New York, May 3, 2007.

14. Gian Enzo Sperone, interview by the author, New York, May 15, 2007.

15. Joe Helman, interview by the author, New York, May 13, 2007.

16. Ibid.

17. John Good, interview by the author, New York, December 15, 2009.

18. Bob Monk, interview by the author, New York, December 12, 2009.

19. Robert Pincus-Witten, interview by the author, New York, December 12, 2009.

20. Robert Sam Anson, "The Lion in Winter," *Manhattan Inc.,* December 1984, pp. 61–71.

21. Jim Corcoran, interview by the author, New York, May 13, 2007.

22. James Mayor, interview by the author, New York, November 14, 2008.

23. Tony Shafrazi, interview by the author, New York, November 16, 2008.

24. Pat Caporaso, interview by the author, Watermill, N.Y., August 5, 2008.

25. "Life Saver" refers to a necklace with a candy Life Saver that Rauschenberg had made for Ileana Sonnabend in the late fifties; ROCI (pronounced "Rocky"), an acronym for Rauschenberg Overseas Cultural Interchange, was a multiyear traveling exhibition to third-world countries that began in Mexico in 1985. The final celebration took place at the National Gallery in Washington, D.C., in 1991.

26. Arnie Glimcher, telephone interview by the author, January 24, 2008.

27. Tony Shafrazi, interview by the author, New York, December 17, 2009.

28. Julia Gruen and Gianni Mercurio, "Leo Castelli," The Keith Haring Show. La Triennale di Milano, Milan: 2005, 143–44.

29. Richard Blodgett, "Making the Buyer Beg—And Other Tricks of the Art Trade," *New York Times,* October 26, 1975, pp. 1, 32.

30. "Castelli Asserts His 'Right' to Set Prices," *New York Times,* Letters to the Editor, November 9, 1975, p. D33.

31. Dr. Bernard Brodsky, *New York Times,* November 26, 1975, MoMA Archives, Tomkins, II. A 76.

32. "About the Arts with Barbaralee Diamondstein," WNYC-TV, 1976.

33. Grace Glueck, "How Do You Price Art Works? Let the Dealers Count the Ways," *New York Times,* January 20, 1976, p. 66.

34. Quoted in Anthony Haden-Guest, *True Colors: The Real Life of the Art World* (New York: Atlantic Monthly Press, 1996), p. 169.

35. Kathleen L. Housley, *Emily Hall Tremaine Collection on the Cusp* (Meriden, Conn: The Emily Tremaine Foundation, 2001), p. 139.

36. Quoted in Housley, *Tremaine Collection,* p. 5.

37. Quoted in Housley, *Tremaine Collection,* pp. 139, 155.

38. Grace Glueck, "Painting by Jasper Johns Sold for Million, a Record," *New York Times,* September 27, 1980.

39. Leonard Lauder, interview by the author, New York, April 16, 2007.

40. Tom Armstrong, interview by the author, New York, February 27, 2009.

41. Arnie Glimcher, interview by the author, New York, October 17, 2008.

42. Tom Armstrong, interview by the author, New York, October 17, 2008.

43. Meryle Secrest, "Leo Castelli, Dealing in Myths," *ARTnews* (summer 1982), pp. 66–72.

44. Secrest, "Leo Castelli, Dealing in Myths."

45. Joe Helman, interview by the author, New York, May 13, 2007.

46. Jeffrey Deitch, interview by the author, New York, March 20, 2009.

47. Ibid.

48. Bob Monk, interview by the author, New York, December 14, 2009.

49. Today, he recalls, "Robert Mnuchin, whom I had known for years, introduced me to Larry. 'Robert is taking a sabbatical,' Mnuchin told Gagosian. 'Maybe he can work here,' Gagosian answered, before asking me, 'What could you do here?' 'Historical shows, working with museums,' I said. Larry was welcoming, correct, efficient. For three full years, I produced thirty historical shows: Jasper Johns's *Maps,* Brancusi, Yves Klein, Pollock, Rubens, Duchamp, for which academics were hired to write the catalogues." Robert Pincus-Witten, interview by the author, New York, December 12, 2009.

30. TRIBUTES, HONORS, A NAME CARVED IN HISTORY

1. Grace Glueck, "Leo Castelli Takes Stock of 30 Years of Selling Art," *New York Times,* February 5, 1987.

2. Susan Brundage and Patti Brundage, interview by the author, New York, June 6, 2007.

3. Agnes Gund, interview by the author, New York, March 14, 2008.

4. Ursula Helman, interview by the author, New York, May 12, 2008.

5. Bob Monk, interview by the author, New York, September 2, 2009.

6. Eli Broad, interview by the author, New York, February 6, 2009.

7. Peter Brant, interview by the author, New York, December 8, 2008.

8. Bil Ehrlich, interview by the author, February 6, 2009, New York.

9. Paolo Rumiz, "Castelli, viaggio sentimentale," *Il Piccolo di Trieste,* October 15, 1986.

10. Piero Kern, interview by the author, Trieste, May 2, 2005.

11. Stella Rasman, "Il Magnifico Triestino," *Il Piccolo di Trieste,* December 1, 1987.

12. Pietro Cordara, "Meglio di Kassel," *Il Piccolo di Trieste,* June 26, 1988.

13. Paolo Rumiz, "Intervista a Castelli, 'A Trieste dico grazie,' " *Il Piccolo di Trieste,* November 12, 1987.

14. Archives, Nadia Bassanese Gallery, Trieste.

15. Nadia Bassanese, interview by the author, Trieste, July 24, 2008.

16. Philippe Dagen, "Leo Castelli, prince des marchands," *Le Monde,* October 29, 1987.

17. Institut François Mitterrand Archives.

18. The scholars currently working on it include Barbara Rose, Judith Goldman, Nan Rosenthal, and Mark Rosenthal.

19. Paul Taylor, "Jasper Johns," *Interview* 20, no. 7 (July 1990), quoted in *Jasper Johns: Writings, Sketchbook Notes, Interviews* (New York: Museum of Modern Art, 1996), p. 251.

20. John Russell, "The Seasons, Forceful Paintings from Jasper Johns," *New York Times*, February 6, 1987.

21. Jack Kroll, "A Johns for All Seasons: Philadelphia Showcases an American Master," *Newsweek* (November 14, 1988): 82.

22. Michael Brenson, "As Venice Biennale Opens, Jasper Johns Takes the Spotlight," *New York Times*, June 27, 1988, p. C15.

23. Michael Brenson, "Jasper Johns Shows the Flag in Venice," *New York Times*, July 3, 1988, p. H27.

24. Steven Henry Madoff, "Venice Biennale: Calm Waters," *ARTnews* 87 (September 1988): 178–80.

25. Robert Hughes, "The Venice Biennale Bounces Back," *Time* (July 25, 1988): 84–85.

26. Vanina Costa, "Jasper Johns: l'art du réel," *Beaux Arts Magazine* 60 (September 1988): 54–63.

27. Pietro Cordara, "Meglio di Kassel," *Il Piccolo di Trieste*, June 26, 1988.

28. Tom Krens, interview by the author, New York, May 24, 2007.

29. Calvin Tomkins, *Off the Wall: Robert Rauschenberg and the Art World of Our Time* (New York: Doubleday, 1980), p. 282.

30. Morgan Spangle, interview by the author, New York, April 14, 2009.

31. William Grimes, "Kirk Varnedoe Is in the Hot Seat as MoMA's Boy," *New York Times Magazine*, March 11, 1990.

32. Grace Glueck, "Castelli Gives Major Work to the Modern," *New York Times*, May 10, 1989.

33. Agnes Gund, interview by the author, New York, March 14, 2008.

34. Robert Storr, interview by the author, New York, April 4, 2008.

35. See Robert E. Duffy, *Art Law: Representing Artists, Dealers, and Collectors* (New York: Practising Law Institute, 1977), p. 430, and Franklin Feldman, Stephen E. Weil, and Susan Duke Biederman, *Art Law: Rights and Liabilities of Creators and Collectors*, 1988 Supplement (Boston: Little, Brown, 1988), p. 289.

36. *MoMA Magazine*, Summer 1989, vol. 2 no. 1, p. 3, Museum of Modern Art Archives.

37. Peter Brant, interview by the author, December 12, 2009.

38. Letter to Annie Cohen-Solal, April 3, 2008.

39. John Russell, "Rauschenberg and Johns: Mr. Outside and Mr. Inside," *New York Times*, February 15, 1987.

40. Robert Storr, interview by the author, New York, April 4, 2008.

41. Susan Brundage, interview by the author, New York, June 6, 2007.

42. *The Leo Book: ICI Salutes Leo Castelli* (New York: Independent Curators International, 1997).

43. Archives of Jean-Christophe Castelli.

EPILOGUE

1. Larry Gagosian, interview by the author, April 25, 2008.
2. Angela Westwater, interview by the author, New York, January 31, 2009.
3. Akira Ikeda, interview by the author, New York, January 24, 2008.
4. David Mirvish, interview by the author, New York, March 21, 2009.
5. Jeffrey Deitch, interview by the author, New York, March 20, 2009.
6. Bob Monk, interview by the author, New York, January 22, 2009.
7. Keith Sonnier, interview by the author, New York, January 29, 2009.
8. Jim Rosenquist, interview by the author, New York, January 29, 2008.
9. Debbie Taylor, interview by the author, New York, February 24, 2009.
10. Bil Ehrlich, interview by the author, New York, February 6, 2009.
11. Betsy Baker, interview by the author, New York, January 26, 2009.
12. Glenn O'Brien, interview by the author, New York, December 16, 2008.
13. Bil Ehrlich, interview by the author, New York, February 6, 2009.
14. Wynn Kramarsky, interview by the author, New York, February 3, 2009.
15. Eli Broad, telephone interview by the author, February 6, 2009.
16. Peter Brant, interview by the author, New York, December 8, 2008.
17. Eli Broad, telephone interview by the author, February 6, 2009.
18. Morgan Spangle, interview by the author, New York, April 14, 2009.
19. Donald Marron, interview by the author, New York, January 28, 2008.
20. Bob Monk, interview by the author, New York, January 22, 2009.
21. Mimi Thompson, interview by the author, New York, February 25, 2009.
22. Jean-Christophe Castelli, interview by the author, New York, November 15, 2008.
23. Marika Keblusek, "Profiling the Modern Agent," in Hans Cools, Marika Keblusek, and Badeloch Noldus, eds., *Your Humble Servant: Agents in Early Modern Europe* (Hilversum, Netherlands: Uitgeverij Verloren, 2006).

INDEX

Page numbers in *italics* refer to illustrations.

ARCHIVES

Archives of the Pollock-Krasner House and Study Center, Springs, New York
Archives of American Art, Smithsonian Institution, New York
Archives of the Andy Warhol Museum, Founding Collection, Pittsburgh
Andy Warhol Foundation, New York
Getty Foundation, Los Angeles
Roy Lichtenstein Foundation, New York
Robert Rauschenberg Foundation, New York
Archives of the MoMA, New York
MoMA Painting and Sculpture Study Center, New York
Archives of the Jewish Museum, New York
Archives of the city of Monte San Savino
Archives of the city of Trieste
Archives of the Synagogue of Trieste
Archives of the Liceo Dante, Trieste
Archives of the Assicurazioni Generali, Trieste
Archives of the Banca Intesa, Milan
Archives of the city of Siklós
Centre Pompidou, Bibliothèque Kandinsky, Fonds Kandinsky, Paris
Archives Pierre Restany, Nantes
Archives Institut François Mitterrand, Paris

PERMISSIONS ACKNOWLEDGMENTS

Grateful acknowledgment is made to the following for permission to reprint previously published material:

Alfred A. Knopf: Excerpt from "To the Mountains in New York" and "What Appears to Be Yours" from *The Collected Poems of Frank O'Hara*, edited by Donald Allen, copyright © 1971 by Maureen Granville-Smith, Administratrix of the Estate of Frank O'Hara. Copyright renewed 1999 by Maureen O'Hara Granville-Smith and Donald Allen. Reprinted by permission of Alfred A. Knopf, a division of Random House, Inc.

ARTnews: Excerpts from "Seeing the Young New Yorkers" by Thomas Hess (*ARTnews*, May 1950), copyright © 1950 by *ARTnews*, LLC. Reprinted by permission of *ARTnews*.

Aufbau-Verlag GmbH: Excerpt from *Transit* by Anna Seghers, copyright © 2001 by Aufbau-Verlag GmbH, Berlin. Reprinted by permission of Aufbau-Verlag GmbH.

Farrar, Straus and Giroux, LLC: Excerpt from "Bob and Spike" from *The Pump House Gang* by Tom Wolfe, copyright © 1968, renewed 1996 by Tom Wolfe. Reprinted by permission of Farar, Straus and Giroux, LLC.

Maureen Granville-Smith: "To Larry Rivers" from *Poems Retrieved* by Frank O'Hara, edited by Donald Allen, copyright © 1977 by Maureen Granville-Smith. Reprinted by permission of Maureen Granville-Smith.

Marsilio Editori S.p.A.: Excerpts from *Giorgia e io: Un grande amore nella Trieste del primo '900* by Anna Fano, edited by Guido Fano, copyright © 2005 by Marsilio Editori® S.p.A., Venezia. Translated here by Annie Cohen-Solal. Reprinted by permission of Marsilio Editori S.p.A.

Annette Michelson: Excerpt from essay by Annette Michelson from *Leo Castelli: Ten Years* (New York: Leo Castelli Gallery, 1967). Reprinted by permission of Annette Michelson.

Barbara Rose: Excerpt from essay by Barbara Rose from *Leo Castelli: Ten Years* (New York: Leo Castelli Gallery, 1967). Reprinted by permission of Barbara Rose.

Leo Steinberg: Excerpts from essay by Leo Steinberg from *Leo Castelli: Ten Years* (New York: Leo Castelli Gallery, 1967), copyright © 1967 by Leo Steinberg. Reprinted by permission of Leo Steinberg.

Universal Limited Art Editions: Excerpt from "US" by Frank O'Hara from *Stones* by Larry Rivers and Frank O'Hara (Bay Shore, NY: Universal Limited Art Editions, 1960). Reprinted by permission of Universal Limited Art Editions.

The Wylie Agency LLC: Excerpt from essay by Calvin Tomkins from *Leo Castelli: Ten Years* (New York: Leo Castelli Gallery, 1967), copyright © 1967 by Calvin Tomkins. Reprinted by permission of The Wylie Agency LLC.

ILLUSTRATION CREDITS

A NOTE ABOUT THE AUTHOR

Annie Cohen-Solal was born in Algeria and earned a Ph.D. from the Sorbonne. She was cultural counselor at the French Embassy in the United States from 1989 to 1993 and has taught at New York University, as well as in Berlin, Jerusalem, and Paris (at the École des Hautes Études en Sciences Sociales). She is the author of *Painting American: The Rise of American Artists, Paris 1867–New York 1948*, and her acclaimed *Sartre: A Life* has been translated into sixteen languages. She is currently Visiting Arts Professor at New York University's Tisch School of the Arts. She lives in Paris; Cortona, Italy; and New York.

A NOTE ON THE TYPE

This book was set in Monotype Dante, a typeface designed by Giovanni Mardersteig (1892–1977). Conceived as a private type for the Officina Bodoni in Verona, Italy, Dante was originally cut only for hand composition by Charles Malin, the famous Parisian punch cutter, between 1946 and 1952. Its first use was in an edition of Boccaccio's *Trattatello in laude di Dante* that appeared in 1954. The Monotype Corporation's version of Dante followed in 1957. Although modeled on the Aldine type used for Pietro Cardinal Bembo's treatise *De Aetna* in 1495, Dante is a thoroughly modern interpretation of the venerable face.

Composed by North Market Street Graphics, Lancaster, Pennsylvania

Printed and bound by Berryville Graphics, Berryville, Virginia

Map of Leo Castelli's New York by Robert Bull

Designed by Maggie Hinders